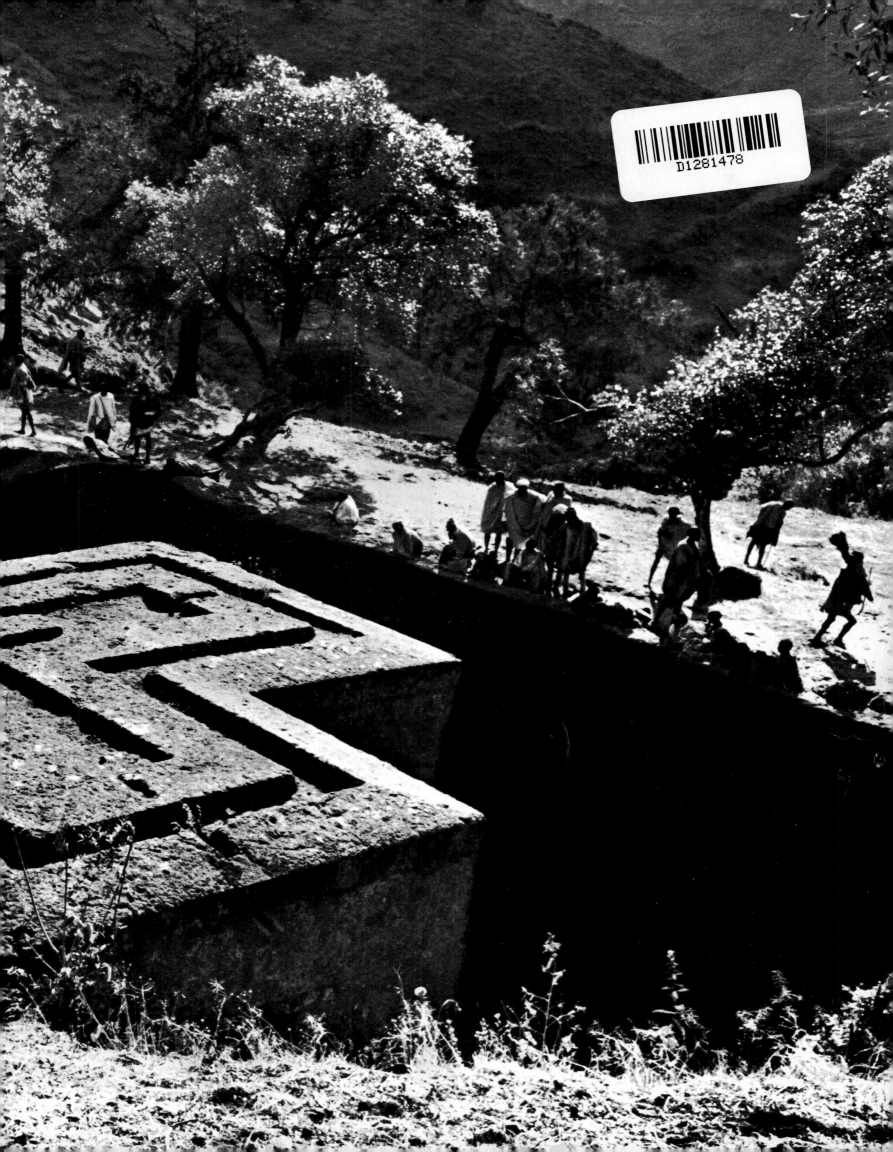

GEORG GERSTER

CHURCHES IN ROCK

Preface by the Emperor Ḫāyla Śellāsē I.

With Contributions by David R. Buxton
Ernst Hammerschmidt
Jean Leclant
Jules Leroy
Roger Schneider
André Caquot
Antonio Mordini
Roger Sauter

Translated by Richard Hosking

GEORG GERSTER

Churches in Rock

Early Christian Art in Ethiopia

PHAIDON

All rights reserved by Phaidon Press Ltd., 5 Cromwell Place, London SW 7
English translation © 1970 by Phaidon Press Ltd., London

Phaidon Publishers Inc., New York
Distributors in the United States: Praeger Publishers, Inc.
111 Fourth Avenue, New York, N. Y. 10003
Library of Congress Catalog Card Number 69–19806

All photographs in this book have been taken by the author
Text illustrations not otherwise acknowledged have been drawn by Albert Gerster

Designed by Ernst Scheidegger AG, Zürich
for W. Kohlhammer GmbH, Stuttgart, Berlin, Cologne, Mainz

Typography and Jacket: Ernst Scheidegger, Zürich
Offset reproduction: E. Sturm, Muttenz
Plates printed by J. E. Wolfensberger, Graphische Anstalt, Zürich,
under the supervision of Hans Frei
Text printed by W. Kohlhammer GmbH, Stuttgart
Bound by J. Stemmle & Co., Zürich
Printed in Germany and Switzerland

SBN 7148 1381 8

For Franziska and Thomas

Preface

The Empire of Ethiopia has a proud heritage of Christianity which dates back to the fourth century. Through wars, migrations, and the changing panorama of history, that Christian heritage has remained constant.

On the remote plateaus of Ethiopia our forefathers have left their monuments. From prehistoric paintings scratched on the walls of cold, damp caves to massive stelae raised by unknown peoples, our land is filled with reminders of our rich and varied past.

Nowhere, however, are we left with such impressive and awesome works as the sunken stone citadels in and around the mountains of Lālibalā and in the even more remote areas of the Empire. Now, in cooperation with the United Nations and the Ethiopian Archaeological Institute, scientists from many nations are working to uncover and preserve these monuments, to learn what they can about the men who carved them, and to record these treasures for the wonderment and admiration of the world.

We welcome this exciting book from the versatile Dr. Georg Gerster, whose artistic eye has recorded so beautifully the rock-hewn churches of our Empire.

We also welcome the discriminating visitor who comes to see these treasures for himself.

Ḥāyla Śellāsē I., Emperor of Ethiopia

Introduction

13 Hidden Treasures

23 *From the highest peak to the salt desert:* North Ethiopia at a Glance

25 *From the moon god to the Cross:* The Mountain Fortress of Christianity

Historical Elements of Ethiopian Culture

29 The Archaeology of Ethiopian Ancient History (By Jean Leclant, Paris)

36 The History of Christian Ethiopia (By Roger Schneider, Addis Ababā)

42 The Ethiopian Orthodox Church (By Ernst Hammerschmidt, Saarbrücken)

51 Ethiopian Architecture in the Middle Ages (By David R. Buxton, Cambridge)

61 Ethiopian Painting in the Middle Ages (By Jules Leroy)

The Monuments

71 *Ethiopia's oldest church:* The Monastery of Mount Dabra Dāmo

79 *Surprises in Tegrē:* The Excavated Churches of Qorqor and Dabra Ṣeyon

85 *A new Jerusalem in the mountains:* The Churches of Lālibalā, a Wonder of the World

92 I. Bēta Madḫanē 'Ālam and Bēta Masqal

95 II. Bēta Māryām

99 III. Bēta Dabra Sinā and Bēta Golgotā with the Śellāsē chapel

103 IV. The second group of rock sanctuaries

107 V. Bēta Giyorgis

109 *Secret of the cave churches:* Makina Madḫanē 'Ālam and Yemreḥanna Krestos

115 *Another monolithic church:* Gannata Māryām

119 *In the shadow of Lālibalā:* Bilbalā Čerqos

121 *Like the pearl in the oyster:* St Michael's of Dabra Salām

125 *Incomparable riches:* Five New Variations on the Theme of Rock Churches

131 *The cruciform basilica as excavated church:* Mikā'ēl Ambo and Čerqos Weqro

133 *Masterpiece of legendary kings:* The Excavated Church Abrehā Aṣbehā

135 *The climber's reward:* The Excavated Church of Guḥ

137 *The church under a straw hat:* Bethlehem in Gāyent

141 *Masterpieces of carving in the church treasury:* The Portable Altars of Ṭelāsfarri Eṣtifānos

References

144 Note on the transliteration of Ethiopian words

144 Bibliography

146 The contributors

147 Sources of the text figures

Introduction

Without the goodwill and co-operation of a large number of people and institutions, this book would not have appeared. D. R. Buxton, Cambridge, E. Hammerschmidt, Saarbrücken, J. Leclant, Paris, J. Leroy, Paris, and R. Schneider, Addis Ababā, not only contributed texts, but their concern and readiness to help were with the work from the start. In particular, the accuracy of the captions owes much to E. Hammerschmidt's knowledge of and passion for detail. A. Caquot of Paris translated all the inscriptions in the pictures and his command of Ethiopian hagiography proved invaluable. A. Mordini of Barga contributed decisively to the success of the venture with directions to locate the treasures, particularly those in the northern part of the country. R. Sauter of Aśmarā most unselfishly put his personal notes as well as the fruits of his comprehensive bibliographical research at my disposal. His infectious enthusiasm for the rock churches helped to overcome set-backs and disappointments. W. Sameh of Cairo helped me with excellent comparative material on the problem of the survival of Islamic decoration in Ethiopia. The debt of gratitude accumulated on seven trips to the highlands and subsequently in the evaluation and absorption of the observations made in the field can only be indicated, not repaid, in a list albeit incomplete:

Mamher Afa Warq, Lālibalā; F. Anfray, Addis Ababā; S. Angelini, Bergamo; L. Bianchi Barriviera, Rome; G. Bürgin, Schaffhausen; J. A. Gray, New York; Habta Śellāsē Tāffasa, Addis Ababā; D. T. Harris, Los Angeles; J. G. Holwerda, Aśmarā; N. B. Millet, New Haven, Conn.; Murad Kamil, Cairo; R. Rahn, Gland; Sergew Ḥabla Śellāsē, Addis Ababā; R. Schnyder, Zürich; Abbā Tawalda Madḫen Yosēf (†), Addigrāt; P. Zimmerman, Zürich.

Hidden Treasures

Since history began, man has been hammering, chiselling, drilling, burning and blasting into the rock. Daily needs, military factors, religious requirements, reactions and reflections have been the motive and reason for this insidious activity. Refuge from foe and climate was sought, communion with powers of the deep awaited, rest longed for, even the last rest, safe from the greed of grave robbers ... But in no other place on earth has intrusion into the hard, cold and dark produced anything comparable to Ethiopia's churches in rock.

Churches in rock. By this I mean grotto churches: churches built under protective roofs of rock (crags undercut by erosion), or wholly or partly built up in caves. I also mean excavated churches: churches carved from the rock, excavations rather than buildings, some concealed in the mountain, others with a façade. Or again semi-monolithic churches: excavated churches with three sides more or less free of the surrounding stone, and of course pure monolithic churches, worked out of a single piece of rock, free on all sides, churches carved with only the base rooted in the living rock, the wonders of the world of monuments (fig. 1).

Monuments. One should not connect this unfortunate word with the idea of lifeless remains. Almost without exception the rock churches are still in use for worship and hence are only open to the bare-footed visitor – the churchgoers, so the priests fear, might inadvertently tread on the angels which throng round consecrated places.

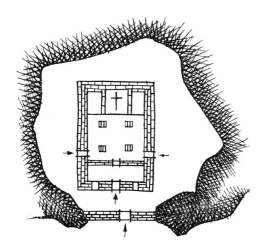

Fig. 1 Ground plans of a grotto church, excavated church, semi-monolithic and pure monolithic churches

Grotto churches, excavated churches, semi-monolithic and pure monolithic churches; in concept, the series seems to suggest advance, a progression from the primitive conditions of cave-dwellers to a golden age of rock church construction. However tempting this outline may be, it is rash and probably only half true, and I anticipate that the minds of those who succumb easily to the temptation of oversimplification will often be confused when confronted with some of the material in this book.

Ethiopia's churches in rock are unique. Yet despite this they are by and large unknown. At a time when man is beginning to travel to the moon it comes as a shock to learn how effortlessly discovery goes on, and yet how evidently unpardonable is the neglect of what is nearest. Only in 1966, in the province of Tegrē, I visited three dozen medieval rock churches which had never yet been seen by non-Ethiopians. None of the churches was more than a day's journey from the highway. I discovered St Michael's of Dabra Salām, an architectural gem, for example, two and a half hour's drive and one hour's walk from the main Aśmarā – Addis Ababā road. I do not

deny that St Michael's plays hide-and-seek very cleverly. A very plain outer church conceals the jewel of the inner church. But this cunning architecture is the exception. The churches waiting to be discovered are mostly not even as remote as Dabra Salām. I was apparently also the first non-Ethiopian to see inside the Church of the Four Living Creatures at Addi Čawa, and I photographed its badly endangered frescoes within sight of the highway five minutes away.

In Ethiopia, rock churches with unique frescoes and other treasures await anyone with good legs or not averse to the company of mules, who is not afraid of a climb up sometimes almost perpendicular mountain sides and whose lungs will still give him strength for art when they are puffing like a grampus in the thin air.

I spotted churches from the sky in a helicopter and small planes. And I tracked them down on the ground in month-long expeditions through the highlands. Mostly I travelled alone but sometimes with a great retinue in the company of a local ruler, with armed escort, rifle-bearers, hangers-on and outriders. On one trip hundreds of men with picks and shovels sent by the governor levelled the way for the vehicles, which were making hard work of the journey overland, and built crossings over streams without ado.

Of course expenditure does not guarantee results and one does not always take first prize. Not every church that one is the first to visit lives up to expectations. There are failures. And more annoying still, one is occasionally unable to make up one's mind whether one has got a winner or not. In many an Ethiopian sanctuary curtains set very close bounds to the visitor's curiosity, that is apart from the gifts, still often *ex-voto*, which have to be veiled and unveiled out of religious necessity. Or the visitor might have to resign himself to being left shut out. The caretaker has gone away on family business and nobody knows or wants to know when he will be back. The team from the Ethiopian Institute of Archaeology was denied entry into the church of Hawzēn (fig. 2), built in front of a cave, 'in their own interests', for, as the custodian did not tire of assuring them, an easily disturbed and dangerous snake lived in the inner sanctuary of the church. Neither the letter of introduction from Addis Ababā nor proof that the expedition's medical kit contained anti-snakebite serum made him change his mind.

Perhaps the hardest test to which the visitor will be put is, to retain the simile of a lottery, to have a winner which he can't take up. For seven hours I trudged with heavy pack to the important grotto church of Jammadu Māryām. The local inhabitants appeared to refuse me entry in quite a hostile way – the exact opposite of the attitude that the traveller in the highlands of Amhara can otherwise reckon on. They scornfully rejected the offer to help bear the cost of taxes as effrontery. Nevertheless by nightfall I got to the church-leader's compound. From far and wide until well into the night the herdsmen who had derided me came to touch the newcomer's arms and legs. The inspection turned out to their satisfaction and the remarks which they whispered to each other were quite complimentary. 'He's a strong man ...' But this recognition was as little use to me next morning as the chaotic identity papers from the capital. The church stayed shut. And as if that were not enough, a nun stationed herself nearby on a piece of rock and with shrill hysteria sang out the refrain 'Don't let him go in! Kill him!' Since the men grimaced as though they would take the frenzied singer at her word, I decided on retreat. There was no longer any question of the mules promised the previous evening. The way back was exactly the same as the way out, a seven-hour march with full pack under the scorching sun.

To be sure, unhappy experiences like this seldom happen, even far off the beaten track. The Christian highlanders of Ethiopia, though a proud and easily offended race, are nevertheless attentive and hospitable. So a wise traveller takes serious note of their intentions and feelings, whether those of a godly housewife or of a dastardly bandit.

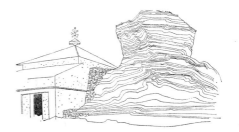

Fig. 2 The church of Hawzēn

Time and again, however, I found that the bandits at least were very easily put off. One evening, as I was camping near a church, a man, who came from nowhere and went the same way, plagued my interpreter with questions. The inhabitants were horrified at such freeness of speech. Didn't he know that he was giving intelligence to the local bandits? My companion was prepared for such expostulations. Quite casually he indicated our machine gun – a tripod in its canvas case – and hinted that we had to use it quite often with dire consequences for the assailant. The tale of the trigger-happy faranj (i. e. foreigner, originally Frank) was rumoured abroad like wild-fire and not a bandit bothered us.

The attention that the lone-ranging discoverer of churches arouses amongst the local population is usually of the most friendly kind. Should he travel at the time of the lesser rains in March or April he will spend the night in a hut erected specially for him. The villagers embarrass their guest with the best of what little they have. There is never lack of ṭallā (millet or barley beer) foaming in a drinking horn, or else he is offered the wholesome national dish, waṭ (a highly spiced goulash), and enjarā (sour flat bread made from ṭēf) to dip into it. And how often did my host part with the costliest drinks on the highland wine list – ṭajj (mead) and coffee! The faranj's presence is recompense enough – the curiosity aroused by a man from Mars could scarcely be greater. The sight of the Frank who, though he arrived riding on a mule, needs a machine to clean his teeth, brought whole villages to their knees. Of even greater interest than the electric toothbrush was the compact nylon sleeping bag – the inhabitants of the highlands, to whom 'night' and 'freezing' are words with the same connotation, were amazed that the foreigner could survive in it out in the open without cover at an altitude of 10,000 feet. Of course they soon found out that the nylon wasn't everything, and that the visitor was cheating. Once, awakened by a sound, as I was reaching for my torch to shoo off what I thought was a hyena, I just made out a figure disappearing into the dark. My supply of anti-freeze had disappeared too – the contents of a flask from which I would take comforting hot sips from time to time in sub-zero nights!

It was marvellous how, when good words failed with the caretaker, alms for the church or its guardian offered at the right time and in the right spirit often succeeded. The surprise and joy that the first glimpse of St Michael's of Dabra Salām evoked, for instance, immediately turned into disappointment and a feeling of frustrated effort. Gabra Giyorgis, the chief priest, seemed to know only one word of Italian: 'basta'. A single glimpse of the architrave in the inner church, 'basta'. Several days later when I returned to the church, a considerable gift of money predictably increased Gabra Giyorgis vocabulary. This time he repeated 'capitano' just as tirelessly, 'io capitano, commando io'. Immediately he issued the necessary instructions for me to be allowed to enter the inner church, without defiling the sanctuary or hurting the feelings of the faithful.

Should I beg indulgence for all my travel anecdotes? Must I give reasons why in my recollection of churches I discovered, the picture of individuals, companions and people who helped and hindered, made just as deep an impression on me as the frescoes and friezes? The same goes for animals. At all events I can never think of the Ethiopian Bethlehem without seeing chickens. I had overpaid so much for a hen that seemed cheap to me, and was a present for one of the company, that farmers besieged me with all the fowl in the neighbourhood and turned my departure from the holy Bethlehem into a flight from unholy clucking. And not just animals – but insects as well. When I was taking photographs at the church of Gannata Māryām ('The garden of Mary'), I had to lie down on the floor for a moment; afterwards, an attempt at judging the degree of torment to which the devil had subjected me yielded a total of four hundred flea bites!

'Are you a Christian?'

The priests used to take their stand with this question, in front of their churches, like the cherubims with the flame of the flashing sword before Paradise. All that was meant was that the stranger desirous of entry should not be a Moslem.

The fear of Islam is deeply entrenched in Ethiopian spirituality. Christianity belongs to the very identity of the Ethiopian kingdom and is the essential power behind its survival for a thousand years and more. But the statisticians, untroubled by the strength of tradition in upholding the state, currently expose the falsity of this identity. The numerical strength of the Christian subjects in proportion to the population of other faiths, especially the Moslem, is not without reason reckoned as a state secret. But the priests' anxiety in enquiring over the visitor's faith feeds less on the contemporary situation than on the historical memory of the Moslem invasion in the first half of the sixteenth century. From 1527 to 1543 the Somali hordes and Turkish auxiliaries under the Emir of Ḥarar devastated Christian Ethiopia. As Imām, Aḥmad ibn Ibrāhīm al-Ġāzi, nicknamed Grāñ, 'left-handed', by the Ethiopians, brought the Moslem south-east together in a holy war and for a time had three quarters of the Christian highlands under his control. Horror of the destruction that Grāñ, the Attila of East Africa, brought about with fire and sword in the name of Mohammed, persists to this day. Paintings in churches built since then show the prophet, on leave from hell, on his camel, bound hand and foot with chains of fire as the Virgin Mary parades his disciples before him with relish. In scenes of the Saviour's Passion the Ethiopian artists depict Christ's tormentors as Moslems, always careful to distinguish their turbans clearly from the ṭemṭem, the turban-like head-dress of the married Ethiopian priests and the dabtarās. (The Moslem wears his turban, which symbolises his shroud, over a skull-cap so as not to get it dirty, whereas the Ethiopian entitled to wear a ṭemṭem puts it straight on his head.)

It may come as a surprise to the visitor, to whom the priests talk just as much about Grāñ as about anyone living, to come upon decorative motives of unquestionably Islamic origin in many rock churches. They disprove the widespread assertion that Ethiopia was completely free from outside influence for a part of its history, and pose the problem of its external relations before Grāñ, and not just with the neighbouring Islamic states.

'Encompassed on all sides by the enemies of their religion, the Aethiopians slept near a thousand years, forgetful of the world by whom they were forgotten.' If that had been so, as Gibbon asserted in the eighteenth century, anything left for the theme of this book would be like setting a foundling on the doorstep of art criticism and architectural history. Relevant written sources are few and unreliable and the archaeologists have only just begun to scratch the surface of Ethiopia. Nevertheless there is scarcely any uncertainty about the basic pattern of medieval Ethiopia's relationships with the outside world and hence the course of possible influences.

Unquestionably the Nile valley played the most important part. The Nine Saints from Rome (Byzantium) – probably Syrian monks who were missionaries in Ethiopia and organised its monastic life – came there via Egypt. The Church of Ethiopia depended on the Coptic Patriarch of Alexandria for the appointment of its leading bishop, the Abuna. References to relations with the Christian kingdom on the Nubian Nile are surprisingly sparse. An Ethiopian ruler requested King George II of Nubia (969–1002) to intervene on his behalf with the bishops in Alexandria to secure the sending of an Abuna. On the eve of the invasion by Grāñ, Nubian envoys requested for their part that the Ethiopian Emperor should send priests for the churches which had been deserted after the break-up of the Christian Nile states. The king refused the request. It is likely, however, that Ethiopia had better neighbourly relations with its mid-Nile brothers in the faith, the professed defenders of the Patriarch of

Fig. 3 Cross from Nubia

Alexandria, than is indicated by chance surviving scraps of tradition, or equally chance discoveries like the hand-cross from Jebel 'Adda in Nubia (fig. 3).

Of course Ethiopia looked not only towards the Nile. The east coast of Africa, Ethiopia included, absorbed influences from Iran across the Persian Gulf and the discovery of the monsoons, described by the Alexandrian navigator Hippalos, considerably shortened the sea route to India, as direct sea traffic replaced the laborious coastal navigation. Ethiopia, by this time an important depot in the African branch of the trade route for incense, spices and cotton, could even look to the Indian subcontinent and beyond that to China. India only receded again into the distance for Ethiopia when the far-eastern and Indian trade transferred from the dangerous sea route to the land route, reopened at the time of the expansion of the Mongol Empire in the thirteenth century, and consequently increased the safety of the caravan routes in Afghanistan and Iran. However, it seems inconceivable to me that there was ever a weakening of Ethiopia's awareness of India as great as the fanciful European medieval notion of *India ulterior*.

Later, when Grāñ's invasion was repulsed with Portuguese help, Ethiopia renewed the old connections. The Jesuit missionaries administered their Ethiopian sphere of activities from the Order's base in Portuguese India (Goa).

Another of Ethiopia's windows on the world was the Ethiopian monastery in Jerusalem. The oldest extant letter of an Ethiopian ruler accompanied a present of gold from King Zar'a Yāqob in 1442 to his fellow countrymen who, on their pilgrimage to the heavenly Jerusalem, had been captivated by the earthly one. It bore words of admiration for the pilgrims who were undaunted by the perils of the long journey. Only on the assumption of the most tenuous and fluctuating relations with this outpost would he have had to provide the isolated Ethiopian community in Jerusalem with such abundant encouragements.

It is one thing to recognise possible routes of foreign influence but another to name those who bore them. A certain ornament perhaps found entry with a book of designs and its owner, a foreign craftsman. At all events, the emasculation of Islamic ornament points to its importation via many intermediate points with ever decreasing knowledge of its original association. In times of persecution, during the periodic outbursts of fanaticism of Egypt's Moslem rulers, Christian Egyptians, among them craftsmen, certainly sought refuge further up the Nile. And in their belongings they brought with them Islamic designs – the caliphs and sultans evidently employed Copts, highly regarded as masons and painters, in decorating their mosques and palaces. It must originally have been Copts who designed the prayer niches in the mosques along the lines of the apse of Christian churches. Yet one cannot avoid admitting that, strictly speaking, we cannot prove the settlement of Coptic refugees in Ethiopia however likely it may be, despite the likewise virtually certain supposition that Coptic craftsmen sometimes accompanied a new Abuna travelling from Egypt. The first of whom there is definite knowledge are Italian painters, apparently Venetians, in the fifteenth century. They brought a lasting influence to bear on the portrayal of the Virgin and Child. Thus, for example, King David I (1382–1411) exchanged four leopards, the skins of a gorilla and of a zebra and spices for two masons, a carpenter and a slater and a complete 'brigatta d'operai' under the supervision of an artist. In the seventeenth century the Portuguese missionaries also repeatedly refer to Indian craftsmen.

Though the routes and bearers of contact are acknowledged, the frequently thorny question of who, to whom and what, still remains. Outside Ethiopia there are two surviving monuments which exhibit the old wood and stone technique so characteristic of early Ethiopian architecture: the Church of St Sergius in Cairo and (as renovated in 608) the Kaaba in Mecca. Following a fire, the people of Mecca rebuilt the Kaaba

with wood from the wreck of a Byzantine ship according to the instructions of a man whom one source identifies as an unnamed Copt who lived in Mecca, whilst the rest of the Arab chroniclers explain him as being a Byzantine carpenter called Baqūm, a passenger on the wrecked ship. The Copts took the credit for Baqūm (as an arabicised *Pachomios*) and his achievement long before K. A. C. Creswell, with philological prodding from E. Littmann, turned the alleged Copt into an Ethiopian. According to his interpretation, Baqūm goes back to an abbreviation of 'Enbāqom, the Ethiopian form of Habakkuk. Certainly this wood and stone method is an ancient technique (fig. 4), apparently widespread in the eastern Mediterranean and ancient Near East, which most likely came to Ethiopia with an early wave of immigrants from South Arabia. If Creswell is right, then Arabia was only recovering what it had originally given.

The amazing likeness of this wood and stone technique to the multi-storeyed stelae (pls. 11–13) of Aksum, the capital of the ancient empire, and also to certain monolithic churches centuries later, soon leads to the question of external influences. 'Can it be chance that at the same time as wooden façades were being copied in stone in Ethiopia, wooden building types were also being copied in India and the amazing styles of the wood architecture of the ancient grotto temples were being reproduced in stone? Can it be chance if later ... shrines were hewn out of the rock, the like of which are only to be found in the almost contemporary "monolithic temples" of Brahmin workmanship in India?' D. Krencker, architect of the German Aksum Expedition asks rhetorically in 1913. To-day perhaps we have more knowledge with less understanding, the making of stone copies of buildings designed in wood, brick and reed is, in any case, a primitive architectural phenomenon. More recent testimony of Ethiopia's dependence on the rock architecture of India is therefore not very convincing.

Fig. 4 Painted faience plaque from Knossos displaying a wooden framework (after *Evans*)

The fact that there is only quite exceptionally any useful testimony as to the age of the ancient Ethiopian churches contributes to the uncertainty surrounding the interdependence of various features. Local attributions are of scarcely any use at all and the visitor to whom the priests reply 'mān yāwqall' (who knows?) to an enquiry after the founder of a sanctuary, is lucky as, between two visits the age of a church might sometimes, according to the priests' information, be altered by many hundreds of years. Or else they argued, in my presence, over which legendary king they should tell me was the founder. To complete the measure of confusion, Ethiopian kings from widely separated periods used the same throne names with the result that sometimes new traditions were apparently grafted on to old. It must also no doubt be borne in mind that old churches, forsaken and forgotten for a time, were re-discovered and put into use again with an appropriate adaptation of the legends of their foundation. For the average visitor the churches are a visual pleasure and their age matters little. But for the researcher who has to arrange his material in the right order so as to draw conclusions from it, it is different. Exact dates would be of the greatest interest to him. But there is an almost complete lack of these. The one single guaranteed date relates to the excavation of a church. According to the statement in an old manuscript preserved in the church, St Mary's of Dabra Ṣeyon in the province of Tegrē, discovered in 1966, was founded in the second half of the fourteenth century. There are three other churches which must have been carved from the rock before a particular year. A deed of gift from the time of King 'Amda Ṣeyon (1314–1344), kept on the spot, mentions the excavated church of St George of Māy Kādo in Tegrē, also discovered in 1966. Historical circumstances rule out the founding of the excavated church Endā Māryām Weqro in Tegrē any later than 1319. And a document in the archives of the Church of the Redeemer at Lālibalā mentions the visit of one Abuna Bartholomew in the year 1410. An over-confident statement derived from the

monuments alone hardly suffices to distinguish convincingly succession from mere proximity. Whilst in Europe the style of church building changed from Frankish to Romanesque and then to Gothic, Ethiopian architecture continued for nearly a thousand years with the forms it had acquired, carrying them on undaunted beyond the political decline of the kingdom of Aksum. This strange inertia makes attempts (such as D. R. Buxton's) to lay down a sequence of form and development, at least for single architectural features, even more difficult. The researcher engaged upon specific stylistic developments is possibly even more at a loss when faced with the frescoes in the rock churches, though for exactly opposite reasons. The chameleon-like highly local folk art, which admittedly claims Byzantine origins, is in clear contrast with the stagnation in architecture, and this heritage survives from church to church with varying quality but with many outstanding examples, unfettered by any obligatory court style. Both the beginning and end of the rock church architecture in Ethiopia lie in darkness, as do the motives for setting these sanctuaries in the rock. In spite of this persistent lack of knowledge, the finds in Tegrē, of which this book gives a first glimpse, have substantially improved our position, and, in the historical landscape of Christian Ethiopia, the Lālibalā group no longer appears quite so surprising to the researcher as a few years ago. The area of the rock churches – the main area of settlement of the two Christian nations, the Amhara and the people of Tegrē – that is the northern highlands – has gained a new centre of gravity. And there are indications of more.

I do not want to contrast a tedious over-abundance with the former paucity. For every church I deal with here, I am omitting three that have little to contribute to the subject. To have wished to indulge in the fetish of completeness would in any case have been premature. Hundreds of rock churches from the Middle Ages still await discovery, or at least someone to make a survey of them for the first time, copy or photograph their murals and make a historical study of their construction.

One may rightly query the aptness of the term 'Middle Ages' to the course of Ethiopian history. On the other hand, Grāñ's devastation does place a huge gap at the beginning of the modern period, at least as far as Ethiopia's monumental buildings are concerned. After Grāñ's death the heyday of the Christian kingdom was over, vast stretches of land lay desolate, settlements were burnt to the ground, priests and monks murdered and most of the buildings in the open plundered and burnt. Possibly even more decisive was the paralysing impression of the complete loss of the native Christian heritage, brought about by the destruction of venerable shrines such as the coronation cathedral of Aksum. Nevertheless the impression was deceptive. Numerous rock churches survived the onslaught of Islam. Not only did the material from which they were made preserve them but their remoteness and obscurity were even more effective allies against Grāñ's hordes.

Ethiopia's centuries of isolation have up to now obscured our knowledge of this highland oasis of Christian culture, more, they have also weakened to an alarming degree the desire for knowledge. I can find no other way of explaining the yawning gaps in our awareness of eastern Christian art and architecture which are so painfully obvious to-day.

The Italian scholar A. Mordini has pleaded with his colleagues for years for a census, a complete inventory of all medieval Ethiopian monuments. His files contain the names and approximate location of more than *fifteen hundred* churches. The book before you originated in reply to his appeal, as an attempt to formulate the problem visually for the first time to its full extent, and to make known all the important monuments, including many not previously noted. It is a timely undertaking, since even modern architecture, having cast its net so wide, is once again occupied with underground and crypt churches.

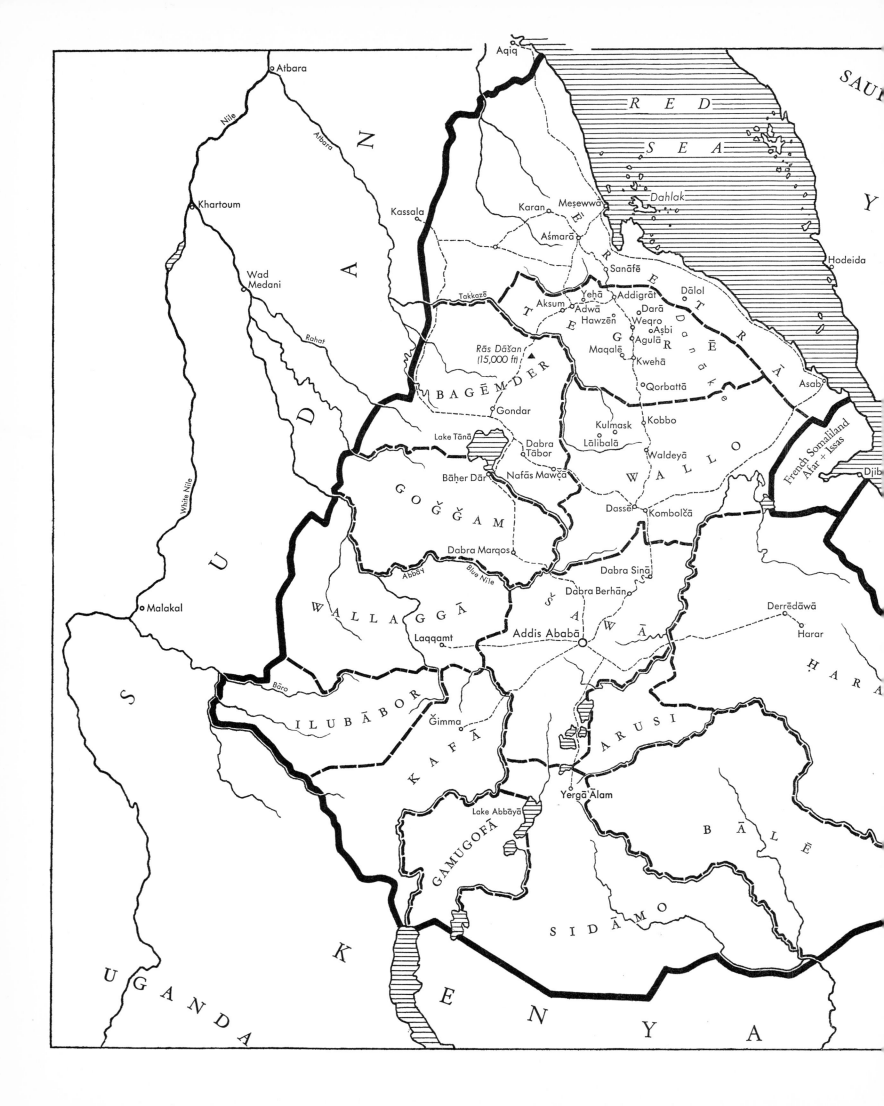

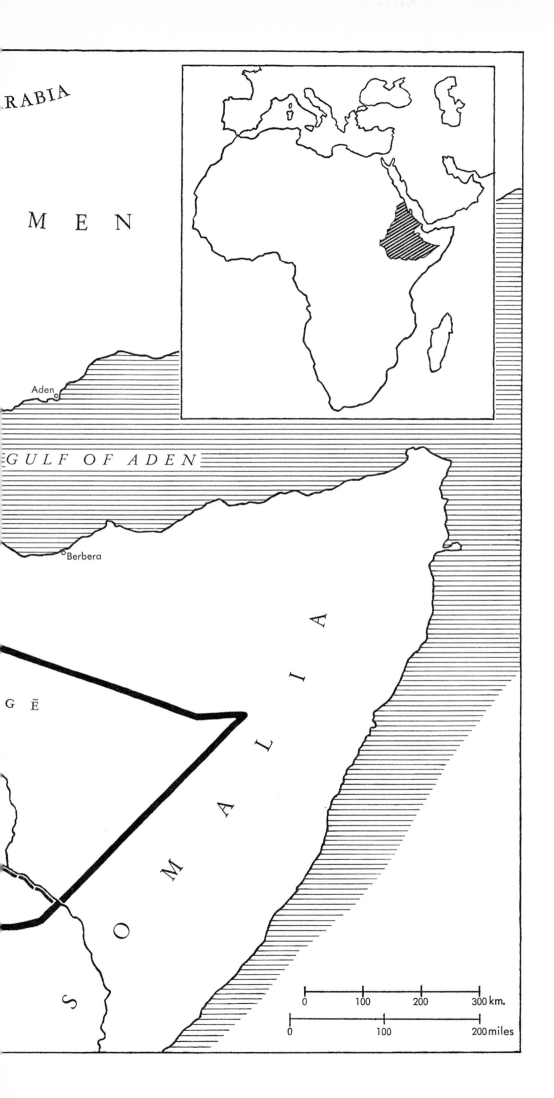

Ethiopia
and its provinces

RABIA

M E N

GULF OF ADEN

Aden

Berbera

G Ē

S O M A L I A

| 0 | 100 | 200 | 300 km. |

| 0 | 100 | 200 miles |

The main emphasis of the map lies on the northern highlands, the kernel of the ancient empire, the habitat of the Christian Amharas and Tigreans, the area of the rock churches. (Drawn by Anton Zell)

It is the eleventh hour for the inventory of the medieval churches of Ethiopia. In many places the old native phonoliths (fig. 5) are still in the service of the church. But progress demands its banal due, with a growing number of cast bells, or indeed any bit of clanging scrap. And not just with bells. Scholars deplore the building of five new churches in the old Ethiopian style of architecture in Tegrē and Ēretrā alone (Aśmarā, Yeḥā, Libānos in Ḥam, Arāmo, Gunā-Gunā), the funds for which might have helped save the group of freestanding structures which can be counted on the fingers of both hands and are fast decaying through lack of money for maintance. In the excavated churches, the colour is crumbling from the weathering rock. And those who use them have no idea of their artistic value. The superintendent of St Michael's of Dabra Salām, whom I asked to clean the spiders' webs from a fresco (since I wasn't myself allowed to set foot in that part of the church), approached it with a coarse twig broom – not giving a thought to what paintings might be brushed away – had I not forestalled his purpose.

Help that doesn't come soon comes too late. Mordini is expecting aid from the cultural organisation of the United Nations – UNESCO, faithful handmaid of rescue work on the Nubian Nile, should make an appeal to the cultural brotherhood of the nations for Ethiopia too. After all, the outlay in simply talking about the Nubian campaign in conferences would alone suffice for financing the job in Ethiopia. Or why not rely on some private Maecenas or foundation? Why not count on the enthusiasm of young, competent architects, surveyors, photographers and restorers who, in return for pocket money and expenses, would compile in the field a scientific catalogue of the monuments, and carry out the most urgent tasks of conservation with the aid of the most modern methods, especially photogrammetry? There is disproportionately little money but very much enthusiasm to call upon, so that nothing of the whole Christian heritage should perish before it has even come to our knowledge.

Fig. 5 Ethiopian phonoliths

Selected Sources
(for full references see page 144)

Islam in Ethiopia: Trimingham.
Christian Nubia: Monneret de Villard, *Storia . . .;* Gerster, *Nubien;* Michalowski, *Faras.*
The letter to the community in Jerusalem: Tekle Tsadike Mekuria (Takla Ṣādeq Makuriya).
The Indian connections: Littmann, *Indien . . .;* Monneret de Villard, *La Madonna . . .;* Raunig.
The rebuilding of the Kaaba: Creswell, *The Kaʿaba . . .*
On building wooden prototypes in stone: *Deutsche Aksum-Expedition* vol. 2.
On the census of Ethiopian monuments: Mordini, *L'architecture chrétienne . . .,* and *La reconnaissance . . .*

North Ethiopia at a Glance

Ethiopia rises from North Africa's steppes and deserts like a mighty cliff-faced island. Layers of volcanic rock lie either directly on their crystalline substructure or over layers of limestone and sandstone, and above them tower the ancient craters. Repeated eruptions and insatiable erosion have fretted the elevated areas and mountain bastions into a frenzy of eyries, table-mountains, terraces, ledges, and towers of efflorescent lava.

The range of high mountains in the north, the heart of the ancient kingdom, the country of the Christian Amharas and Tigreans and the area of the rock churches contrasts with the so-called Somali plateau in the south-east and the wooded highlands in the south-west. The highest point of the northern area is in Samēn at Rās Dāšan, Ethiopia's highest mountain, (over 15,000 ft). As one expects near the equator, the yearly variation in average temperature is relatively slight compared with the daily variations (up to 68° F). The rainfall, 40–80 inches per annum, falls mainly during the season of the big rains, from June to September, and everywhere the wildly carved mountains are evidence of the eroding effect of the monsoon. Furrows scoured in the valley walls at the source of the Abbāy and the Takkazē highlight to what extent Egypt is the gift not of the Nile but of Ethiopia, or rather Ethiopia's topsoil. Despite the altitude, only a little of the precipitation falls as a solid, and then mostly as hail, and only on the shaded slopes near the peak of Rās Dāšan does one find occasional small patches of old snow.

Agriculture and cattle-herding make a decisive impression on the area where the Christian highlanders live. Yet the agricultural topography of the countryside owes less to the differences in rainfall than to the gradation of temperature according to altitude. The floors of the deep-cut valleys where vegetation preferring a warmer climate grows – up to about 6,000 ft – is called the Qwallā. Amharas and Tigreans avoid the hot malarial qwallā. They prefer the temperate Waynā Dagā (vine highlands), the zone between about 6,000 ft. and 8,000 ft. This is where ţēf (Eragrostis abyssinica) grows and has pre-eminence over wheat, barley, sorghum, oats and maize. It is a species of small-seeded grass which outside Ethiopia is only cultivated in South Arabia. From it enjārā, the basic ingredient of the highland diet, is made. The highland farmer, essentially a grower of cereal with only limited interest in legumes and vegetable oil crops, values a plot of ground according to its suitability for growing ţēf. The upper limit for its cultivation corresponds mostly to the upper limit of the waynā dagā. In the moderately cold Dagā which lies above, barley and wheat fields predominate because of sporadic night frosts during the period of cultivation. In Ethiopia the age-old hook-plough (ard) (fig. 6) of the highland farmer furrows the rich volcanic soil to an altidude of nearly 13,000 ft.; it is the only area in tropical Africa which even in the colonial period knew the plough as well as the hoe. Above the upper limit of cultivation begins the Čoqā, the cold upper mountain zone with pasture land, a realm of wooded heath, giant globe-thistles (Echinops giganteus) with heads bigger than tennis balls on swaying stalks and giant stem-lobelias (Lobelia rhynchopetalum).

Unfortunately there are also marked indications of serious deforestation caused by man and beast over thousands of years. This, in combination with the violent summer rains, has caused the appearance of the characteristic symptoms of the cultivated steppes: the deterioration of the local climate, damage to the water economy and acceleration of erosion.

Fig. 6 Ethiopian hook-plough (ard)

1 The mountains of Samēn are the highest in the northern highlands and indeed in all Ethiopia. Samēn's contour is extremely steep. A twenty-five mile profile from the middle peak of Rās Dāšan to the valley of the Takkazē shows a difference in altitude of 10,800 ft. The precipitous massifs and rough mountain plains used to serve the Ethiopian kings in times of trouble as places of retreat and deployment. Today these nooks and crannies protect, along with herds of Gelada baboons (Theropithecus gelada), two animals threatened with extinction: the Abyssinian wolf (Simenia simensis) and the Abyssinian ibex (Capra ibex waliae). Settlement and cultivation keep to the ledges and terraces.

2 A settlement with strip cultivation, perched on a table-mountain in Tegrē. The farmers till the soil right up to the edge of the precipice. The houses with flat turf roofs are farmsteads. The fences are made of wickerwork or dry-built walls. The women often pay for the advantage of a protected position on the ambā by having a long way to go for water. The division of the fields into narrow strips is typical of Tegrē. It saves costly surveys when further subdivision of the plot is necessary, through inheritance for instance.

3 The meandering tributaries of the Blue Nile swell into an impassable barrier in the rainy season. Yawning valleys split the highlands into separate isolated parts. Before the building of the first bridge in the seventeenth century, the high waters at times practically cut off Gojjām, a highland area surrounded by a huge bend in the Nile, from the rest of the Amhara highlands, for months on end.

4 Over the mountains, the cord of highway between Kwehā and Dassē traces calligraphic designs on the landscape. A modern church with a corrugated iron roof glints from its coppice. The church groves are the depressing remains of formerly densely wooded land, the last places of refuge for dozens of species of birds. For man they are oases of luxuriant fruitfulness when all around the cultivated steppes are burning up and withering away at the height of the dry season.

5 A swirl of colours in the desert of salt. This is the helicopter view of the domed top of Mt Dālol in the Danākel depression, a branch of the great rift valley of Africa. Hot springs leave a deposit of salts and the colours – even the yellow, which is suggestive of some sulphurous efflorescence – are due to a certain iron content. Each of the hot springs is active for about a month and as they become quiescent, their deposits slowly lose their colour.

6 The edge of the salt mountain of Dālol has been worn away by periodic rain. A gypsum cap protects the striped salt layers from falling apart. The potash deposits in the Danākel depression amount to many hundreds of million tons. At present they are being worked by an American company. The salt plains surrounding Mt Dālol lie 400 ft. below sea-level. Here caravans get their supplies of cut salt bars for the salt-hungry mountain settlements. To this day salt is still valid currency in out-of-the-way markets. The hell of the salt desert, glistening with the heat, is a perfect foil for the cool damp highlands and experience of it sharpens the senses for their island remoteness.

Selected Sources

On the Geography of North Ethiopia: Stiehler; Werdecker, *Untersuchungen* ... and *Geographische Forschungen* ...; Troll; Simoons; Kuls; Lipsky; Hammerschmidt, *Äthiopien*.

Strip cultivation in Tegrē: Hövermann.

The zoology of Samēn: Brown.

Dālol: exchange of letters with the Ralph M. Parsons Company, Los Angeles.

1 The mountain world of Samēn: the highest part of the northern highlands and indeed of Ethiopia.

2 Settlement with strip cultivation on a table-mountain in Tegrē: The farmers till the soil right up to the edge of the precipice.

3 Meandering tributary of the Blue Nile: in the rainy season it swells into an almost impassable barrier.

4 Calligraphy of the road through the mountains: the cord of highway between Kwehā and Dassē.

5 A swirl of colours in the desert of salt: helicopter view of the domed top of Mt Dālol in the Danākel depression.

6 The edge of the salt mountain of Dālol worn away by periodic rain: a gypsum cap protects the striped salt layers from falling apart.

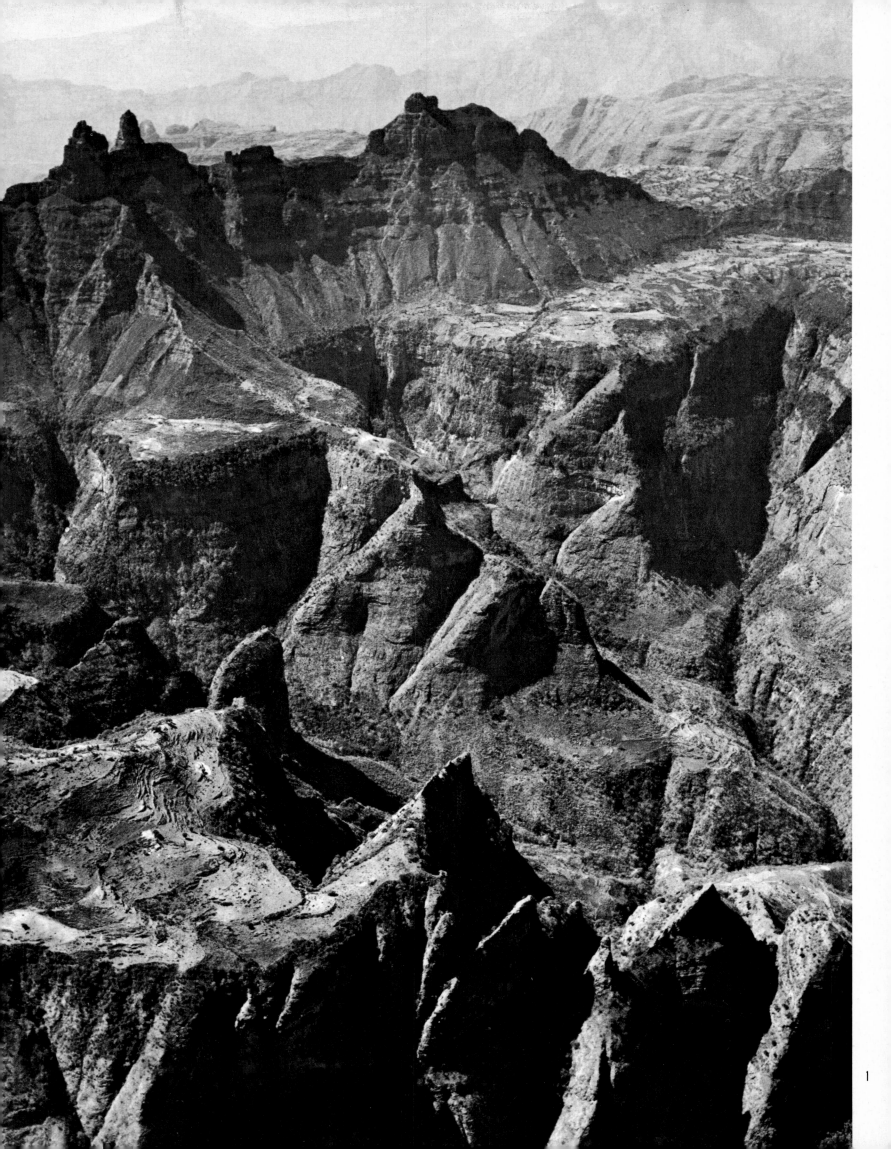

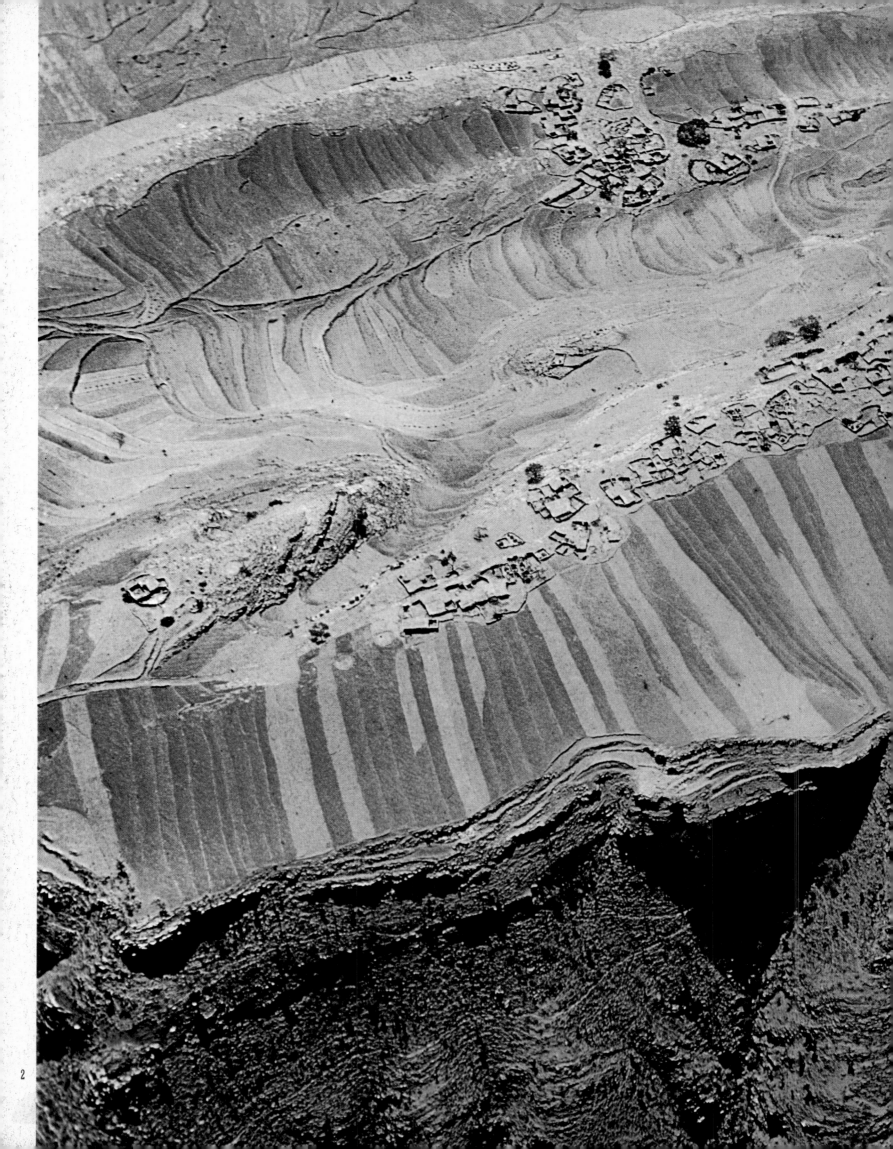

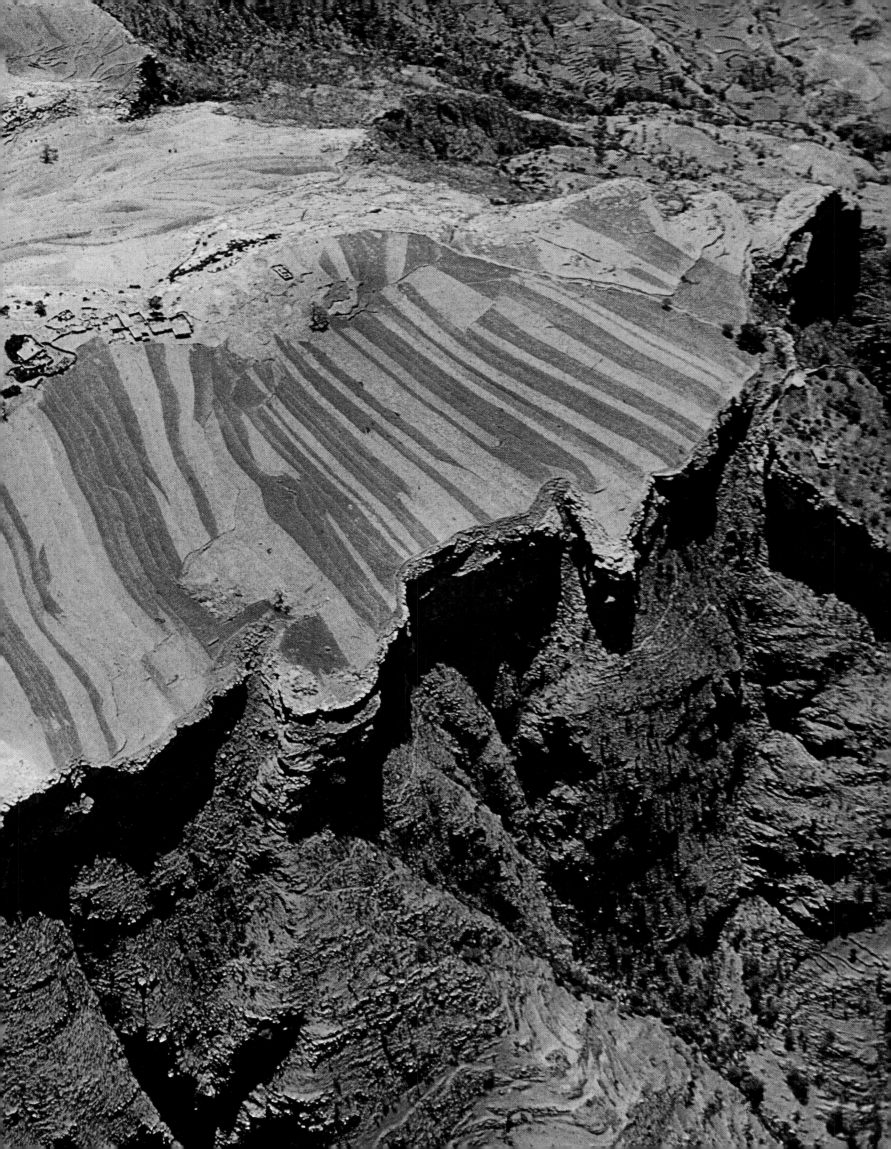

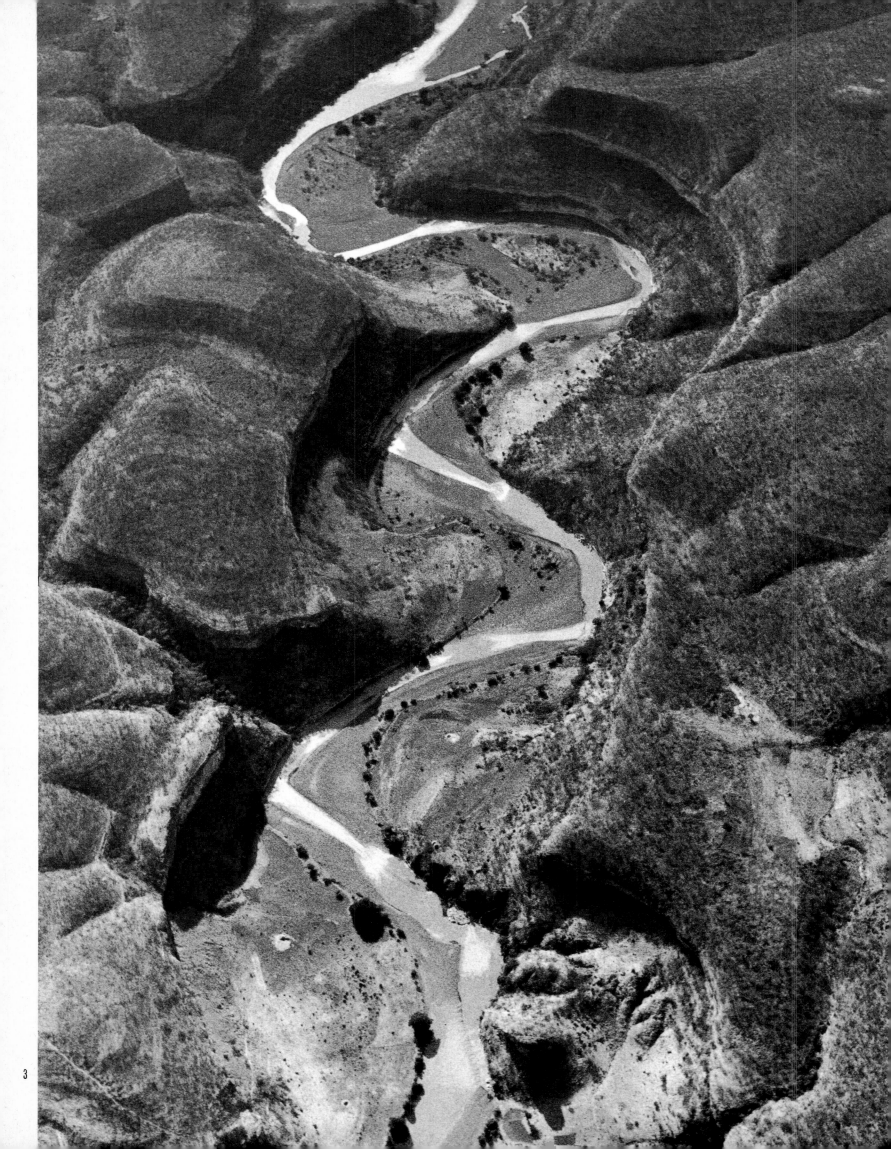

3

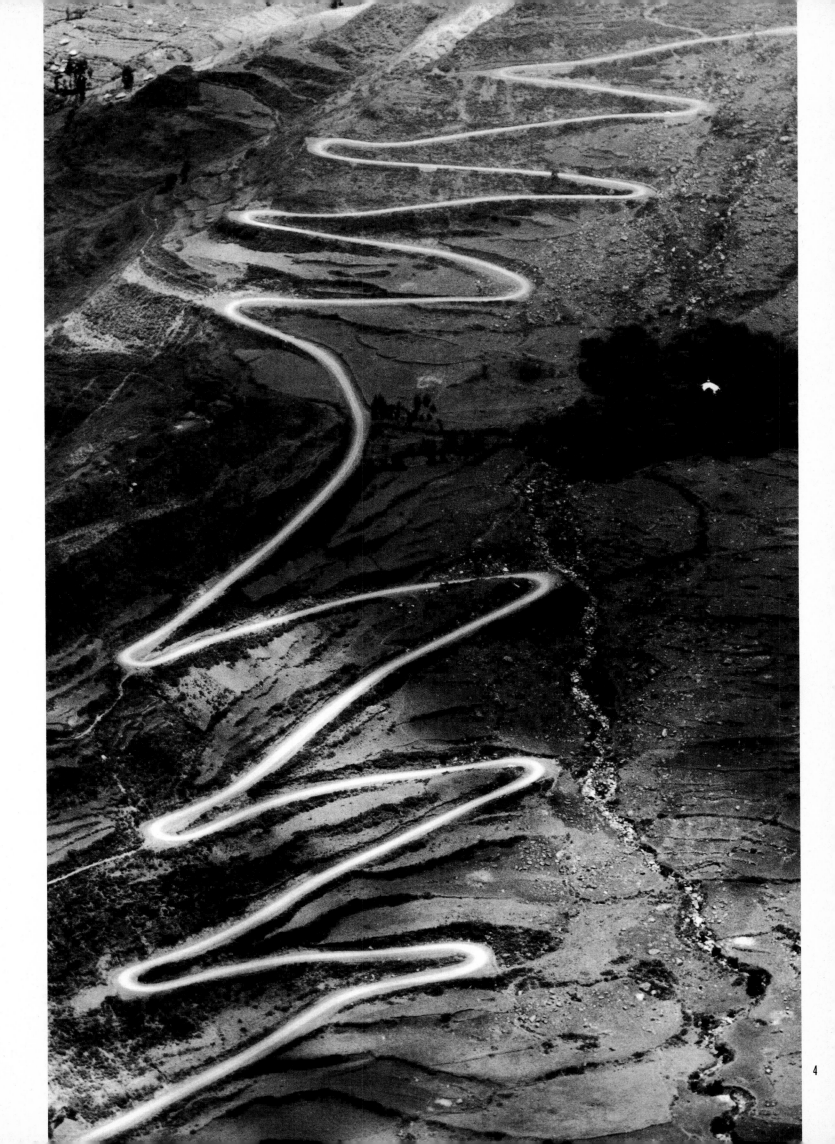

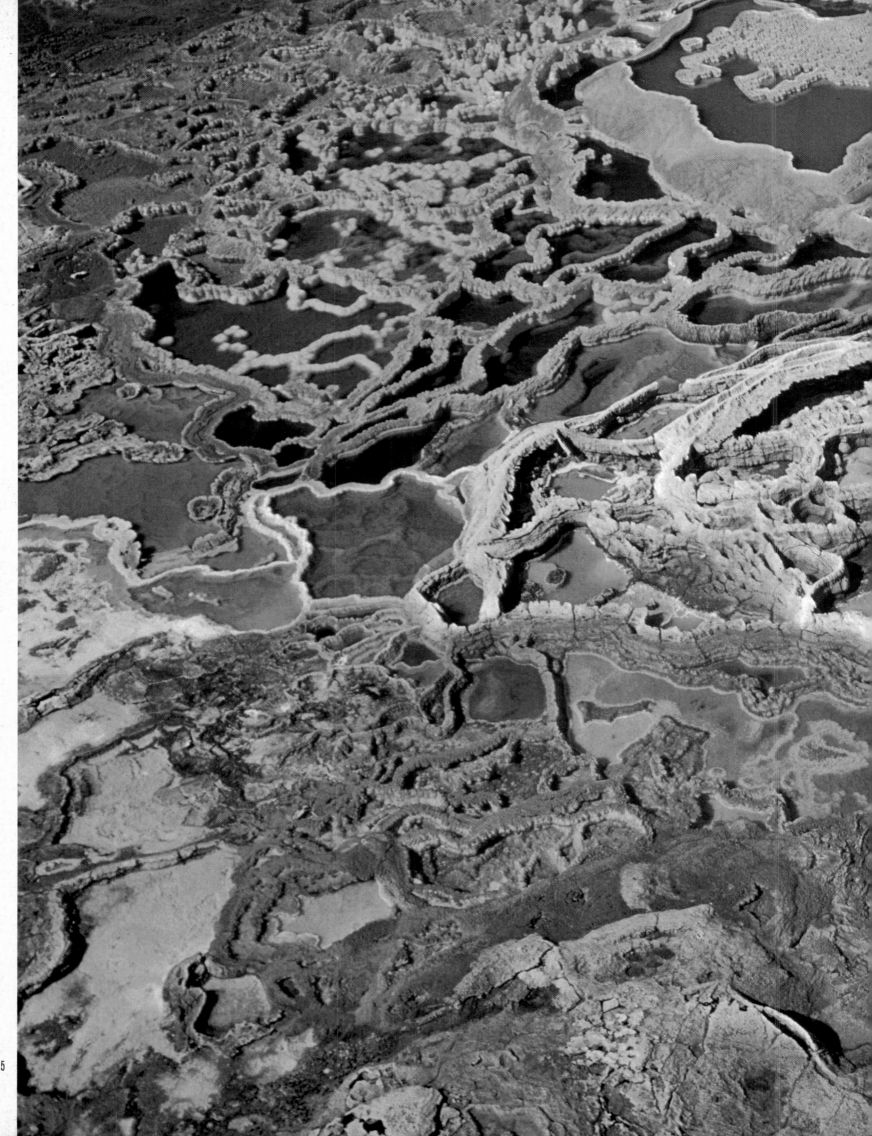

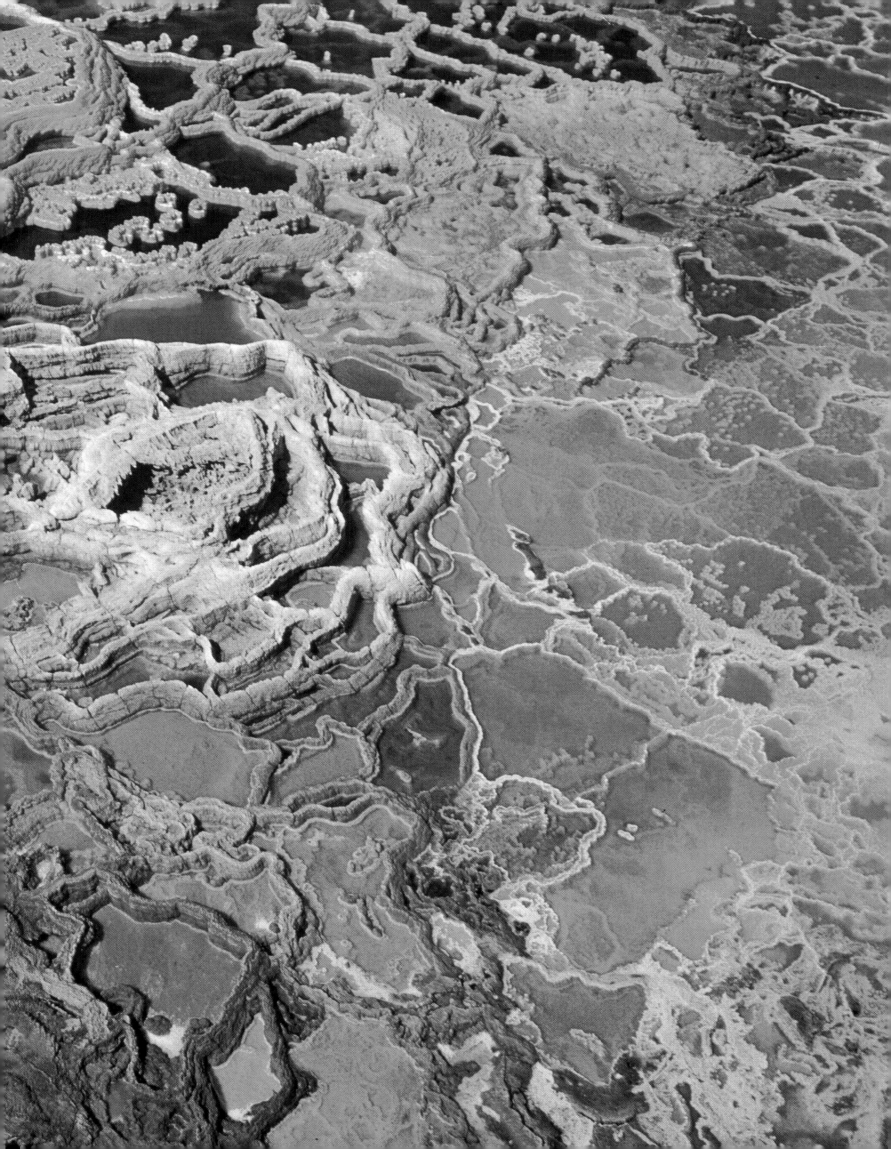

The Mountain Fortress of Christianity

Christianity became the state religion of Ethiopia at the same time as in the Roman Empire. The South Arabian moon god Almaqah made way for the 'God of heaven', the god of the Christians, during the reign of ʿEzānā, king of Aksum in the first half of the fourth century. No other event in Ethiopian history can be compared with this. Upon Christianity Ethiopia based its state, society and culture. The peculiarities of its geography have successfully helped it to defend its special position as the only autochthonous Christian state in Africa against all assaults, particularly those of Islam.

7 Fan or fly-whisk bearers are seen in this section of a bas-relief on the left-hand panel of the throne of Ḥawelti, a site near Aksum. Fig. 7 shows the throne mounted on bull's hooves and in the form of a canopy over the sides and the top. The ibexes forming a frieze on both sides of a tree of life in the middle of the head-piece are perhaps animal symbols of Almaqah. If the throne, which today is a showpiece of the Archaeological Museum in Addis Ababā, was in fact a votive offering, then perhaps the two figures depict the owner and his wife. From the Sabaeo-Ethiopian period (fifth to fourth centuries B.C.), this illustration shows the South Arabian (Sabaean) component of early Ethiopian culture.

8 Carved on one of the huge blocks strewn over the slopes of Gobedrā near Aksum is a prowling lioness. It measures seven feet from the tip of its nose to its tail. The low relief makes one think of Assyrian hunting scenes and Alexandrian mosaics. The circle with the claw cross in front of the beast's jaws seems to have been added later in order to Christianise a pre-Christian Aksumite mode of portrayal.

9, 10 The lion of Kombolča, about 20 miles to the south of Dassē and not far from the main road to Addis Ababā, is probably also from the Aksumite period. The twice life-size sculpture is reminiscent of the Aksumite gargoyle in the form of a lion. The cross marks on the pedestal may well be as old as the sculpture itself. R. Sauter thinks it was made in the late period, when the court apparently sought refuge in the south after the fall of the city. It could have been set up as a sentinel for the temporary royal camp. Only the soundings which the Ethiopian Archaeological Institute are planning will afford certainty over its origin, date and significance.

11–13 The stelae of Aksum are multi-storied memorials made from a single piece of granite. The old Ethiopian style of building on a wooden framework is copied on them in stone, so that smoothly polished and somewhat protruding courses of the wall alternate with 'wooden' frames. Round posts with projecting heads anchor the horizontal beams into the wall and cornerpieces project as they would from wooden door and window frames. The last of the great stelae still standing (pl. 11) measures 65 feet between the door-step of the entrance and the arched apex, its ten stories, counting the ground-floor with its door secured by a sliding bolt latch, all copied in stone. The top of the 'stela in the stream' (pl. 12) shows particularly clearly the plug holes for a missing bronze plate in the sunken area at the top. The stela (pl. 13) which lies in pieces where it fell and broke, in front of the Church of Andā Yāsus, is exceptional in being carved on all sides. The multi-stories stelae date from the period of Aksum's rise to power before the introduction of Christianity (second to fourth centuries) and are probably to be regarded as uninscribed monuments and places of sacrifice for rulers buried elsewhere. Those who commissioned them were

Fig. 7 The throne of Ḥawelti (after *Contenson*)

perpetuating the idea of the semitic stela grave, perhaps stimulated by reports of the wonders of Egypt. However their architectural decoration is based on the local palace architecture. The tower dwellings of the cult of the dead enriched the obviously progressive multi-storied secular architecture of a type which is most closely approached today by the tall houses of South Arabia, whose 'turbans touch the clouds'. The puzzle is by what technical means these locally quarried stelae were erected. The greatest among them, the hundred foot long 'giant stela' is longer than any other monolith of the ancient world. Knowledge of these stelae is indispensible for the study of the rock churches. The monolithic churches of Lālibalā, though younger by a thousand years, are a similar tour de force of the stone-mason's craft.

14 The winged seraphim are from the painted ceiling of the seventeenth century church of Dabra Berhān Śellāsē in Gondar. It depicts the six-winged seraphim of Isaiah 6: 2, with only the front pair of wings visible. Gondar broke with the imperial style of Aksumite architecture, producing for the first time in the realm of painting a rigid court style inspired by foreign, that is to say Portuguese, influence which still has its effect today.

15 The Saviour crowned with thorns in a painting on cloth from the Church of St Mercurius in Lālibalā. It belongs to the class of picture having the piercing of Christ's head ('Gesù percosso') as theme and derives from a highly prized icon kept in the palace of Gondar and borne before the troops in battle. This was the work of a foreign artist, presumably Portuguese, who used a Flemish model of the fifteenth or sixteenth century.

16, 17 Aksum, 'mother of Ethiopian cities'. Christian life flourishes here to the present day among the witnesses of its pre-Christian period. The preaching monk in yellow pilgrim's garb, with fly-whisk and hand-cross, is translating and paraphrasing the Scriptures which the dabtarā under the umbrella is reading out in the language of the Church. In the fore-court of the Church of St Mary of Zion, believers follow the service right next to the top of a stela engraved with a spear. The inscription reads, 'This is the stone from the hall of Bāzēn'. According to Ethiopian tradition Bāzēn ruled Aksum at the time of Christ's birth.

18–20 The timelessness of the cross: choirboys with grass crosses on their foreheads, on Hosā'enā (Palm Sunday) in Lālibalā. A dabtarā with hand-cross and psalter looking through a cruciform window from inside the monolithic church of Gannata Māryām. The incumbent of St Michael's Ambo with hand-cross. The copts rather casually retain the title of honour 'People of the cross'. How much more suitable still would it be for the Christian Ethiopians!

Selected Sources

The throne of Ḥawelti: Contenson, *Les monuments* ... and *Les fouilles* ...

The lioness of Gobedrā: Conti Rossini, *Storia* ...; *Deutsche Aksum-Expedition*, vol. 2.

The lion of Kombolča: Conti Rossini, *Storia* ...; Anfray, *Le musée* ...

The multi-storied stelae: *Deutsche Aksum-Expedition*, vol. 2.

On the thorn-crowned Saviour: Cerulli, *Il 'Gesù percosso'* ... The inscription of Bāzēn: *Deutsche Aksum-Expedition*, vol. 4.

7 Fan or fly-whisk bearers: section of the bas-relief on the throne of Ḥawelti.

8 Prowling lioness on one of the huge blocks strewn over the slopes of Gobedrā near Aksum.

9, 10 The lion of Kombolča, probably from the Aksumite period.

11–13 The stelae of Aksum: multi-storied memorials made from a single piece of granite.

14 Winged seraphim: painted ceiling in the Church of Dabra Berhān Śellāsē in Gondar.

15 The thorn-crowned Saviour: Painting from the Church of St Mercurius in Lālibalā.

16, 17 Aksum, 'mother of Ethiopian cities': Christian life flourishes here to the present day amidst the witnesses of its pre-christian period.

18–20 The timelessness of the cross: forehead crosses, cruciform window of a rock church, hand cross.

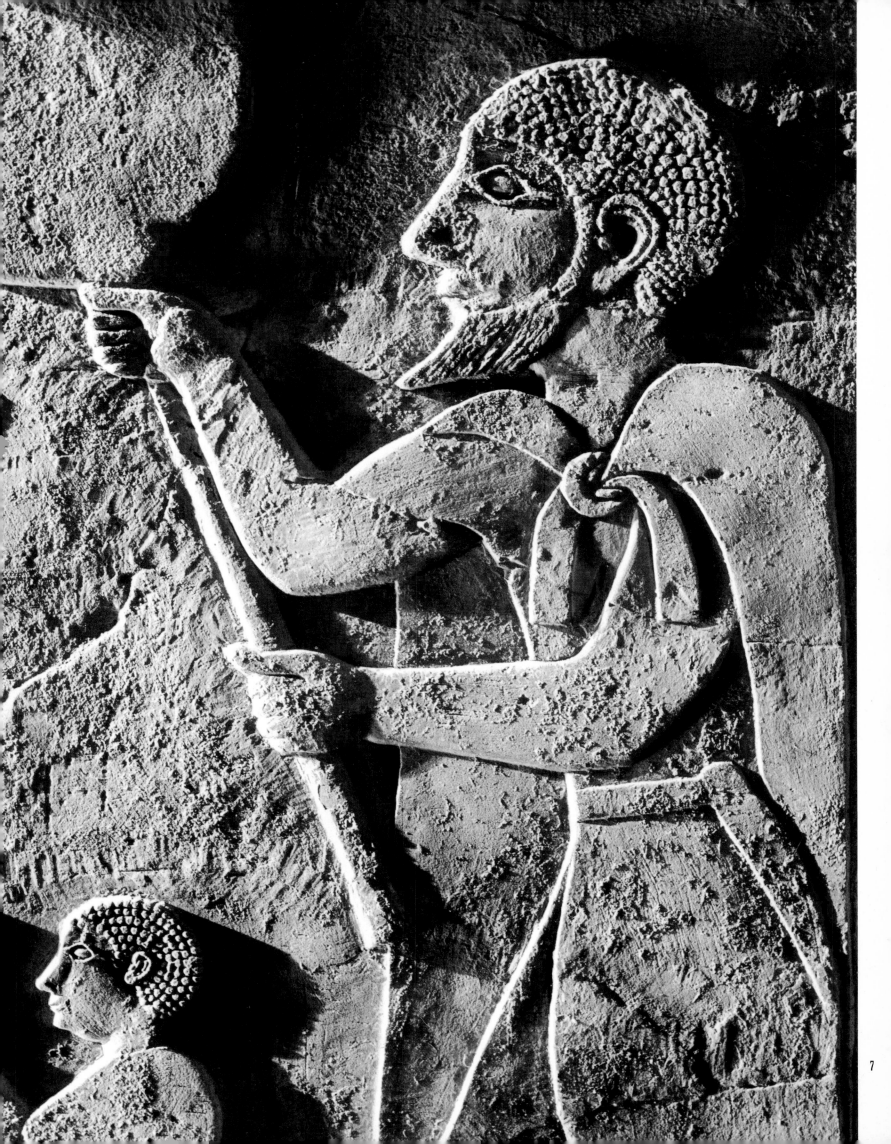

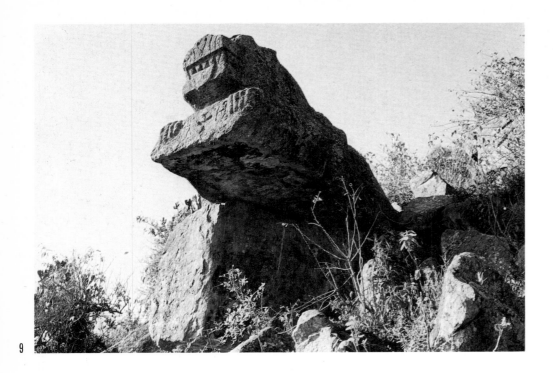

9

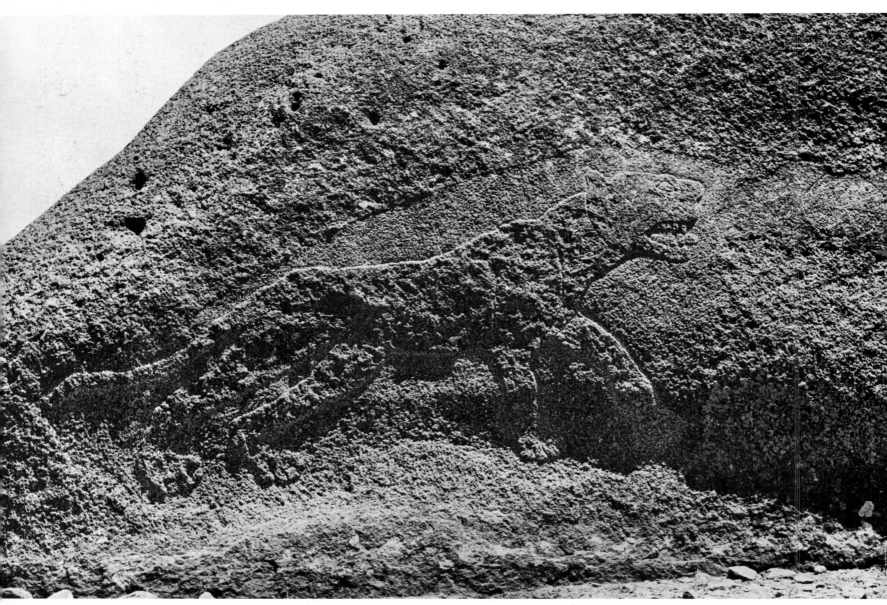

8

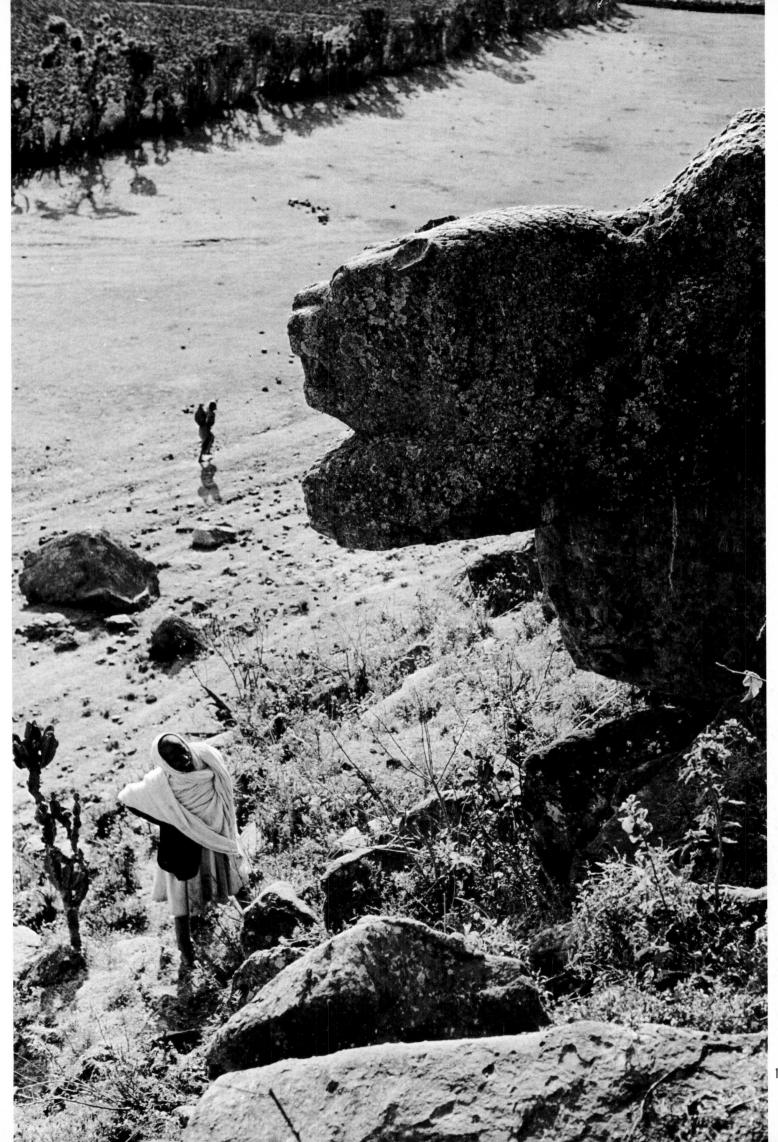

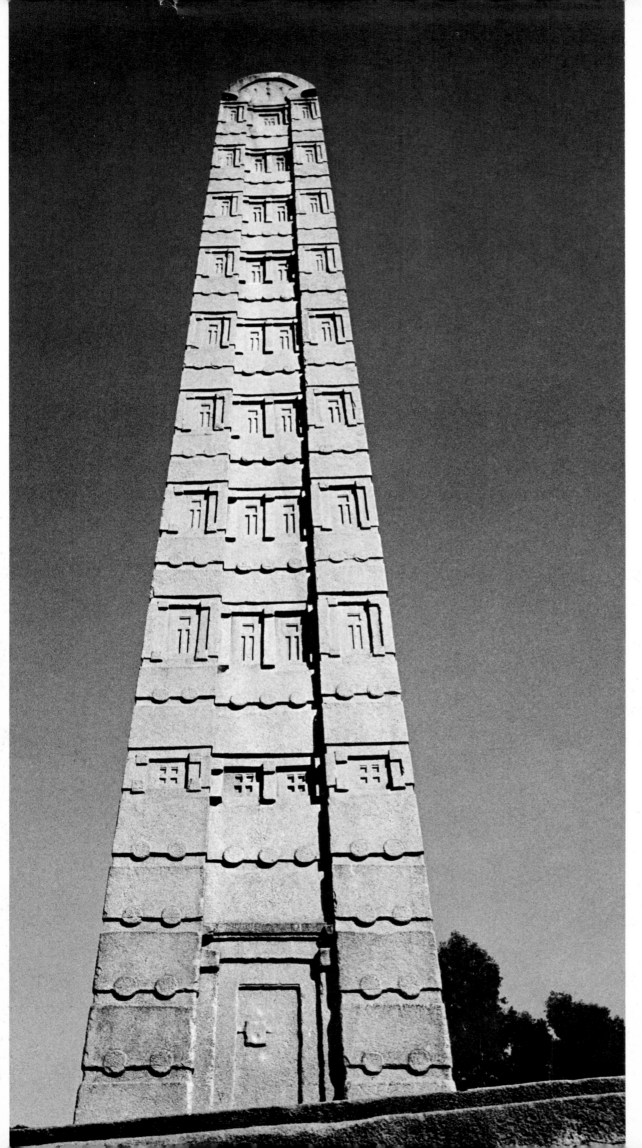

11

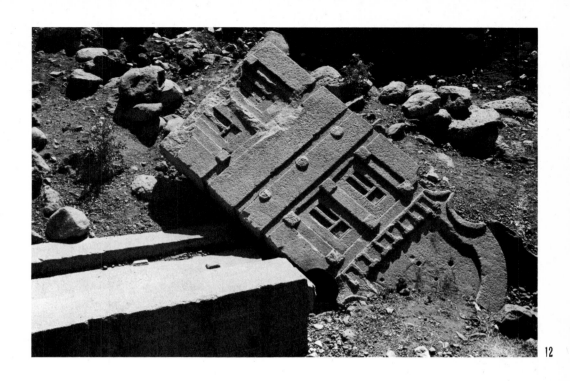

12

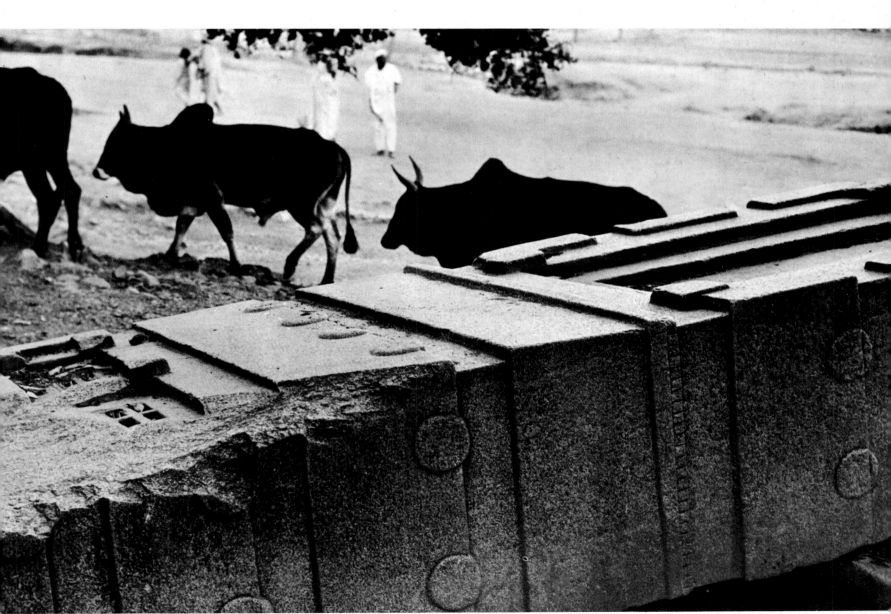

13

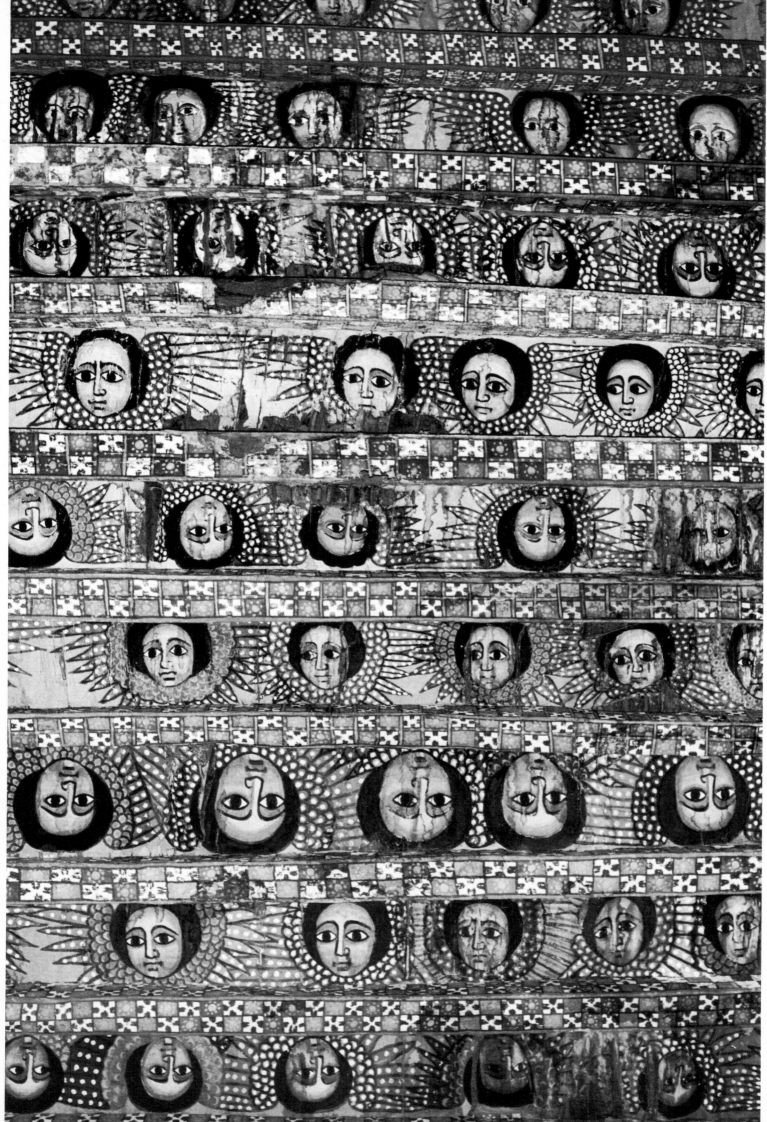

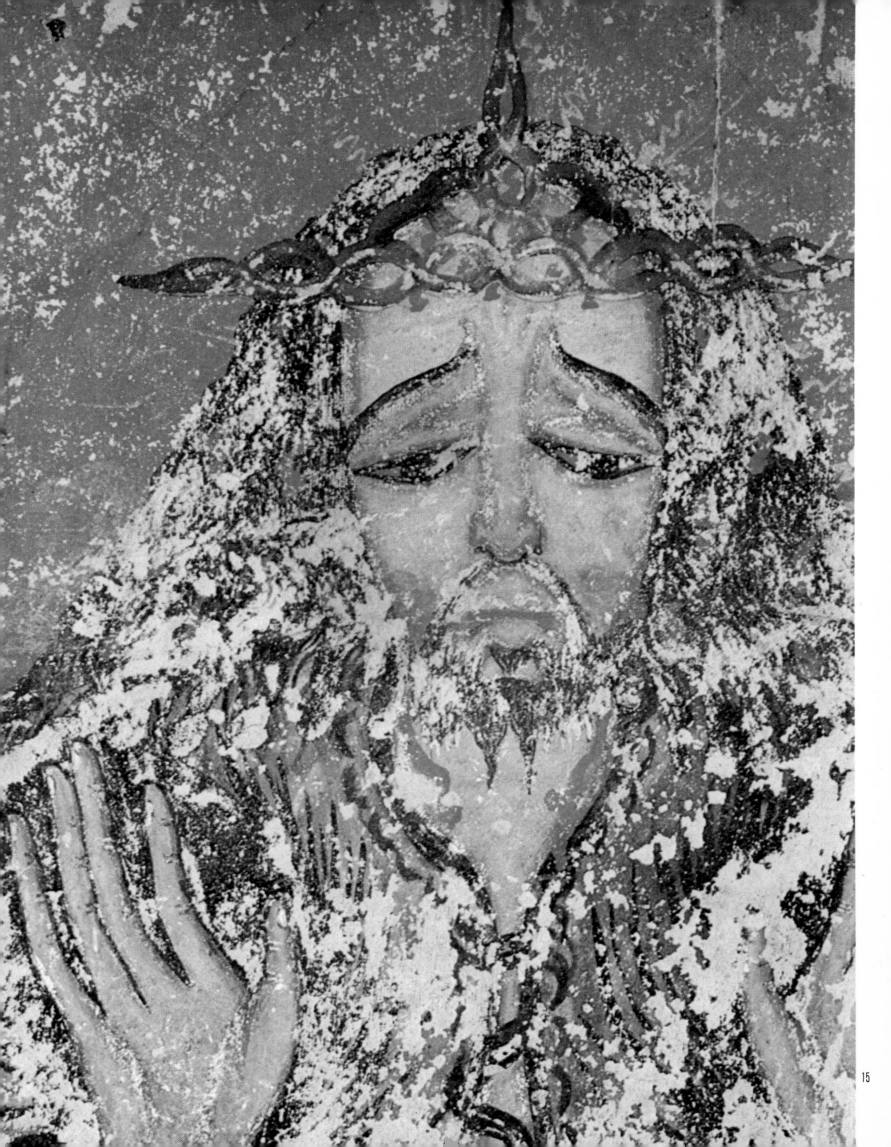

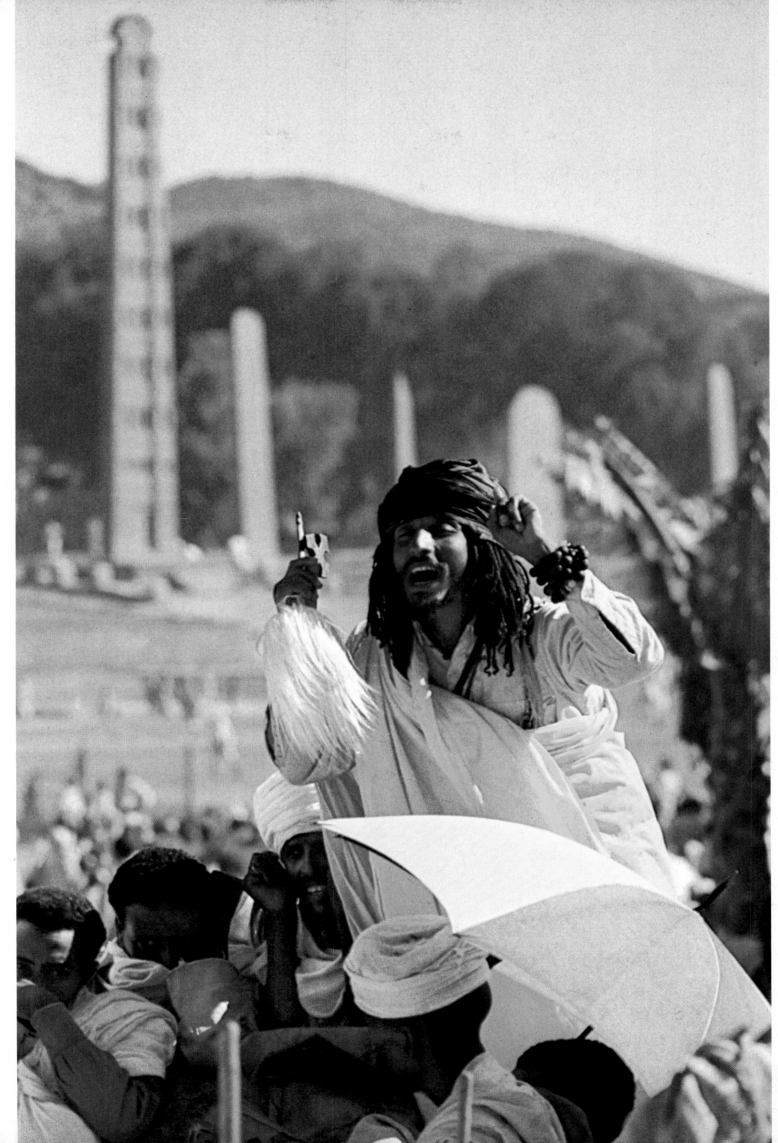

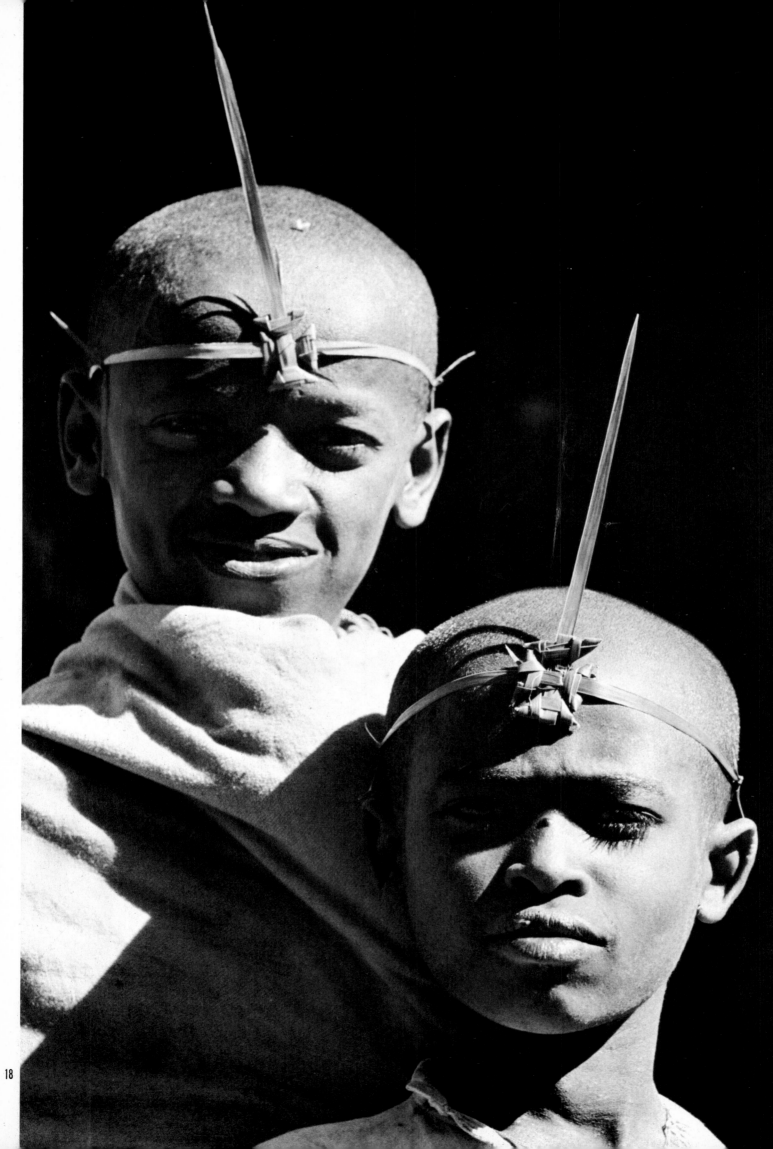

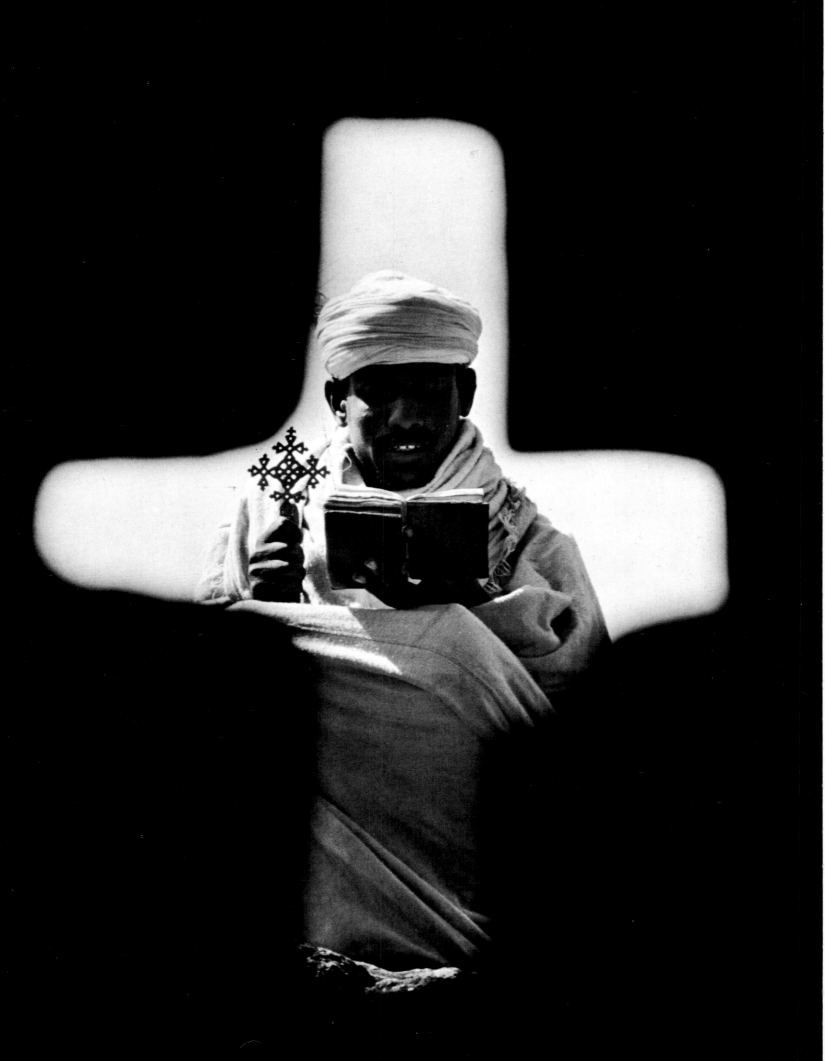

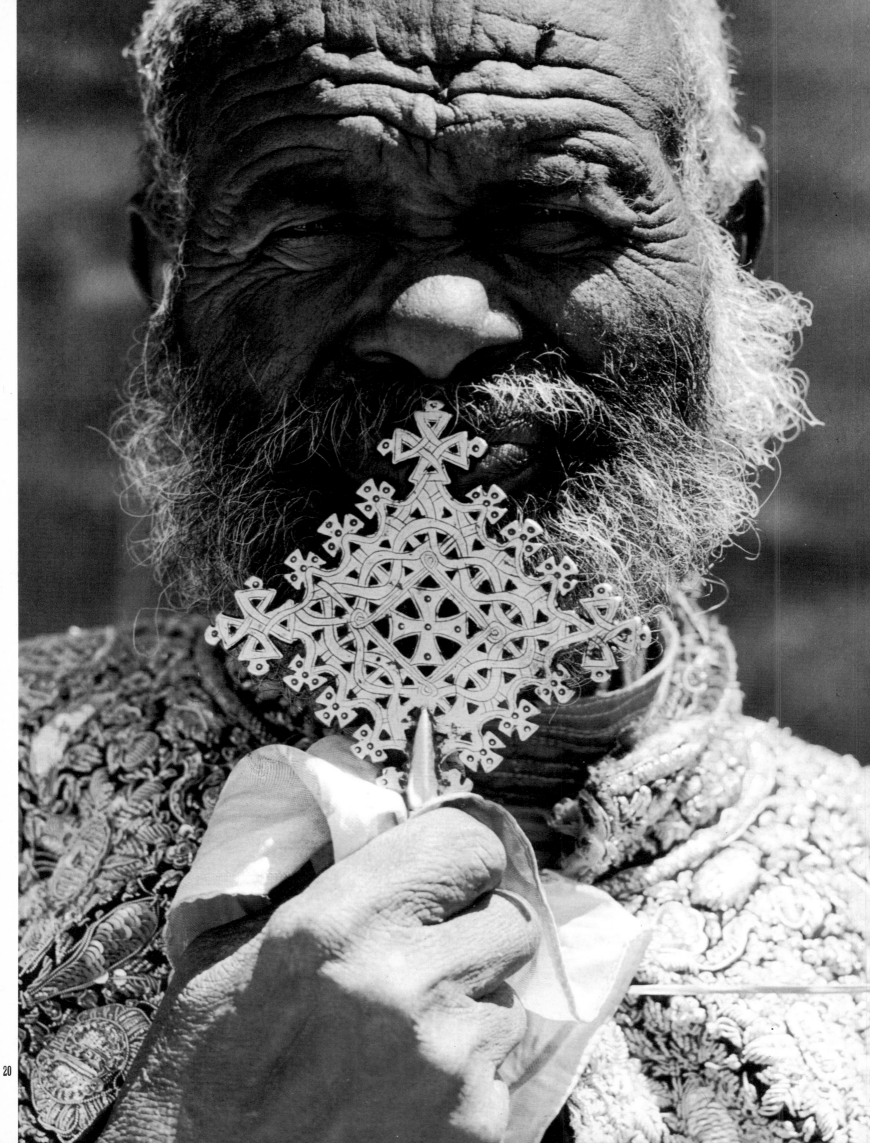

Historical Elements of Ethiopian Culture

Jean Leclant, Paris # The Archaeology of Ethiopian Ancient History

For a long time scholars were inclined to see early Ethiopian culture as nothing more than an off-shoot of South Arabia's. More recent research has shown, however, that from the beginning Ethiopia was more than a mere off-shoot, and that before long it had developed a highly individual culture of its own.

In 1952 the Emperor brought into being a Department of Archaeology as part of the Ethiopian National Library; the size of the undertaking and extent of its activity soon necessitated its transformation into the independent Ethiopian Archaeological Institute. The Sovereign's Act of Establishment and his subsequent generous provision for the Institute have been the turning point in the elucidation of Ethiopia's prehistory. Up till then what was known of Ethiopian archaeology was embodied in the work of Littmann, Krencker and their associates. In 1906 Littmann and Krencker (Deutsche Aksum-Expedition) had worked in the province of Tegrē for a few months and the five volumes in which they reported their finds, observations and excavations in the region of Aksum and Yeḥā remained the basis of Ethiopian archaeology for fifty years. This was later supplemented by further studies and discoveries by Italian travellers and scholars. To this must of course also be added the numerous references to antiquities found in travel accounts of the last century. Much as this all was – and it had very often been obtained in the face of the fiercest opposition – it only amounted to an incomplete and provisional survey.

Thanks only to the efforts of her newly founded Institute of Archaeology, could Ethiopia, at last, take the place which used to be hers in the earliest history of the countries bordering the Red Sea, and indeed take it in a more comprehensive and complex fashion than could have been expected. Today, it is already clear that in the future Ethiopia will be a major area of archaeological activity, as a source of the history not only of the countries bordering the Red Sea, East Africa and the Indian Ocean, but also of the connections between the Mediterranean countries and the Far East.

What assessment can we now make fifteen years after the start of a systematic archaeological research programme in Ethiopia? Obviously we must be careful to avoid superficial theorizing. All research, and especially this, with the handicap of having so much to catch up on, unearths more questions than it answers. In the present state of knowledge, attempts at synthesis are still premature.

So far, most of Ethiopia's prehistory remains *terra incognita*. Rock carvings and rock paintings, especially in the area of Ḥarar and Derrēdāwā, and in the north of the country in the provinces of Tegrē and Ēretrā (Eritrea), but also in Sidāmo, are partly chance discoveries and partly the results of systematic search. Within the whole ambit of African rock paintings, these give Ethiopia an important though not very precise place.

Incomparably older and of the greatest importance, not only for the prehistory of Ethiopia but also for that of Africa in general, is the site of Malkā Qunṭurē, situated on either side of the river Awāš, 30 miles or so south of Addis Ababā and discovered in 1963. Prior to this date, lower palaeolithic industries were more or less unattested in Ethiopia. Now, however, at Malkā Qunṭurē we have four palaeolithic strata which are unusually rich in artifacts, traces of settlements and animal remains, and which stretch in time from the end of the pebble culture to the beginning of the mesolithic period. Industries in more recent strata correspond with East African types

and enable the gaps to be filled. The long occupation of the site resulted in stratified deposits 80–95 feet thick, and this places Malkā Qunṭurē among the foremost prehistoric sites of Ethiopia and of East Africa.

The divergence of Ethiopia's development from that of the African substratum – that is to say Ethiopia's entry into history – took place in a culture which was in constant exchange with South Arabia. In the past it was thought that groups of the Sabaean population from the other side of the Red Sea, having a dominant Semitic culture, invaded the country and subjugated the local Cushitic tribes. However, the conclusions reached from fifteen years of archaeological activity are rather different. The early Ethiopian culture is certainly closely related to the South Arabian, but it existed in its own right in full vigour, not as a pale imitation, and, just as there are similarities on both sides of the Red Sea, so there are divergences and differences. The present state of knowledge from excavations forbids us to think of the oldest Ethiopian culture as a colonial off-shoot of that of South Arabia and nowadays we prefer to call this period of Ethiopian history 'Sabaeo-Ethiopian' in preference to 'South Arabian'.

A visit to the most important sites excavated in the last few years (map, fig. 8) and a tour of the Museum of Addis Ababā with its complement of recent finds offers sufficient evidence of the need for this change of outlook.

Not far from the town that was the heart of ancient Ethiopia, seven miles to the south-east of Aksum, in the area known as Mēlāzo, the first systematic excavation of a sanctuary of the moon god Almaqah is to be found. So far it seems to be the oldest known structure in Ethiopia. It is a small building, rectangular in plan, 8.9 × 6.75 m., surrounded by a wall. It had inscribed hearths and altars of incense, some cubical, others cylindrical, adorned with pictures of the full and crescent moon. In the eastern section of the shrine there was a bench with votive tablets on it, the inscriptions on which were written in an elegant and regular monumental script. It announced that 'two GRB people have dedicated their handiwork to the god Almaqah for W'RN'. From the shape of the letters, the sanctuary can be dated to the fifth century B.C.

The moon god Almaqah is well-known in South Arabian religion. His sacred animal was the bull, and in Mēlāzo two votive statuettes of bulls have come to light. One is of schist and is a powerful object in spite of its small size. The other, of alabaster, is impressive in its severe simplicity. Both bulls (the first one 8.5 cm. long by 5.5 cm. high and the second, 42 cm. long by 40 cm. high) testify to the ancient Ethiopian's unusual degree of artistic skill in depicting animals.

At Ḥawelti, several hundred yards from Mēlāzo, in the first few months of 1959, H. de Contenson made some important discoveries. Here, he uncovered the remains of two rectangular buildings which, however, are not as old as the sanctuary of Mēlāzo. In the passage between them lay the broken remains of two limestone objects which today, restored, are the pride of the Museum of Addis Ababā.

The first of the finds is a canopied throne 1.4 m. high standing on bull's hooves (pl. 7, fig. 7). The posts and canopy are decorated with a frieze of crouching rams with long curled horns. On the sides of the throne a fan-bearer is depicted; before him strides a small figure holding a staff upright in front of him with both hands. On the right-hand side of the throne, a short inscription in South Arabian characters identifies the smaller figure as RFŠ. The technique of the representation and the bearing of the subject is reminiscent of the reliefs of Persepolis. Perhaps we have here one of the thrones mentioned in the texts, such as the one which an Ethiopian ruler set up at the time of the victory celebrations after his triumph over the Nubians at the junction of the Nile and the Atbarā. It may even be the famous throne of Adulis, admired and described by Cosmas Indicopleustes in the sixth century A.D. However, according to the most recent interpretations and discussions (especially

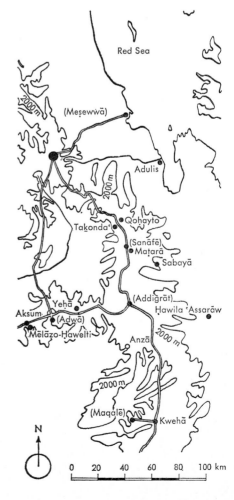

Fig. 8 Map of early Ethiopian sites

30

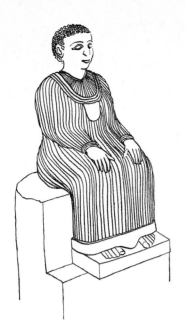

Fig. 9 Statue from Ḥawelti

J. Pirenne's) it is definitely not certain whether the canopied throne of Mēlāzo has any real connection with the 'classical' throne at all.

The second important find is the statue, 80 cm. tall, of a seated woman (fig. 9). Her hands rest on her knees. Her countenance is full of life. The representation of the mouth with its strange beak-like lips is extraordinary. The eyes are surrounded by a kind of ridge. Characteristic of this early Ethiopian period is the peppercorn hair. The woman is wearing a long pleated gown. It is undoubtedly the representation of a person of high rank. On each wrist she wears a four-stranded bracelet and round her neck a heavy necklace is kept in place by a weight at the back. Such necklaces with counterweights are common in the Nile valley. They are also to be seen on South Arabian monuments and are even to this day worn in Ethiopia.

There is yet further testimony to the highly developed art of the sculptor in early Ethiopia, in particular of a second statue, admittedly headless, which was likewise discovered in Ḥawelti, and a seated figure from Ḥawila 'Assarāw, to which we will return later.

De Contenson's finds in Ḥawelti have not by any means been exhausted with the items mentioned so far. Ḥawelti has much more evidence to offer, though this probably comes from different periods. A bench encircled the outer walls of both buildings and clay votive objects lay on it. These were mostly little figures of oxen and other animals, miniature yokes, models of houses (fig. 10) and figures of really gross women with enormous buttocks. Amongst the finds that were discovered not far away were fragments of moulded plaques made of yellow fired clay. The figures in relief on them have wide eyes, a broad nose and prominent cheek-bones; they are richly adorned with necklaces, bracelets and pendant earrings. It is quite feasible that several of the figures are depicted with dislocated hips, reminiscent of the so-called triple flexion (tribhanga) of Indian art. It may be pointed out here that close connections between Ethiopia and India are known to have existed at the beginning of the Christian era.

At this point we must mention yet another direction of cultural connections. At the foot of the mound of Ḥawelti there was a collection of votive objects. Along with

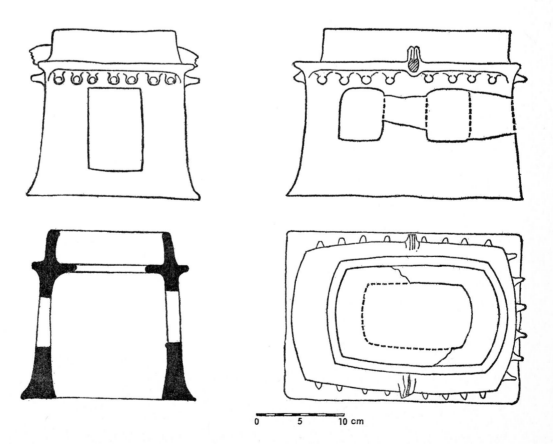

Fig. 10 Model clay house
(after *Contenson*)

0 5 10 cm

31

a considerable array of vessels and metal objects such as might have been put on one side in other Ethiopian sites, were two blue faience amulets, which are indicative of the Nile valley (fig. 11). The first amulet shows the upper part of a female figure with the hairstyle of the Egyptian goddess of love, music and the dance, Hathor. The other is a sort of Ptah-Pataikos with short bandy legs standing before a back-rest in the shape of an obelisk. Many other finds prove early Ethiopia's link with the Nile valley, with Egypt and even with the kingdom of Meroë. Here I should like to mention four metal vessels from Ḥawila 'Assarāw. They were discovered by farmers along with other objects of historical significance, in a cache in the mountains on a track which subsequently leads down to the Red Sea. One vessel, which unfortunately is badly damaged, is hemispherical, a typical Meroitic shape. A second, a bowl measuring 6 cm. in height and 9.2 cm. in diameter at the top (another form common in the Meroitic civilization) has a finely engraved decoration on the outside – nineteen open lotus flowers alternate with lotus buds on stems. Above them runs a frieze of nineteen frogs – an eternity motif in Egyptian religious symbolism (fig. 12). Bowls of this type have already been connected with vessels which are nowadays used in Nubia for keeping milk – indeed similar forms are also found even among Ethiopian pottery. The third piece from Ḥawila 'Assarāw is a small undecorated bowl with a diameter of 12.2 cm. across the rim and of 6 cm. across the base. The base seems to have been put on later. Of the fourth bowl, a very carefully made vessel with punched decoration, only a fragment remains. A frieze of oxen is discernible surrounding the flower pattern on the base, a decoration which appears on objects from the cemetery of al-Kurru, a Cushitic necropolis from the pre-Meroitic period in northern Sudan.

Some other notable finds in the Ḥawila 'Assarāw group should be noted: an animal figurine; two small tripod altars of alabaster; a larger altar of the characteristic South Arabian form, decorated with the design of a palace façade, with the full and crescent moon and an inscription, unfortunately mutilated, of the greatest interest – the dedicatory inscription of one 'mkrb (mukarrib) of D'MT and SB" to Almaqah on the occasion of a victory; and a limestone statue 50 cm. high, the significance of which is still quite a puzzle. It depicts a thick-set figure squatting on a stool. Its hands are on its knees, each clasping a cup. Rosettes, which may originally have been set with precious stones, perhaps in imitation of embroidery, decorate its clothing which is bordered with a series of fringes. The facial expression is cold, almost inhuman. Its mouth has narrow ill-defined lips, the chin is slight. Its great eyes, once set with jewels, have a hollow look. The hairstyle consists of small curls, as though cropped on the forehead. Its ears stick out, shaped like half moons. Is it some divinity or the offering of a suppliant, the image of a woman who implores the god for the gift of motherhood? The latter meaning is suggested by the inscription on the front of the base, its approximate translation being 'To give YMNT a child'. Nevertheless it should be borne in mind that it is not certain whether the base does in fact belong to the statue as they are not a perfect fit.

A final discovery from the treasure of Ḥawila 'Assarāw: the oldest Ethiopian characters known up to the present. They are engraved on a bronze object, a sceptre or a kind of spear, and refer to two conquests by 'GDR, king of Aksum'.

Two further sites should not be omitted from the discussion, even though their finds do not possess the artistic merit of the antiquities so far mentioned. The excavations of Sabayā and Yeḥā produced a great variety and large numbers of pottery and metal objects. Their abundance makes it possible to construct a typology which, in itself of historical value, gives indications of chronology especially for the transitional stage between the Sabaeo-Ethiopian period (fifth to fourth centuries B.C.) and the beginning of the Aksumite period (early Aksumite, end of the first or beginning of the second centuries A.D.). The excavation sites of Sabayā in the sub-province of Āgamē (Tegrē)

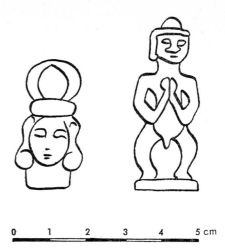

Fig. 11 Faience figurine (after *Contenson*)

Fig. 12 Metal bowl (after *Leclant*)

are situated on a slope. Two of them were discovered by farmers quite by chance. In 1955 and 1956, A. Miquel and I surveyed them and investigated a third site. In 1960, F. Anfray examined a cemetery near Yeḥā among the craggy mountains of Adwā. The cemetery was a hundred yards to the south-west of the ruins of a rectangular building in fine ashlar, at one time the temple of a South Arabian divinity. The graves provided interesting material. In Yeḥā, which must have been an important city, even earlier South Arabian inscriptions were discovered. I myself found, in the course of my investigations, beautifully worked fragments of stone inscribed with the monumental letters so characteristic of South Arabia. Obviously they came from inscriptions in splendid buildings which one would wish to see excavated and studied. Yeḥā was, from the evidence of the grave objects, an important centre of ceramics no less than of metal work. From its workshop came the remarkable animal-shaped trinkets (ibex, lion, bird) with the body cut out to form letters (fig. 13). One can regard them as a kind of brand. In any case their wealth of invention in form and the flexibility of their technical execution bear witness to the masterly skill of Ethiopian craftsmen during the Sabaeo-Ethiopian period or a little later, but still prior to the advent of the Aksumite empire.

Up to the present we know very little about the origins of the real Aksumite culture. It must be equated with the founding of Aksum which quickly became the capital city of the far-reaching empire of the same name at about the middle of the first or beginning of the second century A.D. One of the first jobs to be tackled by the recently founded Department of Archaeology were the puzzling excavations of Aksum, encouraged by the Emperor's express wish.

The ancient Ethiopians were experts in working stone, of which there is no more impressive evidence than in Aksum. Right up to the present there stands there a huge ornamented stela (pl. 11), one of the rightly famed but wrongly called 'obelisks'. Nearby the largest of these monoliths, originally 33.5 metres high, lies in pieces on the ground. There were no fewer than seven of these amazing stelae, colossal but well proportioned, on a stepped monumental base. On the front and sides (in most cases the back is smooth and undecorated) they all exhibit the same decoration, which seems to indicate a tall building of the type which is still to be encountered in South Arabia: a multi-storeyed timber-framed structure with locked door, above which range rows of windows divided by cross-pieces. In the vicinity of these giant stelae Aksum has quite a wealth of stone monuments, though they are mostly just tall, rough-hewn stones.

Characteristic of Aksum but less striking than the stelae, are the thrones. Cosmas Indicopleustes described the one he had seen at Adulis, and the Vatican manuscript of his *Christian Topography* depicts it as on a rectangular base surrounded by four columns. Almost a dozen identical, or at any rate very similar thrones are to be found neglected and in ruins at the entry of the city. Fifteen others can be seen on slightly raised ground in front of the gateway that leads to the great courtyard of the old cathedral. Some of them are still in their original position; the two in front have been used for centuries at the coronation celebrations. The columns which surround them used to support a roof.

The significance of the stelae and thrones remains obscure. The stelae were presumably erected in connection with the cult of the dead. The thrones seem to have been partly votive in purpose, being dedicated to the god whose likeness they carried. Others, however, possibly served as memorials to deceased rulers.

Apart from the stelae and thrones, the description 'typical Aksumite' applies also to numerous terra-cotta heads usually with traces of grey slip, which are as puzzling as they are attractive. A fine-featured face is framed by a wig which stands out from the back of the head. Many of the heads have an opening in the crown and are supported by a very long neck, which leads one to think they are probably stoppers for

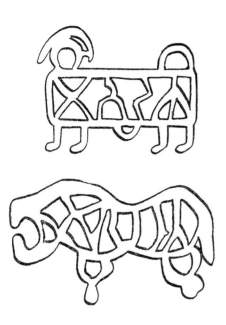

Fig. 13 Identity brands from Yeḥā

amphorae. The facial features give an attractive foreign impression, neither African nor Semitic, so they too raise questions to which we do not yet know the answers.

Very recent work has not only thrown new light on stelae and thrones and has considerably enlarged the corpus of finds but de Contenson, who was able to excavate during the building operations for the modern cathedral adjacent to the old Church of St Mary of Zion, has also gained new insights into the sequence of the different periods of building in Aksum.

Aksum controlled a large area: in the west its border must have been near the present border of the Sudan, in the east it probably reached as far as the border of the Great Rift Valley at the Danākel depression. Since 1959, Anfray has been systematically examining the site of Maṭarā near Sanāfē. The excavations produced the remains of fine buildings in the classical Aksumite style – built-up outer-walls on a stepped base with alternately projecting and recessed wall surfaces, in which rubble filling is held in between layers of squared stone. This method of construction corresponds exactly to the reconstructions put forward by the Deutsche Aksum-Expedition for the extensive palace areas of the capital. It is rather more difficult to determine the northern and southern limits of the Aksumite empire. According to present knowledge, its southern-most point was at the stela of Anzā and the neighbouring ruins of the Church of Endā Qirqos Aguddi, about half-way between Sanafē and Maqalē.

It is certain that the kingdom of Aksum kept up active relationships with the Nile valley as well as the Far East and the Mediterranean. A hermaphrodite figurine and a small bronze animal found at Aksum were presumably introduced from Alexandria. A magnificent censer with a handle in the form of an ibex hunt (fig.14), found by Anfray at Maṭarā, also points to this city. Maṭarā illustrates its connections with the world of Rome with a hoard of gold – a bronze vase was found containing necklaces and pendants, concealed among which were fourteen of the last Roman gold coins of the first and second centuries bearing the effigies of the emperors from Nerva to Septimius Severus. Aksum's political and economic strength was based on the harbours of the Red Sea coast of Africa. Adulis, the most important of these, not far from modern Meṣewwā (Massawa), lay on the trade route from India and the Far East to Meroë on the Middle Nile. Aksum supplied the Romans with African exotica including ostrich feathers and above all ivory. In markets round the Mediterranean, Ethiopian ivory was still fetching the highest price in the time of Cosmas Indicopleustes. As customers, the Aksumites' main purchase was Roman wine. An elephant's tusk which Anfray salvaged from an Aksumite level at Adulis gives an emphatic reminder of the chief article of export.

Kingship quickly developed in Aksum. The oldest literary evidence we have so far is a reference to it by Ptolemy in the second half of the second century. The history of the earliest kings is still very obscure; we just know a few names, which we cannot list chronologically. The earliest Ethiopian king known by name, Zōskalēs, was 'hide-bound and grasping, yet noble and with a strong attachment to Greek culture'. The Periplus of the Erythraean Sea, which according to the latest research is to be placed in the third century, gives him this characterisation and describes him as ruler of practically the same section of the Red Sea coast as is under the present control of His Imperial Ethiopian Majesty. Under Zōskalēs and his successors, thanks to brisk trade, Aksum was a rich city with a flourishing culture. It was at this period that the multi-storeyed stelae were erected. The 'Kephalaia', a work stemming from the sphere of Mani, speaks of 'four world kingdoms' – Aksum, along with Rome, Persia, and most probably China.

A short Greek inscription, found some time ago to the north of Aśmarā, mentions one Sembruthēs 'king of the kings of the Aksumites'. Sembruthēs, whose mighty deeds in Meroë and South Arabia are related in that Greek inscription, is possibly the king whom Cosmas Indicopleustes later describes in Adulis. The inscription could

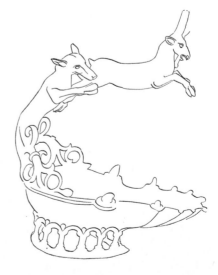

Fig. 14 Censer

34

also, however, refer to GDR whose exploits on the other side of the Red Sea are described in South Arabian inscriptions.

Other names of kings appear on a series of gold and silver coins. Although they can be arranged according to type and weight, they cannot be put in chronological order. One Endybis appears on them; his coins have the same weight as the gold quinarii of Diocletian's predecessors. Afilas and Usanas appear at about the time of Constantine's gold reform in 306; then there is Wazēb, who chose Ge'ez instead of Greek for his inscriptions; then Ella Amida and finally 'Ēzānā.

In Aksum itself the deeds of 'Ēzānā are described in a number of texts inscribed on stone, one of which bears a trilingual inscription in Greek, Sabaean and Ge'ez. These inscriptions commemorate the king's victory in battle over the rebellious tribes of the north. In most of them ancient divinities of South Arabia are invoked. One of them, which was written after the victory over the Nubians and Cushitic peoples at the Atbarā and Nile theatres of war, and which mentions the erection of several thrones, is directed to 'the Lord of Heaven', the god of the Christians. And on the coins of 'Ēzānā the cross displaces the sign of the crescent moon enclosing the full-moon. The general view is that this happened at the time when Constantine made Byzantium the imperial residence (about 330). From then on Ethiopia is Christian.

Selected Sources

The classic basis of Ethiopian archaeology: *Deutsche Aksum-Expedition.*

More recent summaries: Leclant, *Le Musée . . .; Frühäthiopische Kultur.*

The foundations: Contenson, *Les premiers rois . . .; Les principales étapes . . .; Les subdivisions . . .;* Anfray, *Notre connaissance . . .*

The prehistory: Baillord, *La préhistoire . . .; Les gisements . . .;* Chavaillon.

Ḥawelti-Mēlāzo: Leclant, *Haoulti-Melazo . . .;* Contenson, *Les monuments . . .; Les fouilles . . .*

Ḥawila Assarāw: Caquot/Drewes.

Aksum: Leclant, *Les fouilles . . .;* Contenson, *Les fouilles à Axoum . . .*

Yeḥā: Anfray, *Une campagne . . .*

The art of the 'Sabaeo-Ethiopian' period: Pirenne, *Arte sabeo . . .*

The excavations of Maṭarā: Anfray, *La première campagne . . .;* Anfray/Annequin, *Maṭarā . . .*

Reports of excavations are currently published in *Annales d'Éthiopie,* Addis Ababā 1955 ff.

The History of Christian Ethiopia

Roger Schneider, Addis Ababā

The adoption of Christianity as the state religion under king ʿĒzānā, in the fourth century, was a critical date in the history of Ethiopia and the beginning of a completely new epoch lasting to the present day.

Christianity became an important, often decisive factor in the Ethiopian national consciousness. As a national religion it undoubtedly played a great role in maintaining independence through centuries of isolation. In times of need, it was the bond which so frequently held together provinces that were drifting apart in the face of Islam, their common foe.

The art and literature of Ethiopia are Christian. In the course of her development over the centuries her identity, always unmistakable especially in art, was also affected by foreign influences, but in every case, these influences became weakened in contact with the Christian heritage. As for contacts with Coptic Christianity, right from the beginning the Ethiopian Church depended on the Patriarchate of Alexandria, and, until quite recently, Egypt sent the Ethiopians their chief bishop. There were also contacts with the representatives of other Christian confessions in Jerusalem as, despite every danger and difficulty, Ethiopian pilgrims had, from time immemorial, journeyed to the Saviour's tomb and there is evidence of an Ethiopian colony in Jerusalem since the Crusades. Finally, from the end of the Middle Ages, contacts with the Orient – though slight and often hardly verifiable – exist.

What was the immediate effect of ʿĒzānā's conversion? How far did the subjects follow the example of their lord? It is more than likely that even in the kingdom of Aksum the official recognition of Christianity did not lead to a general Christianisation of the country. At all events the evidence for such an acceptance is lacking. The heathen emblem of the crescent and full-moon disappears from the coins and the cross appears in its place (fig. 15). On pottery, too, the cross appears more frequently and, for a while, crosses are the only archaeologically relevant indication of the new period which had begun in Ethiopia.

For the next century there is nothing which justifies the idea of a thriving Christian community in the Aksumite Empire. This situation apparently only changed after the Council of Chalcedon (A.D. 451) which proclaimed the unity of both natures undivided and without confusion in the one person of the God-man Jesus Christ, and condemned the doctrine of the single nature (monophysitism). From Syria and probably also from Egypt, monophysite monks fled from the policies of the Byzantine Church. According to Ethiopian tradition the historically somewhat elusive Nine Saints of Rome (i. e. Byzantium) completed the final conversion of the country and introduced monasticism.

About 520, Cosmas Indicopleustes visited the kingdom of Aksum. He reports finding churches, priests and numerous Christians. By that time, apparently, Christianity had established sound roots. A little later king Kālēb even undertook a campaign to the Yemen, where Ḏū Nuwās, a Jewish ruler, was persecuting the Christians. Ḏū Nuwās perished on the battlefield. Kālēb first installed a native regent, but after a year the Ethiopian troops rebelled against him and replaced him with Abrehā who, according to information from the Byzantine historian Procopius, was a former slave from the household of a Greek merchant in Adulis. Abrehā seems very soon to have made himself independent, at least in effect.

Fig. 15 Coin of King Usana (6th cent.)

At that time, too, Byzantium was evidently becoming more interested in South Arabia and Ethiopia. In fact one might have supposed that a Christian kingdom, and one situated on the sea-route to India at that, would have cultivated official contacts with Byzantium of its own accord. The accounts of Aksumite history seemingly bear this out as an obvious fact. However, this hypothesis no longer bears close scrutiny. Prior to Kālēb's expedition to South Arabia, reliable accounts of official contacts between the East Roman Empire and Aksum are wanting. Only under Justinian do we hear of a Byzantine embassy to South Arabia and Aksum. Justinian, involved in vigorous disputes with Persia, sought on the one hand to mobilize the South Arabian army against Persia and on the other to win over the Ethiopians as allies in breaking the Persians' monopoly as middlemen in the silk cloth trade. Justinian's messengers were to have persuaded the Ethiopians to take the silk trade into their own hands since they could buy silk direct from India and could ship it to Byzantium by-passing the Persians. But Justinian's scheme remained a dream. We have reports from several subsequent embassies from Byzantium, but we do not know what the points were on their programme of discussions. One can only suppose that they must have been similar to what has just been outlined. As soon as Byzantium and Persia had concluded an armistice, the reason for diplomatic contacts with Ethiopia ceased to exist and Byzantine embassies to the court of Aksum are not mentioned again.

By the end of the sixth century Persia had conquered the whole of South Arabia. Its control even extended to the Red Sea and one must assume that Aksum's sea-trade with the Mediterranean lands was affected by it. Unfortunately any evidence of its effects is lacking.

The Islamic conquests of the seventh century in the Near East and North Africa completely cut Aksum off from the outside world. Thus began a period of isolation which lasted for centuries. The link with the Patriarchate of Alexandria was basically preserved, but in practice it was frequently broken. For Europe, Ethiopia and the Ethiopians faded into the oblivion in which they remained for nearly a millennium.

Cut off from the surrounding world and its cultural stimuli, the kingdom of Aksum had to rely on its own resources. For the period from the seventh to the thirteenth century native sources are wanting, if one disregards the legends and traditions which are mostly of very recent origin and which in any case seldom agree with each other. Into this category fall the various king lists we possess. Not only do their names differ, but even their order. And what is more annoying, the names of three rulers attested on contemporary coins do not appear on the lists. So one must for the present rest content with the more or less plausible hypotheses about the conditions and events of this period.

Archaeology indicates a period of cultural regression. Architecture deteriorates and building construction lacks in care. The coins become noticeably cruder and about the year 800 minting seems to have stopped completely. As for literary activity, no evidence of any kind is available.

The political situation also continued to remain in the dark. As early as the seventh century the Dāḥlak Islands had fallen into Arab hands. The power of the Bēǰā tribes in the north had now covered the greater part of Ēretrā. Up till then the northern provinces of present-day Ethiopia, Tegrē and at least partially Ēretrā, had formed the kernel of the kingdom of Aksum. But now, according to the usually held hypothesis, a slow advance towards the centre and south of the northern highlands began and the political centre of gravity gradually shifted from the old capital city to the middle provinces.

At the beginning of the tenth century Ethiopian power was apparently re-consolidated. Arabic sources describe how the might of the Negus reached as far as Zaila', and even Dāḥlak again owed him tribute. There is mention, too, of treaties with

Yemenite rulers. Then towards the end of the century the picture suddenly changes. Arabic chroniclers report a queen who conquered the kingdom of Aksum, destroying its churches and monuments and overthrowing its king. Who the queen was, whence she came and for how long she ruled we do not know. Only this much is certain: she weakened the Ethiopian kingdom for a long time to come. This weakening probably facilitated the spread of Islam along the coast as well as in the south and as far as the eastern spurs of the highlands, especially in Šawā (Shoa). A series of Moslem states arose – Bāli, Ifāt, Šawā and others – which were to menace Christian Ethiopia from outside for centuries.

Shortly before the middle of the twelfth century a new dynasty appears, the family of the Zāgwē. Their home was the country of Lāstā, and there, in the city of Roha, they established their residence. There are wide-spread legends and quite irreconcilable traditions concerning the founding and history of the Zāgwē dynasty. Apart from Lāstā, the authority of the Zāgwē made itself felt principally in parts of the present-day provinces of Bagēmder and Tegrē. Alongside it, in Amḫārā proper, a family seems to have established itself more or less dependent on the Zāgwē and boasting Solomonic descent. From this family later arose Yekuno Amlāk, who brought to an end the dominion of the Zāgwē. Further to the south and south-east extended a series of Moslem states.

The Zāgwē furthered the Church and its missionary activity. They also strengthened the links with the Coptic Church. Under these conditions religion and literature took on new life. Their most glorious, certainly their most famous achievement was, however, the excavation of the monolithic churches in Roha (fig. 16), which tradition ascribes to king Lālibalā (c. 1190–1225). After him, the capital city Roha bore the name Lālibalā.

It might be useful here to add a word on the divisions of Ethiopian history. The value of arranging it into categories such as 'Antiquity', 'Middle Ages' and 'Modern

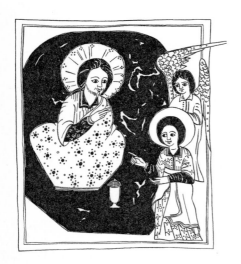

Fig. 16 The creation of the churches of Lālibalā (from a 19th cent. ms. in the British Museum)

Period' is slight for reasons which hardly need further explanation and there is agreement on the uselessness of this pattern, but not however on what to substitute for it in the case of Ethiopia. One possibility consists of taking as the central point Ethiopia's conversion to Christianity under 'Ēzānā and to differentiate sharply between pre-Christian and Christian Ethiopia. This is the one we have adopted here, primarily to achieve a practical division of the material, although a threefold division seems preferable to me. The first period would range from about 500 B.C. to the end of the rule of the Zāgwē, with obviously numerous subdivisions. I see the unity of this epoch in a certain continuity of development within the same cultural climate,

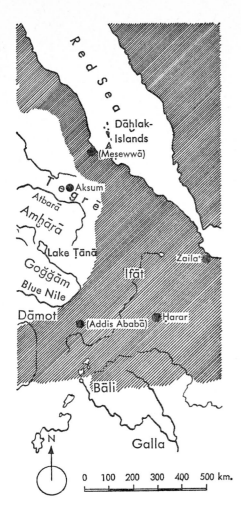

Fig. 17 The Ethiopia of 'Amda Ṣeyon; Moslem area shaded (after *Trimingham*)

and not least in the continuation of the political centre of gravity in the north of the country. The second would begin in 1270 and last until the middle of the nineteenth century. It arose from the previous period and another, or rather considerably changed, cultural climate, due to the lack of stable urban settlements and the different languages – the use of Amharic in place of Ge'ez. Above all it indicates the shift of the political centre from the region of Tegrē towards the south. Here, too, certain events such as the appearance of Grāñ suggest themselves as a basis for further subdivisions.

The recognition of Yekuno Amlāk in 1270 and the 'restoration' of the so-called Solomonic dynasty introduces this second period. If we accept a late tradition, his assumption of power was brought about peaceably thanks to the national saint Takla Hāymānot. However there are justifiable doubts about this version of the story.

With the Solomonic dynasty there begins an endless flow of indigenous historical sources. It is true that to start with their material is extremely meagre, but it is not long before we meet with regular chronicles.

We can only form a very approximate picture of the reign of Yekuno Amlāk and his immediate successors. The centre of the kingdom strayed yet further south towards Amḥārā. In contemporary Arab sources the king of Ethiopia appears as 'ruler of Amḥārā'. There are some indications that in the northern provinces the Amharic assumption of power provoked opposition. To start with, the most important task of the new kings was to consolidate their rule internally. Towards their Islamic neighbours they evidently preferred a cautious political approach.

Of Yekuno Amlāk's immediate successors we know scarcely more than the names. It is only with 'Amda Ṣeyon (1313–1344) that the sources become more informative. Shortly after he ascended the throne, he came into conflict with the clergy because he had married one of his father's concubines (according to another tradition, his sister). Several monasteries around lake Ṭānā trace their foundation to the time of 'Amda Ṣeyon. One might wonder whether these foundations were not at least partly connected with the quarrel between king and clergy – the monks withdrawing into remote areas away from the king's persecution. But this quarrel represents only one episode in the glorious reign of 'Amda Ṣeyon. The echo of his warlike deeds has long been heard in the history of Ethiopia and he annexed for all time the districts of Dāmot and Gojjam to the kingdom (map, fig. 17). But his most significant victory was won against the Islamic sultanates which had grown strong in the south and south-east. In a series of military expeditions he broke their power and levied tribute on the Islamic rulers. In the south he extended Ethiopia's border as far as the Awāš.

The struggles with Moslems continued under 'Amda Ṣeyon's successors. Victories alternated with defeats, but ultimately the Islamic border states experienced a slow progressive weakening. In 1402, under king David (according to another source, in 1415 under king Yeshaq), the Ethiopian army pushed forward as far as Zaila' and captured it after a short siege. Sultan Badlāy ibn Sa'ād ad-Dīn, who had fled to Zaila', lost his life and his country, Ifāt, in eastern Šawā.

The incorporation of Ifāt into the kingdom of Ethiopia completely displaced Islam from the highlands. The Moslems had to withdraw eastward to the Somali plateau and the kingdom of Adāl with Dakar (near Ḥarar) arose as their new centre. By now the kingdom of the Negus stretched in the south far beyond the Awāš – even the fertile areas of the south-west recognized his sovereignty. Indeed the strict organisation of such an extensive kingdom became too much for the powers of the throne. The Negus became the over-lord of a feudal state, the *neguśa nagaśt*, 'king of kings' (i. e. emperor) – and less of a central authority radiating directly to the furthermost corner of a mighty kingdom. Within the kingdom pockets of heathen and Islamic groups lived on, and the Jewish Falāša stubbornly exerted their independence in

the inaccessible mountainous region of Samēn. No wonder that separatist movements frequently kept the king busy.

King Zar'a Yāqob (1434–1468) recognized this problem and sought to remedy it. He too, like his predecessors, conducted a war against his Islamic enemies. He won a great victory over the Sultan of Adāl and brought to Ethiopia a lengthy respite from Moslem attacks. But he could not hope for permanent security. The bordering Islamic states had connections with the rest of the Islamic world, which could rush to their help (and later did so), whilst Ethiopia, a rather loosely-knit organisation of states, lay isolated, surrounded by enemies and cut off from the Christian countries of Europe who only knew of its existence by rumour. Zar'a Yāqob's policy is sometimes explained as an attempt undertaken deliberately to strengthen the Ethiopian state in the context of this precarious balance of power. This interpretation is however rather too 'modern'. It assumes that the king, in the seclusion of his mountain fortress, could form a clear picture of the state of affairs in the outside world and gave a true account of it; which is questionable.

However that may be, Zar'a Yāqob's policy recognized two complementary goals: the strengthening of the national religion, i. e. official Christianity established by the king, and the consolidation of the state and its central power. Inexorable persecutions were designed to stamp out all heathen remnants. The same implacability was directed at heretical Christian creeds. The king himself laid down the true religion and the organisation of the Church and clergy in the smallest detail. To break the power of the feudal lords in the provinces, he made the administration directly dependant on the throne. He himself appointed the provincial governors from the ranks of the civil service or members of the royal family. Altogether his attempts at political reform had only limited success and did not outlast his reign. On the other hand his ecclesiastical reforms made an ineradicable impression on the Ethiopian national Church. Zar'a Yāqob ranks as the most significant ruler between Yekuno Amlāk's accession and the Islamic invasion in the sixteenth century. Under him, Ethiopia saw her borders extended further than ever before. During his time she had no fear of foreign invasion. A centralised administration functioned for a short time. State endowed churches and monasteries flourished to the encouragement of literature, schools of scribes copied manuscripts and new translations appeared. Even literary self-expression grew and the king himself got to work as an author. It is certain that Zar'a Yāqob was one of the principal figures of Ethiopian history. As a man, however, he is not nearly so attractive. All too frequently he gives the impression of narrow-minded fanaticism. Humility was not one of his virtues. He was obsessed with pathological suspicion, and baseless slanders brought cruel punishments to the innocent.

Under his successors – Ba'eda Māryām, Eskender, Nā'od, Lebna Dengel – the political scene changed but slightly. Despite occasional Moslem raids and internal uprisings, Ethiopia on the whole enjoyed a period of prosperity.

At the beginning of the fifteenth century contacts were even established with the Orient. Several undoubted testimonies to European craftsmen in Ethiopia have also been preserved from this period, among them an enamelled copper plaque with a picture of the kings Nā'od and Lebna Dengel in European dress (fig. 18). Finally, in 1520 a Portuguese embassy visited Ethiopia and remained there six years. Portugal's interest was aimed at a possible base on the sea-route to the East-Indies. Alvares, chaplain to the embassy, compiled the first European eye-witness account. The report of his journey is all the more valuable since it reflects the state of affairs shortly before the devastating Islamic invasion.

In 1527 a tidal-wave swept over Ethiopia under the leadership of Aḥmad Grāñ. Grāñ's hordes overran the greater part of the kingdom, plundering and burning down

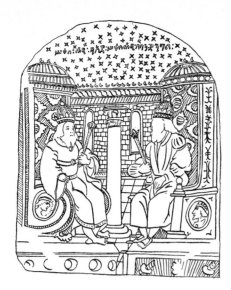

Fig. 18 The Kings Nā'od and Lebna Dengel

churches and monasteries. The king fled with a handful of loyal followers from one province to the next, whilst his subjects were either killed or obliged to submit to Islam. Ethiopia was on the brink of ruin. Only the northern part of the country, Tegrē and the modern Ēretrā held out after a fashion against the onslaught. In the end the issue was decided by a small army of Portuguese which landed in Meṣewwā in 1541 and helped to beat the Moslems decisively. Grāñ himself was killed in battle in 1543.

Liberated, Ethiopia was littered with ruins. But before it could recover from the exhaustion a new storm blew up. Galla tribes overran the south-eastern provinces, gradually pushed forward along the eastern edge of the highlands and in Šawā and Wallo took possession of even greater areas of the highlands. Their northernmost outposts were settled along the south-eastern border of Tegrē around the district of Qorbattā. In these difficult times Ethiopia was fortunate in producing a number of distinguished rulers. Claudius (Galāwdēwos; 1540–1559) and Śarṣa Dengel were both great warriors. The former fell in battle against the Emir Nūr of Ḥarar. The latter made war on the Falāšā in the north-east and on the Turks in the north. Principally, however, he – like his successors – found it necessary to ward off the Galla incursions which showed no signs of abating.

During the reign of Susneyos (1607–1632), the Catholic Jesuit mission (the price paid for Portuguese help) achieved its greatest success: the king went over to Catholicism and tried to impose the new creed on the people. Rebellions, however, thwarted the intentions of the king and his advisers, until at last Susneyos reversed his policies and abdicated. His son Fāsiladas (1632–1667) expelled the missionaries and a new period of isolation began for Ethiopia. Fāsiladas chose Gondar as his capital city and erected there, along with other buildings, the palace still named after him. His successors, especially Iyāsu the Great (1682–1706) and Bakāffā (1721–1730), continued this building activity. Most of the palaces and many churches are today little more than well-preserved ruins. But even so they reveal something of the glory of the former royal city. Painting also flourished at that time and to a certain extent literature experienced a temporary revival. But the prosperity did not last long. By the middle of the eighteenth century the monarchy had lost all effective power. Anarchy was universal. The rulers of the various provinces quarrelled with each other over the supremacy, rebellions were the order of the day, the kings danced like puppets in the hands of soldiers of fortune.

With an iron fist the usurper Theodore (Tēwodros, 1855–1868) tried to re-unite the kingdom under a central administration. He failed in the attempt, but initiated Ethiopia's third period, the modern. Under Menilek II (1889–1913) the ancient empire finally recovered its unity and greatness.

Selected Sources

Ethiopian history: Budge, *A History . . .*; Conti Rossini, *Storia . . .*; Doresse. They must all be used with care.
Ethiopia and Islam: Trimingham.

The Ethiopian Orthodox Church

Ernst Hammerschmidt, Saarbrücken

The Ethiopian Orthodox Church (the name 'Coptic Church' is wrong, since Coptic is a synonym of Christian Egyptian) has, according to article 126 of the Imperial Constitution of 1955, the position of 'Established Church' *(maśaratāwit bēta krestiyān)* of the State. In many respects it is unique among the Eastern churches. There have been influences at work in it which were not present, at least not to the same extent, in the other oriental Churches. On the other hand it should not be overlooked that many things only appear strange and unique at first glance. Anyone who looks below the surface will soon see that he is dealing with central Christian ideas and categories of thought which are also those believed in the West.

We wish to outline as briefly as possible the structure and character of this Church, which in the West was for a long time considered a remote and rather curious phenomenon, but which now, in quite a short space of time, has come to the fore in the interest of quite a wide public.

The conversion of the kingdom of Aksum associated with the names of the two Syrian missionaries Frumentius and Aidesius and with King ʿEzānā began in the fourth century. At the time of the Christological controversies, the task of building up the Christian establishment was carried out by fugitives from the church of the Byzantine empire. Among them, the Nine Saints of Rome ('Rome' referring to the Byzantine Empire) have a prominent place. Probably monks driven out of Syria who came to Ethiopia about A. D. 500, they were: Aragāwi Za-Mikāʾēl, Panṭalēwon, Garimā, Afṣē, Gubā, Alēf (or ʿOṣ), Yemʿātā (or Maṭāʿ), Liqānos and Ṣeḥmā. The activity of these men was so important for the establishment of Ethiopian church life that it is chiefly to them that tradition ascribes the great achievements of the past. This applies, for example, just as much to the slaying of a serpent tyrant as to the translation of the Gospels into the old Ethiopic language, Geʿez. With the influx of these Syro-Hellenistic forces the so-called monophysite direction of Christological teaching found entry into Ethiopia. One must be especially careful at this point, for it cannot be said that the teaching of the Ethiopian Church is actually monophysite. In the Aksumite period, when attempts were made to translate philosophico-religious concepts (such as 'physis') into Geʿez, considerable difficulties arose, since the translators did not have at their disposal words having such a precise meaning as the original Greek words had developed through centuries of discussion. Seen from the point of view of the history of doctrine, the principal problem of Ethiopian Christology lay in the hazy distinction between *bāḥrey* and *hellāwē*, which are both used for the Greek 'physis'. In the Ethiopian mind, however, bāḥrey had not so much the significance of *natura* as of *natura subsistens* or *persona*. Hence the unwillingness of the Ethiopians to attribute to Christ two bāḥreyāt (plural) since in their eyes this was tantamount to Nestorianism. Recently, research has been undertaken with the conclusion that an essentially orthodox conception of the manhood of Christ, in agreement with the teaching of the State Church, is obscured by apparently monophysite formulae. This also applies to the sphere of liturgical texts. Today it is realized that the monophysite tone of certain Ethiopian theological expressions is merely verbal monophysitism, i. e. formulae and phraseology stemming from the anti-Nestorian world of thought of Cyril of Alexandria (died A. D. 444), which have an almost monophysite tone but which in the meaning of established church orthodoxy prove to be completely defensible. Of course, with this theoretical statement it should not be disputed that Ethiopian church life exhibits

a unique character. One must therefore distinguish carefully what belongs to the Christian message and what belongs to the trappings. Along with the influences of the pre-Christian outlook of the country, a factor contributing to the uniqueness of the Ethiopian church is that, apart from its temporarily very loose connection with the Coptic Patriarchate of Alexandria, it was very soon thrown on to its own resources and so of necessity had to develop along lines of its own. Non-Christian (Semitic and Cushitic) elements and the independent development dictated by circumstances played their part in the formation of Ethiopian church life and formed that body with which we are confronted today.

Viewed formally, the structure of the Ethiopian Church is strictly hierarchical, that is, it has perpetuated the traditional structure of bishop, priest and deacon. If today (since 1959) the Patriarch and Catholicos is at the head of the Ethiopian Church, it is the result of a very recent development, as is the institution of archbishops administering dioceses, the borders of which are contiguous with the provinces of the state. Up to 1959, the Ethiopian Church was administered by a Coptic bishop, the Abuna, selected by the Coptic Patriarch of Alexandria from among the monks of Egyptian monasteries or other suitable candidates, and consecrated for Ethiopia. For the right of appointing the Abuna of Ethiopia, the Coptic Church claimed the authority of the spurious eighty-four so-called Arabic or Oriental canons of the Council of Nicaea (A.D. 325) which required that the Abuna of Ethiopia should always be a Copt. As a Copt, the Abuna's confidence in the Ethiopians was very small, hence from the spiritual point of view he remained pretty isolated. More than once, difficulties in the nomination of an Abuna were occasioned by misunderstanding resulting from the great distance involved, and sometimes it was quite a long time before a new Abuna arrived in Ethiopia. Later on, the Moslem authorities in Egypt viewed the Patriarch of Alexandria's contact with Ethiopia with suspicion on principle and occasionally even censored his letters, so that it became usual from the thirteenth to the fifteenth centuries to direct the request for a new Abuna not to the Patriarch, but to the Sultan of Egypt. Sometimes a great variety of gifts accompanied this request. Now and then there were even quarrels over the person of the Abuna when it was considered that he did not meet the requirements of his office.

Egypt's ecclesiastical hegemony over Ethiopia was only once seriously disturbed. When the Patriarch of Alexandria, Cyril III (1235–1243) consecrated, in Jerusalem, an archbishop for the Copts of Syria – an act which was the prerogative of the Syro-Jacobite Patriarch of Antioch, Ignatius II – the latter retaliated by consecrating the Ethiopian monk Thomas as Abuna of Ethiopia. So towards the end of the thirteenth century there seem to have been two Abunas in Ethiopia, the one Antiochene and the other Alexandrine. Nevertheless the Ethiopians soon broke free of the Syrian hierarchy.

While Ethiopia was awaiting a new Abuna, the leadership of the Church was *de facto* in the hands of the highest local dignitary, the Ečagē, who exerted immense influence as adviser to the king as well as director of the church administration and head of all the monks and monasteries. But since he was not a bishop, he could neither ordain deacons and priests nor consecrate other bishops. Originally the head of St Stephen's monastery, Lake Ḥayq (Wallo province), held the position of Superior of all monks, but soon after 1445 it was transferred to the head of the monastery of Dabra Libānos in Šawā (Shoa).

The spiritual head of the ancient imperial capital, the Nebura'ed of Aksum (who today also holds civil authority within his sphere), also had a special position. As the kingdom's political centre of gravity shifted first to Lāstā with its capital city Roḥa (later called Lālibalā) then southwards to Šawā, in the course of time the office of Nebura'ed was divested of its original significance and was felt more and more

to be an embodiment of ideal values. Apart from the head of the district of Aksum, there is only one other cleric bearing the title of Nebura'ed and that is the head of the church of Addis 'Ālam (west of Addis Ababā) built by Menelik II, by which the Emperor hoped at that time to create a southern counterpart to Aksum.

In Ethiopia, as in all oriental churches, the central ecclesiastical position is that of priest (Ge'ez: *qasis*, Amharic: *qēs*). According to Ethiopian doctrine his particular duties are 'to baptize, celebrate the Eucharist and distribute it, to bless the people, preach the Gospel, teach, admonish, advise and perform any other religious work'. The ordination of a priest – in which the presentation of the liturgical vessels is lacking – consists essentially of the laying-on-of-hands by the (arch)bishop, pronouncing the words, 'Receive thou the Holy Ghost' (according to J. Assemani, *Reple eum Spiritu sancto*). The preliminary to the priesthood is provided by the diaconate which was and still is conferred at quite an early age. When the young deacon wished to continue on the path to the priesthood, he would, in the past, usually have been instructed in the necessary discipline by an older priest or he would have gone to one of the country's numerous centres of clerical education, some of which enjoyed wide fame, such as Bēta Leḥem in Gāyent for church music, Gondar and Dabra Libānos for Biblical exegesis. This is still partly so today. In addition, however, there is now the possibility of studying at the Theological College of Holy Trinity in Addis Ababā, which dispenses an education based on a foundation of modern scholarship.

A unique feature of the Ethiopian Church is the function of the *dabtarā* (from the Greek 'difthéra') whose main task is the care of church music and reading of lessons as well as certain scribal duties. The dabtarā does not, however, belong to the circle of the ordained (unless he received deacon's orders in his youth or should happen to be a former priest) and has no place in the pyramid of the ecclesiastical hierarchy. His job requires a certain knowledge of the traditional church scholarship but allows him comparative freedom in his way of life – a special mode of living, dedicated to a spiritual calling, is not required of him.

Ethiopian monasticism has a very great significance; there are innumerable monasteries and somewhat fewer nunneries. They are divided into two kinds: the so-called 'convent communities' in which all live permanently as members of a large religious community, having no private possessions; and the sort called *qurit* or *equrit*, for whom the monastery is merely an occasional meeting place – for the most part these monks and nuns go their own way regulating their life of asceticism as they think best.

Despite the occasional dark side to monasticism it is scarcely possible to exaggerate the value of the monasteries for the country's culture. They were and still are centres of church life as well as of theological tradition and in not a few cases treasure houses of Ethiopian literature. Dabra Bizān and Dabra Dāmo in north Ethiopia, St Stephen's monastery in Lake Ḥayq, mentioned above, and Dabra Libānos in Šawā are only some of the most famous names. The Ethiopian monastery in Jerusalem should not be forgotten, either. From time immemorial the area of Lake Ṭānā, lying on the borders of the provinces of Gojjām and Bagēmder, has been a centre of the monastic life. Many a legend is linked with the lake's islands. It is alleged that the Mother of God with the Christ child lived for a time during their flight from Bethlehem on the island of Ṭānā Čerqos, the very island which is supposed to have harboured for 600 years the Ark of the Covenant which was stolen from Jerusalem, before it was brought to Aksum. South-east of the largest island called Daq is the island of Dāgā Esṭifānos, whose peak is surmounted by the monastery and basilica of St Stephen. Here is the burial-place of some of Ethiopia's most famous rulers: Yekuno Amlāk (1270–1285), Dāwit I (1382–1411), Zar'a Yā'qob (1434–1468), Za-

Dengel (1603–1604) and Fāsiladas (1632–1667). It is simply impossible to tell what and how many treasures there may be among the church vestments, liturgical vessels and Ethiopic manuscripts hidden in the churches and monasteries of the lake.

The persecution of Christians by the Fatimid caliph al-Ḥākim (A.D. 996–1020) apparently caused many Copts to flee from Egypt to Ethiopia and the migration continued until later. In the second half of the thirteenth century Coptic monks brought their church's liturgical and theological works with them to Ethiopia and infused new life into the literature of the Ethiopian Church. Since the re-establishment of the Solomonic dynasty (1270), especially since the reign of 'Amda Ṣeyon (1314–1344), we can notice a flowering of Ethiopic literature. Nevertheless we should not speak simply of a new beginning. It must be considered likely that a stream of literary tradition, so far unidentified, continued on from the fall of the kingdom of Aksum in the tenth century until the beginning of the rule of the Amḥārā. It also seems questionable to me whether the liturgy of the Ethiopian Church underwent such a radical change that, according to Mordini, the style of church in which the 'Holy of Holies' (maqdas) is formed as a rectangular structure with three doors in the middle of the nave should be attributed to it. It is difficult to imagine a change in the eucharistic liturgy which would necessitate a displacement of the maqdas within the area of the church. Since we know so little of the individual stages in the development of the Ethiopian liturgy, it is as well to refrain from unduly far-reaching conjectures.

Ethiopian church architecture is discussed in detail elsewhere in this book. Suffice it to observe here that the threefold division of the Ethiopian church building (1. maqdas: the sanctuary with the altar, which may only be entered by the priest conducting a service; 2. qeddest: the place for the non-officiating clergy and the distribution of the Eucharist to the people; 3. qenē māḥlēt: the outermost ambulatory for choristers and people) does not unquestionably need to have its prototype in the threefold plan of the Temple in Jerusalem. Not long ago M. Rodinson showed that one must draw a very careful distinction here – the threefold plan is in no way specifically Ethiopian, but is a feature of the early Christian church. The early Christian basilica was already threefold in principle, and even the Coptic churches followed this arrangement. In the Orient, the threefold division was considered later on as a symbol of the Trinity, and also as prefiguring the tabernacle or temple to be erected in the New Jerusalem.

This also applies to an important piece of furniture which is essential to every Ethiopian church: the tābot on the altar. This is simply a slab either of wood or stone with engraved decoration and a short inscription, such as 'Tābot of St George' (fig. 19). The bishop consecrates not the church but the tābot, which then confers sanctity and honour to the whole place. In a broader sense the tābot can also signify the maqdas as well ultimately as the whole church, which is dedicated to the tābot's patron saint or festival.

These slabs are currently understood to be imitations of the Tables of the Law, which are supposed to be in the Ark of the Covenant at Aksum. As E. Ullendorff has shown, this is also the explanation of the shift in meaning of the expression 'tābot'. The original meaning was chest, and then through the application of pars pro toto the word came to signify the contents of the chest, the Tables (of the Law).

Here too, reference to an Old Testament feature, the Tables of the Law, is secondary. The tābot is primarily nothing more than the kind of altar slab such as is usual in the other oriental churches and which has a parallel within the Roman rite in the altare portatile. Only later, apparently in connection with a strong movement which tried to make Ethiopia out to be the true Israel, was the altar slab interpreted as a copy of the Ark of the Covenant. So with this, as with many another

Fig. 19 Three tābots (the inscription is omitted, after *Hanssens/Raes*)

'Jewish' element in Ethiopian Christianity, especially in its religious practice, it is necessary to investigate whether there is a direct link with the Old Testament or Judaism, or whether its origins are to be explained as nothing more than the common heritage of ancient oriental Christianity.

The tābot, which is kept in a wooden cupboard with shelves called the *manbara tābot*, serves as a kind of 'altar-stone' upon the altar during the Eucharistic liturgy. At the celebration of the Eucharist, the priest spreads a cloth *(māḥfad)* over the altar slab and then places upon it the small paten *(ṣāhel)* and the chalice *(ṣewwā)*. In the small paten he places another cloth, also called māḥfad, and upon this the eucharistic bread *(qwerbān)* is placed. The chalice is in a rectangular case called the 'throne'. Over the chalice and paten there are two veils *(kedān)* and a third *(makdan)*, which is sometimes large enough to hang over the front of the altar, is spread over them both. The eucharistic elements are administered with a crosshandled spoon called 'erfa masqal. There is also among the liturgical vessels the *masob*, a strong raffia basket of the kind one sees all over the country in a wide variety of sizes. Its purpose is for bringing the bread prepared in 'Bethlehem' (see below) to the officiating priest before the start of the liturgy. Since this object is described as *masoba warq* (golden masob), one might have supposed it would be a large metallic paten. H. Engberding has shown, however, that this expression applies not to the colour of the masob but rather to its use, since in the service of preparation of the Eucharist *(śer'āta qeddāsē)* it is hailed thus: 'Thou art the casket of pure gold wherein the manna is concealed, the bread which came down from Heaven bestowing life on all the world.'

As mentioned above, the eucharistic bread is prepared in 'Bethlehem', a small house within the church confines. This seems to reveal a unique Christology of the Incarnation according to which the Eucharist is seen as a participation in or consummation of the whole life of Christ, from his birth in Bethlehem to his sacrifice on the cross (in the Eucharist, the sacrifice on the altar).

A clay pinnacle with an iron cross usually decorates the roof of an Ethiopian church, since the ubiquity of the cross is in general a typical characteristic of Ethiopian Christianity. Crosses confront us in many hundreds of varieties, from the small pendant crosses, handcrosses and processional crosses (fig. 20) right up to the huge roof cross.

In liturgical vestments the practice of the Ethiopian church exhibits considerable latitude. In theory the priests' vestments consist of the following: 1. The *Qamis*, a sleeved tunic similar to the western alb; 2. the Girdle *(qenāt)*, which secures the Qamis; 3. the *Mōtāḥet*, also called *enged'ā*, a broad stole similar to the Greek Epitrachēlion; 4. the *Kāppā*, the priest's overgarment which, with certain reservations as to detail, corresponds to the Latin *pluviale*; 5. the *Lānqā*, a cape like a mozetta, with five long streamers. The origin of the Lānqā is to be sought in animal skins which used to be worn as a cape by the nobility of the realm; 6. the head cloth called *ḥebānē, qaṣalā* or *gelbāb*, which extends to the forehead and touches the shoulders. Today, however, this is not in universal use in the liturgy. Crowns *(aklil)* are usually only worn by deacons and the heads of certain churches as a sign of their dignity. The highly coloured and often ornamented umbrellas of great variety are a mark of distinction of the clergy; in the marriage service the bridal couple receive the Eucharist under a red umbrella.

This inventory, however, merely represents the ideal arrangement, which in practice differs widely. In many village churches at the liturgy the priest only wears Qamis and Kāppā, not always even the moṭāḥet. If the priest is very poor, he makes his own Qamis and only buys the Kāppā. The deacon wears either Qamis and Lānqā, Qamis and Kāppā or Qamis and Motāḥet, which in this case, of course, has a somewhat different shape from the priest's.

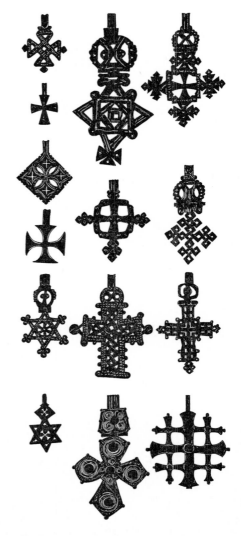

Fig. 20 Pectoral crosses

The individual development of these liturgical vestments is not known. The written sources regarding them are somewhat confused and the terminology very vague. In this connection one must bear in mind that much of the relevant terminology, taken over into Ge'ez from the Arabic of Egyptian religious literature, would not have been intelligible to Ethiopians without further explanation. Possibly further research into Ethiopian literature will come up with a detail here or there which will shed some light on the course of its development.

In the centre of the liturgical life of the Ethiopian Church is the celebration of the Eucharist *(qwerbān)*. The basic belief runs throughout their tradition that the celebration of the Eucharist stems from the Lord's command. Through his word and with his help, made effective by the priest's action, the Eucharistic elements (bread and wine) are united with and truly changed into the body and blood of Christ.

The Ethiopian Church possesses a comparatively large number of different liturgical forms which we have yet to discuss. It seems probable that, to start with, elements of the Syrian liturgy affected the shaping of the Ethiopian. But despite this and later Coptic influences, in the course of time it developed independently to such an extent that today it forms a unique liturgy. A considerable part of the Ethiopic *anaphoras* (the anaphora is the prayer of consecration of the Eastern churches, the extensive, richly varied counterpart of the canon in the Roman liturgy) is an original creation of native church poetry which flourished throughout the monasteries of the land. Admittedly the poetic emphasis occasionally comes through so strongly that the text almost threatens to break free of the traditional framework of the anaphora. But here too the fundamental structure of the eucharistic liturgy is faithfully preserved, even if no longer in true proportion. By fundamental structure, I mean the offertory with the lections, the eucharistic prayer of consecration with the words of institution and the invocation of the Holy Spirit upon the eucharistic elements (Epiclesis) and the distribution of the elements.

So far, we know of twenty different anaphoras, of which the Ethiopians only recognize fourteen as canonical. The remainder, which appear in various manuscripts, are only of academic interest since the Church makes no use of them. In the following attempt at classifying the anaphoras, the un-canonical ones are marked with an asterisk:

1. The normal liturgy is the Anaphora of the Apostles, which is derived from the anaphora of the Egyptian liturgy (the so-called *Traditio Apostolica* of Hippolytus of Rome). It is simply an extended form of this liturgy enriched with various texts. With it is grouped the Anaphora of Our Lord Jesus Christ which corresponds to that of the *Testamentum Domini nostri Jesu Christi*.

2. The anaphoras which are translations of liturgical forms from elsewhere: the anaphoras of Basil, Mark* and James* the brother of Our Lord.

3. The texts which certainly or in all probability originated in Ethiopia itself and consequently have to be considered as original poetical creations of the Ethiopian Church: St Cyriacus of Behnesā's anaphora of Mary, the great and lesser* anaphora of St Cyril, the Palm Sunday anaphora of St Gregory, St Gregory's anaphora of the Nativity, St Gregory's anaphora of Mary*, the alternative form of St Gregory's anaphora of Mary*, the anaphoras of SS. Epiphanius, Dioscorus, and James of Serug, of the 318 Orthodox Fathers of Nicae, of SS. Athanasius, John Chrysostom, John the Evangelist and the anaphora of Our Lady Mary*.

Unfortunately we are for the most part still unable to locate the position of the greater part of these anaphoras in the development of the Ethiopian Eucharist. The anaphora of Basil is a translation of the Graeco-coptic liturgy of St Basil, that of Mark, of the Alexandrine liturgy of St Mark, whilst the anaphora of St James the brother of Our Lord proves to be a translation of the Syrian anaphora of the same name. Consequently all three can be considered as testimony to the two great sources

of influence, the Egyptian and the Syrian. On the question of the original form of the Ethiopian liturgy there is no agreement. I have argued in favour of the priority of the anaphora of the Apostles and the anaphora of Our Lord, and more and more this seems to me to be the most likely hypothesis. Most of the Ethiopian anaphoras appear for the first time in manuscripts of the fifteenth century, but that does not in any way mean that they might not be older. Language and style help in ascertaining the date of composition, as well as quotations of Scripture since, up to the present, we have no precise insight into the development of the Ethiopian Bible text. In this connection one should always bear in mind that in liturgical practice scriptural quotations always approximate to the usual current Bible version. From all this uncertainty, we can see that our present state of knowledge of the development of the liturgy has little to contribute to the interpretation of church architecture (cf. above).

On no account should one seek the reason for the existence of so many rock and cave churches in the structure of the Ethiopic liturgy. Of course one will wonder why it is that this sort of church building should have arisen in Ethiopia, but the grounds adduced for this development are outside the liturgical sphere. The question of the rock churches of Ethiopia should be thought of in terms of historical architecture and not of some vague history of religion.

Despite its conformity with the structure of the common early Christian Eucharist, the Ethiopian liturgy exhibits many unique features. In this category belongs *Mēlos,* the sword of fire which is mystically to slay the Lamb and which is found in the Epiclesis of several texts. Thus in the anaphora of James of Serug, 'And Mēlos shall be sent the terrifying sword of fire, and shall appear over this bread and cup and shall accomplish this eucharist!' W. H. Worrell's explanation, that Mēlos and its numerous variants in the magic texts are the name Solomon (which in Ethiopian tradition also signifies a secret name of Christ) read backwards, has found no general acceptance.

The liturgy is celebrated on Sundays and Festivals, Saints' days and other specified days of the church year. The custom of the daily celebration of the Eucharist is also found. Another practice kept up in the Ethiopian realm is the observance of the Sabbath – a peculiarity which in the past gave rise to the accusation that the Ethiopian church had lapsed into 'Judaism'. The Ethiopian sources, however, generally stress the different character of the Ethiopian Sabbath (*Sanbat*) from the Old Testament Jewish Sabbath. In any case, at least in part, the Christian world was positively opposed to the observance of the Sabbath. Undoubtedly there are Jewish features recognizable in the Ethiopian observance of the Sabbath but without impugning this heritage, the Sabbath, being quite familiar to the Ethiopian Church, was felt to be part of Christian discipline.

Ethiopian services acquire a special tone through the use of various musical instruments such as the great harp *(baganā)*; the sistrum *(ṣanāṣel)*, a rattle with five metal discs arranged on two transverse wires, which probably originated in Africa and then became the symbol of ritual music in Egypt (fig. 21), and the long drum *(nagārit)*. With the prayer-stick *(maqwāmiyā)* – which is primarily a support during the long services – the dabtarās tap the rhythm during their sacred dance.

The division of the church year stems from an early period. In its main points it has hardly changed throughout the centuries. The Ethiopian's round of liturgical festivals is based on the Coptic, but in many cases unique elaborations developed. The Coptic-Ethiopian year begins on the 29th August of the Julian calendar and is divided into twelve months of thirty days each with a small additional month of 5 days (in leap years 6 days). In Ethiopia there is no division between the ecclesiastical and civil calendars, they are both identical. During the year there are movable feasts, such

Fig. 21 Sistrum

as Easter, Ascension, Whitsun, and also immovable feasts. Prominent among the latter is the feast of Masqal on 17th Masqaram (i.e. 14th September Julian/27th September Gregorian). As well as being a religious festival it is also a national one. One of the greatest feasts is Ṭemqat, the festival of Baptism on 11th Ṭerr (i.e. 6th January Julian/19th January Gregorian). On the eve of the festival, the tābot of every church is carried in festive procession to some nearby piece of water and is then blessed at sunrise. The faithful bathe in the water that has been blessed, a custom which has been misunderstood as a re-baptism. This ceremony, however, only represents a kind of renewal of the grace of baptism, in respect of the purport of the festival, Jesus' baptism in the Jordan.

Alongside these recurring festivals of the church year, the Ethiopian Church possesses a peculiarity already present in its first stages in the Coptic Church, that of repeating certain festivals on the same day of every month. Thus on the 5th of every month the feast of St Gabra Manfas Qeddus, the saint upon Mount Zeqwālā (southeast of Addis Ababā) is celebrated, on the 12th that of Michael the Archangel, on the 16th Kidāna Meḥrat (Covenant of Mercy), a festival of Mary, and on the 29th, the feast of the nativity of Our Lord. The Ethiopians observe the fast days very strictly, of which there are no less than 250, 180 of which are binding on all.

With the Eucharist at the centre, the other sacred rites of the Ethiopians are grouped around it. The gate of entry into the congregation of the people of God is passed in Baptism (*ṭemqat*), the service for which is built up from the Coptic rite. Confirmation (*mēron* i.e. Myron) follows on baptism immediately. In it the nose, lips, ears, breast, soles of the feet and shoulders of the baptized are anointed. Formerly the priest used to place a crown on him, but this has been replaced by a cord twisted from threads of three different colours (as a symbol of the Trinity) – the *mātab*, always worn by the Christian Ethiopian. On entry into manhood, this cord is exchanged for a blue one, or for a gold necklace with a cross. The mātab is often misunderstood by outsiders as a charm. Although there are some wearers who revere it as an amulet, it is neither in origin nor significance connected with any kind of magical practice, despite the idea that one should never be parted from one's mātab. As a symbol of baptism it is at the same time the symbol of a steadfast and openly confessed Christian faith. Anyone who has set aside his mātab is considered to have set aside his Christian faith. Hence the saying; 'Mātab krestennā yallawm', i.e. 'he has no mātab (and thus) no Christian faith'.

Soon after birth, circumcision *(gezrat)* is performed, but not as a religious command but simply as a 'custom of the father'. The Ethiopians also practise the rites of penance *(nesseḥā)*, unction of the sick and matrimony. Only a minority get married in church. The majority are satisfied with civil marriage, which allows divorce. A priest may be present at this and pronounce a blessing, but this does not give it the status of a rite of the Church.

The Church surrounds the death of a believer with rich ceremonial that not only encompasses the burial rites themselves but also includes remembrance of the deceased in memorial services *(tazkār)*. The tazkār is made up of two elements, one religious and the other social. The religious element consists of services of prayer for the deceased on the 3rd, 7th, 12th, 40th, 80th, and 120th days and the social element of the meal of remembrance, in which the relatives and friends of the departed, as well as the clergy, take part.

What has been said in this short survey applies, for the most part, not only to the Ethiopia of the Zāgwē period and the first few centuries of the restored Solomonic dynasty. The sources are still too sparse to be able to determine in the ecclesiastical sphere exactly what belongs to this period and what is either earlier or later, not to mention the fact that in the ecclesiastical sphere revolutionary changes to a traditional

structure are not very likely. The Emperor Zar'a Yā'qob's (1434–1468) attempts at reform gave many fresh impulses but that is not to say that he introduced changes in every case. It is much more likely that he tried to sift what was already available and arrange it afresh, so as to inspire it again with life.

In the past, people were all too often inclined to see in Ethiopian Christianity nothing more than a thin veneer over a basically 'heathen' mode of thought, a mechanical, ritualistic Christianity of the third or fourth rank. But now we think differently. It is true that there is much in Ethiopia (as everywhere else) which has become a matter of form, whose content and message are no longer comprehended. On the other hand it should not be overlooked that the majority of Ethiopian Christians are imbued with a deep faith, a faith which is frequently bound up with external forms without these being their ultimate significance. The Ethiopian Church is a reality of daily life and therefore the external forms must also be included in this life. Whoever has experienced how, at the service on Good Friday, the people throw themselves to the ground, forgetting the world around in a rush of fervour, and crying a dozen times 'Kiryālāyson' (*Kyrie eleison*), can hardly believe that all this is merely lip service.

Selected Sources

No study of this subject can afford to ignore: Grohmann; Hyatt; Matthew, *The Teaching of the Abyssinian Church ...;* Drower; Ullendorf, *Hebraic-Jewish Elements ...* and *The Ethiopians;* Cerulli, *Storia ...* and *Il monachismo ...;* Hammerschmidt, *Studies ..., Kultsymbolik ..., Symbolik des orientalischen Christentums, Äthiopien.*

David R. Buxton, Cambridge

Ethiopian Architecture in the Middle Ages

This chapter deals with Ethiopian architecture of the Middle Ages, but in order to understand it we have to go back to an earlier period of Ethiopian civilization, to the great days of the Aksum Kingdom in pre-Christian and early Christian times. Derived originally from South Arabia, and brougth in by the early immigrants who founded the Aksum Kingdom, the peculiar Ethiopian building technique does not bear much relation to any of the familiar styles of world architecture surviving today.

The period we have to consider is a long one and a striking feature of this architecture is its essential constancy over the centuries. Its basic traditions remained unaltered for something like two thousand years, finally losing their force towards the end of the medieval period. The Ethiopians remained faithful to this style, not merely because they found it a practical method of building, but also, of course, because of its traditional momentum and its aesthetic value. Architectural forms often survived when their structural significance had gone. Thus, even when built-up structures were copied in solid stone, nearly all their features were laboriously reproduced in the new material, where they had absolutely no meaning except as decoration.

This transmutation of the style into stone happened as early as the fourth century A.D., notably in the great stelae of Aksum, while in the Middle Ages whole churches were hewn from the solid rock and these, being almost indestructible, have survived in far larger numbers than their built-up prototypes and contemporaries. In fact, much can be deduced about the old Ethiopian style by a study of these later imitations, some of which faithfully reproduce even minor features of the early built-up churches.

Although the old Ethiopian style could not really survive the great disturbances of the sixteenth century (when the whole country was over-run and ravaged by Moslem invaders) its tradition is not quite dead even today, as travellers in the northern highlands can easily verify. Here rectangular churches with some early features are still sometimes built in the villages. Further south the round church (typically with a thatched roof) is universal. However charming and characteristic these churches may be, they belong to a very different and a much less ancient tradition. I regard them as glorified round huts and consider speculations as to their possible early Christian origin to be unfounded.

Before attempting an architectural description of the early churches, I must make one general observation: these shrines, whether old or new, whether crude in their structure or sophisticated, almost seem to form part of the rugged Ethiopian landscape. Their extraordinary charm often owes much to a romantic, even a fantastic setting. Looking back on a long residence in Ethiopia I recall, not without nostalgic emotion, the thrill of visiting ancient churches on hardly accessible mountain tops or deep in gorges, others in caves or crannies among the mountains, others again in more peaceful surroundings, on lake-shores and islands. But these churches belong to the people as well as to the landscape, for they are no dead monuments of some forgotten cult but the shrines of a live and continuing Christian tradition.

What then do these buildings look like? To gain a quick visual impression of the great pre-Christian structures at Aksum – ancestors of all that came after – the reader should refer to Krencker's reconstruction here reproduced from the report of the

German Aksum expedition (fig. 22). The reconstruction – not altogether fanciful – was based upon the following sources of evidence: a. the foundations of the Aksumite palaces excavated by the German expedition, and of which practically nothing remainted above ground; b. the monastery church of Dabra Dāmo, where the same expedition found Aksumite techniques actually *used* in the still surviving super-structure; c. the great pre-Christian stelae of Aksum in which built-up forms (identical to those used at Dabra Dāmo) are scrupulously imitated in solid stone.

Although there was certainly a large element of speculation in Krencker's recon-struction, later evidence has gone to confirm his conclusions. I regard it as a masterly

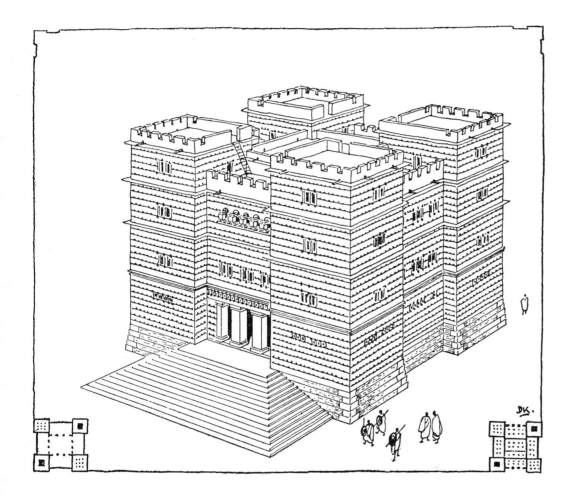

Fig. 22 Aksumite palace (after *Deutsche Aksum-Expedition*)

attempt to visualise one of the more ambitious structures, probably a royal palace, of the capital city as it might have appeared in the first few centuries of our era, before the conversion of the Kingdom to Christianity.

Nothing like this palace has survived, but the contemporary stelae, even though mostly in fragments, remain as they were. These stelae are elaborately carved to represent multi-storeyed towers – up to a maximum of thirteen storeys in the giant stela now collapsed. Each has a sculptured door, complete with latch or ring, at the base (fig. 23). These mighty monuments amaze us because of the technical skill that must have gone into their quarrying, transport and erection and still more to their sculptural adornment carried out with mathematical accuracy. I have already mentioned that this decoration imitates the forms of local architecture; moreover

Fig. 23 Base of a multi-storied stela (after *Deutsche Aksum-Expedition*)

the stelae, in section, show the form of common Aksumite plans. Therefore these are not merely decorated monoliths but elaborate architectural fantasies which represent what the architects of Aksum would have liked to build, even though they could not achieve it.

When the German party climbed the rope to the monastery of Dabra Dāmo, on its level mountain-top encircled by cliffs, they found a church built up in the very technique whose outward forms are mirrored in the giant stelae. This building has become the classic type of the ancient Ethiopian church, employing as it does the forms and methods of pre-Christian Aksumite architecture, while at the same time incorporating new features of Christian origin. Although its date has not yet been and perhaps cannot be determined accurately – for a good deal of reconstruction has certainly occurred at various times – it could be, basically, as early as the tenth or eleventh century. It is early enough to partake fully of the old Aksumite tradition, and at the same time serves as a point of departure for any study of the Ethiopian built-up or rock-hewn churches of later centuries.

At this point, an analysis of the distinguishing features of the early Ethiopian style needs to be attempted.

Plans. These invariably show parts of the walls recessed and others projecting. Nearly all earlier Aksumite buildings take the general form of a square, which was only lengthened to an oblong (and then on a comparatively small scale) in Christian times (fig. 24).

Foundations. Typically these are built up above ground-level to form a solid plinth or pedestal, the sides of which are not vertical but rise in a number of shallow steps. There are conspicuous examples among the early buildings at Taḵondaʿ and Qoḥayto (on the old route to the Red Sea coast, cf. map, fig. 8) as well as among those at Aksum, and some South Arabian buildings also possess this 'stepped' character. It is indicated in Krencker's reconstruction (fig. 22) and is still seen in some medieval churches (cf. pl. 94).

Columns and capitals. Monolithic stone columns, square in section but usually with chamfered edges, were widely employed in the early buildings. They have bases and capitals, the latter of several different designs, some being more or less cubical, others 'stepped'. Both sorts are copied in some of the rock-hewn churches.

A quite different type of capital must have come into use in the timber-built interiors of Aksumite architecture: it arose from the use of wooden brackets to support the ends of horizontal roofing beams. As can be seen in later Christian buildings, such brackets could be used singly against a wall and sometimes in pairs or in threes on a free-standing pillar so they were not originally thought of as capitals at all. Later all four brackets were used for the sake of symmetry, even if they had nothing to support, and this composite capital came to be regarded (as some rock-churches show) as an indivisible unit.

Wall structure. This peculiar technique may have been widespread in various parts of the world in early times but its whole-hearted adoption seems to be a special characteristic of the Ethiopian style. The principle is that walls of rubble and earth-mortar are reinforced at intervals by means of horizontal timbers let into the inner and outer surface of the wall. In addition short round timbers penetrate the thickness of the wall; they project freely outside (forming the so-called monkey-heads) and a few go right through, projecting inside as well. They are slotted below and fit down over the longitudinal timbers, anchoring them firmly into the wall. Krencker's diagrams, based on Dabra Dāmo, show the typical wall and window construction very clearly (fig. 25).

When in their original condition such walls have the rubble layers plastered and projecting, while the timbers, retaining their dark natural hue, are slightly sunk in.

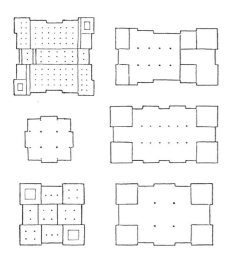

Fig. 24 Aksumite ground-plans (after *Deutsche Aksum-Expedition*)

The effect of alternating darker and lighter stripes – especially with the addition of rows of monkey-heads – is most decorative.

Doors and windows. These are an integral part of the wall-structure just described. The corners of each door or window-frame consist of short *squared* timbers passing right through the wall (which they help to strengthen) and their ends project freely both inside and outside. Nothing is more characteristic of the style than these squared corner-blocks which are nearly always present even in the simplest and crudest of the

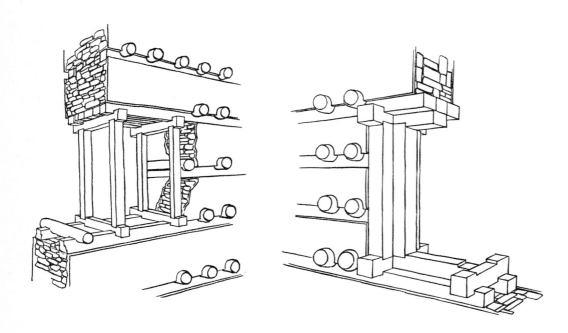

Fig. 25 Monkey-headed walls with windows and doors (after *Deutsche Aksum-Expedition*, re-drawn)

rock-hewn imitations of the early churches. Important entrances may have an extra ornamented beam, also with square blocks at either end, above the door-frame, and this ancient detail was copied in the stone stelae.

Internal friezes. These are an attractive decorative feature of nearly all the built-up and rock-hewn churches and there can be little doubt that they were extensively used in the principal rooms of Aksumite buildings. They consist essentially of rows of joined-up blind panels (or alternate ones may admit light) constructed exactly like single windows, with the usual corner blocks. The only difference is that the vertical elements of the frames are shared between adjacent panels. The evidence of rock-churches suggests that such friezes ran round the top of the walls of some Aksumite halls, being surmounted by a panelled ceiling, and the effect must have been sumptuous indeed.

Roofs and ceilings. The more ambitious Aksumite rooms and halls must have had their flat ceilings divided into larger or smaller rectangular panels. Examples in the rock-churches often show the crossed beams used to roof-in these spaces, and even the brackets which supported the beams (pl. 182). Important rooms may have had splendid coffered ceilings as in the narthex at Dabra Dāmo, mostly no doubt combined with friezes. However, the more complex church roofs probably show the influence of Christian architecture and are described below.

All the above features belonged to the buildings of Ethiopia's classical antiquity (up to the mid-fourth century A.D.). Most of them were accurately copied in the monolithic stelae of Aksum and later incorporated in Christian churches. In these, however, we see new influences, derived no doubt from early Christian churches

elsewhere. Plans are no longer square but drawn out to form an oblong, in order to accommodate a basilican layout – i. e. nave and aisles similar to those in western churches – inside. Henceforth the following additional elements become incorporated in the style:

Arches. A chancel-arch gives access to the sanctuary at Dabra Dāmo though, being put together out of wooden segments, it does not possess the structure of a true arch. It seems likely that pre-Christian Aksumite buildings were wholly trabeated and lacked such arches: there is no sign of them on the stelae. Later churches had additional arches which took the place, for instance, of the horizontal beams in the colonnades of the nave. As a rule they are beautifully carved with geometrical designs and these were later copied in some of the rock-hewn churches.

Domes. Ethiopian built-up churches have a small dome over the sanctuary. These domes were, like so many other features of the earlier Christian style, copied in the solid stone of the rock-hewn churches. There is nothing to suggest that domes existed in pre-Christian buildings and we can guess that they were introduced, with the arch and the basilican plan, after the adoption of Christianity in the fourth century. In some rock-hewn churches, especially those of Tegrē, we find a number of extra domes in addition to the one crowning the sanctuary.

Nave-roofs. The few remaining built-up churches have (in the case of Dabra Dāmo had) interesting high timber roofs over the nave. These rise above the ornamental friezes already mentioned, which take the place of the triforium or clerestory of a western church. These nave roofs do not terminate in a sharp ridge like ordinary western roofs but are truncated at a certain level so that they flatten out on top. The framework of rafters is strengthened by massive tie-beams which, in the more ambitious examples, are connected to the roof-top by means of paired uprights. Some of these roofs give the impression that the builders were seeking to reproduce the shape of a barrel-vault, a form which could more readily be achieved in rock-churches, where it is common.

A survey of the architectural remains of the Middle Ages must begin with the few built-up churches still standing. Obviously such buildings preceded the excavated rock-churches which are, almost invariably, close copies of those built in the normal way. But it does not follow that all built-up churches are earlier than the rock-hewn ones. On the contrary, some could be contemporary with, or later than the great flowering of rock-church architecture, which we believe to have occurred in the thirteenth and fourteenth centuries.

Dabra Dāmo has already been referred to as the earliest known Ethiopian Christian building still standing more or less intact. This unique church forms an important link between early Aksumite architecture and the later medieval churches. The fact of its survival in so exposed a situation is really astonishing but no doubt its inaccessible position, preserving it from human assault, was even more important than any protection against the elements. However, the other surviving built-up churches enjoy the perfect protection (as well as concealment) of great caves, or at least of crevices in the rock, and so are wonderfully preserved.

The singularly perfect built-up church of Yemreḥanna Krestos is not far away from the famous rock-churches of Lālibalā, several of which reproduce its various features accurately. In spite of its extraordinary freshness, I myself have maintained that Yemreḥanna Krestos must be anterior to the Lālibalā group, and therefore not later in date than the end of the twelfth century. Certainly, the prototypes of Amānu'ēl and Māryām at Lālibalā must have been, if not Yemreḥanna Krestos itself, then churches identical to it in style.

In the same mountainous region the enchanting little church of Makina Madḫanē 'Ālam occupies another enormous cave. Its picturesque raised roof and dome correspond

exactly to the traditions of the style but otherwise – by comparsion with Yemreḥanna Krestos – great simplification has occurred. This seems to point to a considerably later date.

The other built-up churches illustrated in this volume also seem to me to be later, perhaps much later in date than Yemreḥanna Krestos. They could indeed have been built at any time up to the wars of the sixteenth century when all building activity came to an end and when vast numbers of existing churches were destroyed by the Moslem invaders.

Bethlehem is the name given to a very curious church whose masonry walls and thatched outer roof give little clue to its interior disposition. It belongs, in fact, to the group of churches now being considered, but there is much to show that its builders did not really understand the style. I conclude that it is one of the latest of this group, dating from a time – possibly the fifteenth century – when the old traditions of Ethiopian architecture were weakening. The nave at Bethlehem has lintel-beams supported on clumsy bracket-capitals, and the friezes they carry abut awkwardly against the sides of the chancel arch. Semi-circular windows (for which there is no real precedent) surmount the frieze and above this comes the nave roof, which attempts to follow the pattern of Yemreḥanna Krestos. But whereas the roof at Yemreḥanna Krestos is perfect, here it has gone wrong: note, for instance, the paired uprights standing on the tie-beam which have parted company with their sculptured terminal bosses. The dome, too, though its effect is attractive, has odd defects. Its arched wooden ribs, instead of springing from brackets, which would have been perfectly logical, have functionless brackets set *between* them. Again, we find carefully cut stone between the ribs of the dome, also filling the spaces between the timbers of the nave walls: this is a misuse of masonry. Evidently those who built this church were expert masons but understood little about the traditions of Ethiopian timber work.

St Michael's of Dabra Salām, on the contrary, shows a lively appreciation of the principles as well as the decorative value of the traditional style. This charming miniature church, squeezed into a crevice (rather than a cave) in the region of the great eastern escarpment, was first described as recently as 1966. It is partly built up and partly hewn from the rock. It possesses, though on a minute scale, the essential elements of a church such as Yemreḥanna Krestos. The inner church, the whole of which now constitutes the sanctuary, exploits to the full the ornamental possibilities of the old Ethiopian technique, including the enrichment of monkey-heads which – since the walls are built in cut stone – are not really required here. Another interesting feature is the 'stepped' plinth which points right back to early Aksumite models.

Moving on from built-up to excavated churches we must first consider the Lālibalā group. The clustered rock-churches of Lālibalā, nestling deep among the mountains of Lāstā, form a complex unique in Ethiopia and probably unique in the world. The Ethiopians have rightly decided that it could be one of their greatest tourist attractions and have taken pains to make the place accessible by air. This is right and proper; yet those for whom the wonders of Lālibalā were the reward of strenuous days on foot or mule-back can be forgiven for regretting the old days of its loneliness.

Lālibalā offers a novel experience even for hardened antiquarians. We find all stages of rock-church development, from excavated interiors hardly noticeable outside, through partly detached churches with one more worked façades, to the completely free-standing 'monolithic' type where the entire church is sculptured externally as well as internally. The last mentioned are the most ambitious of the rock-churches.

The technical expertise and the organisational skill deployed at Lālibalā seem fantastic and one is not surprised by the tradition that skilled assistance from Egypt was involved.

Although this may be true, there is little sign in the style of these churches of any foreign influence. The more important ones reproduce with scrupulous fidelity the forms of the Ethiopians' own traditional style. The inspirer of the great work is said to have been King Lālibalā himself, a monarch of the thirteenth century, but so vast an undertaking must surely have been continued under his successors and may well have lasted into the following century.

One Lālibalā church – Abbā Libānos, which is only partly isolated from the rock and merges with the cliff above – takes after Dabra Dāmo in that its nave colonnades support flat lintels, not arches. All the other principal rock-churches at Lālibalā have arches instead of lintels on either side of the nave, and so represent a stage in the development of the style more advanced than Dabra Dāmo. Two of these churches, Amanu'ēl and Māryām, show very close kinship with Yemreḥanna Krestos and are obviously inspired by a group of built-up churches of which Yemreḥanna Krestos itself is (unless something new remains to be discovered) the only surviving example. These two rock-churches have plans almost identical to that of Yemreḥanna Krestos, though their north-south sections show lofts over the aisles (as at Dabra Dāmo) which were omitted at Yemreḥanna Krestos owing to the cramping effect of the low cave roof. This conformity extends to the imitation in stone of the timber and masonry building technique (at Amanu'ēl) and to many features of the internal decoration. There is one interesting difference in detail: the logical bracket-capitals of Yemreḥanna Krestos, which have just three brackets when only three have anything to support (fig. 26), are replaced at Lālibalā by the symmetrical, quadruple variety conceived as a unit. This is an indication that the style of Yemreḥanna Krestos ante-dates that of the rock-churches, though there is very little to distinguish them.

By far the biggest of the Lālibalā rock churches is that of the Saviour of the World. Its prototypes have disappeared, though the writer has argued that it might have been inspired by the original church of St Mary of Zion at Aksum, demolished in the sixteenth century. Here, if anywhere at Lālibalā, we are reminded of western architecture and can imagine ourselves in a great early-Romanesque crypt, congested with columns.

The peculiar, tall church of St George stands in a deep pit of its own, well separated from the two principal groups. Its plan is cruciform, and the roof bears one ornamental cross within another in high relief. The whole thing looks suspiciously like a stone copy, on a gigantic scale, of a wooden portable altar or *manbar*. One novel feature of this church is the presence, high on its outer walls, of absolutely untraditional ogee windows (which terminate in floral scrolls surmounted by a cross); they also occur outside the Golgotha and Śellāsē crypts. External arches of this form are also used in the curious church dedicated to the Archangels Gabriel and Raphael. In each case, I suspect a later period of excavation when the force of the native tradition was no longer all-powerful. These are the only pointed arches at Lālibalā, but they have nothing to do with European Gothic. They were inspired, perhaps, by one of the Moslem styles of Egypt or Western Asia.

We may pass, finally and very briefly, to the outlying rock-churches of this group, none of which have the quality of those of Lālibalā itself. Bilbalā Čerqos exhibits ogee arches which link it with the (presumably) younger members of the Lālibalā group. Far more interesting, however, is Gannata Māryām – the Garden of Mary – a late rock-church which is full of decadent features, and yet is a particularly attractive one. Its massive external colonnade and blind ornamental arcades which lie flat on the roof are both inspired by Madḫanē 'Ālam (Saviour of the World) at Lālibalā.

While the whole study of old Ethiopian churches is very new – almost nothing was known of them, with the single exception of Dabra Dāmo, until the last thirty years –

Fig. 26 Triple-bracket capital (the third bracket is hidden)

the importance of the northern rock-churches has only now been realised. It is true that one Tigrean rock-church, Endā Māryām Weqro at Ambā Śannāyt, was fully documented by Mordini in 1939, nevertheless the photographs reproduced in this volume form the first comprehensive pictorial record of this group of churches, and are enough by themselves to prove their extraordinary interest, both from the point of view of architecture and of painting. The writer labours under a disadvantage in that, as he has only seen one of these churches himself, he possesses no complete mental picture of the buildings as a whole, or of their setting and geographical position. However, most of their architectural features are made clear by the photographs themselves.

Among the most complete and best executed of Tigrean rock-churches is the one dedicated to the legendary twin kings, Abrehā and Aṣbehā. One of the most interesting things about it is the connection with pre-Christian Ethiopian architecture revealed by the Aksumite columns and their stepped capitals, used, as they would always have been, to support a horizontal beam. At Mikā'ēl Ambo exactly the same arrangement is found, and at Čerqos Weqro the same again, except that here the other type of Aksumite capital – the cubical type – has been imitated. In this respect Čerqos Weqro is even nearer to Dabra Dāmo, where there are re-used Aksumite columns with the same form of capital, than the two other churches just mentioned. At Lālibālā there is nothing quite so close to the old tradition, for Abbā Libānos, which does have lintels on Aksumite-type columns, shows capitals of a peculiar composite form – i.e. bracket-capitals superimposed on the Aksumite 'cube' (fig. 27). Elsewhere at Lālibālā (unlike Tegrē) the whole trend is towards multiplication of arches, as foreshadowed at Yemreḥanna Krestos.

Fig. 27 Capital in Abbā Libānos

Another of these northern churches, St Saviour's of 'Āddi Qāšo, also provides a link with early Aksumite buildings, but this time we are led to speculate about their built-up superstructures and the possible aspect of their principal rooms. In the western vestibule of this rather roughly excavated church, and also in its nave, we find friezes at the top of the walls, immediately above which come flat, coffered ceilings. These ceilings are obviously copied from wooden prototypes and the one in the vestibule is exactly the type of the narthex at Dabra Dāmo – itself suggestive of some important room in a secular building. What is interesting at Āddi Qāšo is the panelled ceiling immediately superimposed on a continuous frieze; this is an extremely decorative arrangement which might well have been used in the palaces at Aksum.

Other roofing devices are found among the northern rock-churches. For instance Abrehā and Aṣbehā, already mentioned above, has a fine ceiling-panel supported (if we accept the illusion) by crossed beams resting on brackets (pl. 182). This cross, of course, is no Christian symbol, but simply the effect of crossed, interlocked roofing-beams used to cover a rectangular space; such beams are freely copied in the rock-churches but the brackets, clue to their real meaning, are nearly always omitted. An elaborated version of the same system is seen imitated at Endā Māryām Weqro (pl. 172). Here a large ceiling-rectangle is shown spanned by means of principal crossed beams, and the four smaller resulting squares are in turn covered-in by secondary crossed beams, which appear to rest on top of the big ones.

I have pointed out that the presence of one sanctuary-dome is normal in all these churches. But some Tigrean rock-churches are distinguished by the introduction of extra domes. The number of these at Endā Māryām Weqro sets a record. However the finest Ethiopian church yet known which displays prominent domes is that of Dabra Ṣeyon. Here we find, not merely saucer-domes scooped out of a flat ceiling, but something very like real Byzantine domes rising on pendentives – an effect emphasised by elaborate painted decoration. I know of no other Ethiopian church

with such a strikingly Byzantine interior, and the possibility of direct influence from some domed church in the west cannot be excluded.

Some of these domes, which would not otherwise be of special interest, are made memorable by the frescoes which adorn them. Here I shall mention only Abuna Daniel in Qorqor and, more especially, the church of Guḥ.

Enough has been said, I hope, to enable the reader to interpret the architectural subjects which are illustrated so beautifully in this volume. The essential background to bear in mind is that all these Ethiopian churches belong to an indigenous style of very marked and unmistakable character. When the habit arose of making churches out of solid rock – of constructing them by cutting away, instead of building up – their style was not changed in any way whatever. Practically all the features of the original churches were in fact copied so faithfully that it is probably safe to reconstruct the built-up prototypes – mostly now lost – from a study of the rock-hewn derivatives.

Why were all these churches ever hewn from the solid rock? The subject has been discussed, and some fanciful theories – to which I myself cannot subscribe – put forward. It has been pointed out, for instance, that certain Indian temples constitute the only exact parallel to the monolithic churches of Ethiopia. This is true, but the styles are totally different, and there is no need to draw the conclusion that there was Indian influence on the rock churches of Lāstā or Tegrē. On the other hand it is quite possible that the Ethiopians had some knowledge of the excavated temples and burial-chambers of Egypt, and of the rock-hewn churches of Cappadocia in Asia Minor. They could have been influenced by these examples, but a desire to achieve permanence may well have been their main motive in adopting this difficult and laborious technique.

The two great groups of rock-hewn churches, which have been considered separately above, do show – in spite of the variety within each – somewhat different tendencies. The designers of Lālibalā became absorbed in the development of the arch and departed considerably from the earliest pattern of the Ethiopian church, as typified by Dabra Dāmo. Those unknown rock-excavators of the churches in Tegrē were rather more interested in the multiplication of domes than of arches. At the same time they adhered more closely to their aboriginal models – early Christian and even pre-Christian – which was perhaps not unnatural, since the monuments of the old Aksum kingdom were comparatively near at hand.

This divergence among the rock-hewn churches must clearly have been initiated among their built-up predecessors. My impression is that these two main groups – the concentrated group at Lālibalā, and the more scattered one in Tegrē – underwent a parallel development. Both were based upon the same early prototypes, but neither was derived from the other, even if there were some interactions. Without entering into the historical evidence, it seems highly probable that the rock-churches of the two regions were roughly contemporary, the great period of construction extending from the thirteenth to the early fourteenth century.

During this time there was a change of dynasty, the last of the Zāgwē kings, of whom Lālibalā was one, being overthrown by a prince of the Solomonic line. Yet this must have been a prosperous and comparatively peaceful period, since it would be unimaginable, otherwise, that such vast works of Christian piety – and all the skill and man-power they represent – could have been undertaken. Even so we are almost entirely ignorant of the social and cultural background of the times. The historians still have to explain how it was that the rulers of this remote kingdom – almost cut off from the remainder of Christendom – could have conceived and carried out such immense and difficult tasks.

Selected Sources

Deutsche Aksum-Expedition; Mordini, *La chiesa ipogea ...*, *Il convento ...*, *La chiesa di Aramò*, *La chiesa di Baraknaha* and *L'église rupestre ...*; Monti della Corte; Buxton, *Ethiopian Rock-hewn Churches*, *The Christian Antiquities ...*, *Ethiopian Medieval Architecture ...*; Matthews/Mordini; Doresse; Sauter, *L'église monolithe ...* and *Où en est notre connaissance ...*; Bidder; Bianchi Barriviera, *Le chiese monolitiche ...* and *Le chiese in roccia ...*; the excavation reports of Leclant, Contenson, Anfray and Annequin.

Jules Leroy, Paris

Ethiopian Painting in the Middle Ages

Like all Christian countries, Ethiopia has surrounded itself since its conversion to Christianity with a world of pictures which not only can tell us a great deal about the faith of the people and their distinctive conception of religion, but which also reveals their cultural relations with the rest of Christendom.

To make a correct assessment of the iconographic significance and artistic rarity of the full range of what they created, one has constantly to bear in mind the two principles which govern not only the religious art of Ethiopia, but also that of the whole Orient. They apply especially to sacred painting, which was the only kind practised in Ethiopia after its conversion.

It is only in our century that secular painting has flourished, using subjects from daily life or national history. Thus, in a church at Adwā, we find a painting of the famous battle that took place there. It depicts the tumult of war with fire-belching cannons and officers in striped uniforms. What tourist has not found pleasure in the gaudy pieces of calico painted with scenes from the life of the Queen of Sheba? And, of course, the Ethiopian youth of today is more enthusiastic about the pictures that celebrate the soldier who twice won the Olympic marathon than about religious subjects.

Older painting has nothing of this, being the expression of a people deeply imbued with religion. This religious basis has endowed the art with two fundamental principles, the influence of which works in two ways: on the one hand, guiding the artist in doing his painting and on the other, bringing out the meaning of a picture to the viewer. The first principle is connected with the oriental Christian's concept of a picture and refers not, as is commonly maintained, to 'icons' in the strict sense, but to any religious work of art, whether sculpture in stone or wood, pictures on canvas, frescoes or mosaics. This concept is based on the idea, developed by Platonic philosophy, that no work of art can attain the perfection of the original. This proviso is especially valid for the representation of such lofty beings as Christ, the Blessed Virgin or the saints who, freed from the limitations of their earthly life, henceforth stand outside of time and have taken on an eternal form. The artist is playing traitor if he deviates from these guiding principles which set before him a tradition likewise sacred in origin. How old it is no-one can say. But a brief glance at the Christian art of the Orient shows that it has imposed itself on everyone and everything with a force that seems tyrannical to us, since the West has developed a quite different conception of art. For us, it signifies above all the expression of a unique personal feeling, the reaction to some living being or event. An oriental artist worthy of the name does not seek reality and its ever changing aspects, but tries to express the inexpressible. The different styles of Western painting, such as impressionism, expressionism, realism as well as abstract art, are all equally foreign to him. Should he wish to achieve the full likeness of a model from nature, he would be offending against the second principle of sacred art. Such art does not seek to arouse passions. It pursues the psychological aim of reminding the viewer of the story of salvation and guiding his thoughts to the spiritual. Thus transferred in spirit from the visible to the supernatural world, he ought henceforth to lead the life of a believer. In this way painting is no longer purely representational even when it 'represents' something, but is first and foremost educational. The Church fathers never ceased to instil this didactic duty, especially at the time of the iconoclastic controversy (eight to ninth centuries). Thus one

of them explained: 'What writing signifies to the literate, so pictures do for those who cannot read. From pictures, the untutored learn how to conduct themselves. For the learned, they are a substitute for the book.' Or in the words of the Bishop of Cyprus, written at the time of Ethiopia's conversion: 'Pictures are ever-open books which the Church expounds and esteems.'

With this interpretation, the picture rediscovered its original purpose as picture-writing, and reminds one of the pictographic origin of all ancient scripts. From it, developed both the overriding characteristics of Oriental painting: its hieratic rigidity and the simplicity of its motifs.

Ethiopia, evangelized by Syrian and Egyptian missionaries, quickly developed connections with Byzantium and had to reconcile itself to the conditions outlined above. It submitted to them, but with its characteristic desire for independence which endeavours to adapt all foreign borrowings in literature, art and culture to its own nature. The paintings illustrated in this book indicate how this people created their own 'Ethiopian' style of painting which is neither to be confused with the Byzantine-Oriental productions, nor with that of Africa, of which it is indeed geographically a part.

Strangely enough, the first evidence of Ethiopian wall-painting comes from an Islamic source. In his history of the world, Ṭabarī describes among other things the exile in Ethiopia of a group of Moslems. In one passage he tells of a woman who after her return to Mecca constantly made enthusiastic remarks about the paintings she had admired, whilst in exile, in the Cathedral of St Mary of Zion at Aksum. It hardly matters whether this is fact or fancy, a legend or the historical truth. Either way it is an indication that these Ethiopian paintings were known in early Islam and that they had a marked effect even on non-Christians. This fact is not so surprising, for modern Islamic research is more and more inclined to explain the Koran's sporadic links with Judeo-Christian tradition by pictures of the Old and New Testaments which the Prophet had seen and misinterpreted.

The subjects of the wall-paintings in the Cathedral of Aksum – mother of all subsequent Ethiopian churches – remain as unknown to us as their style. They perished with the destruction of the first cathedral, built by Ēzānā's successors. The church which now stands on the same site dates from the first decades of the seventeenth century. Its paintings, of which some are not older than the present century, certainly do not reproduce the pictures which were destroyed. Nevertheless they acquaint us with certain of the main features of Ethiopian painting: frontality of the people depicted, hieratic disposition, application and distribution of the colours over large areas using a limited number of basic shades – red, green, blue and yellow. Black is used to separate the figures from their surroundings and to emphasize the shape and folds of their clothing. By and large these are also the characteristics of Byzantine-Oriental painting. They are so striking that in the past travellers have not hesitated to speak of 'the Byzantine paintings of the Ethiopians' – an obviously false description if other criteria are taken into consideration: the ethnic peculiarity of the faces, the hands with the long tapering fingers and above all the deeply-set enlarged eyes, which hollow out the face and put the viewer under their spell.

The progressive disappearance of the old churches, taking place before our very eyes under the pretext of modernisation, ranks with Aḥmad Grāñ's devastation to which the Aksumite cathedral was sacrificed. The result is quite deplorable. There is an almost complete lack of evidence of the murals from the Middle Ages – a term we use in connection with Ethiopia to mean the period extending from its conversion to the beginning of the sixteenth century. Until recently, we knew almost nothing at all about this period, but lately there have been many expeditions – such as those on which this book is based – the purpose of which was to learn whatever was possible

from the surviving remains and thus improve our present unsatisfactory state of knowledge. Consequently the outlook is not completely hopeless.

Long ago, students of the history of Oriental as well as Western painting discovered that substantial connections existed between the decoration of books and buildings. To be sure there is a difference of size and technique, but the subjects and manner of representation are similar enough to enable us to pass from one medium to the other should there be a gap in our knowledge of either of them. As far as books are concerned, the situation is now a great deal better than it was. We can, without any trouble, produce several manuscripts to satisfy our thirst for knowledge as regards medieval painting. However, so far, none of the known manuscripts take us further back than the year 1,000. The oldest of the early manuscripts date from the beginning of the fourteenth century, with a few exceptions: two recently discovered manuscripts, on the basis of peculiarities of decoration and script, could date from the tenth or eleventh centuries although unfortunately, owing to the absence of the last few folios, a more exact dating is not possible. The small total number and comparatively recent date of even the oldest of the manuscripts indicates the fearful extent to which the great destruction affected even this field of activity. At all events we know that the Ethiopians produced a significant number of manuscripts in the beautiful Ge'ez characters which were inherited from the ancient South Arabian script. Amongst the known books still in existence, those decorated with miniatures are rare. Moreover the term miniature is unsuitable, since it is reminiscent of the fine examples of the Latin and Byzantine Middle Ages, which fill whole pages with lavish pictures on a gold ground or with fancifully executed decorative letters. It is quite different in Ethiopia where the artists had no knowledge of the use of gold for aureoles until quite recently. Instead of 'miniatures' one should preferably speak of 'paintings on parchment'. They consist of a unified area of colour which is painted either directly on the page or sometimes upon a background painted blue or green. As already suggested above, it is simply a matter of transferring monumental painting to a greatly reduced area.

The subjects of the paintings are easily classified. All the extant illuminated books from that period are Lives of Saints or Gospels (strangely enough not a single Old Testament has been found). From this we may conclude that the ancient wall-paintings scarcely depicted anything other than events from the life of Christ and pictures of national saints, naturally with a large place for the Virgin Mary since one of the most characteristic traits of Ethiopian Christianity is the, to us, exaggeratedly overdeveloped cult of Mary. There has been a certain amount of evidence of this situation available and the present book brings more to light. Fortunately the devastation of the sanctuaries of the Middle Ages did not go so far as to cause the disappearance of all evidence of medieval architecture. What were irrevocably lost in the great destruction, or have been destroyed more recently before our very eyes, are the built-up churches as opposed to the rock-churches. This book, for the first time, adds a significant selection of new examples, mostly from the province of Tegrē, to the best known group of these, the monolithic churches of Lālibalā.

At this point we must discuss the decoration of these rock-churches. To begin with, one is struck by the fact that there is no figurative sculpture. This lack is especially noticeable to the Western visitor who is accustomed to the rich statuary of our romanesque and gothic cathedrals. In this not only do the psychological differences of the two worlds find expression, but especially the two different religious outlooks. Here Ethiopia obviously affirms its adherence to the other Christian churches of the Orient, all of which repudiate sculpture. Only in Armenia is a plastic figurative art known. Its connections with romanesque art have often been noticed by historians. Even then, this sculptural decoration is only found on the outside walls of Armenian

churches. It is never tolerated inside the areas devoted to divine service. This almost universal ostracism by the Christian Orient with regard to statues may seem like a heritage of Judaism, whose ban on any 'graven image' has been followed since the Ten Commandments; above all, however, it exhibits the fear, so often expressed by the Fathers of the Church, that simple souls, confronted by these three-dimensional creations, would fall into idolatry. The wholesale condemnation of sculpture contributed greatly to the development of painting.

Consequently one does not usually expect to find plastic art in Ethiopia. The several timorous bas-reliefs of saints which have turned up were probably at one time painted and are in any case so delicate that they scarcely project from the rock face from which they were carved. The few other examples from the Church of Golgotha at Lālibalā or the recently discovered churches in Tegrē only confirm the general rule and underline all the more clearly the universal extent of paintings made either directly on the walls or on a layer of plaster, like a fresco.

Their subjects fall into two categories. Many churches merely have a purely ornamental decoration made up of innumerable combinations of geometric figures, lozenges, squares, circles and broken lines, which dance before the eyes in a multitude of arabesques. Although less complicated than the highly developed works of Islamic art, this decoration reveals the same dislike of figurative representation. The decorations of the Church of St Mary of Dabra Ṣeyon, the vaulted ceiling of the Church of Abrehā Aṣbehā and the ornamentation of the grotto church of Yemreḥanna Krestos offer good examples of this. From time immemorial the Ethiopians have expressed themselves in the art of composing recurring, intersecting and endlessly knotted lines. Of their mastery in this field, the beautiful processional and hand-crosses are still witnesses today. In church painting, these basic geometrical figures serve as an ornamental framework for the cross, to which the Ethiopians bring a devotion as pronounced as that which they offer to the Blessed Virgin. Despite the ubiquity of the cross as decoration, I do not think that every element of composition needs to be explained symbolically. Likewise I should like to add in passing a warning against attributing too great a meaning to the animals, both wild and tame, found here and there in the paintings. They are a last remnant of the pictures with which the first generations of Christians decorated their places of worship. They did not even shrink from hunting and fishing scenes, a custom which St Nilus (died about A.D. 450 at Sinai) was the first to denounce. After a temporary disappearance, these motifs re-emerged in the Byzantine Empire because of the iconoclastic controversy. In the West they were kept much longer and they dominated romanesque sculpture and even floor mosaics – an art form the Ethiopians apparently never knew, at least up till now no trace of it has ever been found. The second source of inspiration for artistic decoration is perhaps most clearly seen in St Mary's Church, Lālibalā. There, side by side with purely ornamental decoration, we find a frieze of figurative scenes just below the ceiling of the aisles. What is left of it shows, without any divisions of frames, the Visitation of Mary, the miracle of the loaves and fishes, the healed paralytic carrying his bed, Christ with the woman of Samaria at Jacob's well and Zacharias' annunciation of the birth of John. From these few clues we may conclude that the complete frieze originally displayed the whole Gospel story in the same fashion as the most copiously illustrated Gospel manuscripts. A number of examples of book illustration from the fourteenth and fifteenth centuries show unmistakable connections with some of the wall-paintings described here. For example the curious paintings in the Church of St Mary at Qorqor (pl. 37): a round arch supported by pilasters, with pictures of animals decorating the tympanum of the arch and scenes from the Bible on the uprights. Here we have an exact copy of the famous tables of the Canons of Eusebius, which list parallel Gospel passages, written within an architectural framework on the first pages of a book of the Gospels. Such

architectural frameworks are also familiar elsewhere in illuminated manuscripts (fig. 28).

The picture of a martyr under an arch in Dabra Ṣeyon (pl. 49) is especially reminiscent of the saints in the arched niches of the Church of Golgotha in Lālibalā (pls. 79, 80). They all seem to be imitations of those pictures of the Evangelists which are meant as a kind of portrait of the author, in books of the Gospels. I likewise consider, for example, the picture of Christ's entry into Jerusalem (St Michael's of Dabra Salām, pl. 158) to be the reproduction of a miniature. Like the paintings in the Bēta Māryām Church in Lālibalā it belongs to a cycle of pictures of the life of Christ.

This book considerably enriches our knowledge of fourteenth and fifteenth century mural art. The overwhelming majority of paintings indicate their close relationship by the use of quite definite characteristics. The subjects' facial type, for instance, is characterised by large and ogling eyes, the nose is often absent and the beard shaggy –

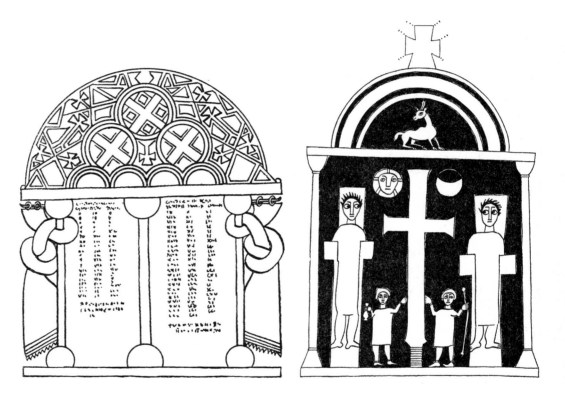

Fig. 28 Table of Canons and Crucifixion in an architectural framework, from a fourteenth or fifteenth century ms

features which are equally present in the stocky figures in contemporary book illustration. The Gospel manuscript of the National Library in Addis Ababā, which can be dated with certainty to the years 1300–1325, and Princess Zir's Gospel book of 1400, at present in New York, are especially suitable for comparison. In each of these the same artistic setting can be seen and we can assume that they all date from the same period.

Naturally there are differences from one style of painting to the next. But these variations of design, palette, and subject arrangement are not at all surprising, but rather confirm a situation which also exists in the manuscripts. No two books or frescoes from that period are completely alike. But in spite of some differences, there are cases where one can definitely ascribe two works to the same hand. Under these circumstances it is best not to speak of studios, schools or scriptoria even though in all probability they did exist. Only after the recovery of the Christian empire, which Aḥmad Grāñ's invasion brought to the brink of destruction, did the situation change with a break-through to a new school of painting.

What interests us here are the cultural and artistic results of Grāñ's presence. They were not all bad. Even though that war was responsible for the destruction of innumerable works of art, as we can see from the history of the conquest of Ethiopia written by the Imam's chronicler, it did bring some advantages through the influx of foreigners which, as usual, Ethiopia saw as a means of cultural enrichment. One favourable result was to be seen in the presence of the few remaining Portuguese who had survived the war against Grāñ. They settled in the vicinity of Gondar, not as colonial overlords but as farmers, and for nearly a century they maintained permanent contact with Europe. Peaceful cooperation had a marked effect even on painting, and gave rise to a stylistic revolution.

Contact with the West had already existed before the sixteenth century. As we learn from the written sources, European, that is to say Italian, visitors and craftsmen were already coming to Ethiopia at the beginning of the fifteenth century. Among them were artists appointed by the Negus. But these foreigners were few in number and cut off from their environment. Often they only stayed in the country for a short time – except those whom the emperor prevented from returning home. The names of some of them have entered history, as for example that Brancaleone 'pictor venetus' about whom a whole legend was created. Most of them remained anonymous, which is neither regrettable nor surprising since it is certain that not a single one of them could compare with contemporary artists at work in Italy. We have proof of this from time to time in the discovery of frescoes or paintings on cloth in some remote church or other. Their Ethiopic inscriptions do not obscure the fact that a foreign hand has been at work. Pictures of this kind originate either genuinely from a foreign artist or from an Ethiopian who adopted his style and technique. Although none of these works so far recognized are of any importance, they at least provide us with some idea of how the union of two schools of art was achieved – an amalgamation which, after the death of Aḥmad Grāñ in 1543 and after the empire's recovery, gave rise to the most felicitous productions. The restoration in the political and social spheres was accompanied by the erection of new places of worship. Over fifteen years of unremitting warfare had robbed the country of its churches. In their place arose new ones, some of which, mostly in the north, retained the old basilican plan, whilst others took on a circular form exactly like that of the native dwellings. Round churches like this certainly existed before but it was from the sixteenth century onward that they gained increasingly in popularity and became the Christian hall-mark of the village in Ethiopia.

Lively artistic activity naturally followed on from the reconstruction, since empty walls and ceilings cried out for decoration and adornment with pictures. Perhaps never before had the Ethiopian painter had such wide scope. Some artists, enthusiasts for decoration, even ventured to paint the outside walls, although admittedly this practice was only carried out sporadically. On the other hand it is hard to imagine a round church without the centrally placed Holy of Holies (maqdas) being decorated with paintings from top to bottom all the way round. As before, the subjects are all scenes from the Gospels and the lives of saints arranged according to set iconographic rules. This set of rules always remained sufficiently flexible to permit a church's founder a certain amount of licence in the direction of his personal religious beliefs. As a result of this, one occasionally encounters pictures of the most unexpected saints.

Thus we find, in a church at Enṭoṭṭo above Addis Ababā, pictures of St Theresa and the Sacred Heart which, despite the Ethiopian style, indicate a foreign origin. Menelik's wife endowed the church, and the decoration is indicative of the empress's eclecticism. The Roman elements in the imperial chapel would surprise no-one who could visualize the overtures to Western culture which were present from the fifteenth century and have persisted up to the present day.

About 1635 Gondar became the capital of the kingdom. The new style of painting called 'Gondarene' is most easily appreciated in the churches of this city and its surroundings. But probably the oldest example of it is to be found in the church of Gorgorā on Lake Ṭānā. Also significant for this style are the fragmentary paintings from a Church of St Anthony now in the collection of the Musée de l'Homme in Paris. Now, of course, painting was no longer exclusively done straight on to the wall. More usually the artist painted in his 'atelier' on material which was subsequently stuck on to the wall in the church. One result of this was to facilitate their subsequent removal. Although the static formality of the medieval painting, a heritage of the Byzantine-Oriental tradition, continued to be observed, there was a certain penetration of new ideas. Even the rows of saints, which are essentially a product of the monumental style, appear to take on new life: the figures are no longer shown in strict full-face but in three-quarter as well; they face each other, indicate gestures and make themselves clearly understood by sign language. If we examine the subjects used by this school of painting, we discover that the choice of the Gospel scenes no longer rests exclusively on the earlier – hence Byzantine – tradition; it is modelled on Italian or German engravings such as were found in the Catholic and Protestant Bibles after the Renaissance. In the years 1650–1700 a manuscript of the Gospels was apparently very popular, since we know of five identical examples of it. It 'ethiopicised' the Arabic Gospels printed in Rome in 1591, which had engravings by Roberto Tempesta and which for their part were often only 'italianised' engravings of Dürer.

From the fusion of elements of Western art and the old Ethiopian tradition, the Gondarene painters created an independent school. It is characterised by the beauty and noble bearing of its figures in colourful garments, by the elegant narrow faces with almond eyes, wavy hair and carefully kept beards. This is how the Ethiopian ideal type was depicted. We should probably place the newly discovered church of Guḥ in Tegrē in this school.

To all appearances, at the beginning of the eighteenth century a new style of painting, closely copying Western models, superseded the Gondarene school. In it we have more or less successful attempts at introducing light and shade, modelling and perspective. The backgrounds are painted in the liveliest colours without heed to the dazzling effect resulting from the juxtaposition of strong shades of green and yellow. The painting of Christ wearing the crown of thorns in the Church of St Mercurius at Lālibalā (pl. 15) is a good example of the new approximation to European modes of representation. It clearly goes back to a Western original and could hardly have been executed before the eighteenth century. The pathetic expression in the suffering Christ's gaze reveals the Western influence evinced by most works of the later style.

At that period India too, and especially the Portuguese colony of Goa, must be reckoned as a further source of stimulus. Since the art history of this province of India, so Western and Christian in outlook, is practically unknown, we are unable for the present to put forward much solid evidence for reciprocal interdependence. In several manuscripts, however, it can be detected and perhaps the picture of an elephant at Dabra Salām (pl. 156) is a case in point.

This sketch of the history of Ethiopian painting leaves many questions unanswered. A worthwhile review must be preceded by scientific exploration and this has scarcely begun for an artistic legacy which is one of the most important in Africa. There are many churches and monasteries which have never yet been visited by foreigners; there is no catalogue of the known material; its chronological sequence can only be ascertained in exceptional cases. This preliminary work must nevertheless be done if more exact statements on the development of painting in Christian Ethiopia are ever to be made. At the moment the best we can do is to point out directions, indicating paths for future research, the results of which may even refute our present beliefs.

We do not wish to conceal the limitations of our present knowledge. So let the reader judge leniently the lack of precision which could scarcely have passed unnoticed. These pages were designed merely as an introduction, their intention was to reveal to the reader a realm of art which is probably completely new to his world of thought.

Selected Sources

Studies on the sources of Ethiopian painting and individual problems of iconography: Budge, *The Lives...*, *The Miracles...*; Monneret de Villard, *La Majestas Domini...*, *La Madonna di Santa Maria Maggiore...*, *La "Coronazione della Vergine"...*; Cerulli, *"Il Gesù percosso"...*; Buchthal; Leroy, *Recherches...*

On individual works: Conti Rossini, *Un codice...*; Griaule, *Peintures...*; Staude, *Les peintures...*; Monneret de Villard, *Note...*; Mordini, *Un' antica pittura...*; Sadwa (Ṣādwā); Skehan; Playne; Jäger, *Äthiopische Miniaturen, Some Notes...*; Leroy/Jäger/Wright; Leroy, *L'évangéliaire..., Pittura etiopica.*

The Monuments

The numerical order of the monuments corresponds with that of R. Sauter's list ('Où en est notre connaissance des églises rupestres d'Éthiopie', *Annales d'Éthiopie*, vol. 5). The churches discovered since the publication of this list (1963) or at all events first described since then, have four-figured numbers according to an expanded numerical system which Sauter will establish and explain in a revised list brought up to date and yet to be published. For every monument listed, Sauter's list gives an almost complete bibliography up to 1963.

The reader may well have come to the conclusion from studying the preceding contributions that scholarship is far from unity of teaching in matters relating to rock-churches. Hence the author wishes to stress that he alone is responsible for the opinions expressed in the introductions to the individual monuments or groups.

Plans that could not be based on a survey are indicated as being schematic and provisional sketch-plans.

The Monastery of Mount Dabra Dāmo

The island mountain on whose flat top the monastery of Dabra Dāmo is situated is reached by the highway between Adwā and Addigrāt. At kilometer 60, a road, which in the dry season is passable even for vehicles with very little ground clearance, branches off leading right up to the sides of the ambā.

The hour-long journey through wonderful landscape is enough to transport the visitor into a state of rapture. Candelabra euphorbias are in full bloom. A troop of long-tailed monkeys is torn between panic-stricken flight and apish curiosity. The Ethiopian mountain-goat, called sasā, leaps on to heaps of boulders with hoofs flying. Screeching parrots rest on the candelabra of the spurge trees, with humming hornbills below and, occasionally, thousands of partridges obstruct the road.

But one is quickly brought back to one's senses at the foot of the steep cliffs. The monastery entrance (a gate on the edge of the cliff extending in front of the proper gateway) is almost 50 feet above the foot of the cliff. There are no steps to facilitate access. No handrail to grasp. No ladder. No lift of the kind in which the visitor reaches the interior of many an oriental monastery. Nothing but a rope plaited from strips of leather, which dangles down from the overhanging rock.

The leather rope is explained in the foundation legend. Za-Mikā'ēl, called Aragāwi – one of the Nine Saints who, in about 500 B.C., spread the new doctrine from Aksum and prepared the way for Ethiopian monasticism – chose the inaccessible ambā as his place of prayer and penance. At God's command, a serpent which lurked on the mountain top had to bring Za-Mikā'ēl there in the coils of his tail – a scene very frequently depicted in Ethiopian devotional pictures. An archangel constantly watched over him with drawn sword so that the dragon should do the saint no harm. The legend further relates that Za-Mikā'ēl, when he had settled into his hermitage, asked the king of Aksum to build a church on the spot where the serpent had set him down. To facilitate the construction the king had a ramp built. However, after the completion of the church, it was pulled down at the saint's request – from then on a rope was to remind each visitor of the miracle which the Almighty had wrought for the benefit of his servant. Of course the connection is more immediately obvious to an Ethiopian than to a foreigner, since in Ethiopia a snake is often described as 'rope of the earth'.

Without the serpent's help, those climbing up with the rope can scarcely avoid some tingling of nerves. But Ethiopia's (supposed) oldest monastery is worth a touch of vertigo.

In good times Dabra Dāmo's community of monks could boast a thousand members and more, not including the pious women who built huts at the foot of the holy mountain, upon which no female being is allowed to tread. Today, less than three hundred monks and novices live on the ambā. The monastery possesses extensive lands in the neighbourhood cultivated by peasants. In addition to this, prior to the Italian occupation, taxes were levied throughout the whole district, a right which was interrupted under the Italian rule when state subventions replaced the traditional taxes. After the war the monastery reverted to the earlier system, but apparently their tax collector was rather badly received by the peasants. Within the area, the monks perform various functions, especially in the judicial sphere.

The monastic village on the flat mountain-top is scarcely distinguishable from any other settlement in the province of Tegrē. The majority of the monks live in individual multi-roomed, flat-roofed houses of rubble, the upper storey of which is devoted to prayer and contemplation. To each house belongs a fenced-in garden and every group

of houses is surrounded by a high wall pierced by several gateways. Only the monks of a second, poorer, class live together in one house or in separate, rather wretched cells. The communal house and kitchen are only used occasionally, on feast days and for the reception of guests. Usually each monk eats at home by himself. The most important communal buildings are two churches, both of them dedicated to the founder of the community. The smaller is on a ledge of rock sixty feet below the top of the ambā and on its east face. It indicates the spot where, according to the legend, Za-Mikā'ēl was carried up in the mysterious fashion related above. The second church honours the place where the saint set foot on the mountain top. A dry-wall, 9 feet high, encloses the church, a bell tower and various water cisterns both for sacred and profane use; the treasury stands in a similarly enclosed, connected courtyard. A two-storeyed gateway secures the entrance to the complex of buildings.

The second, larger church, Endā Abuna Aragāwi, is the pride of Dabra Dāmo. It is not only – in its foundations – Ethiopia's oldest free-standing building still remaining, but it is also the one which has been the best studied. The German Aksum-Expedition laid the foundations of every future investigation of this monument by a short visit in 1906. The Servizio Etnografico of Italian East Africa and the Missione Archeologica in Aksum saved the church for posterity before it collapsed, with repairs, props and corrugated iron roof. Mordini, who lived for several months on the ambā, was the first to include the whole ambā in his researches. In 1948 the English architect D.H. Matthews, with the help of funds from the Emperor's privy purse, restored the church and in doing so explained the unique construction of the walls down to the last detail for the first time.

The church, 20 × 9 m., is a basilica with a nave and two aisles and two vestibules (figs. 29, 30). The flat wall-surface is broken by projections and indentations. The wall is built up of courses of small flat unsquared stones bound with mortar, with beams let in at intervals where the masonry is levelled off horizontally. The cross-bars of the timber framework, which are clamped to the longitudinal beams as 'binders' and anchor these to the wall structure, project as 'monkey-heads', a term which the Deutsche Aksum-Expedition introduced into the scholarly literature from the local terminology. Matthews was unable to confirm the expedition's view that the 'binders' as a rule went right through the wall, tying the outside and inside longitudinal beams to each other: rounded timbers going right through with monkey-heads both on the inside and the outside are the exception. The door and window frames, with their massive structure of beams, also contribute to strengthen the framework. Their corner-pieces, although square rather than round in cross-section, also jut out like the monkey-heads.

Of the two vestibules, the outer is a later addition, even though it is still probably quite early. Its roof has three divisions; the arrangement of the timber-work in each division makes a pattern of squares set corner to side. From the inner vestibule, the church's true narthex, steps lead to the upper storey. Three columns, one of wood, support the ceiling on bracket capitals. It is coffered and is iconographically of the greatest interest. The representations of Ethiopian fauna and mythical beasts in the coffers have laid the foundation for Dabra Dāmo's artistic fame. Six monolithic columns, some with cube-shaped base and capitals, divide the aisles from the nave. On them rest the wooden architraves and entablature: a frieze constructed after the pattern of windows, in which adjoining panels share a single element of the frame. This frieze is even continued on the walls of the sanctuary. Its 'metopes' – the panels of the blind windows – are filled with carved decoration (fig. 32). Altogether they make up something of a pattern book of favourite Ethiopian designs in the Middle Ages and beyond. The carved horseshoe-shaped arch set into the dividing wall between the nave and sanctuary is also of wood and so originally was the small dome over the sanctuary, which has a raised floor. Recently, however, the painted wooden

Fig. 29 Ground-plan (after *Deutsche Aksum-Expedition*, amended by Buxton)

Fig. 30 Cross-section of the nave with sanctuary arch and left aisle (after *Matthews*)

Fig. 31 Ceiling-beams of the porch

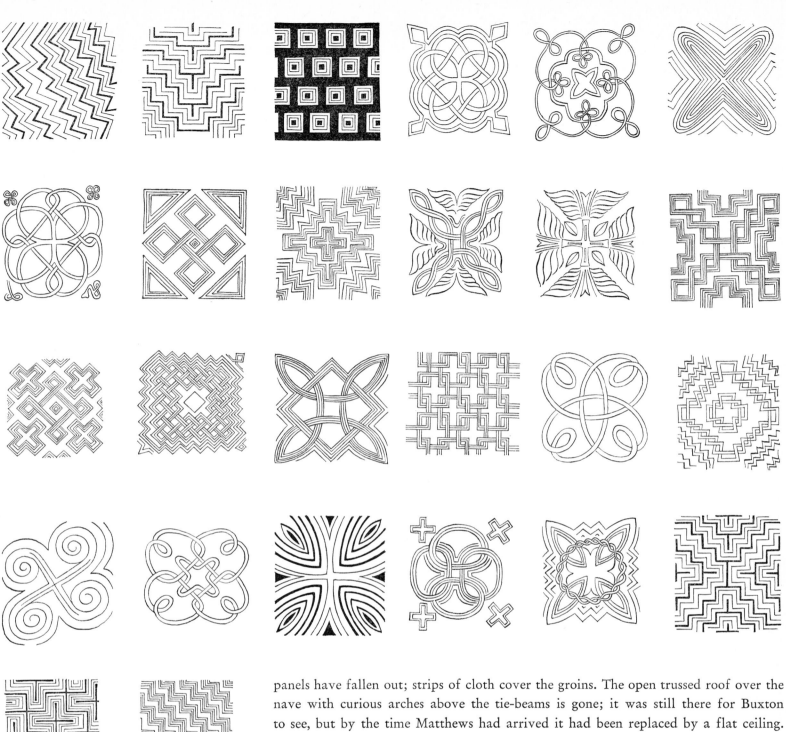

Fig. 32 Carved decoration of the meto-
pes (after *Matthews*)

panels have fallen out; strips of cloth cover the groins. The open trussed roof over the
nave with curious arches above the tie-beams is gone; it was still there for Buxton
to see, but by the time Matthews had arrived it had been replaced by a flat ceiling.
The interior of the church receives direct light through windows in the aisles and a
window at the west end of the nave which opens on to a light-well above the inner
vestibule; and indirect light through windows of the nave opening into the lofts
above the aisles.

The question of the age of the church and of the coffered ceiling poses a problem
of great difficulty to scholars. The only point of agreement is that the problems of
the age of the church and of the ceiling must be dealt with separately. The three
preserved groups of coffers are the remains of a much greater collection which quite
possibly were not even made for the church. The animals which figure on them hardly
constitute a bestiary; they contain no parables of Christ nor the story of Salvation and
the possibility should not be ruled out that similar coffered ceilings were the standard
decoration of the Aksumite palaces. There was a definite place for the representation
of local animals in Aksum, and it is sufficient to recall the lioness of Gobedrā (pl. 9)
in this context. As for the date of the ceiling, in the present state of knowledge any
date between the seventh and eleventh centuries has its partisans. Mordini tentatively

places it in the eighth century and suggests dating the wood by means of the radio carbon method. The date of the church itself is also uncertain. Matthews thinks there was a precursor of the building possibly already in the pre-Christian period of Aksum, and moreover considers that its renovation took place between the twelfth and fourteenth centuries. Buxton dated the church originally to the ninth or tenth centuries.

The question of the exact age of the church has little bearing on its indisputable significance for the history of architecture, and not just Ethiopian architecture. One of the very few free-standing medieval buildings of Ethiopia to have survived the Moslem invasion of the sixteenth century, it is no less than the 'missing link'. On the one hand it offers the most satisfactory illustration imaginable for the Aksumite – and ancient Oriental – wood and stone method of building, depicted on the multi-storeyed stelae. The points of similarity concern the 'stepped' masonry of the podium of the church, where – in the north-east – it cannot be built on to the living rock; the enlivening of the walls by means of alternating projecting and recessed surfaces and their reinforcement by a timber framework with monkey-heads; details of the decoration: the window frame arrangement underlying the frieze as well as the tooth pattern carved on the door-lintel which are already in evidence on the multi-storeyed stelae and probably were among the preferred decorations on and in the building of the royal city. On the other hand, right from the start, the church is planned with its function as a Christian building with a basilican plan in mind. Without this monument, details of rock-church architecture would remain unexplained. The diagonal arrangement of the ceiling timbers of the outer vestibule (fig. 31) might have been a model for the ceiling reliefs in the vault church of ʿĀddi Qāšo (pl. 162).

Numerous grottos and caves dot the Ambā as burial places of the monks in the area of the small church. Pious men even outside the monastery used to long for their eventual burial in Dabra Dāmo; from time to time, bodies were brought here from afar and lifted up on the rope to their last rest on the holy mount. This part of the Ambā, which the monks protect from the curiosity of strangers since they hold it in especial reverence, requires a lot more study. Mordini, who was able to do some preliminary work, discovered near the small church a grotto structure possessing a dome and niches, which presumably owes its artistic prominence to the fact that it is considered to be the hermitage of Za-Mikāʾēl (figs. 33, 34). The crypt of this building, of which there is evidence under the built-up church and which probably has some connection with the chamber suspected to be under the hermitage, might well contain the grave of the holy founder and/or the first heads of the monastery.

Undoubtedly the history of the monastery goes back to the beginnings of Ethiopian monasticism. Written records only go back to the fourteenth century. Before that, one has to rely on archaeological information and historical traditions. Particularly striking

Fig. 33 Ground-plan of the cave hermitage (after *Mordini*)

Fig. 34 Cross-sections of the cave hermitage (after *Mordini*)

are the comparatively frequent finds of Arab coins from the period of the Omayyid and Abbasid caliphs but an almost complete lack of Aksumite coins; this suggests Dabra Dāmo's close proximity to flourishing centres of Islam. The pagan queen, under whose invasion the kingdom of Aksum broke up in the tenth century, is also supposed to have captured Dabra Dāmo and, like Gabra Masqal before her in building the church, she made use of a ramp to capture it. The Zāgwē dynasty favoured the monastery of Dabra Libānos in Ham; it is therefore no wonder that in Dabra Dāmo's king-list, the Zāgwē kings are suppressed and in their place the rulers 'in exile' are enumerated. With the restoration of the Solomonic dynasty in the thirteenth century a new heyday began. The saintly monk Takla Hāymānot, to whom Ethiopian history ascribes the mediation between the Zāgwē usurpers and the rightful rulers, is himself supposed to have lived on the ambā for a few years. Royal favour down the centuries made Dabra Dāmo a centre of the religious life and, in the worldly sphere, a state within a state with considerable riches and significant cultural influence. Mordini mentions the monks' fruitful literary activity. In the sixteenth century Dabra Dāmo was the refuge of the royal family. Several times the mountain fortress successfully withstood year-long siege by the hordes of Grāñ. The remains of King Lebna Dengel, who often resided in Dabra Dāmo, have been preserved in the northern sacristy of Endā Abuna Aragāwi. His successor, King Galāwdēwos, likewise sought refuge on the ambā and was besieged there for a year by Grāñ's troops. Cristovam da Gama, a son of the navigator, in 1541 freed queen Sabla-Wangēl whom the Imam's warriors had imprisoned for four years on Dabra Dāmo, and used the ambā as an arsenal and munitions depot during his daring expedition. Where Grāñ had failed, the Turkish pasha 'Uzdamēr succeeded. In 1557 or 1558 he invaded Ethiopia from the Yemen with stronger artillery and took Dabra Dāmo, massacring the monks and, according to a contemporary account, turning the church into a heap of ruins. Of this destruction and the consequent reconstruction, strangely enough not a trace has been found, unless one dates the present disorganised arrangement of the panels of the coffered ceiling to the sixteenth century. The reports of the Jesuit missionaries make no mention of the monastery, from which Mordini concludes that the monastic community went through a period of eclipse and decay in the seventeenth century. However the following century meant revival for Dabra Dāmo, as many manuscript fragments from the monastery indicate. According to the account of the Scot, James Bruce, the monks at that time were in addition active slave traders. Finally, in the nineteenth century the first European visitor clambered up the rope.

21 The ascent up the rope on the cliff-face, with the entrance of the monastery. The fortified gateway lies behind this portal on the same ledge. From there a tortuous path zig-zags up to the heights of the ambā, partly on natural ledges in the precipitous rock-face, partly over steps hewn out of the rock. The entrance is situated on the north-east of the table-mountain, where the cliff-faces are lowest. The second rope is used for the transport of material. The monks help expected visitors with an additional rope, pulling up the newcomer with all their might. For the unexpected traveller, however, it can happen that he waits in vain for help at the foot of the cliff. Before one's very eyes, monks, seminarists and monastery servants climb up and down the rope with the ease of the angels on Jacob's ladder up to heaven. They dance up rather than climb up the cliff, reckoning with every bump and dip in the rock, swinging from side to side on the rope like monkeys in the jungle – proof enough that strength signifies little and technique everything. The visitor who dares to attempt the ambā with nothing more tangible than this demonstration has still to make the painful discovery that the terrifying moment of stepping down into the void on the way back far exceeds all worries of the ascent. While his legs struggle for the cliff in panic

and his hands feel downwards on the leather snake, St Takla Hāymānot comes very much into his mind. During his descent the devil cut the rope and the Lord, who had greater things in store for his servant, despatched three pairs of wings to land him safely on the ground.

22 Vertical cliffs rise from a steeply sloping scree base and thrust the monastic mountain-top village heavenwards as though on an altar: the ambā of Dabra Dāmo. The whole of the flat mountain top (7,268 ft above sea-level) – aerial photo from the west – comprises the monastery; the surrounding cliff-faces descending perpendicularly 650 feet obviate the need of monastery walls. The length of the ambā is about 1,970 feet. The monastic village is split up into a dozen groups of houses behind protective walls. The area of the church of Endā Abuna Aragāwi (with corrugated iron roof) occupies the spur at the north-east of the ambā, near the place of ascent. The small church and grave area – out of sight in the photograph – lie on a ledge in the south-east below the group of houses nearest the upper edge of the picture. Inside and outside the protecting walls, cisterns have been dug out of the living rock. The slimy algae ocvering the stagnant rainwater does not deter the monks. Quite the contrary! It is only the water out of the green-coated cisterns that fits their idea of drinking water. On the ambā solitary olive trees and eucalyptus grow amid the short grass. Among them the hump-backed cattle graze – fattening for the monastery's communal kitchens. The mind boggles at the thought of the manipulation of the rope required to hoist the animals up to the top.

23 An example of characteristic old Ethiopian (Aksumite) architecture: part of the south façade of the monastery church. The projections and indentations of the wall are Aksumite, as are the stone and wooden corner-pieces at the angles of the projections and the olive-wood framework between the courses of rubble in which each 'binder' projects out over the wall. These 'binders' are called 'monkey-heads' from the native re'esa hobāy. The window-frames also have projecting cornerpieces. Slates projecting as a kind of ledge protect the walls from the rain. The highly decorative effect created by the monkey-head style of architecture is surely quite insufficiently appreciated. The smooth white plaster masking the rubble structure of the wall between the beams of the wooden framework has peeled off.

24 The northernmost of the two wooden porch windows which are of the same shape and differ only slightly in the design of the lower panel. It admits light to the stairway leading to the upper chambers. A transom divides the window. The upper half, pierced in order to admit light, consists of an arch – a window decoration already attested on one of the multi-storied stelae. The step construction at the foot and head of the central column and pilasters is known from Aksumite bases and capitals. In the same way, the profiling of the shaft evidently reflects the shapes of the Aksumite columns. A kind of strip maze fills the lower, blind, half of the window-light with a pattern of clockwise swastikas. The addition of the first porch, already carried out at quite an early stage, preserved the monkey-head style of construction of the wall, whose ornamental lustre had only temporarily been exposed to the weather as the church's main façade; the plaster covering the courses of rubble shows why the wall-faces on the stelae of Aksum are portrayed as smooth.

25 A section of the largest of the three remaining groups of coffers in the ceiling of the inner vestibule. The cross-pieces form three times five square panels with a 23 cm. side. Each panel is filled with a different carved design; several of the panels are missing. Originally the ceiling must have been made up of at least eight groups of coffers. The present arrangement apparently reflects a comparatively recent and rather tasteless version; the panels with purely geometrical patterns hardly belong to the original. On the panels fully visible in the section portrayed, the following scenes and figures are recognizable from left to right: a snake devouring its prey; a dog-like

beast of prey – wolf, jackal or hyena – attacks a horned animal (antelope?); a cross with arms ending in palmettes, with additional palmettes in the corners of the panel; a pair of gazelles arranged opposite each other with each one's front half entwined with the other, set antipodally one pair above the other below an equilateral cross.

26–33 Animal figures on the coffered ceiling of the inner vestibule. The remaining panels with pictures of animals hardly represent the work of one hand as the quality of the renderings is too varied. Several – plates 26 and 32 – are shapeless and clumsy; possibly the artist just did not have a personal knowledge of certain species. On the other hand others – like plates 27 and 29 – are small masterpieces convincingly true to nature yet with a powerful stylisation. The panels in the pictures show a lion rearing itself up (26); a wolf-like beast of prey attacking a large antelope with young, beneath vegetation (27); two gazelles or antelopes facing each other on either side of something like a tree of life (28); two pairs of (Oryx?-) antelope, with each antelope of a pair facing the other and drinking its milk, the two necks being entwined. The pairs are arranged opposite each other feet to feet (29); an elephant feeding on leaves (30); a dromedary in front of a palm (31); a rhinoceros with a dog-like animal standing next to a plant (32); a hump-backed ox on the move, surrounded by creepers and turning its head to the viewer (33). On other panels we find (fig. 35): a griffin with necklace of plants; an animal hard to identify – wild donkey (Matthews), hippopotamus (Mordini) – attacked by a hyena; an antelope, back-hoof in its mouth, with its young; a family of antelopes, the mother suckling her young; birds (peacocks and pigeon) drinking from a cup or flower; a giraffe (?) attacked by a leopard (?), with a third animal in the background; gazelles, one of which is suckling her young, the other being in full flight; antelopes running in opposite directions; a dragon swallowing a fish (?); two

Fig. 35 Animal figures on the coffers

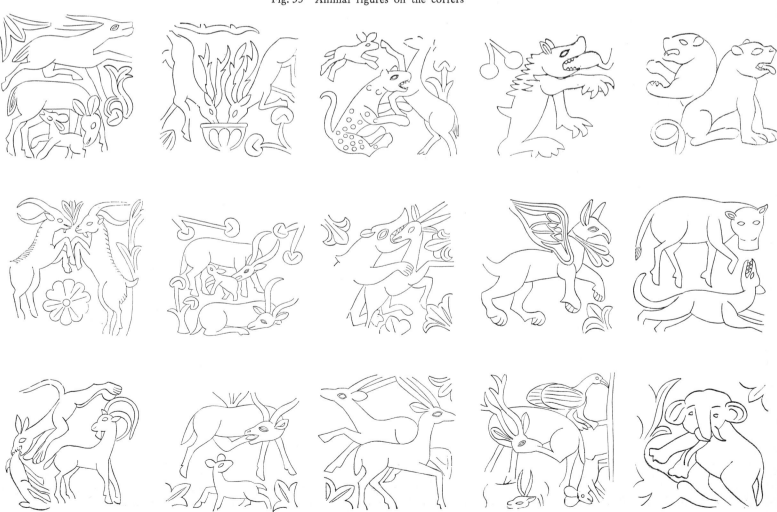

ibexes facing each other on their hind legs above a rosette; an ibex looking backwards at a beast of prey which has just killed its quarry; a stag licking one of its hind legs, with an animal at rest and a bird; beast of prey with an antelope in its jaws; stags drinking from a vessel or flower; lions squatting; an elephant on the move. It should just be noted in passing that the last two panels mentioned – like several others known from the literature – are to be sought in vain in position or even in the church at all. One suspects that learned visitors, whose conscience allowed what better judgement ought to have denied them, accepted them as gifts from the monks for their collections. Yet despite all the losses, the coffered ceiling still conveys the impression of completeness and as wood-carving is unparalleled in Ethiopia. (Several panels from the old church of Aśmarā, no longer standing, and which can now be seen in the museum there, are apparently later imitations of the ones at Dabra Dāmo, or of a similar coffered ceiling). There is no difficulty in finding parallels to the animal groups and plant decoration in Hellenistic, Copto-Byzantine, early Islamic and Fatimid Egypt especially in carvings and on textiles. At the same time one should certainly bear in mind that even the artists in the Nile valley enjoyed a much older and geographically more extensive oriental heritage. Details of the compositions – such as the favourite entwining of animals or the heraldic confrontation of two identical animals – reflect a thousand years of ancient tradition and are already to be met with on Sumerian cylinder seals. Mordini and Matthews prefer to consider Eastern influence which Ethiopia might have received via South Arabia without the detour through the Nile valley. Mordini's argument uses examples from the art of the Achaemenids and Sassanids, Matthews even considers connections with the Indus Valley cultures. Dabra Dāmo's connections with India are not to be excluded out of hand: on the ambā a hoard containing gold coins of the Kushan kingdom (Hindu-Kush and North West India) from the first to the third centuries was discovered. In itself, of course, the find of coins is not very strong evidence; the circumstances by which this exotic treasure came to the mountain will probably never be explained.

Selected Sources

The cave on the ambā decorated with reliefs, the supposed hermitage of the monastery founder, is no. 6 in Sauter's list of the rock-churches; as a built-up structure Endā Abuna Aragāwi is not dealt with in it.

On the ambā, monastery and church: *Deutsche Aksum-Expedition,* Vol. 2; *Buxton, The Christian Antiquities . . .;* Matthews, *The Restoration . . .;* Matthews/Mordini, *The Monastery . . .;* Doresse.

On the coffered ceiling: Mordini: *Il soffitto . . .* and *Uno sconosciuto capolavoro . . .*

21 The ascent up the rope on the cliff-face, with the entrance of the monastery. The fortified gateway lies behind this portal on the same ledge.

22 Vertical cliffs rising from a steeply sloping scree base, thrusting the monastic mountain-top village heavenward as though on an altar: the ambā of Dabra Dāmo.

23 An example of characteristic old Ethiopian (Aksumite) architecture: part of the south façade of the monastery church.

24 The more northern of the two wooden porch windows.

25 Section of the largest of three remaining groups of coffers in the ceiling of the inner vestibule.

26–33 Animal figures on the coffered ceiling of the inner vestibule.

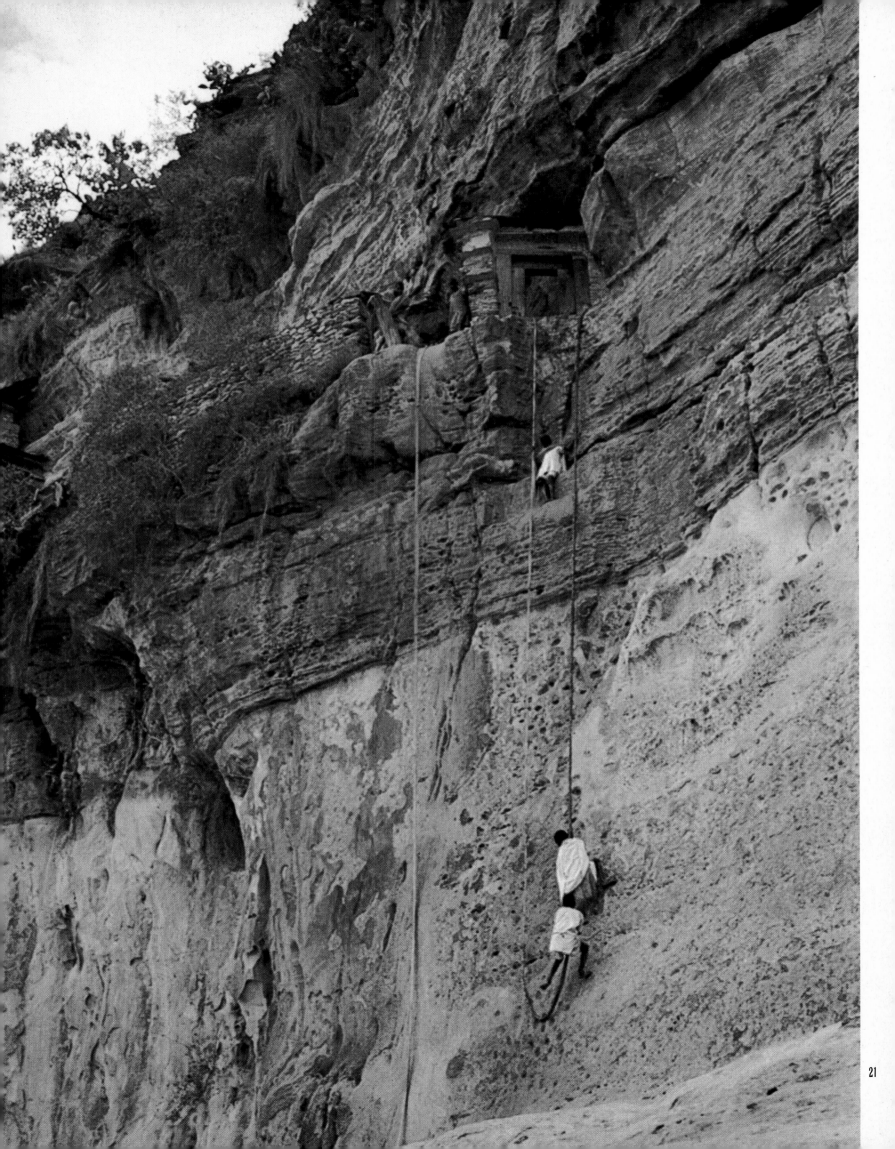

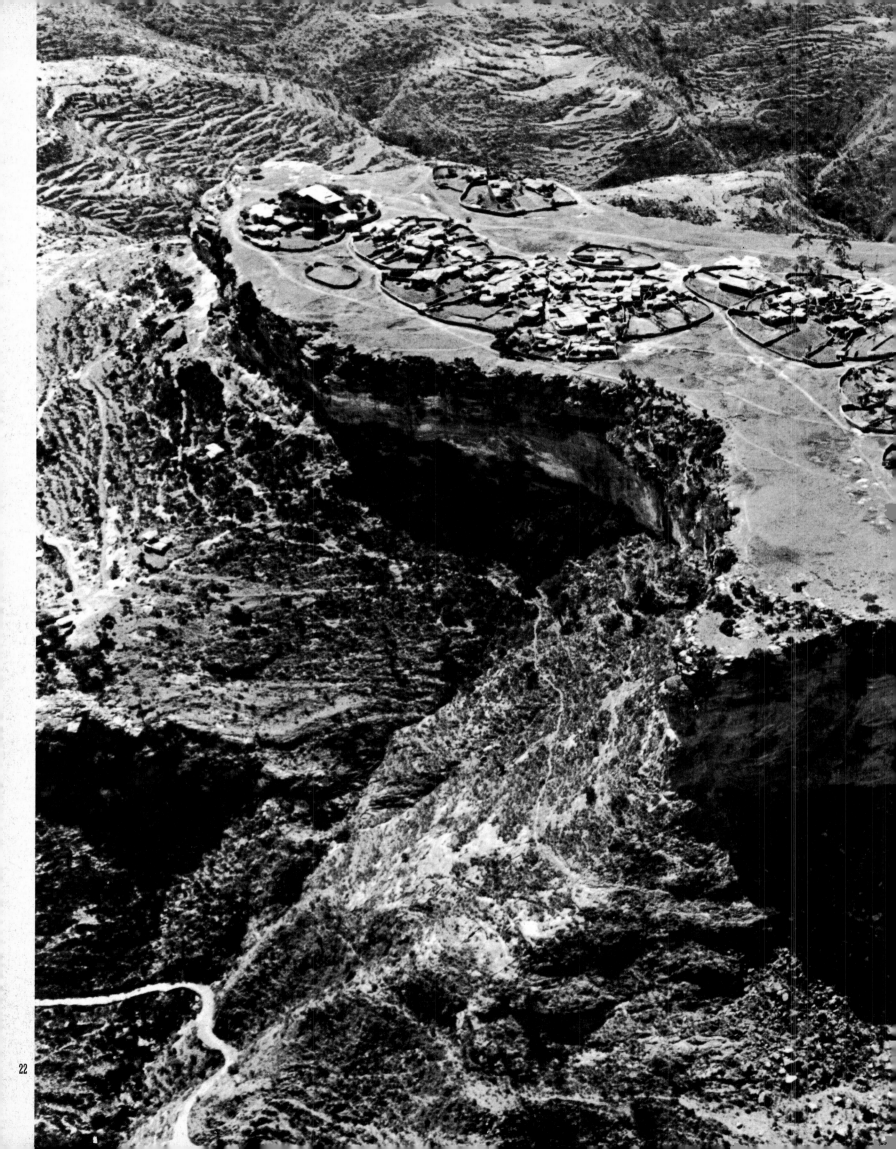

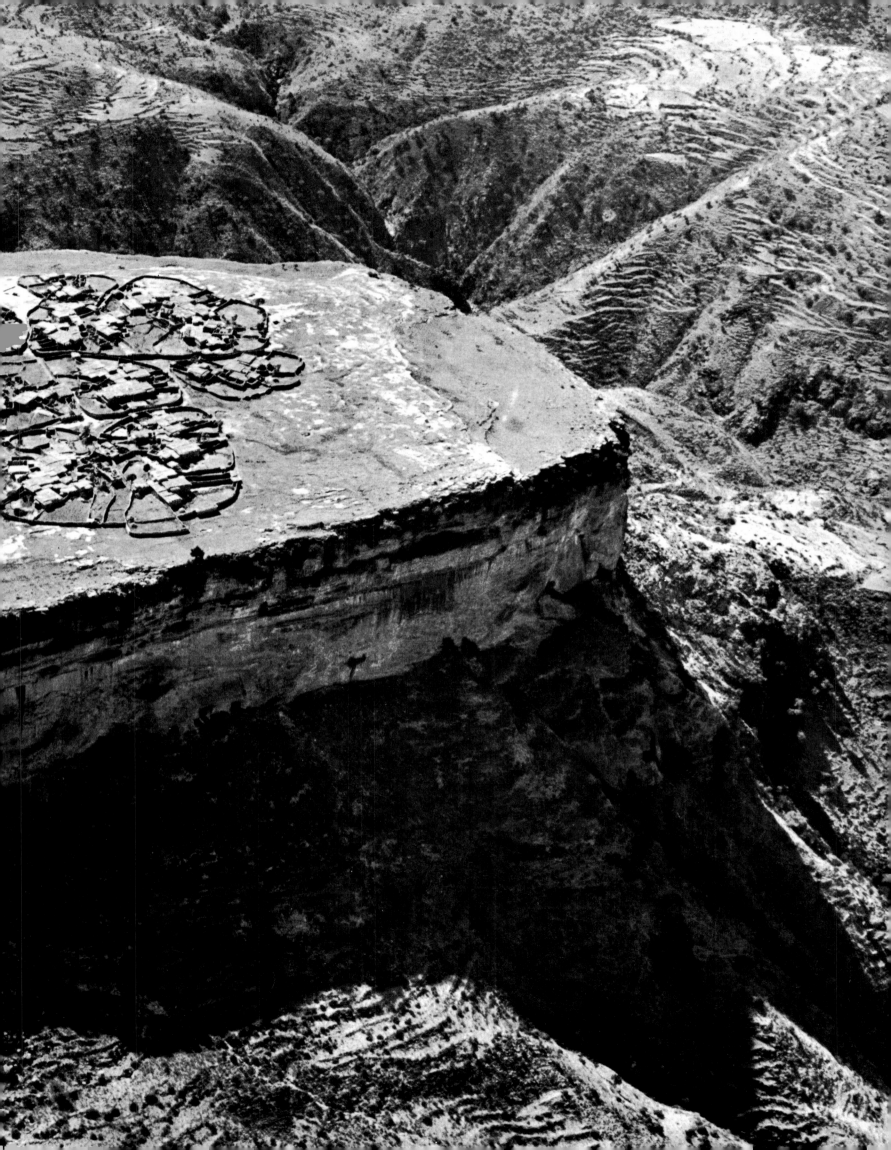

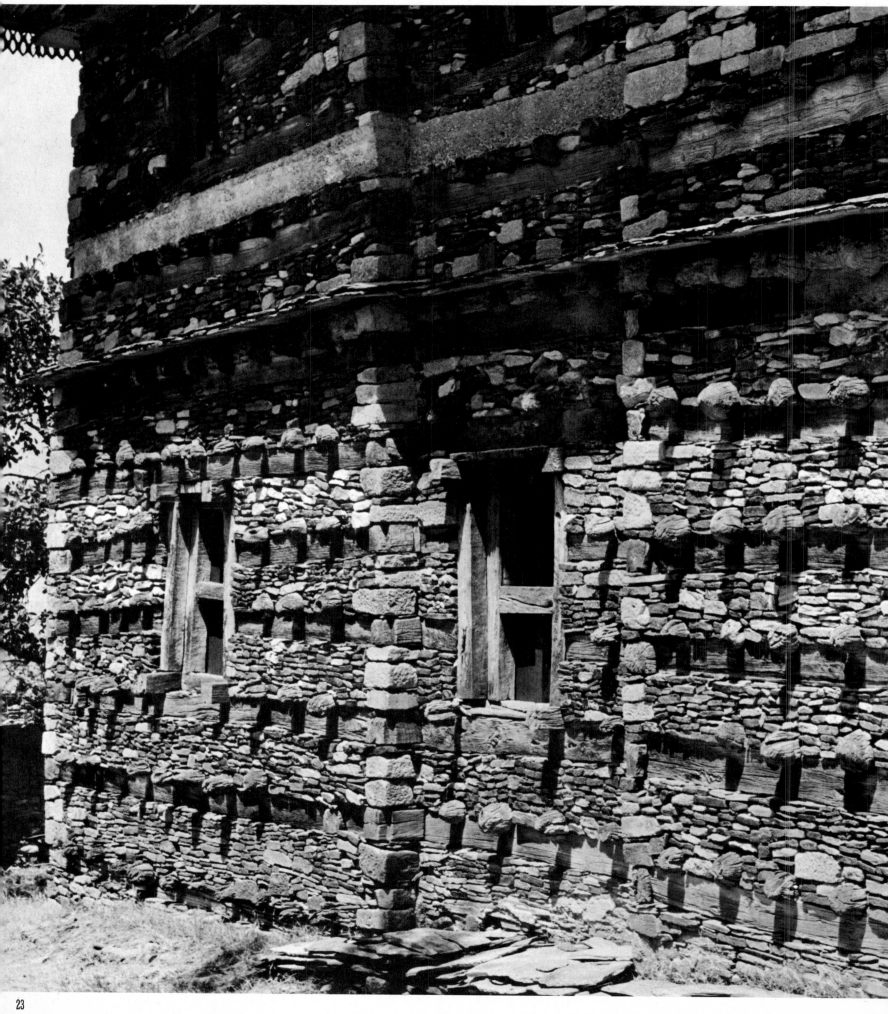

23

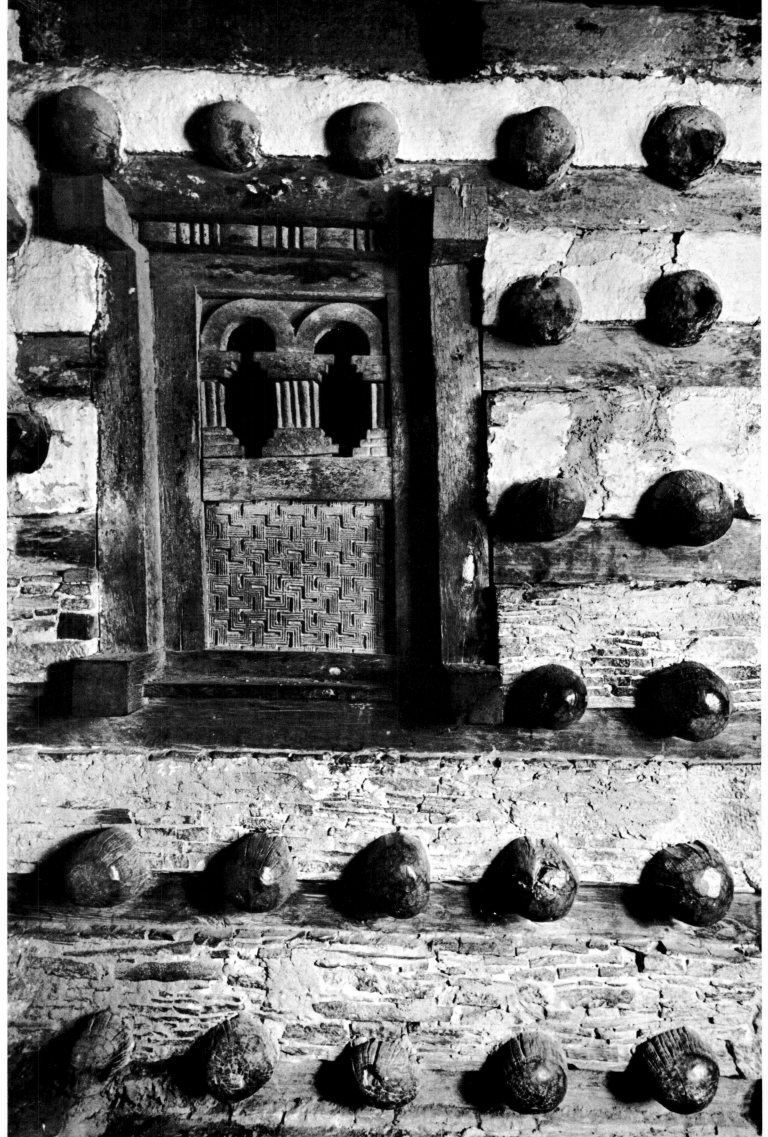

24

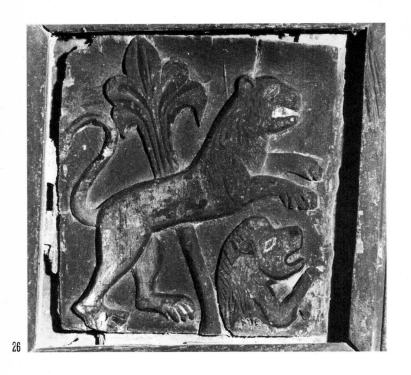

26

27

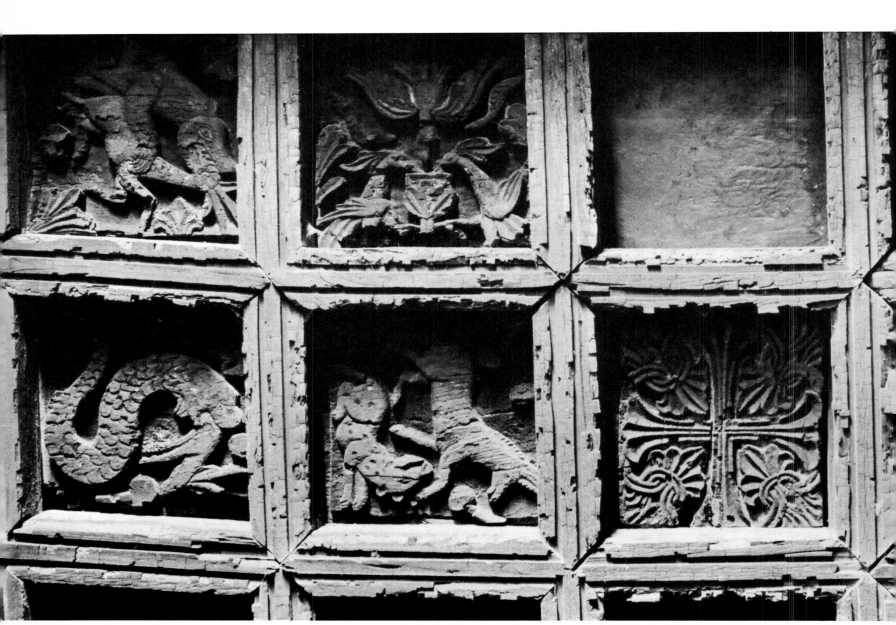

25

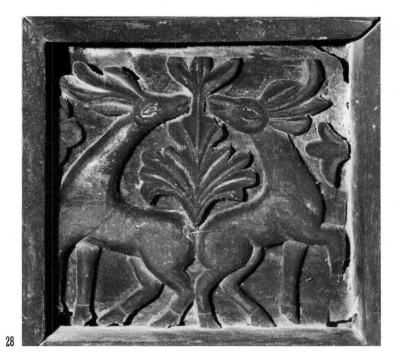

28

29

30

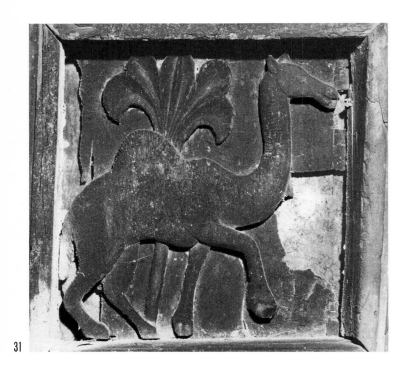

31

32

33

The Excavated Churches of Qorqor and Dabra Ṣeyon

For years Mordini has been warning the world of scholarship against building up their studies of the problem of the Ethiopian rock churches on a hackneyed fragment of the vast unknown total collection. The merit of having proved him justified belongs to an unassuming Catholic cleric who died in 1967. Abbā Tawalda Madḫen Yosēf, secretary of the missionary bishop in Addigrāt, questioned his orthodox fellow-countrymen either personally or through reliable intermediaries and thus amassed evidence of something quite incredible: in the heart of the province of Tegrē alone, in the sub-provinces (awrajjā) of Tambēn, ʿĀgamē and Hulatt Awlāʿlo, with concentrations near the market towns of ʿĀbiy ʿAddi, Hawzēn and Aṣbi, there exist hundreds of medieval rock churches which await scholarlw investigation (map, fig. 36).

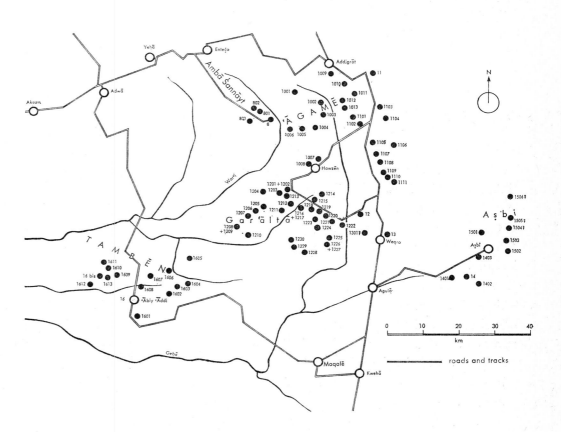

Fig. 36 Rock churches in the heart of Tegrē. A question mark after the number from Sauter's list indicates uncertain location (beginning of 1968)

Early in 1966, on the basis of the available information and in co-operation with the provincial authorities, the Ethiopian Archaeological Institute commissioned a group (R. Schneider, Abbā Tawalda Madḫen Yosēf and G. Gerster) to make a reconnaissance in Garʿāltā, a district in the sub-province of Tambēn which promised to be particularly rewarding. Garʿāltā, with its 'western' film scenery of mountains, seems to be a kind of Ethiopian Arizona. An Arizona, however, without motels or desperadoes. But nevertheless an eldorado with the choice intellectual pleasure of constantly stimulating and satisfying the passion for discovery. Twelve days produced the same number of churches, none of which had ever been entered by a non-Ethiopian. And for every church located, the scouts reported, according to local rumour, two more yet to be found ... The most important discoveries will be presented in this and subsequent chapters.

The two churches of Qorqor are an hour's climb into the mountains above the village of the same name which can be reached by Land Rover from Hawzēn. The larger, older one is dedicated to the Virgin, the smaller and more recent to a monastic saint called Daniel. Only the former is still in use today. Both of them are completely imprisoned in the living rock, both in the same hill-top. If any attempt was ever originally made at working the façade at Endā Māryām, the results today are no longer visible; a part of the narthex, in danger of collapse or collapsed already, was replaced at some unknown time by a porch in the locally favoured dry-stone work.

The Church of St Mary, facing east and with a basilican ground-plan with a nave and two aisles, has few architectural surprises to offer. The vestibule occupies the width of the whole church. Two pairs of free-standing columns (cruciform in section) are connected with each other, and with corresponding pilasters on the end and side walls, by arches; only the last two bays of the nave lack the dividing arch. The altar space and last two bays of the nave are domed, the upper walls of the nave are decorated with a running frieze of metopes, partly doubled. Bas-reliefs on the face and under-part of the arches contribute to the church's decoration quite apart from the frescoes (from more than one hand and from different periods) on the walls, columns and pilasters. Only when the church receives the cleaning it so urgently requires will a reliable idea of the value of its murals be possible.

In describing excavated churches, of necessity we use vocabulary which exists for describing parts of a *building* and for indicating *constructional* architecture. For this reason I should like to emphasize here that in an excavated church, columns, arches, domes and every other conceivable part are of one and the same piece of rock which the masons have hollowed out by excavating the mountain. Under these circumstances descriptions can only be comparisons at best: admittedly the word 'column' indicates a fixed form, but only exceptionally is its function the same in the completely different conditions obtaining in rock architecture.

As an excavation, Endā Māryām does not exactly display great vitality. Individual details are coarse and clumsy. In contrast, its dimensions are impressive. With a width of 10 metres at the west end, it is more than 16 metres long and about 6 metres high in the nave.

Endā Abuna Dāne'ēl, only a minute's walk along the side of the mountain from the Church of St Mary, consists of two interconnecting rooms (fig. 37). They are both practically square, the first having a side of about four metres long, the second, about three metres. Both exhibit a small niche in the west wall and the second room has a socle 30 cm. high in the middle. Figurative painted decoration is limited to the first room. The question of how these two rooms were used for religious services remains open.

Also unanswerable, at least for the present, is the question of the age of the Church of St Mary. One cannot help stressing that considerations of architectural history allow the adoption of any date between the seventh and fourteenth centuries – give or take a century – bearing in mind the resistance to change of architectural forms in rock. The study yet to be done on the ornament of the oldest frescoes might considerably reduce this time-span. Several facts even invite comparison with the newly discovered Christian art of the Nubian Nile valley. I am quite struck, for example, by the similarity of a picture of the Archangel Raphael, painted below a blind arch with a tenth or eleventh century crowned archangel in the cathedral church of Faras (fig. 38). All attempts at dating the church by way of the murals must surely take into consideration that even the oldest frescoes do not belong to the original furnishing of the shrine. The fresco of Raphael, reckoned stylistically with the oldest paintings, is clearly a later addition to the arch with its birds in relief. Architecture and frescoes seem to date the church of St Daniel to the sixteenth century.

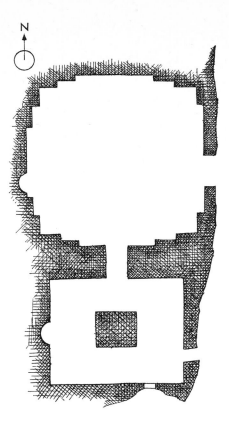

Fig. 37 Ground-plan of the Church of St Daniel

Fig. 38 Archangel Raphael

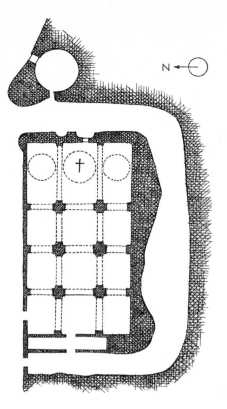

Fig. 39 Ground-plan of the Church of St Mary of Dabra Ṣeyon

Less uncertain than the Church of St Mary at Qorqor as regards age is yet another church excavated in the mountain face, also an hour's walk above the valley bed, the church of Dabra Ṣeyon dedicated to Mary. Its dedication is *Kidāna Meḥrat* ('Covenant of Mercy'), here to be understood as by-name of the Virgin, with whom Jesus, according to a tradition in the 'Miracles of Mary', made an agreement that all who call on her name and can show some good deed will be saved. Endā Kidāna Meḥrat complies with the plan of the east-facing basilican arrangement with a nave and two aisles, with a narthex extending practically the full width and three pairs of free-standing columns linked to each other and the corresponding wall-pilasters by arches (fig. 39). The church is 10 m. wide, 22 m. long including the vestibule and 9 m. high. The 'construction' is distinguished by five peculiarities. First, the church shows that a start had been made at working the north façade. Second, a high passage cut out of the rock surrounds the whole church. Third, the three shallow domes over the sanctuary form pendentives, i.e. spherical triangles resulting from the base-circle of the dome resting on a square supporting structure. Fourth, shallow niches filled with painted decoration and pictures of saints give the walls of the church the appearance of a columbarium. Fifth, in the passage outside the east wall of the church a loop-hole leads to a circular domed cell decorated with bas-reliefs. The priests and monks of Dabra Ṣeyon associate it with Abuna Abraham, the founder of the church and monastery.

Schneider discovered in the church treasury a manuscript, of the sixteenth century at the latest, containing the life of Abuna Abraham. According to this, Abraham's father came from Šawā to Tegrē in the third year of king Sayfa Arʿed (1344–1372). The church and monastery must have been established at the turn of the century during the reign of King David (1382–1411). The manuscript tells of a vision of Abraham according to which he addresses his disciples with a speech and then starts hacking into the rock – up to now the only reference in an old, possibly even contemporary, source to the 'building' of a rock church. The 'Gadla (Acts of) Abraham' gives one year and nine months as the time it took to build. Apart from Abraham's disciples it mentions no other helpers. The evidence of the monument itself fits in well with the information suggesting a comparatively late date of construction. The church's oldest pictorial decoration derived from Islamic ornament apparently also belongs to the end of the fourteenth century. Similarly, other excavated churches with external passage, for which the grotto churches standing free under their protective roof of rock possibly figured as models, must also be late products of Ethiopian rock architecture: this goes for St George's Church in the Bilbalā district (Sauter, no. 25) as well as for that of Abbā Libānos in Lālibalā.

34 In every crag a church. The mountain landscape of Garʿālta on the way up to the churches of Qorqor. The claim that a church lurks in every mountain crag is at worst a pardonable exaggeration.

35 The Church of St Mary of Qorqor: view from the first bay of the nave into the low left aisle. The ceiling over its first bay is similar to that (fig. 31) already seen at Dabra Dāmo. The bottom of the shafts of the columns at present resemble tree-trunks: the damage caused by rising damp from the bases of the pillars has largely contributed to this appearance. The foliage borders below the pictures of saints reflect Islamic prototypes.

36 Royal priest, possibly Melchizedek, or a martyr priest, with a chalice: fresco on the left column of the first pair (pl. 35).

37 Blind arch with interlaced decoration and scenes from the earthly paradise on the northern end of the vestibule. Left and right of the arch, ostriches (?). Within the arch, doves are painted on the wall and below them, each within its own further recessed arch, a doglike animal looking back and a pair of gazelles with a tree of

life. On the column shown on the right is Eve with the serpent, below which is a figure, identified in the inscription as 'the false witness', being beguiled by serpents; on the left column are motifs of men and serpents not identified by inscriptions. For other pictures of animals facing each other or intertwined, see plates 26–33. The presence of Eve justifies the whole group being called a representation of paradise; another relevant factor being that the earthly paradise has always been thought of as something of a zoo, even the pre-Christian one in which Orpheus the divine singer wandered. Formerly, the artist received his inspiration from the tables of the Eusebian canons, which indicate the parallel passages in manuscripts of the gospels. Architectural settings, often with birds fluttering around, provide a framework for the columns of references in these illuminated manuscripts. The source of inspiration is quite clearly revealed by one in particular. The painted arches above the canon tables and other miniatures often rest on their respective pillars or columns in a manner open to technical dispute (fig. 28). Indeed at Qorqor the artist who decorated the wall originally adopted such an arrangement, but later on a successor felt it to be patently unarchitectural: he painted Eve and the false witness next to the pillar a second time, so that it now suggests a support directly below the arch. A second arch with the archangel mentioned above (fig. 38) decorates the wall of the first bay in the left aisle. Both of them indicate the close connection between book illustration and church decoration.

Fig. 40 South-Arabian sphinx (after *Pirenne*)

38 Two gazelles in heraldic arrangement facing each other on either side of a tree of life: detail from plate 37.

39 Creatures with human heads and camels' bodies in heraldic juxtaposition: fresco in the third bay of the left aisle. These crowned (?) hybrids are holding a fish and their tails end in serpents' heads (like the griffin in pl. 64). One can scarcely refrain from supposing that they are somehow connected with the incompletely understood idea of a winged sphinx. Perhaps representations of a type of South Arabian sphinx of the first century served as a model (fig. 40), the wings turning into the hump of a dromedary. Animals with paw uplifted are known from the same area of culture. Book illustration offers numerous examples of the transformation of animals from the original, partly through association with the local fauna, partly through misunderstanding or through lack of care. Peacocks become hornbills, deer antelopes, land birds sea birds, a two-headed eagle is called 'birds that live in the depths of the sea'. The inscription on the present fresco gives as description 'sea-monsters'. The sea is the mother of all marvels and oddities . . . Beneath the mythological creature on the left is the Visitation ('Māryām and Ēlisābēt – instead of the usual Ēlsābēṭ – greeting each other'); on the right is 'The Virgin Enbāmerēnā'.

40 'Eve beguiled by the serpent': detail from plate 37. Eve, with the leaf over her nakedness, is evidently by the same hand as the 'sea-monster': here, as there, we have the conflict between rendering in profile and face-on. The earlier model – on the pillar to the right, out of the picture – shows a much more full-face representation.

41 Christ in Glory (Maiestas Domini) surrounded by the Four Living Creatures and symbols of the Evangelists: mural in the second bay of the left aisle. The inscription to the left of the aureole says: 'Jesus and the Four Living Creatures bearing the wheel' (?) (Ezek. I: 15 ff.). On the right: 'And this is a picture of . . . (illegible).' Under the aureole in a later hand: 'Jesus Christ'. The inscription identifies it as the Apocalyptic Vision (Rev. IV.: 2 ff.; Ezek. I: 5 ff.; Isa. VI: 1 f.; Dan. VII: 9) in distinction to the similar subject, often confused with it, of the Ascension of Christ. The Four Living Creatures have a festival of their own in the Ethiopian calendar. Beneath the Maiestas Domini the artist has painted Christ's entry into Jerusalem.

42 The paintings in the Church of Daniel, the monastic saint of Qorqor. Within the dome there are four archangels shown 'orans' while their wings form a square around

the hub of the dome (symbol of the celestial sphere?), with the four Evangelists around the edge. On the walls, in clockwise direction from above the entrance, we have Mary and Child between Paul and Peter; Zacharias; Peter, supreme head of the bishops; James the son of Zebedee; David the psalmist; George; Joseph (?); Jacob; Abraham; Isaac; Theodore the oriental (here with the by-name Banādlēwos); Stephen; Melchizedek; Moses; Aaron; Mercurius; Julian the apostate with Basil and Gregory; Thomas; two saints whose inscription has been disfigured; Christ's baptism in the Jordan. The description of Peter as 'supreme head of the bishops' is not enough to imply that it was painted under the influence of the Jesuit mission in the sixteenth century; it is much more likely to mean: head of the apostles, head of the bishops of the primitive church in office at the time of Peter. The transition from the square room to the circle of the shallow dome gives rise to pendentives (hardly more than hinted at) and a stepped effect on the ground-plan in the corners.

43 Stephen, Melchizedek, Moses and Aaron with censers as priests of the Temple: fresco in the south-west corner of Endā Abuna Dāne'ēl. See the previous picture.

44 Folding book made of thirty-four sections of parchment, mounted as a wheel: it is used for processions and is kept in the treasury of St Mary's of Dabra Ṣeyon. A similarly conceived fifteenth or sixteenth century 'leporello' in thirty sections – saints framed above and below with bands of a continuous pattern – is preserved between book covers at the Church of Ṭānā Qirqos, on the island of the same name on Lake Ṭānā. Perhaps this 'leporello' was also originally exhibited to the faithful as a wheel picture.

45 Archangel, Mary and Child, apostle, patriarchs and prophets: painting on parchment, detail from the wheel picture. The inscription on the fifth figure from the top right reads: 'Picture of St James, brother of Our Lord'. The strip pattern of interlacing partly recurs in the decoration of the Church of St Mary.

46 The Church of St Mary of Dabra Ṣeyon: the cupolas of the sanctuaries above pendentives ('Byzantine cupolas'). The shallow cupola over the southern sanctuary has been destroyed (upper edge of the picture). The patterns of interlacing and arabesques in the cupolas and spandrels, on the reveals of the arches and panels of the blind arches are unmistakably of Islamic influence, no doubt from Egypt. There are no corbels in this church and capitals are scarcely apparent.

47 Blind arch on the side wall of the northern sanctuary: detail from plate 46. The blind arches, unsupported by corbels, are in a way suspended in mid-air. The painted filling-designs of the frieze of metopes (which are employed here as pure decoration, un-related to their original function) to a certain extent elaborate the classic pattern with fioriture. An Islamic ornament comparable with the interlaced pattern in the panel of the arch can be seen on the bottom of a dish from Mameluke Egypt (fig. 41).

48 Great arch and vaulted ceiling over the third bay of the nave. With the geometrical design on the surface of the vault at the upper edge of the picture, the artist imitates wainscoting, etc., constructed of coloured pieces of wood – an art especially practised in the Islamic world. The axes of the vaulted ceilings above the bays of the nave run alternately at right angles and parallel to the centre axis of the church. Rock fillets painted with bands of plaiting imitate the battens of a wooden roof.

49 Martyr with chalice: fresco in a slightly indented niche terminating in a round arch on the wall of the left aisle. The name inscribed on the left is illegible; on the right: 'the martyr'.

50 Saints in niches in the right aisle. The names of Gabra Krestos (upper left), Awsānyos the martyr (lower left) and Yosṭos the martyr (lower right) can be read. Such niche decorations are typical of Dabra Ṣeyon; otherwise I have only seen the beginnings of them in the porch of Čerqos Weqro. One must consider the architectural frames so popular in book illustration as their models. The arches are apparently modelled in

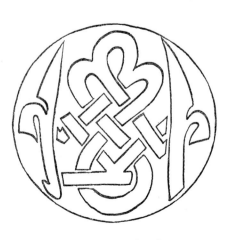

Fig. 41 Bottom of a dish (after *Bossert*)

the plastering of the wall. The arches and pillars are decorated with strips of interlaced design and ribbon-interlaced crosses with arabesques in the spandrels.

51 The domed circular room in the rock to the east of the passage. Low relief figurative and geometric motifs decorate the dome and the walls. Is this an oratory, a sacristy, a monk's cell? Each possibility has been considered and then rejected. I think it is the place for the church's 'Bethlehem': the place where the eucharistic bread is made. Its isolated position east of the sanctuary fits this interpretation since it is what the liturgy prescribes for the 'Bethlehem'. An opening ensures the dispersal of the smoke caused by baking the bread. There is a similar but undecorated 'Bethlehem' in Lālibalā. There, as here, it is nowadays identified as the founder's favourite place of prayer, his private chapel as it were.

52 Unnamed saint with cross and censer: detail from the frieze of figures below the base of the dome. The inscription 'Gabriel' refers to the archangel to the right of the saint; see the following picture.

53 Mary and Child, flanked by crosses and the archangels Michael and Gabriel: relief below the base ledge of the dome. Mary is seated – like King David at Endā Abuna Dāne'ēl – on a native folding stool instead of on a throne. Nevertheless this kind of Madonna, shielded by angels' wings, belongs iconographically to the majestic style rather than to the maternal, even though it is not clear which Byzantine type it reflects: the Hodēgētria (guide) or the Nikopoia (bringer of victory). She holds the Christ Child on her left arm. A foreign artist (Venetian ?) is supposed to have sparked off a controversy during King Ba'eda Māryām's reign (1468–1478) concerning representations of the Madonna, by painting Mary in the Western manner with the Child held in her left arm, an abhorrence to his hosts who regarded 'left' as synonymous with 'worthless, inferior'. Monneret de Villard had already doubted whether before Ba'eda Māryām the Madonna was always depicted with the Child on her right arm. The relief shown here, probably from the fourteenth century, strengthens his objection.

54 The worked front (north façade) of St Mary's Church: the mason has imitated in stone the Aksumite wall built up in strips with reinforcement of wood. Any exact idea of the purpose of the monkey-head binders in this kind of construction eluded him. The binders project from the layers of wall instead of clamping the horizontal beams in the wall. I know of no other imitation of monkey-head architecture in rock.

Selected Sources

Endā Māryām and Endā Abuna Dāne'ēl of Qorqor: Sauter no. 1201 and 1202.

Endā Kidāna Meḥrat of Dabra Ṣeyon: Sauter no. 1219.

On Faras: Michalowski. 'Covenant of Mercy': Hammerschmidt, *Äthiopien*.

South Arabian representations of animals: Pirenne, *Chronique* . . .

On the re-interpretation of animals in Ethiopic MSS.: Skehan.

The Maiestas Domini in Ethiopia: Monneret de Villard, La 'Majestas Domini' . . .; Leroy, *Objectifs* . . .; Ricci, *Note Marginali* . . .

The folding picture of Lake Ṭānā: *Koptische Kunst*, no. 552.

Islamic ornament for comparison: Bossert.

On the 'Madonna controversy': Basset; Conti Rossini, *Un codice* . . .

On the iconography of the Madonna: Monneret de Villard, *La Madonna di S. Maria Maggiore* . . .; Réau, vol. 2; Felicetti-Liebenfels; Leroy, Une 'Madonne Italienne' . . . and *Notes d' Archéologie* . . .

34 In every crag a church: the mountain landscape of Gar'ālta.

35 The Church of St Mary of Qorqor: view from the first bay of the nave into the low left aisle.

36 Royal priest, possibly Melchizedek, or a martyr priest, with a chalice.

37 Blind arch with interlaced decoration and scenes from the earthly paradise in the vestibule.

38 Two gazelles in heraldic arrangement facing each other on either side of a tree of life.

39 Creatures with human heads and camels' bodies in heraldic juxtaposition.

40 'Eve beguiled by the serpent.'

41 Christ in Glory.

42 The paintings in the Church of Daniel, the monastic saint of Qorqor.

43 Stephen, Melchizedek, Moses and Aaron.

44 Folding book made of parchment, mounted as a wheel: processional picture in St Mary's of Dabra Ṣeyon.

45 Archangel, Mary and Child, apostle, patriarchs and prophets: detail.

46 The Church of St Mary of Dabra Ṣeyon: the cupolas of the sanctuaries above pendentives.

47 Blind arch on the side wall of the northern sanctuary: detail from pl. 46.

48 Great arch and vaulted ceiling over the third bay of the nave.

49 Martyr with a chalice.

50 Saints in niches in the right aisle.

51 The domed circular cell in the rock to the east of the passage.

52 Saint with cross and censer.

53 Mary and Child, flanked by crosses and the archangels Michael and Gabriel.

54 The worked front (north façade) of St Mary's Church.

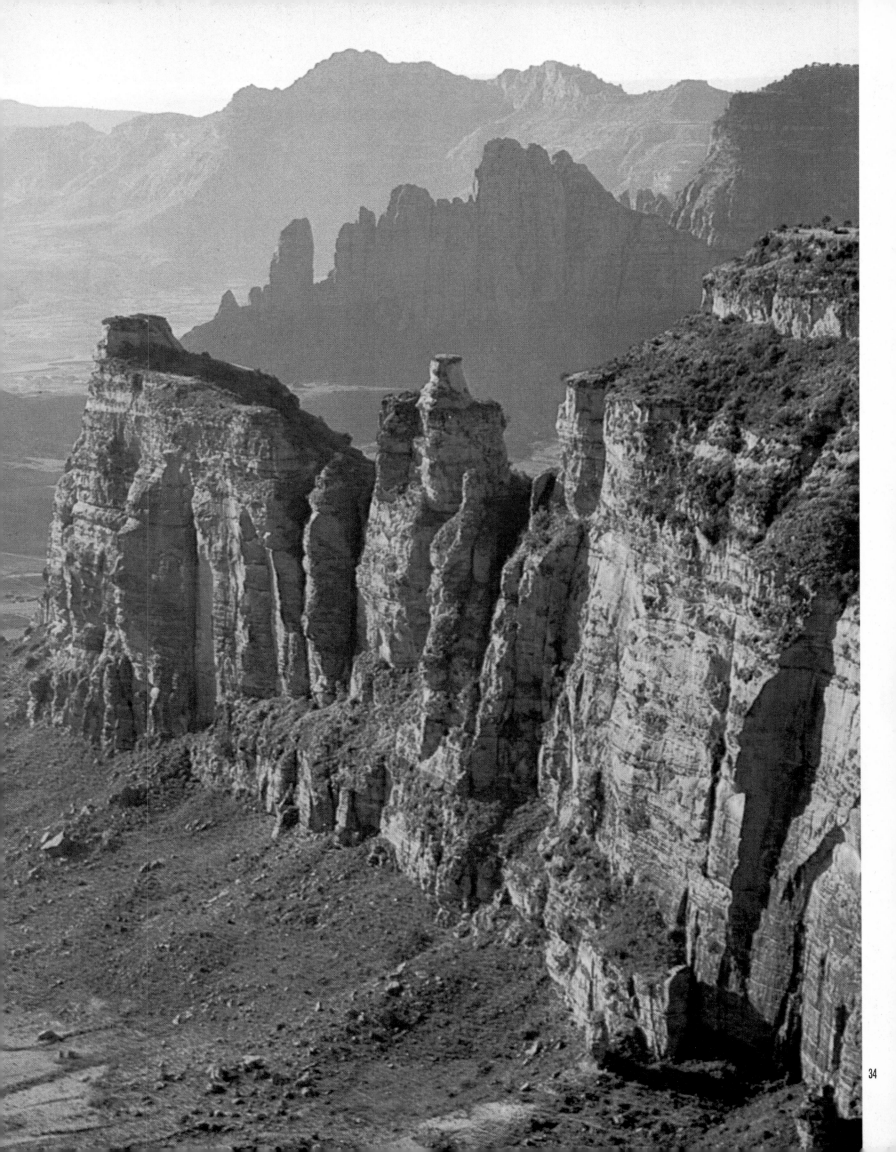

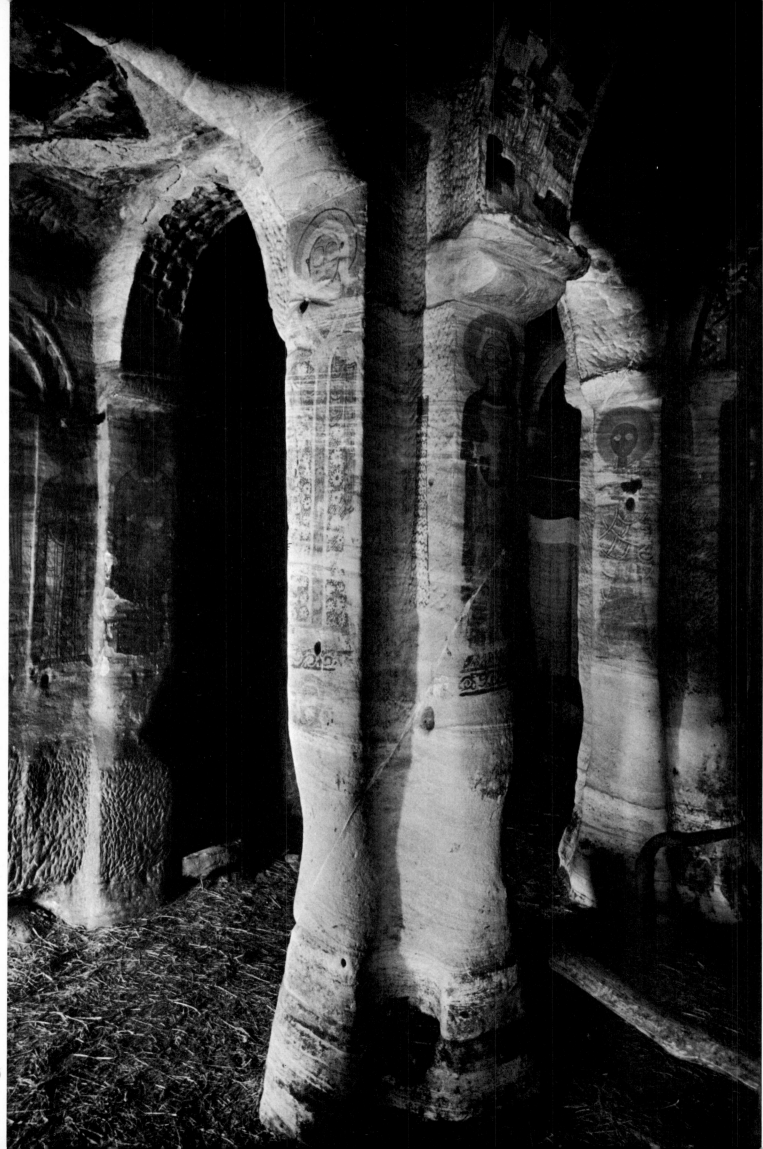

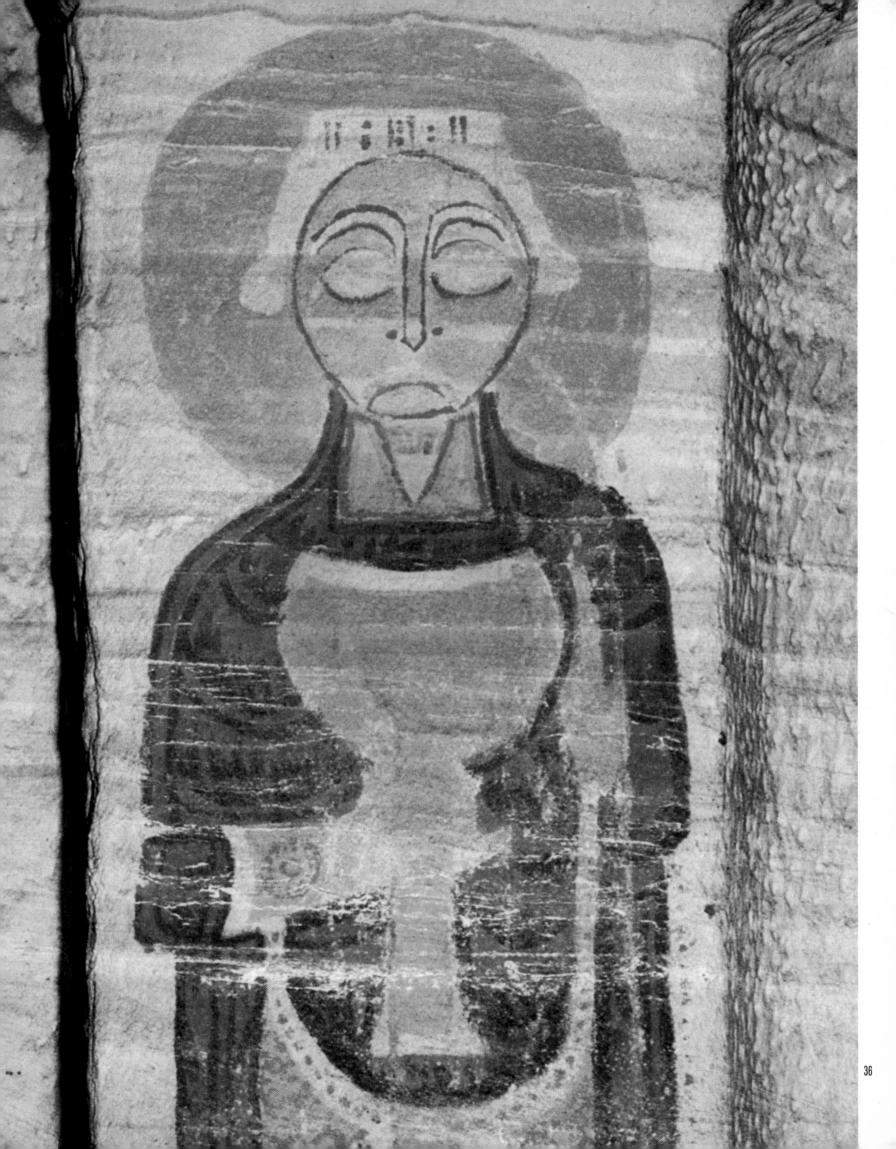

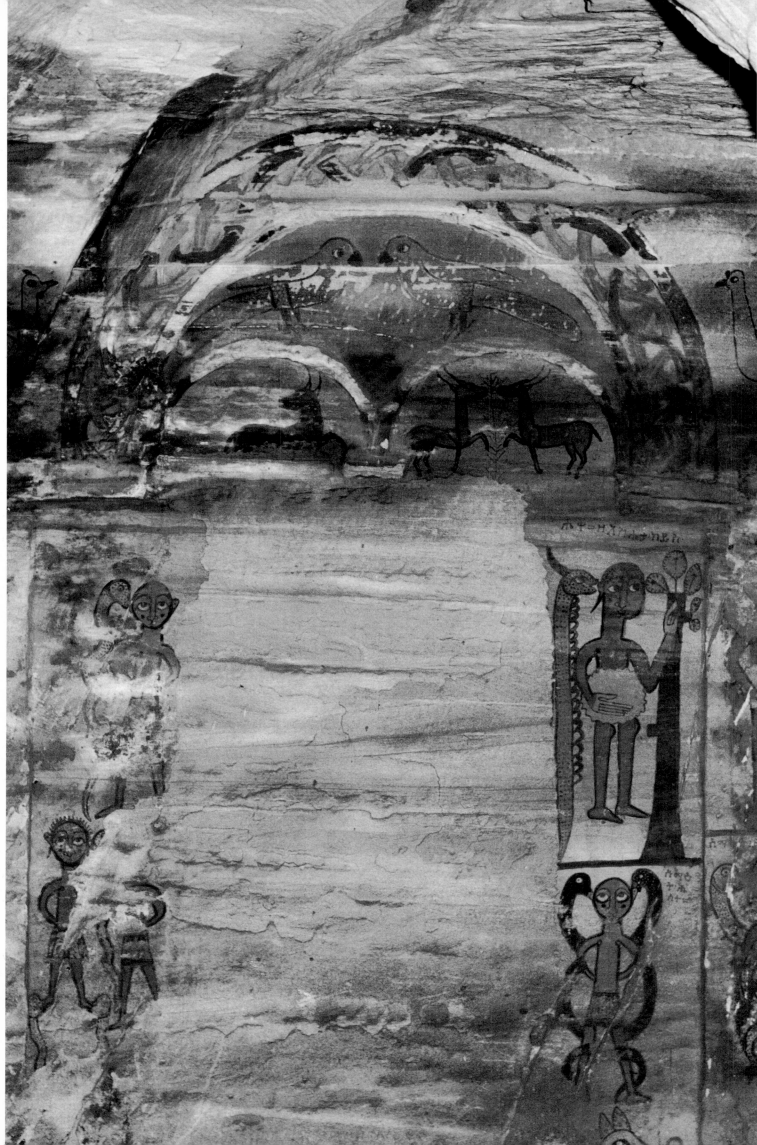

38

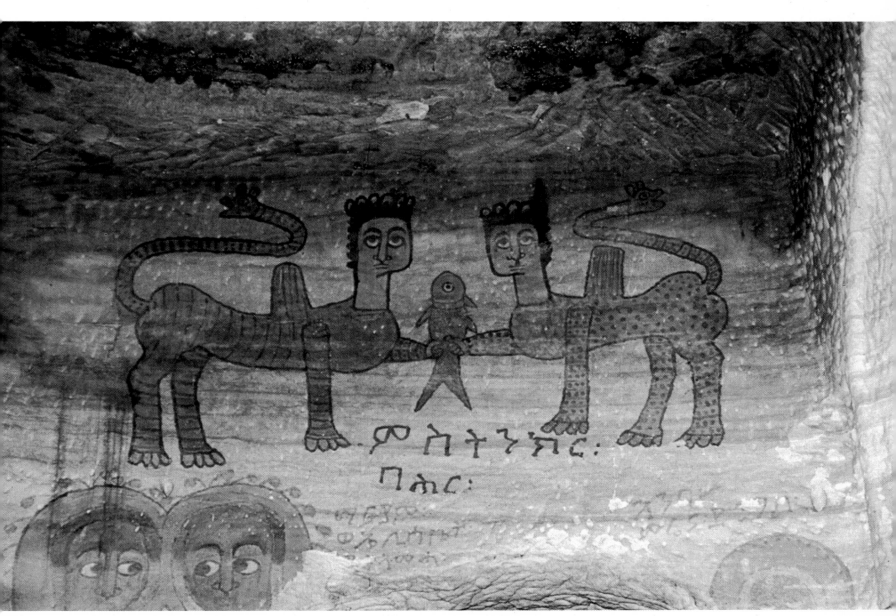

39

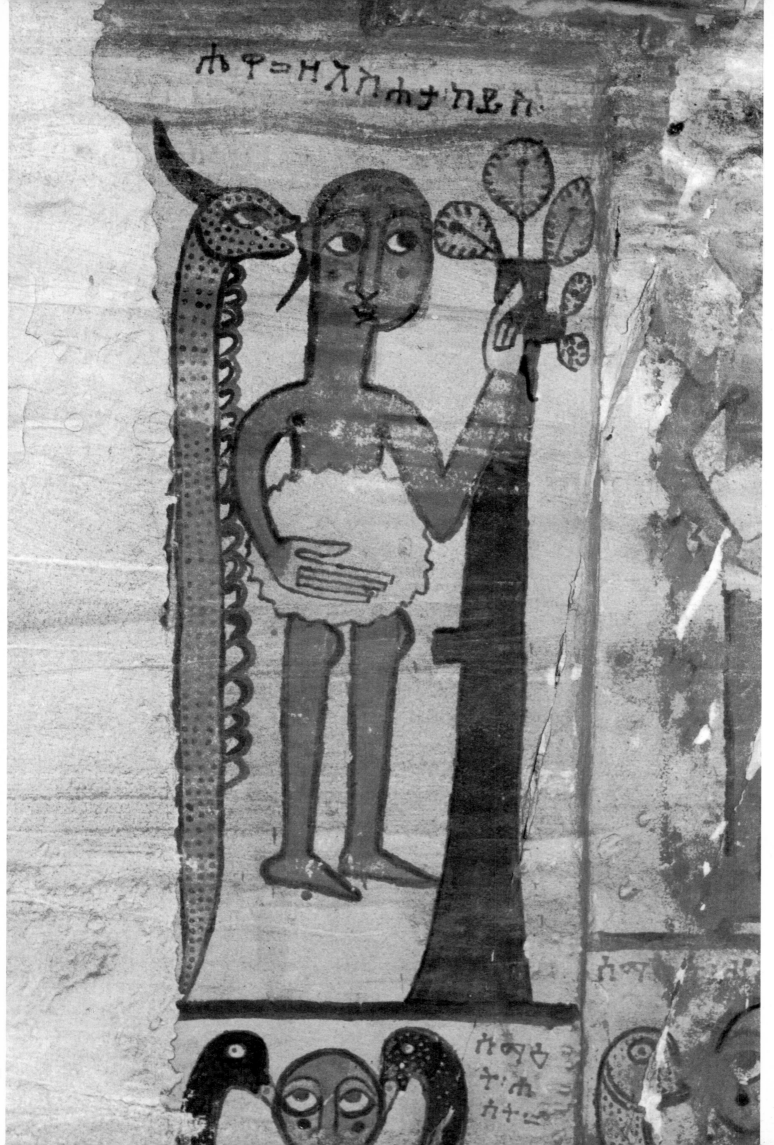

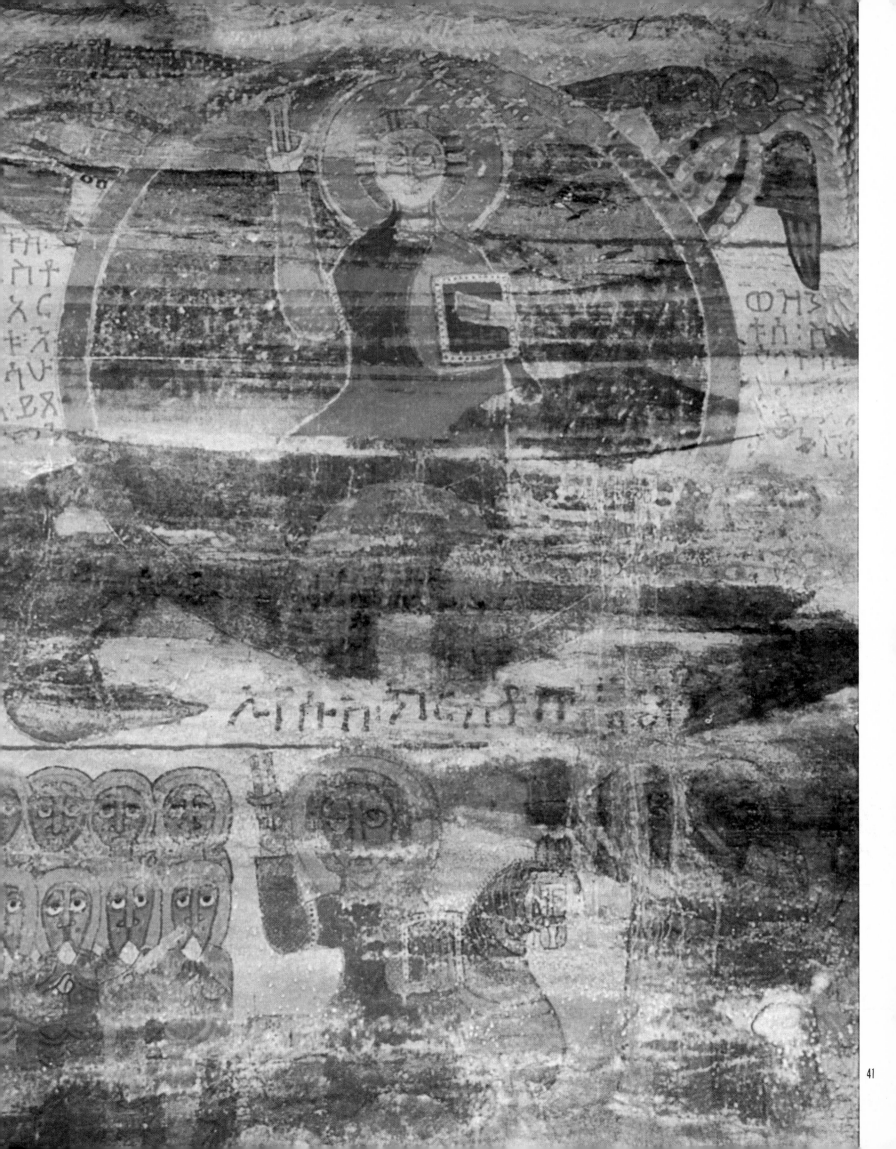

41

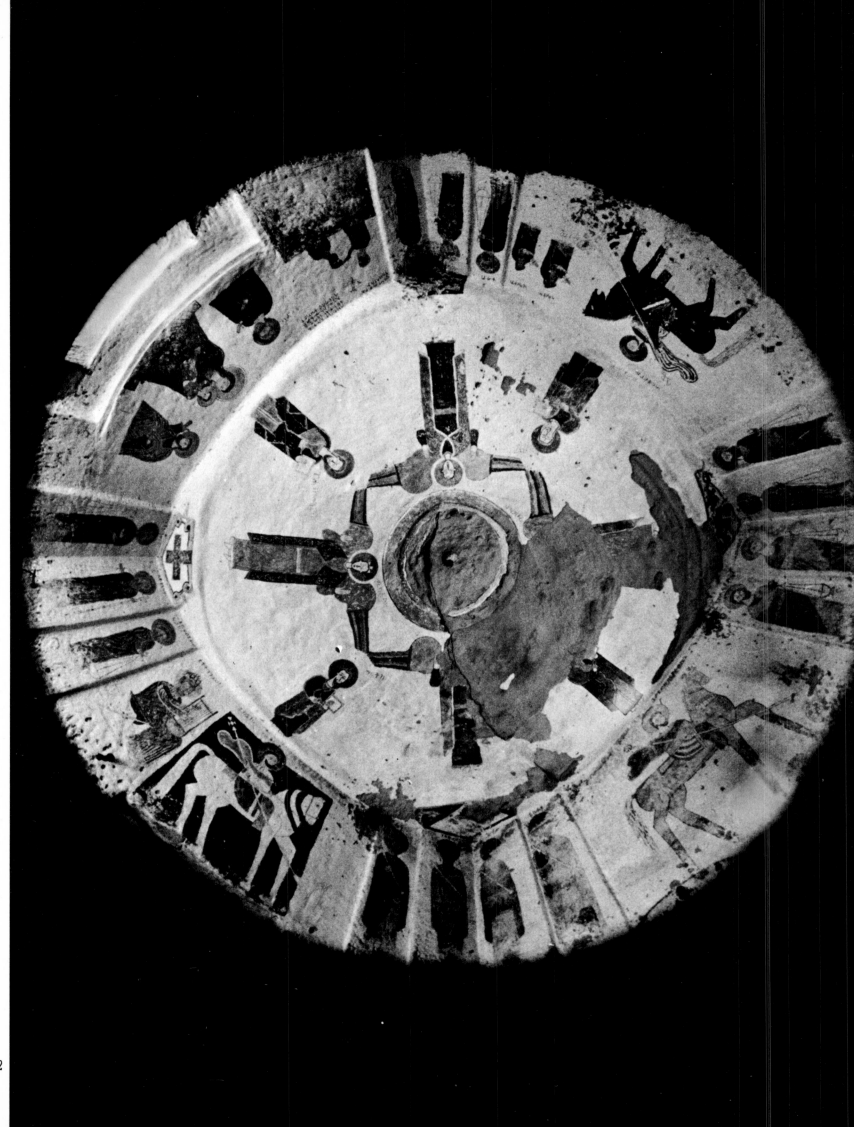

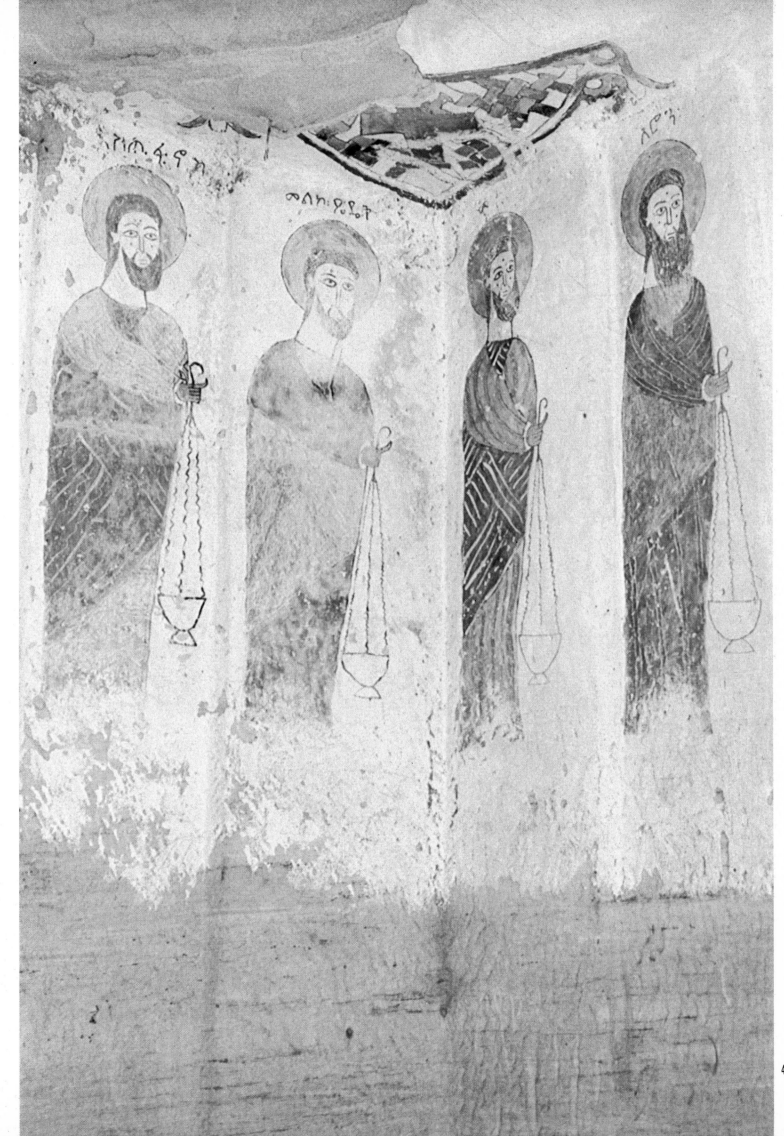

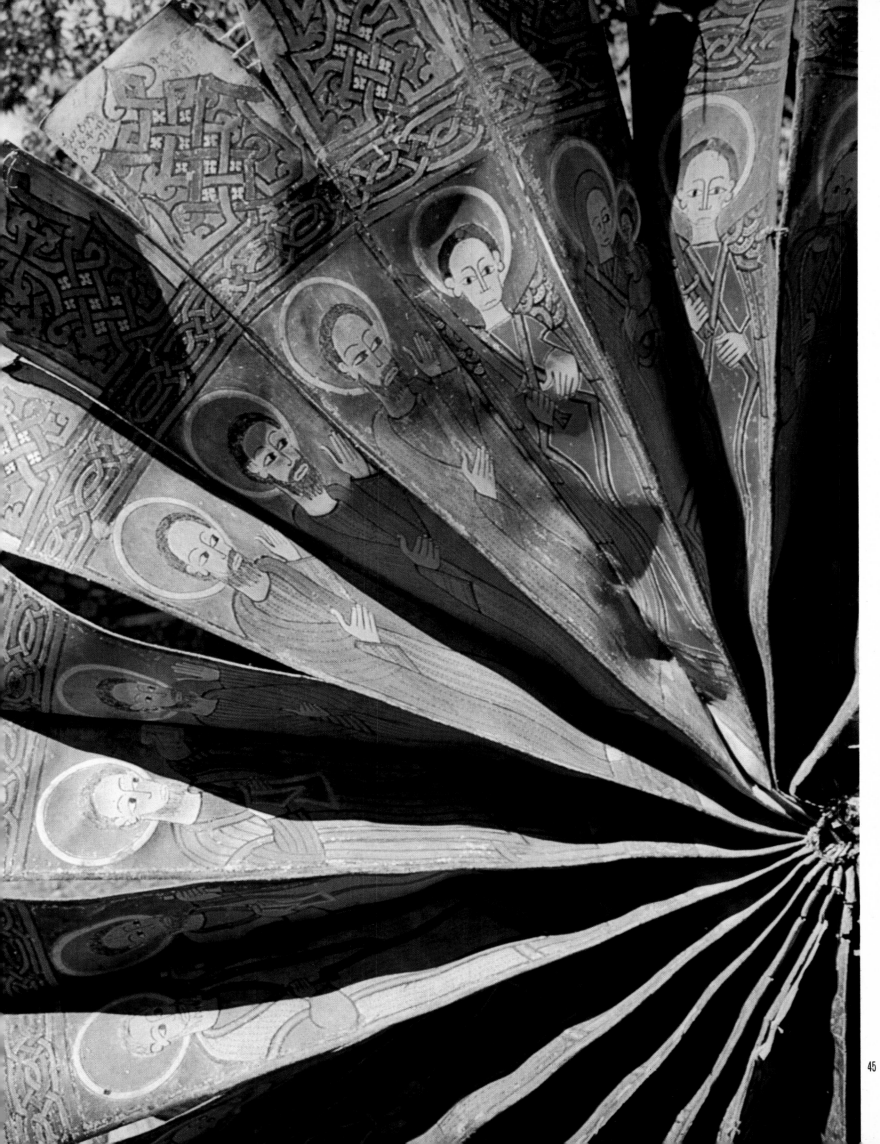

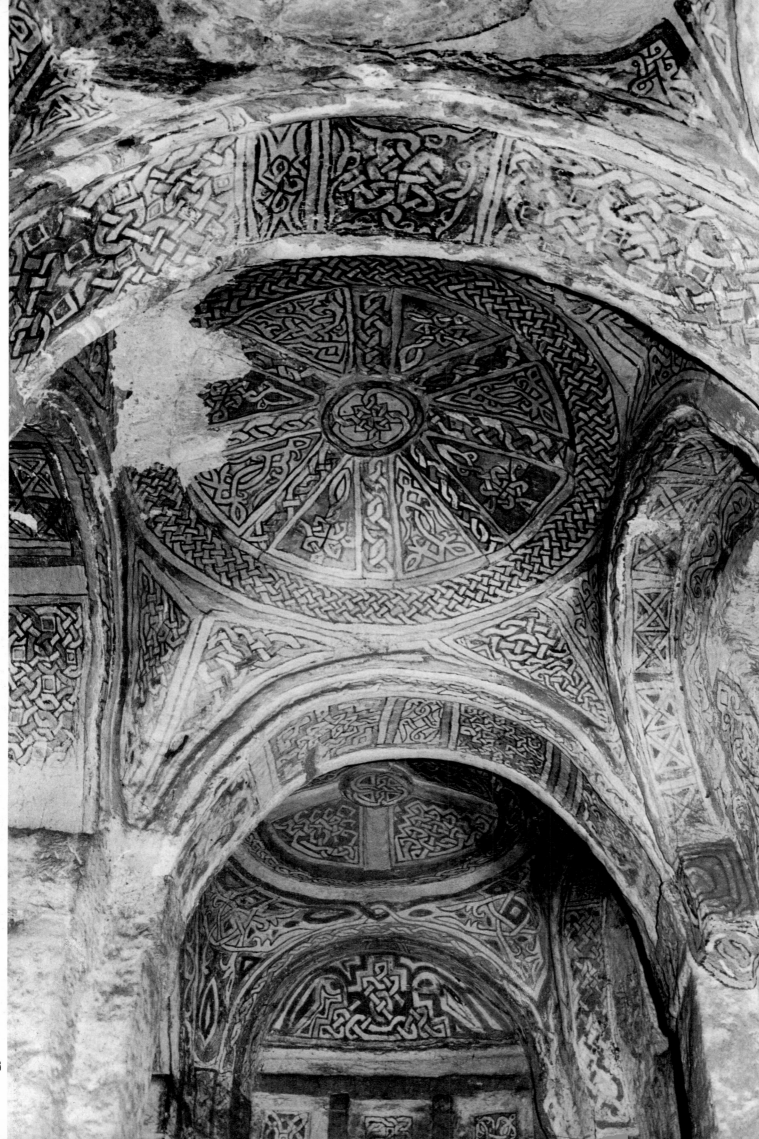

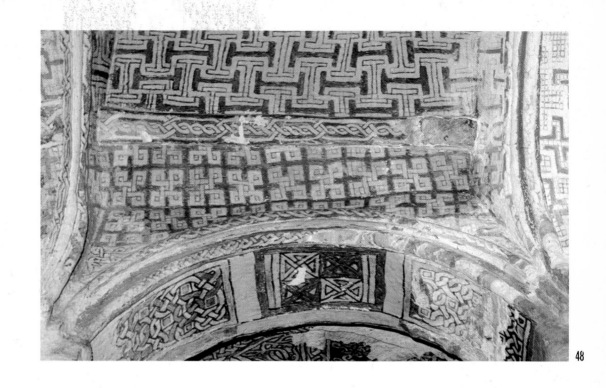

48

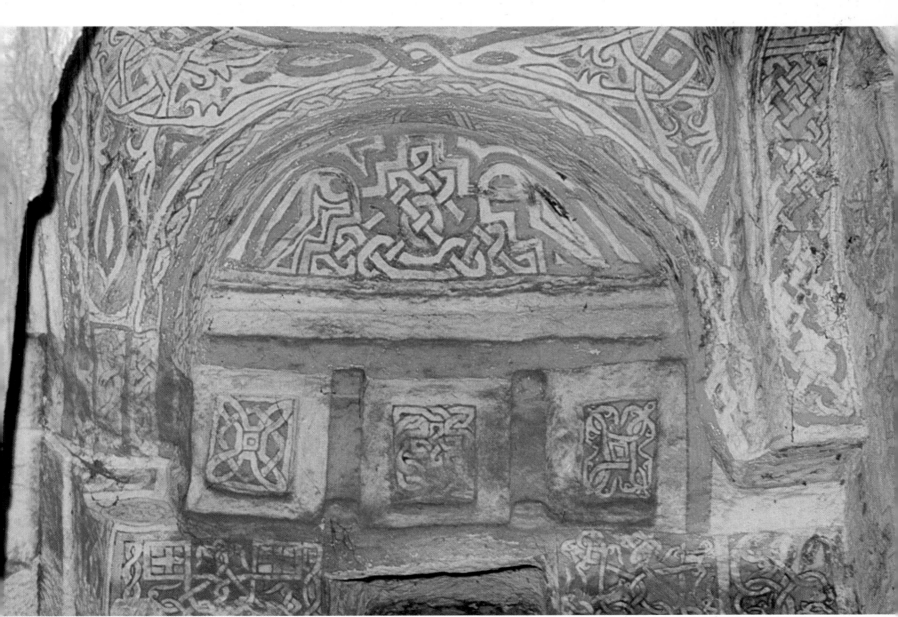

47

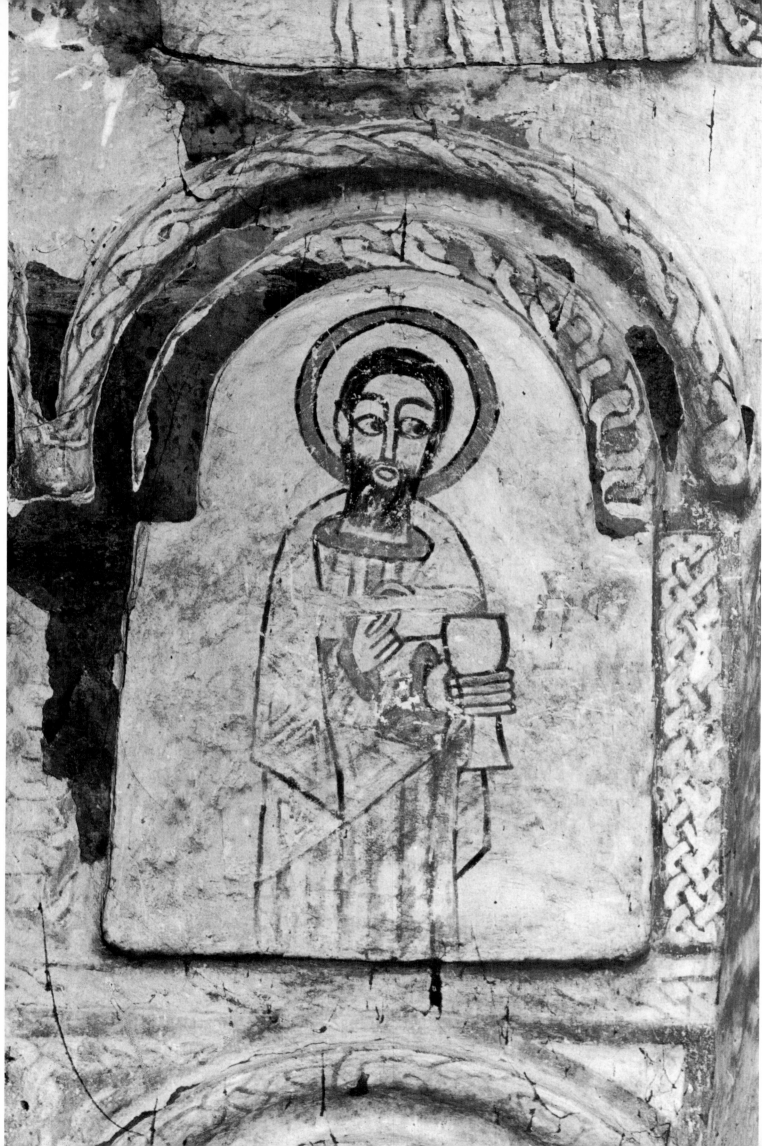

49

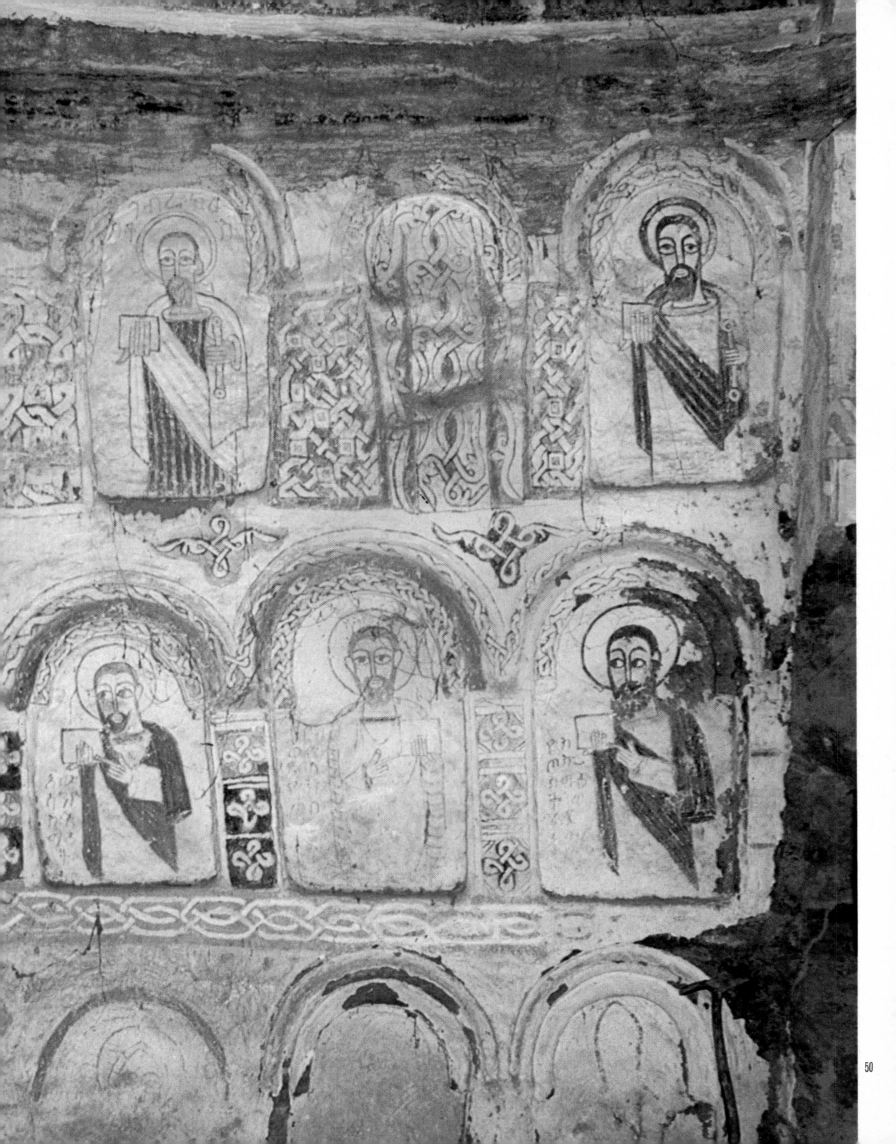

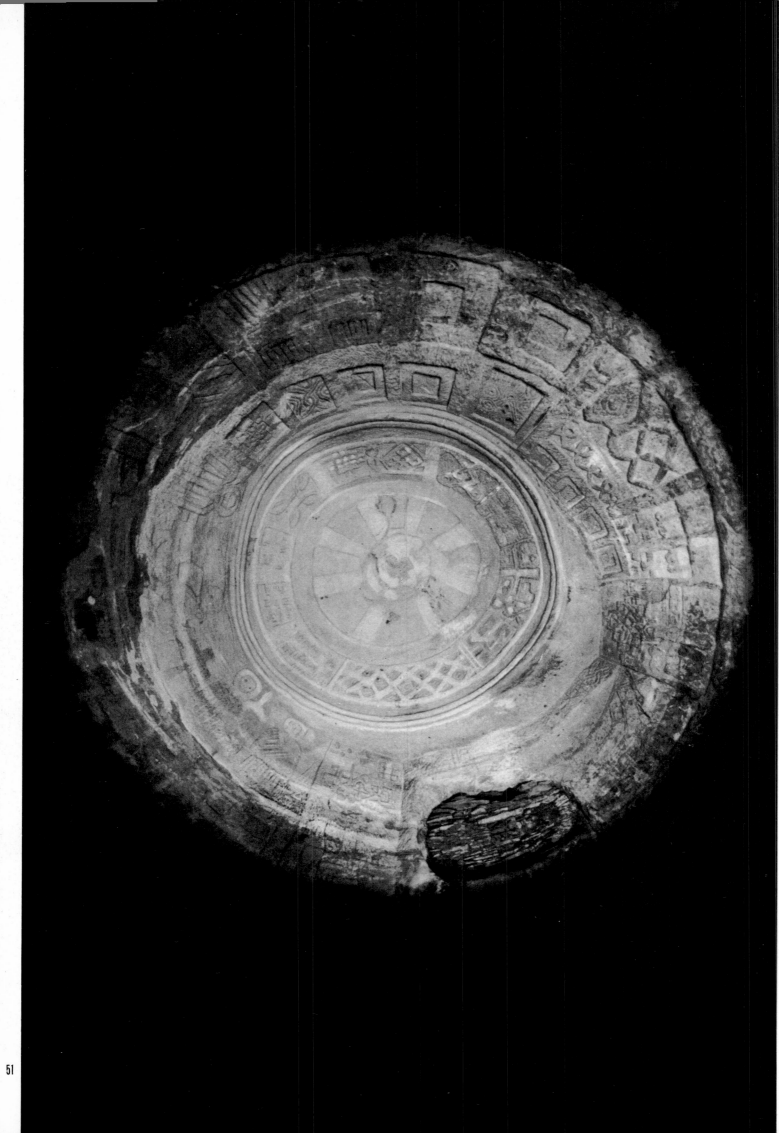

52

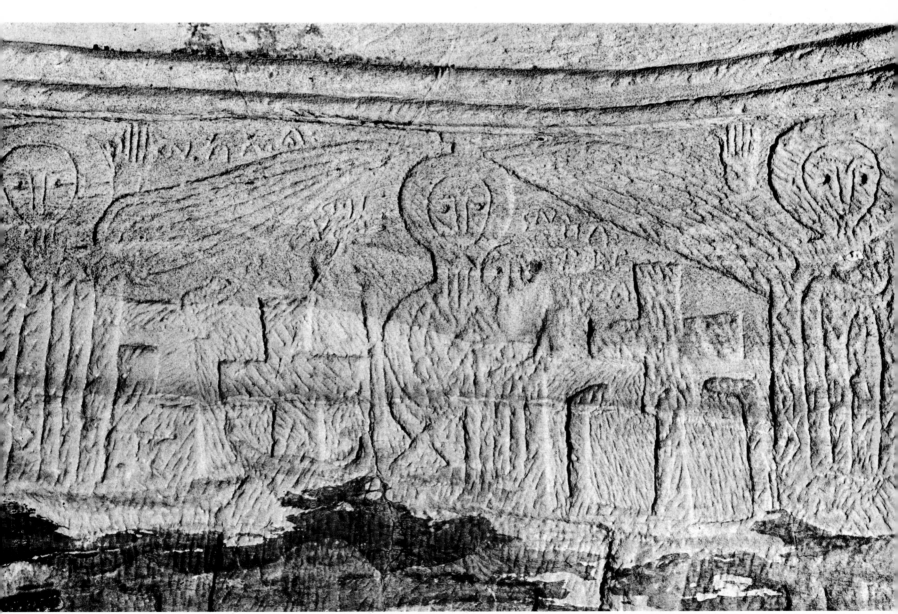

53

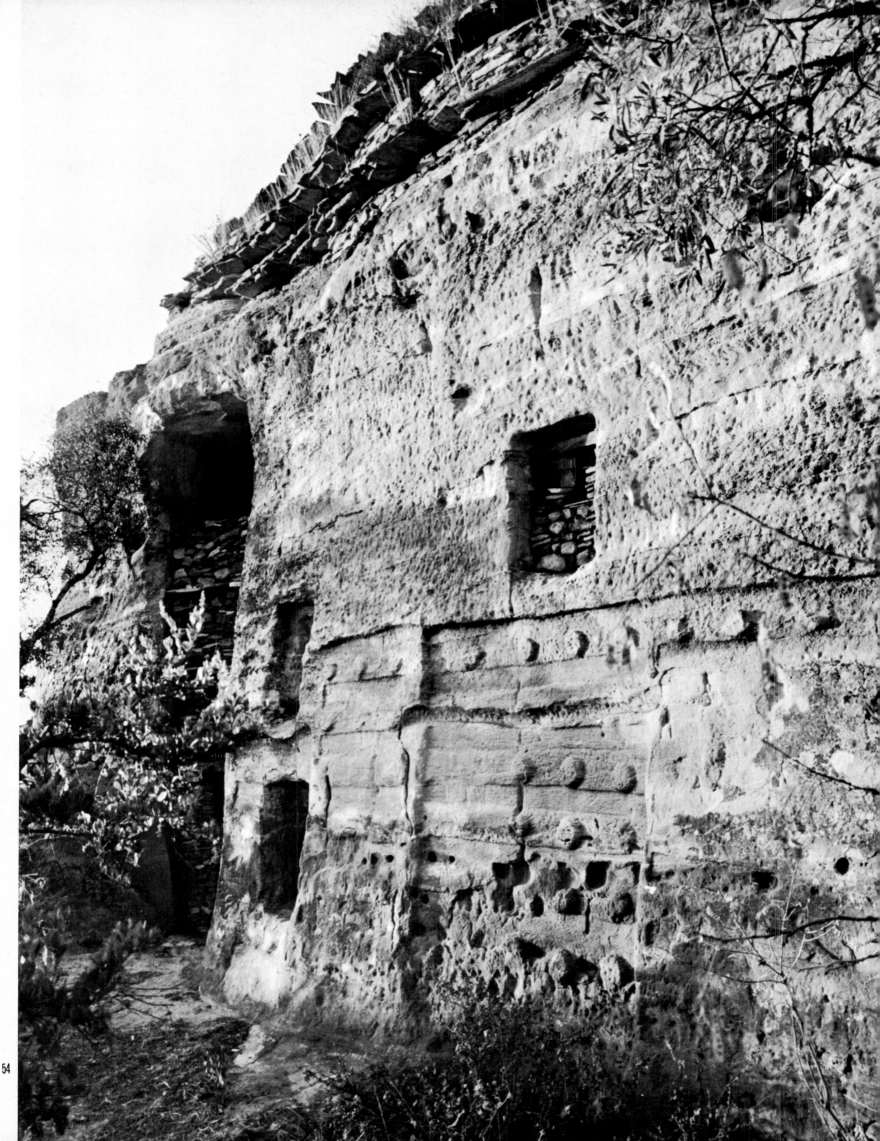

The Churches of Lālibalā, a Wonder of the World

Isolation and intensity are an essential part of the effect of all the Ethiopian rock churches. At Lālibalā, in the heart of Lāstā (province of Wallo) they are the very essence of this wonder of the world. Francisco Alvares, chaplain of a Portuguese mission to Ethiopia and the first European visitor to Lālibalā at a date sometime between 1521 and 1525, did not hesitate to assert that the churches he had come upon there were unique, and he doubted whether his report would be believed: 'I weary of writing more about these buildings, because it seems to me that I shall not be believed if I write more ...' After 450 years, and despite the exaggerated interest that the Seven Wonders of the Ancient World have attracted, the modern traveller still experiences Alvares' astonishment. And the difficulties of making the incredible credible have not diminished.

Lālibalā: a monastic township on a terrace in the south west flank of Abuna Yosēf, at an altitude of 8,500 ft., with a mamher (abbot) as its head, and undergoing the tiresome transition from the traditional order of Church and State united, to the current separation of these powers. A conglomeration of two-storeyed circular huts with walls of dry-stone work, a style of house imported from the north, a kind of historical survival. A lively market town, centre for distribution of the salt from Danākel. Here is a town of 5,000 inhabitants which at the important church festivals receives as many pilgrims and more, both hosts and guests a fiercely independent race of people considering themselves first and foremost as Agaw-Amhara and only then as Ethiopians. Lālibalā is all this, and yet the visitor can be forgiven if Lālibalā means nothing else to him than a dozen rock churches made in and of andesitic tufa which crops out unevenly all over the place, giving out a tile red glow from the silver of the country olive groves.

There are two groups of churches, one on each side of the Yordānos, a partly channeled mountain stream, and another church separated from the rest (fig. 42);

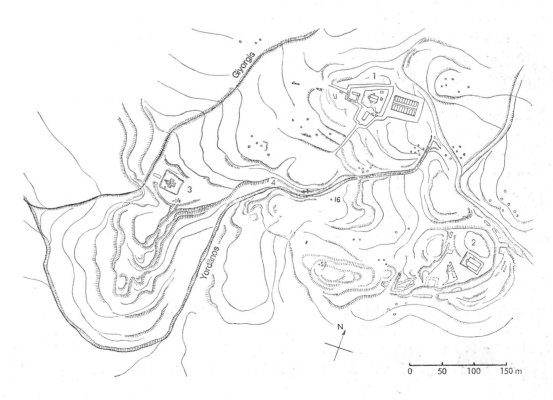

Fig. 42 Ground-plan of Lālibalā: First group of churches (1), Second group (2), St George's Church (3), Monolithic cross (4) in the River Jordan (after *Monti della Corte*)

twelve churches and chapels, not including various shrines no longer in use; four monolithic churches in the strict sense, the remainder excavated churches in every stage of separation from the mother rock, and it is not without reason that this unique assembly dominates the visitor's attention.

Of course the conception of distinct groups destroys the complex unity of the lay-out; the excavations which have been going on since 1967 have rightly pursued the goal of restoring, even visually, the lost image of the holy town as an undivided entity. Nothing is easier than to be aware of the discrepancy between what the individual description of the monuments can at best effect, and the overruling genius of this organism in the rock. Let the visitor only subject himself to the shafts and galleries, courts and halls, tunnels, gateways and terraces! No need to heed the choir-boy tales of secret passages and chambers – the labyrinth is labyrinthine enough as it is. Surprises lurk in every corner. Without any warning, the visitor suddenly catches sight of a church below, crouching at the bottom of a pit. Or else, crawling through an insignificant hole in the rock he finds himself, equally unprepared, at the foot of a church towering up to heaven. From inside come song and drum-beat – the rock itself seems to be singing and booming. The pigeons coo in the church's pit. Out of the blue triangle formed by the corner of the pit a hawk plummets from the sky like a stone. The wings of the doves clap against the tufa, white feathers dropping against the red rock. For seconds quaking terror reigns. Then a supernatural peace intervenes anew, the church sings and booms once more to the praise of God, the *genius loci* spins the web of enchantment ever more thickly around the visitor.

It is perhaps superfluous to repeat yet again the definition of a monolithic church in the strictest sense: it is a sculpture carved out of one block worked both inside and out, with its base still rooted in the mother rock. Its position in the bottom of a pit reveals the technique chosen. The workers who did the heavy excavating laid an oblong block of stone bare by sinking a rectangular trench in the tufa. From this monolith the stone masons chiselled out the church, shaping the exterior and the interior along the lines of built-up architecture, retaining stone for the columns and pilasters, beams and arches. Unconcerned that in the rock more powerful side-thrusts would keep the ceiling in position, they copied the buttresses and the supports of built-up structures. They added nothing, but simply took over the ideas; the 'con-struction' of a monolithic church really means its excavation. It is most likely that the stone-masons worked from the top downwards, proceeding without scaffolding. At each level of excavation the finishing sculptural work followed right on from the rougher excavation. For proceeding with the ceiling, vaults, corbels and capitals inside, entry was gained through the uppermost row of windows. At the same time the façades grew in depth. As a rule the masons finished the details before proceeding further down. The level of the proposed floor was reached first of all on the western face of the church, in the area of the three entrances. The comparative softness of the stone which hardens in time after cutting, did not impose any special requirements on the tools; however, oil lamps and torches were of no use as working light during the burrowing and it is conceivable that they used polished bronze mirrors to reflect the sunlight or smokeless alcohol lamps.

The monoliths of Lālibalā provide few clues as to the procedure of the excavation. For all that, however, it is striking that the windows of the uppermost row are never provided with fillings, presumably because they were used during the first phase of the work as entry-windows and for the removal of the debris. Far more extensive conclusions are possible about details of the built-up churches on which the churches in rock were modelled. Arched windows are almost always found in the monolithic churches in the upper storey. The obvious supposition is that the Aksumite architects had no knowledge of stone discharging arches and therefore placed wooden-arched

windows with openings where they could not be pushed in by the wall above. Yet to think of Lālibalā as a collection of deceptively imitated built-up structures and ghost-like architectural fossils is a mistake. The churches in the bottom of their pits – grotto churches, as it were, in caves open to the sky at once captured and shielded by the stone – take on a new meaning. Whilst it is more than a by-product of technical necessity – freeing the monoliths from their surroundings by trenches – it resisted technical advance: the removal of the surrounding stone would not have caused any difficulties, indeed here and there it would even have saved work. Nevertheless it was not done.

The success of a sculptured church depended on a high degree of manual skill. Too much stone must not be removed as reconstruction was only possible to a limited degree. The work demanded of the architect an astonishing degree of ability in visualising space and in envisaging plans. The choice of the measurements of the rough block for the church masterpiece to be was based not only on the four outer walls, but it also had to have reference to the parts of the building which projected from the surface of the wall – corner-pieces of the window frames, roof guttering and gargoyles. Not only the individual churches but the contextual arrangement of all the churches put to the test those two gifts of the born architect – the ability to see round corners and to think for the future. The churches of the same group have a three dimensional relationship to each other (fig. 43): you leave the courtyard of one monolith at ground-level and walk out on to the roof of the next. The churches in a group are set on several levels (fig. 44). Above all, the planning was especially concerned with measures for carrying off the heavy summer rains. The rock bottom of all the pits slopes slightly. With churches whose orientation conforms to the slope of the terrain, the ridge of the roof, guttering edges, base of the windows and plinth are slanted in line with it in addition to the specific precautionary measures against the rain. In the most

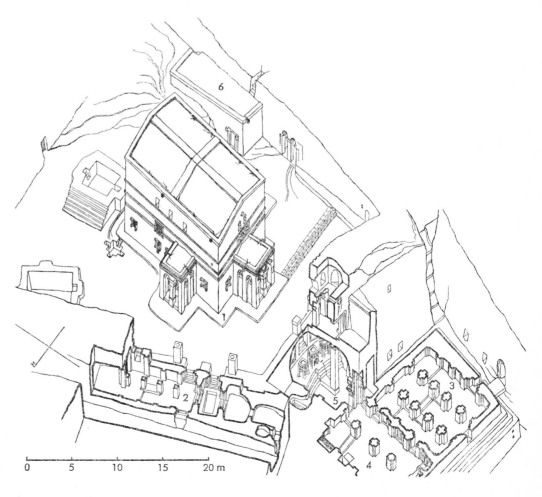

Fig. 43 Partly sectional view in isometric projection of St Mary's Church (1), the Church of the Cross (2), the Church of Mt Sinai (3), the Church of Golgotha (4) and the Chapel of the Trinity (5) (after *Bianchi Barriviera*)

0 5 10 15 20 m

recent attempts at restoration it was found sufficient simply to restore the original conditions to ensure sufficient drainage.

It is usually taken for granted that we know much more about the how, when and why of the churches of Lālibalā than we do about the remainder of the Ethiopian rock churches. Sober examination does not however support this conviction. At any rate enough is known not to be caught by I. Bidder, who thinks that the foundations of Lālibalā were already established in pre-Christian times for the celebration of nature cults. The barrage of utterly inconsistent literary and pictorial references from every source with which this author assails her readers has up till now provided only one sacrifice: herself. She alone stubbornly believes what discovery has ruled out. There is not the slightest doubt that the majority of the shrines were Christian from the start, Byzantine churches in the widest sense with a basilican layout, the three prescribed ritual entrances, with galleries, chancel arch and domed sanctuary. For variations from this plan there are satisfactory explanations which suffice without vague mysteries of light and water.

Tradition ascribes the rock churches to King Lālibalā, one of the last rulers of the Zāgwē dynasty, who reigned about A.D. 1200, a contemporary of Prince Barbarossã, the Sultan Saladin and Genghis Khan. The Ethiopian Church conferred sainthood on the king and called Roḥa, the capital city of the Zāgwē, Lālibalā after him.

According to the legendary life of the king, the Gadla Lālibalā, he grew up in Roḥa. He was the brother of the ruler, who, made jealous by prophecies of kingship for the boy, tried to poison his rival with a cup of hemlock. But this only purged him of a tapeworm – a clinical detail which would be familiar to Ethiopian listeners, inveterate eaters of raw meat – and cast Lālibalā into a death-like three-day sleep. In the trance an angel showed him the wonders of the Seven Heavens, among them being the churches which, according to God's command, he was to build from the bowels of the earth after he arose from his apparent death. First of all, however, he withdrew into the wilderness, took a wife at God's command, and flew with an angel to Jerusalem. When Lālibalā's time came, Christ appeared to the king in a dream, taxed him with his hostility to his brother and required him to seek out Lālibalā and abdicate in his favour. Anointed king under the throne-name Gabra Masqal, 'Servant of the Cross', Lālibalā continued his life of monastic penitence and humility. With the help of the angels, he carried out the task he was given in heaven. By day the angels worked side by side with the stone-masons, but by night they worked another shift on their own so that every morning the workers were amazed at the progress of the building. Solomon, with the help of the King of Tyre, erected the Temple and his own palace in dressed stone, wood and mortar in twenty years; in the same time, however, with the help of the angels, Lālibalā created without mortar, wood or dressed stone a dozen churches from one single piece of rock.

Fig. 44 Staggered section of the second group with the Church of Emmanuel (1), Church of Mercurius (2), Church of Abbā Libānos (3) and the roof of the Church of the Archangel (4) (after *Bianchi Barriviera*)

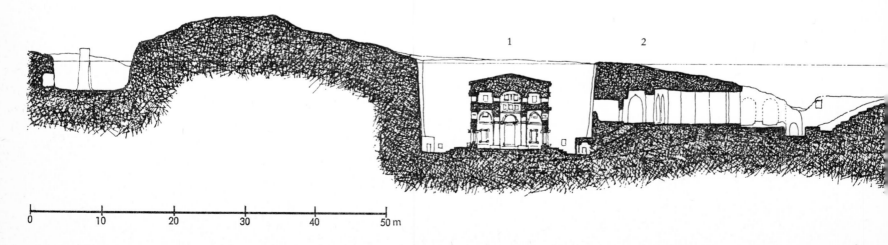

The historical account also credits Lālibalā with the more worldly purpose which reveals his true state of mind: that of starving out Islamic Egypt by diverting the waters of the Nile and Atbarā. Presumably he only gave this plan up under the protests of learned monks. His advisers must have feared that the Moslems would transfer to the newly irrigated areas on the Red Sea coast and from there would press in on the Christian mountain fortress.

The less sparing the legend is in gaudy detail, the more reticent it is with tangible facts. It is clearly a late product of the tradition which it pretended to establish and apparently originated at a time when the creation of the monolithic churches could no longer be envisaged without the aid of Heaven. In identifying the king with Christ – expressly and by analogy: such as the way the circumstances of his birth intimated his kingship, his 'resurrection' and the chastisement he endured for his wife's sake as Christ did for his Church – it made powerful propaganda for his place of burial, the New Jerusalem in the mountains of Ethiopia. 'He who does not make his way to the holy city of Roḥa is like a man who feels no desire to see the face of Our Lord and Saviour Jesus Christ.' Thus, the pilgrim to the grave of Lālibalā shares in the same benefits as the visitor to Christ's grave in Jerusalem.

In connection with the establishment of the New Jerusalem, two triumphs of their traditional Moslem enemies are sometimes referred to. In the year 1144, Edessa capitulated before the siege machines of the Seljuks – the city whose king Abgar V had allegedly corresponded with Christ himself and who had kept Jesus' letter as a talisman. And in 1187 Saladin captured Crusader Jerusalem. The news of both these events spread like wildfire throughout the Christian world; we have no reason to suppose that even in Ethiopia the bad news did not stir the faithful. There was a small Ethiopian community living in Jerusalem and the legend of the mighty kingdom of the Prester John, which at that time had gained ground in the West as the likely cure of all Near Eastern troubles, probably fed directly on the news of the Christian king in the mountains which reached Jerusalem with the Ethiopian pilgrims. Do these facts and fancies, together with a comparison between the Arabic name of the town Edessa, al-Ruhā', and the Ethiopian Roḥa justify us in the further conclusion that the exchange of letters between Abgar and Christ was already known even in Ethiopia at such an early date? Do they press us to the explanation of Roḥa as a substitute Edessa and Lālibalā as a substitute Jerusalem? First and foremost the fall of Edessa and Jerusalem indicated a thrashing for the Franks' Eastern policy, bringing in its wake pogroms for the Franks and Latin Christians. The monophysites, who as heretics had suffered considerably more vexation from their Latin brothers than from the Moslems, often greeted political revolution as a liberation. If we believe an admittedly late Greek source, it was Saladin who fulfilled the Ethiopian desire for a chapel in the Church of the Holy Sepulchre and an altar in the Church of the Nativity.

3 4

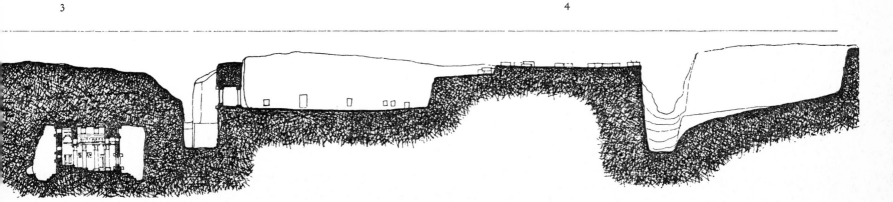

I think it is just as well to see Lālibalā's rise less as an echo of events outside Ethiopia as in its connection with the (supposed) history of the country itself. Certainly the churches are the works of a pious enthusiasm to build; but perhaps this is not as completely true as priestly tradition would have us believe today. Traces of military establishment are numerous and alongside the churches there was apparently a royal palace-like residence with farm buildings, stable and prison.

In the tenth century, the kingdom of Aksum collapsed under the onslaught of a bloodthirsty queen, Judith or Esther, who probably led her tribal warriors out from Samēn. The dissolution had no doubt already set in, the mountain tribes merely executing a death sentence which had already been passed. More than a century later the central authority re-constituted itself in the south around the Zāgwē, princes of the Cushitic Agaw tribes, former allies of the murderess or even just beneficiaries of the heap of ruins she had left behind. The Zāgwē, who must have felt themselves heirs of Aksum, undoubtedly had worries over their legitimacy, perhaps vis-à-vis the feudal nobility but certainly with respect to the clergy who at first opposed the upstarts. They gave the kingdom a worthy capital city – Ethiopia's first since the fall of Aksum and the last before Fasiladas took up residence in Gondar (1635). And what should be more appropriate than to have the new residence oriented towards Aksum, the pivot of dynastic legitimacy? In 1270 the saintly monk Takla Hāymānot, according to the legend, negotiated an agreement between the Zāgwē and the Solomonic-Aksumite dynasty whose latest offspring had found refuge in Šawā (Shoa). The Zāgwē abdicated in return for their recognition as the lords of Lāstā. The price was enormous: a third of the land for the Church. And the changeover must have necessitated much bloodshed and disturbance. The focus of power drifted even further to the south – and henceforth the Ethiopian chroniclers relegated the Zāgwē interlude to oblivion. On the one hand the Zāgwē must be condemned as usurpers. On the other, a semi-legitimate origin had been subtly built up for them when they conciliated the clergy by building churches and encouraging missionary activity and produced saintly rulers like Lālibalā, which implied that before Solomon, whose 'heart was not perfect with the Lord his God' (I Kings 11:4), had made the Queen of Sheba the ancestress of the rightful dynasty, he had already seduced her handmaid who gave birth to the first Zāgwē. The genealogical whitewashing of the Zāgwē displays priestly cunning and presumably went hand in hand with the removal of their residence from the political sphere and the transformation of Roḥa into Lālibalā, the religious foundation and place of pilgrimage. From the beginning, the idea of a new Aksum had included that of a new Jerusalem, but Aksum itself – whither Menelik, son of Solomon and the Queen of Sheba, had brought the Ark of the Covenant stolen from the Temple – was a new Zion, hub of the (Ethiopian) universe. It was the priests' duty to build up more strongly the aspect of religious symbolism, to allot new purposes to the secular buildings (or excavations), which had become a disturbing element in the religious scene, and to enrich the processional way in and around the town with the geography of the Holy Land. The pilgrims seem to have assembled for the holy tour at a monolithic cross in the Jordan (fig. 45), the place of Christ's baptism, not far from the 'Mount of the Transfiguration'. And the desire to make one's last journey from this sacred place transformed Lālibalā into one great cemetery, with interments even in niches in the rock of the passages and pits, in the floor and even in the columns of the monolithic churches. One visitor, on entering a rock chamber previously overlooked, suddenly found himself in the company of desiccated corpses sitting upright, shoulder to shoulder against the wall.

A. Raffray, a nineteenth century traveller, claims to have seen a manuscript according to which King Lālibalā had craftsmen brought from Alexandria and Jerusalem to work on the monolithic churches. This story is the stuff of legends:

Fig. 45 Monolithic cross in the Jordan

Fig. 46 Double eagle (painting in the Church of St Mary)

Fig. 47 Byzantine (11th cent.) and Islamic (12th cent.) double eagles (after *Rice*)

Alexandria, seat of the Patriarch, and Jerusalem were holy cities and helpers coming from there would have been so to speak on a par with the angels. On the other hand the assistance of immigrant craftsmen is not to be ruled out. About the turn of the millennium, at the time of al-Ḥākim's persecution of Christians, Ethiopia was a haven for Coptic refugees. Alvares mentions the 'Gibetas' as creators of the monolithic churches (probably a corruption of 'gebeṣāwi', the Egyptians) – indigenous white men. And certainly the changes in the Near East in the twelfth century caused many monophysite Christians to look to Ethiopia, the promised land of religious liberty. It must however be emphatically maintained that possible external assistance did not affect the ancient Ethiopian character of the architecture. In so far as foreign influence is discernible, it must already have been absorbed by pre-Christian and early Christian Aksum. That is true for the (doubtful) Indian borrowings – from the time when Aksum conspired with the Romans for the opening of a sea-route to India (to the detriment of the caravan trade-posts on the classical silk and spice route). It was certainly true of the early Syrian-inspired church plans. It is even true of a detail such as the Persian ogee-arch which first entered Egypt in the tenth century – it is already attested on a fragment of a stela in Aksum. The painted and plastic decoration of a shrine such as the Church of St Mary certainly took Near-Eastern ('Byzantine') motifs from the contemporary stock. However the source of individual details remains uncertain. The double-headed eagle in St Mary's Church fig. 46), is a motif of Mesopotamian derivation which, however, at the time was finding great popularity in Byzantine as well as in Islamic silk factories (fig. 47). Textiles of every manufacture reached Ethiopia by way of Egypt – which had a special position as agent – but also in growing measure from trade passing through the Moslem border states which pressed in upon the highlands to the east and south.

For all this, since the location of so many new rock churches is in the north, the problem of dependence on foreign inspiration takes second place behind the key question: what place do the Lālibalā monoliths occupy in the full range of rock churches? Did the inspiration come from the churches in the north or from those in Lāstā? Or is it a matter of parallel development as Buxton believes? I am inclined to see in Lālibalā the full flowering of an art practised since the Aksumite period, with major works in Tegrē appearing both before and after Lālibalā. The quickest way of proving this by examples would be to complete the survey of all Ethiopian rock churches. However, even this could hardly explain the *tour de force* of the monolithic churches found only in the Zagwes' home country.

Legend sees in the monoliths of Lālibalā the creation of *one* will, of *one* soul aflame with mystical zeal. To be sure, a cautious estimate of the time taken to remove a good 100,000 cubic metres of rock with the means available at the time would require more than one generation. And the men who in the face of the New Jerusalem sought to destroy worldly inclinations, did not shrink from sweeping changes, perhaps not even from the building of an additional church (Bēta Abbā Libānos).

Grāñ's invasions apparently passed Lālibalā by. According to one account he had the town filled in, since he could not burn it down; according to another the pits and excavations were filled in to protect them from Grāñ's plunderers. Neither version turns out to be true: in September 1543, the Portuguese conquerors of the Scourge of God admired 'twelve churches each hewn from a single block'.

Danger came for Lālibalā from the partly bad state of the rock chosen for the churches (particularly in what is probably the oldest group, here described second) and from water. This penetrated through the cracks both natural and due to stress and brought whole sections of buildings to the point of collapse. The first start at restoration came in the years between the visit of H. Dabbert in 1926 and the expedition of A. A. Monti della Corte (and others including L. Bianchi Barriviera)

in 1939, the second attempt, in the fifties. Both of them turned out to be useless, in vain trying to check the destruction with cement, corrugated iron and oil-paint. Restoration activities worthy of the name, linked with archaeological research, began in 1967 under the direction of S. Angelini with the financial backing of the International Fund for Monuments, New York, and an Ethiopian committee formed for the preservation of Lālibalā.

Danger more deadly than the constant damp and dirt brought by water is threatened by the perpetual comings and goings of tourists – arising from the over-accessibility of the erstwhile inaccessible secret holy place. Dabbert rode for twenty-three days from Addis Ababa to Lālibalā and, less than ten years ago, the journey still cost the traveller at least seven days on mule-back. Now there are tracks from Kobbo and Waldeyā to Lālibalā, both negotiable in a day, and scheduled flights land in its vicinity. Admittedly the rainy season severs both connections. But in the foreseeable future the asphalt of an all-weather road between Dassē and Gondar may well grope towards this marvel.

Selected Sources

Alvares' account: Beckingham.
On the 'construction' of a monolithic church: Sauter, *L'église monolithe* . . .
The life of Lālibalā: Perruchon.
The Ethiopians in Jerusalem: Cerulli, *Etiopi* . . .
The legend of Prester John: Hennig; Richard.
The older descriptions of Lālibalā are purely of historical value. Recent studies are Bianchi Barriviera, *Le chiese monolitiche* . . . and *Le chiese in roccia* . . .; supplemented by Dabbert and Monti della Corte.
An indispensible work full of ideas: Buxton, *The Christian Antiquities* . . ., also *Travels* . . .

I. Bēta Madḥanē ʿĀlam and Bēta Masqal

The Church of Bēta Madḥanē ʿĀlam ('House of the Redeemer of the World') is the most important of all the Lālibalā churches, it is also the largest and noblest of the Ethiopian rock churches (figs. 48, 49). This mighty carved church was cut free from a block of stone 33.7 metres long, 23.7 metres wide and 11.5 metres high. The surrounding external columns are aligned with the host of columns within. Here four longitudinal arcades, each of eight bays, divide the interior into four aisles and a nave – the aisles with flat ceilings and the nave with barrel-vault. Arched ribs and the sanctuary arch in the vaulted nave and cross-arches joining the arcades in the aisles form the transverse divisions. Where the longitudinal or transverse arches meet the walls, they are supported by pilasters which are connected by blind arches. Dividing walls, mostly only reaching up to the base of the arch, mark off a narthex and a staircase leading to an upper room at the west end and, at the east end, on a raised floor level, the sanctuary and sacristies. The decoration in relief on top of the roof – eight arched blind arcades – reflects the eight bays of the interior. The shape of the bottom row of windows varies according to their position on the side or end walls of the church (fig. 50). Moreover the infilling designs of the lower part of the windows in the east wall are all different: a continuous pattern based upon raised clockwise swastikas, leaving Greek crosses in the intervening spaces, alternates with a pattern of anti-clockwise swastikas. The same alternation is also to be seen

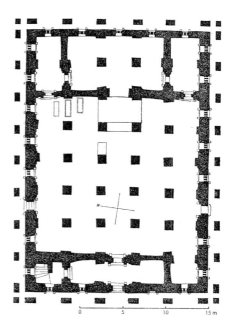

Fig. 48 Ground-plan of the Church of the Redeemer (after *Bianchi Barriviera*)

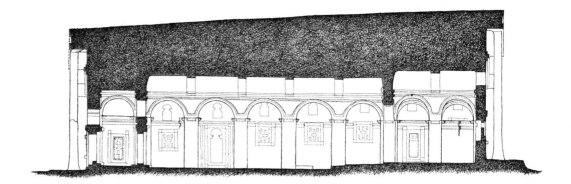

in the windows of the outer porch at Dabra Dāmo. Individual windows of the upper row, holes in the wall in the shape of arched recesses (with the inevitable corbels), contain the remains of gesso or stucco tracery inlaid with coloured glass, which seems to be a later addition (under Islamic influence). In principle the round arch was employed throughout the church.

The significance of the church for the faithful just as well as for the student (as proof of the Zāgwēs' concern for legitimacy) was heightened by the conjecture, first expressed by Dabbert, that Bēta Madḫanē ʿĀlam is a copy in rock of the Church of Our Lady of Zion at Aksum, which was destroyed in the sixteenth century and was the principal shrine of Ethiopian Christianity. Buxton, who formed the same hypothesis independently of Dabbert, bases his view not only on the fivefold division of St Mary's of Aksum as reported by Alvares (whose description is otherwise quite useless), but also takes into consideration data on measurements and figures given for the old cathedral in the Chronicle of Aksum. It is conceivable that the cathedral was originally a heathen shrine, only later taken over for Christian worship; this would explain its peripteral design. Buxton leaves open the question of how close the correspondence is between the original and the monolithic copy. The Chronicle of Aksum attributes 3815 monkey-heads to St Mary's Cathedral, which obviously was a show-piece of old Ethiopian monkey-head architecture. Against that – compare, for example, Bēta Amānuʾēl (pl. 88) – the half-hearted imitation of monkey-heads even in the door and window frames is striking. The windows of the bottom row in the north, south and east walls are without any indication of the original structure; only two carelessly executed monkey-heads set much too low bring to mind the solid beams of Aksumite window frames.

The interior of the church is without decoration, apart from mouldings and some scroll-work in relief on the spandrels of the arches; in particular there is no painting of any kind. Because of this fortunate lack of decoration the architecture comes into its own. During the religious service on a feast-day such as Easter, with the songs and dances of the dabtarās, the praise of God and the architecture melt in these mighty halls into a unity of devotion.

In the church treasury is kept a sheet of parchment written in three languages which is important for the history of the Ethiopian script. It is bound with a book of the Gospels. The Coptic text describes the visit of Abuna Bartholomew in 1410; the Arabic text relates to a gift of land to another church during the reign of King David I (1380–1409/10); the text in Geʿez recounts the bestowal by King Lebna Dengel of a piece of land to the son of a retainer killed by Grāñ in 1531.

The excavated chapel of Bēta Masqal ('House of the Cross') is a broad gallery in a bulge in the rock on the northern edge of the courtyard of Bēta Māryām and is 11 m. long by about 3 m. wide. A row of four pillars divides the space into two aisles spanned by arches (figs. 51, 43).

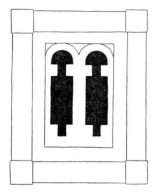

Fig. 50 Windows of the bottom row from the outside

55 The south-east corner of the Church of the Redeemer. The corner pillar is connected with adjacent pillars by a slab of stone decorated with a sarcelly cross. The gallery between the colonnade and the outer wall of the church itself is only 70 cm wide. On the sides of the church the mouldings run parallel to the eaves of the roof; on the ends the upper moulding is slightly gable-shaped. A worshipper stands barefoot before the façade of the east end; the pious Ethiopian shows respect even to the exterior of a church by kissing it and removing his shoes.

56 The mighty sculptured church on its plinth: the excavation — more of a bed of rock than a pit — measures 45 × 43 × 10 m. The low-pitched saddle-backed roof lies directly on the order of columns without any entablature intervening, so that there is no pediment as there would be in a Greek temple. A frieze of round arches decorates the edges of the roof. The exterior of the church reveals the extensive and not always successful restoration of the nineteen fifties (gutter spouts and coats of paint!). At the time of the first scientific survey of the Lālibalā churches by Monti della Corte and his fellow-workers (1939), the roof and colonnade showed severe signs of weathering.

57 View from the fifth bay of the nave diagonally through the south aisles in the direction of the vestibule. The columns, without bases, have pseudo-capitals composed of corbels. There are corbels of the same shape resting on a string course for the abutment of the arched ribs in the barrel-vault of the nave. There is a moulding around the face of the arches. The naked rock glistens where for centuries it has been polished by the bare feet of the faithful.

58 View from the fifth bay of the first aisle on the right, facing the wall reaching up to the base of the arch, and dividing off the narthex.

59 The façade of the Church of Bēta Masqal in the north wall of the courtyard of the monolithic Church of St Mary. Of the two visible doorways with monkey-head framework, the right-hand one leads into the church, the left into a back room. The huge pillar-stumps either side of the doorways on the plinth serve as points of assembly for processions. The interior of the church gets light in two places from this façade: the body of the church through a window with a swastika-cross design in which only a Greek cross is pierced right through as the real source of light, and the sanctuary through a window, the field of which is pierced with a Maltese cross to let the light in. A frieze of arches with mouldings between two projecting horizontal courses finishes off the façade at the top. The spandrel between the extrados of the fourth and third arches (counted from the right) contains a cross in relief beneath a decoration of stylised foliage. On the left St Mary's Church looms into the picture.

60 The rock courtyard of the Church of St Mary: on the right, the façade of the Church of the Holy Cross, on the left, part of the monolithic Church of St Mary. In the foreground, the cistern hewn into the courtyard. Pilgrims jump into the water thick with algae, either to renew the grace of baptism or for the healing of bodily infirmities. Those who cannot swim hang panic-stricken on to a rope while they kick about in the miracle-working 'soup'.

Selected Sources

Bēta Madḫanē ʿĀlam: Sauter, no. 35.

Bēta Masqal: Sauter, no. 38.

The textual sources for the appearance of the old Church of St Mary of Zion in Aksum: Beckingham, vol. 2.

The trilingual page in the church treasury: Monti della Corte; Beckingham, vol. 2.

55 The south-east corner of the Church of the Redeemer.
56 The mighty sculptured church on its plinth.
57 View from the fifth bay of the nave diagonally through the south aisles in the direction of the vestibule.
58 View from the fifth bay of the first aisle on the right, facing the wall reaching up to the base of the arch, and dividing off the narthex.
59 The façade of the Church of Bēta Masqal.
60 The rock courtyard of the Church of St Mary: on the right, the façade of the Church of the Holy Cross; on the left — cut off — the monolithic Church of St Mary; in the foreground, the cistern hewn into the courtyard.

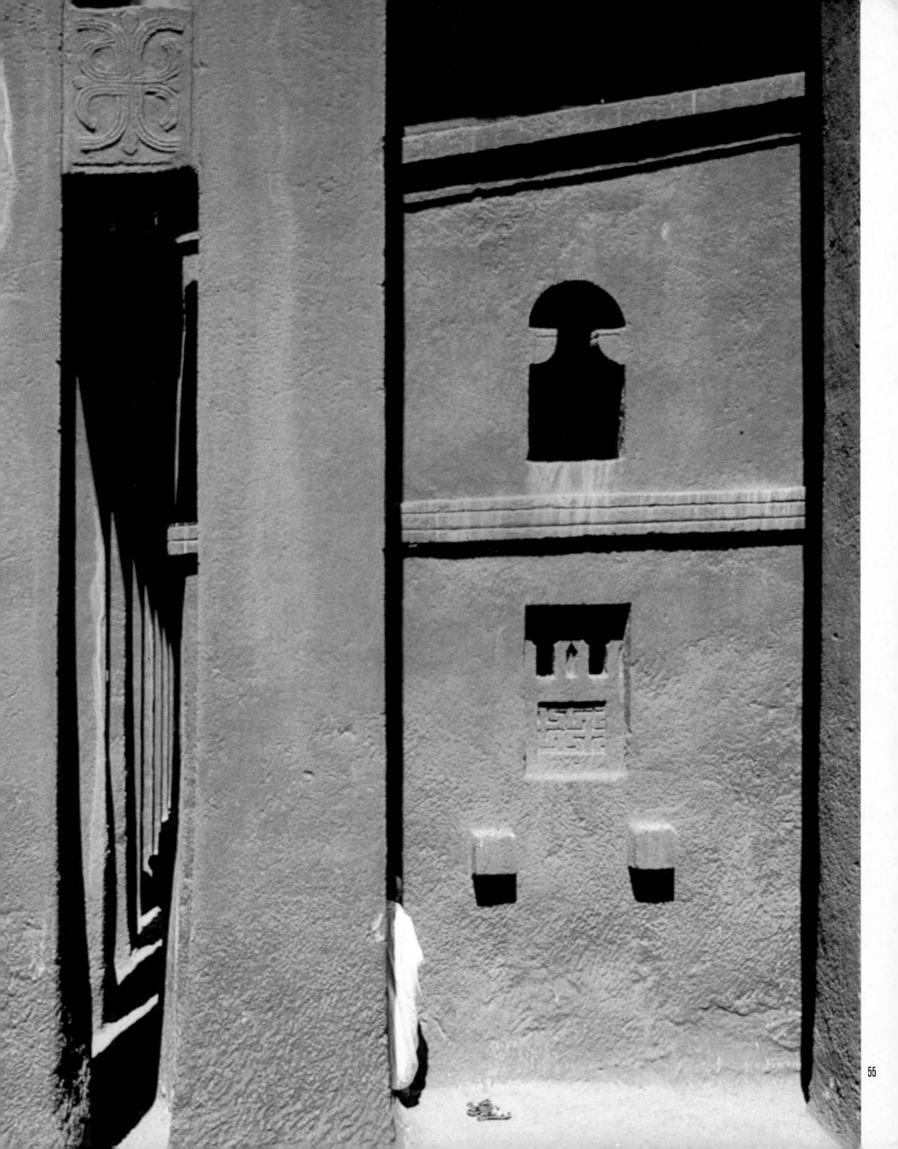

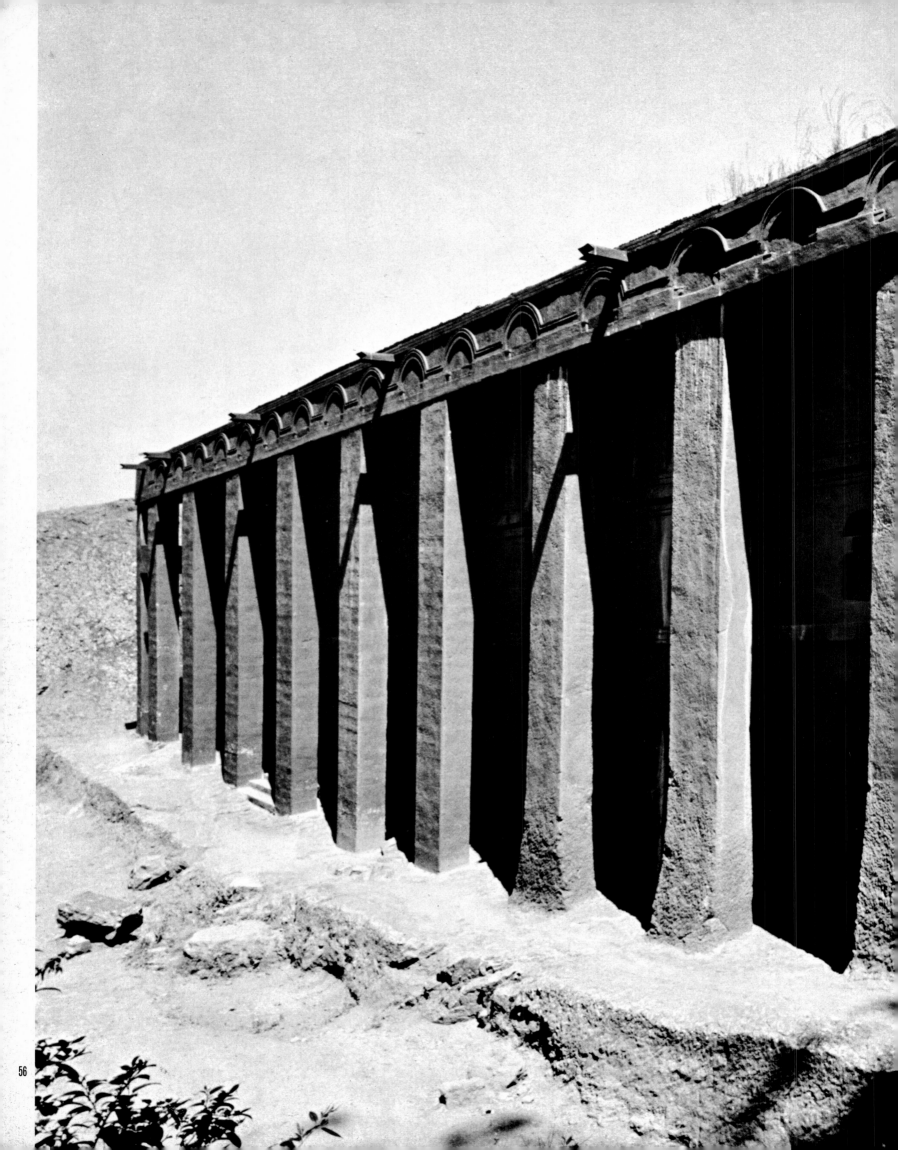

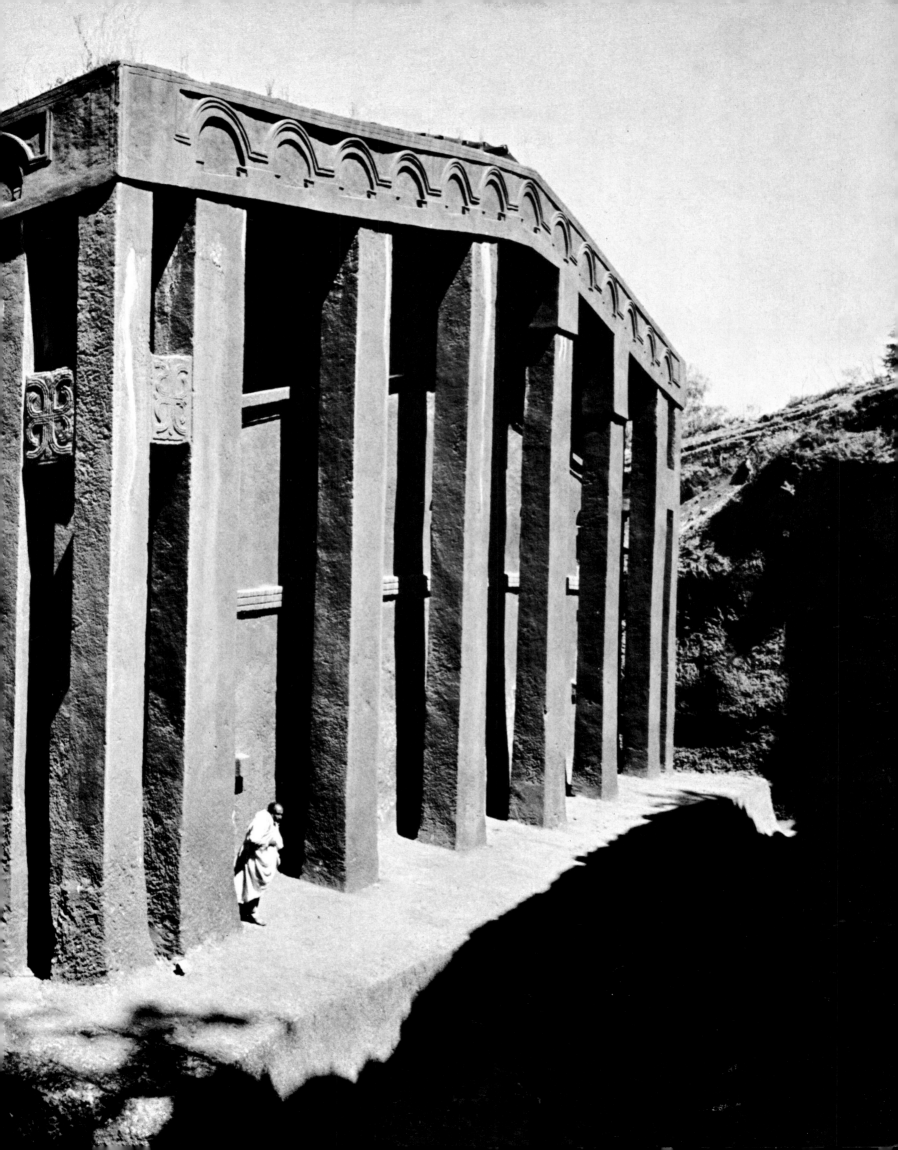

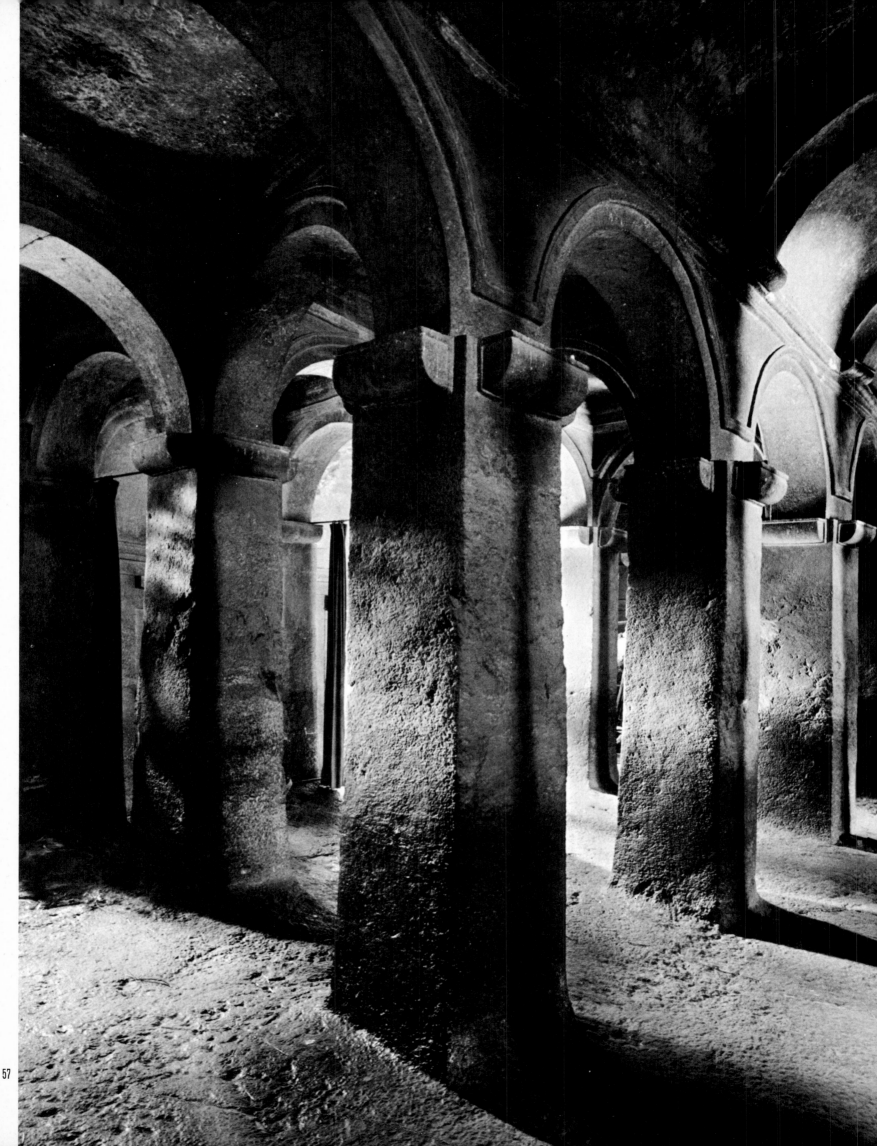

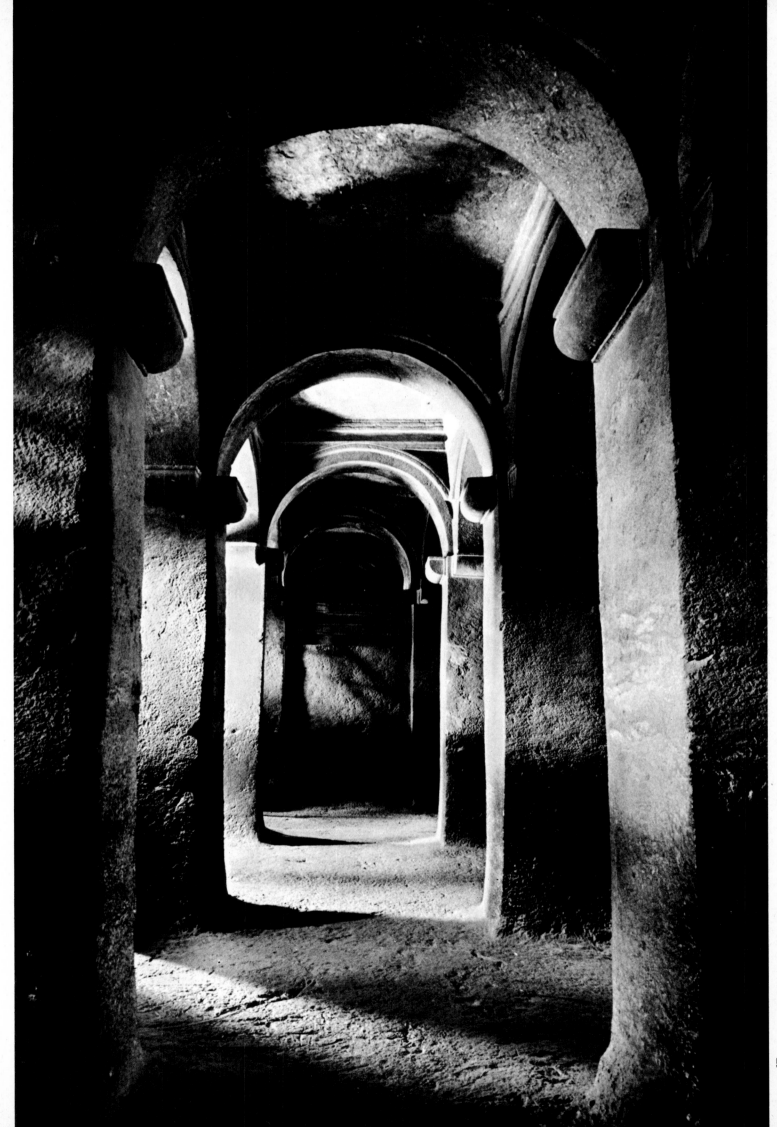

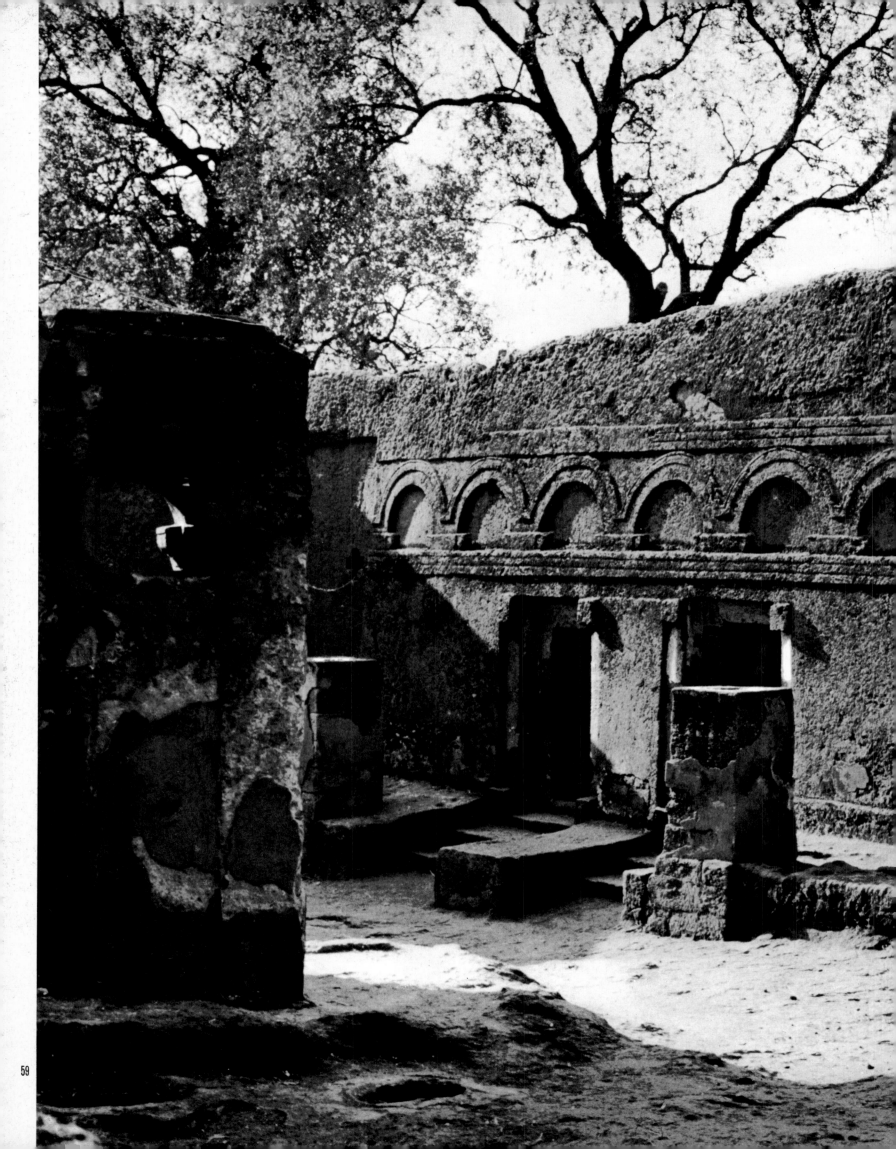

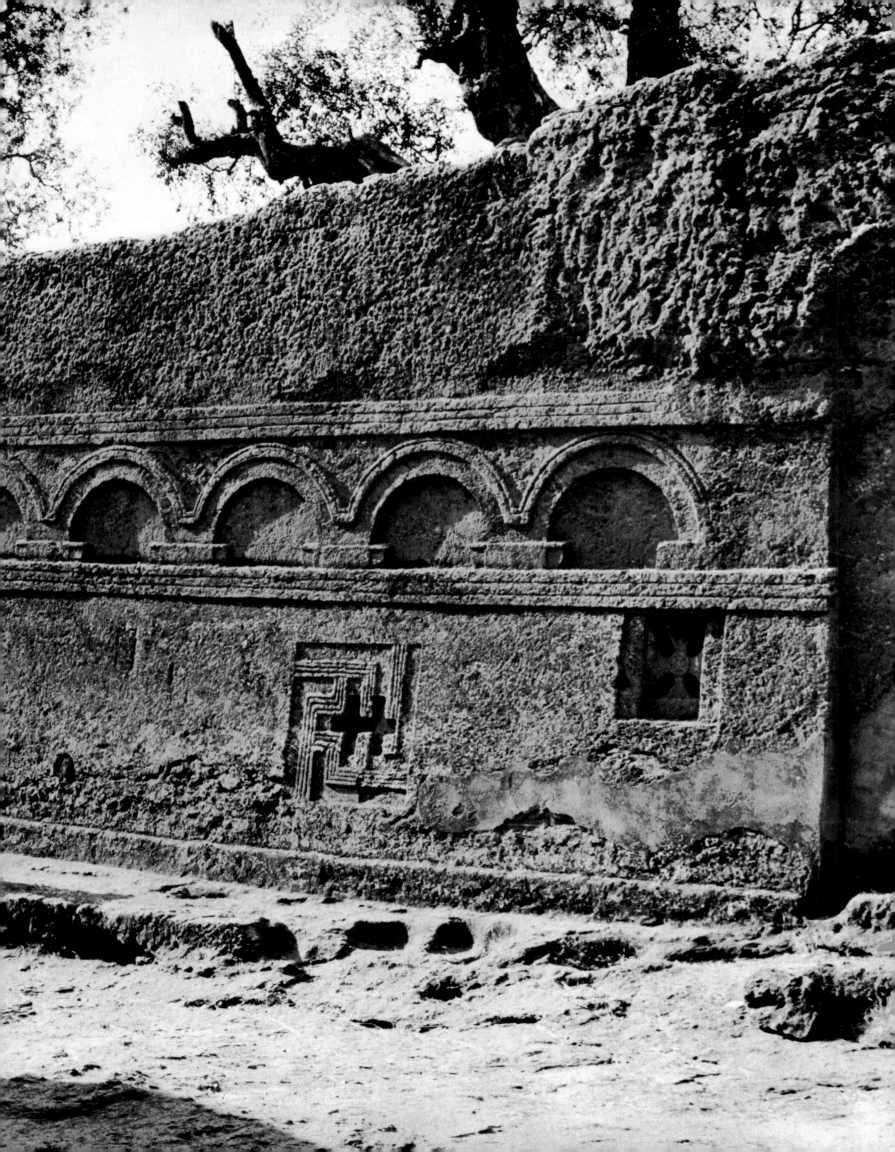

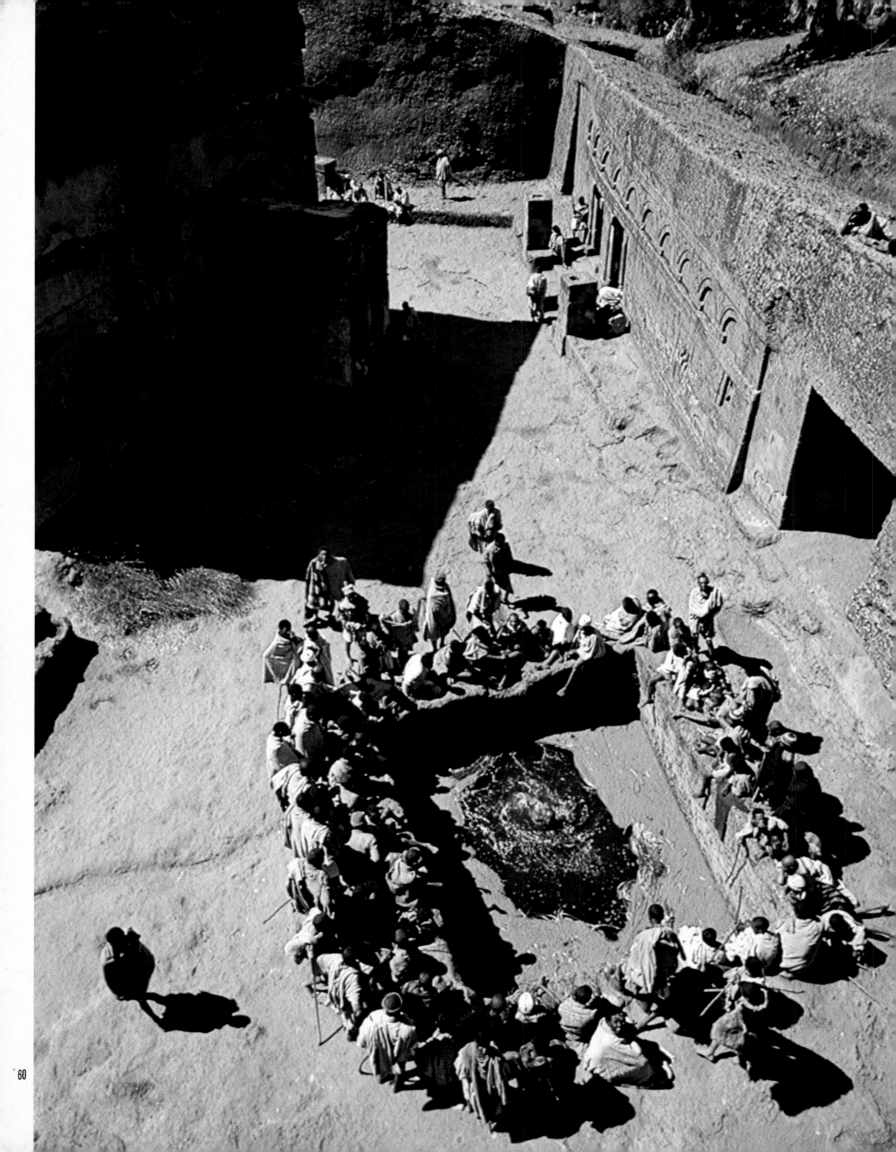

The Churches of Lālibalā, a Wonder of the World

II. Bēta Māryām.

No sanctuary is more beloved of Lālibalā's clergy, no rock courtyard in the holy city more packed full of pilgrims on holy days than the monolithic church Bēta Māryām ('House of Mary') which holds a position of pre-eminence. Tradition links this church with King Lālibalā who showed it special affection, attended mass there daily and on special occasions was to be seen with members of the royal family in the royal 'box', hollowed out of the western wall of the courtyard opposite the main entrance to the church.

At first this jewel picked out by royal favour makes little impression. The exterior of the church is rather rough and its walls have still not fully shed the cement skin with which the slovenly attempt at restoration by a Greek builder under the Empress Zawditu (1916–1930) covered it. (Monti della Corte, for example, was unable to discern the decoration of the saddle-back roof – the cross in relief – because of the layer of cement on the roof). From the outside St Mary's differs from every other Ethiopian church, whether built-up or monolithic, in having porches in front of the

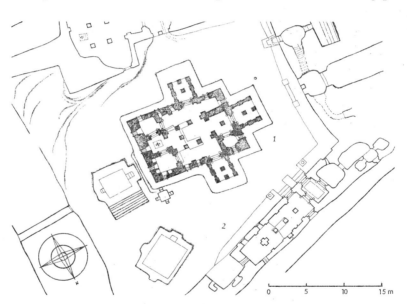

Fig. 51 Ground-plan. 1: St Mary's Church. 2: Church of the Cross (after *Bianchi Barriviera*)

three entrances (fig. 51). Each porch has an almost flat, very slightly pitched roof, a double entrance beneath round arches with corbels, a central pillar without base or capital which supports the flat ceiling, and a doorway opening into the church in the style of an Aksumite door-frame with monkey-head corner posts. In the side porches a barrier reaching up to the bottom of the corbels shuts the openings in the arches. A bas-relief above the western porch and partly discernible reliefs on its entrance columns – left and right a lion (?) and on the middle pillar of the double entrance a cross already observed in the external gallery of the church of Bēta Madḥanē 'Ālam – lend emphasis to the main façade. Around the outside of the church, mouldings contribute to the decoration. The windows of the first row – without lintel or sill but with imitated mullions – all display monkey-heads; the pattern of the piercing of the window space and of relief designs elsewhere display an extensive variety of forms of cross: Latin cross, saltire, swastika, sarcely cross and croix pattée. On three of the sides the windows of the upper row are

undecorated and rectangular, only on the west face do arched openings beneath a quatrefoil break this simplicity. Nevertheless, even these lack framework and monkey-heads. Additional windows between and even below the two rows mostly pierce the wall in cross shapes. Their effect is erratic and they are, at least partly, later additions to increase the light. The exterior of this church cannot help but disappoint expectations engendered by its special reputation. However, disappointment vanishes on seeing its interior: a fully developed basilica with narthex, nave and two aisles, galleries and a domed sanctuary with adjoining rooms like sacristies (fig. 52). Two sets of three round arches on columns and pilasters form the arcades between the vaulted nave and the flat-roofed aisles. Transverse round arches divide the aisles into three bays, and in the nave vault, arched ribs on corbels form the divisions. A chancel arch separates the nave from the sanctuary. Around the high walls of the nave runs a frieze of metopes derived from the early Ethiopian arrangement of window frames with monkey-heads. In this church, as in Bēta Amānu'ēl and Yemreḥanna Krestos, it seems to have the same use as in the palaces of Aksum: its 'metopes' are – at least along the sides – alternately decorated areas and windows between the galleries (which are lit from the outside) and the nave. In other buildings the frieze is present in a strictly formal manner, as pure ornament without any hint of its original purpose of providing light. The galleries, a rather grand name for the low passageways that they are in reality, are reached from a cell to the left of the narthex through a kind of chimney. This provides a direct connection between the left gallery and the area above the narthex. If a visitor wishes to go from this area to the gallery on the right he should have a head for heights. Where the side and end of the church meet, the points for stepping off and on lie diagonally opposite each other and only a daring step over the void, above the corner of the nave, will get you there. From such church mountaineering it seems improbable that the galleries were ever really meant to be used as such, least of all by King Lālibalā himself, as tradition suggests. All the doorways inside the church imitate the Aksumite framework. Of special note is a single column in the geometric centre of the church (excluding the narthex): it rises in the nave right up to the vaulting, without a base, but with a capital above which is the usual corbel arrangement. Neither in Ethiopia nor anywhere else is there any prototype of a pillar of this kind. However, one might think that the central pillars of the porch and the narthex or the central prop in certain rectangular chapels – such as in Dabra Dāmo – could have inspired it. Is it then an architectural trifle? Hardly. Perhaps the mystical topography of this Ethiopian Jerusalem, if only it were fully known, could offer an explanation. Since in one of King Lālibalā's visions Christ allegedly touched the central pillar with his hand, it is protected from unwanted gaze by a covering. The priests call it by the Amharic word for 'one' and 'pillar' – pillar of unity in the faith – and say that the past and future of the world are written on it. However, feeling the pillar under the covering gives no clue as to any inscription. In any case it would be naive to hope that an inscription on the pillar would reveal the reason and significance of the whole place, solving the puzzle of Lālibalā.

The lack of decoration in the Church of the Redeemer is in contrast with the passion for ornament in St Mary's. In the nave, bas-reliefs, some of which are painted, decorate the shafts of the columns, the capitals and corbels of the columns and pilasters, and the archivolts of the arches. The spandrels, the string courses above the arches, the area of the frieze of metopes, when they are not used for providing light, and the barrel-vault – the soffit as well as the eastern end-wall – only have painted decoration. The brush decoration in the aisles is still more selective, being on the corbels of the pilasters, the arches and mouldings, and on and close to the ceiling. The figurative, mostly biblical pictures are kept for the smooth strips of wall beneath

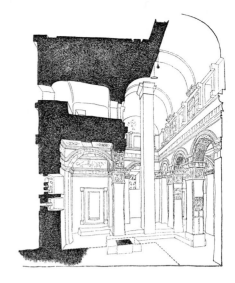

Fig. 52 Perspective section (after *Bianchi Barriviera*)

the ceiling, both on the outer face of the nave wall and on the end-walls of the aisles where they terminate against the sacristies and narthex. The application of the paint is partly directly on to the rock, partly *al fresco* on plaster. This has almost completely flaked off, so that the frescoes in the vaulting and the frieze of paintings beneath the ceilings of the aisles, which must have been the pride of the church, have been lost except for a few remains. According to a local tradition the church is supposed to have been painted or repainted during the reign of Zar'a Yā'qob (1434–1468), who promoted the cult of Mary even by force of arms. One is tempted to assign the tempera paintings – that is to say the rosettes on the ceiling – to the period of this ruler. On the other hand the painted frieze and the Annunciation scene in the vaulting may be as old as the church itself.

61 Four windows one above the other in the east wall give light to the sanctuary. The middle two lights – a Latin cross and an arched opening on corbels – have obviously been put in later as the mouldings show.

62 Two windows of the north wall, from inside looking out: a clockwise swastika above a Greek cross, through the top of which one can see a window of the Church of Bēta Masqal opposite. Inside the church the deeply set windows copy neither framework nor monkey-heads.

63 Aerial view of St Mary's and its rock courtyard in the dawn light. The church, measuring 13 × 9.2 × 9/10 m. without porches stands on a plinth in a trapezoid excavation, the walls of which have been worked externally as well. To the left of the picture, in the eastern wall of rock, is the entrance to the tunnel leading to the Church of the Redeemer; opposite the entrance a baptismal or ablutionary tank, now dry, stands above the floor of the courtyard, with steps going up to it. Jutting out of the south wall is the chapel Bēta Danāgel ('House of the Virgins' – maidens martyred under Julian), Sauter no. 37; on the southern wall of the rock is the mausoleum of Rās Kāsā Dargē, defender of Lālibalā, a building of the present century.

64, 65 Relief of riders each fighting a dragon, above the porch of the main entrance. The disks that look like haloes or the sun above the horses heads are the riders' shields. In the old church of Aśmarā there was a piece of wood-carving (to which Sauter drew my attention) showing a rider with shield represented in the same style (fig. 52.a). The nature of the monster with a spear through it is uncertain. A reptile and a griffin with serpent-headed tail, symbol of devilish might, are fleeing from the hooves of the horse in front; a bird of prey, eagle or vulture, is sitting on its hind quarters. Despite the lack of haloes, equestrian saints (Demetrius and George?) are no doubt intended. This relief depicting knightly valour is opposite the 'box' in the rock, in which King Lālibalā allegedly watched the open air festivals. Of course it, too, may well be a later addition, like the windows above it which were apparently inserted later.

66 Diagonal view of the interior of the church from the western end of the right aisle. The shafts of the pillars – the first pair on low bases – have bevelled edges as do their capitals. The arches rest on the usual corbel-impost combination; a fourth corbel, without function, protrudes into the nave for the sake of symmetry. The relief decoration alternates cross shapes with geometrical fret patterns. The motif on the capitals reminded Bianchi Barriviera of an extremely stylised angel. A rather more likely comparison would be with the crux ansata, also the ancient Egyptian symbol of life (fig. 53), the arms of which resolve into volutes. The carved archivolt imitates the wood-carving of built-up churches. Winged creatures have been painted in the spandrels of the nave, among them the peacock, a symbol of the resurrection and the double eagle, a symbol of Christ and of royal might.

67 The ceiling above two bays of the right aisle. Each section is divided by cruciform fillets of rock. In the crown of the archivolts of the arcade arches there are alternately,

Fig. 52.a Rider with shield

a cross, the arms of which terminate in three cusps like a flower, and a star of David with a similar cross inscribed. The somewhat irregular architecture aids the floral effect of the (Islamicising) rosettes and circle patterns on the ceilings and archivolts of the transverse arches. Perhaps one should observe here that the principal work of Ethiopian Marian poetry, a hymn of 156 strophes on the Mother of God, is called 'māḥlēta ṣegē', song of the flower.

68, 69 Bearded saints with scrolls in a decorated area of the frieze of metopes in the nave. The metopes not designed as windows are painted and divided by fillets. The saints have not been identified.

70 The Visitation in the frieze of pictures below the ceiling of the right aisle. The inscription reads: 'Mary and Elizabeth'.

71 Mary, astonished at the angel's message, draws the crimson thread upwards: part of the Annunciation (fig. 54), badly damaged, painted in the vaulting of the nave. The Annunciation of Christ's birth to Mary whilst spinning reminds one of her descent from royal blood. The high priest (according to the account in the proto-gospel of James) had commissioned eight virgins of the lineage of David to make the curtain for the temple; Mary was one of them.

72 The sun between rosettes painted on the underside of an architrave which separates the first bay of the right-hand aisle instead of an arch. The sun as a symbol of Christ is frequent in Ethiopian hymnology; see plates 103, 104, 134/136.

73 Fighting humped oxen and fowl on the painted frieze below the ceiling of the left aisle. A bird is watching the cockfight. It is easy, while looking for the inner meaning of this and other lively animal groups from Ethiopian daily life set in between scenes from the Bible, to attach too much symbolism to them as such interpretations ignore the naive pleasure in living things which also led the illuminators to enliven their parchments with such delightful crowds of creatures, particularly birds.

74 The man sick of the palsy, healed, returns home with his bed (Matt. 9: 2 ff.); the woman of Samaria draws water from Jacob's well in Christ's presence (John 4: 5 ff.): scenes from the painted frieze below the ceiling of the right aisle. The inscriptions read: 'Jesus and the sick of the palsy', 'Jesus and the woman of Samaria'.

75 Christ enthroned blesses the bread and fishes: scene from the frieze of pictures below the ceiling of the right aisle. The inscription 'Jesus blesses the two fishes and five loaves' links it with the miracle of the loaves and fishes to feed the five thousand (Matt. 14: 19). But the artist seems to have had the feast at Simon the pharisee's house in mind as indicated by the inscription for the picture at the left ('Mary the sinner'). This belongs to a picture of the 'woman who was a sinner' of Luke 7: 37 ff. – one can see part of her 'alabaster box of ointment' – whom early church tradition identifies with Mary Magdalene (Luke 8: 2).

Selected Sources

Sauter, no. 36.

On the iconography of the rider with shield: Lefebvre des Noëttes, vol. 2, fig. 344; Sauter, *L'église d'Asmara* . . .

On the manifold forms of the crux ansata: Cramer, *Das altägyptische Lebenszeichen* . . .

On the iconography of the Annunciation: Réau, vol. 2; Cramer, *Koptische Buchmalerei*.

Fig. 53 Coptic crux ansata

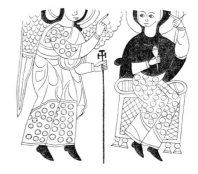

Fig. 54 The Annunciation

61 Four windows one above the other in the east wall to give light to the sanctuary.

62 Two windows of the north wall, from inside looking out: a clockwise swastika above a Greek cross.

63 Aerial view of St Mary's and its rock courtyard in the dawn light.

64, 65 Relief of riders each fighting a dragon, above the porch of the main entrance.

66 Diagonal view of the interior of the church from the west end of the right aisle.

67 The ceiling above two bays of the right aisle.

68, 69 Bearded saints with scrolls in a decorated area of the frieze of metopes in the nave.

70 The Visitation in the frieze of pictures below the ceiling of the right aisle.

71 Mary, astonished at the angel's message, draws the crimson thread upwards: part of the Annunciation.

72 The sun between rosettes painted on the underside of an architrave.

73 Fighting humped oxen and fowl on the painted frieze below the ceiling.

74 The man sick of the palsy, healed, returns home with his bed; the woman of Samaria draws water in Christ's presence.

75 Christ enthroned blesses the bread and fishes.

61

62

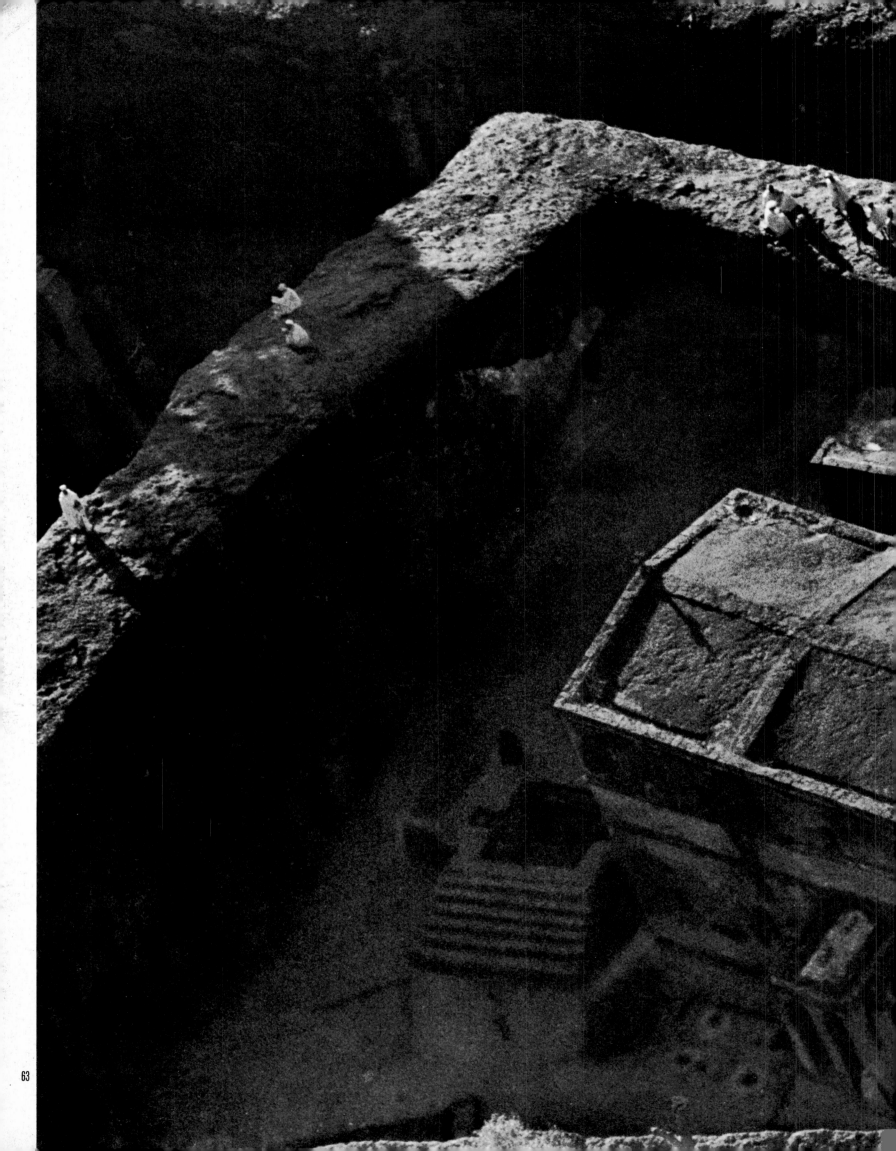

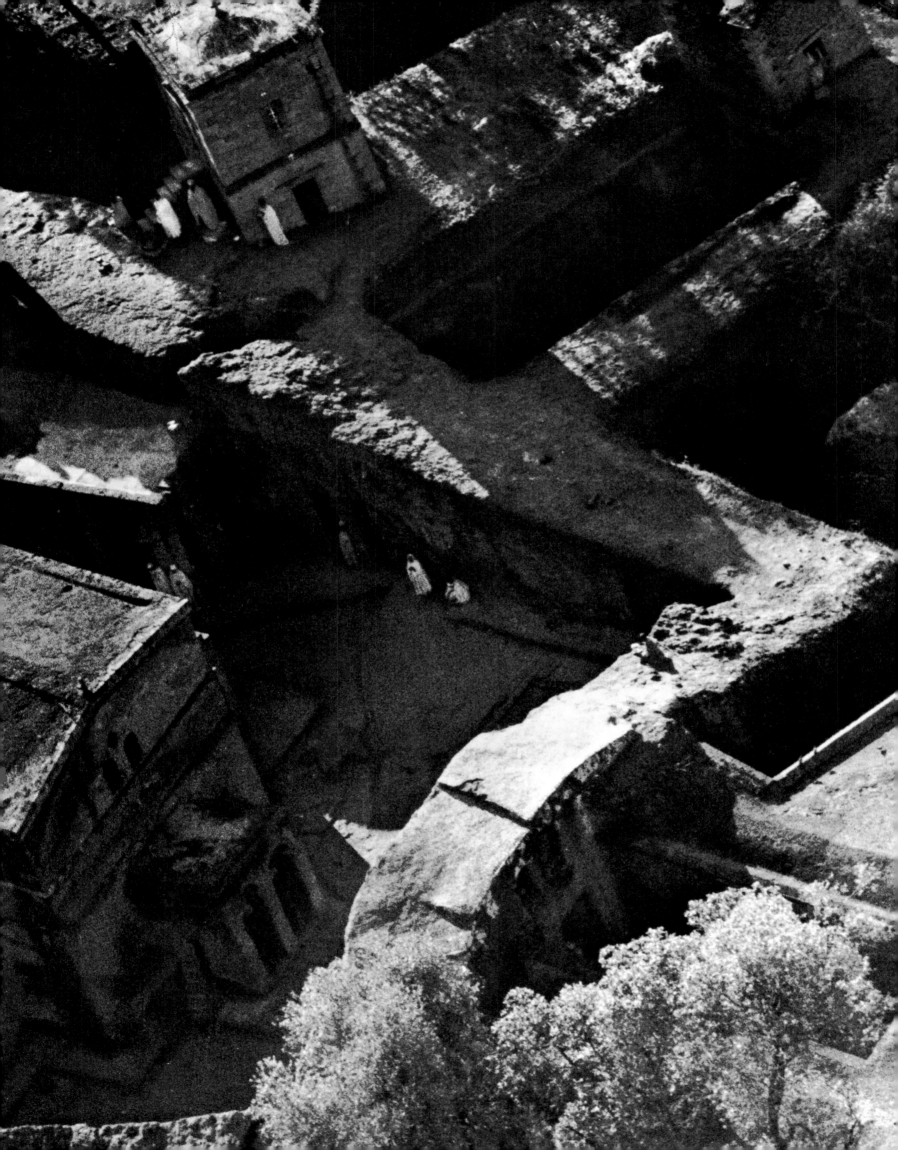

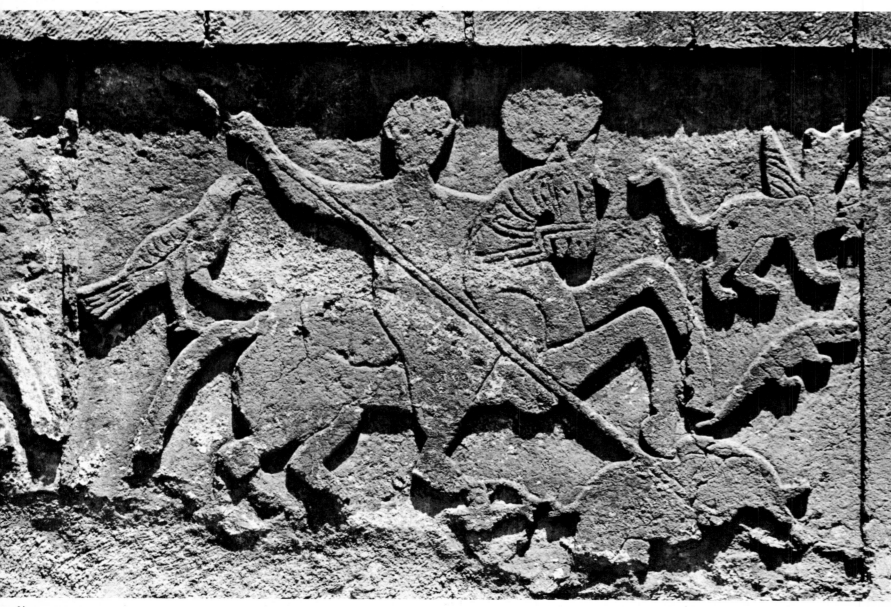

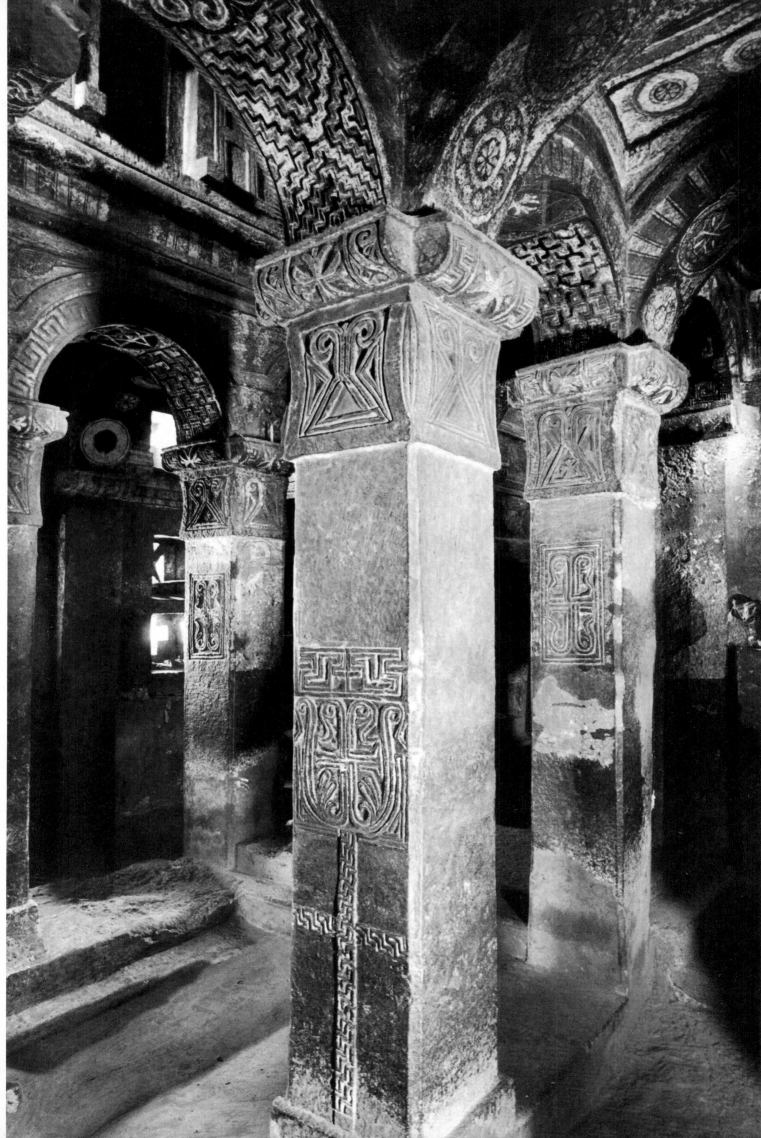

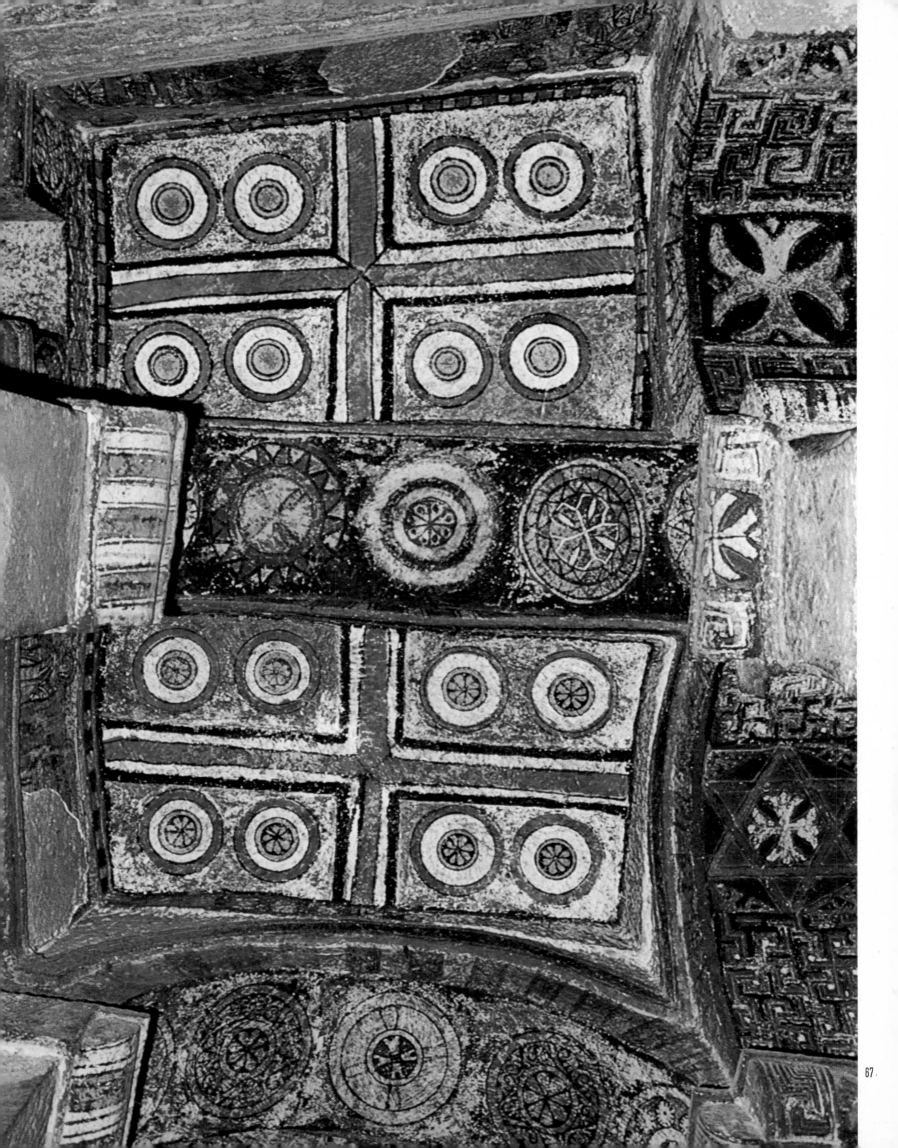

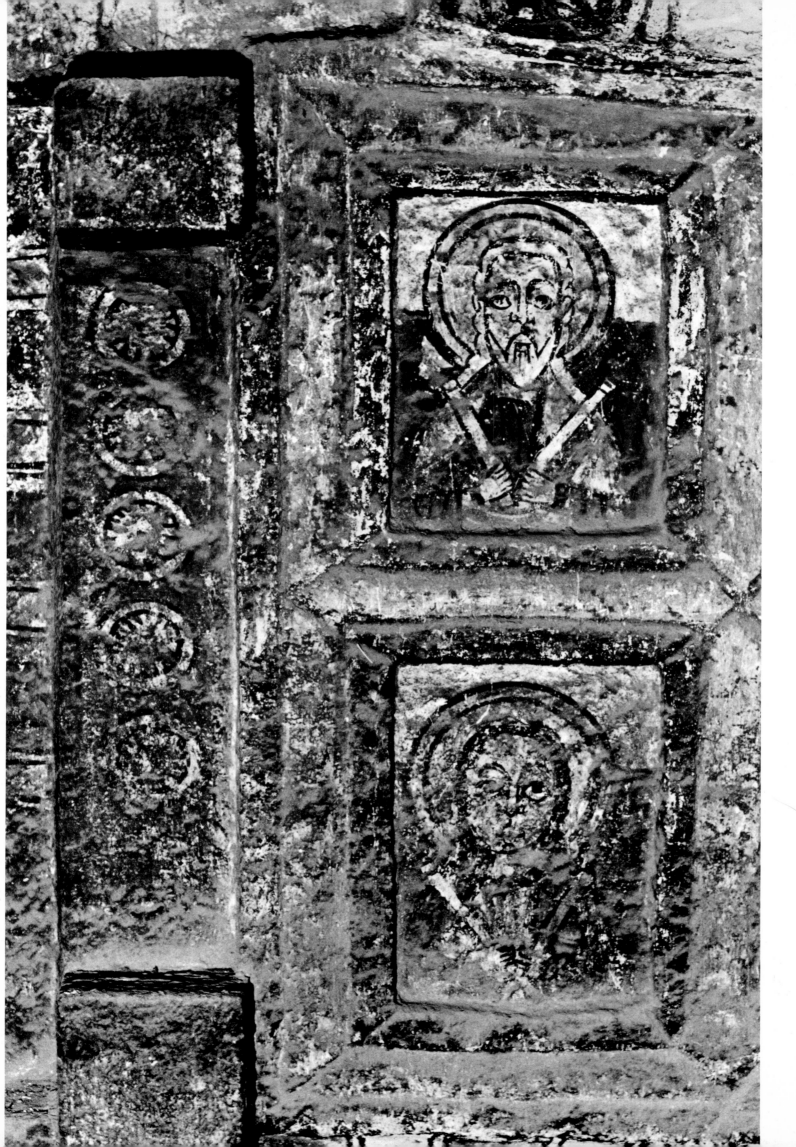

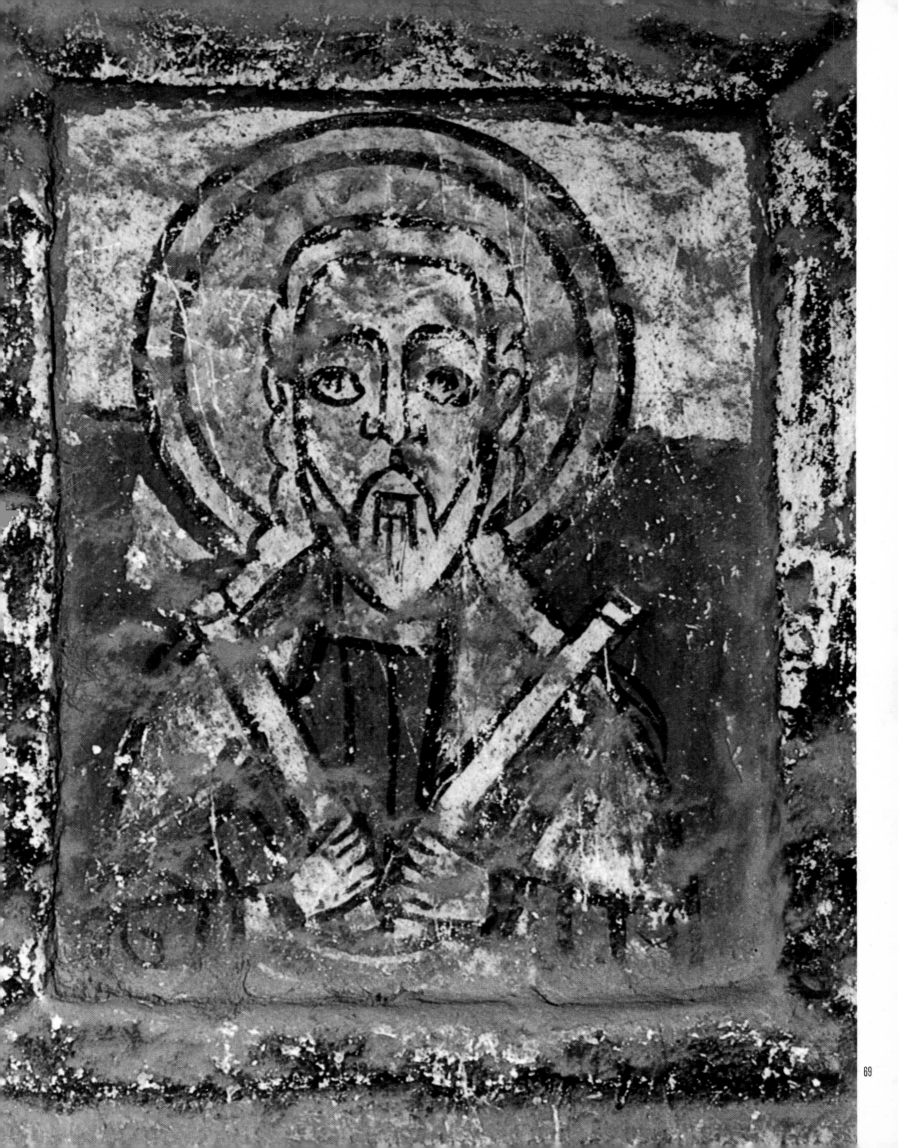

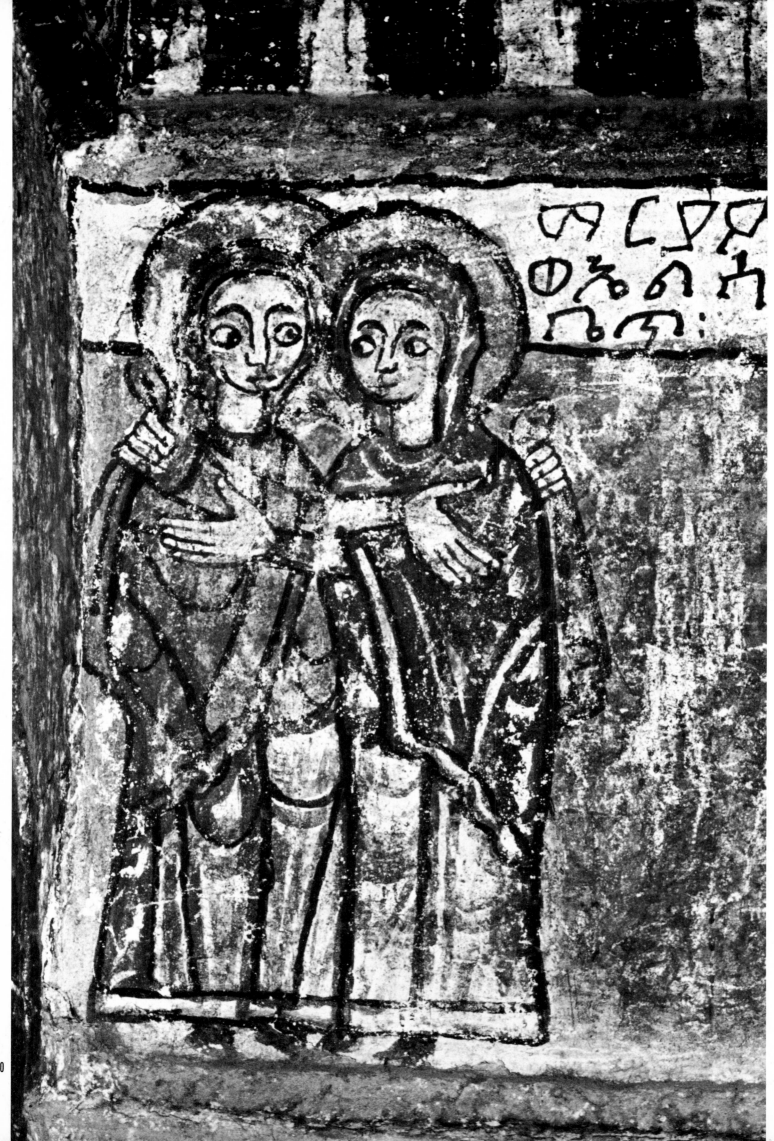

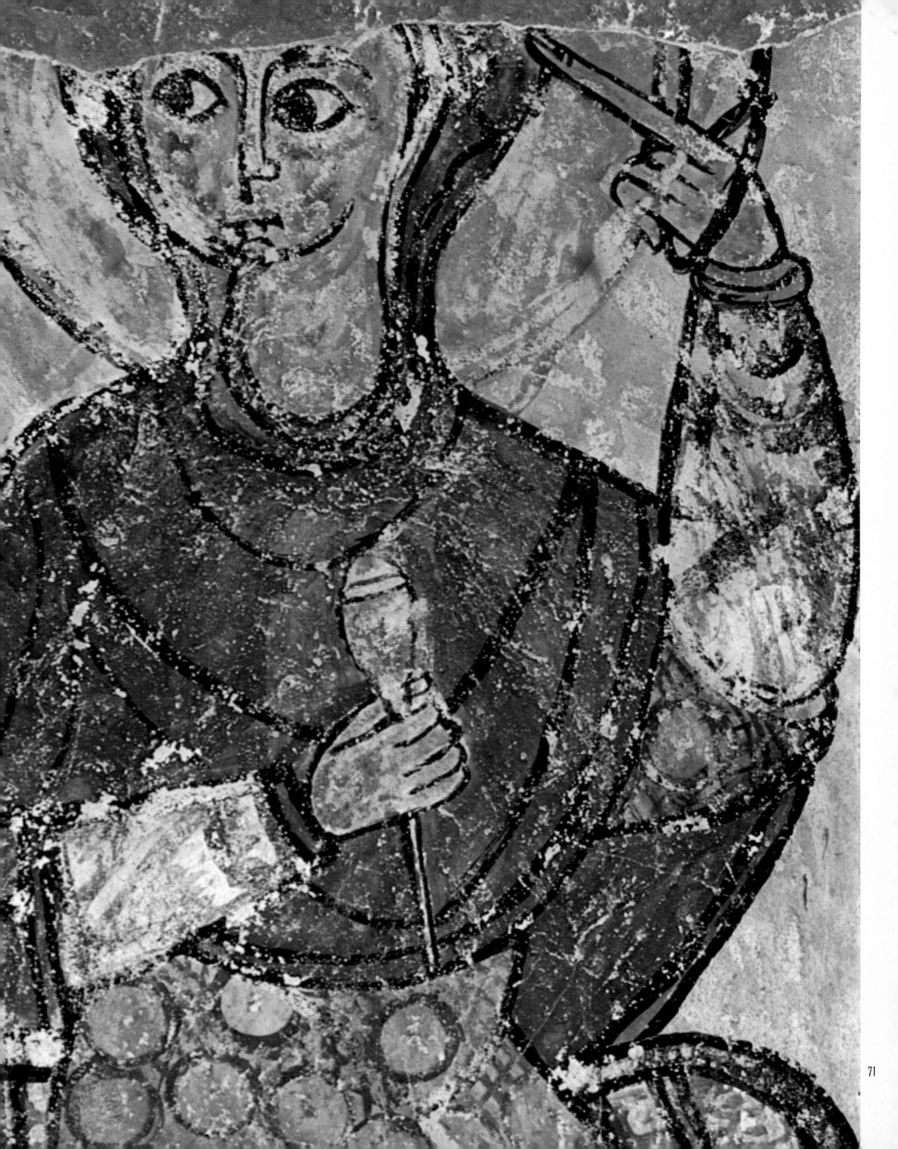

72

73

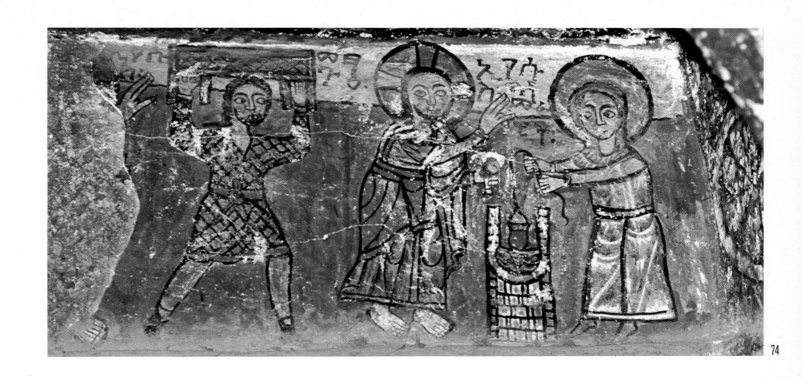

74

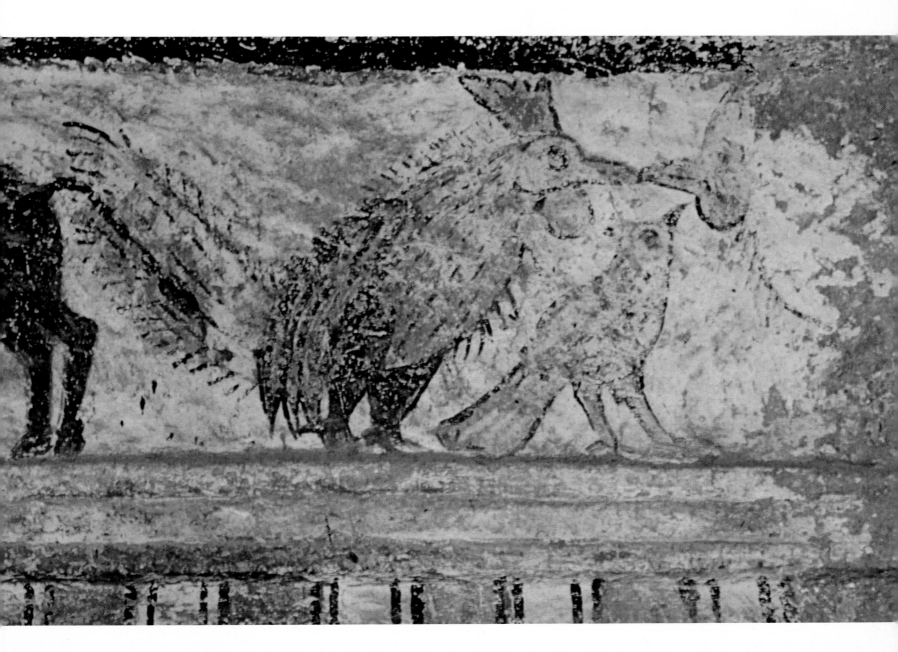

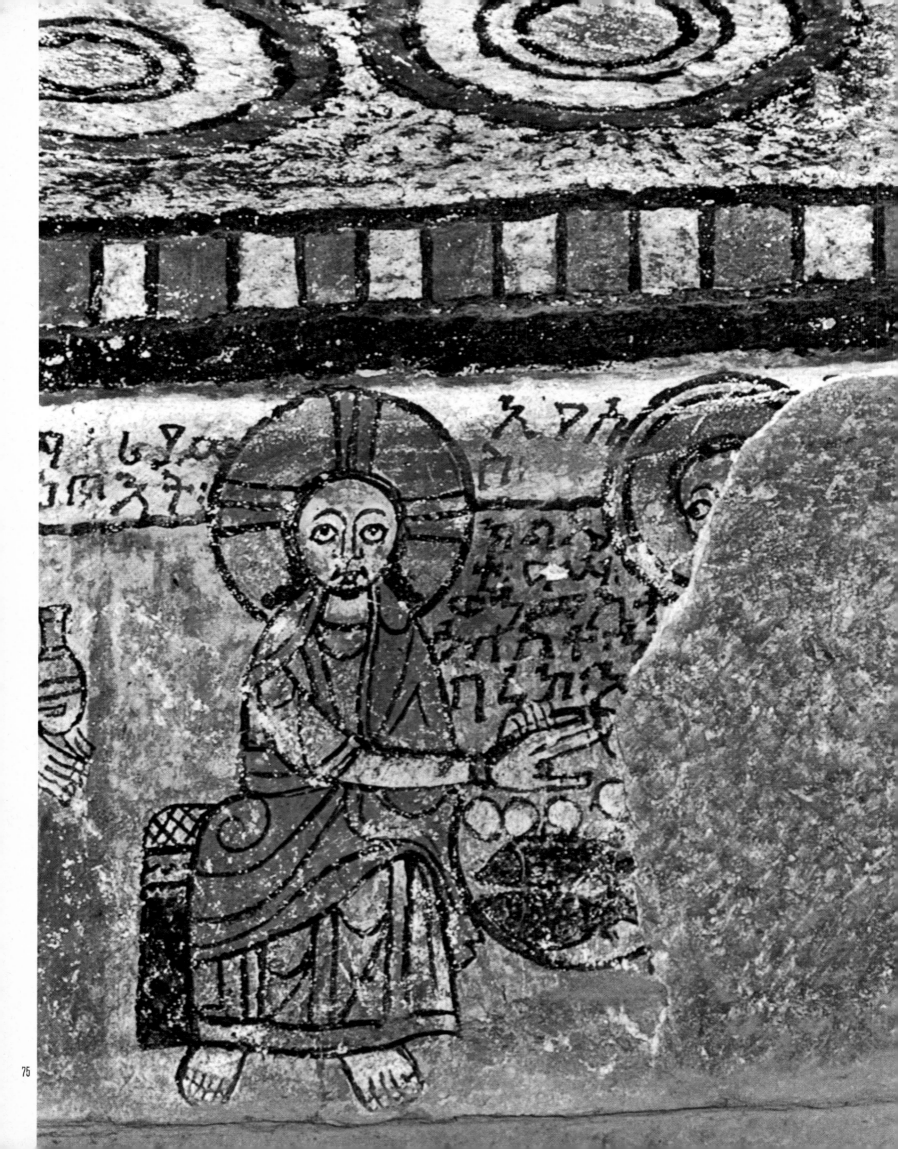

III. Bēta Dabra Sinā and Bēta Golgotā with the Śellāsē chapel.

The air of mystery which the churches of the Redeemer and St Mary draw from the atmosphere of their environment is present to a far greater degree in the churches in the western rock spur of St Mary's courtyard. They complement the first group: the churches of Mt Sinai and Golgotha, hewn side by side out of the rock, the Śellāsē (Trinity) Chapel and the block of rock called 'Adam's tomb' (figs. 43, 55). In this

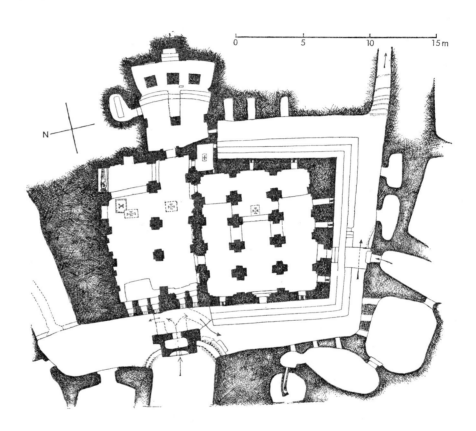

Fig. 55 Ground-plan of the Churches of Mt Sinai and Golgota with the Chapel of the Trinity (after *Bianchi Barriviera*)

setting, at once concealed and Cyclopean, the mystical significance of the holy city is heightened: the double church forms a bridge between the covenant of the giving of the law and the covenant of reconciliation concluded on the Mount of Calvary; the Śellāsē Chapel brings home the Mystery of the Trinitarian God as the foundation of the work of salvation.

It is possible that the Trinity Chapel was originally the sanctuary of the Church of Golgotha, which nowadays is used as an independent and quite separate church. On the other hand, the orientation and raised chancel of the Church of Mt Sinai weigh against the supposition that originally they, too, belonged to the Golgotā-Śellāsē combination as vestibule and choir. The presence of several tābots in the double church causes a tiresome confusion in the naming of the churches in that the Church of Mt Sinai is usually called Bēta Mikā'ēl. The differentiation offered here is based on information from Mamher Afa Worq. The Church of Mt Sinai is one of the semi-monolithic creations; with its steep stepped plinth three metres high, it is exposed on three sides by the excavation of a trench which hardly warrants the name of

courtyard. The exterior walls are smooth without dividing mouldings, with two rows of windows. Differing from the type shown in plate 84, in the bottom row of the south façade there are openings for light in the shape of paired arches on pillars; the equivalent to them are to be found in the Church of the Redeemer. However, unlike the latter, two of these windows show vestiges of decorative bosses on the upper edge of the window panel (fig. 56). Their significance as true, that is to say round, monkey-heads, not extant elsewhere in Lālibalā – and even in this instance copied in an architecturally meaningless and useless position – remains uncertain. There is an absence of false, square monkey-heads – the corner members of door and window frames – and the three essential doorways, the northern one of which provides a link with the neighbouring church, are simple arched openings. Inside the church, round arches connect two rows, each of four pillars which are cruciform in cross-section, and the corresponding pilasters on the walls; they divide the space into a nave and two aisles each with five bays. The architectural decoration of mouldings under the ceiling and archivolts is supplemented by crosses in relief on the blind arches, on the surfaces of the ceiling and on the pillars (fig. 57).

Fig. 56 Windows of the Church of Mt Sinai

The Church of Golgotha, which can be entered through the neighbouring church, represents the type of excavated church with one worked façade. Semi-circular and cruciform piercings in the wall provide the double nave of the church interior with light and air. Flattened arches connect a row of three pillars (each without base or capital and cruciform in section) with each other and with the corresponding pilasters; they rest on the usual undecorated corbels. Bas-reliefs of saints, mostly larger than life, decorate arched niches on the walls. In the past, curtains, grime and the condition of the figures made it difficult even to establish their number. Dabbert counted one figure, Monti della Corte, nine of them. Both were wrong; there are seven of these standing figures. At the east end of the right-hand nave, doors open on to the neighbouring church – which are additional to the principal linking doorway – and on to a cell called 'Iyasus' (Jesus). Above both these, traces of painted decoration are discernible. It is not certain whether these doorways were subsequently pierced through the positions of two other figures in niches. An arched tomb recess in the north-east corner of the church displays behind a wrought-iron grille a recumbent figure worked in high relief with an angel in low relief above its head. Not far from this 'tomb of Christ' there is a moveable slab let into the floor of the church. It is supposed to be above the tomb of King Lālibalā. It is not known whether it merely covers a hollow in the rock or is perhaps the entrance to a crypt.

Fig. 57 Capital of the Church of Mt Sinai

The description 'crypt' sometimes used with reference to the third shrine of the area, the Trinity Chapel which is almost completely imprisoned in the rock, does not correspond to the facts. Lālibalā's most secret and holiest place is entered without descent through a gateway in the east wall of the Church of Golgotha. Before it was surveyed in Monti della Corte's expedition, its existence was barely a rumour, and up to this day only a few visitors have seen inside it. It is even forbidden to most of the priests in Lālibalā. I have Mamher Afa Worq to thank for allowing me to be the first person to attempt to give an adequate photographic portrayal of this innermost shrine of Lālibalā (pl. 81). A single pillar supports the structure, a barrel vault horseshoe shaped in the rear section, and flat-arched above the platform with the monolithic altars. This pillar has no base and rises up more than five metres high in the middle of the chapel to the apex of the vault. Its pseudo-capital of corbels connects with it at the point where the apical groin crosses an arched rib. Like the 'one' pillar in St Mary's, coverings hide this pillar from the gaze of the inquisitive. No inscription is revealed by feeling the bare stone under the cloth. Statements to the contrary encourage the tourist passion for peace of mind which scorns a real secret as disagreeable, just as it experiences a sensation of thrill in the purveying of secrets.

The Church of Mt Sinai measures 9.5 × 8.5 m. and of Golgotha 10.7 × 6 m. The Trinity Chapel is trapezoid in plan, measuring 4.6 m. along the west wall, 6.5 m. wide across the east wall and with a middle axis 7 m. in length.

76 Dance in praise of God: in the early light of Christmas morning the dabtarās stride and stamp on the walls surrounding St Mary's Church. To the booming of the drums and rattle of the sistra the song swells, bodies rock to and fro and prayer sticks rise and fall. On the 29 Tāḫśāś (25. Dec. Julian, 7 Jan. Gregor.), a sea of the faithful, with whom the onlookers merge, spills over the surrounding high spots and fills St Mary's courtyard. The visitor, overpowered by the splendour and tumult of the processions and the drama on the lichen-encrusted rocks, easily succumbs to the temptation to exaggerate the liturgical significance of the dance of the dabtarās. It is not part of the eucharistic liturgy and its origin is disputed. The thought of King David leaping and dancing before the Ark of the Covenant (II. Sam. 6: 14, 16) comes to mind. On the other hand a liturgical scholar such as Hammerschmidt prefers to see it as an African rather than a Jewish element.

Fig. 58 Processional crosses from Lāli-balā (cross on the left after *Bianchi Barriviera*)

77, 78 Processional crosses of brass and bronze owned by the churches of Lālibalā: the first from the treasury of Bēta Amānu'ēl, the second, from Bēta Gabre'ēl Rufā'ēl. The design of these and other processional crosses from the Zāgwē sphere of influence (fig. 58) is different from all the others I saw in Ethiopia because of their curling projections – an ornamental interpretation of birds' heads. In Ethiopia the association of cross and bird is common: it is to be seen on processional crosses and royal crowns from the monasteries of Lake Ṭānā and throughout the whole country in church roof decoration (fig. 16). The arched terminal of the first cross, imitating the form and decoration of the frame of a crown, refers symbolically to 'the crown of life' (Rev. 2: 10). The rings in the picture in colour belong to the socket; they hold the ribbon which is wound round the lower stem of the cross when it is used in the services.

79, 80 Saints with cross-staves and books in arched recesses in the Church of Golgotha. The feet of the second figure are rooted in the rock base. The false doors as well as the saints show traces of former painting. Some of the standing figures – which number seven in all – wear the turban, others wear the hood associated with the toga-like wrap. On the question of identification, the inscriptions, inscribed at a later date – 'Qirqos' above the first figure, 'Giyorgis' above the second – do not help any further. According to Mamher Afa Warq the figures represent priest-kings of the Zāgwē dynasty: the alleged St George might be none other than King Lālibalā himself. I am not happy about this attribution – the unknown is replaced too hastily by the unknown. Bianchi Barriviera put forward as a 'tentative hypothesis' that they might be the Nine Saints; he asserted that there were originally nine figures, supposino that two of them had subsequently been sacrificed for openings in the wall. Since then, a painting in the more recently discovered church of Guḥ has satisfied our desire for fuller knowledge: in it, too, the nine missionaries are almost without exception depicted as wearing turbans (pl. 191). Bianchi Barriviera's speculation is also historically tangible. The nine monks from Syria, architects of Aksumite monastic and church life, 'belonged' to the northern part of the country. Their portrayal in this holy place around Christ's tomb and Lālibalā's tomb would have fitted in with the Zāgwē rulers' supposed requirement of legitimacy – as did, later on, the trans-formation of the kings of this dynasty (after its fall from power) into politically less compromising saints. The only representation of one of the Nine Saints which can be identified – by an inscription – in the Lālibalā area is of Abbā Ṗanṭalēwon in the church of Gannata Māryām. What is hard to explain is the deliberate mutilation of most of the upright figures. Maybe they are victims of iconoclastic puritanism. Cer-tainly these figures in strong relief inflamed the ancient Christian abhorrence of

sculpture in the round which continues in the Eastern Church today. It remains to be explained, however, why the iconoclastic fury passed by the most easily accessible figures on either side of the doorway – 'Cyriacus' and 'George'.

81 Inside the Chapel of the Trinity with its three altars – both space and furniture from a single piece of rock – one appreciates the true Lālibalā. Apart from here, the only other monolithic altars I have found are in the excavated church of Māy Kādo – Sauter, no. 1008 – and in the church of Endā Māryām Weqro in the district of Ambā Šannāyt, both in Tegrē. The base of the altar curves with the steps of the platform. The depressions in the rock floor are presumably post-holes for some kind of canopy. On the front of the altars on the left and right is written 'Krestos', Christ, and 'Parāqlitos', Paraclete – the Holy Spirit. Two shallow, round-arched niches behind them contain the remains (likewise deliberately damaged) of figures in relief. Monti della Corte let either the Mamher or the interpreter pull the wool over his eyes: the nativity ox and ass in human form, to which he refers, has made mischief in the literature ever since (Bidder!). Certainly a cross halo is clearly to be seen in both arches. This was probably a representation of the Trinity in the guise of the Person of Christ or of the 'Ancient of Days' (Dan. 7: 9). Nowadays the middle, deep, niche only contains a tābot wrapped up in a cloth. Because of the very short distance between the Holy Pillar and the altars, only the extremely wide angle of the fish-eye lens can provide an impression of the area; consequently distortion is unavoidable.

82 'Ox-faced winged creature with hands upraised in prayer: one of the four sacred beasts at the foot of the central monolithic altar. Plate 81 shows the creature with the face of a man, fig. 59 those with the face of a lion and an eagle. The arrangement on the four sides of the altar follows Ezekiel (1: 5 ff.), the attitude of prayer has reference to the Apocalypse (Rev. 4: 6 ff.). The question is to what extent it is intended to embrace the Four Evangelists in the representation of the vision of the creatures with wings. It remains to mention the 'Church Rule', one manuscript of which argues that the altar in every Ethiopian Church is the symbol of the four apocalyptic creatures, and that the tābot is that of the Trinity and of Christ's tomb.

83 The keel-arched window providing light and air for the Jesus cell of the Church of Golgotha. The inner band of moulding framing the window ends in foliage on the corbels of the arches. The two outer bands of moulding are entwined above the arch with the bottom loop of a croix pattée, giving rise to half-palmettes on the left and right. The motif is reminiscent of the signs used by Coptic calligraphers to indicate a division (fig. 60). A neighbouring window, similarly decorated, opens into the Chapel of the Trinity.

84 Windows of the upper and lower rows in the east wall of the Church of Mt Sinai. A nun wanders along the trench leading to the outer wall of the hidden and forbidden Chapel of the Trinity in order to pray at it.

85 'The Tomb of Adam' in front of the west wall of the Church of Golgotha: a hollowed-out monolith, the ground-floor of which serves as the western entrance to the first group of churches. On the upper floor it contains a hermit's cell. King Lālibalā's New Jerusalem could not omit Adam's tomb: Christian tradition located it on Golgotha. The first man, author of sin and death, here awaited redemption through the blood of Christ, the second Adam (I. Cor. 15: 45), the author of life.

Selected Sources

In *Sauter,* Bēta Dabra Sinā is no. 39, Bēta Golgotā is no. 40 and the Šellāsē Chapel no. 41.
On the 'Church Rule': Griaule, *Règles* . . .

Fig. 59 Lion- and eagle-faced creatures

Fig. 60 Coptic paragraph divider, 9th cent. (after *Petersen*)

76 Dance in praise of God: in the early light of Christmas morning the dabtaras stride and stamp on the walls surrounding St Mary's Church.

77, 78 Processional crosses of brass and bronze owned by the churches of Lālibalā.

79, 80 Saints with cross-staves and books in arched recesses in the Church of Golgotha.

81 Inside the Chapel of the Trinity with its three altars – both space and furniture from a single piece of rock – one appreciates the true mystical Lālibalā.

82 Ox-faced winged creature with hands upraised in prayer: one of the four sacred beasts on the foot of the central monolithic altar.

83 The keel-arched window providing light and air for the Jesus cell of the Church of Golgotha.

84 Windows of the upper and lower rows in the east wall of the Church of Mt Sinai.

85 'The Tomb of Adam' in front of the west wall of the church of Golgotha: a hollowed-out monolith, the ground-floor of which serves as the western entrance to the first group of churches.

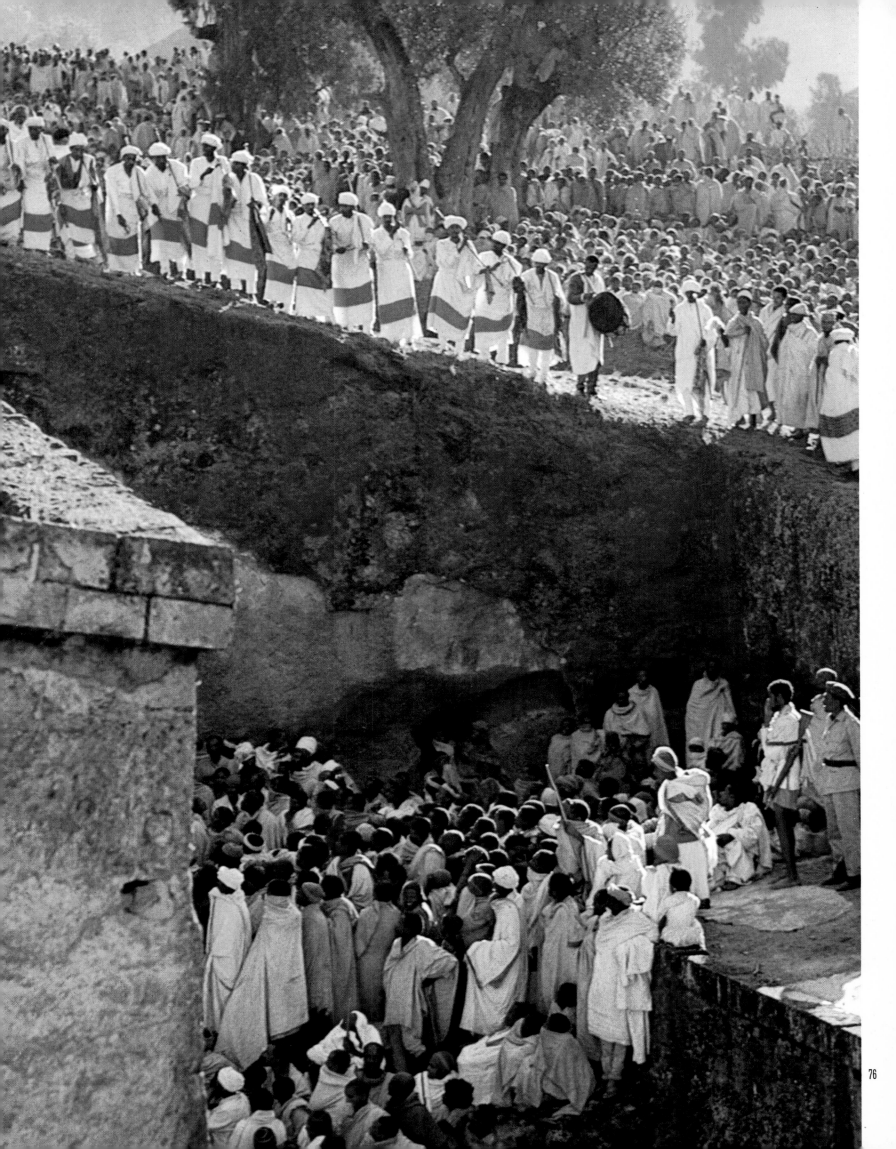

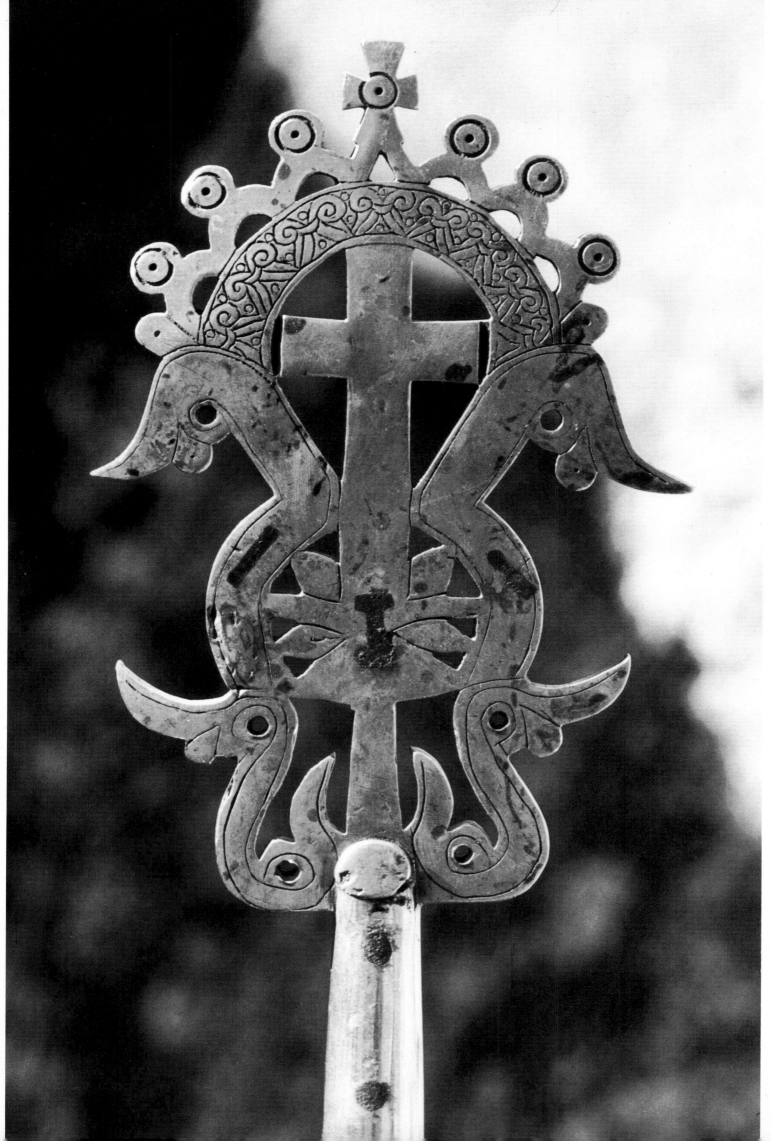

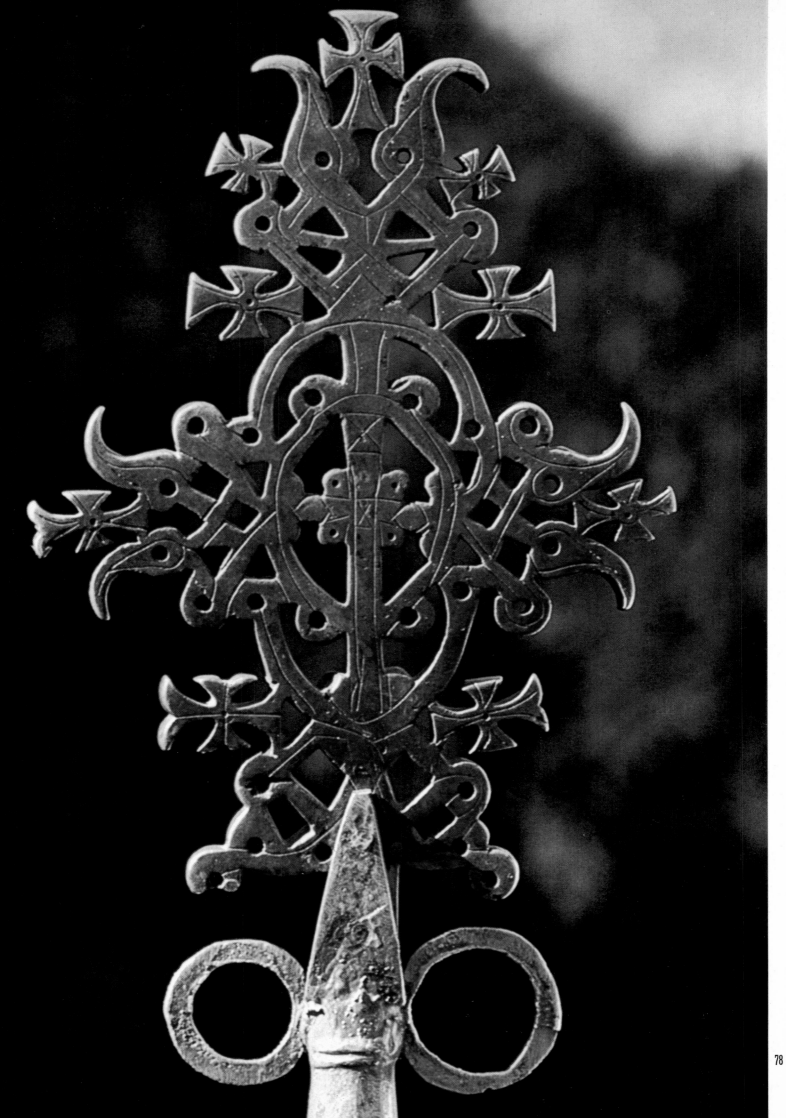

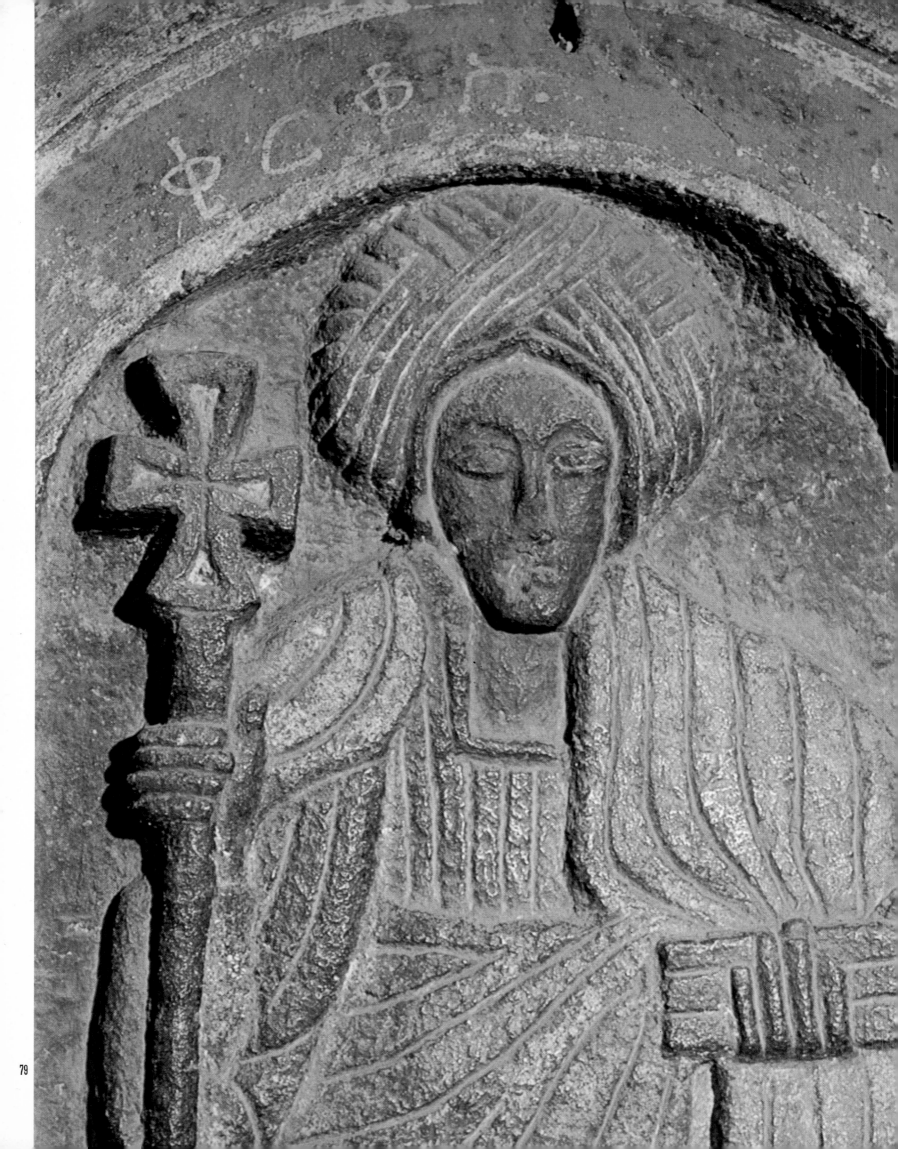

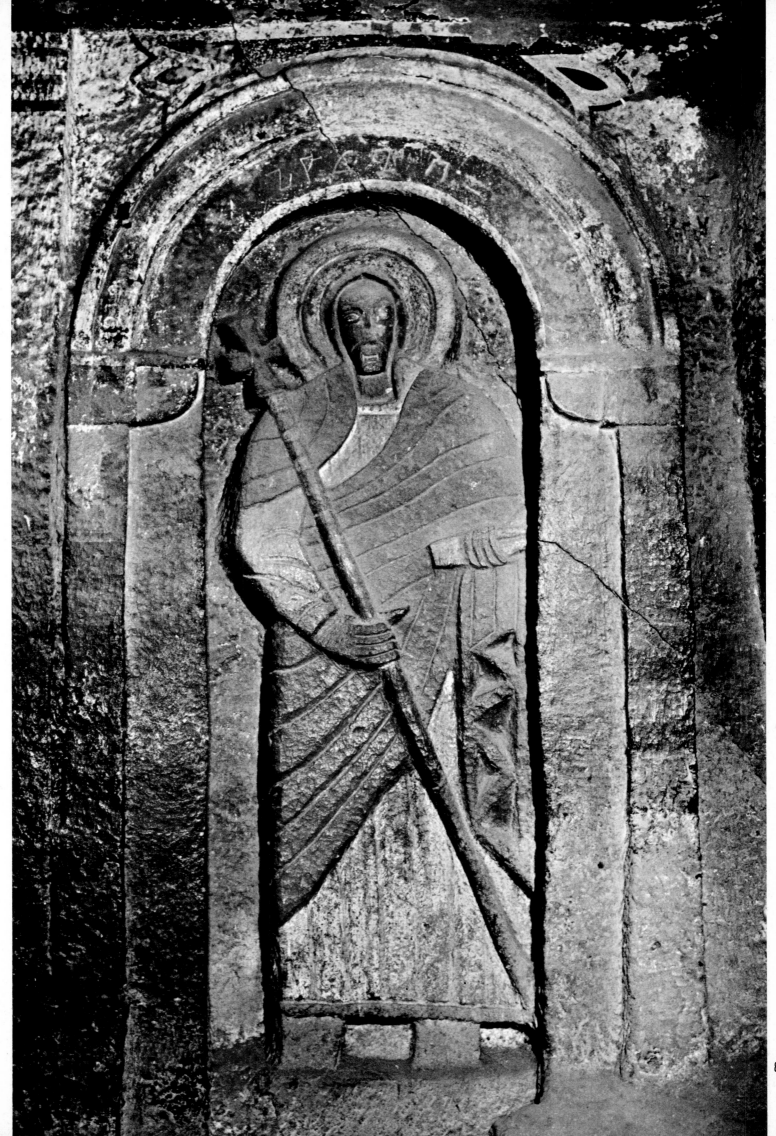

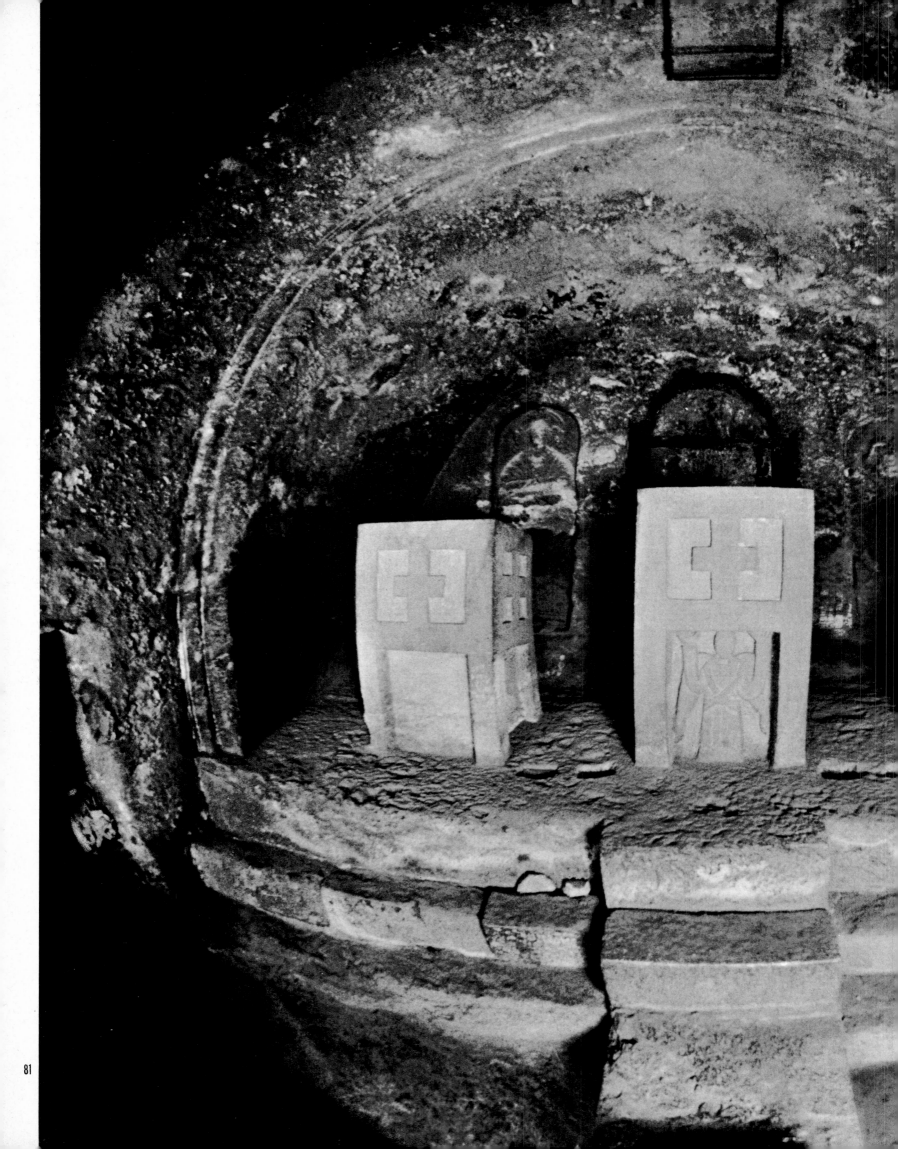

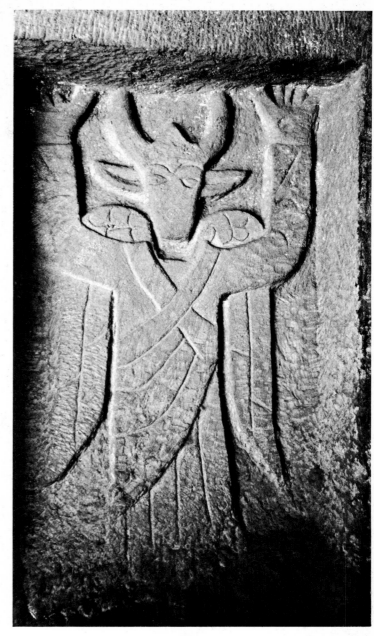

82

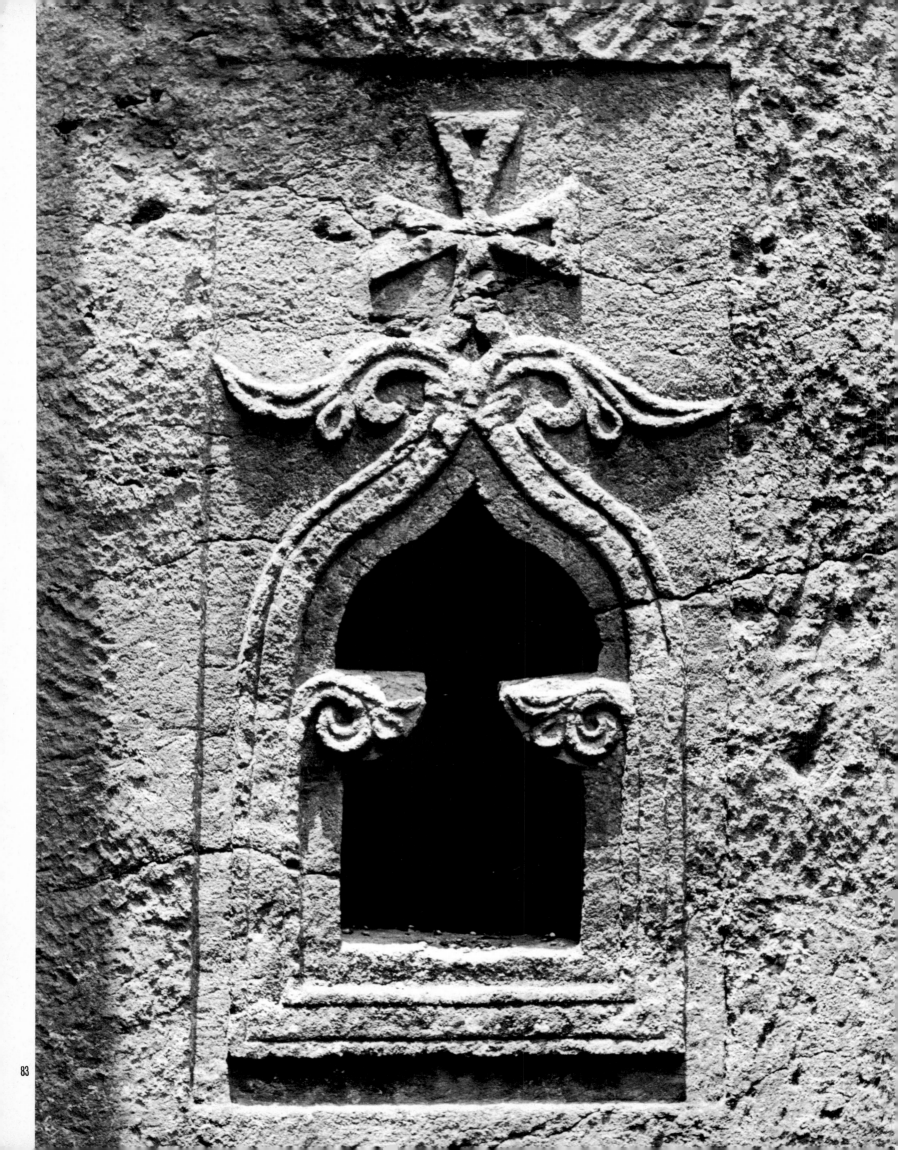

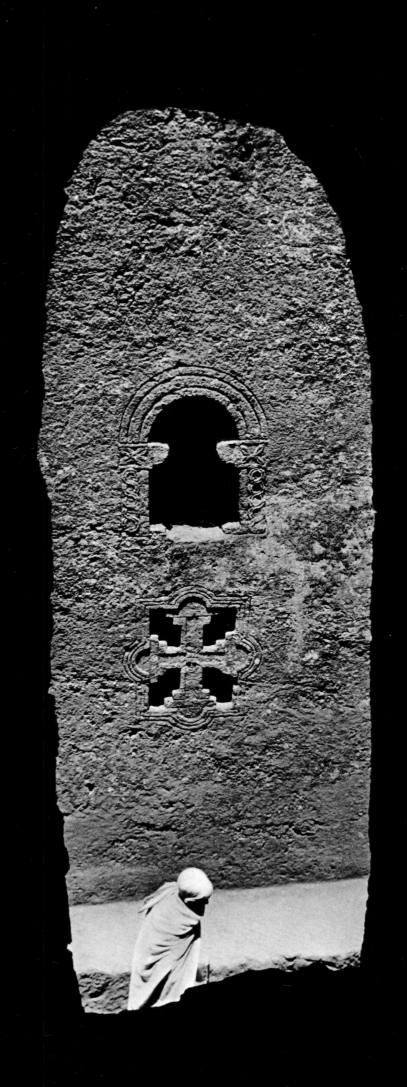

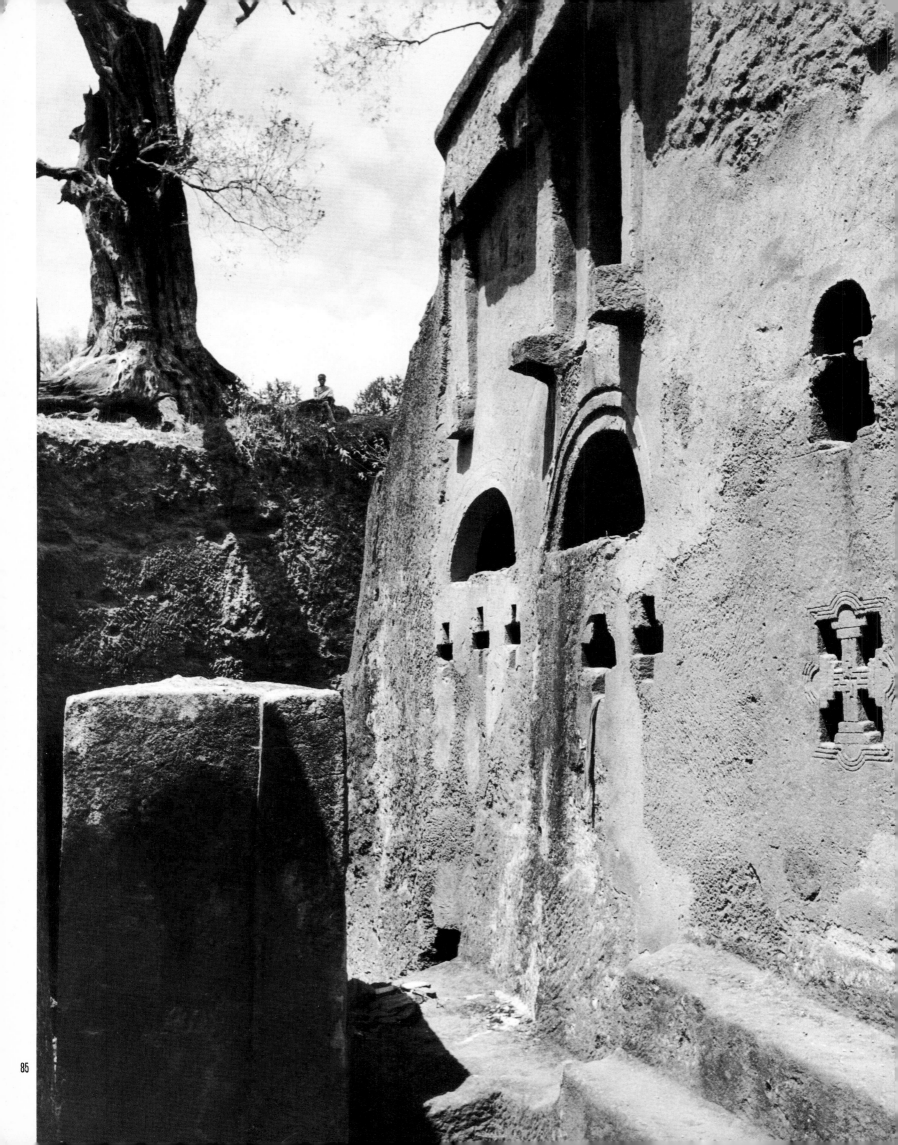

Fig. 61 Window of the Church of Emanuel

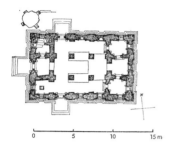

Fig. 62 Ground-plan of the Church of Emanuel (after *Bianchi Barriviera*)

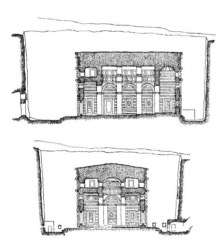

Fig. 63 Longitudinal and transverse sections of the Church of Emanuel (after *Bianchi Barriviera*)

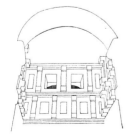

Fig. 64 Frieze of metopes of the Church of Emanuel

IV. The second group of rock sanctuaries

A deeply incised wide trench, a Cyclopean creation, surrounds on the north, east and south the mass of rock from which King Lālibalā's stonemasons formed the second group of sanctuaries. To find the right way in the system of galleries, passages and paths is quite a task in this group: scattered debris, rubble and washed away soil hide the most easily visible connecting paths. Even today, the trench which divides the hump of rock into two projections and provides access to the church complexes is, in places, filled up with earth. Its task of carrying off the heavy rains and providing protection for the outer trenches has now ceased. Fig. 42 gives some idea of the configuration of both groups of churches in relation to each other. The most recent excavations have once more brought to light the trench passages that join them.

There is no doubt that the second group of monuments will be better understood when the serious archaeological investigation of Lālibalā, started in 1967, is completed. Apparently only two of the churches were planned as such. Both the others were used for secular purposes in the Zāgwē period. The priests took them over for worship much later, after the Zāgwē fall from power, when Lālibalā became an exclusively religious centre. Perhaps one should not altogether blame the undeniable neglect of the state of repair of this group on the friability of the stone. After all this was the residence of a dynasty which, though it sent saints to heaven, was in the end a political failure.

The only true monolithic church of the group – Bēta Amānu'ēl, sculptured from a block of red tufa measuring $18 \times 12 \times 12$ m. – may have served the king as palace chapel. No church in Lālibalā is more carefully executed – built with far greater attention to being vertical and square. And none could give a stylistically more convincing alibi to a king who perhaps wanted to found just as much a new Aksum as a New Jerusalem. Actually the church on its stepped platform with projections and perpendicular indentations in strips imitates the old Ethiopian wood and stone method of construction rather too slavishly. If one did not have the monastery church of Dabra Dāmo and the cave church of Yemreḥanna Krestos as examples (the latter probably being the *cappella palatina* of the Zāgwē ruler of the same name!), one could nevertheless quite easily reconstruct the built-up original from the rock copy. At the three entrances, in front of which the stepped platform widens into landings, the Church of Emanuel imitates the Aksumite framework of wooden beams in building technique. The bottom and top (third) row of windows even exhibit a fully developed frame with corner posts; in the former, the surface is pierced in the middle by a cross and in the corners by rectangular perforations, in the latter, the openings for light are without fillings. The middle row of windows consists of the usual rectangular wall-piercings with a terminal round arch on corbels. The division of the interior (figs. 62, 63) is like that of St Mary's Church, only the central pillar is lacking. In the Church of Emanuel, the double frieze of metopes in the nave produces a curious effect (fig. 64). The lower one is purely ornamental, the upper contains windows, between decorated areas, which distribute light from the galleries into the nave and on into the sanctuary. This doubling of the characteristic old Ethiopian ornament, scarcely met with otherwise, testifies to the architect or builder's determination to be, if possible, more Aksumite than Aksum. Maybe Bianchi Barriviera has found the right meaning

of it: he considers the lower frieze to be an ornamental reconstruction of a peculiarity in the built-up original, namely the sharp-edged heads of the beams which supported the ceilings of the aisles and the floors of the galleries.

The church dedicated to the monastic saint Abbā Libānos is semi-monolithic and has also been a church from the start. Bēta Abbā Libānos is like a cave church. One can go right round it. Like the visible façade, the sides facing the dark surrounding passageway are also worked and they only adhere to the living rock by the roof (figs. 65, 66). The exterior and interior both emphasize the Aksumite tradition, but without the excess zeal of the Church of Emanuel: platform, projections, monkey-heads in the windows and doors, frieze of metopes ... Its ground-plan follows that of the Church of Emanuel, but the smaller measurements – 9.5 × 7 m. ground area by 7.5 m. high – reflect the absence of galleries. The architect has left solid the northern corner area next to the narthex, where the staircase is normally housed. One special feature of the church is that, apart from the sanctuary arch and the arch between the narthex and the nave, the church has flat lintel-beams in the tradition of Dabra Dāmo.

The areas at present or until recently used as the Church of St Mercurius – Bēta Marqorēwos – and as the Church of the Holy Archangels – Bēta Gabre'ēl Rufā'ēl – neither face the east nor are recognisable as shrines through any kind of decoration or symbol. The Church of St Mercurius occupies the eastern part of a subterranean hall, which opens on to a courtyard with heavy irregular pillers (fig. 62). The Church of the Archangels – three angular spaces with pillars and pilasters, sandwiched in between two courtyards – accentuates the west end of the group with a monumental

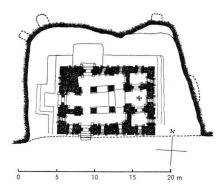

Fig. 65 Ground-plan of the Church of Abbā Libānos (after *Bianchi Barriviera*)

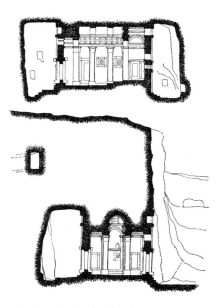

Fig. 66 Longitudinal and transverse sections of the Church of Abbā Libānos (after *Bianchi Barriviera*)

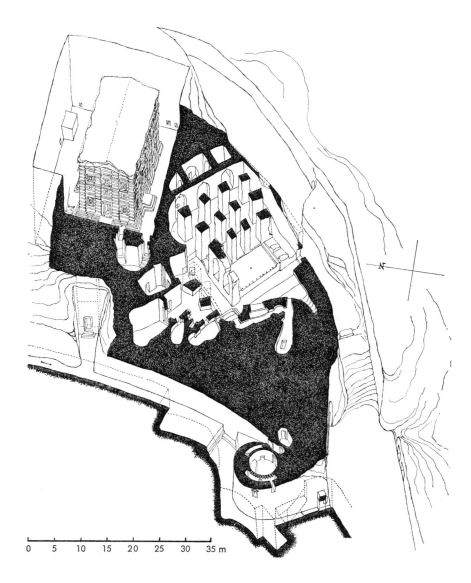

Fig. 67 Isometric sectional view of the Church of St Mercurius and 'Bethlehem' (after *Bianchi Barriviera*)

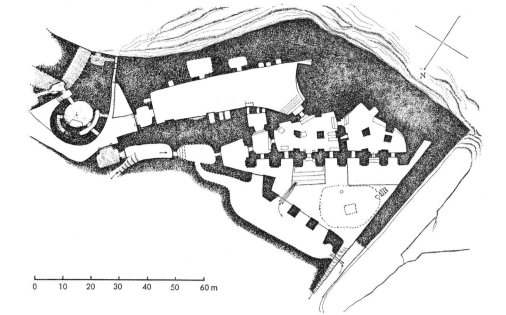

Fig. 68 Ground-plan of the Church of the Archangels (after *Bianchi Barriviera*)

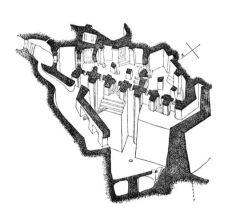

Fig. 69 Isometric sectional view of the Church of the Archangels (after *Bianchi Barriviera*)

façade (figs. 68, 69). Part of the former royal residence? Very likely. Angelini found indications of clasp fixtures for chains. The priests of the Church of the Archangels whisper about undiscovered dungeons and forgotten treasure chambers. Beneath their church stretches a cistern of undetermined size. Wells open out into the floor. A priest showed Dabbert a heavy silver cross which he claimed to have fished out of the murky water with a noosed rope. Individual details of the secular establishment will remain uncertain as long as the remains of buildings, which are apparently complementary to the rock spaces above the ground, are only superficially investigated.

A passageway more than 50 m. long, which runs into the right-hand aisle, links the Church of Emanuel – branching off half-way towards the Church of St Mercurius – with a low circular room in the solid rock (fig. 67). Apparently, before the tunnel caved in, the chapel served as 'Bethlehem': the bakery for the preparation of the Eucharistic bread. The architectural layout of the total complex obviously does not allow for it to have been constructed in the liturgically prescribed position east of the sanctuary.

86 A nun, prayer stick and shoes in hand, leaves the courtyard of the Church of Emanuel. The hole is undoubtedly a doorway subsequently pierced, possibly the enlargement of a drain which carried the water off the courtyard into the outer trench. The steep walls of the pit are encrusted with lichens.

87 Worshippers before the south entrance of the Church of Emanuel: the framework of beams of an Aksumite door has been just as faithfully copied in the rock as has its position in the wall. The horizontal patterning of this monolithic church reproduces the striped masonry of an Aksumite building – the alternation of wooden beams and slightly projecting, smoothly plastered layers of rubble (cf. pl. 111). The measurements of this feature of the rock copy correspond to the original proportions: about 40 cm. high for the masonry and half as much for the beams of the framework.

88 The Church of Emanuel (south façade) in its rock pit: the flair for detail, which is evident in this stone reconstruction of an old Ethiopian wood and stone building, bear comparison with the ingenuity of the Aksumite stonemasons, the creators of the multistoreyed stelae. The architectural original, it is true, was a framed structure without the binders with projecting (true) monkey-heads. Mouldings divide the surface of the walls horizontally in addition to the subdivision based on the wood and stone sandwiched style of construction. The indentations in the walls, in which all the doors and windows are placed, reflect the internal divisions of the church, as do the

mouldings: the number of aisles and bays, the position of the galleries and the height of the vault. The removal of the ugly corrugated iron roof during the work of restoration in 1967/68, as well as of the paint which was unsuitable in both texture and colour, both dating from the fifties, greatly improved the Church of Emanuel.

The church of the monastic saint Abbā Libānos, with walls cut free from the rock and worked, but still joined to the mother rock above, only displays its southern side. The wall projections of the original model have been transformed here into external pilasters corresponding to the pillars and pilasters inside. The horizontal division of the façades (not merely the south face) is principally achieved by the three rows of windows: one row with Aksumite frames and cruciform piercings, two of the windows being blind (in the north-west corner of the church, which has been left solid in place of the stair-well leading to the galleries); above this, unfilled openings for light with ogee-arches; on top, where the galleries would have been, a row of square false windows. Clumsy restoration during the reign of the Empress Zawditu badly affected the monolithic appearance of the church. There is still some semblance of the dike which formerly protected the church area from the outside world. There are other churches in the vicinity of Lālibalā – Bilbala Giyorgis (*Sauter*, no. 25) – and in Tegrē – Dabra Ṣeyon – which likewise are freed from the rock on the sides but not on top, and with only the one worked façade.

The monumental façade of the part of the royal residence which was used for the Church of the Holy Archangels: openings in a rock gallery opposite frame sections of the blind arcade which change according to the visitor's position. The façade continues the old Ethiopian style of breaking the line of the wall by projections and indentations; as in the church of Abbā Libānos, the projections give the impression of a kind of wall-column. Deep niches are set into the indentations in the wall; two niches contain doors, five of them, windows. Keel-arches – flattened ogees – terminate both windows and niches. A platform enlarges the landing in front of both doors in this façade. Originally they both led into the void, since there is more than ten metres from the edge of the platform to the bottom of the rock courtyard. Tree-trunks nowadays provide the church-goers with a means of access by bridging the gap between the rock gallery and the platform on the left.

King or martyr: fresco on a pillar in the Church of St Mercurius. Local tradition sees the one depicted as wearing a crown, the central figure of a group of three, as King Lālibalā between two other Zāgwē saint-kings, Yemreḥanna Krestos and Na'akweto La-'Ab. According to another interpretation, the group of three is made up of the princely officials Shadrach, Meshach and Abed-nego, the three men in the fiery furnace (Dan. 3: 1 ff.). In 1967 both explanations lost all credibility with the removal of the Gondarene canvas painting which was stuck on to the lower part of the pillar (pl. 15). Under a thick layer of čeqā, local clay mortar, appeared more figures similarly crowned and likewise unidentified by caption. The fact that the fresco was overlaid with a cloth painting, dated to the seventeenth century at the earliest, unfortunately has little if any value in determining the age of the fresco. Probably this tempera painting was not done in Lālibalā at all, but in Gondar, and was stuck on at a time which cannot be determined more precisely.

Selected Sources

In *Sauter* Bēta Amānu'ēl is no. 44, Bēta Marqorēwos no. 45, Bēta Abbā Libānos no. 46, Bēta Gabre'ēl Rufā'ēl no. 47, Bēta Leḥēm no. 48.

86 A nun, prayer stick and shoes in hand, leaves the courtyard of the Church of Emanuel.

87 Worshippers before the south entrance of the Church of Emanuel: the framework of beams of an Aksumite door has been just as faithfully copied in the rock as has its position in the wall.

88 The Church of Emanuel (south façade) in its rock pit.

89, 90 The Church of the monastic saint Abbā Libānos, with walls cut free from the rock and worked, but still joined to the mother rock above, only displays its southern side.

91, 92 The monumental façade of the part of the royal residence which was used for the Church of the Holy Archangels: openings in a rock gallery opposite frame sections of the blind arcade which change according to the visitor's position.

93 King or martyr: fresco on a pillar in the Church of St Mercurius.

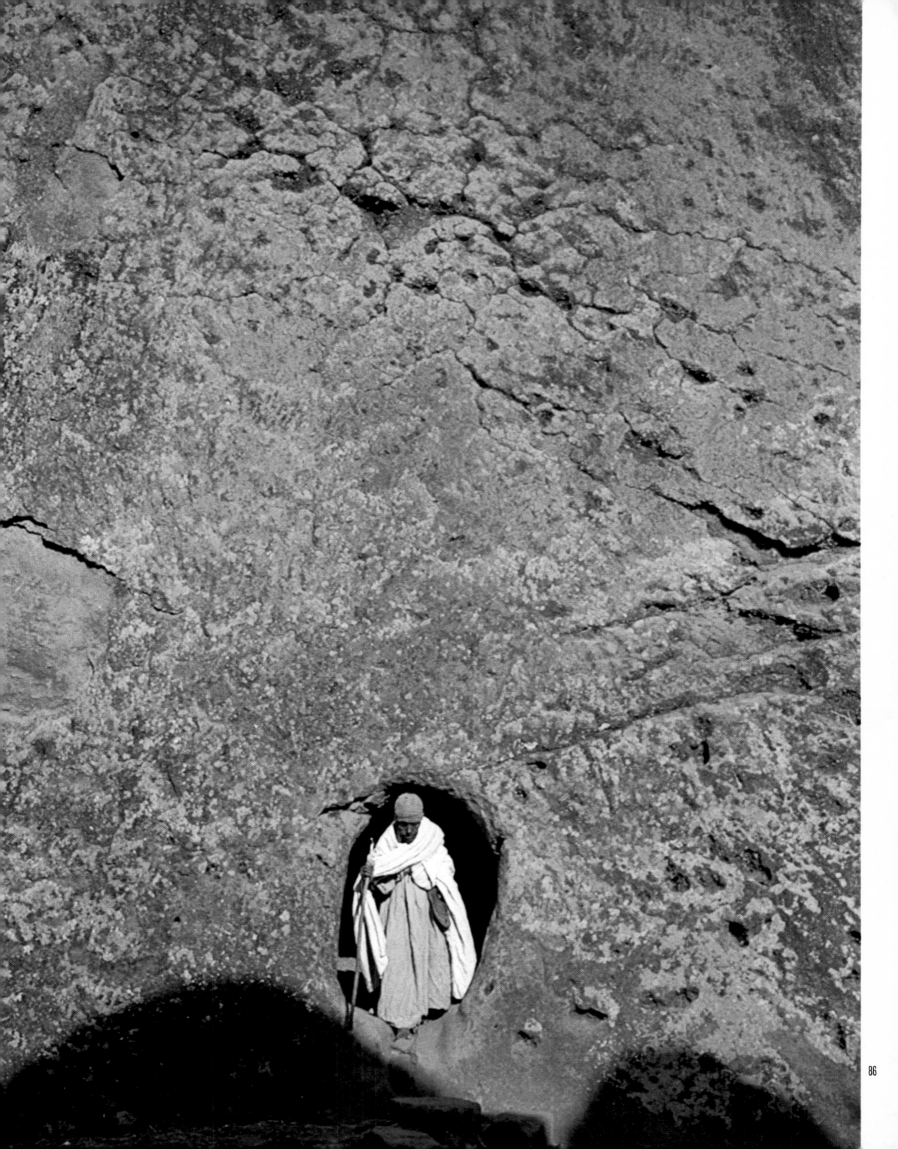

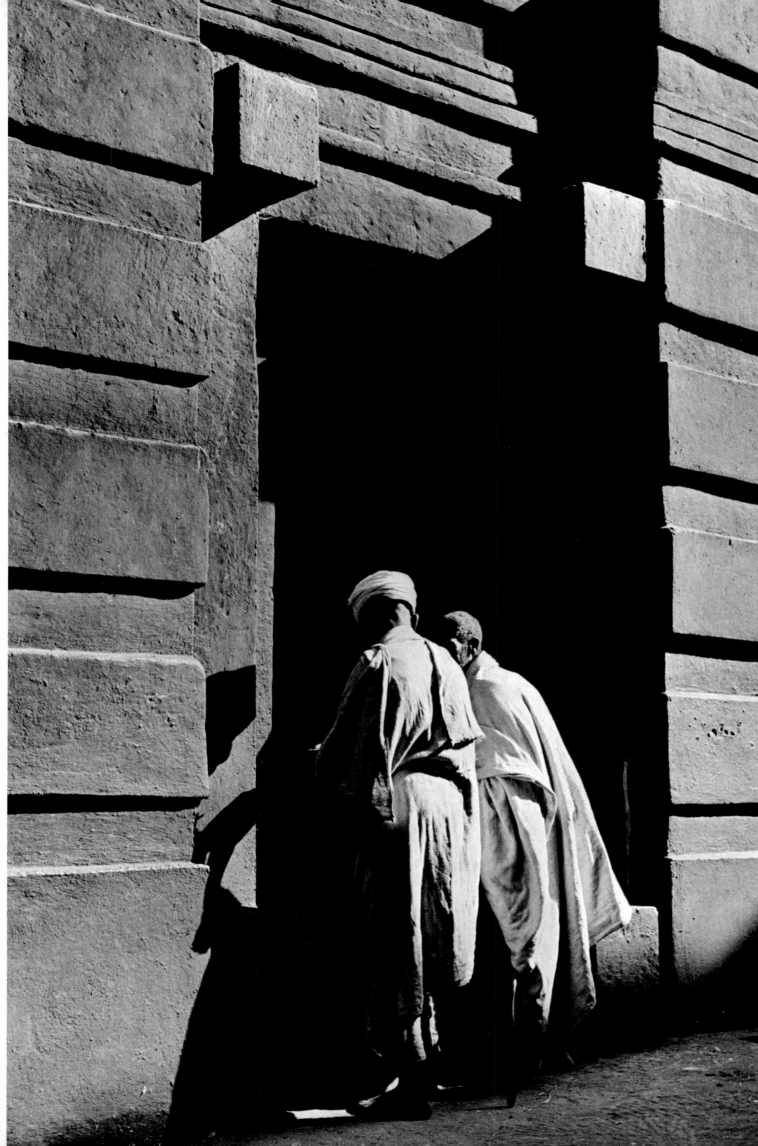

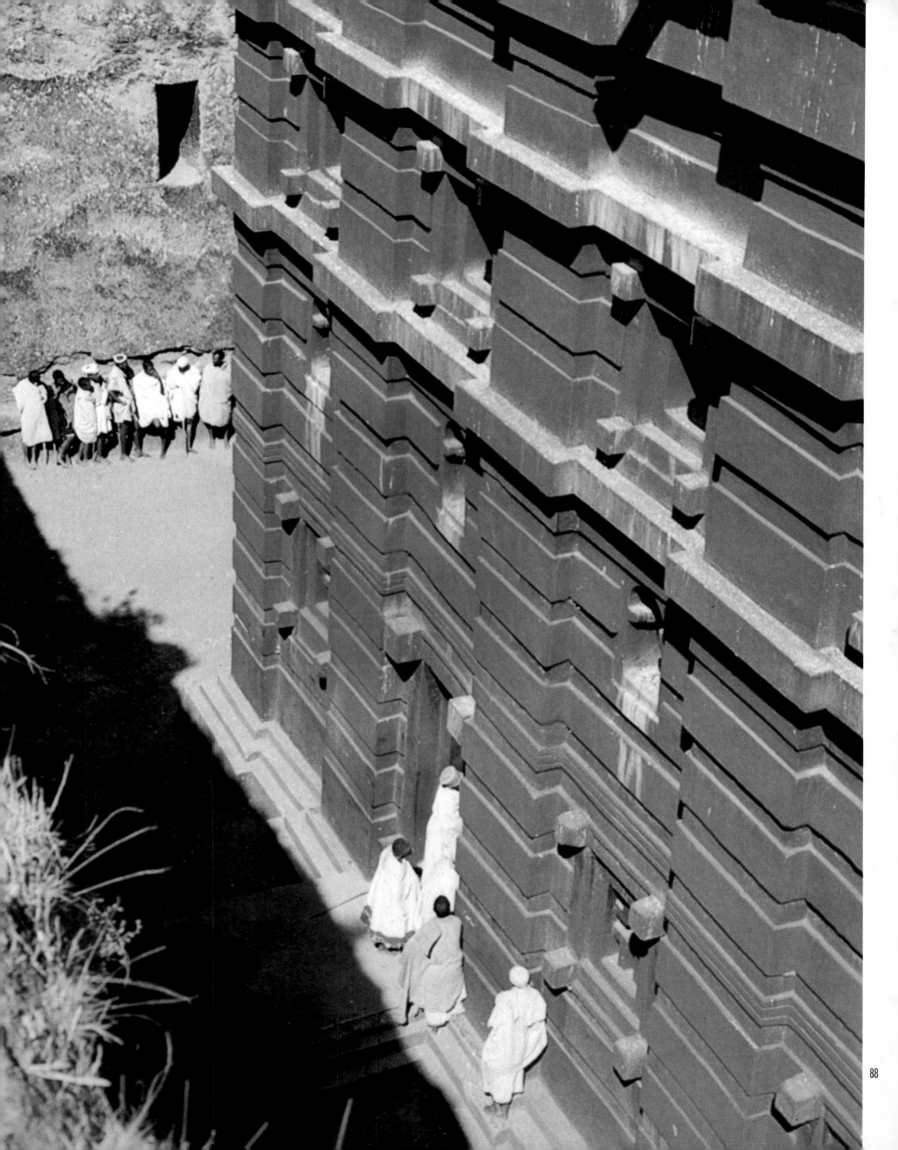

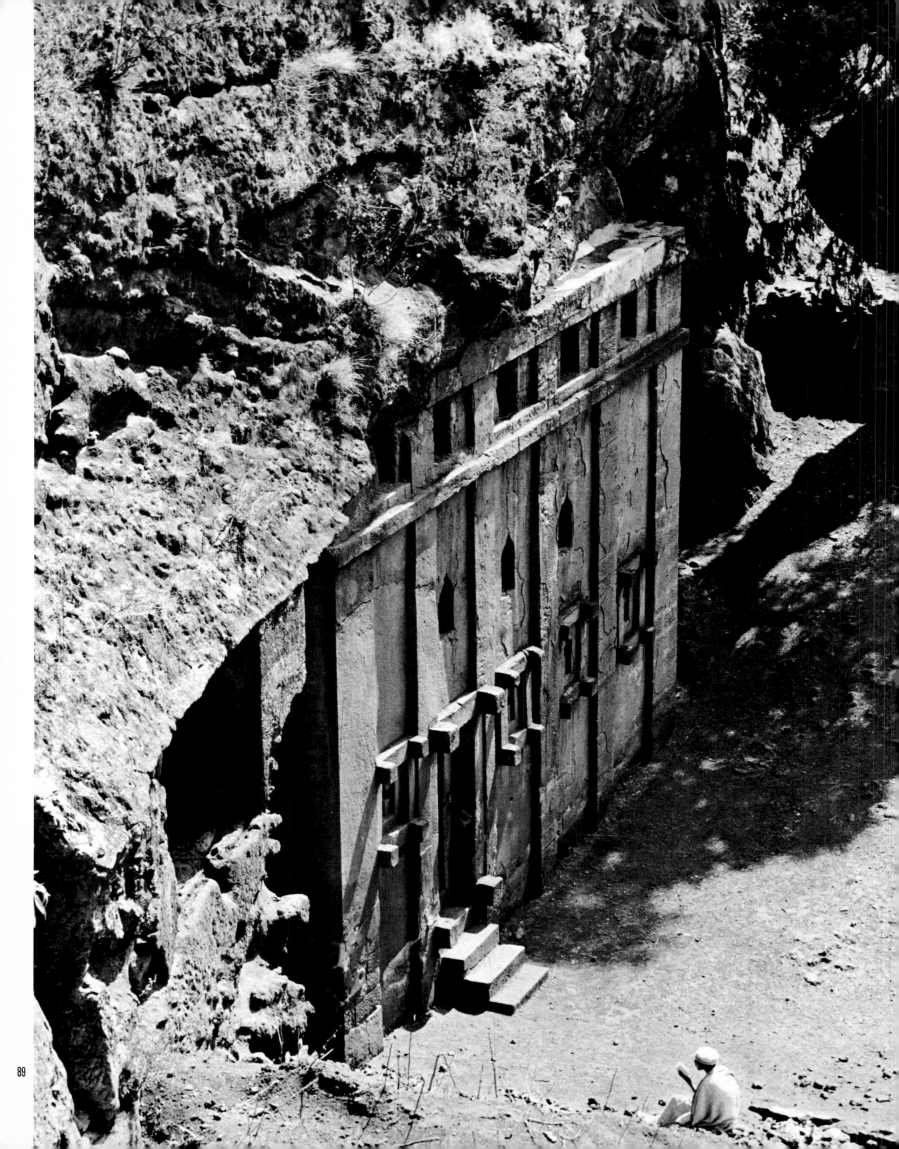

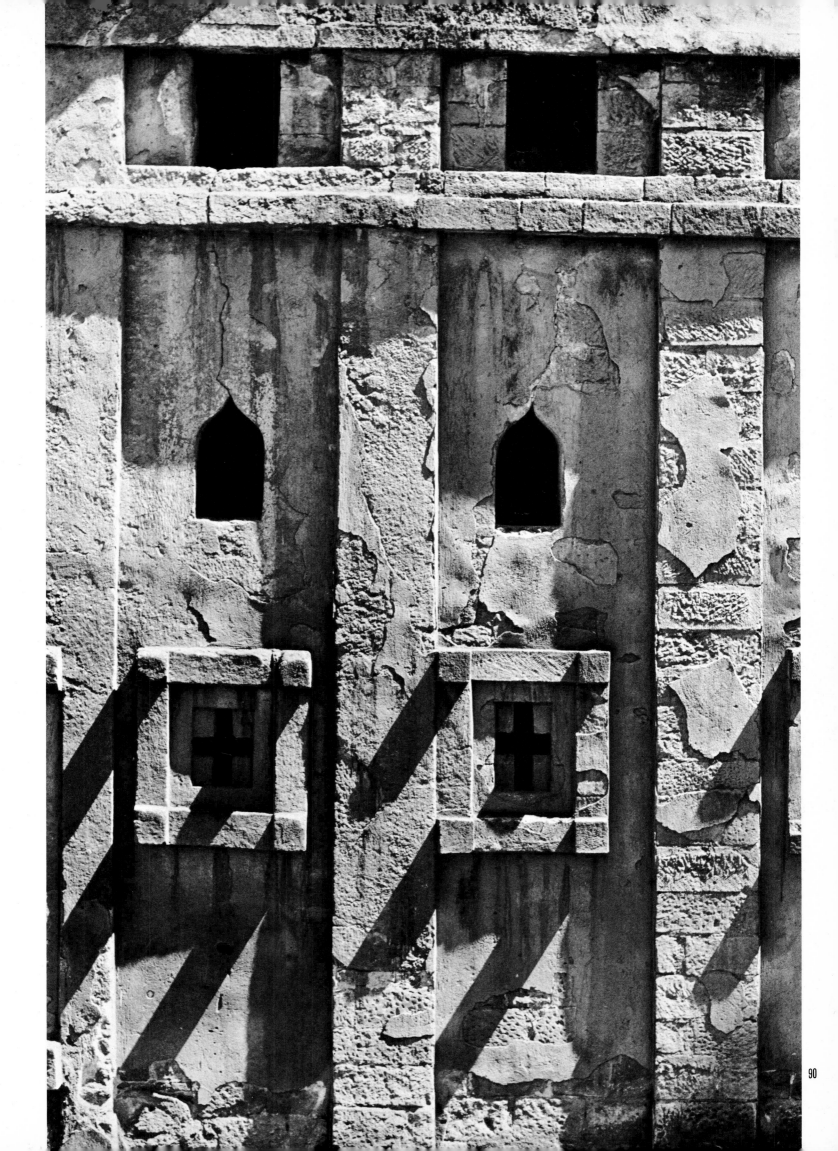

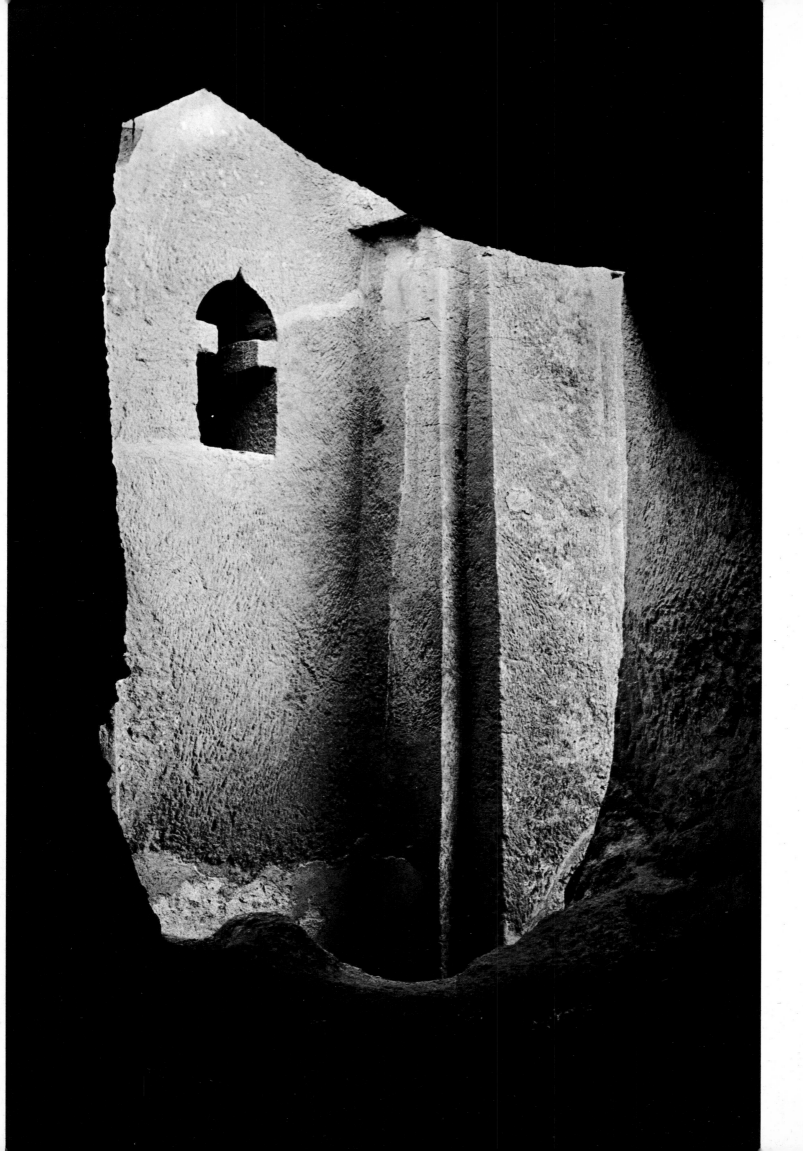

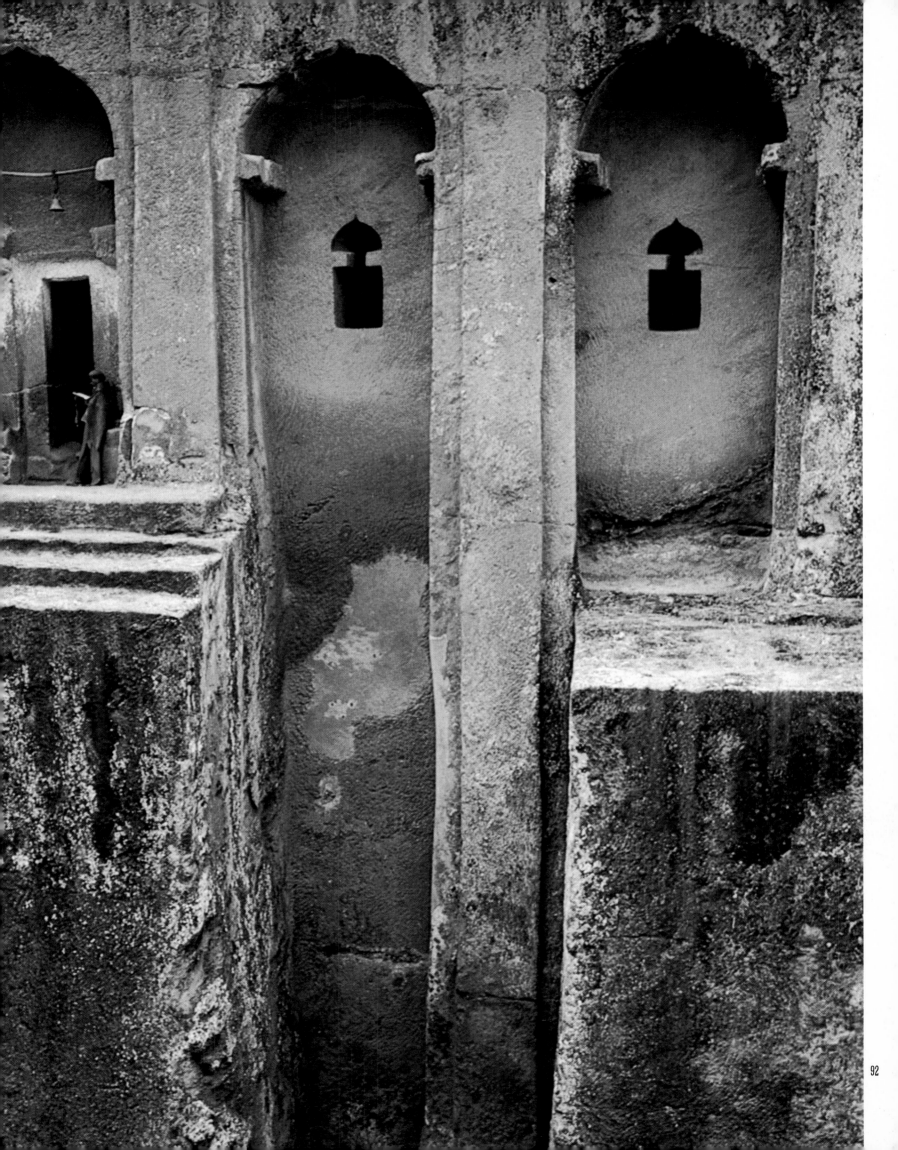

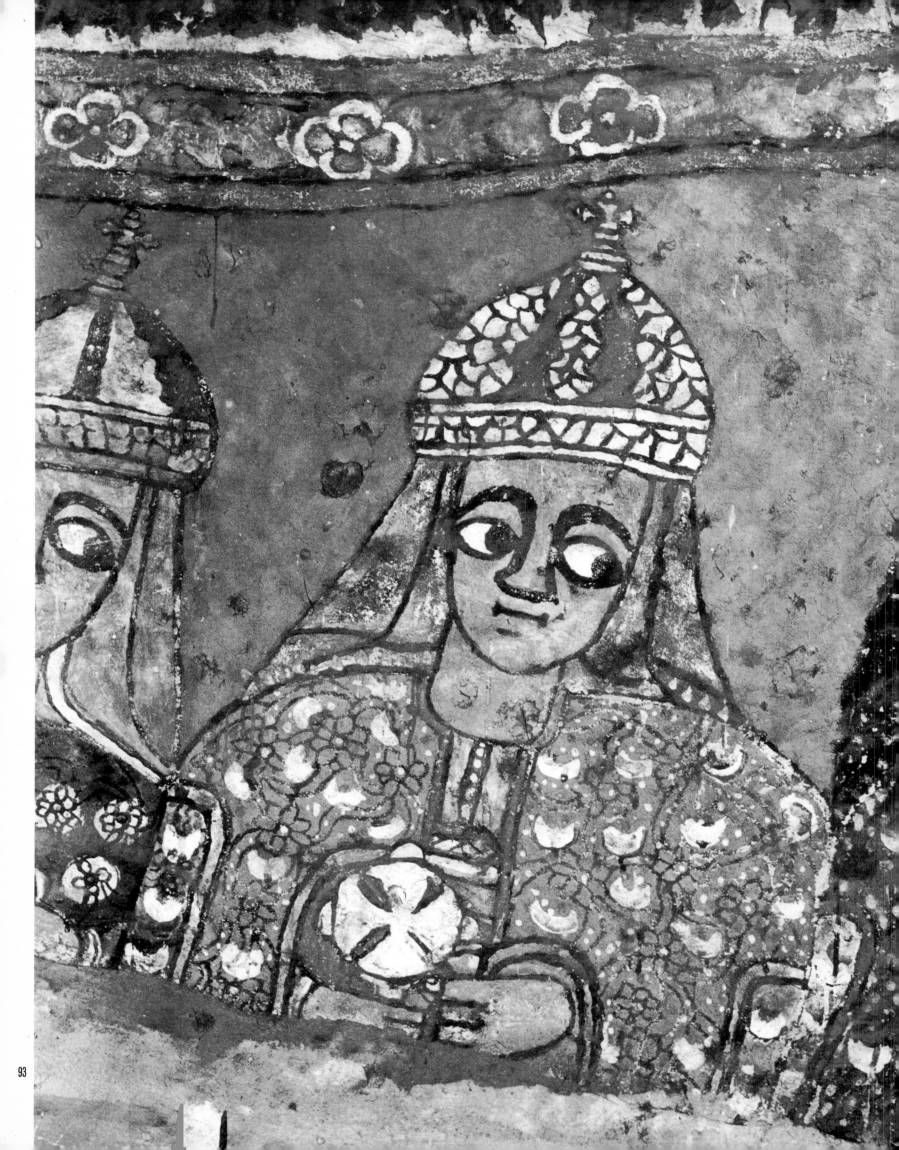

The Churches of Lālibalā, a Wonder of the World

V. Bēta Giyorgis

The 'House of St George' is situated a few minutes walk to the south-west of both groups of churches, on its own and secluded (fig. 42). Tradition bases this remote location on a legendary event: after the completion of both groups, the equestrian patron saint of the warlike Ethiopians appeared to King Lālibalā, in full armour and brandishing his sword, and complained that no church had been designed for him. The king promised without delay to offset this omission with the most beautiful church of all. St George seems to have ascertained the seriousness of the royal promise in person at the proposed site; at any rate the monks show pilgrims the prints of his white horse's hooves on the bottom of the pit.

Fig. 71 Sectional isometric view (after *Bianchi Barriviera*)

Fig. 70 Ground-plan (after *Bianchi Barriviera*)

The cruciform plan of the church differs from all other known monuments of Ethiopia (figs. 70, 71). The only comparable form is in liturgical furniture, the manbar (fig. 71, see also pl. 210). I have only come across cruciform manbars within the Zāgwē sphere of influence; perhaps such manbars and the church of Bēta Giyorgis go back to a common model now lost, or the one suggested the other. The church interior is a single cruciform area without free-standing pillars or monolithic altars. From the intersection, round arches with archivolts open on to each arm of the cross. The arches rest on pilasters with corbels and imposts, the decoration of which is the same as that on the pseudo-capitals of the arched windows. The domed sanctuary is three steps above the floor-level of the rest of the area.

No description of this church could omit the word 'elegant'. It is indisputably a well-proportioned testimony to architectural ingenuity and expertise in the working of the stone; perhaps it really is a later work: the creation of sculptors who, in working on the other monoliths of Lālibalā, had refined the technique of sculptured churches to the utmost. Of course, its unusually good state of preservation contributes to the impression of elegance – the result either of being used less and hence having less wear and tear, or of a better quality of tufa in the rock eminence chosen for it. There

Fig. 72 Cruciform manbar

is very little direct borrowing from the Aksumite canon of architecture: the stepped platform as well as the projecting corner beams in doors and windows (of the bottom row) come from that source. Indirectly, however, even the tower-like character of the church is connected with Aksum, the corner towers of its palaces and the tall houses reflected in the multi-storeyed stelae. On the other hand, to derive the ground-plan from the convergence of the four corner towers into the form of a cross is probably going too far. Bianchi Barriviera emphasises the mausoleum-like aspect of the building. In any case it must have been conceived as a church right from the beginning, as is shown by its east-west positioning and the dome over the sanctuary.

Fig. 73 Windows of the upper row

94 Aerial view of the church of Bēta Giyorgis: a cruciform structure, with three equi-lateral crosses one inside the other as roof decoration, rises from a cruciform triple-stepped platform, the shape of which is only broken by the landings in front of the three doorways. The excavated area is 12 m. deep, 19 m. wide and 23 m. long. Above the socle, the church was made from a block of stone 10.6 m. high with a length of 12.5 m. Access is gained by communicating trenches with gateways and tunnels leading into a hallway before opening into the court: the first trench goes from St George's stream, a tributary of the Jordan, up to the bottom of the excavation, whilst the second, which eventually meets the first, comes down from the pit's upper edge. The walls of the rock court are larded with burial niches, cells and – on both sides of the hallway – chambers. In the floor of the court there is a cistern or baptismal font.

95 The church of St George in its pit: no other monument emphasizes the singularity and mystique of the monolithic churches so strongly. Wild olives surround the church's pit, which is cut into a slope slightly falling away to the south-west.

96 The main entrance to the church as seen from the hallway of the subterranean ap-proach: the threshold has two steps, the door-frame has projecting beams and, as a unique feature of this church, there is a most impressive framework on both sides and the top. The flight of seven steps begins two paces outside the hallway.

97 The dome with incised croix pattée above the sanctuary in the eastern arm of the cruci-form church. Shadow emphasizes the base circle of the dome. The features decorating the windows are found in an elaborate form on the outer walls.

98 The flat ceilings in the west, south and north arms of the church are decorated with crosses in relief. In contrast to this, the ceiling of the intersection is undecorated. The internal cornices correspond to the string-courses and multiple mouldings on the outer walls of the church as division into storeys. Similar mouldings are already to be found on the giant collapsed stela in Aksum.

99 The church as seen from the southern edge of the pit. On the north, south and west sides, gutters and spouts drain the water from the roof. The spouts were made from stone reserved from the block during the building of the church. The nine windows of the bottom row, with imitations of the Aksumite framework, are blind, and do not appear on the inside of the wall. The twelve windows of the upper row correspond to those in the Church of Golgotha (pl. 83): they both have ogee-arches crowned with a semi-palmette-cross motif. The decoration of their pseudo-capitals is, however, quite divergent; in the case of St George's it is seemingly without architectural sense, and strengthens the tradition that this church is later than the others.

Selected Sources

Sauter, no. 43.

94 Aerial view of the church of Bēta Giyor-gis: a cruciform structure, with three equilateral crosses one inside the other as roof decoration, rises from a cruciform triple-stepped platform.

95 The Church of St George as seen from the northern edge of the pit.

96 The main entrance of the church as seen from the hallway of the subterranean approach.

97 The dome with incised croix pattée above the sanctuary in the eastern arm of the cruciform church.

98 The flat ceilings in the west, south and north arms of the church are decorated with crosses in relief.

99 The church as seen from the southern edge of the pit.

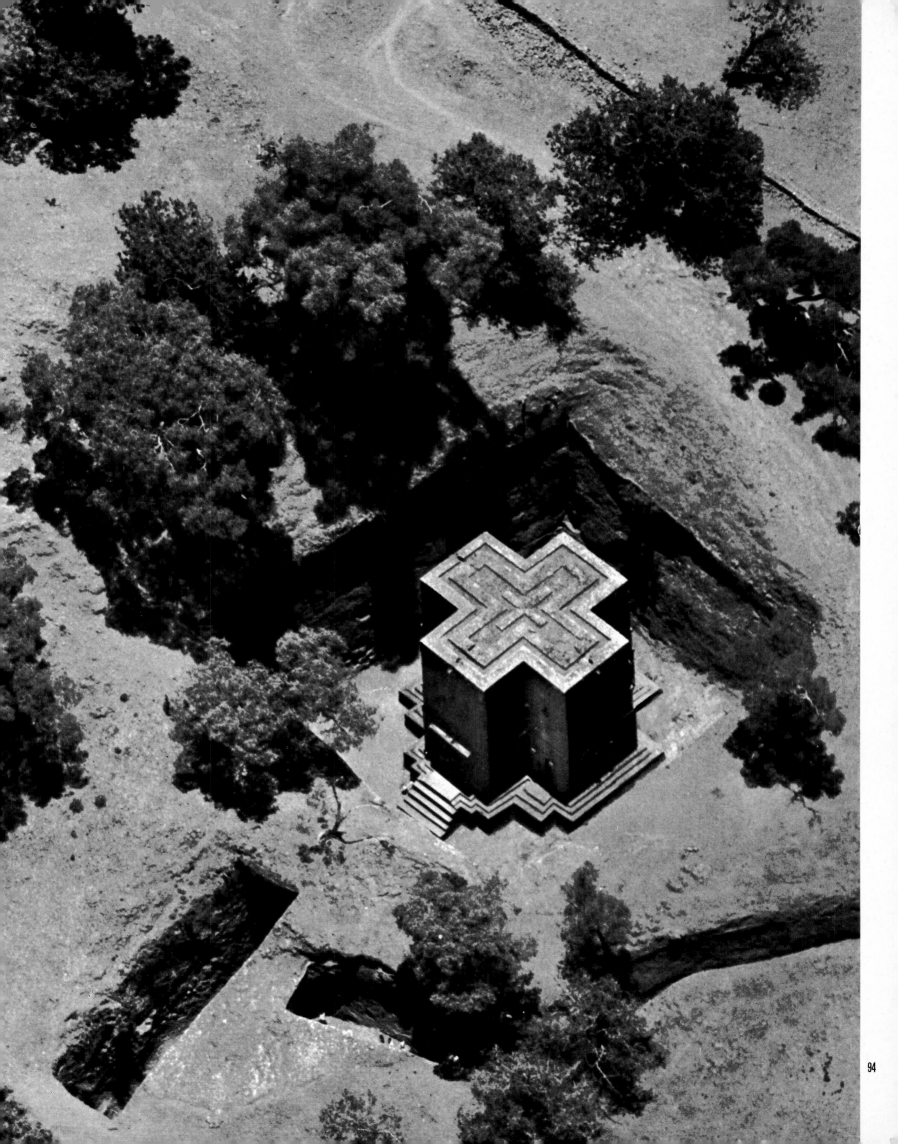

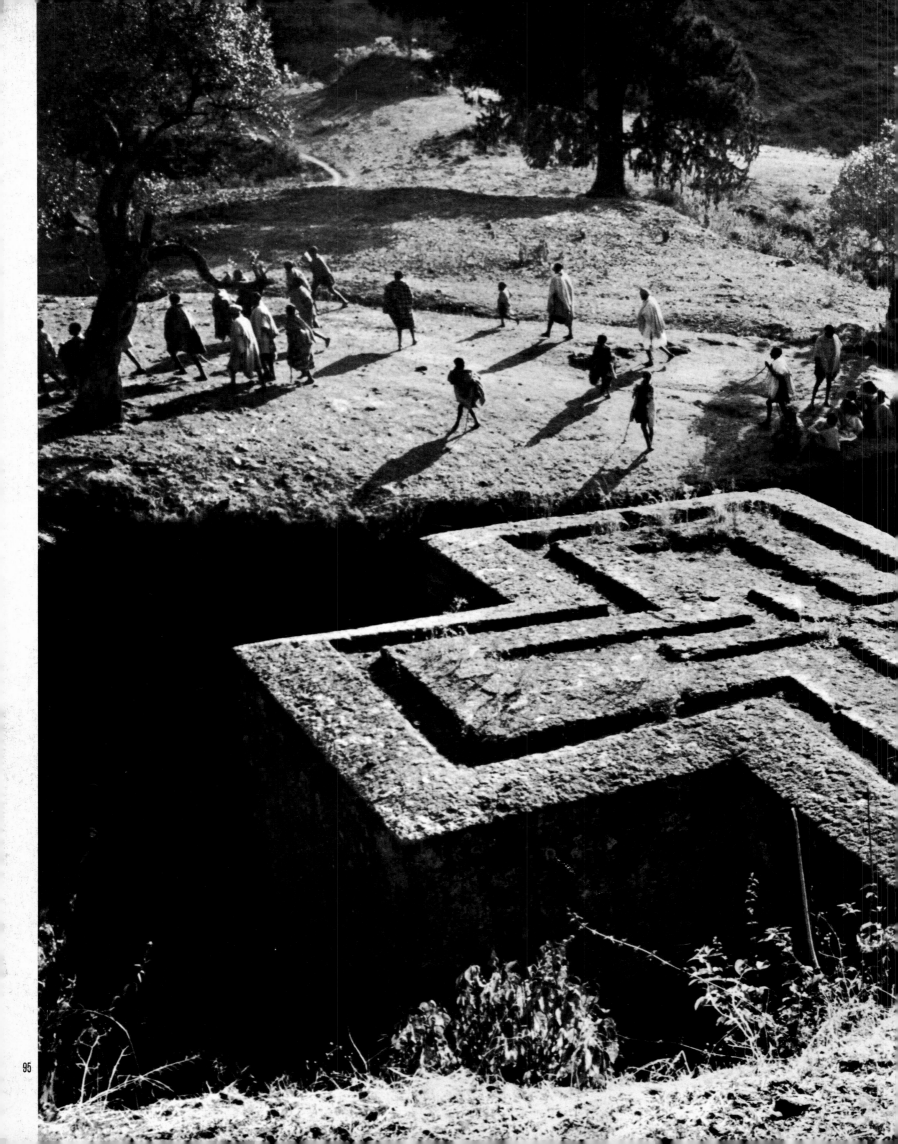

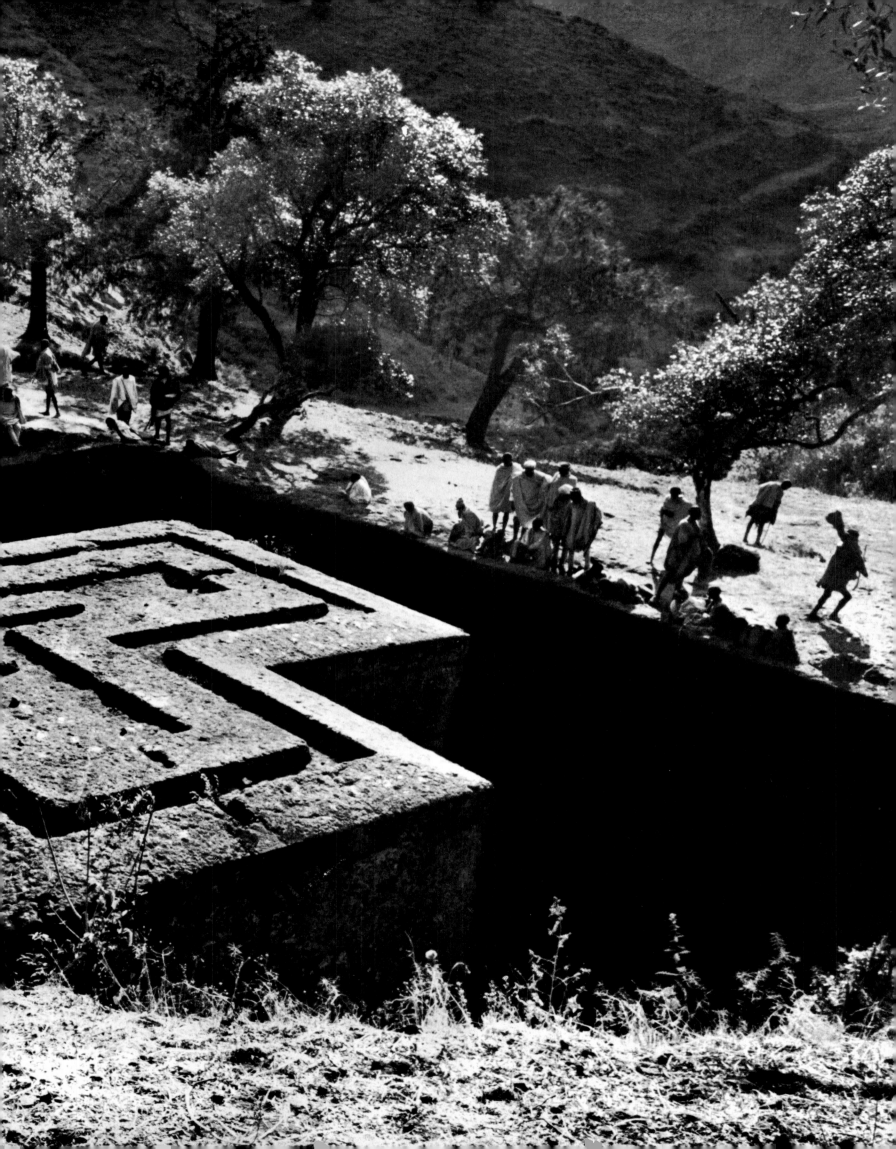

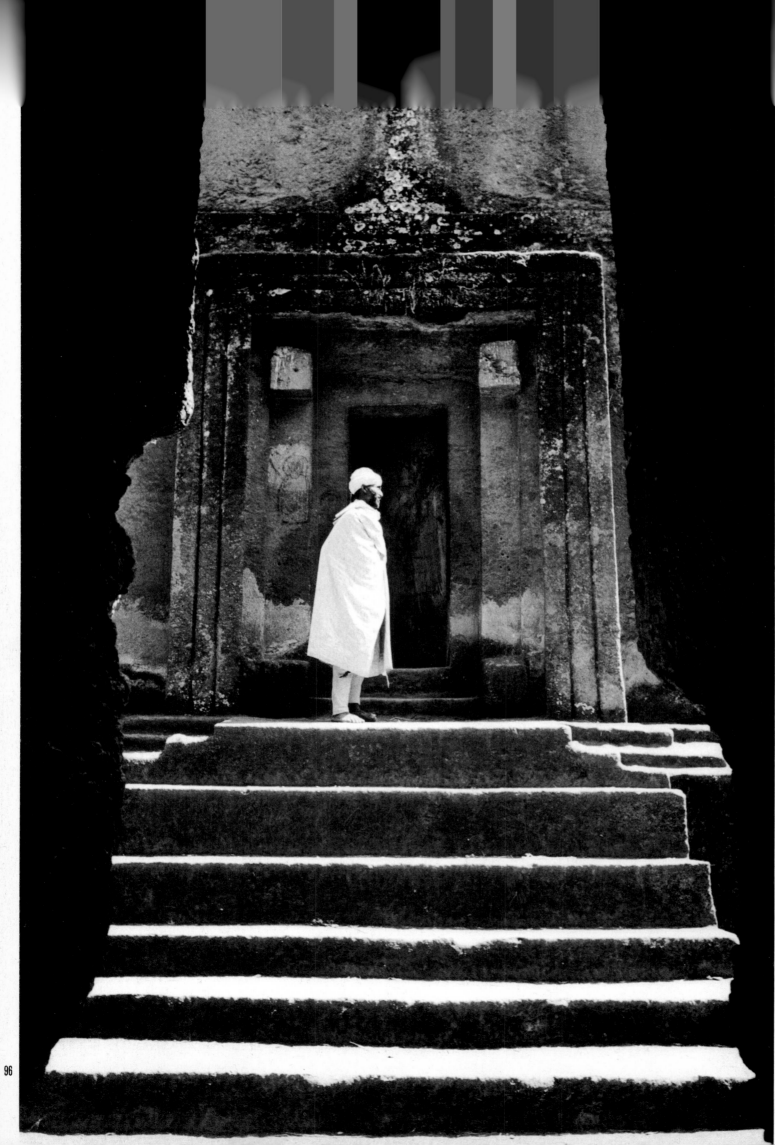

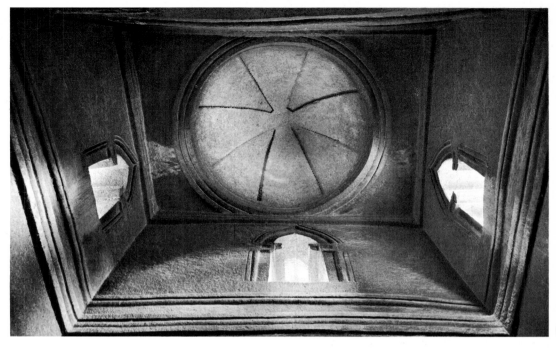

97

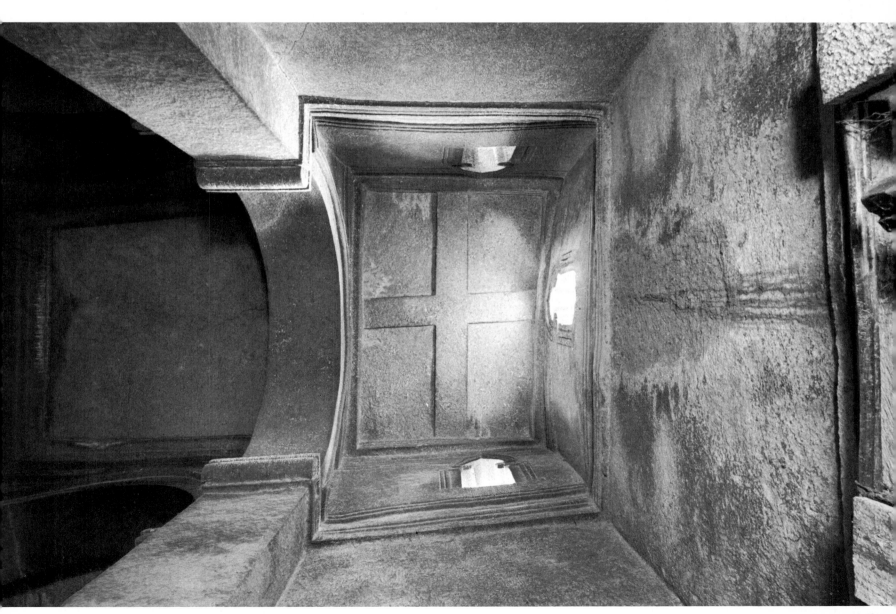

98

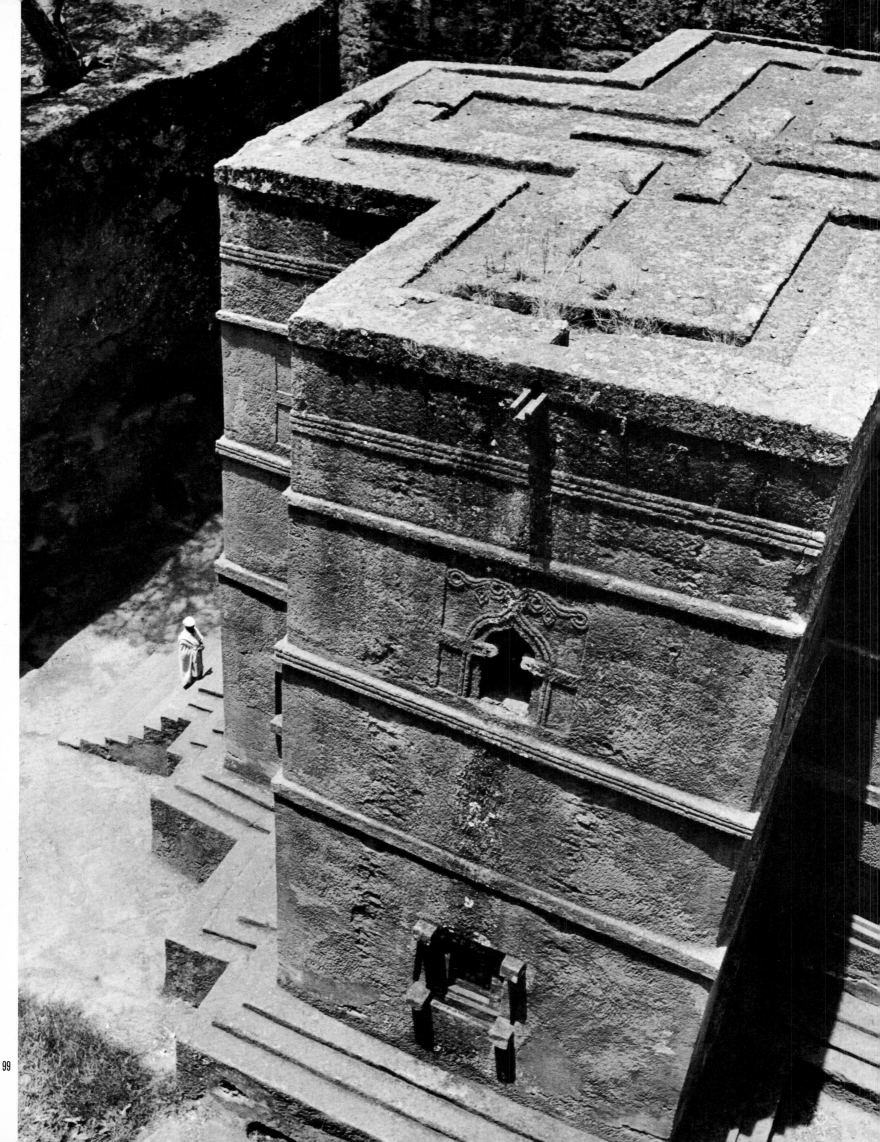

Makina Madhanē 'Ālam and Yemreḥanna Krestos

No less amazing than the sculptured monolithic churches are Ethiopia's built-up cave churches, which are to be found in the home country of the Zāgwē. The two oldest and most impressive are situated on different spurs of the mountain ridge forming a peak in Abuna Yosēf, near Lālibalā. Makina Madhanē 'Ālam is east of Lālibalā, about two hours climb above Gannata Māryām, (p. 115) and Yemreḥanna Krestos is six hours on foot and mule to the north-north-east. The mule path crosses bush mountain pastures on which grow gnarled, pinnate-leaved koso trees, from the flowers of which the Ethiopians make a decoction to cure tapeworm. However, owing to the low temperature and the steep climb, interruptions for this purpose are rarely made on expeditions to these two churches. Alvares, who was the first European to visit Yemreḥanna Krestos, for a time thought that he was on the point of death from breathlessness and cold, and today the same diagnosis is often made. In the sixteenth century, a strong slave pulled the Portuguese priest over the mountain on a rope. Needless to say, this method is no longer practised.

The church dedicated to the Redeemer of the World – Madhanē 'Ālam – is set in a huge gaping cavern in the eastern slope of Makina, a spur of Abuna Yosēf. This church, more or less oriented, exhibits a modification of the Aksumite 'sandwich' construction which is virtually unique in Ethiopia: here, instead of alternating masonry and wood, there are polished wall sections of levelled-off rubble between layers of dressed blocks of reddish tufa. As one would expect in the case of a wooden frame-work, the latter are set back slightly. A cornice of dressed stone of similar workman-ship but modest dimensions crowns the striped masonry. The building above this is built of rubble or (as in the case of the roof and dome) is a wood construction plastered with čeqā. The windows in the striped masonry have wooden frames with sharp-edged monkey-heads, although some of the frames are incomplete, badly pre-served or less carefully executed. The main entrance in the west fulfils the require-ments of the Aksumite building canon by having a wooden framework of beams and monkey-heads. In contrast to this, on the side entrances the lower monkey-heads are missing: two dressed stones projecting over the face of the wall give rather a bad imitation of the upper ones. (One could not expect binders with true, i.e. round monkey-heads, in a building without a wooden frame.) Above the windows in the striped masonry there are, with the exception of the sanctuary window with all the Aksumite accessories, the plainest of openings. In describing a church nearby, Makina Ledata Māryām (Sauter, no. 56) which is also a cave church, Miquel, referring especially to its close relationship to the Church of the Redeemer, makes the following statement: 'The Arab influence is undoubted: it is like any Moslem tomb, especially the sepulchres of Damascus. Perhaps we have here a mausoleum built by Aḥmad Grāñ and subsequently transformed into a church.' There can be no question of this in either of the churches in this locality. Both stand in the tradition of basilican church construction as it is known in Ethiopia in built-up, excavated and monolithic churches. The church of the Redeemer has a nave and two aisles. The aisles are flat-roofed; the nave, rising considerably above these, lies under an open raftered roof – a saddle-back roof with a rounded ridge. Architraves, each held up by one pillar, support the upper walls of the nave, from which a wooden sanctuary arch leads into the Holy of Holies. This is surmounted by a wooden dome of curved rafters. There are no porches or galleries, though their absence cannot be attributed to lack

of space in the cave. Architectural decoration is restricted to the wooden parts: reliefs on the architraves and front of the sanctuary arch; a frieze of metopes without window openings, above the epistyle; bracket capitals and imposts beneath the roof-beams and decorative bosses upon them. The church's painted decoration is rich and noteworthy, even though it is largely in poor repair or damaged beyond recognition. It consists of geometrical designs on the outer surfaces of the sanctuary arch, on the underside of the architraves and roof-beams, on the bracket-capitals, in the metopes and in the spaces formed by the purlins and rafters of the roof-planking and by the lath-work of the ceiling over the aisles. Most notable of all, however, are the frescoes with predominantly figurative representations – by the doors and along the aisles, and, in the nave, on the upper walls and in the stone-lined triangle formed by the gable. Some of the paintings seem to be of recent date, particularly a hunting scene; on the whole, however, both building and decoration are contemporary. Particular features of style are reminiscent of the painting in the church of Gannata Māryām.

B. Playne, who discovered this church, was misled into dating it long before those of Lālibalā, probably because of the absence of arcades, a characteristic of Dabra Dāmo. The priests support her view: they ascribe its construction to the mythical King of Aksum, Gabra Masqal (sixth century). However the results of research have dated the church nearer the time of Lālibalā or even later. Indications of a 'late style' are undeniable: absence of plinth and narthex; the imitation, technically inappropriate, of the wood and stone method of construction; the employment of conventional features of construction divorced from their original purpose, such as corbels without anything to support and monkey-head binders without anything to bind. The neighbouring Church of Ledata Māryām, which according to local tradition is also a foundation of Gabra Masqal, seems to have been constructed by builders several generations later.

The descent through the juniper wood, with streaming wisps of lichen, prepares the visitor for the sanctuary bearing the name of the Zāgwē king, Yemreḥanna Krestos ('Let Christ be our guide').

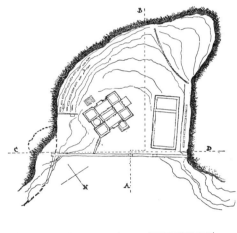

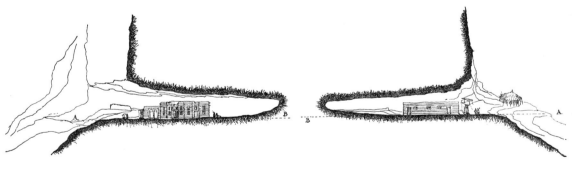

Fig. 74 Plan and sections of the cave of Yemreḥanna Krestos (after *Bianchi Barriviera*)

The church shares the cave, in which it glistens like a jewel in the gloom, with a second building (fig. 74). Rectangular, with two doors and two rooms, and striped walls like those in the church but without the interruption of the surface area of the wall, its scholarly importance lies in its being the only example of secular built-up architecture (dwelling?) of the Zāgwē period. Today it is used as a treasury and a lumber-room. Behind a little dry-stone wall at the back of the cave are scattered bones and also whole shrivelled up corpses wrapped in matting and rags. For centuries, monks and nuns have favoured this hallowed cave as a place of burial. To the foreign

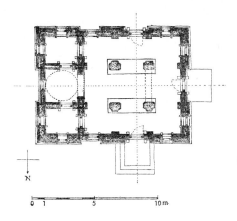

Fig. 75 Yemreḥanna Krestos: ground-plan (after *Bianchi Barriviera*)

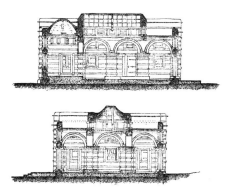

Fig. 76 Transverse und longitudinal sections (after *Bianchi Barriviera*)

Fig. 77 Islamic ornament on a decorated beam

inquirer, however, the priests glibly make the macabre collection out to be the sacrifice of an encounter with the Grāñ. Or else, their imagination carried away by the word 'mummy', they explain them as the remains of Egyptian slaves, the building labourers. They hold a grave on the northern side of the church in especial awe as being that of its founder. However questionable our knowledge of Yemreḥanna Krestos may be – whether he in fact lived and, if so, when; whether he was a predecessor of Lālibalā, as the majority of the chroniclers assert – the church perpetuating his name is undoubtedly regal (figs. 75, 76). It is oriented and stands on reddish dressed stone. Angels are supposed to have procured this from Jerusalem, but Alvares found the quarry for it, which still had traces of the stone-chisel, not far from the cave. Alternating in strips on its walls are white plastered layers of rubble bedded in mortar and slightly inset horizontal beams of wood dark with age. Vertically the wall is divided by projections and indentations which reflect the internal divisions. The projections at the four corners, a feature of the oldest Aksumite building tradition, are characteristic of this church. By continuing the wall upwards in these parts they are made into proper corner towers. Without exception, all the windows and the three doors have frames with projecting corner posts. True monkey-head binders, however, are lacking as they would be technically superfluous, since the corner overlapping of the horizontal beams wherever the surface of the wall is broken, as well as the corner-pieces of the doors and of the unusually numerous windows, which interlock with the horizontal beams, bring ample stability to the wooden framework. In the interior of the church, with its flagstone floor, nave and two aisles, the striped walls are quite bare. The two pairs of pillars and the pilasters have the same patterning: the former being built of layers of light and dark stone, the latter in the stone and wood technique of the walls; in these, however, as in the pillars, the dark stripe projects – not the light one as in the walls. The arches which, with the exception of an archi-trave between the first pair, join the pillars to each other and to the pilasters seem to be made of stone partially covered with wood. All parts of the church above them are made of wood: the low flat ceilings of the aisles and the first bay of the nave which takes the place of the vestibule; the frieze of metopes which runs around the upper walls surrounding the nave and in which two 'metopes' on each side form windows above the roofs of the aisles and lead into the open, i.e. the cave; the saddle-back roof with open framework above the second and third bay; the dome over the sanctuary which has a raised floor. The dome and saddle-back roof, both superstructures visible from the outside, are placed between the corner towers. The arches and other wooden parts of the interior are profusely decorated with carvings, marquetry and paintings – the latter directly on to the wood or on to the stucco-like plaster. This decoration – including the ornamented beam above the lintel of the south entrance (fig. 77) – poses the problem of cultural relations with the world of Islam.

Buxton considers this church to be a kind of link between Dabra Dāmo and the monolithic churches such as Bēta Amānu'ēl in Lālibalā, and agrees with tradition in dating it to the twelfth century. Although there is nothing against this dating, there is not much positive evidence in its favour – perhaps even less than Buxton supposes. For example, the frieze of metopes in Yemreḥanna Krestos – as a means of admitting light – seems much closer to its original function than in Dabra Dāmo, where it is already formalised as a purely decorative feature. The corner towers, too, seem to go back beyond Dabra Dāmo. Apart from such objections, even if Yemreḥanna Krestos is an intermediate type between the churches already mentioned, it can hardly be demonstrated how and when, as a building in the intervening period, the church is to be located. It seems that over the centuries the Ethiopian builder had the choice of architectural patterns which arose from each other, and yet continued an equivalent development individually.

A recent construction of another cave church in the neighbourhood (Sauter, no. 52) is dedicated to Na'akweto La-'Ab, the last of the Zāgwē kings.

100, 1 The Church of the Redeemer in the mouth of its cave. A dry-stone wall with gatehouse protects the entrance to the cave. A second wall surrounds the west, north and east faces of the church, which is about 4.5 m. high, 8.3 m. long and 6 m. wide. During divine service the small open space in front of the west end acts as a choir owing to the lack of a proper vestibule. The beam-heads of the raftered roof above the nave are visible from the outside – indicating that the interior bracket capitals under the roof beams are there purely for visual effect.

102 Painted ceiling decoration above the right aisle of the Church of the Redeemer. Swastikas and typically Islamic patterns (pl. 47) decorate the roof beams and the parts of ceiling between the lath work.

103, 4 Sun and moon in the gable space above the sanctuary arch and above the lintel of the main entrance. The pictures in the gable are identified by inscriptions: as in most Ethiopian pictures of the crucifixion, the sun is on the right and the moon is on the left. To what extent the simile of the moon equalling the Church holds good in such a juxtaposition (on the grounds that Christ equals the Sun) remains questionable. In churches where there are pictures of unidentified, single heavenly bodies, they may unhesitatingly be regarded as the sun, especially when they are on the right of the central axis of the church area (pls. 72, 134, 136).

105 Cocks – fighting? – next to the sun above the main entrance; a second pair of fowl is next to the moon, opposite. In the Christian symbolism of animals the cock is not only a symbol of Christ and the resurrection, but also of the priests as the rousers of sleeping souls. The bestiaries even excuse his pugnacious tendencies: they consider him to be a model of the good Christian who fights for the salvation of his soul.

106 Saint and cross beside and above the southern side-entrance. The croix pattée, like the Teutonic cross above the main entrance, has arms of different lengths.

107 Figure from the legend of St George within an architectural framework with side-supports sprouting branches. The inscription refers to one of St George's miracles: 'The widow in whose house George made the pillars come into bloom.' The artist has depicted the woman in an attitude and dress indistinguishable from those of the saints on the other side of the adjacent entrance.

108 Clean-shaven saint with hand-cross: excerpt from a frieze of largely unidentified personages with haloes, in the right aisle. Their hands, in a devout attitude in front of their breast, appear from beneath a wrap in the middle of which the undergarment shows through. For the clothing see also the frescoes of Guḥ (pls. 188–191).

109 Mood of breathtaking peace: a new day in the highlands. The sun illuminates the cliffs of Abuna Yosēf; the circular hut and trees on the mountain terrace in front of the cave church of Makina Ledata Māryām are still in the shadow.

110 Yemreḥanna Krestos: window of the north façade with pierced stone filling, seen from inside the church. For a view of the cross and arch motif from the outside see plate 111.

111 The gloom of the cave increases the decorative effect of the striped walls of the Church of Yemreḥanna Krestos: the north-eastern corner tower and the adjacent indented section of the wall of the north façade. Wood and stone fillings alternate in the windows of the two visible rows. In the great majority of cases they are pierced right through, but in several false windows they are just done in relief. The true windows can be shut on the inside with shutters. No two filling designs are exactly the same.

112, 3 Interlaced designs in the wooden and stone windows of the east end: the carved quarter-light of a window in the bottom row (fig. 78) and – beneath a fillet decorated

Fig. 78 Window in the eastern façade

Fig. 79 Mythical beasts (upper panel after *Monti della Corte*)

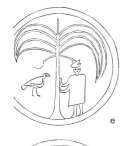

e

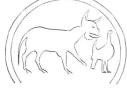

b

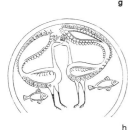

g

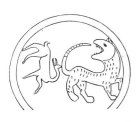

h

Fig. 80 Medallions on the ceiling of the vestibule (first bay of the nave)

with dog-tooth and diagonal incisions – the pierced filling of a window in the second row. Both filling motifs have Islamic models. In particular, the ornament made up from the intersection of a complete circle with segments of circles is frequently seen in wood on the pulpit of mosques and as tooling on the bindings of Korans.

114 The cave church of Yemreḥanna Krestos and its treasury beneath the rock ceiling. Mourners accompany the deceased to the grave. A wall of rubble and earthen mortar shuts off the cave's opening, which is 45 m. wide. Its height and depth do not, as it happens, support Alvares' claim that it could accommodate three large ships including their masts. Straw bound with dove's dung covers the floor. According to tradition, the founder of the church once lived in the secular building which now serves as the treasury. The 6 m. tall corner towers of the church, which is about 12 × 9.5 m. in size, practically touch the roof of the cave. Nevertheless its cramping effect on the layout of the church, which Buxton points out, is not visible at all from the outside. The large number of windows counteracts the darkening effect of the cave and the clump of trees. The wall which was later erected in the 'sandwich' technique between the north-east corner of the church and the wall across the mouth of the cave support the bells in a twin-arched opening.

115, 6 Mythical beasts, the second one in front of a tree, painted on panels of wood. The panels, which are nailed to the lintel of the northern entrance, derive from some foreign object, perhaps a casket taken as booty during the wars against the neighbouring Islamic states, and dedicated to the church. The Indian or Persian affinities were already obvious to Monti della Corte, and Monneret de Villard discussed the panels in a note on works of the 'Deccan' style. The miniatures in early Arab compilations of ancient Indian myths should come within the sphere of discussion, as also, probably, should the guardian animals in front of pagodas. Two panels (fig. 79) – probably one side and the lid of the casket – were handed over to the Italian expedition in 1939 but these were lost during the war. The priests keep silent about the whereabouts of the fifth one reported by Monti della Corte.

117 The saddle-back roof with open truss above the second and third bays of the nave. Obviously the cave hindered its construction. The ridge is more definitely flattened than it would otherwise have been and the base lines of the slope of the roof have been shifted into the church. Tie-beams and the connected uprights have decorative bosses; purlins and rafters form coffers on the surface of the roof. The frieze of metopes completely fills the upper walls of the nave – also a result of the compressing effect of the cave. On each side the frieze contains two windows, and the middle one of the three metopes on the altar side may originally have been an opening for light. In contrast to the coffers, its decorated surface is not only painted but carved as well.

118, 9 Rosettes in entwined strip on the soffits of arches in the arcade. The stone arches are painted over a coating of plaster. The rosettes contain crosses with fioriture and stars of David. Hexagrams and sarcelly crosses are also found in the decoration of St Mary's in Lālibalā (pls. 66, 67). Whilst there they seem to be religious symbols, in Yemreḥanna Krestos their ornamental significance seems to be more important. Such decoration with rosettes is likely to be found in any mosque – actually one encounters the crown rosette of plate 119 in the great mosque of Kairouan (ninth century).

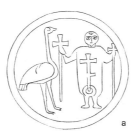

j

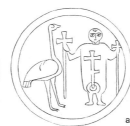

i

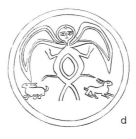

a

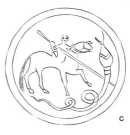

d

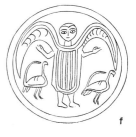

c

f

120 Flat wooden ceiling with inlaid double crosses and squares above a bay in the right aisle. Inlay work is foreign to Ethiopian art, though it is a very popular means of decoration in Islamic art. The technique of marquetry itself indicates a foreign origin: the juxtaposition of inlays takes into consideration an extreme change between a dry and humid atmosphere as determined by the Egyptian but not Ethiopian climate.

121 Painted elephant on an inlaid ceiling (portion). Inlaid squares form hexagons on the ceiling above the second bay of the left aisle – in front of the north entrance. Painted rosettes of Islamic origin, stellate flowers, stars of David and four figurative motifs – elephant, rider on horse-back, lion with a bird and also a running bird outside the section shown here – fill the star-shaped areas. The Christian symbolism of animals rates the elephant as the most religious of all creatures. In particular its sexual inertia is attributed to modesty.

122–8 Painted medallions on the flat ceiling above the first bay of the nave. 122: Lion biting at its tail. 123: Square-rigged boat with a lamp on the bow and a net astern on a night fishing trip. Simon, James and John in an unsuccessful attempt prior to the miraculous draught of fish (Luke 5: 1 ff.)? The simulated inlay of the ornament framing the medallions is just as Islamic as the type of ship and rigging are characteristic of Christian sea-faring. 124: Winged worshipper with peacock and scorpion. 125: Two wild cats (lions?). 126: Riders on an elephant. The mahout in front, with two passengers in the howdah, the rear one with a stick. Frumentius and Aedesius in India? 127: Hybrid, half vulture, half man. 128: Rider with a switch in his right hand and his left hand on the reins. Fig. 80 illustrates further medallions: (a) man with crosses on staves near an ostrich, (b) dog-like creature, (c) dragon-slayer, (d) bird-bodied angel in attitude of prayer with two hares, (e) man and bird under a palm tree, (f) winged worshipper with two peacocks, (g) lion and gazelle (?), (h) two peacocks and two fishes, (i) double eagle and (j) winged worshipper. Fig. 81 demonstrates the division and arrangement of the motifs on the ceiling. In Yemreḥanna Krestos one is indeed far from the naturalistic reproduction based on the observation of local fauna that is on the ceiling of the vestibule in Dabra Dāmo (pls. 25–33): we now find the scorpion has several legs too many and the peacock is only distinguished from the ostrich by the strange sweeping tail. No doubt there is now a symbolic meaning for such creatures. The ostrich, which lays its eggs in June, buries them in the sand and forgets them, suggests the devout Christian who trusts in God's help; the peacock, whose flesh was thought to be incorruptible, symbolises the resurrection and immortality of the soul; fish, lion and eagle are Christological symbols.

129 Mountain juniper (Juniperus procera) shrouded in lichen: the men stand like statues beneath the giant trees and conceal their hands under the šammā, propping themselves up on their sticks as if on a third leg. The juniper wood creates the gloom of a sacred grove around the church of Yemreḥanna Krestos in its cave.

Additional sources

Makina Madḫane ʿĀlam: Sauter, no. 57; Yemreḥanna Krestos: Sauter, no. 33.

On the Church of the Redeemer: Playne; Miquel.

On Yemreḥanna Krestos: Alvares (Beckingham); Monti della Corte; Buxton, *The Christian Antiquities . . .*; Bianchi Barriviera, *Le chiese monolitiche . . .*; *Le chiese in roccia . . .*

On the mythical beasts: Monneret de Villard, *La chiesa monolitica . . .*, p. 233.

On the Islamic influence: Mordini, *Un'antica porta . . ., La chiesa di Aramò*.

The great mosque in Kairouan: Creswell, *Early Muslim Architecture, vol. 2, pl. 85.*

On the Christian symbolism of animals: Blankenburg; Réau, vol. 1.

On the representation of ships: Moll; Landström.

Aedesius and Frumentius: Hennig.

Fig. 81 Arrangement of the medallions, numbers referring to the plates, letters, to the line drawings

100, 1 The Church of the Redeemer in the mouth of its cave.

102 Painted ceiling decoration above the right aisle of the Church of the Redeemer.

103, 4 Sun and moon in the gable space above the sanctuary arch and above the lintel of the main entrance.

105 Cocks – fighting? – next to the sun above the main entrance.

106 Saint and cross beside and above the southern side-entrance.

107 Figure from the legend of St George within an architectural framework with side-supports sprouting branches.

108 Clean-shaven saint with hand-cross.

109 Mood of breathtaking peace: a new day in the highlands.

110 Yemreḥanna Krestos: window of the north façade with pierced stone filling.

111 The gloom of the cave increases the decorative effect of the striped walls.

112, 3 Interlaced designs in the wooden and stone windows.

114 The cave church of Yemreḥanna Krestos and its treasury beneath the rock ceiling.

115, 6 Mythical beasts painted on panels of wood.

117 The saddle-back roof with open truss above the second and third bay of the nave.

118, 9 Rosettes in entwined strip on the soffits of arches in the arcade.

120 Flat wooden ceiling with inlaid double crosses and squares.

121 Painted elephant on an inlaid ceiling.

122–8 Painted medallions on the flat ceiling above the first bay of the nave.

129 Mountain juniper shrouded in lichen: the men stand like statues beneath the giant trees.

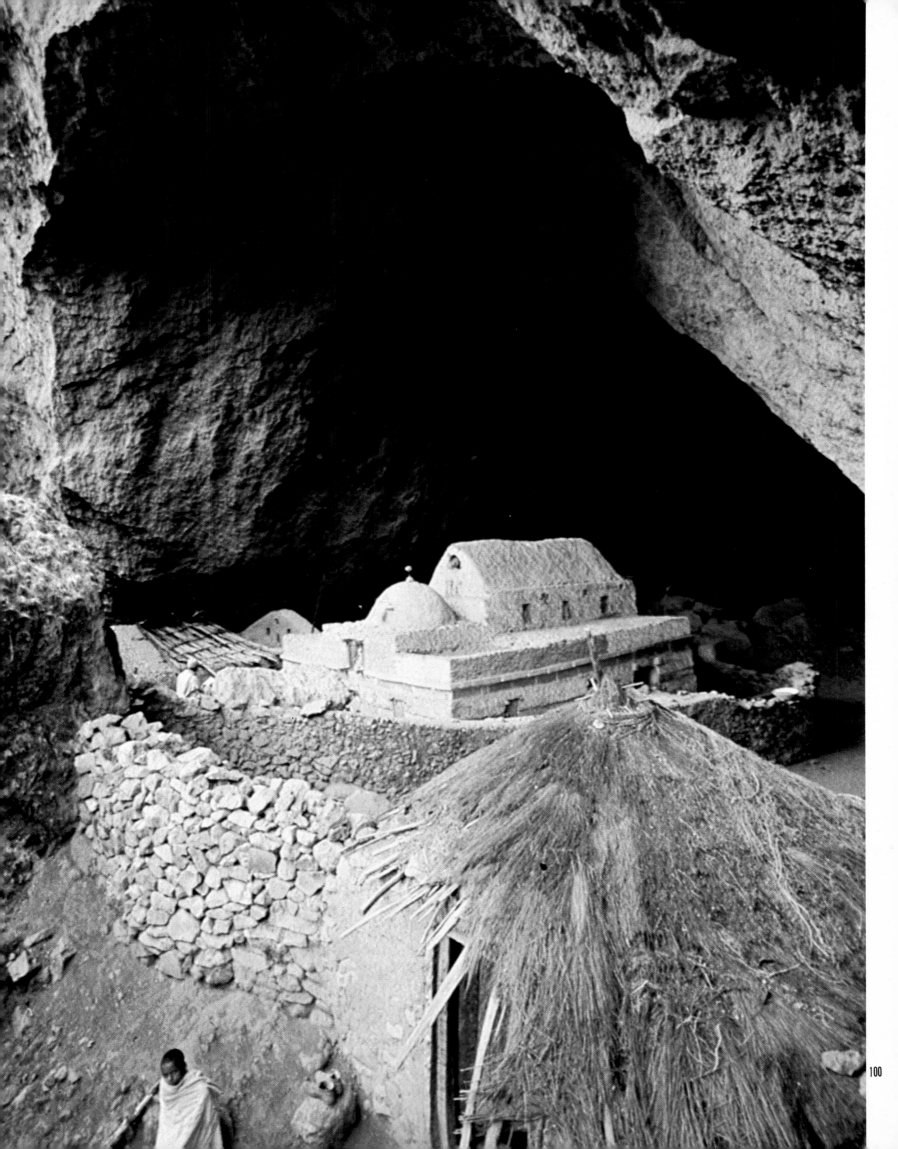

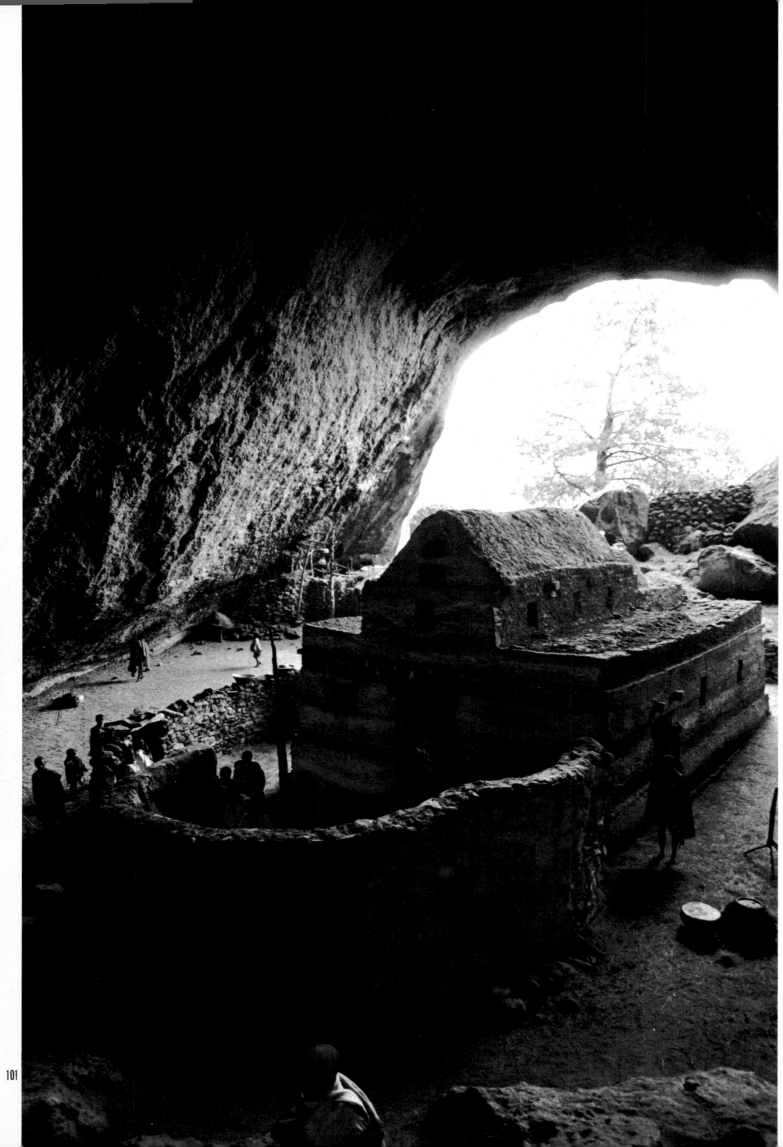

102

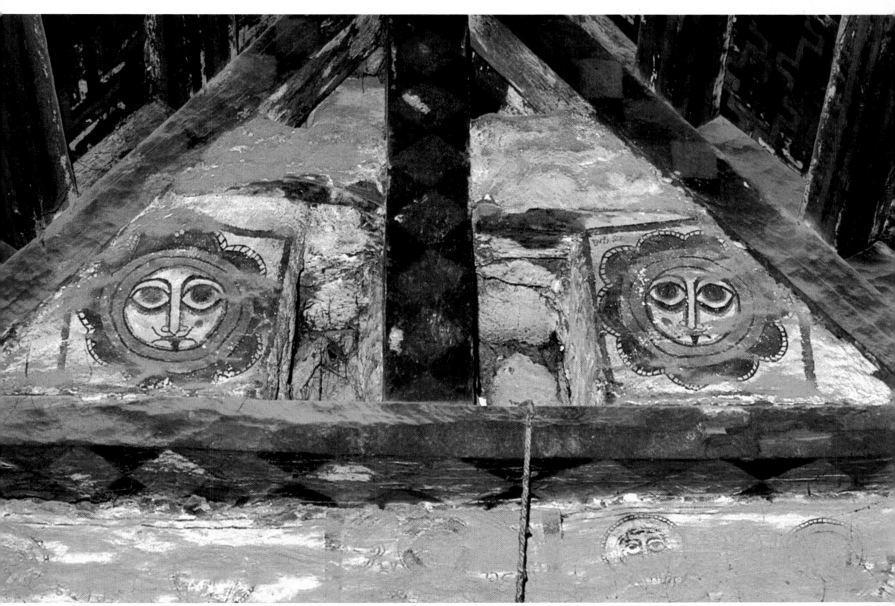

103

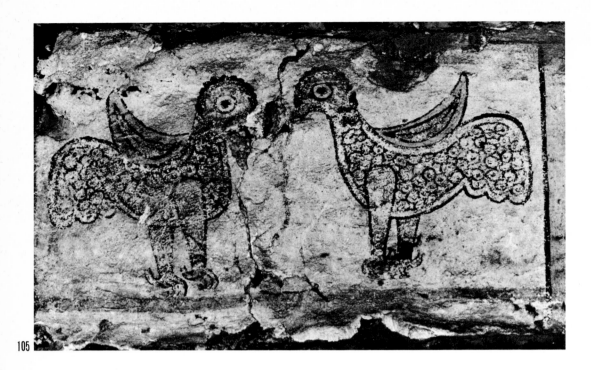

105

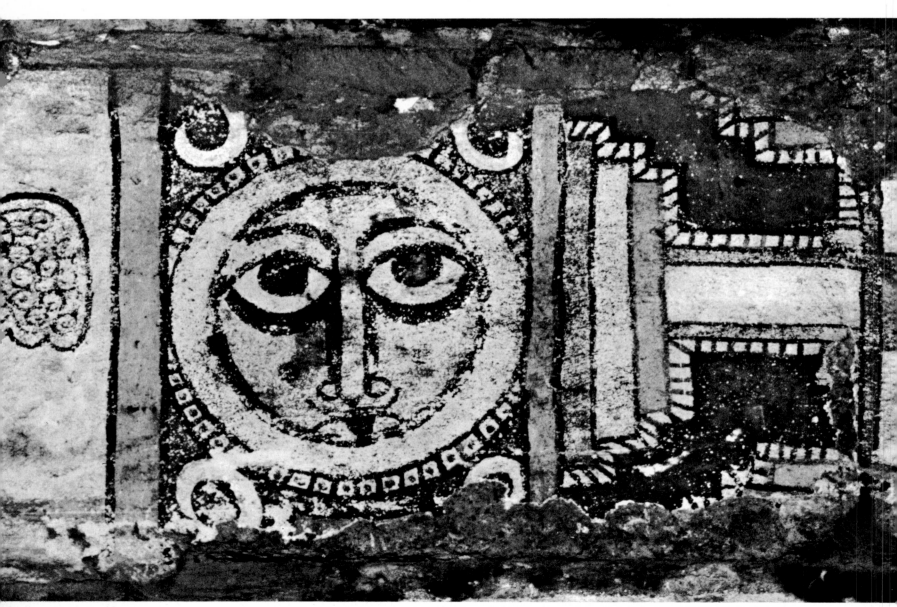

104

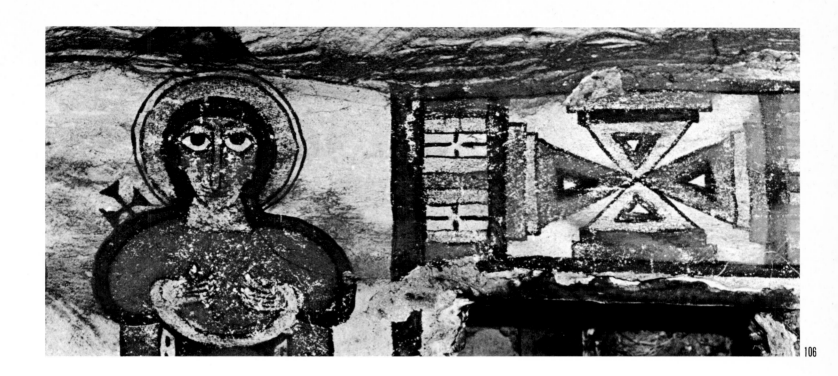

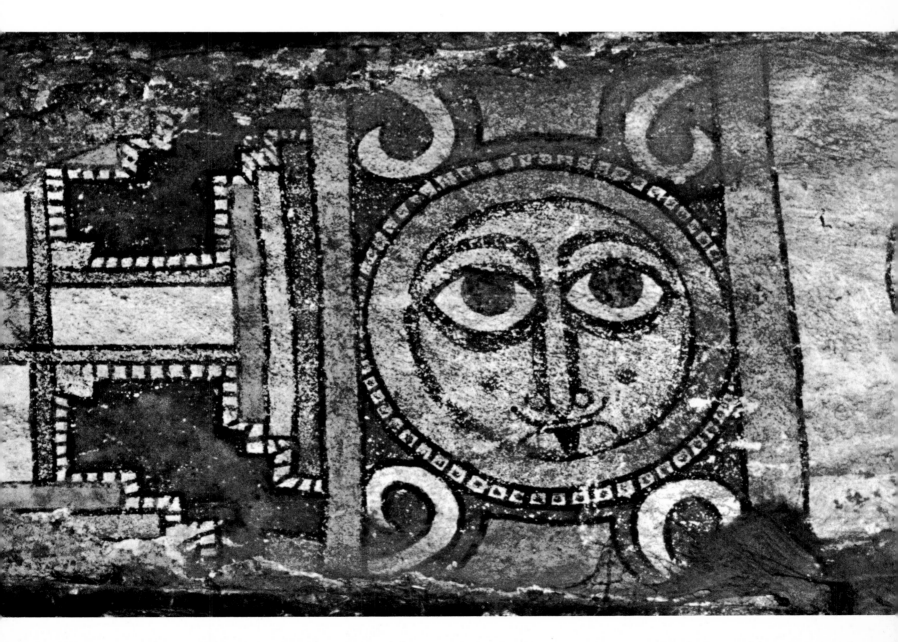

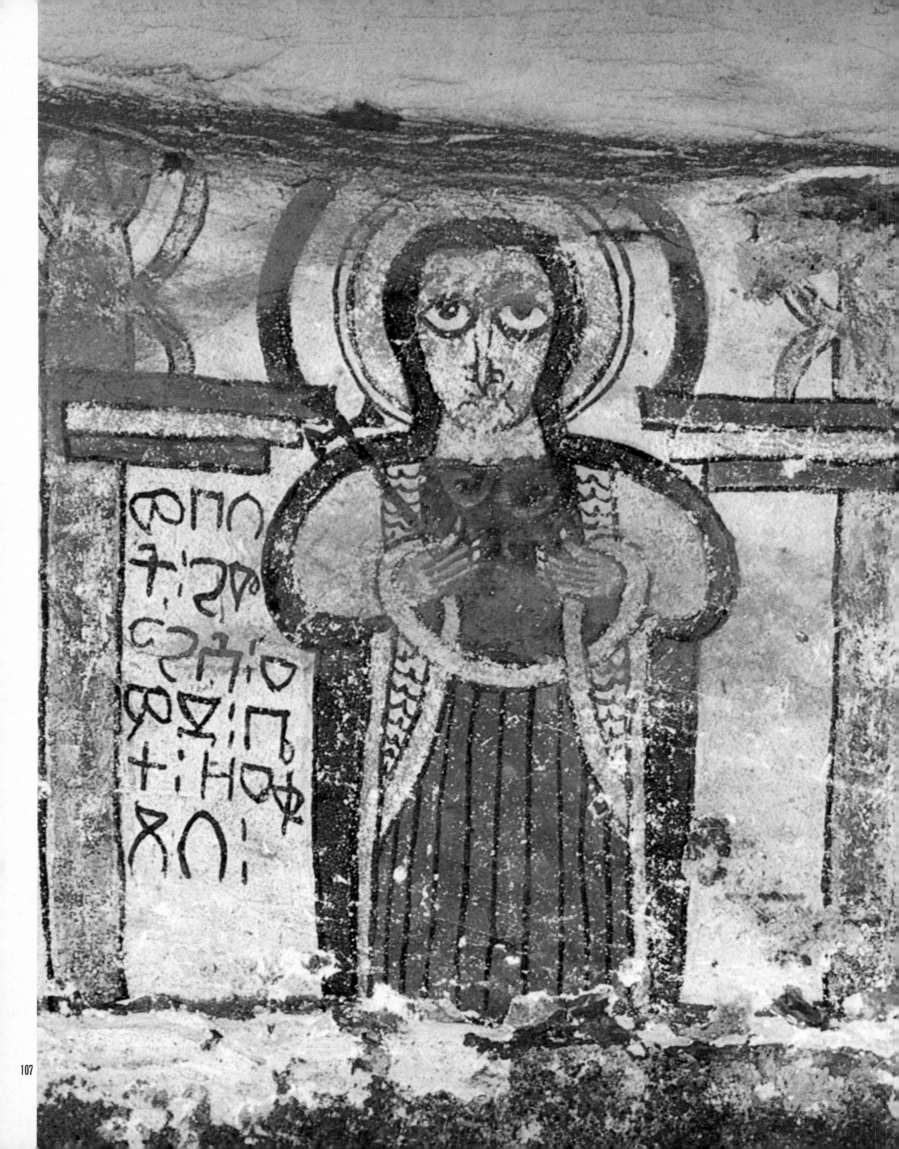

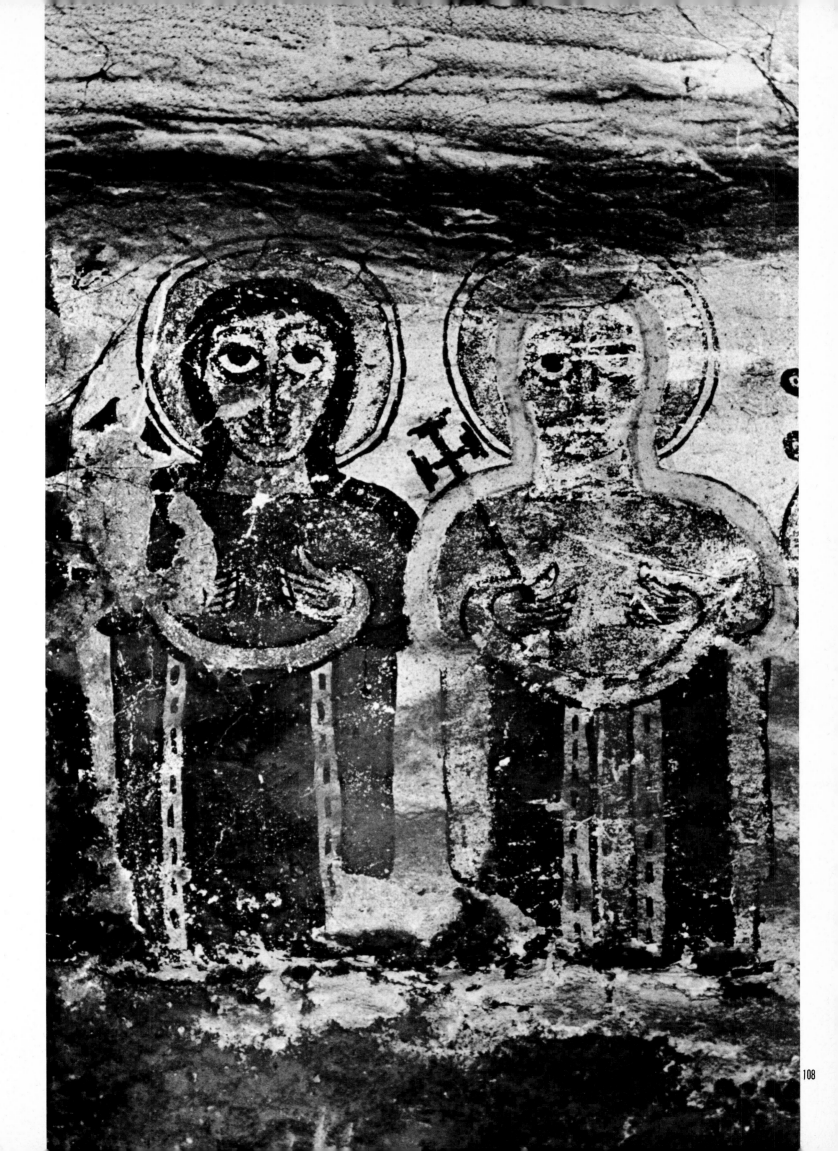

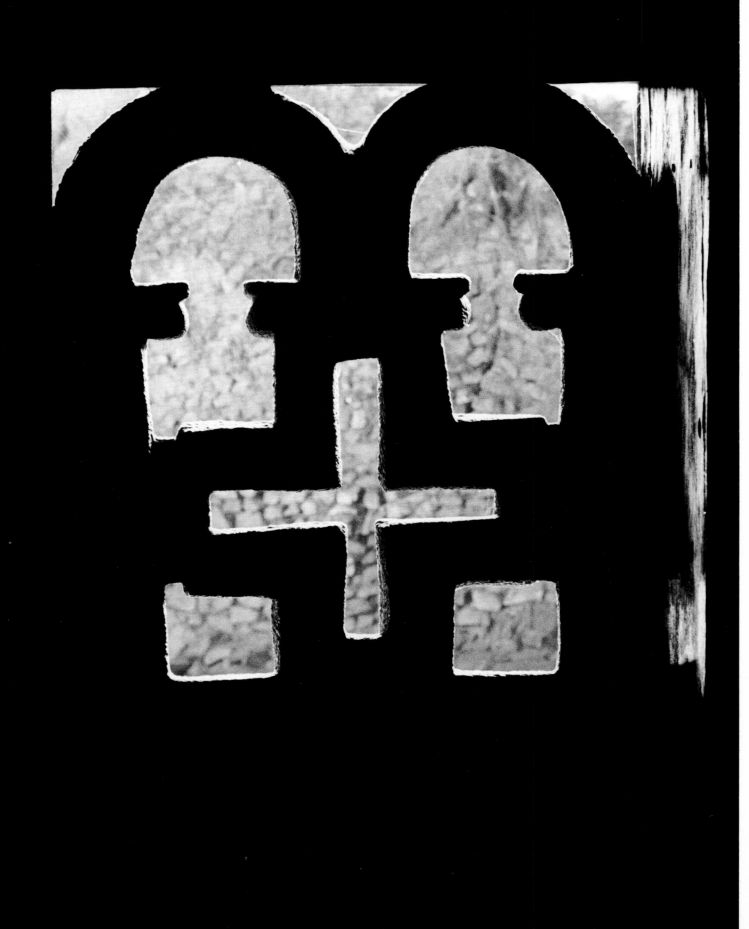

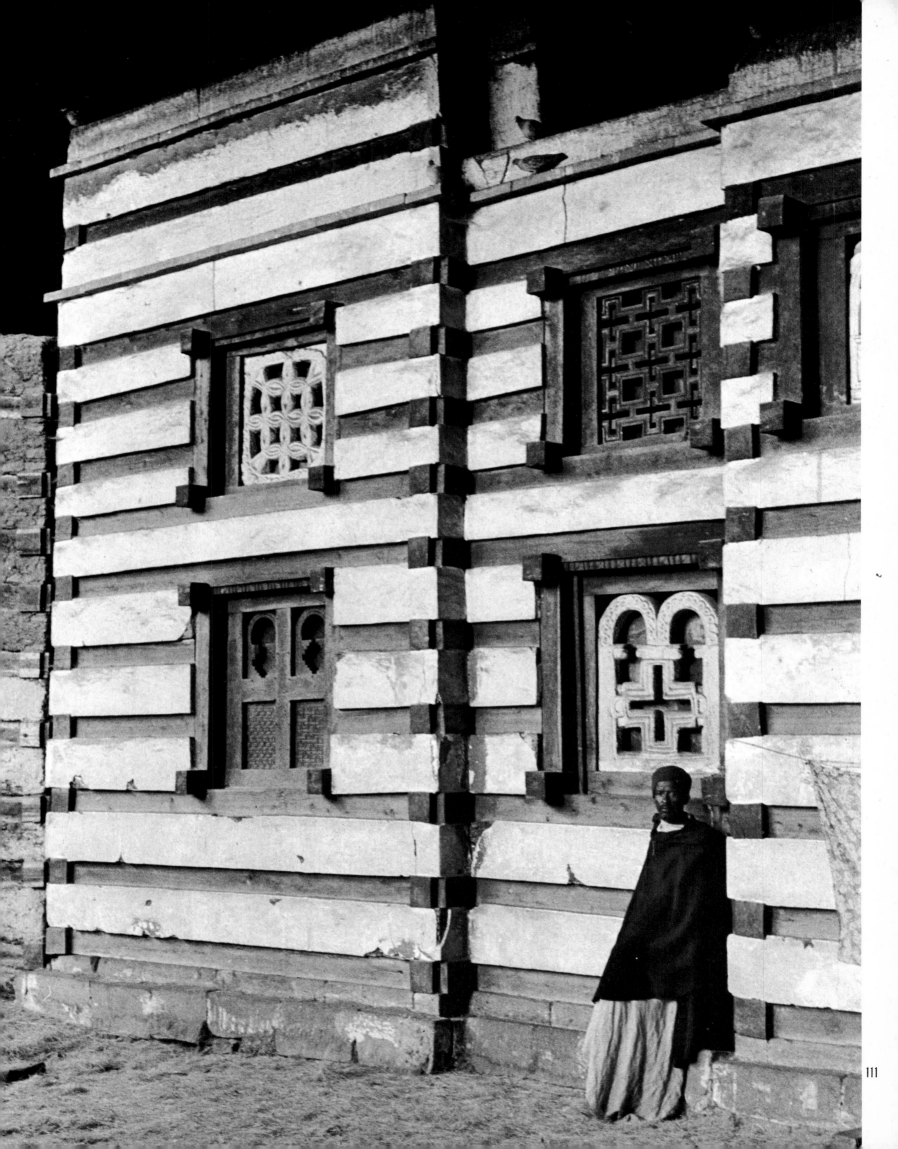

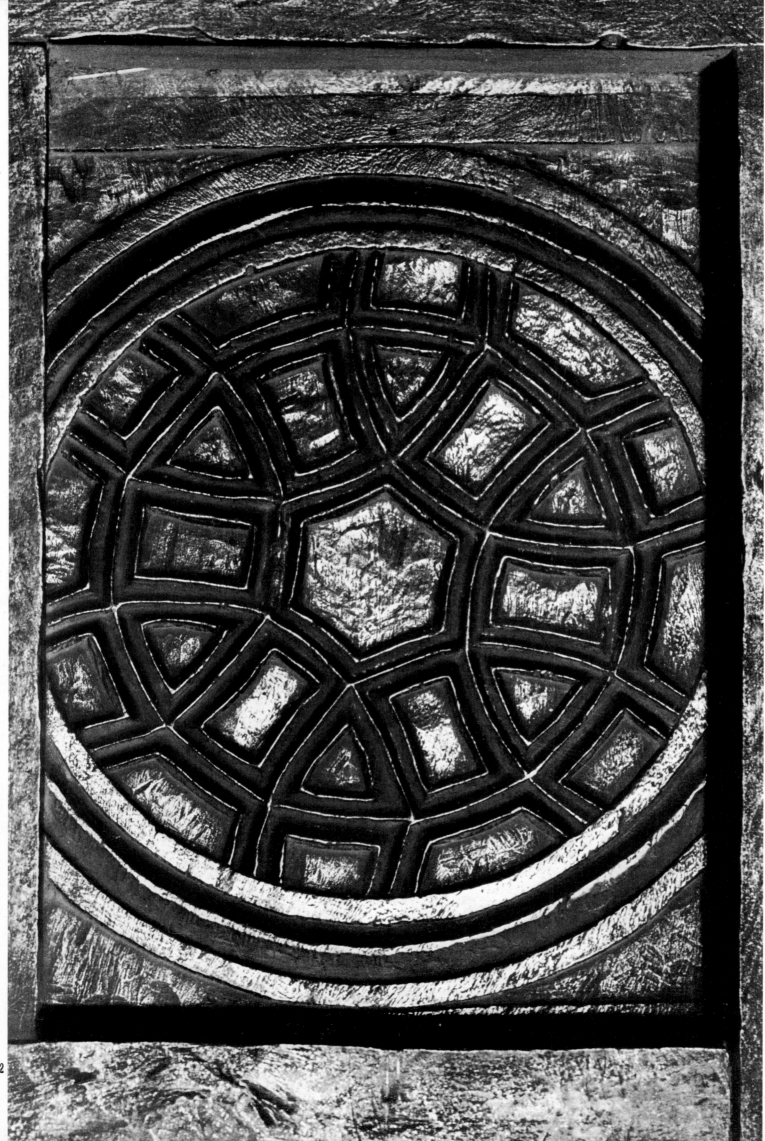

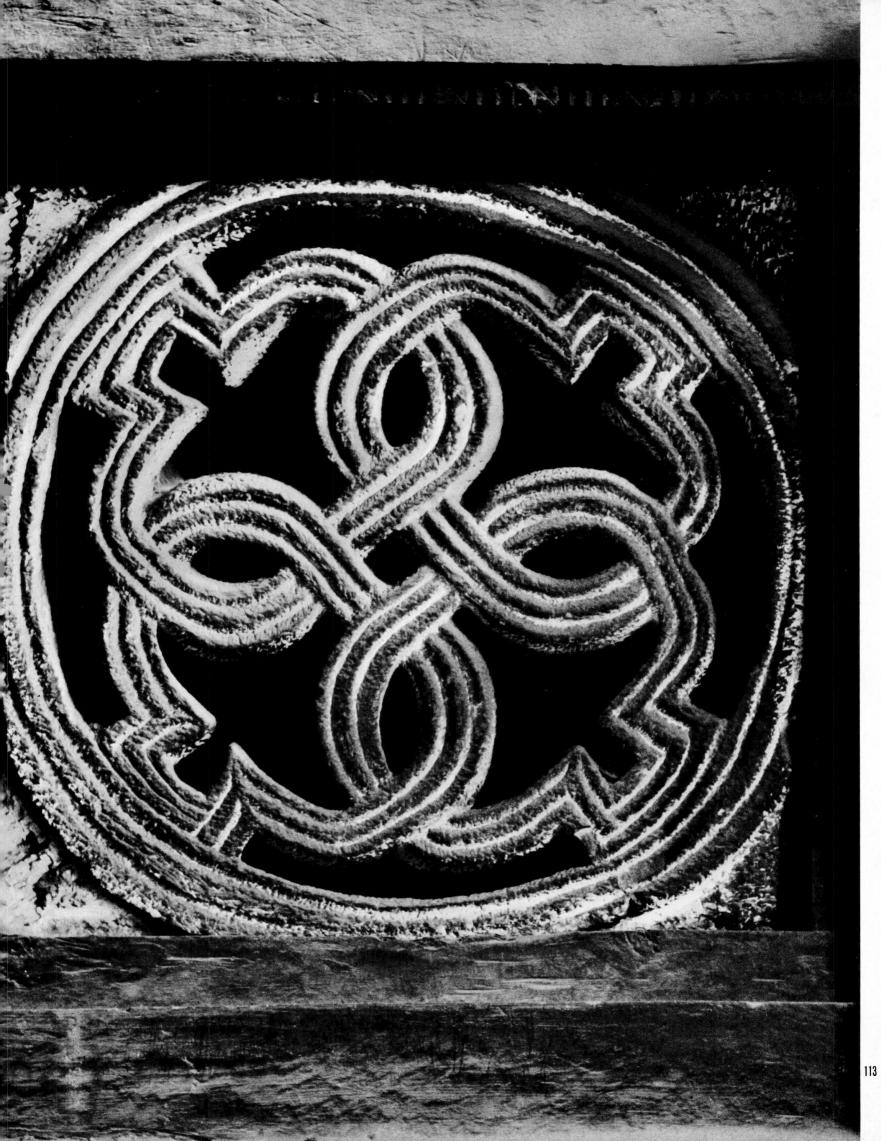

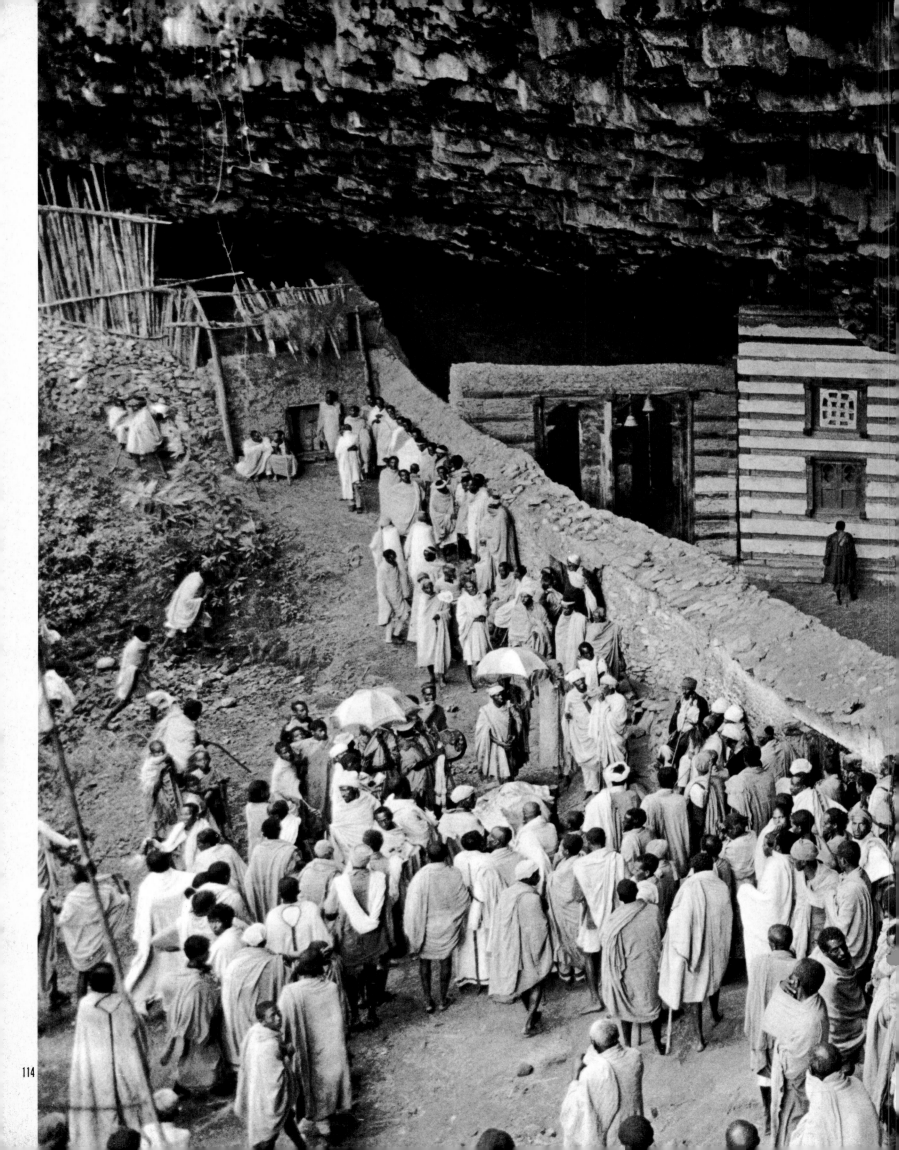

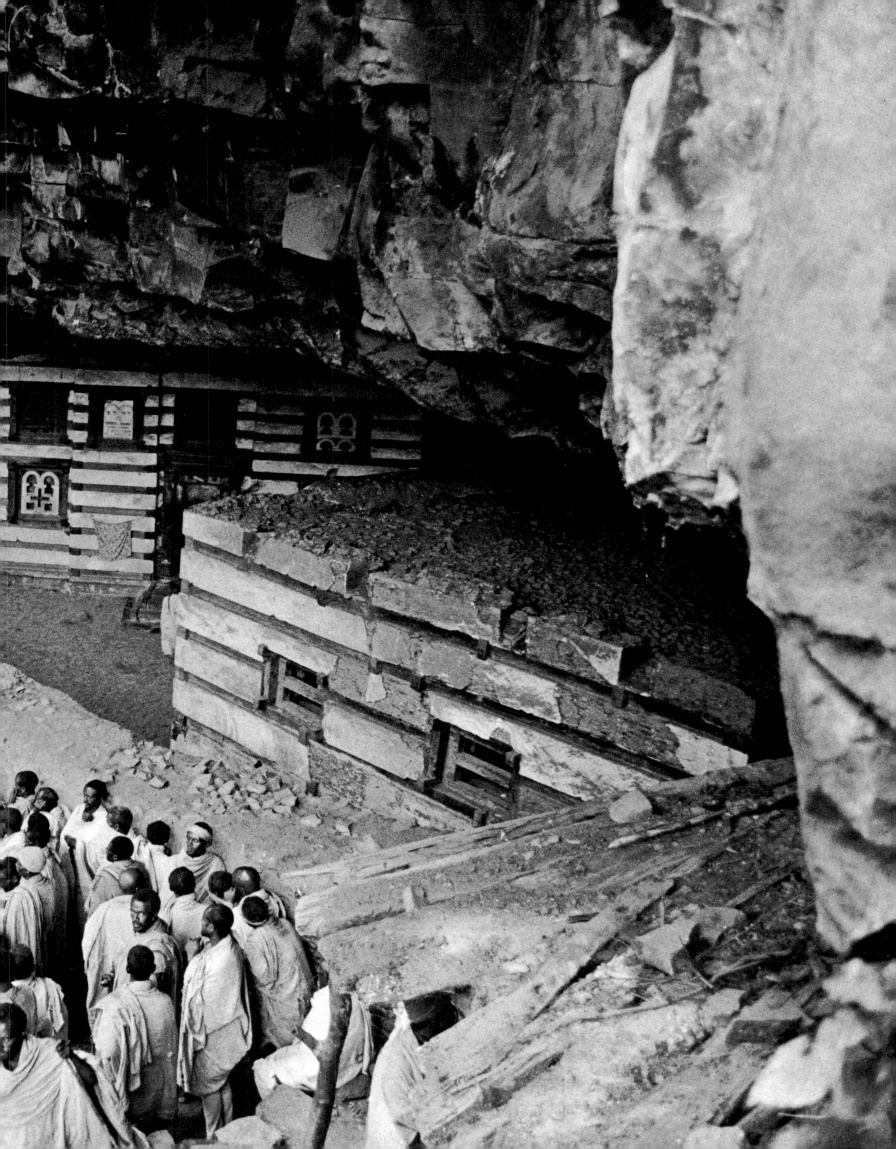

115

116

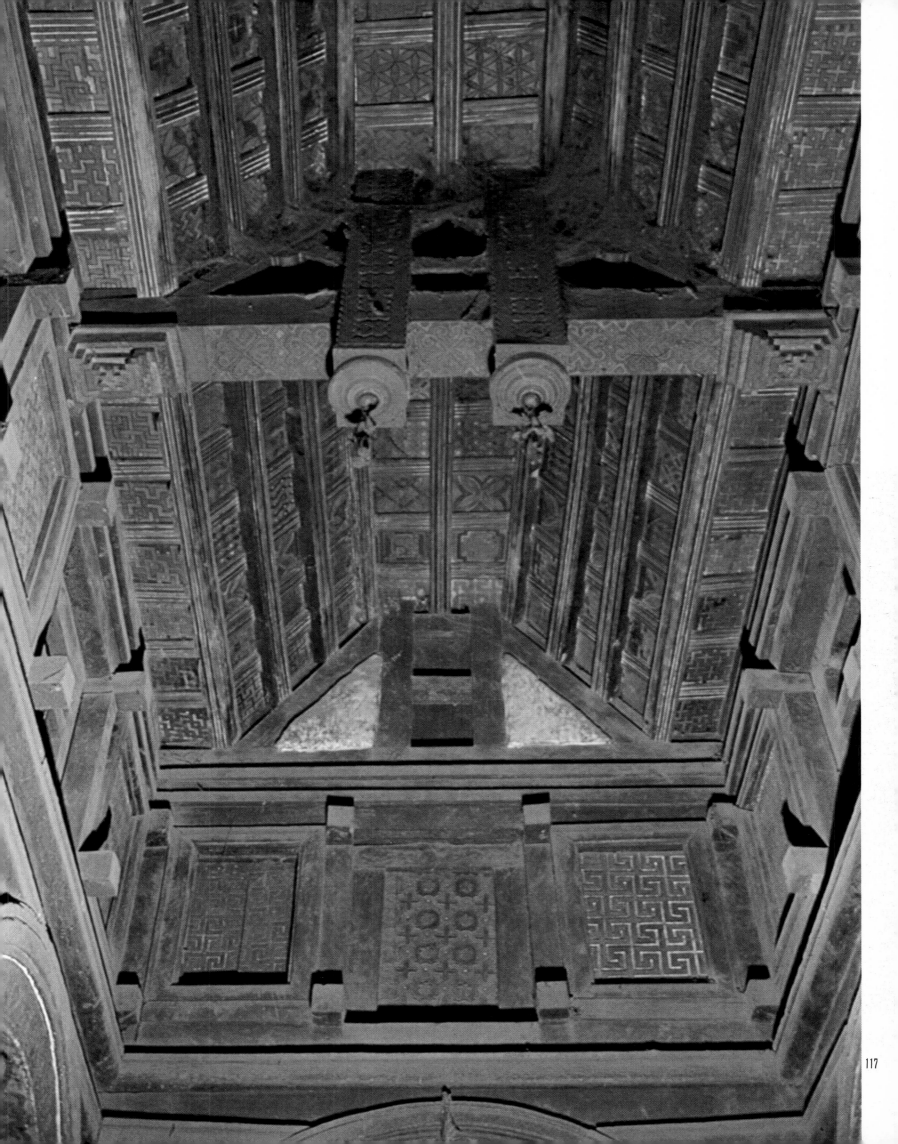

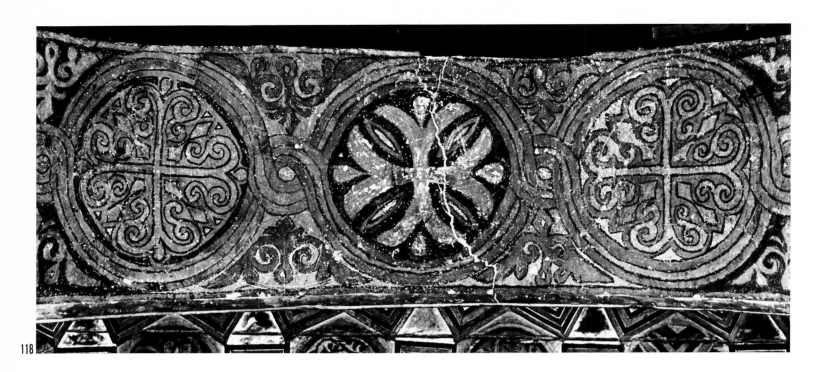

118

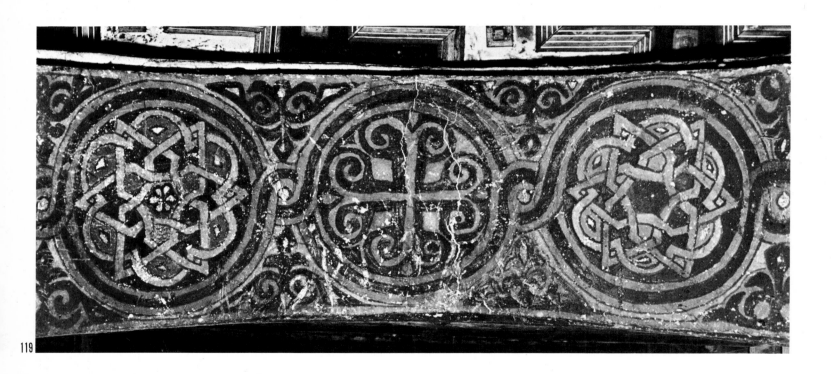

119

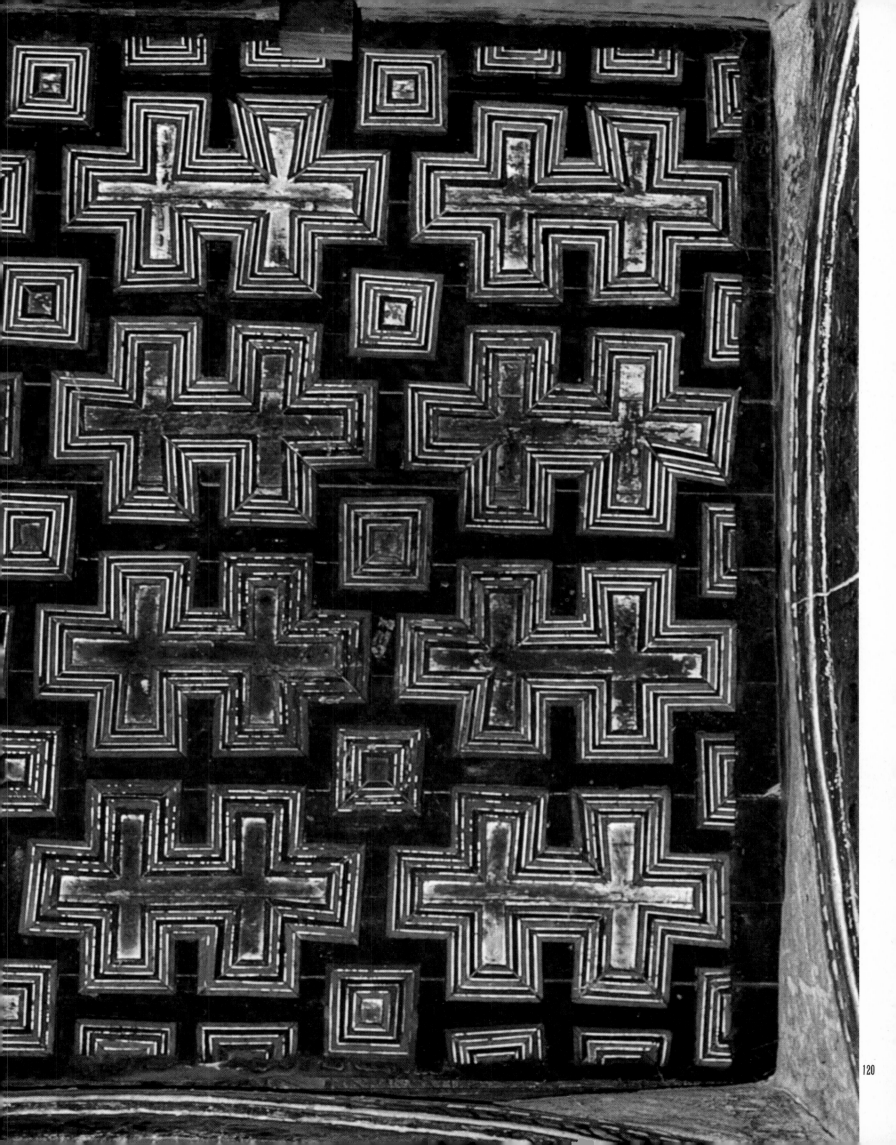

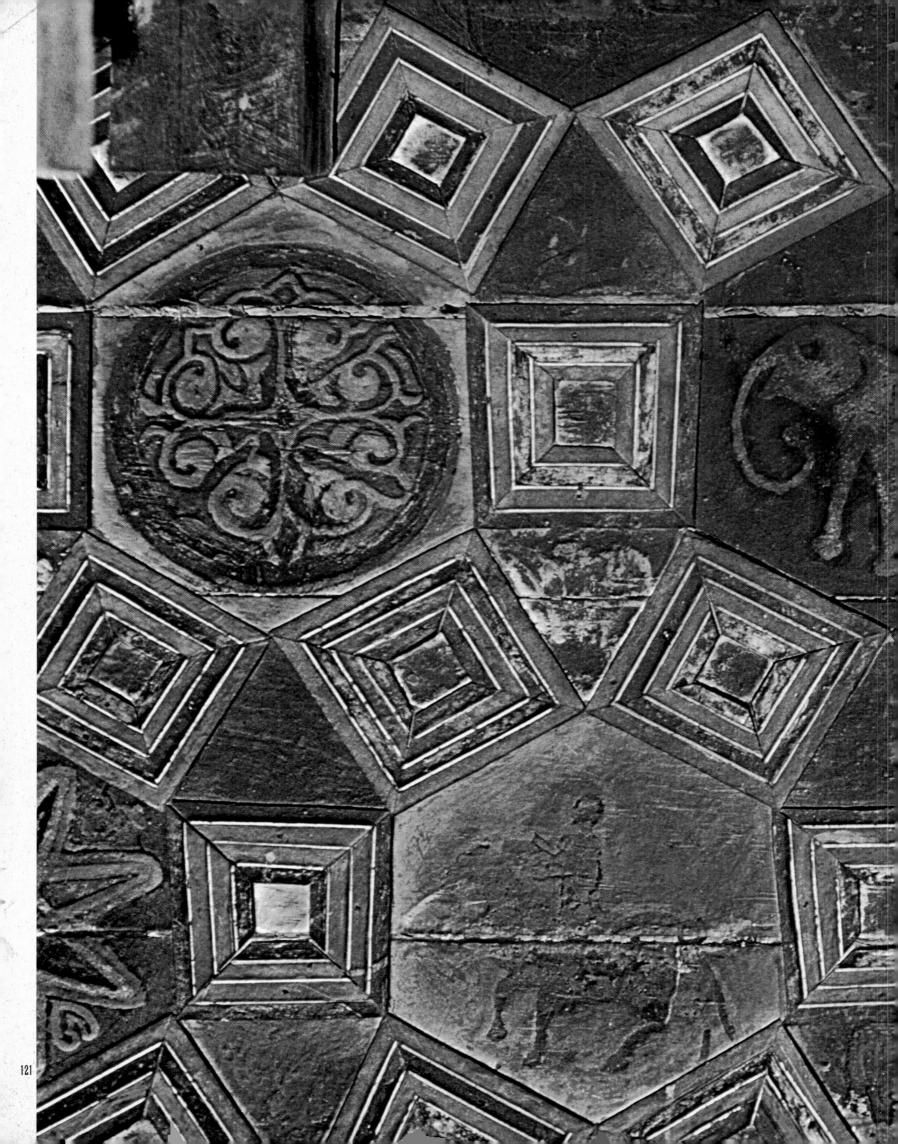

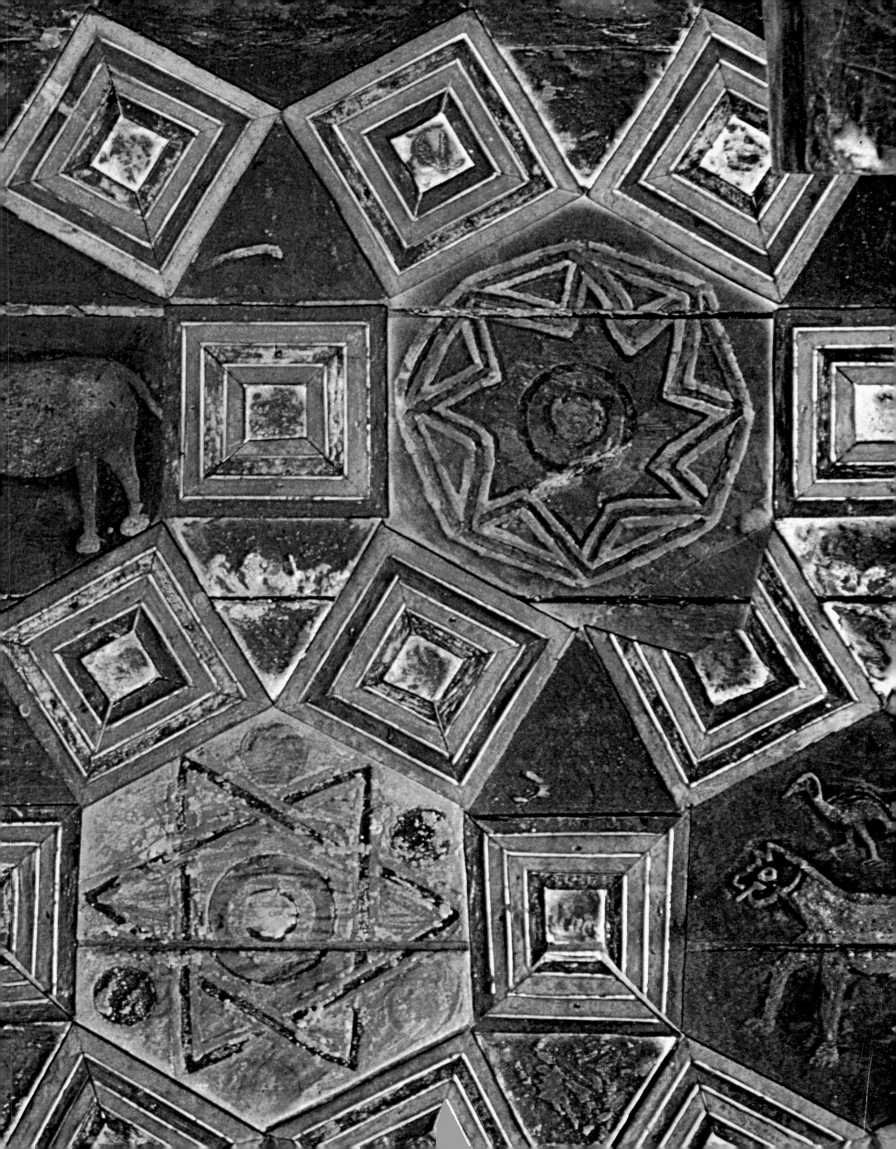

122

123

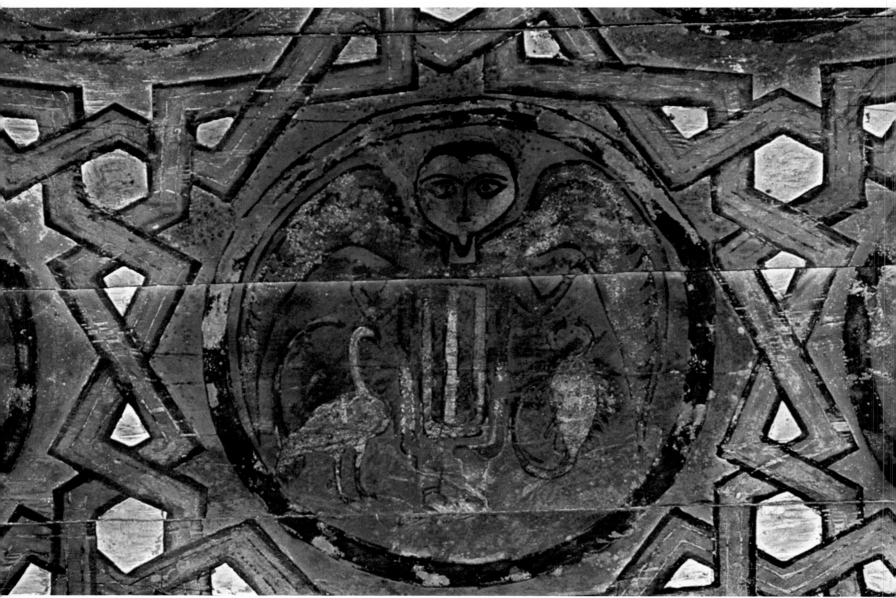

124

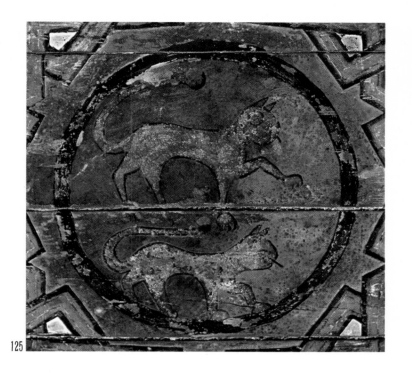

125

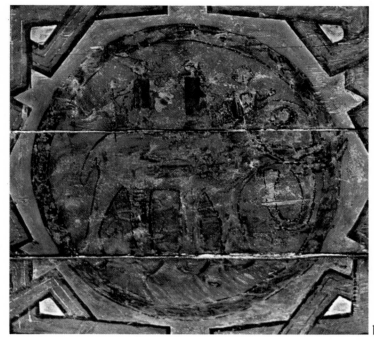

126

127

128

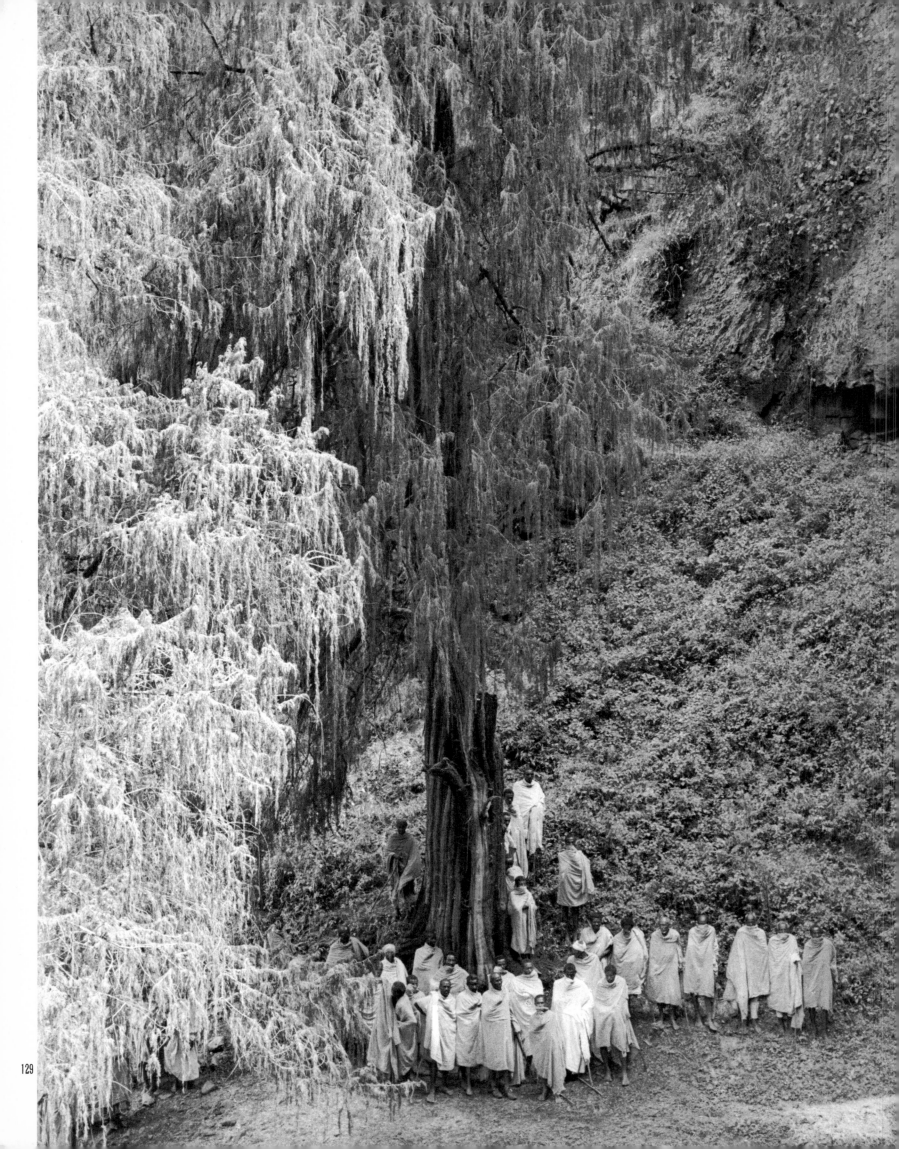

Another monolithic church:

Gannata Māryām

The Church of Gannata Māryām ('Garden of Mary') is near the 90 kilometres point on the road from Kobbo, or Waldeyā, to Lālibalā. Its proximity to the amazing churches of Lālibalā – one hour's drive, four hour's ride – has lessened rather than stimulated the appreciation of this noteworthy church.

With Weqro Madḫanē 'Ālam near Dabra Tābor (Sauter, no. 20), Gannata Māryām is one of the few rock-churches outside of Lālibalā which stands in a pit free from the rock on all sides except the base. In contrast to the churches of Lālibalā, which remain hidden from the visitor until the last moment, since their roofs lie on the same plane as the edges of the pits, Gannata Māryām is visible from afar – an impressively solemn work of sculpture in red tufa, surrounded by candelabra euphorbia, olive trees and prickly pears. The church's pit is excavated in a steep slope falling from north to south, so that its southern edge gives an uninterrupted view of the block of rock, about $20 \times 16 \times 11$ metres, which has been transformed into a church.

Closer consideration of the design (figs. 82, 83) confirms the impression, arising from the first visual impact, of a massive, somewhat cumbersome dignity.

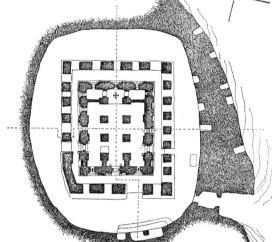

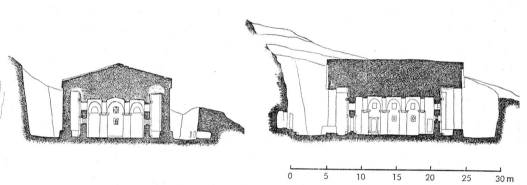

Fig. 82 Ground-plan (after *Bianchi Barriviera*)

Fig. 83 Transverse and longitudinal sections (after *Bianchi Barriviera*)

The pit of the church, forming the courtyard, is entered through a breach in the south wall with a gatehouse. Opposite the west façade of the church, a lobby reached by steps is hewn from the rock with three rooms cut into the stone, two of them communicating. Both on the outside and the courtyard side, the south wall contains several small burial caves or hermitages. The pillars of the colonnade surrounding the church stand on a socle which is broken where the doors give entrance to the church. In the west end, however, the gap is considerably displaced in relation to the main entrance on the central axis. The measurements, number of the columns and the distance between them differ from façade to façade. The undecorated architrave supports a slightly projecting saddle-back roof with gently sloped surfaces. Inside the colonnade the wall of the church has alternating indented and projecting elements. Inside the church, the aisles are separated from the nave by two rows of square pillars as well as two short pieces of wall on either side of the main entrance. The pillars have no base and are surmounted by the usual pseudo-capital of carved corbels and imposts – a combination which here stands out somewhat from the pillar and makes a cruciform substructure for the almost horsehoe-shaped

arches. The corbel-imposts are narrower than the columns and the arches are even narrower – a circumstance which further emphasises the ponderosity of the supports. A sanctuary and sacristies are at the east end beyond the nave and aisles. The ceiling of the aisles is generally flat whilst that of the nave follows the line of the saddle-back roof. Visitors have criticized the workmanship as being careless and ungainly, and indeed both the outside and the inside of the church have not been properly squared-up. Nevertheless the workmen can be acquitted of the accusation of jerry-building. The masons had to contend with a particularly hard tufa studded with eruptive fragments. In the north-west corner of the church especially, a deep fissure necessitated deviation from a symmetrical ground-plan.

Fig. 84 A pillar of the second or third bay (after *Bianchi Barriviera*)

Local tradition names the founder as Yekuno Amlāk, the first ruler of the Solomonic dynasty, which succeeded the Zāgwē. If that is so, the church would have been built towards the end of the thirteenth century, and was probably an attempt by the new ruler to demonstrate his legitimacy, in the heart of the area of Zāgwē power, with a characteristic building which would still have been regarded by his contemporaries as a current Zāgwē achievement. This would mean that the technique of 'construction' of monolithic churches, even if no longer practised, could nevertheless still be revived either by rounding up local talent or by calling in foreign specialists. The evidence of the monument itself does not gainsay the oral tradition. This church is no experiment in preparation for the masterpieces of Lālibalā. There is recognisable evidence of copying – individual details presupposing the existence of the Lālibalā churches. In the arrangement of the colonnade and surface of the roof it emulates Lālibalā's Church of the Redeemer which, for its part, is presumably a copy of the coronation cathedral in Aksum. There is no architectural information to determine the temporal relationship between the Lālibalā group and Gannata Māryām. However, the church itself, as well as the walls of the pit and surrounding undisturbed rocks, are encrusted with a yellow lichen which can also be seen in Lālibalā. A comparative study of the lichenous growth should give valuable information.

Apart from the four central columns and their corbels, the interior of the church lacks architectural decoration. However it is richly painted on plaster all over the walls, corbels, arches, spandrels and ceiling. Unfortunately, time has ravaged these unique, archaic and entertaining frescoes. The stucco is flaking off and the colours are fading. The paintings can scarcely be younger than the church itself, since in the decoration of the soffits the ornamentation and arrangement is obviously dependent upon the carved arch-soffits of medieval Ethiopian built-up churches. The artist had a predilection for animals. Birds chirrup over biblical and legendary scenes, and kids are leaping on a frieze below the ceiling. It is remarkable that some of the saints or details from their lives portrayed in these paintings do not figure in the Ethiopian Synaxarium (though doubtless in the Coptic one). Contributing to the impression of consistency of artistic style in this church is the artist's restricted palette: earthbrown, ochre, green and a vivid blue. This palette is nevertheless a testimony to the constancy or, conversely, the inconstancy of individual pigments: blue – pulverized azurite? – lasts better than any other pigment. The artist's preference for geometrical ornament, which does not even change for the angel's wings, occasionally gives the saint's apparel something of a harlequin effect. The varying treatment of nimbus, head-covering – with or without hood – and the style of beard bears no discernible relationship to the illustrated saint's position in the hierarchy. There is no parallel here to the gesture of stroking one's beard known from Viking and Romanesque art: the saint's hands rest pensively on the breast without touching the beard. The letters of the inscriptions confuse the palaeographers by apparently being both modern and ancient. 'This church will be an important document for the history, yet to be recorded, of the Ethiopian script' (Caquot).

130 The lobby cut from the rock wall of the church's pit: a dabtarā during divine service. He supports himself on his crutched stick in the characteristic Ethiopian attitude of prayer. The lobby and rock chambers connected with it are the favourite resting places of the worshippers, who join in the service outside the church.

131 The church in its rock pit. Blind arcades with Latin crosses decorate the roof. The Mediterranean appearance of the landscape, and the external colonnade which seems to belong to a peripteral temple, contribute to the classical impression given by this church.

132 The colonnade in front of the south façade of the church. Doors and windows, one of which is blind, are placed in the recessed sections of the wall. The heads of the binders in the door and the window frames, projecting according to the Aksumite rule of building, have been copied in stone. In the picture, a swastika motif fills the panel of the (blind) window.

133 Window of the south façade with pierced Greek cross. The entry of light opposite through a window in the north wall forms a second cross within it. Fig. 85 shows other styles of window. The lunettes, so characteristic of Gannata Māryām, are striking. They are either hafted on to the top of a window, set over crosses or

Fig. 85 Windows of the bottom row

arranged as the decoration of window fillings. In this series, the possible origin of the motif can be seen: the attempt to popularize an arch arrangement, as it is already found on the so-called 'stela by the stream' in Aksum, and is seen, almost degenerate in form, above the lintel of the main entrance of Gannata Māryām (fig. 86).

134 Window of the west façade and above it the symbol of the sun. In the window filling, beneath two arched piercings, we see part of a painted design appearing in the church – interlaced quadrangles. The traces of paintings and inscriptions are of recent date. In replying to an enquirer's request, the priests explain the heavenly body as the sun or moon. There is no reason, however, to be concerned about the South Arabian moon god of the pre-Christian religious substratum of the Ethiopians. The picture of the sun is usually encountered in Ethiopian churches directly above the main entrance or sanctuary arch – or both, as for example in the cave church of Makina Madḥanē ʿĀlam (pls. 103, 104). In Gannata Māryām the window in question is just to the right of the main entrance.

135 Sun between rosettes with crosses on the soffit of an arch.

136 Sun between Teutonic crosses on the front of an arch in the nave. From an early period the rays of the sun were considered as a symbol of Christ, 'the Sun of righteousness' (Mal. 4: 2); the chief liturgical festivals of the Incarnation – Christmas and the Epiphany – as birthday celebrations for the Bringer of Light, were originally sun feasts; Ethiopian hymns of Mary celebrate her as mother of the sun: 'Gateway of the Sun', 'Throne of the Sun'. The orientation of churches has reference to the rising of Christ – the apsidal shells or domes over the sanctuary represent the eastern part of the firmament of heaven, in which Christ, as the sun, rises.

Fig. 86 Decorative frieze above the main entrance

117

137 Christ as Lord of All on a throne decorated with crosses. Its base reflects representational architecture. In the oriental fashion, the pantocrator sits with one leg folded beneath him. He presses a book to his breast with both hands. The inscription relates it to the marriage feast in Cana of Galilee (miracle of the wine). The complete, badly damaged painting shows, to the right of Christ, Mary standing and pointing to her son, and on his left, in two registers, what are presumably the wedding guests, seated on folding stools in western fashion. The representation of Christ without any reference to the story of the biblical scene of which he is the focal point, illustrates its significance in the life of Christ: with his first miracle, 'the Lord of All manifests his glory' (John 2: 11).

138 Holy monk. The painting is incomplete or – more probably – has faded and the inscription has been curtailed. One can make out 'Abuna Adām . . . for us'.

139 St Minās with a spear. The inscription – 'Hail, Abbā Minās' – does not indicate which Minās is intended. Of almost two dozen saints of this name, the sixty-first patriarch of Alexandria claims the greatest place in the Ethiopic Synaxarium. However the indication of a weapon rather suggests Minās the soldier, the most popular saint and martyr of Coptic Egypt.

140 Hor, the hermit, as dragon-slayer. 'Abbā Hor the anchorite who slew the dragon.' With his right hand he grasps a staff with cross and trident, with his left he throttles a devilish monster or serpent swallowing up the head of a ram. What is otherwise known of the Egyptian hermit of this name does not fit in with a dragon-slayer. Caquot suggests that the myth of the Egyptian God Horus, slayer of the Apophis serpent, has come in here through cultural osmosis.

141 Abraham prepares to slay Isaac. The inscription above the ram with a horn caught in the thicket – 'Behold the Lamb' – forges the link between the sacrifice of the old covenant (Gen. 22) and that of the new (John 1: 29).

142 Shenute of Atripe, Abbot of the White Monastery in Upper Egypt and reformer of Coptic monasticism. Painting on the soffit of the arch which has the sun symbol (pl. 137) on its crown. The inscription refers to Shenute by the name by which he is principally known in Ethiopia, 'Hail, Abbā Sinodā'.

143 Corbel-capital and arches on a pillar of the left row. On the soffit of the arch which opens into the left aisle, there is an Egyptian saint ('Hail, Abbā Yawḥani') and on the face of this arch there is a simple lattice design. The soffit of the arch spanning the nave is decorated with crosses with pointed ends and with eight-pointed stars. The face of this arch has rosettes and knot-work and, on the crown, the sun between Teutonic crosses. This cross-star ornament is encountered on the ceiling of the Capella Palatina in Palermo (twelfth century) and is to be found from the tenth to the fifteenth centuries on glazed tiles from Persia and in Egpyt. Carved, painted and inlaid, in Ethiopia it also forms part of the ornamental resources of the cave church Yemreḥanna Krestos. Archangels ('the holy angels') are painted on the ceiling. The frieze of metopes, a typical element of the Aksumite stock of forms which one would really expect to find in this church, is absent.

Additional Sources

Sauter, no. 55: Descriptions and references in Monti della Corte; Findlay; Buxton, *The Christian Antiquities* . . . and *Travels* . . .; Playne; Bianchi Barriviera, *Le chiese monlitiche* . . . and *Le chiese in roccia* . . .; Gerster, *Mariä Paradies*.

On the position of the sun: Grohmann, pp. 237, 309.

On symbolism in the church: Sauer; Hautecœur.

Comparative Islamic material on the cross-star ornament: Hautecœur/Wiet; Kühnel, *Islamische Kleinkunst*, p. 111.

130 The lobby cut from the rock wall of the church's pit: a dabtarā during divine service.
131 The church in its rock pit. Blind arcades with Latin crosses decorate the surface of the roof.
132 In the colonnade in front of the south façade of the church.
133 Window of the south façade with pierced Greek cross.
134 Window of the west façade and above it the symbol of the sun.
135, 6 Representation of the sun on arche.
137 Christ as Lord of All on a throne decorated with crosses.
138 Holy monk.
139 St Minās with a spear.
140 Hor, the hermit, as dragon-slayer.
141 Abraham prepares to slay Isaac.
142 Shenute of Atripe, Abbot of the White Monastery in Upper Egypt and reformer of Coptic monasticism.
143 Corbel-capital and arches on a pillar of the left row.

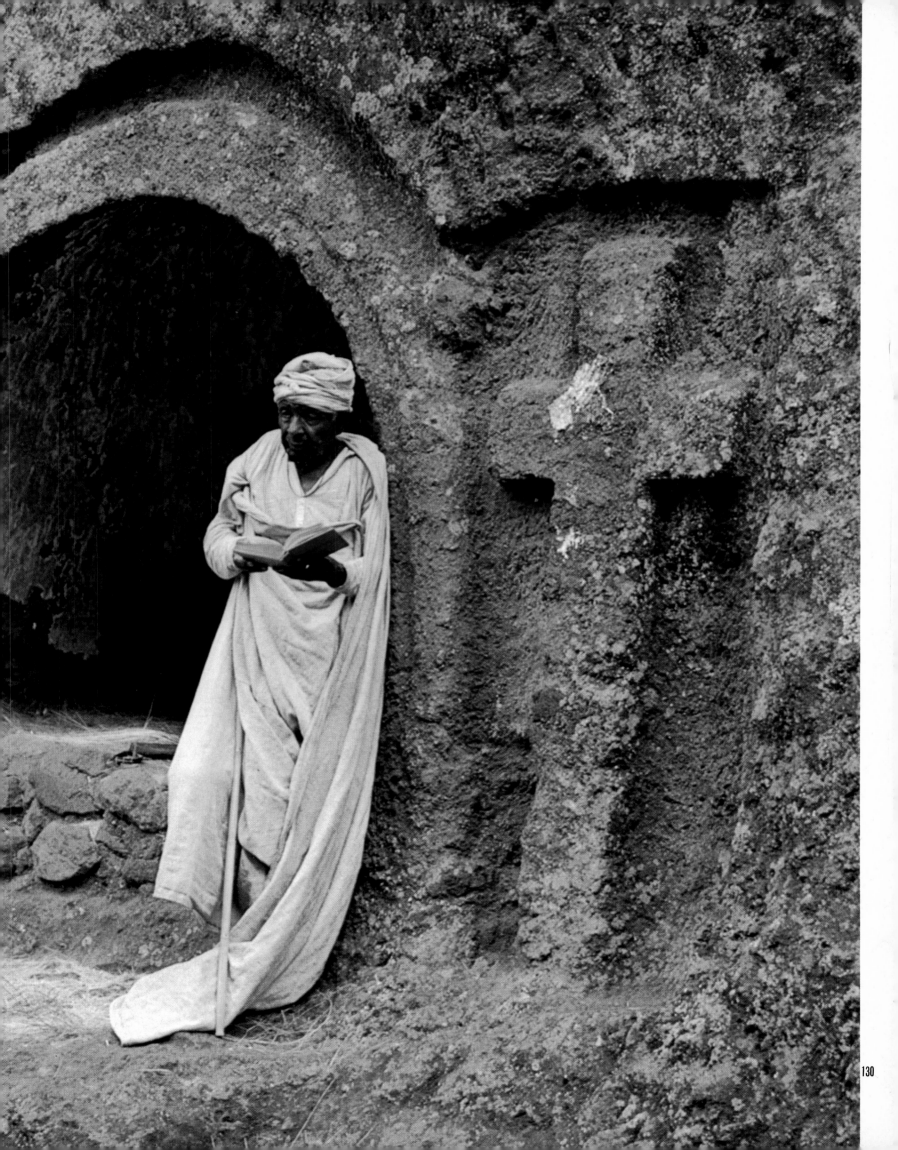

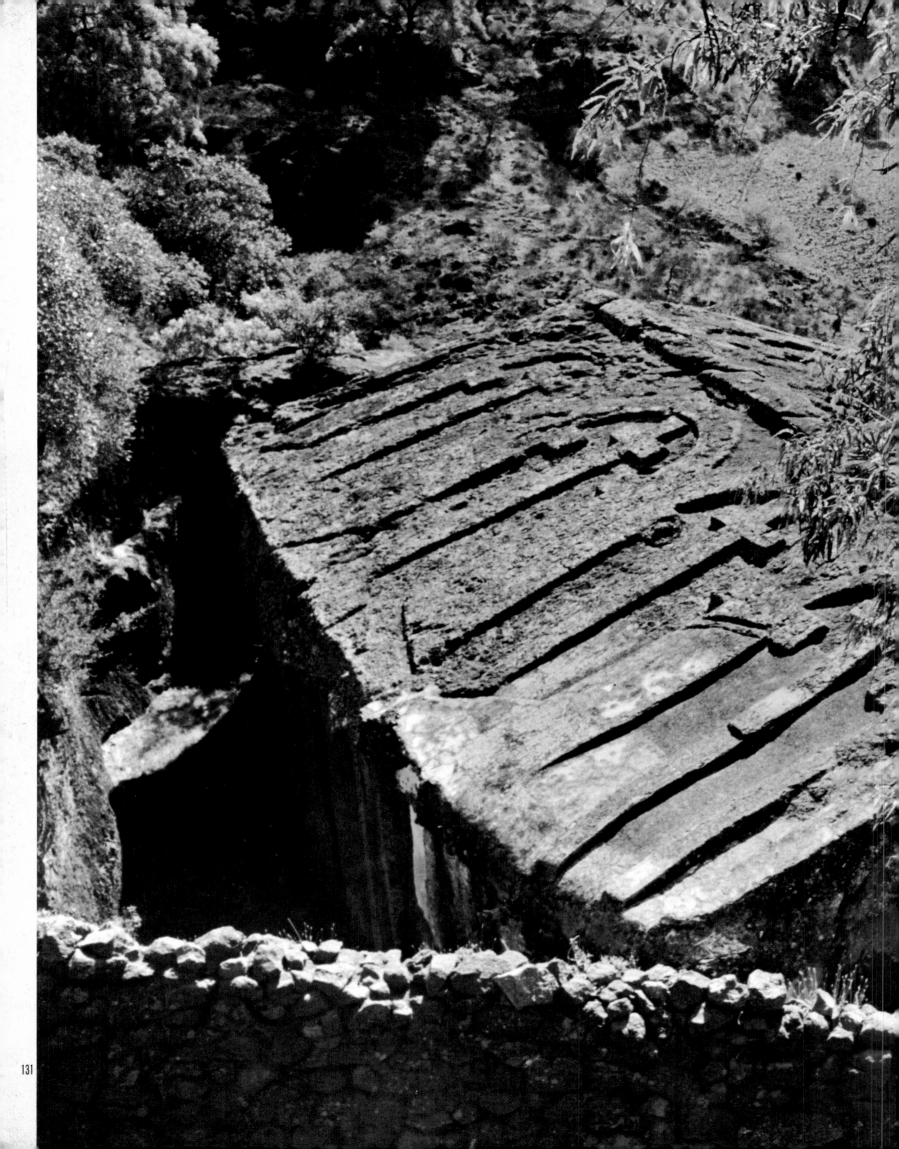

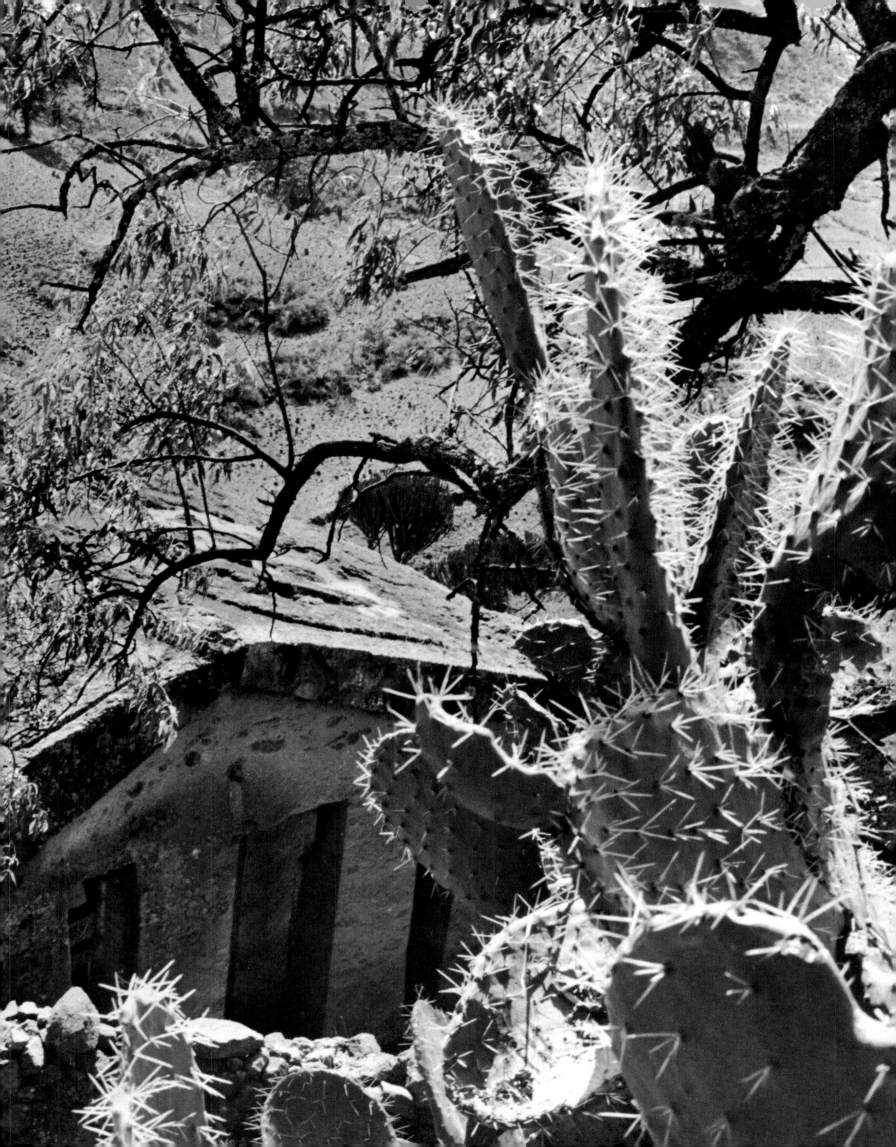

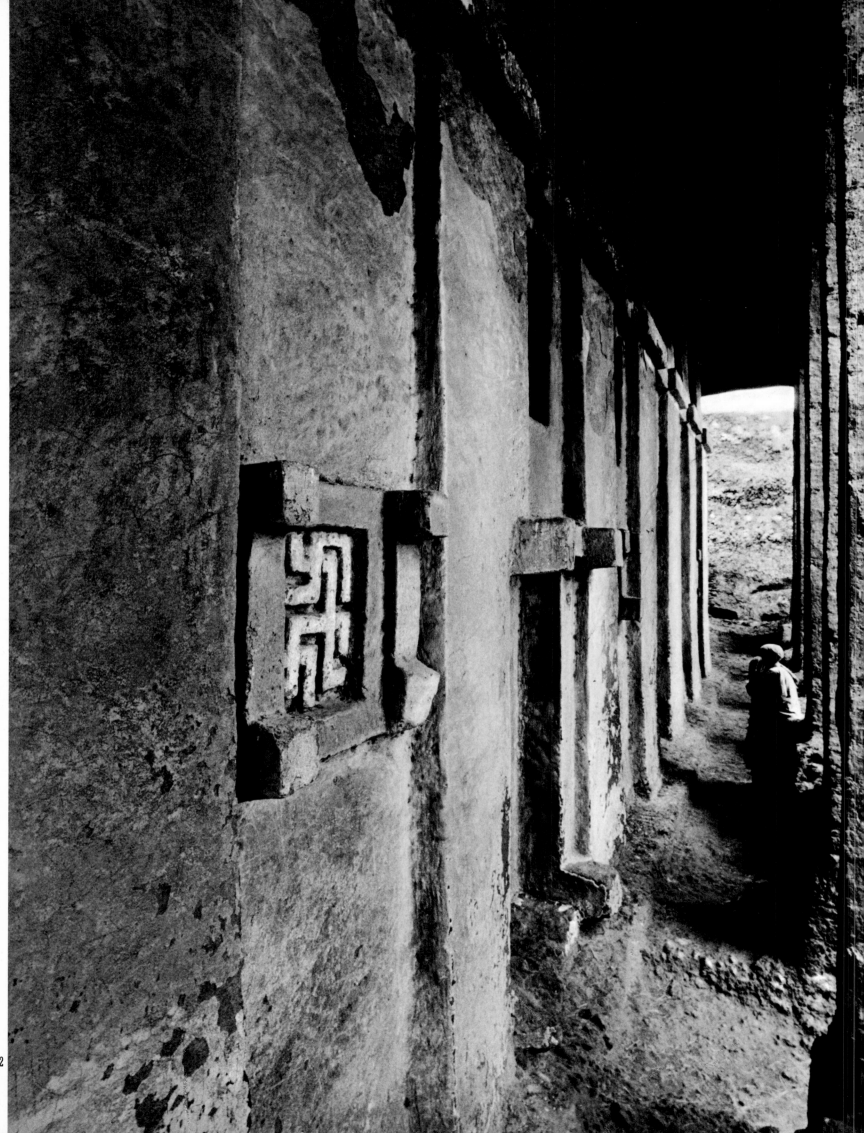

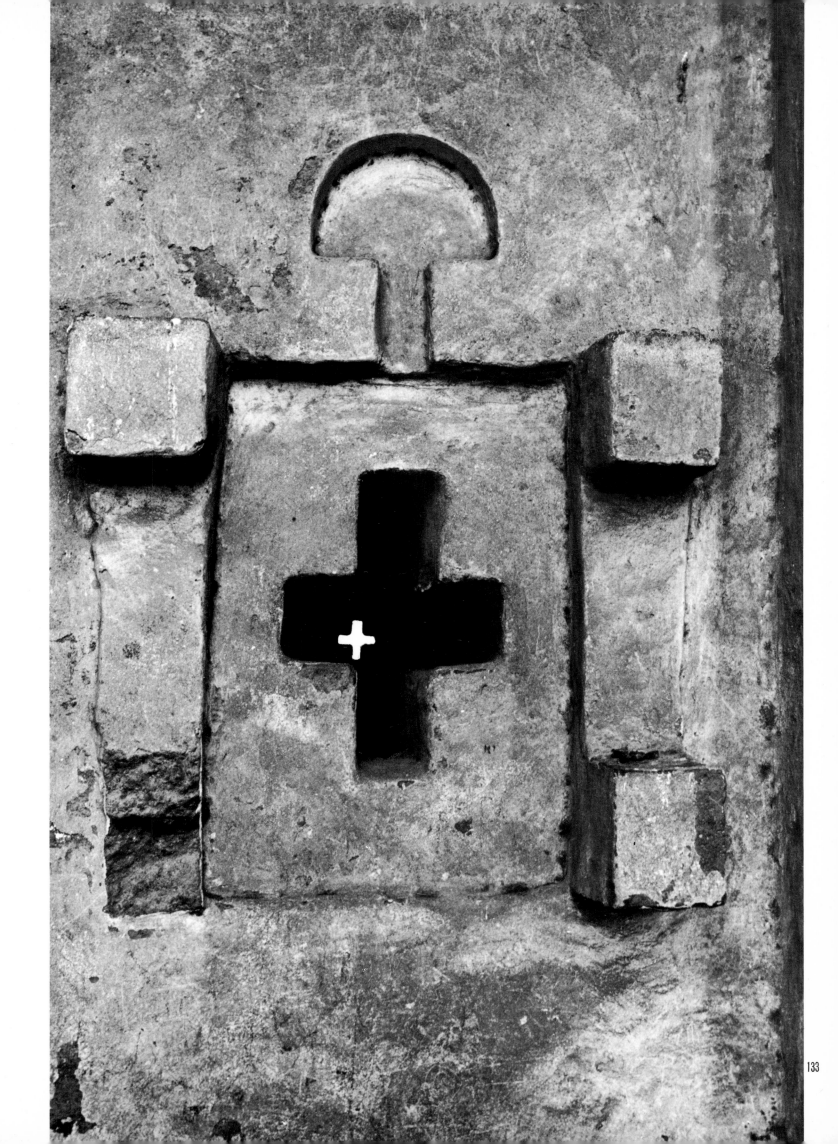

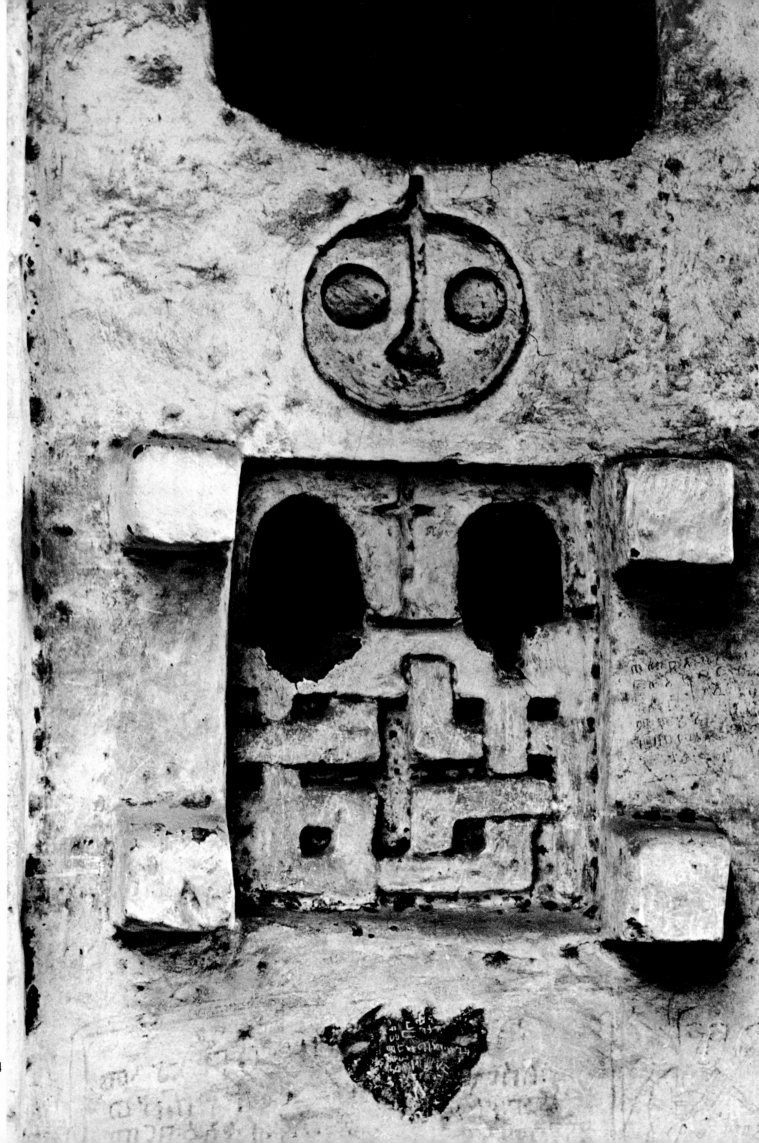

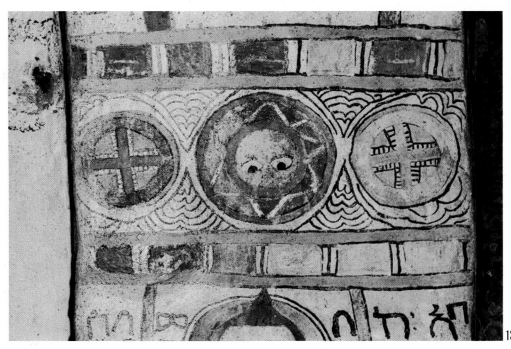

135

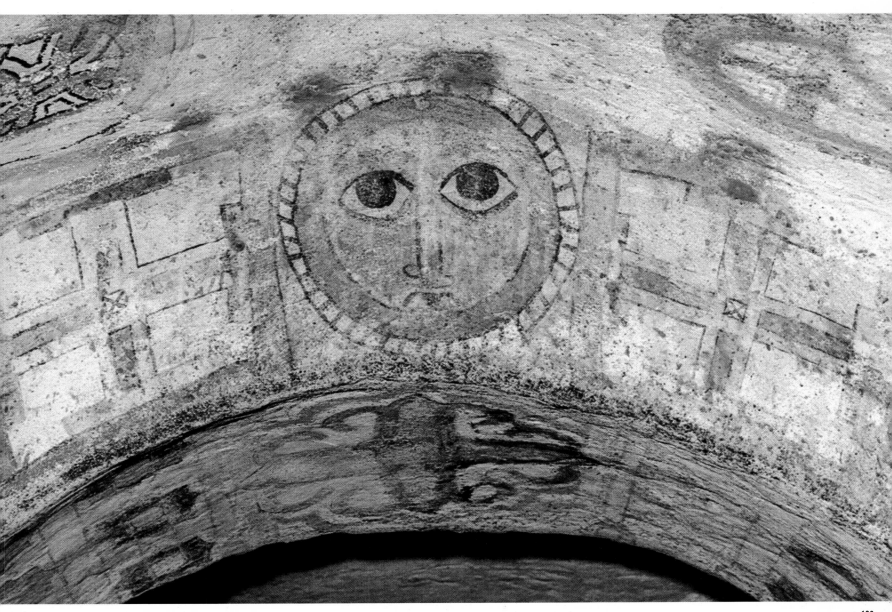

136

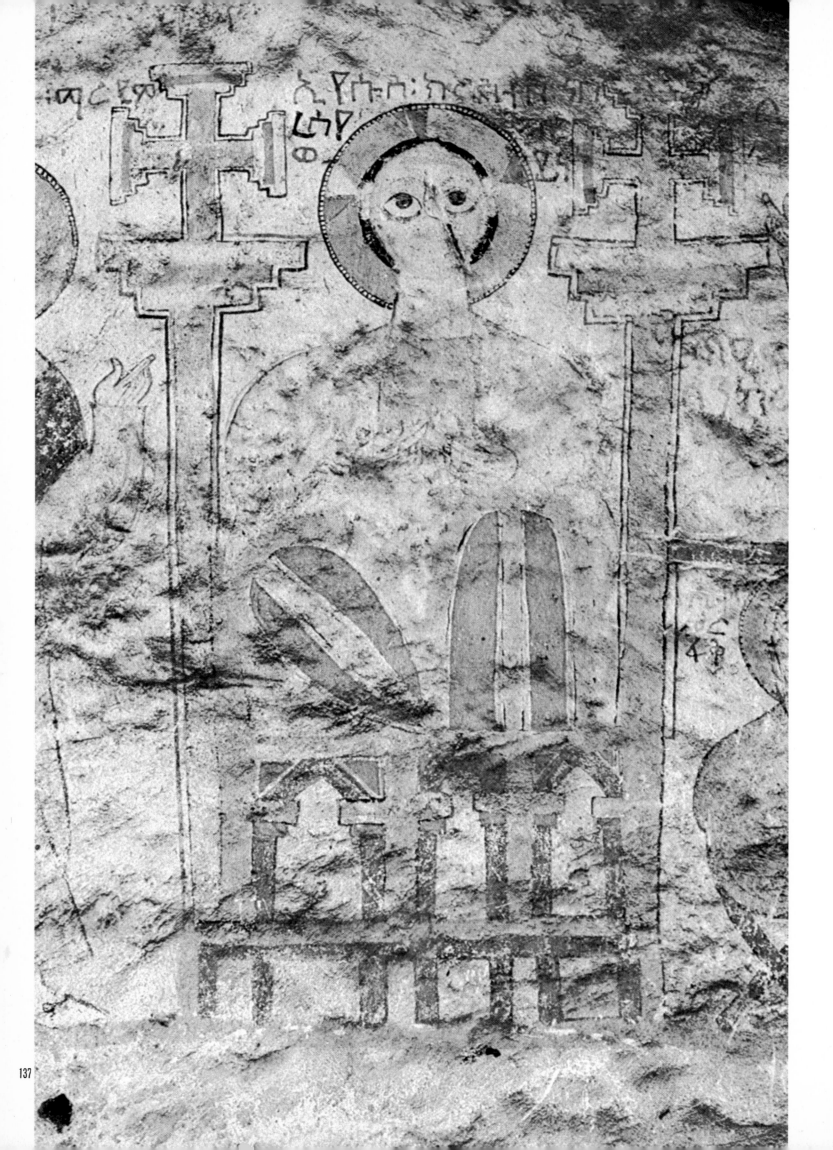

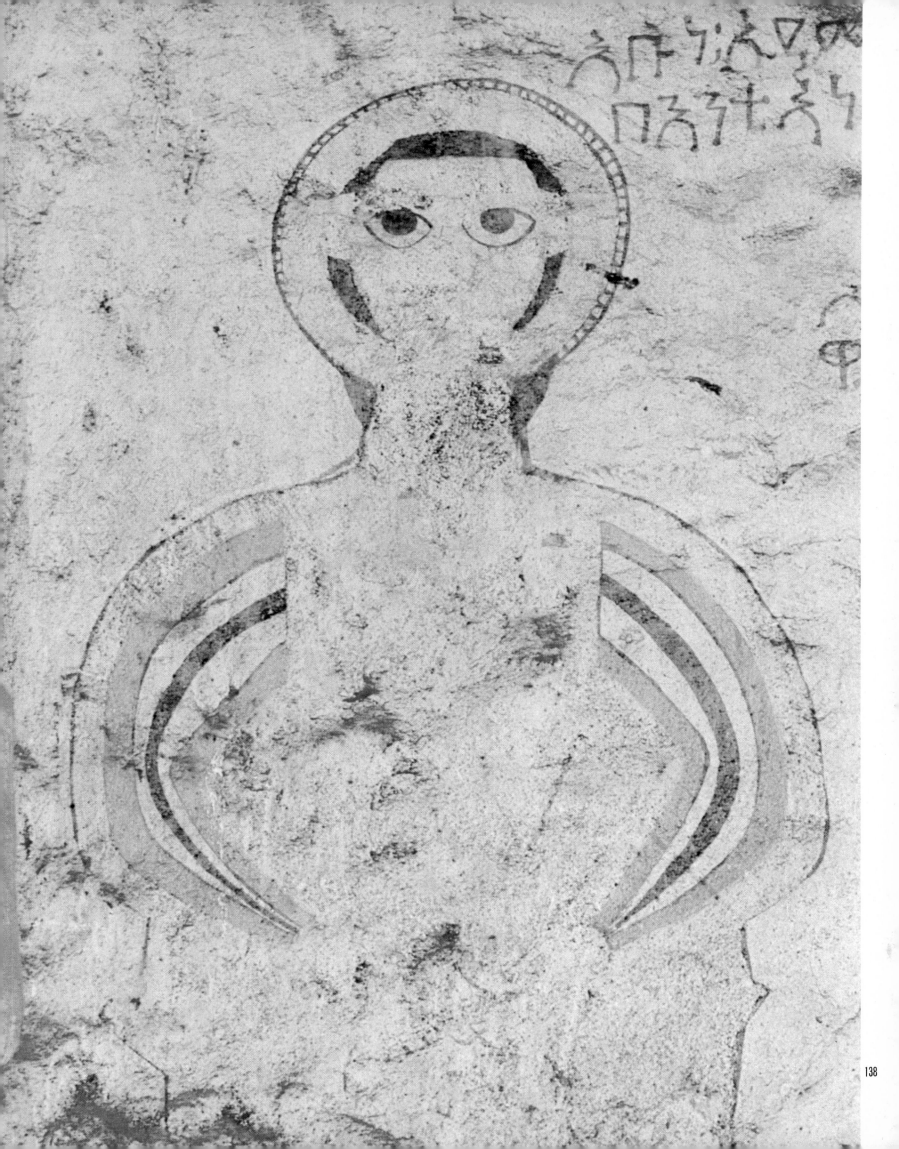

138

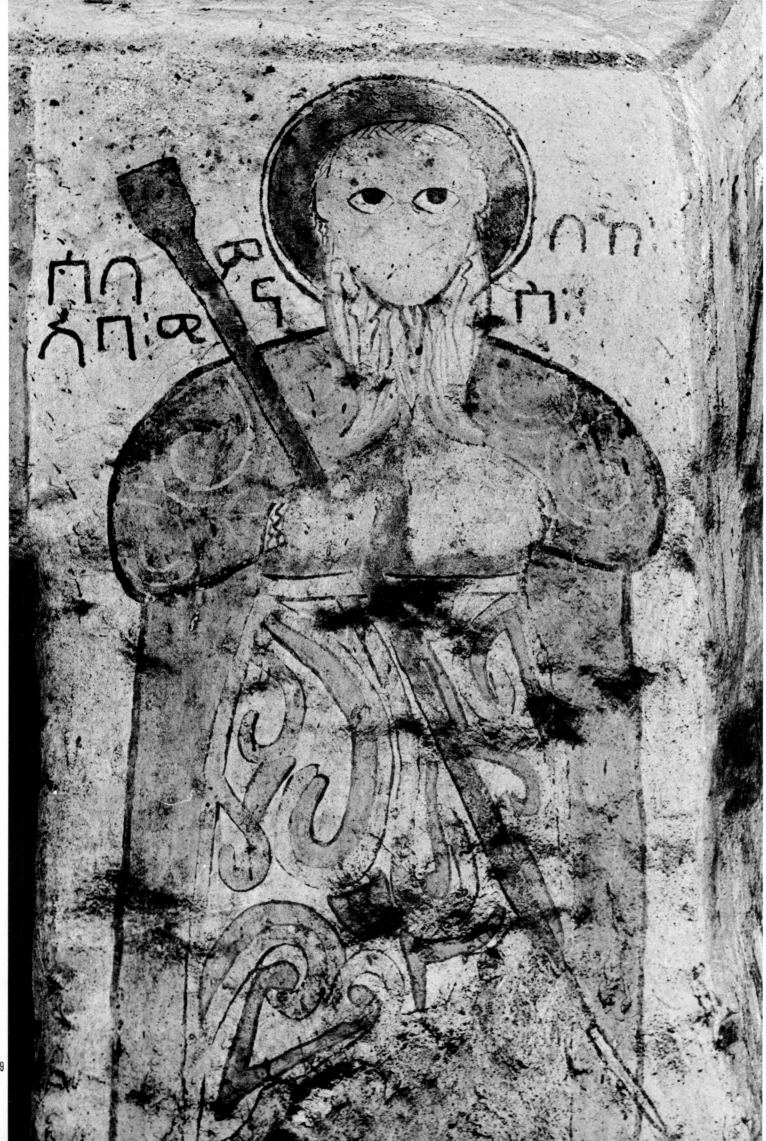

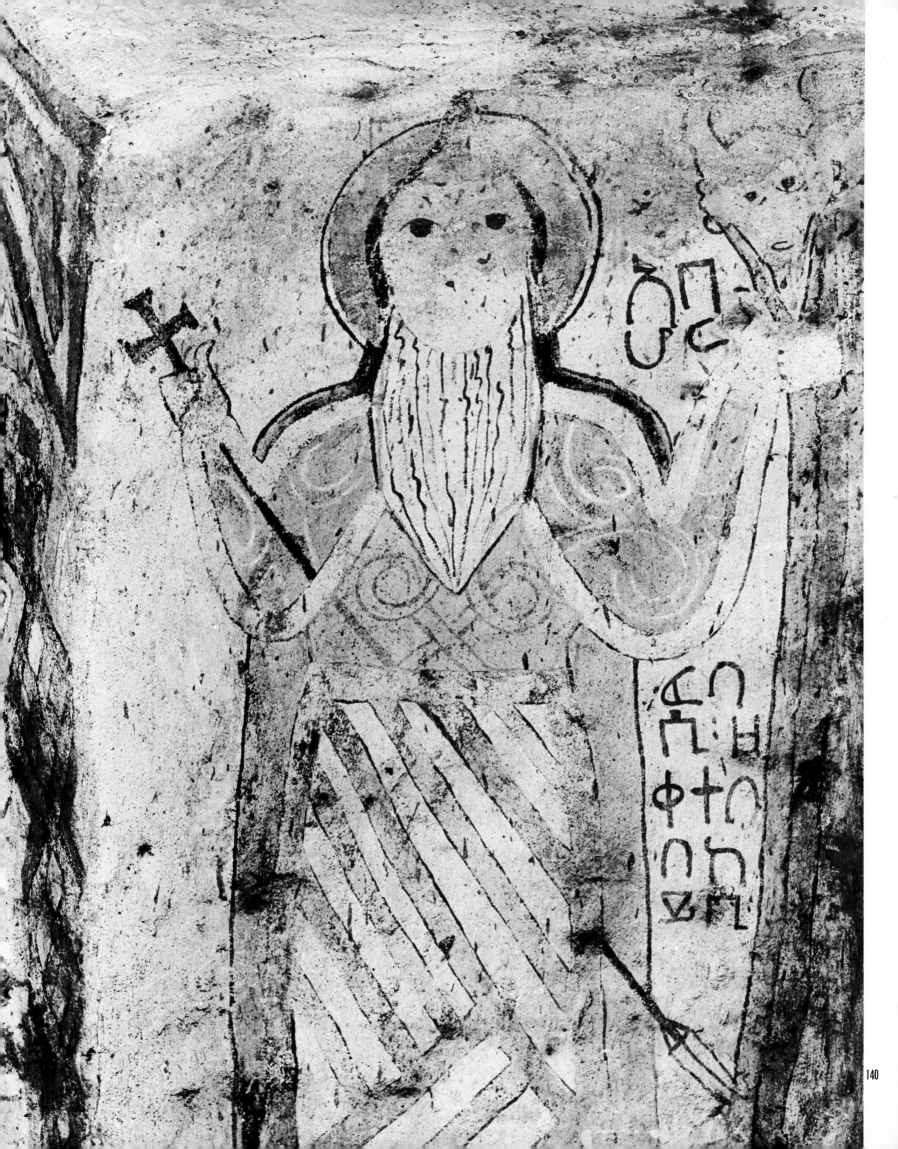

140

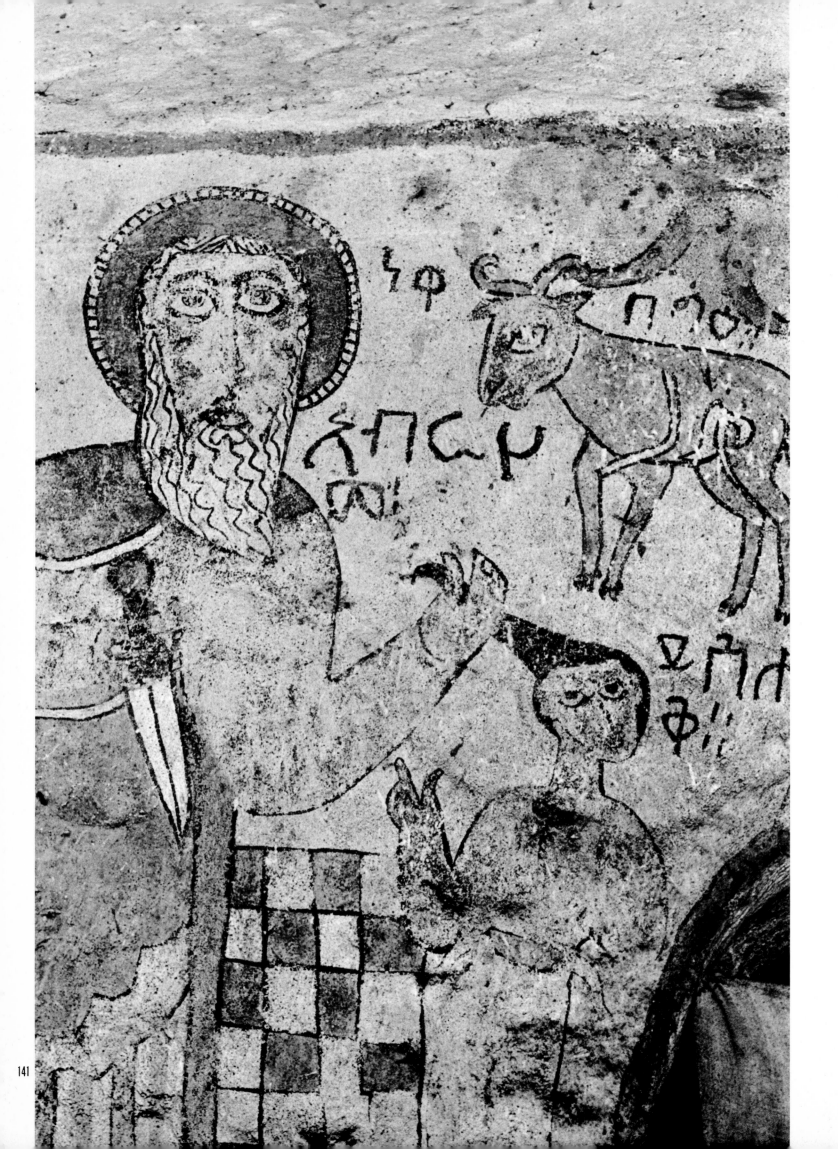

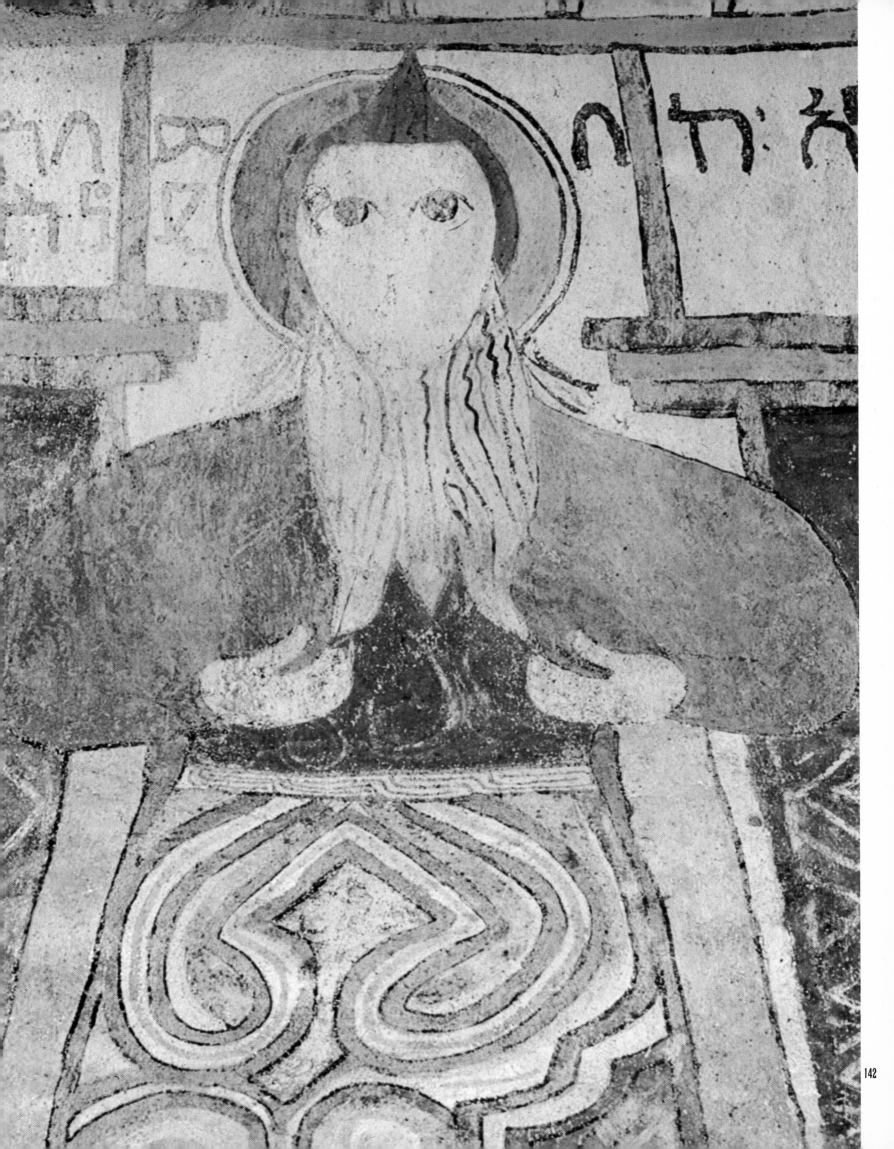

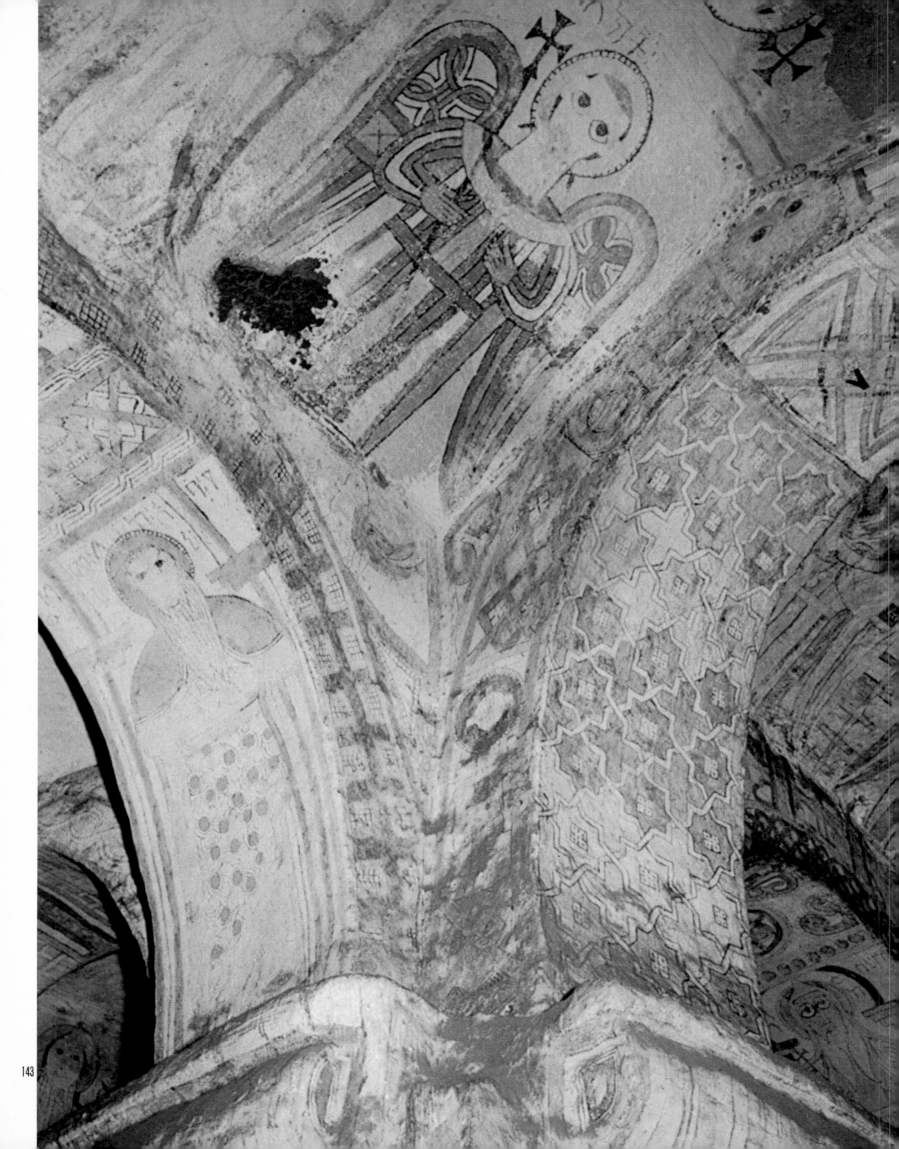

In the shadow of Lālibalā:

Bilbalā Čerqos

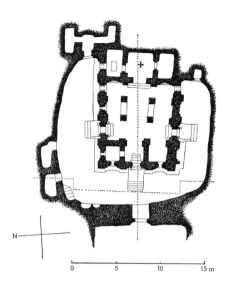

Fig. 87 Ground-plan (after *Bianchi Barriviera*)

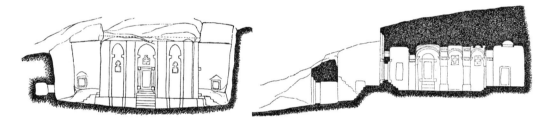

Fig. 88 Transverse and longitudinal sections (after *Bianchi Barriviera*)

Fig. 89 The 'baldachin' in front of the sanctuary arch (after *Bianchi Barriviera*)

The semi-monolithic church of Bilbalā Čerqos – still attached to the mountain by its roof and east end – lies one day's ride to the north-west of Lālibalā.

The site has been worked from a piece of tufa sloping from east to west (figs. 87, 88). The courtyard contains numerous chambers, niches and hollows, which today are empty but were probably originally for burials. The church stands on a platform, the old Aksumite stepped base. Steps connect the different levels at both the main entrance and side-doors. The floor of the church is somewhat lower than the threshold of the main entrance; nevertheless the floor of the sanctuary rooms is several steps higher than the nave and aisles. Inside and out, the entrances copy in stone the Aksumite door framework with its mighty monkey-head beams. The internal division of the church is similar to that of Gannata Māryām. Here, too, there is a kind of vestibule formed by connecting walls between the west end and the first bay on either side of the main entrance. But Bilbalā Čerqos shows less restraint in the use of architectural decoration. In cross-section, the first two pillars are cruciform; decorated soffits enliven the arches. Some details of decoration can be found only in this church. The four free-standing pillars – with base, cubical capital and the usual corbel-impost combination – are lengthened on the side facing the nave; this extension is surmounted by yet another corbel with impost. The arches of the second and third bays are corres-

pondingly flatter. There is another curiosity: besides the small cupola over the sanctuary, the church possesses a second dome in front of the sanctuary arch. This is not, however, let into the rock, but hangs like a baldachin – not unlike a giant upturned bowl, the foot of which joins the stone of the ceiling (fig. 89). As in Gannata Māryām there is no frieze of metopes. Some of the windows have been walled in, others are blocked with hives of wild bees and daubed with the wax. But the bees themselves have done no harm – tradition holds them in high esteem and there are legends told of sacred bees who protected churches from marauders. Perhaps this regard can be interpreted from the ancient belief that the bee was a symbol of chastity and the virgin birth, based on the mistaken conception, widespread in the ancient world, that bees reproduced by parthenogenesis. Like Gannata Māryām, this church is decorated on a coating of whitewash from the capitals upwards. Or rather it was decorated. It cannot be long before the last bit of plaster will flake off. Foreign determination to preserve the paintings can unwittingly cause their destruction. While I was taking photographs, I used a crooked tree-trunk with several branches as a ladder – this latter being unknown in Ethiopia – manoeuvring the heavy, unwieldy log from position to position with all possible care. Several days later, when I returned to the church, I discovered traces of fresh disturbance. With good intentions but ignoring the shower of falling plaster, the priests and deacons, whose curiosity had been aroused by the foreigner, had continued the investigation of their church on the improvised ladder ...

Another feature worth mentioning is the carefully executed wooden door with several interlocking frames between the qeddest and maqdas (choir and sanctuary). Being built as an afterthought into the clear space below the sanctuary arch (fig. 89), it has no monkey-heads and is probably later in date.

Tradition ascribes the church to King Kālēb (sixth century) and names some of his family as founders of the other churches in Bilbalā. This is the basis of the special regard which the church of the boy martyr St Cyriacus (Čerqos) enjoys. Nevertheless one can place no value on this attribution for dating, not even for a relative chronology in relation to Lālibalā. As with Gannata Māryām, Buxton sees the church as a work subsequent to the Lālibalā achievement. All the same, he admits that two other churches of Bilbalā – St George's (Sauter, no. 25) and the Four Living Creatures (Sauter, no. 31) – might be older. It depends very much on whether one attributes the careless, unoriginal effect of ungainliness to a late date in comparison with the virtuosity evident in Lālibalā, or credits it to initial primitiveness. At present the answer cannot be decided. In any case, following the most recent discoveries in Tegrē, we can no longer only look for possible journey-work in the immediate vicinity of Lālibalā, but, until the opposite is proved, prefer to consider the Bilbalā churches as copies within the sphere of the great masterpieces.

144 The north-west corner of the church: the west end with main entrance joins the north side. The respective lengths measure 8.7 m. and 12.5 m., the end being 6 m. high. The arrangement of the façade – podium and cornice, with niches in the recessed parts of the walls which are arched at the top with corbels, and windows usually pierced in the same shape – is reminiscent of the front of the Church of the Archangels in Lālibalā (pl. 92). Its ogees have, however, been abandoned in favour of the simple pointed arches.

145 David (?), sitting in oriental fashion with one leg folded under, pointing to a book with the exhortation from the psalter, 'The fear of the Lord is the beginning of wisdom' (Ps. 111:10). The painting fills the area between the corbel-imposts of the right-hand pillar of the third bay. The side arches rise from the lower corbel-imposts above which the arches spanning the nave are added on the upper corbel-impost. On the cubical capital there is a strip pattern derived from a series of loop-crosses.

146 Luke and John, the evangelists, with hand-crosses and books. They are in the space between the corbel-imposts of the right-hand pillar of the second bay.

147 Capital, corbel-imposts and their arches on the right pillar of the first bay. On the ceiling we see the Fathers of the Church in arcades on both sides of a strip of cross-rosettes. On the soffits of the arches there is an intertwined pattern and the Islamic cross-star combination already encountered in Gannata Māryām (pl. 143). The cubical capital has a design derived from a series of loop-crosses.

Additional Sources

Sauter, No. 29. Descriptions and references in Monti della Corte; Buxton, *The Christian Antiquities*; Playne; Bianchi Barriviera, *Le chiese monolitiche* and *Le chiese in roccia*.

144 The north-west corner of the church: the west end with main entrance joins the north side.

145 David (?), pointing to a book with the exhortation from the psalter, 'The fear of the Lord is the beginning of wisdom'.

146 Luke and John, the evangelists, with hand-crosses and books.

147 Capital, corbel-imposts and their arches on the right pillar of the first bay.

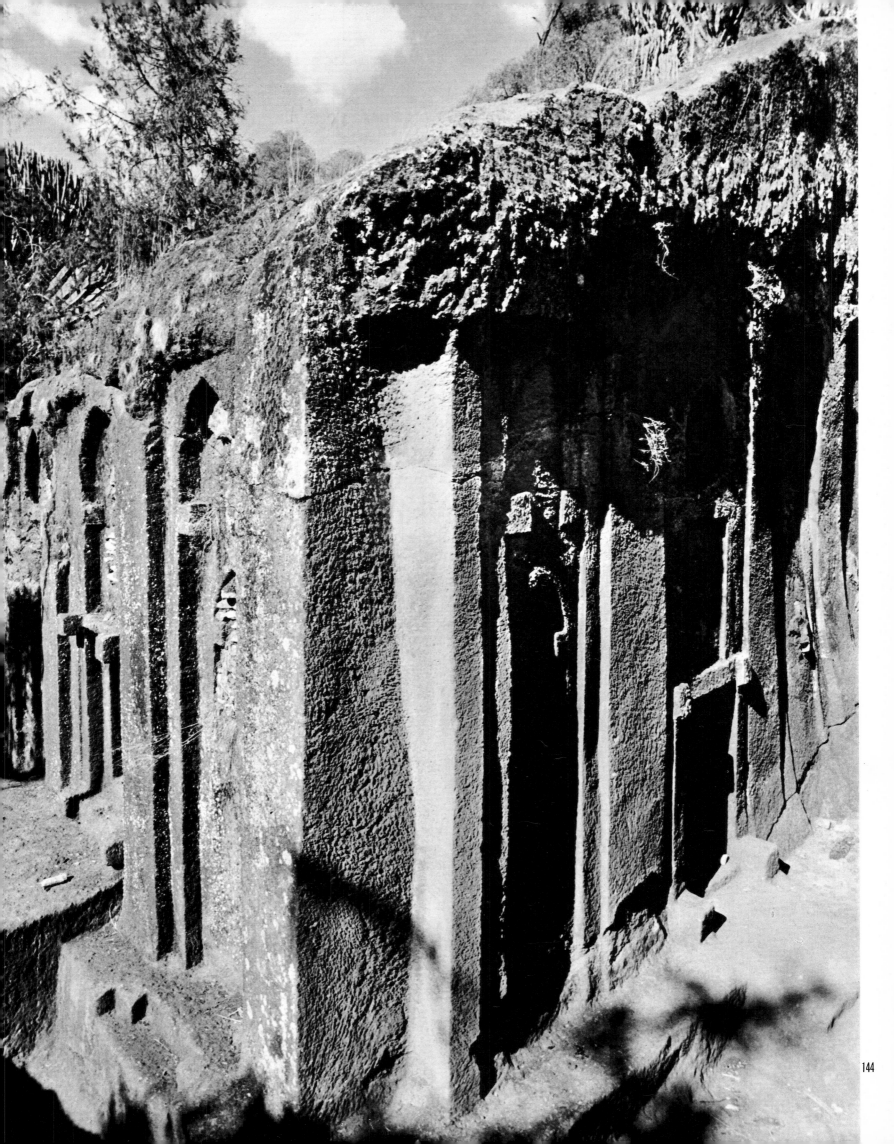

144

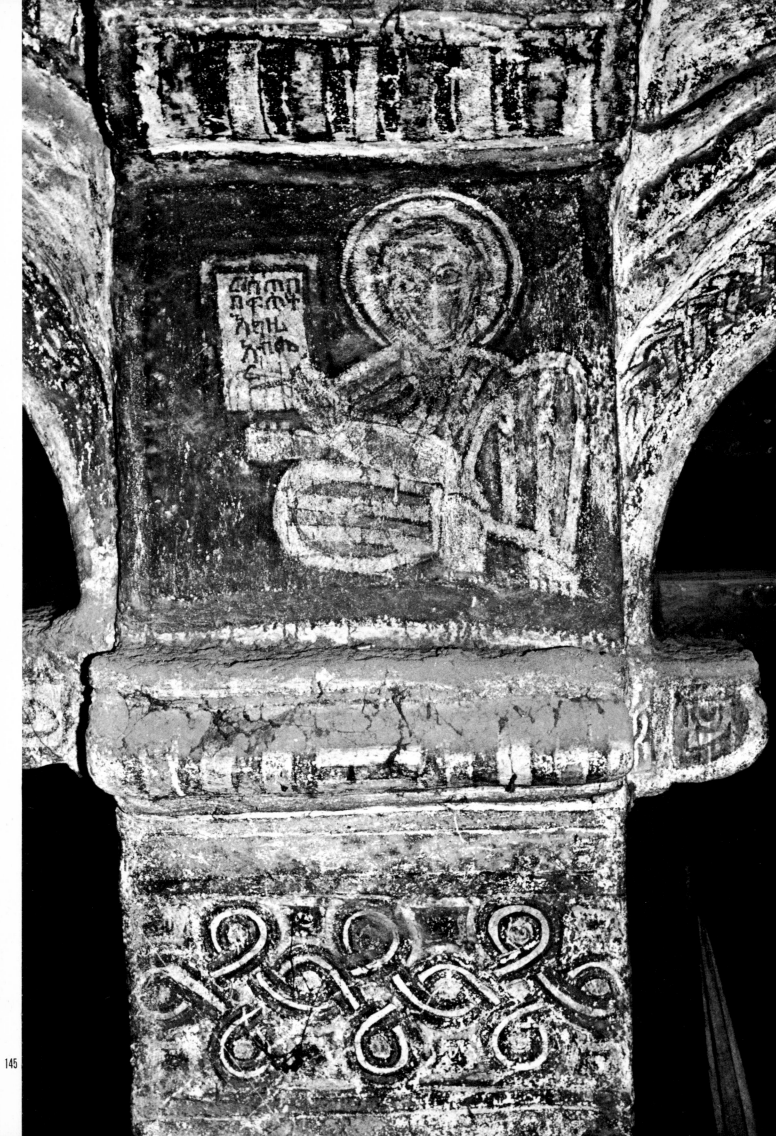

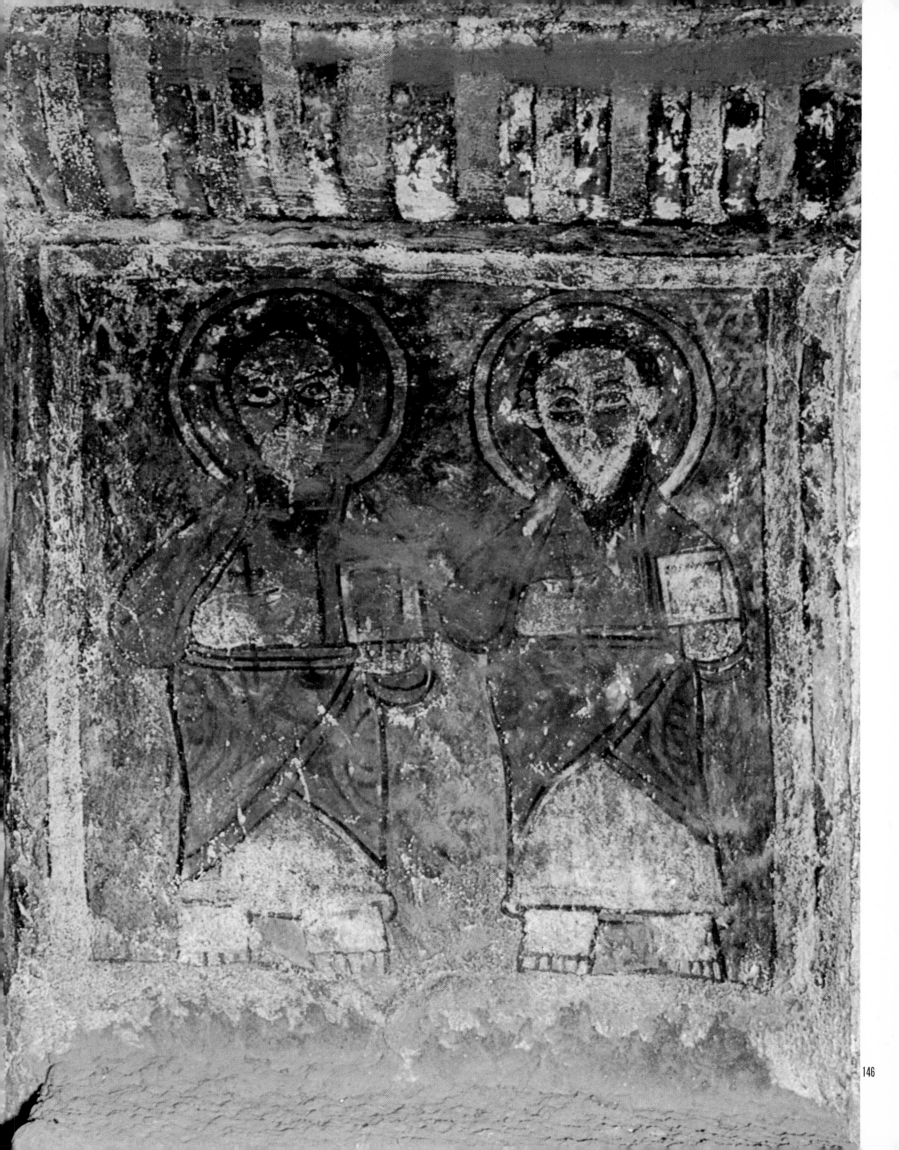

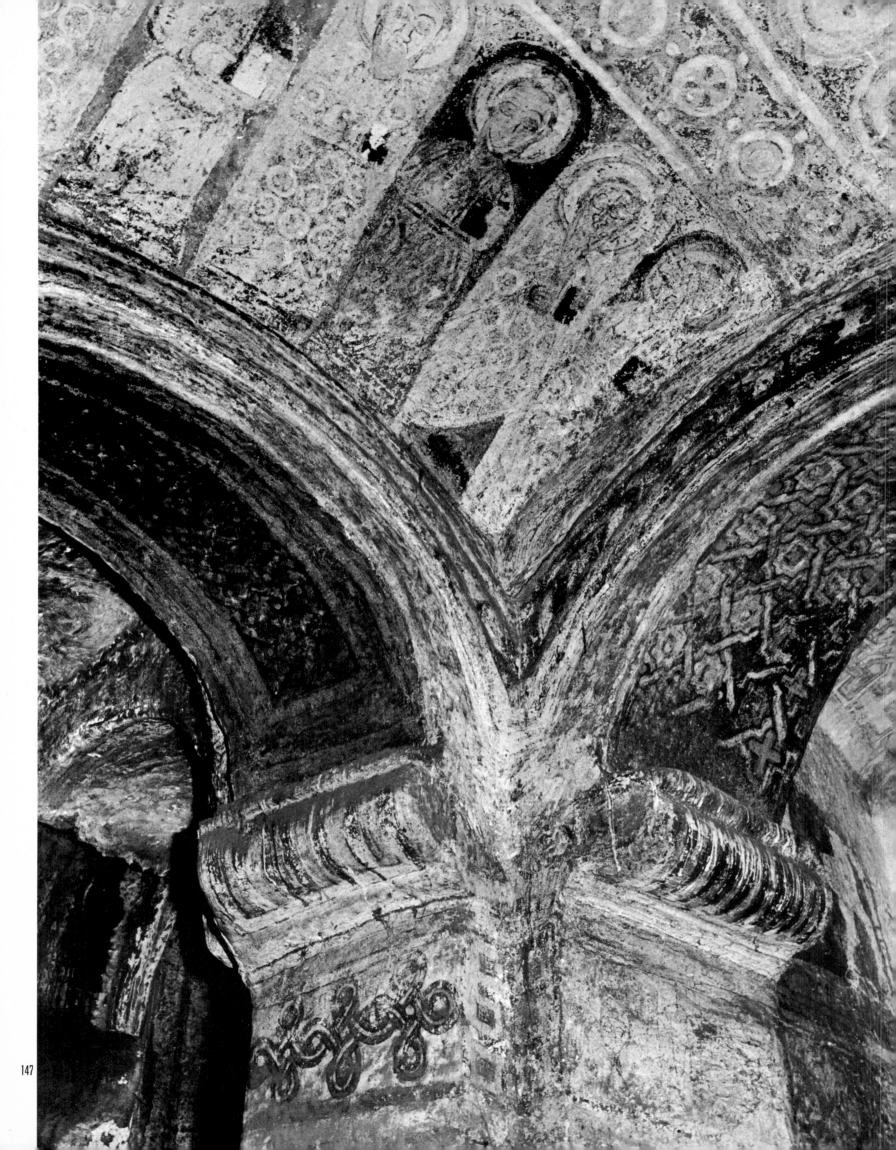

St Michael's of Dabra Salām

Like the pearl in the oyster:

Endā Mikā'ēl of Dabra Salām is one of the splendid discoveries of 1966. Being the first non-Ethiopian to enter its dark interior, I involuntarily cried out for joy at having found something so much greater than what I had been looking for. I had gone in search of an excavated church and stumbled on a cave church instead.

In conversation with the pundits – Mordini, Sauter, Abbā Tawalda Madḥen Yosēf – the locality of Dabra Salām was suggested as the site of an ancient church on the basis of Ethiopian hearsay. However, we could learn nothing more exact of its location than 'the other side of Aṣbi' (even though, as it later turned out, the maps of the Italian Istituto Geografico Militare of 1934 already indicated the locality), and there were even conflicting opinions on the best route to Aṣbi. Eventually I put my luck to the test after the conclusion of the Ethiopian Institute of Archaeology's reconnaissance expedition to Gar'ālta, in which I had taken part. At my request, Schneider, the leader of the expedition, accompanied me on my search.

We had success from the start. St Michael's of Dabra Salām crouches under a canopy of rock on a ledge in a steep mountain scarp about six miles to the north-west of Aṣbi. Admittedly the first impression of it is deceptive: seemingly a conventional church of no architectural significance. Only on entering does one become aware of the church that this chapter is about – the outer church is a new casing hiding the old inner church, as the oyster does the pearl.

The inner church is an oriented basilica with a nave, two aisles and narthex, and is more or less square on a base of 6.5 m. (fig. 90). It is not detached from the overhanging ledge of rock. On the north and west sides its stepped podium is attached to the rock of the cave. In the space cut free above it one can walk right round the church. A channel in the rock brings water from a spring in the back of the cave past the west end of the church to a baptismal font. Above, the church unites with the rock roof. Its façades show undiminished, as in no other Ethiopian church, the decorative value of the Aksumite style of wood and stone building with monkey-heads; in otherwise comparable churches either the strengthening of the wooden framework with monkey-heads is lacking (Yemreḥanna Krestos) or else there is no white layer of plaster on the sections of wall between the wooden beam-work (Dabra Dāmo). In contrast with all other known examples of this sandwich style of construction, here in Dabra Salām, at least in the visible sides, the strengthening wooden beams alternate not with the usual rubble bedded in earth mortar, but with masonry of dressed stone. The face of the wall is broken by projections and indentations. Doors and windows are also in the best Aksumite tradition. The squashing effect of the low cave is nevertheless seen in both of these: despite the heavy beam framework, the doors are disproportionately low and the windows of the second row, which in any case are lower than those of the bottom row, are placed immediately above them. The narthex can only be entered from the side. From it a doorway leads into the nave. Arcades, each with two arches, supported on pillars and pilasters, separate it from the aisles. The flat ceiling of the nave is high up and is surrounded by a decorative frieze of metopes. A sanctuary arch intervenes between the nave and the sanctuary. The latter lies under an apsidal shell with a frieze of metopes similar to the one in Abrehā Aṣbehā (pl. 183). The spaces either side of the sanctuary are chapels or sacristies. Blind arches on the walls of the low, flat-roofed aisles pair with the arches in the arcade of the nave; there is even a blind arch in the west wall corresponding

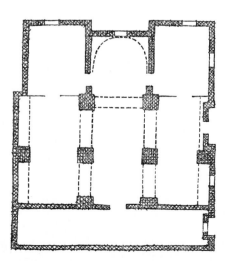

Fig. 90 Sketch-plan of the inner church

to the sanctuary arch. Pillars, bracket-capitals and abutments are each made from a single piece of stone. The upper walls of the nave with the frieze of metopes and the semi-dome above the sanctuary have been hollowed out of the living rock of the overhanging cave-roof. Smaller sections of wall, too, are monolithic. On the other hand the freestanding and blind arches are of built-up masonry. The striped character of the outer walls cannot be seen inside the church any more than the recessing of the surface of the wall, the monkey-head technique or the use of selected dressed stone. Beneath the plaster that is falling off, only a rather plain masonry backing of layered rubble can be seen inside. A wooden framework – independent of the horizontally laid beam-work visible on the outside – strengthens the inside walls in places. Frescoes decorate the walls, the pillars and pilasters, the surface area of the blind arches, and the soffits, faces and spandrels of the arches.

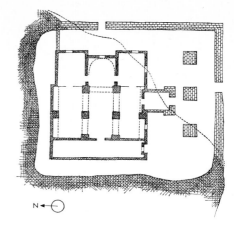

Fig. 91 Sketch-plan of the full lay-out

St Michael's confuses the visitor in two ways. Firstly, it is a hybrid in the way already indicated – four-fifths a built-up cave church, but still one-fifth an excavated church. Secondly in the course of time, at the earliest in the fifteenth century, it must have undergone a total change. Originally planned as a complete church, and probably used as such at the beginning, today it is simply the sanctuary of a larger establishment, the 'outer church' – an extension with built-up dressed stone pillars. As in other Ethiopian churches, such as the one in Bethlehem or the small church above the founder's tomb in Dabra Dāmo, the transformation came about in conformity with a new conception of church planning which was influenced more perhaps by fashion than by liturgical requirements. It required the maqdas, as the sanctuary, to be a square, or at least rectangular, free-standing structure within the church. The walls of the outer church probably arose from a partitioning-off of the cave, such as is usually common to cave churches. When the old church changed its function into being the sanctuary of a larger building, this entailed a change of orientation because of the lack of space. This church could no longer face east since the cave only permitted an extension in a southerly direction. I imagine that the curious 'sanctuary arch' before the southern façade of the inner church (in the axis of the new main entrance) was put there to give some structural expression to the alteration. There are indications that the date of the transformation was comparatively early: the person who commissioned the church still recognized the need and significance of the sanctuary arch, and the artisans who erected it still possessed the 'sandwich' technique of wood and stone building. The priests still preserve a memory of the former threefold division of what is now the maqdas. After the tābot was removed to the former sanctuary, I was allowed to enter those parts of the inner church which were originally set apart for choir and communicants, just as in other Ethiopian churches.

As to the founder of St Michael's, the priests sometimes name Abrehā and Aṣbehā, sometimes Gabra Masqal – fourth and sixth century kings of Aksum who are historically somewhat elusive. Obviously this cannot be seriously considered. In the case of the cave church Yemreḥanna Krestos, Buxton once argued that the lack of monkey-heads indicated a development of the old Ethiopian style. However, precisely because of the wealth of monkey-heads present in Endā Mikā'ēl, I consider it to be appreciably younger than that other cave church: whereas they are absent in the latter since technically they were irrelevant, here we find a superfluity, despite the fact that technically they have just as little significance in the freestone work. Doubtless the architect had benefited from his lesson on Aksum – stepped podium, projections and indentations, striped walls with monkey-heads, corbels functionally employed, stepped capitals in the stone window-fillings – but his building somehow has an effect too good to be quite true. For example the stepped podium is an architectural sham, since the floor of the church is on the same level as the floor of the crevice. Hence the church is probably to be dated to the late Middle Ages.

148 St Michael's of Dabra Salām, as it was seen by the discoverer from outside: an ordinary church, architecturally unexciting, nestling under an overhanging cliff. Churches of this kind – rectangular and with string courses of stone slabs to protect against dripping water – abound in Ēretrā (Eretrea) and Tegrē by the hundred. The Ethiopian who had gone to fetch the key to the church was away for an hour and I had already begun wondering whether the inside would be worth the wait.

149, 50 The unique, fascinating sanctuary which lay hidden within the commonplace outer church. No other building still extant gives one such an intense appreciation of the decorative effect of the old Ethiopian monkey-head style, admired by the Arabs in a church at Ṣan'ā in pre-Islamic days. The sill of the upper windows is simultaneously the lintel of the lower ones: the narrow crevice necessitated the window frames being placed together. The building owes its unusual state of preservation to the protection afforded by the overhanging cliff. The stonemasons and carpenters did meticulous work. Admittedly the angle joints formed by apparently interlocking beams of the framework are false – the corner blocks are cut to give this impression. The hatchet-hewn beams, dark with age, give the impression of wrought iron. The built-up 'sanctuary arch' with architrave stands on pillars of striped masonry in front of the south façade. Its whitened dressed stone blocks are of somewhat larger dimensions than those of the church walls.

Fig. 92 Painting of the Madonna in S. Maria Maggiore

151 The window above the entrance to the narthex as seen from inside the vestibule. The slab of stone (whitened at one time) filling the window is pierced with crosses in such a way that the remaining fillets form a swastika design. The vestibule lies beneath a wooden ceiling divided into two areas by a transom. The first area has embossed equilateral crosses of wood-moulding, the second is coffered. The layered masonry of the inner wall shows through the plaster which is flaking off.

152 Blind window of the second row with pierced stone filling. The carved arches with stepped design on their bases and capitals as well as the moulding of the shafts and arches derive from the oldest Aksumite tradition. Another similar window is to be found on the other side of the entrance with the sanctuary arch.

153 The window at the front of the sanctuary with an elegant rosette as stone filling. Its importance lies not merely in its circular pierced filling, but also in its position – it forms a row on its own.

154 The window above the south entrance with an icon of the Madonna on the inside of the shutter. The mantle drawn over her head, the Syrian maphorion; the crossed hands; the napkin, the 'mappula fimbriata' of noble ladies: all these point to the holy picture in S. Maria Maggiore attributed to St Luke the evangelist (fig. 92). After 1570, Jesuit missionaries distributed copies of this icon throughout the whole Orient; in Ethiopia its iconography displaced all other modes of representing the Virgin and Child. A carved pattern of interlacing, forming crosses, decorates the outside of the shutter (fig. 93). The church's remaining shutters are undecorated and open inwards. In the opening of the window illustrated there is an unusual combination of cross and arches: stepped bases and capitals and moulded columns as with the stone filling (pl. 152). On both sides, spurred guardian birds are painted on the stone layers. On the value of the inscription 'Birds of the Sea' see the description of plate 39.

Fig. 93 Carved pattern of interlacing

155 Pilaster capital for blind arches in the left aisle. The mixed character of the building can be seen particularly clearly here: on the pilaster, which is apparently cut from the living rock, rests the corbel, which has taken the place of the capital and on which built-up blind arches rest. The lower half of the decorative cross is carved out of the corbel, while the upper half is modelled in the plaster.

156 Elephant-riding saints: fresco on the wall of the western end of the left aisle. The rider at the rear seems to be kneeing the animal and driving it on with a whip; the one in front must be the passenger. If this is the correct interpretation, then the picture

shows little familiarity with elephant riding. In contrast with the picture of an elephant in Yemreḥanna Krestos (pl. 126) there is neither howdah nor mahout. And those depicted? Perhaps Aedesius and Frumentius in India or, more likely, Thomas, the apostle of India, with a disciple who wears a halo – as might be expected in the company of the saint. The Acts of Thomas, relating the apostle's missionary activities and martyrdom in India, used to be read even in Ethiopia. Early Ethiopian familiarity with tame elephants can be assumed: according to Littmann the title of the emperor prescribed for court ceremonial, and corresponding to our 'your majesty', originally had the meaning 'O elephant'. The year Mohammed was born, the Aksumite governor in the Yemen went to Mecca with elephants to avenge the desecration of the church at Ṣanʿā, the very one with striped masonry and monkey-heads. Sura 105 of the Koran celebrates the events of the so-called year of the elephant. However, from then on, we hear nothing of elephants for work or riding until the expedition by Napier, who led the army from Bombay against Theodore in 1867/68 with elephants.

157 The west wall of the right aisle and nave. The upper walls of the nave, beginning with the frieze of metopes, have been carved from the living rock of the mountain ledge. On the soffits of the arcade there are floriated crosses; monastic saints are painted on the pilasters and walls, those in the blind arches being in the attitude of prayer.

158 Christ's triumphal entry into Jerusalem: detail from a fresco on the forefront of the left aisle on the altar side. In western fashion, Christ is astride the ass, holding a palm frond in his left hand and the donkey-reins in his right. The inhabitants of Jerusalem are spreading garments in his path and waving branches. The Lord, the apostles and the people, shouting Hosanna, wear a strange sash over their garments (see pl. 159).

159 Un-named monastic saints with books, holding a sash over their garments: fresco on the forefront of the left aisle on the altar side. The artist was not really very good at anatomy. The sash might be a liturgical vestment, either the moṭāḥet or engedʾā, a kind of stole which is worn by the priests and, in a different fashion, by deacons.

Additional Sources

Sauter no. 1501. Description: Gerster, *Die Michaelskirche.*
On the iconography of the Virgin: Monneret de Villard, *La Madonna.*
The elephant in Ethiopia: Littmann, *Indien.*

148 St Michael's of Dabra Salām, as seen by the discoverer from outside: an ordinary church, architecturally unexciting.

149/50 The unique, fascinating sanctuary which lay hidden within the commonplace outer church.

151 The window above the entrance to the narthex as seen from inside the vestibule.

152 Blind window of the second row with pierced stone filling.

153 The window at the front of the sanctuary with an elegant rosette as stone filling.

154 The window above the south entrance with an icon of the Madonna on the inside of the shutter.

155 Pilaster capital for blind arches in the left aisle.

156 Elephant-riding saints: fresco in the left aisle.

157 The west wall of the right aisle and nave.

158 Christ's triumphal entry into Jerusalem: detail from a fresco in the left aisle.

159 Un-named monastic saints with books: fresco in the left aisle.

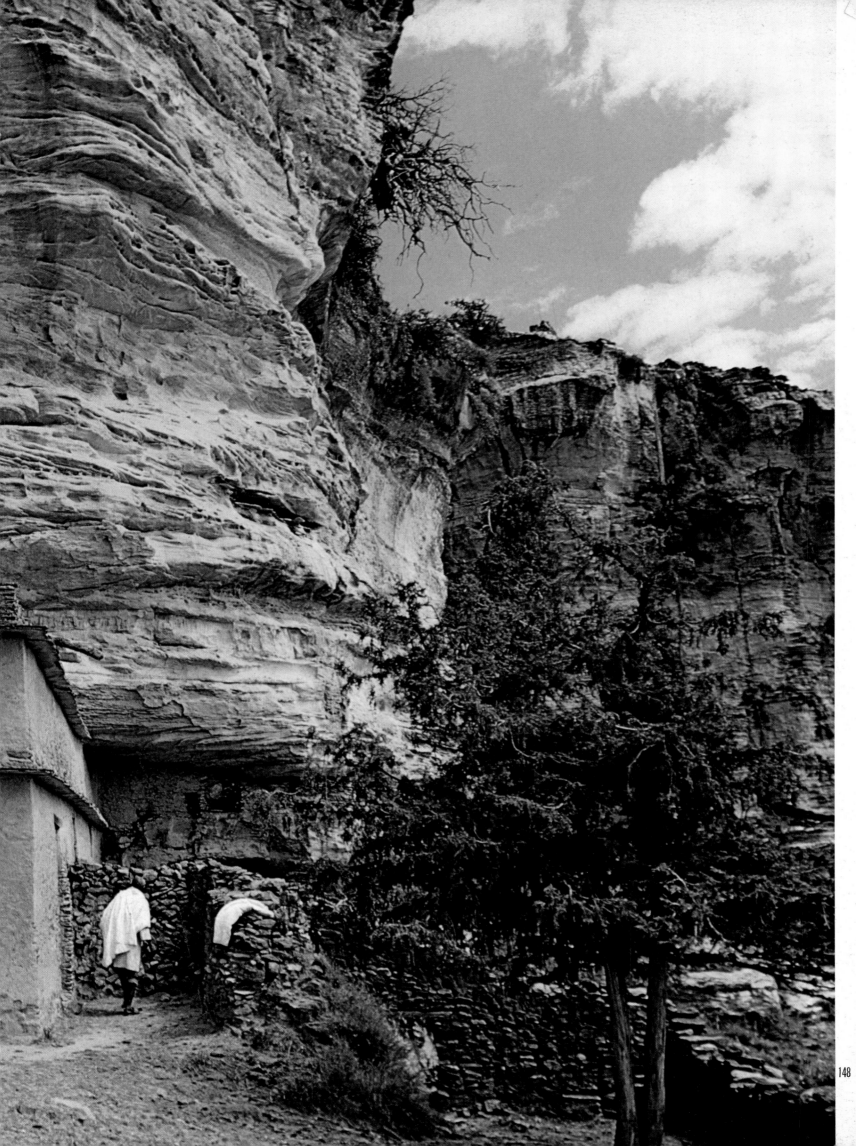

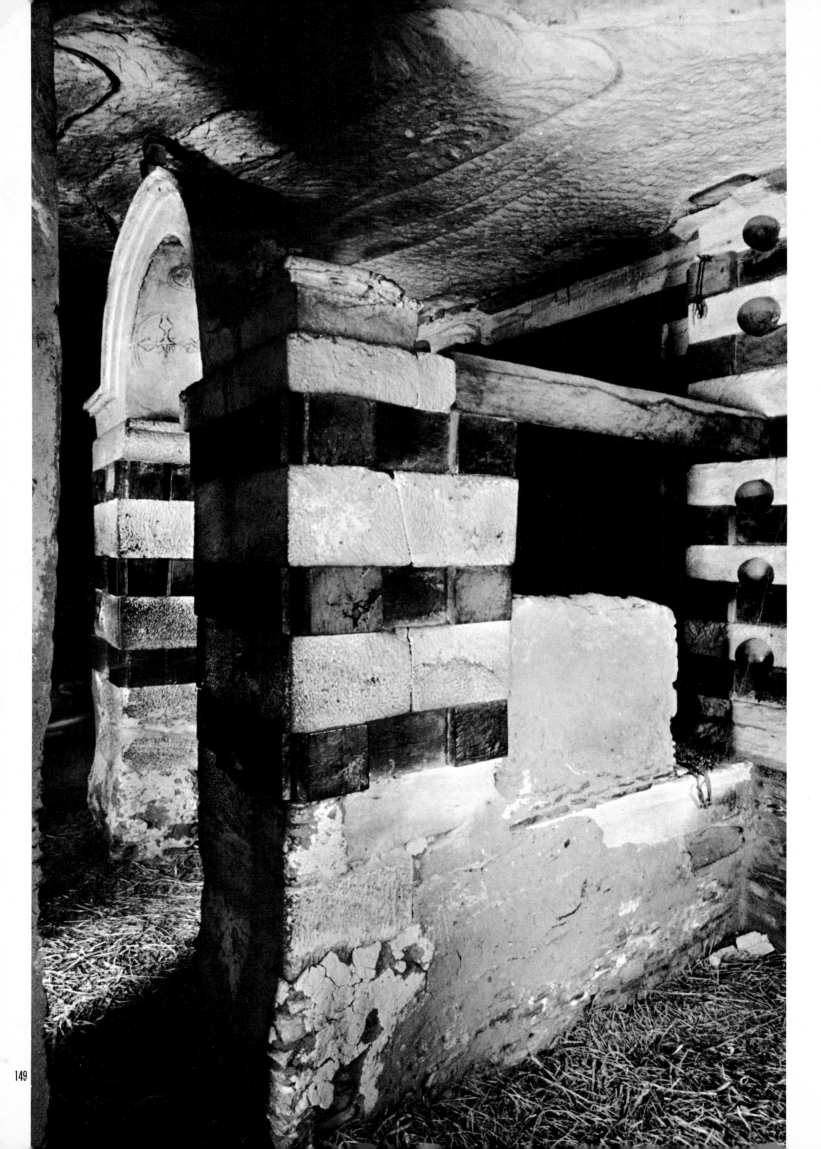

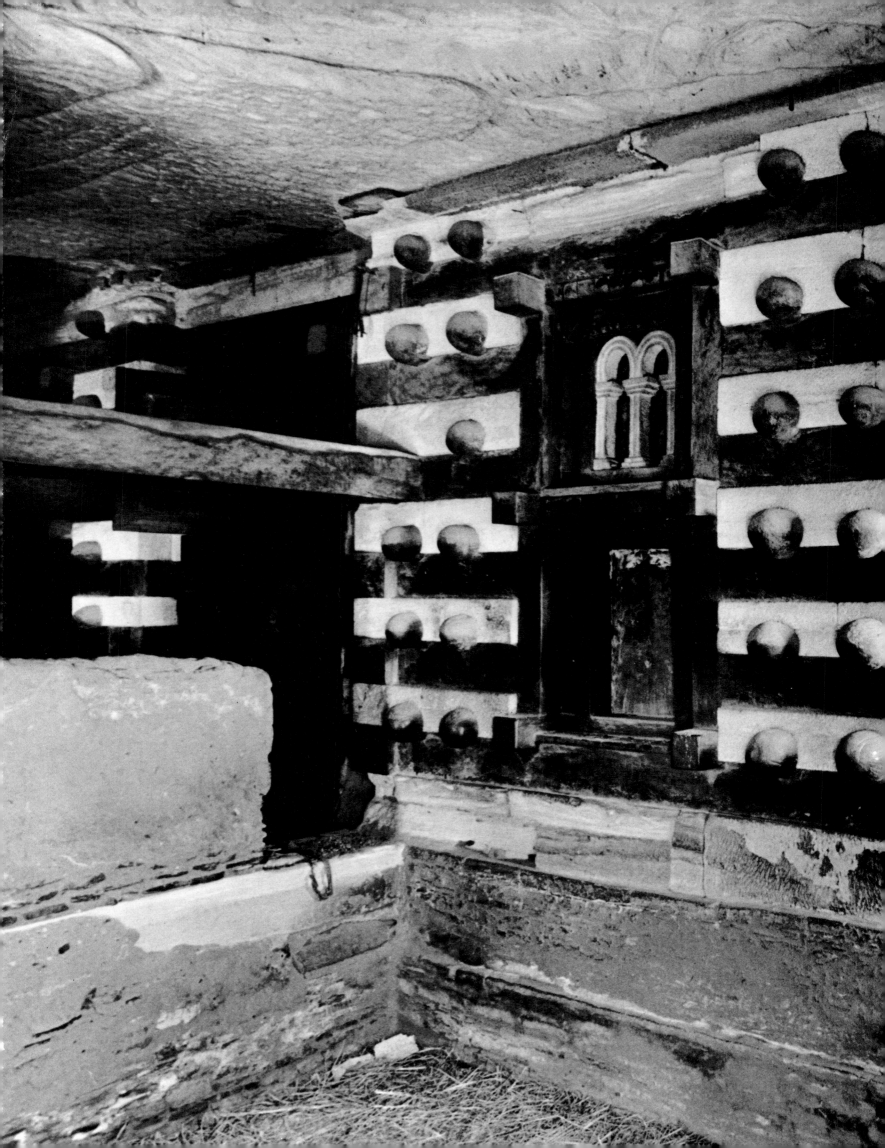

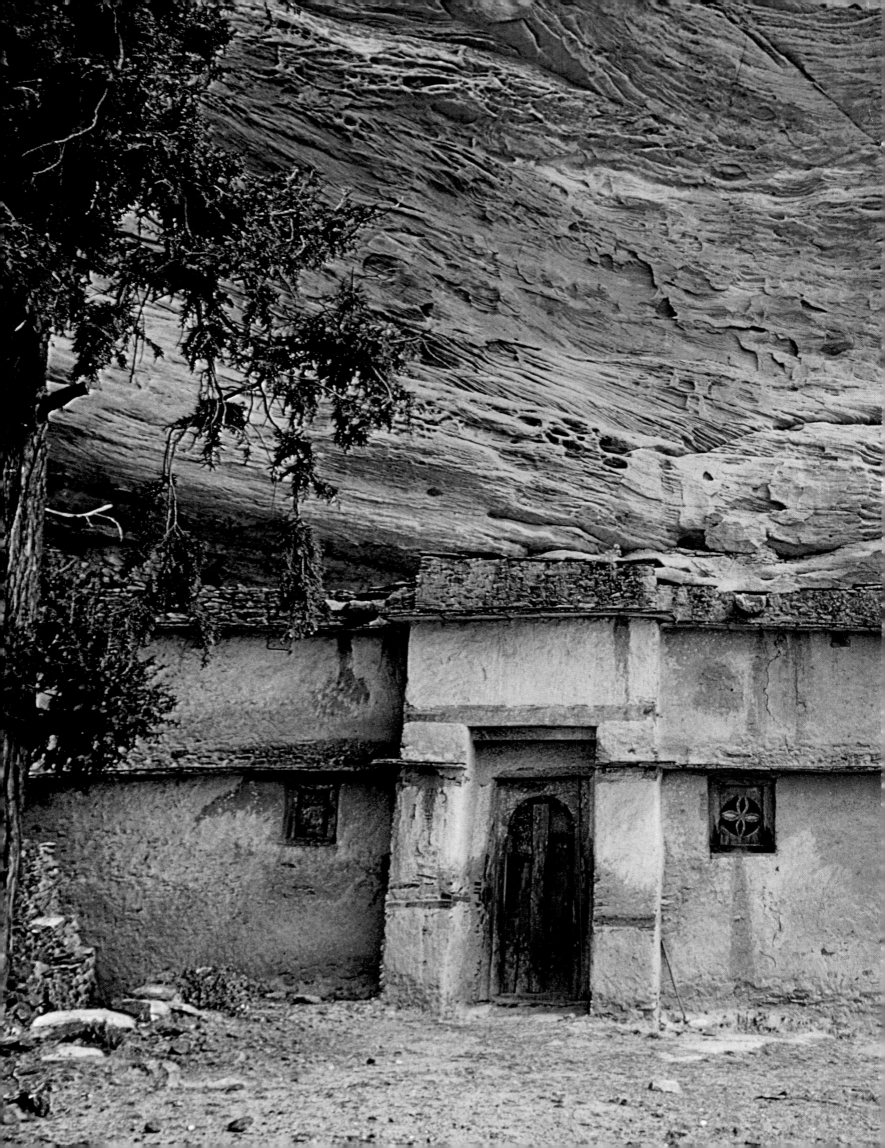

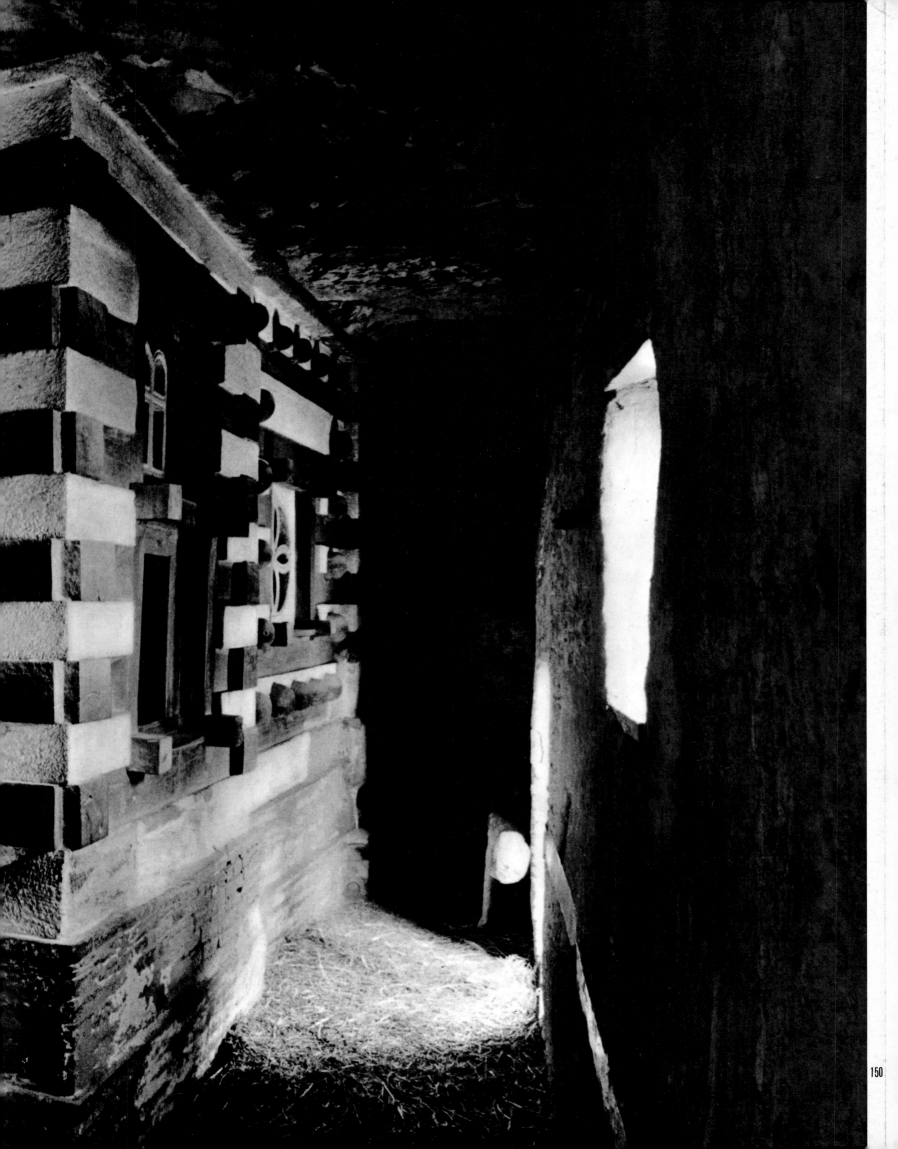

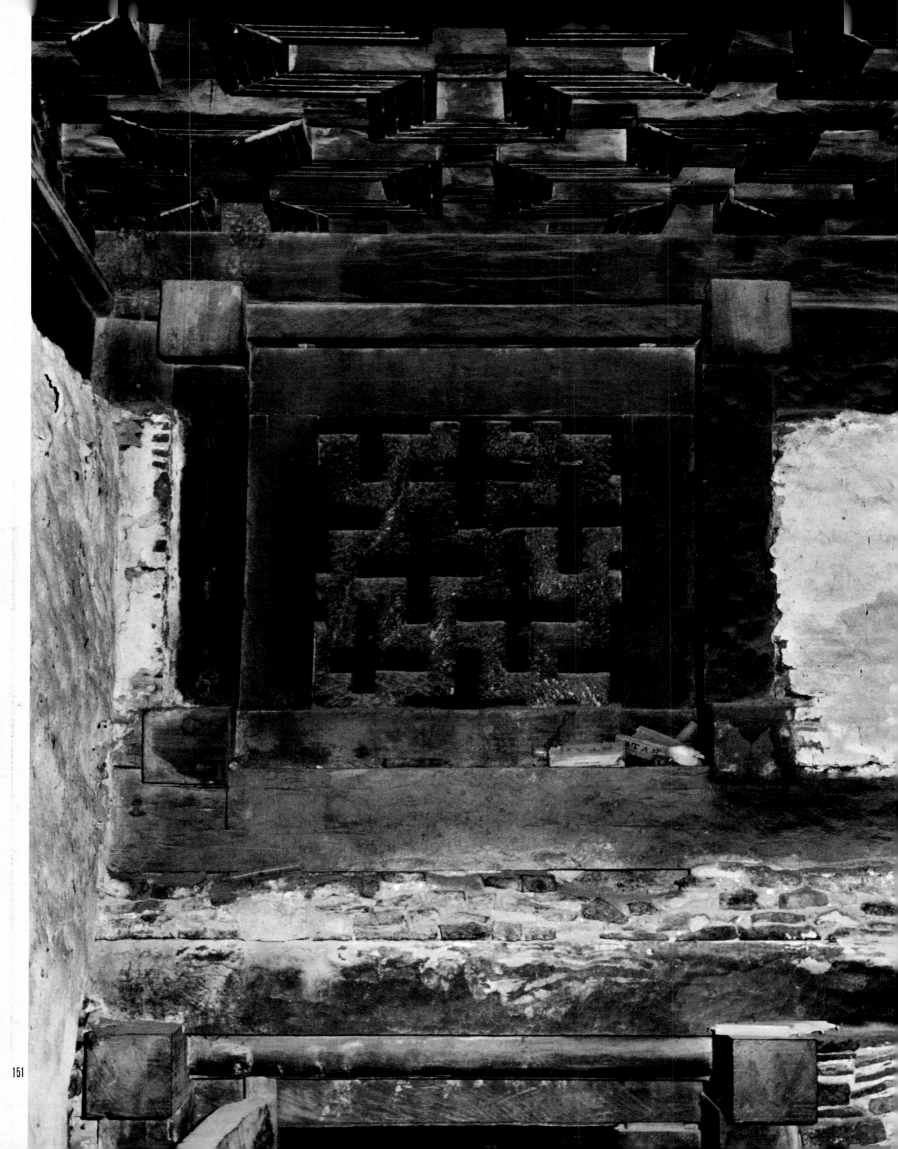

152

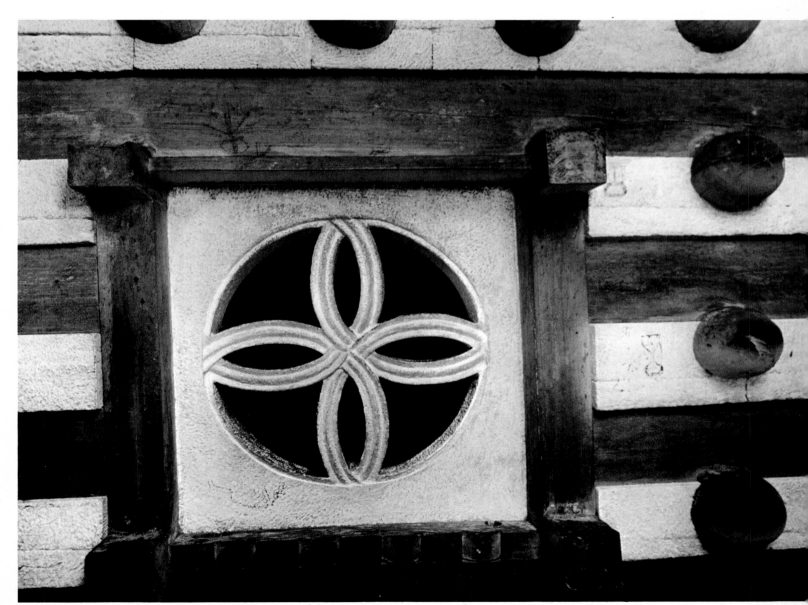

153

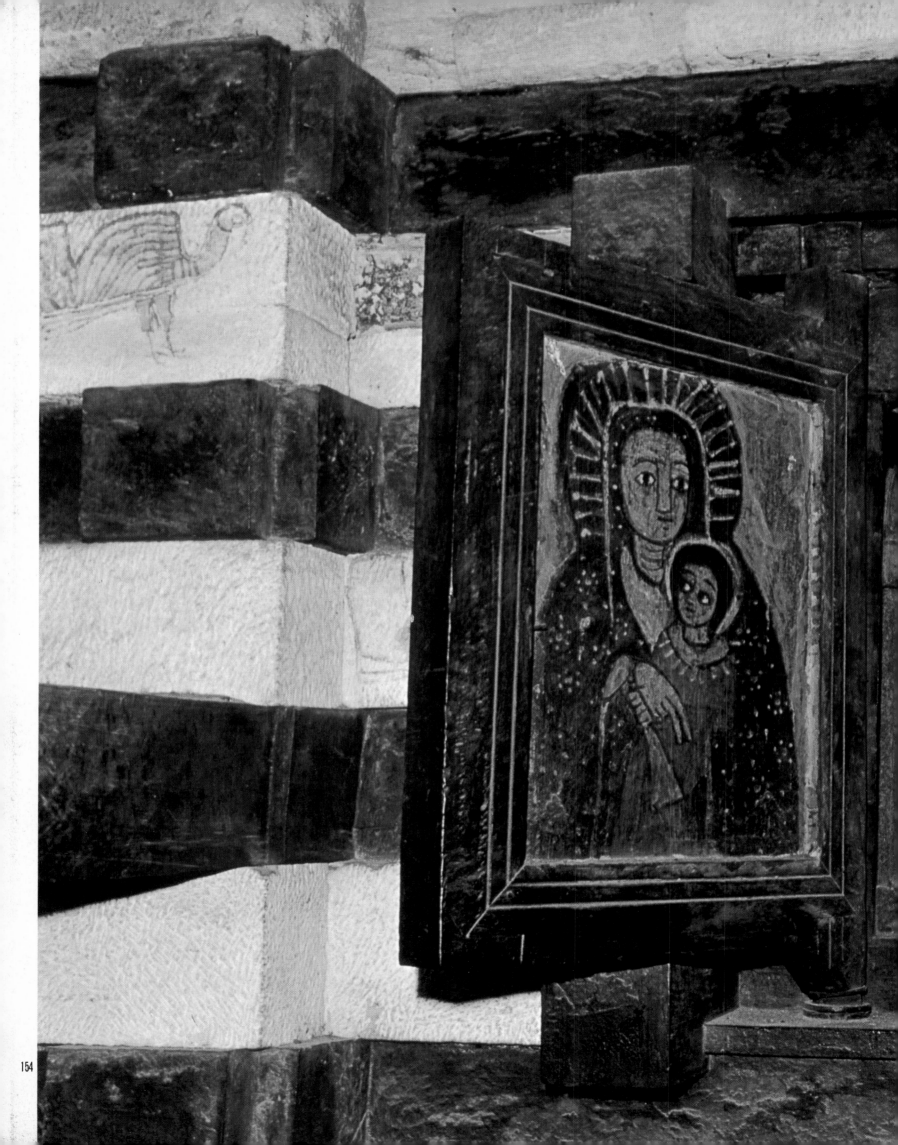

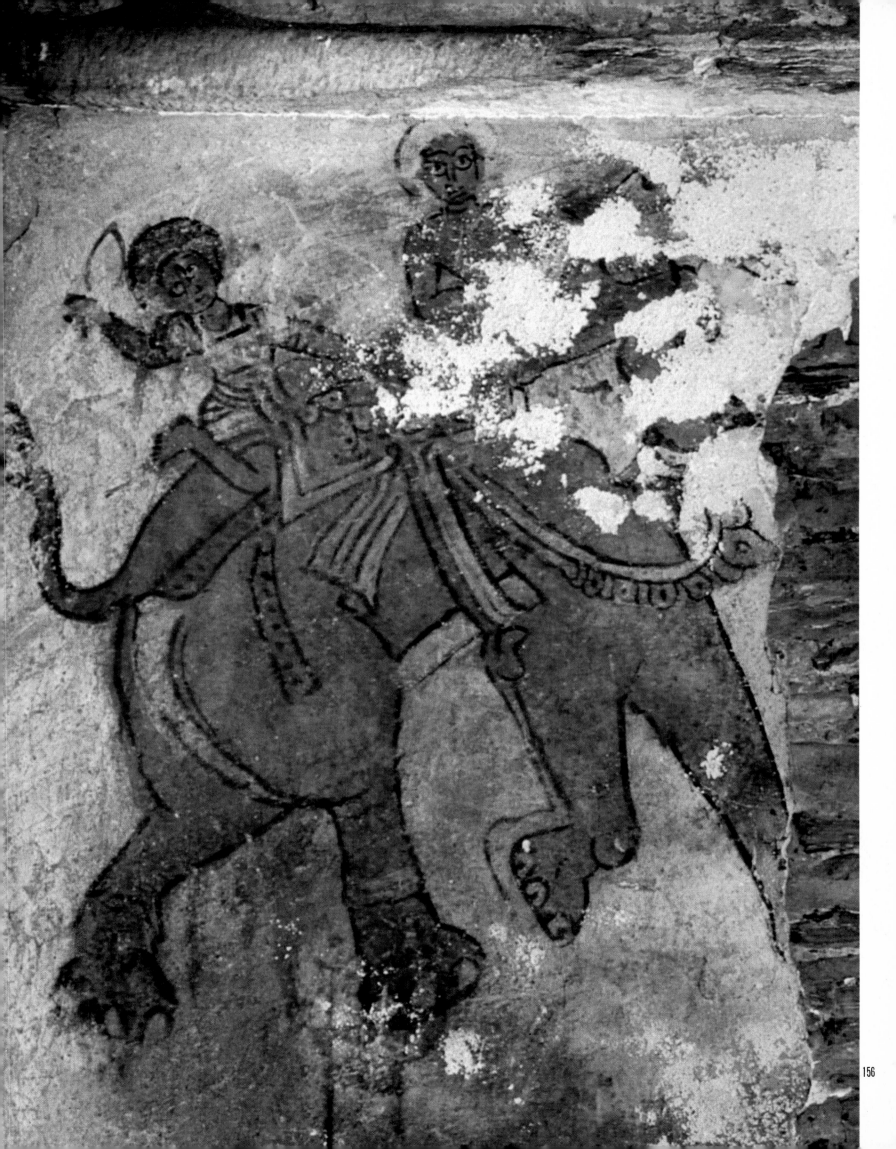

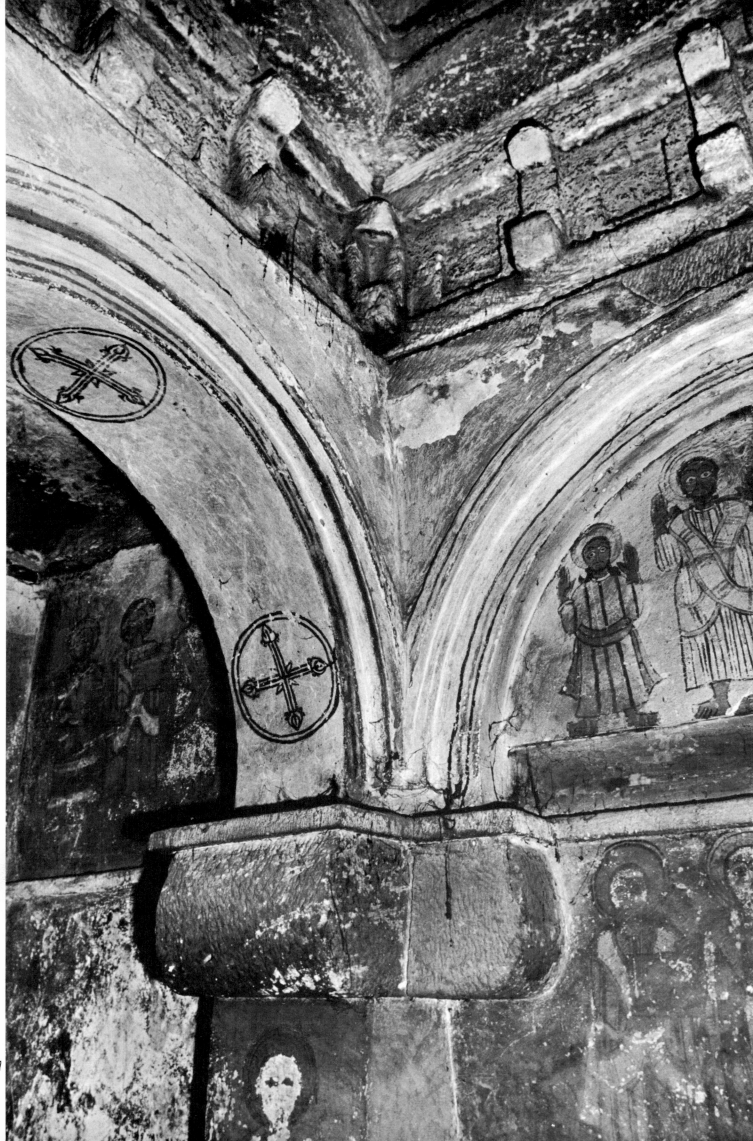

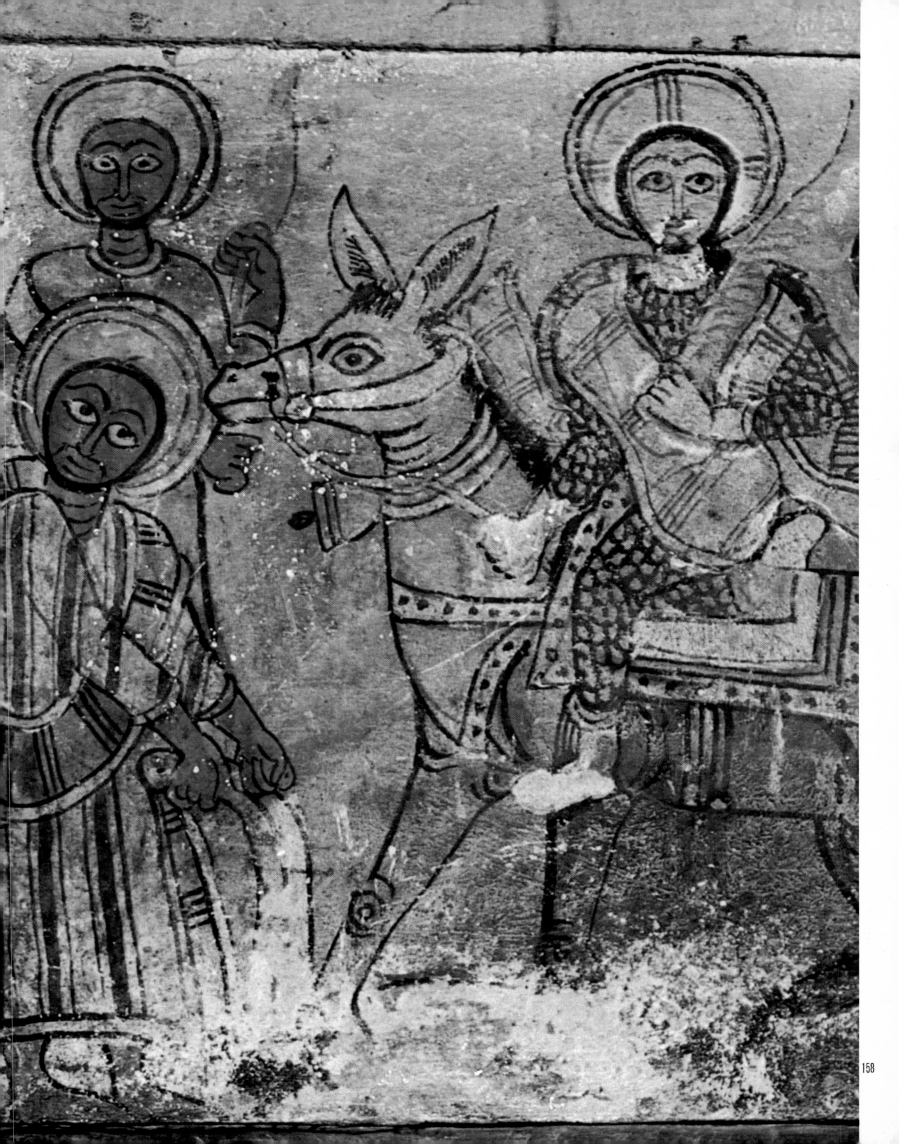

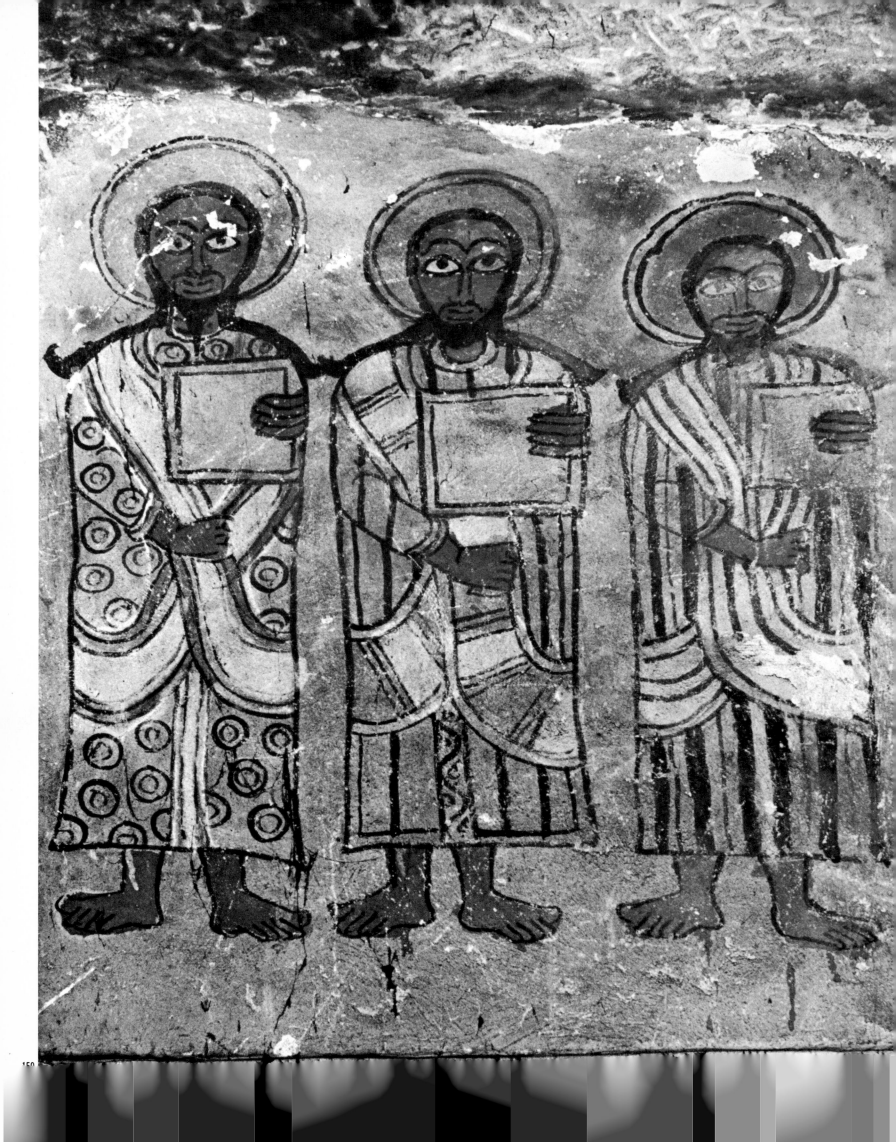

Five New Variations on the Theme of Rock Churches

This chapter deals with the Church of the Redeemer at ʿĀddi Qāšo, the Church of the Four Living Creatures at ʿĀddi Čawā, the Chapel of the Trinity at Degum, the Church of St John Boanerges (Mark 3: 17) at Maʾaquddi and Endā Māryām Weqro. To claim that these churches have been dealt with together because of their geographical proximity – they can be located with their number in Sauter's register in fig. 36 – is merely an excuse. I have a no more convincing reason for this grouping than that I visited these five sanctuaries – three of which, not previously visited by non-Ethiopians, as the companion of Schneider – on five successive days. And no justification other than astonishment that there are so many, sometimes surprising variations on the rock church theme.

There is no difficulty in reaching Endā Madḥanē ʿĀlam or ʿĀddi Čawā: the latter is just over half-a-mile south of the village of Senqātā in a ledge of rock ten minutes walk away from the road; the former is an hour's hike from the road, in a cliff face seven miles south of Senqātā. The traveller passes Senqātā on the road from Aśmarā to Addis Ababā between Addigrāt and Weqro.

The Church of the Redeemer of ʿĀddi Qāšo is an oriented basilica with a narthex, and two aisles and a nave ending in apses, and seems to represent a comparatively old architectural design (fig. 94). Its narthex was originally a colonnade, half-open towards the front, with three door openings in the rock partition which measured a little over human height (fig. 95). Later on the opening between the pillars was walled up almost to the brackets supporting the architrave.

The pillars show traces of weathered decoration in relief. The sparing use of open arches in this excavated church also gives the impression of antiquity. They are

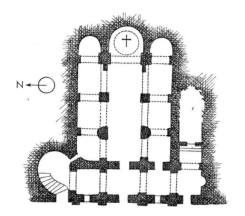

Fig. 94 Sketch-plan of the Church of the Redeemer

Fig. 95 Façade of the Church of the Redeemer

confined to the vestibule. Arches link the true narthex with lobbies cut from the rock at each end, the southern one of which provides the connection with a lady chapel of undetermined dimensions. Above the sanctuary there is the hint of a dome, otherwise the ceilings are flat, in harmony with the lintels dividing each aisle into

three bays. The ceilings of the aisles and narthex are decorated with bas-reliefs with geometric motifs, most of them imitating roof structures or wood decorations in built-up churches.

The Church of the Four Living Creatures of 'Āddi Čawā gives quite a crude impression in comparison with the Church of the Redeemer. On entering, one initially takes it to be an enlarged natural cave. This observation, however, does not long withstand critical scrutiny. The 'cave' exhibits all the elements of an oriented basilican lay-out: vestibule, nave and two aisles each with two bays, and apses (fig. 96). Arches link the pillars to each other and to the appropriate pilasters; the only exceptions are two architraves resting lengthwise on the first two pairs of columns. The floor of the sanctuary is raised. Built-up partitions reaching up to half the height of the space divide the apses from the aisles. The second bay of the nave and the apses have domed ceilings; the domes partly imitate wooden cupola construction. The church measures about sixteen metres deep. However rough and coarse the excavation may be, both as a whole and in detail, its fresco decoration must have been quite remarkable. There are traces of crumbling and fading murals on pillars, arches and architraves. Pieces of a carved wooden screen – probably the forerunner of the present masonry partition – lie against the wall.

The Trinity Chapel of Degum and St John's Church of Ma'aquddi are both in the administrative district of Gar'āltā. The best way to get to them is across country by wheeled transport from Hawzēn.

The layout of Degum is something of a puzzle. It can only be fully understood as a rock excavation originally intended to be a place of worship (fig. 97). It is oriented. Its main space, three metres high and a bare four metres wide and long, gives the impression of a threefold division by its two imitated lintels, supported only at the ends. False roof-beams in the 'aisles', resting on pilasters, strengthen this impression. The sanctuary arch at the far end of this area leads to the almost square sanctuary beneath a false-beam cross. A hatch beneath a blind arch in its east wall was probably for the reception of the eucharistic bread. The side openings into lobbies are closed at the top by an architrave on pilasters, in front of which is an arch on quarter-columns (pl. 169). Numerous socket holes in the rock show that extensive use was made of wooden parts. Their absence today makes it difficult to understand the plan. If it wasn't originally excavated for worship, it could have been an Aksumite rock tomb, from Aksum's Christian period – the last resting place of some notable or kinglet whose remains were subsequently removed to a church. Or perhaps after the burial, it was the crypt of a church built around and above it. That there were such tomb-church combinations within the sphere of Aksum is suggested by the results of the excavations at Maṭarā. On reflection, too, the fact that St Michael's of Degum, only a stone's throw from the Trinity Chapel, embodies two similar though rather smaller excavations, fits in with this interpretation. In the Trinity Chapel the entombment could only have been achieved in the central space: the side-rooms are not large enough to hold a sarcophagus.

St John's of Ma'aquddi is much less problematic: narthex, oriented nave and two aisles divided into three bays, with traces of a dome above the third bay of the nave, and sanctuary chambers. However, here as well, there is a slight arbitrary deviation from the basilican plan, the kind of divergence that gives zest to all the Ethiopian rock churches. Instead of the usual three pairs of freestanding columns with intervening arches, this church interior has only two pairs. The first two bays of the nave and aisles have been united without supports into a kind of inner vestibule. Here, a vaulted ceiling with a longitudinal ridge rib and transverse arched ribs indicates the nave, while imitations of a flat trabeated ceiling suggest the aisles. This inner vestibule (and it alone) is decorated with the most delightful frescoes. Quite exceptionally the murals can be

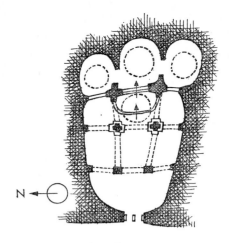

Fig. 96 Church of the Four Living Creatures: sketch-plan

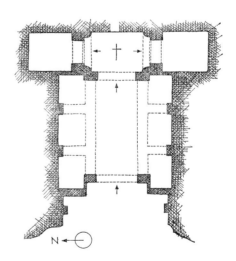

Fig. 97 Trinity Chapel: sketch-plan

dated: they were executed during the reign of King Fāsiladas (1632–1667). The west wall shows the king himself, on horseback with umbrella and standard bearers, fighting the enemies of the kingdom. There is no possibility, however, that the late date of the mural decorations would also apply to the excavation of the church.

By far the most architecturally noteworthy of the five monuments is Endā Māryām Weqro. It is situated in the district of Ambā Śannāyt and is nowadays reached by vehicle over a rough track nearly forty miles long. The track branches off the road from Addigrāt to Adwā seven miles after Entečo.

Although it was already mentioned by C. Barradas, a Jesuit missionary in the seventeenth century, it was described for the first time by Mordini in 1939. With its rather plain exterior it is somewhat inconspicuous. Its front, the south façade with three doorways, consists of the smooth, continuous but unworked face of the cliff from which it has been excavated. Nevertheless inside the mountain the visitor is surprised by one of the most impressive Ethiopian rock churches. Its measurements alone are remarkable: 23 m. at its longest point, 9 m. at its highest. Its ground-plan is basilican: narthex, nave and two aisles with the nave rising very much higher than the aisles, a sanctuary on the central axis, with a monolithic altar as well as a side chapel with a socle in the middle (figs. 98, 99). The floor of the sanctuary is considerably higher than that of the nave. The side-room off the east end of the left aisle was presumably formerly used by the priests for storing the church utensils. The vestibule has two storeys. The partly built-up upper storey is connected to a walled-up grotto outside the church, probably a hermit's cave. Formerly the occupant lowered himself on a rope into the inside of the church through a hatchway above the main entrance, as the worn stone indicates. Arches link the two pillars in the vestibule with each other and with the corresponding pilasters. In contrast to this, the pillars inside the church bear architraves as well as arches. The architraves separate the nave from the aisles in the first and second bays, and there

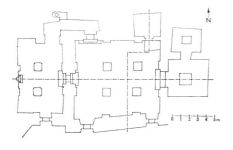

Fig. 98 Endā Māryām Weqro: ground-plan (after *Mordini*)

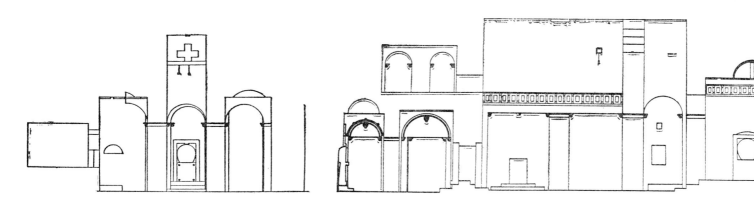

Fig. 99 Transverse and longitudinal sections (after *Mordini*)

is one across the nave to divide off the second bay. The Aksumite frieze of metopes decorates the upper walls of the first two bays of the nave, several bays of the aisles and the sanctuary. The arrangement of the ceiling, however, brings great distinction to the church: crosses and no fewer than fourteen large and small domes (fig. 100).

Across the second bay of the nave, near the ceiling, runs a wooden beam with decorative studs and two carved blocks dangling on chains – a unique element in this world of bare stone. I saw beams with similar pendants in many rock churches in Tegrē; fig. 101 shows that of Māy Kādo (Sauter, no. 1008). According to the priests each pendant contains a diamond (ebna admās) and serves as a protective charm –

as an amulet for protecting the roof (probably a reminder of the danger of fire in the old built-up churches with wooden roof frames). The explanation can be found in the *Physiologus,* to which the precious stone Admās symbolises Christ: '... fire has

Fig. 100 Ceiling patterns (after *Mordini,* re-drawn and corrected)

no power over it, neither have the fumes of the smoke. And if it is in a house, then no demon can enter nor any vain thing ...'

Endā Māryām Weqro is also notable for a circumstance that has nothing to do with the monument itself. It is one of those very few rock churches to have, at least with the greatest probability, a *terminus ante quem.* It seems that by the Zāgwē period the area around Ambā Šannāyt had attained a special importance. It can be shown to have played an important part in history at the turn of the thirteenth and fourteenth centuries. Shortly after 1319 the local ruler revolted against the Solomonic dynasty. But King ʾAmda Ṣeyon nipped the uprising in the bud. For more than two centuries the historical sources remain silent. Then in the sixteenth century a document mentions the area once again. It mocks the ruler of Ambā Šannāyt as the 'chief of the apes': the feudal overlord of the rebelling vassal had wrought such havoc that the country, depopulated, had fallen to the apes. In view of this information, the establishment of such an important and costly church after 1319 is ruled out. Local tradition, which of course is not always trustworthy, considers it to be a work from the first centuries of Aksumite Christianity. Opposing this, Mordini puts forward a date between the twelfth and the beginning of the fourteenth century – agreeing with the high point of worldly might displayed in this area.

160 In the narthex of the Church of the Redeemer at ʿAddi Qāšo. The window and door frames are wooden with projecting cornerposts in the Aksumite manner. In addition to the geometrical decoration on the beams, which fill the space between the lintels of the doors and the sills of the window frames, there are also two monkey-heads (fig. 102). At the end of the hallway behind the arch, there is a small vestibule with the steps of the north entrance. Lattice-work imitated in the rock fills the three sections of the ceiling. Beneath it, unusual in the narthex, runs the Aksumite frieze of metopes.

161 Coffered ceiling with decorated fillings and frieze of metopes in the narthex above the entrance to the nave. A crude cross in relief decorates the underneath of the roof-beam imitated in the rock.

162 Ceiling with low relief above a bay of one of the aisles. Here, too, we have the reproduction in stone of wooden beam-work. The so-called lantern ceiling apparently provided the model for the design: to cover a square opening, the carpenters laid the beams or boards diagonally over the corners of the square and repeated the process

Fig. 101 Beams with pendants

Fig. 102 Decorated beams above the doors

Fig. 103 Lantern ceilings in Ma'aquddi

Fig. 104 Rosette

Fig. 105 Cross with looped arms

in order to make smaller and smaller squares until the opening had been filled. In the great monastery church of Dabra Dāmo (fig. 31) there is such a timber ceiling with beams set across the corners. I saw rock copies at Saqoṭā (Sauter, no. 21), 'Ābiy 'Āddi (Sauter, no. 1221), Degum Ayrafadā (Sauter, no. 1218), in the Church of St Mary at Qorqor, the Trinity Chapel of Degum and the Church of St John at Ma'aquddi (fig. 103). Obviously lantern ceilings are not peculiar to Ethiopia, but are a very old, geographically widespread method of closing over a space. Today one still meets them in Hindu-Kush, and in the caves of Bamian in central Afghanistan there is a copy in rock. The Ethiopian examples display an advanced formalisation of the model which becomes a mere pattern and is usually enriched with elements, also conceived as purely ornamental, which in fact are of quite different origin: at 'Āddi Qāšo, coffers between the arms of a cross with a rosette.

163, 4 Ceilings in low relief above the second and first bays of the nave. The rosettes between the arms of the cross – the pattern of the second bay of the ceiling – are reminiscent of the painted ceiling of the church Bētā Māryām at Lālibalā. A larger relief rosette is also to be found above the southern lobby of the narthex (fig. 104). The decoration above the first bay imitates a wooden ceiling with applied slats which build up crosses and decorative panels. Beneath the ceiling is the Aksumite frieze of metopes; on the west wall there is an arched niche over the window above the main entrance and on the first pair of pillars, there are relief crosses, the arms of which terminate in loops (fig. 105) – here, too, one is reminded of Bētā Māryām's floriated crosses.

165 The Church of the Four Living Creatures of 'Āddi Čawā: view from the first bay of the right aisle into the narthex. Rising damp and the structural weakness of the layered rock have caused the destruction of the pillars. A layer of chaff, heaven for the vermin, makes do for a carpet.

166 Priests with hand crosses censing, and birds – fresco on the second arch over the nave. When asked, the church's priests identify the picture (to which two more figures belong) as the Four Living Creatures. Ethiopian tradition canonized them under the names of Alfā, Lēwon, Qwanā and Ayār, the Ethiopian and Coptic churches commemorating them on the 8th Ḥedār (4th November Julian/17th November Gregorian). Here the artist sees them as priests; the incense symbolizes 'the prayers of the saints' (Rev. 5: 8). The archaic-modern impression of the fragmentary work is partly due to the use of a stencil and partly to the differing durability of plaster and pigments.

167, 8 Entrance and first hall of the Trinity Chapel (formerly a rock tomb?) at Degum, no longer in use. The forecourt was probably covered at one time. This is suggested by the sockets for wooden beams on the walls. The entrance, too, had threshold and lintel beams. Post holes in the hall and sanctuary probably anchored a wooden partition and the superstructure for a baldachin over the altar.

169 The sanctuary arch seen from the sanctuary. Square-based pillar with bevelled edges and stepped capital are elements of the early Aksumite tradition before the introduction and spread of Christianity. The round arch indicates a period later than the fourth century. The quarter-columns which support the blind arches above the entrance to the side lobby have an unusual effect. If this complex really was founded as a rock tomb, the person buried must have been a very distinguished personality. The masons pursued their excavation with unusual care.

170 Saints and apostles: painting on the north wall of the Church of St John of Ma'aquddi (seventeenth century). In the upper row (from left to right): Abbā Liqānos, Bartholomew, Philip, Matthew, John, Thaddeus and Peter. In the lower row: Abbā Madḫānina Egzi', Abbā Gabra Masqal za-Lagāso (i. e. Abbā Gabra Masqal of the monastery of Lagāso in Tegrē) and Abbā Iyokyās. Instead of the prayer-stick, Abbā Liqanōs holds a thurible. There are spelling mistakes in the inscriptions.

171 Endā Māryām Weqro: the central bay at the back of the narthex with a niche for the throne of some dignitary. In the ceiling above it there is a dome. The decorative bosses on the crowns of the arches, at the points where beams cross each other (pl. 172) and on the underside of the architraves (pl. 173), are among the unique features of this church.

172 The ceiling above the central bay at the front of the narthex. As in ʿĀddi Qāšo the frieze of metopes turns up in the vestibule as an element of decoration. The archivolt mouldings under the arches in the narthex seem curious – that is to say where they lead to a division of the impost-plates and corbels, as in the double arch linking both pillars to each other (fig. 106).

173 Ceiling of domes above the first (above) and second bays of the right aisle. Throughout the whole church, the arches and architraves rest on the usual false capitals of impost-plates and rounded brackets. The frieze of metopes also decorates some bays of the aisles.

Additional Sources

Endā Madḥanē ʿĀlam of ʿĀddi Qāšo: *Sauter*, no. 111.
Endā Arbāʿtu Ensesā of ʿĀddi Čawā: *Sauter*, no. 1105.
Endā Šellāsē of Degum: *Sauter*, no. 1215.

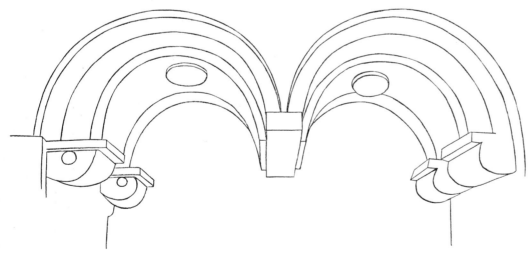

Fig. 106 Double arch

Endā Yoḥannes Nagwadgwād of Maʾaquddi: *Sauter*, no. 1220.
Endā Māryām Weqro: *Sauter*, no. 8.
Description of the latter: Mordini, *La chiesa ipogea . . .* and *L'église rupestre . . .*.
The Ethiopic *Physiologus:* Hommel; Conti Rossini, *Il Fisiologo . . .*
On the festival and significance of the Four Living Creature in the Copto-Ethiopic
 tradition: O'Leary; Fenoyl; Leroy, *Objectifs . . .*

160 In the narthex of the Church of the Redeemer at ʿĀddi Qāšo.
161 Coffered ceiling with decorated fillings and frieze of metopes in the narthex above the entrance to the nave.
162 Ceiling with low relief above a bay of one of the aisles.
163, 4 Ceilings in low relief above the second and first bays of the nave.
165 The Church of the Four Living Creatures of Āddi Čawā: view from the first bay of the right aisle into the narthex.
166 Priests with hand crosses censing, and birds – fresco on the second arch over the nave.
167/8 Entrance and first hall of the Trinity Chapel (formerly a rock tomb?) at Degum, no longer in use.
169 The sanctuary arch seen from the sanctuary.
170 Saints and apostles: painting on the north wall of the Church of St John of Maʾaquddi (seventeenth century).
171 Endā Māryām Weqro: the central bay at the back of the narthex with a niche for the throne of some dignitary.
172 The ceiling above the central bay at the front of the narthex.
173 Ceiling of domes above the first (above) and second bays of the right aisle.

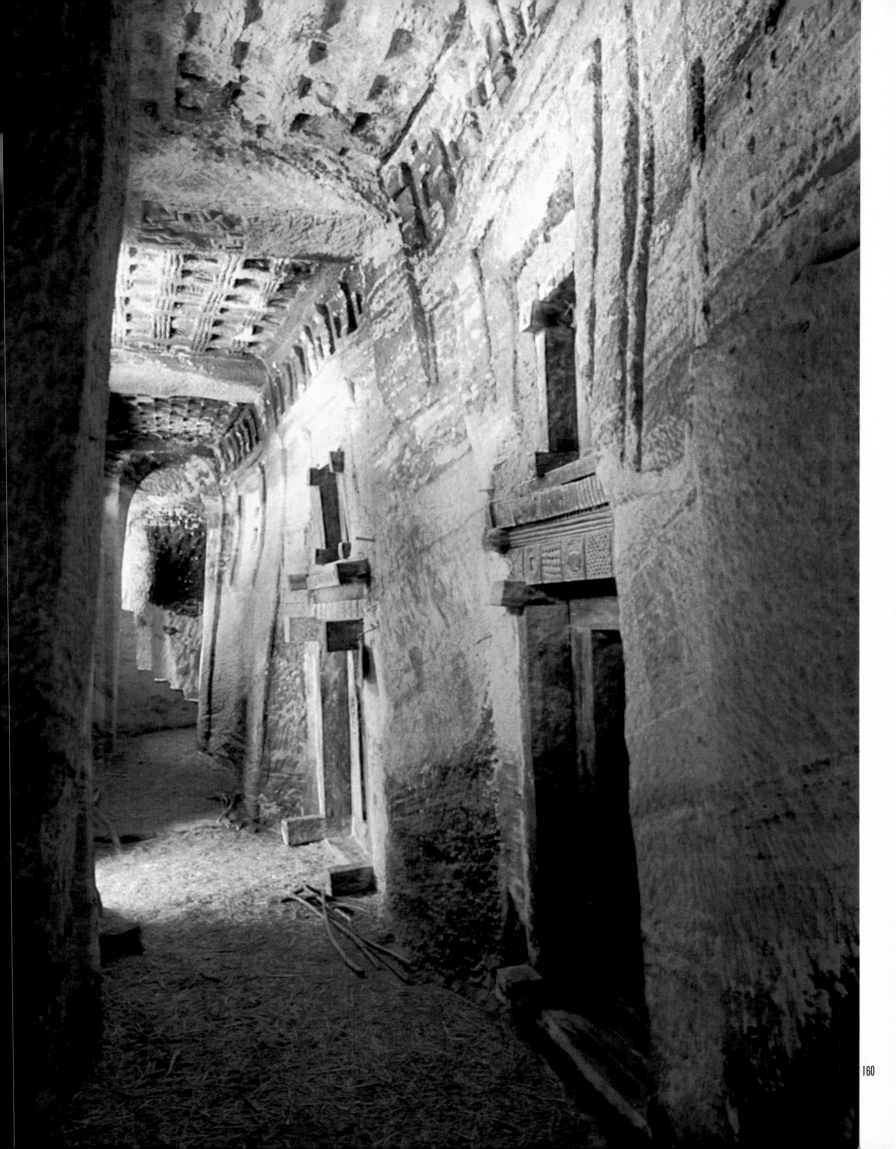

162

163

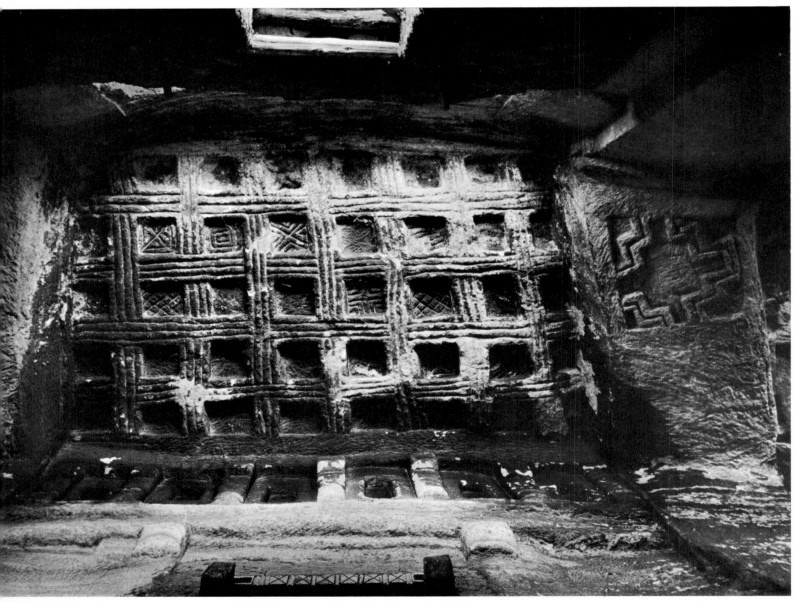

161

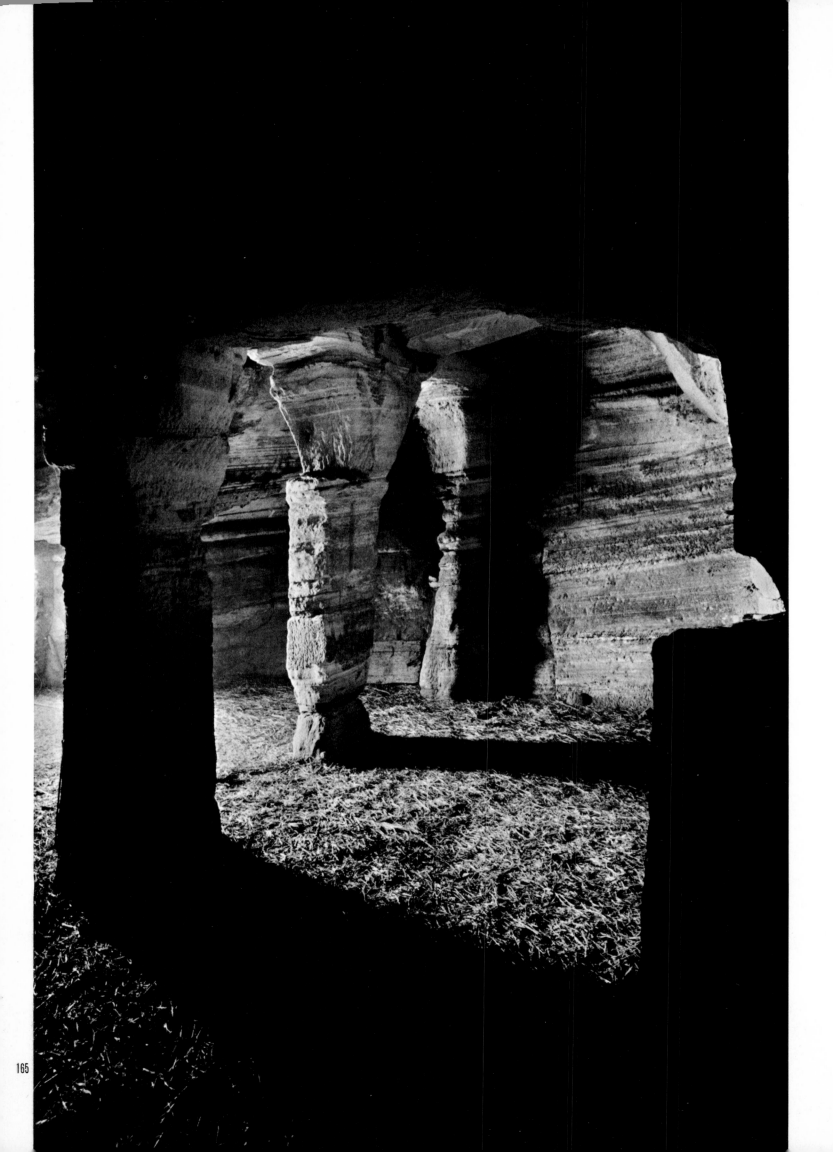

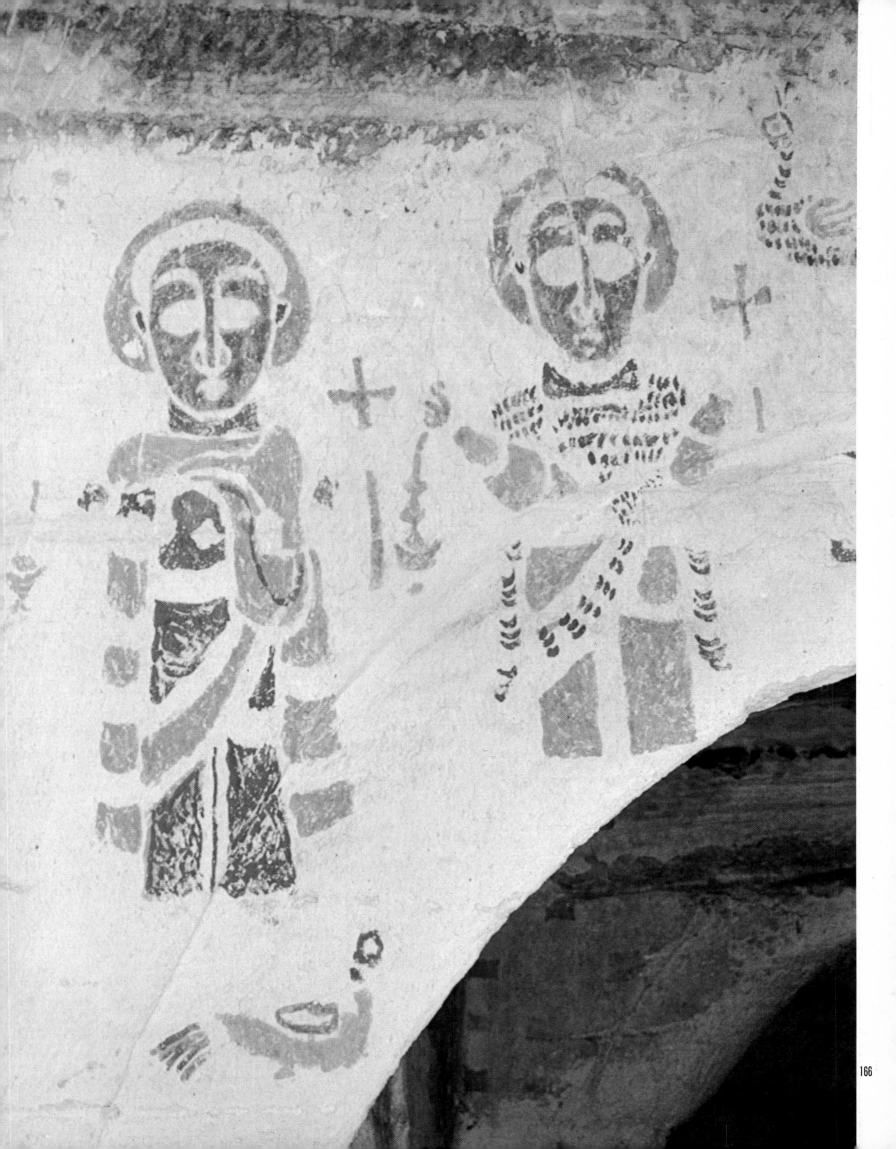

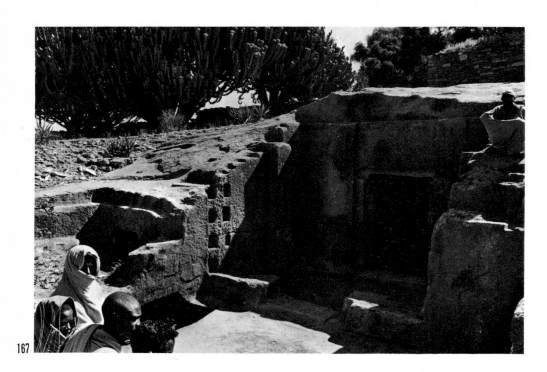

167

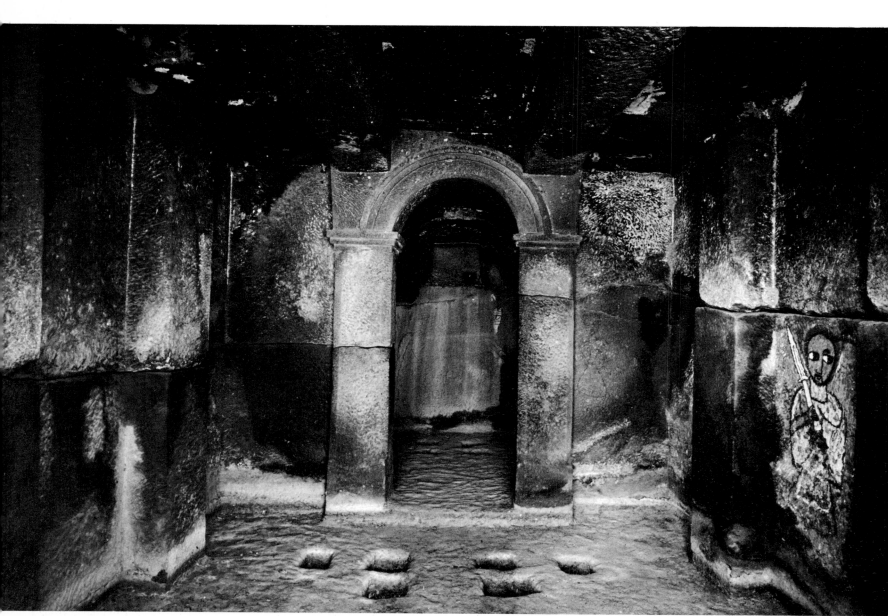

168

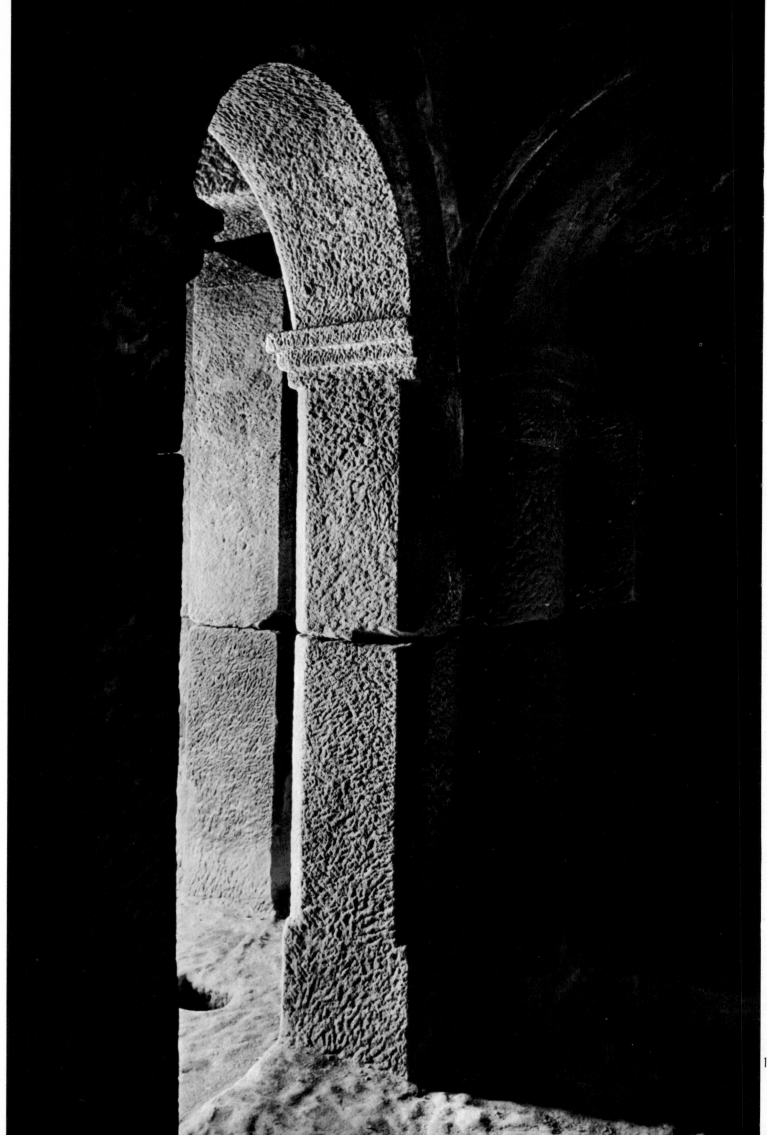

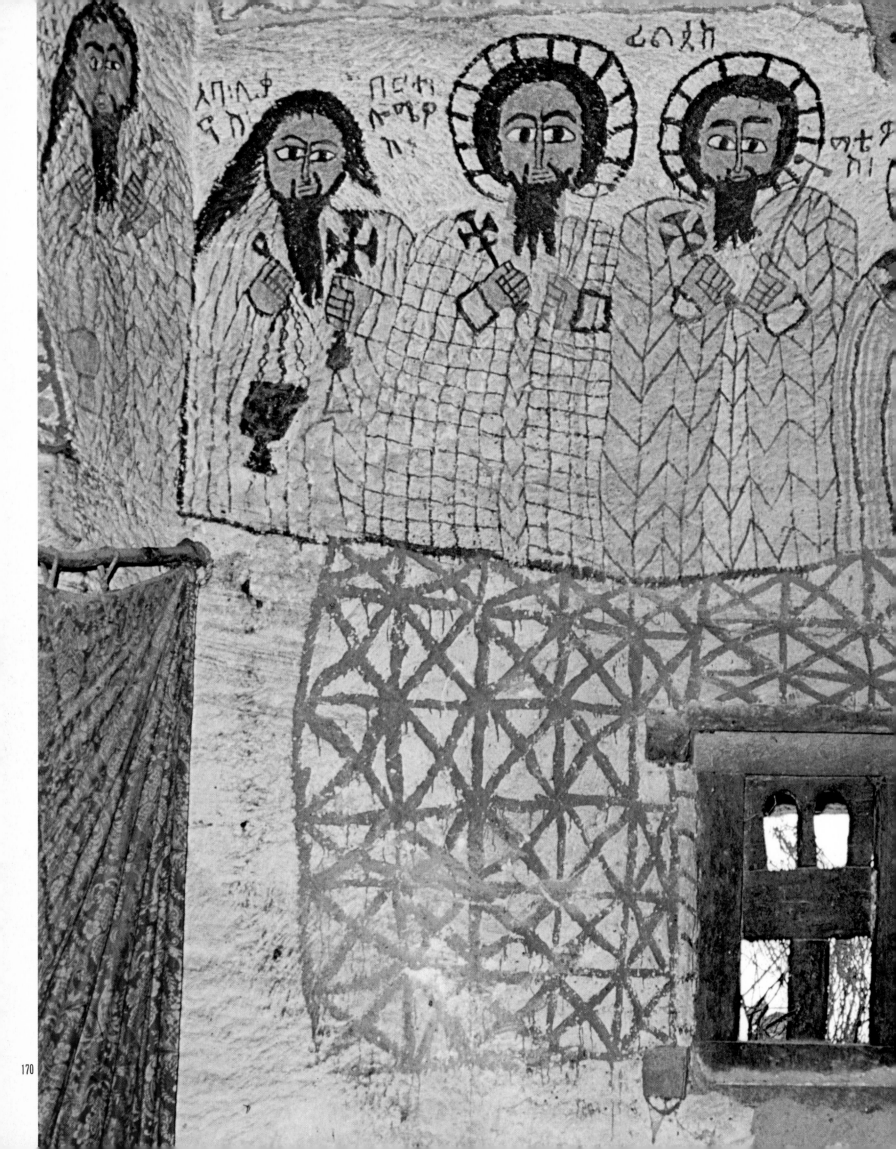

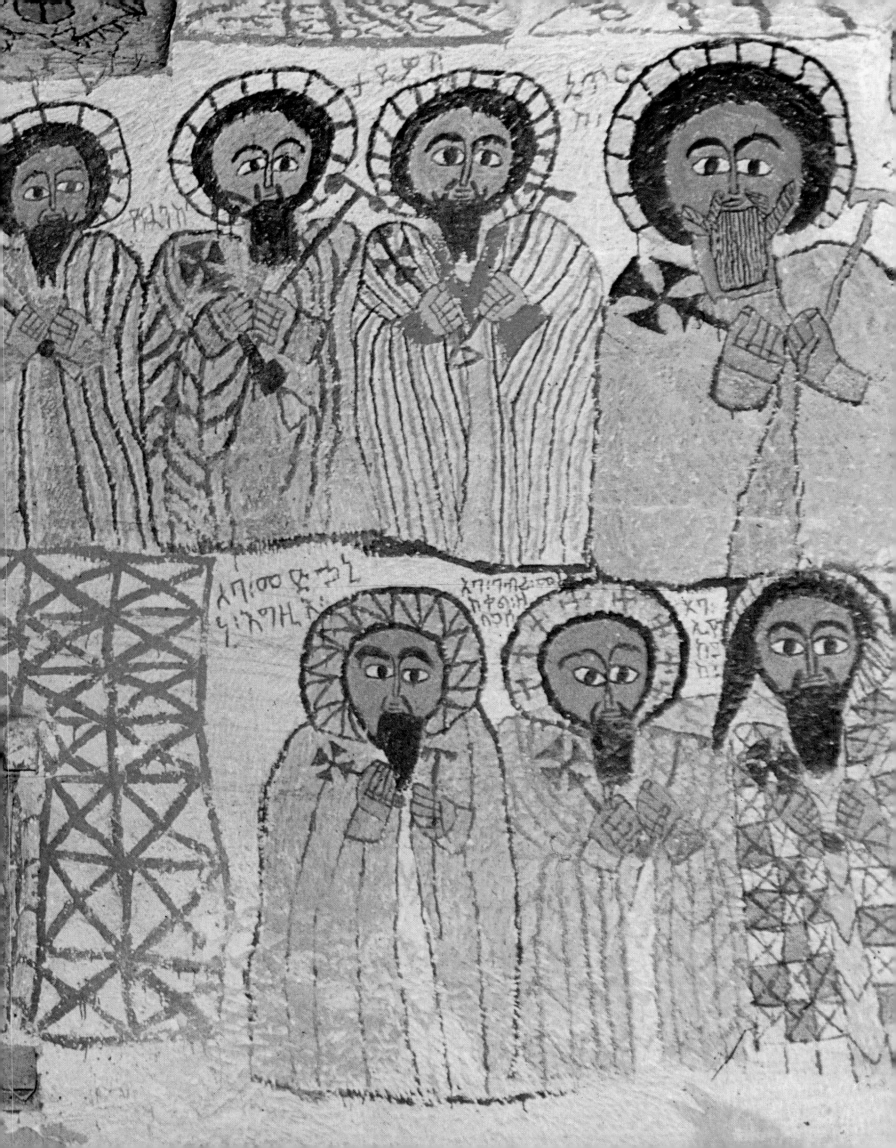

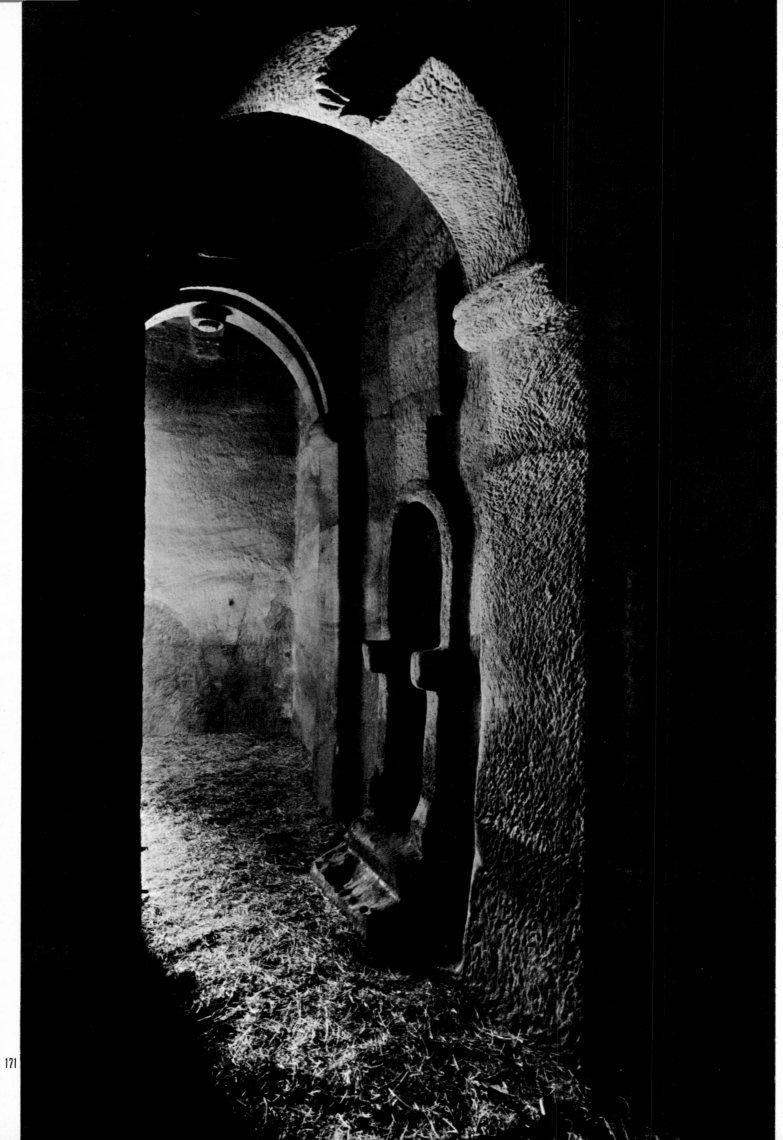

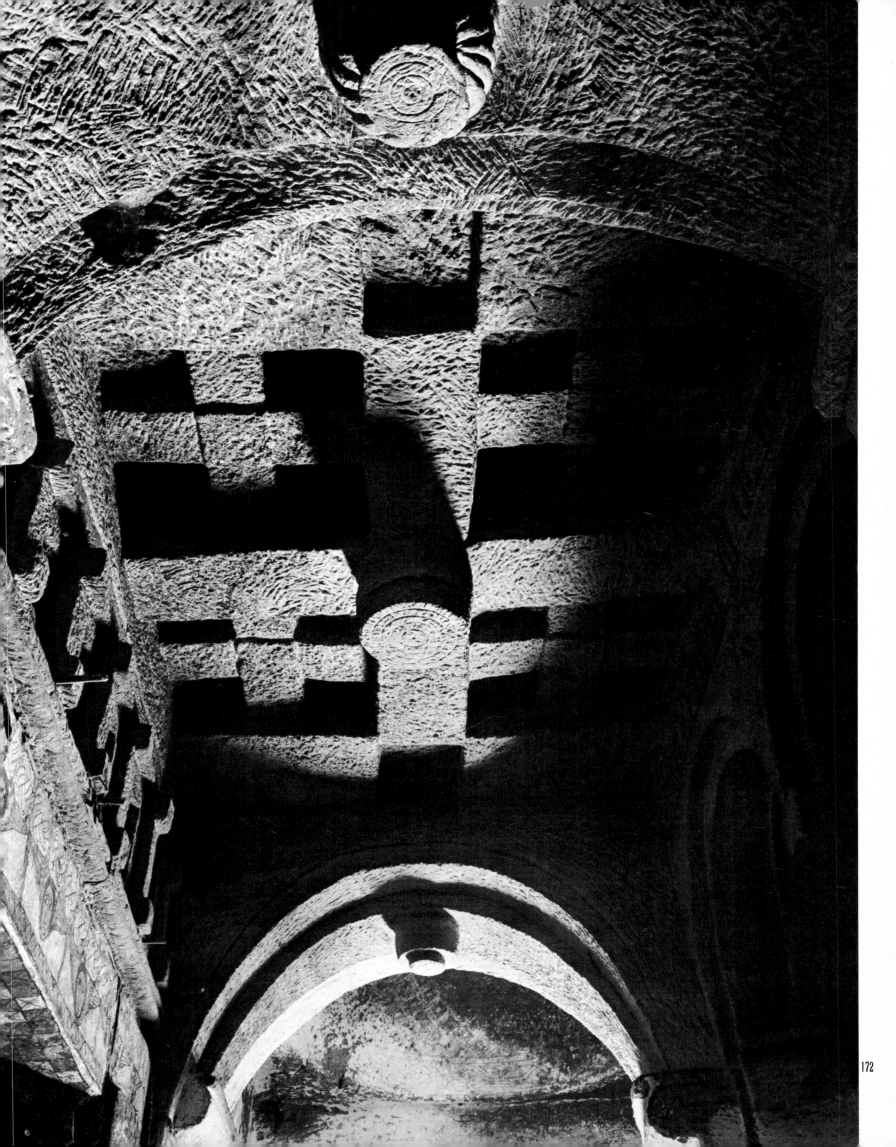

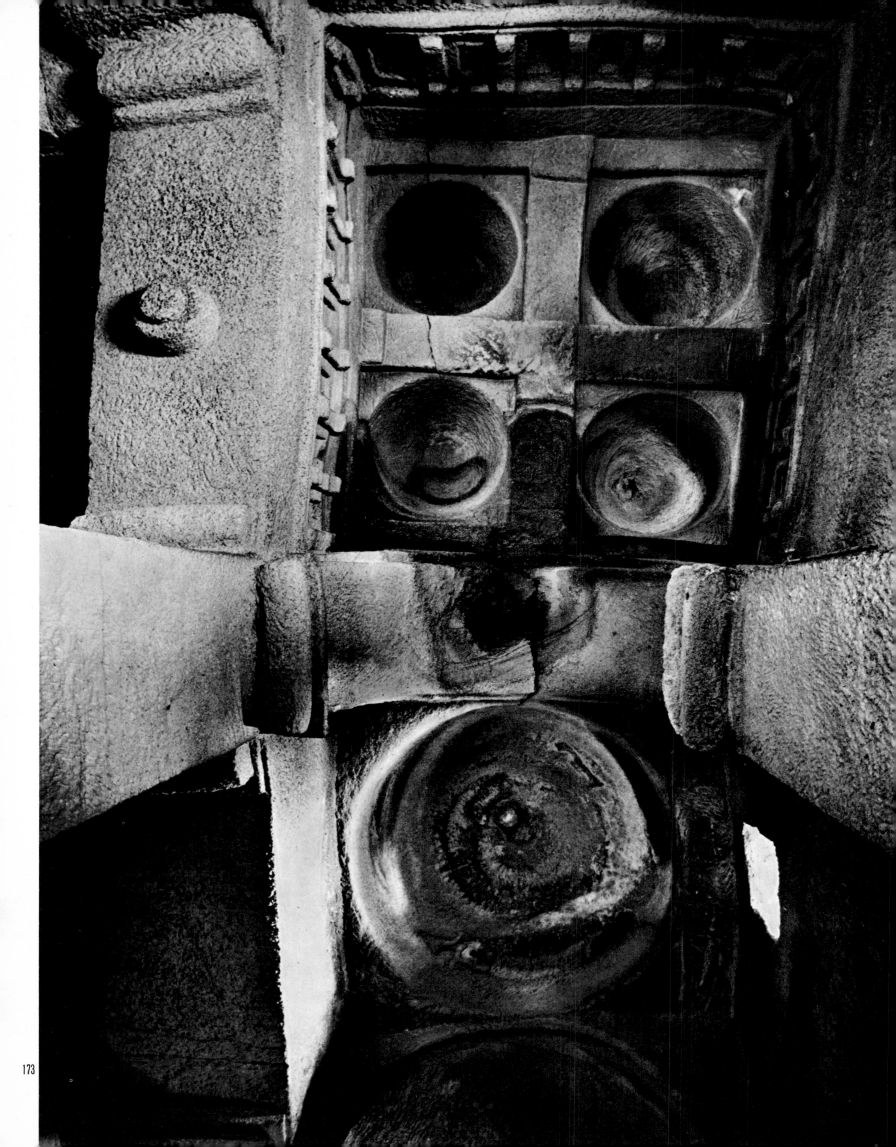

Mikā'ēl Ambo and Čerqos Weqro

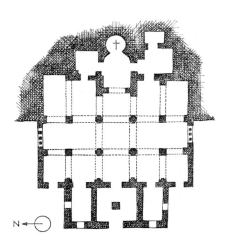

Fig. 107 Sketch-plan of Mikā'ēl Ambo

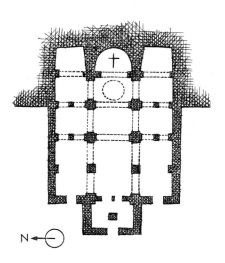

Fig. 108 Sketch-plan of Čerqos Weqro

The small table-mountain with its Church of Mikā'ēl Ambo is most easily reached from Agulā, a village between Weqro and Kwehā on the highway connecting Aśmara and Addis Ababā. The head man of a village twelve miles east of Agulā, on the road to Aṣbi, provides a guide familiar with the locality, in whose company the rest of the journey is completed in an hour and a half's trek.

I do not know of any trip in Ethiopia of greater attraction with regard to the countryside. The ambā in question offers a view of paradise. Cascades of green fall over the partly overhanging cliffs; juniper, olive and fig trees cling on to strips of rock. A wood of tree-sized candelabra euphorbia surges like a wave against the scree base; aloes, with flame-red blossoms on branched spikes bursting forth from a crown of fleshy leaves, carpet the floor of the valley. Aloes and red-hot pokers, thick-leaved plants like house leeks and other leafy succulents reserve their places on the narrowest of rock ledges.

At the edge of the precipice the priests and dabtarās, seen from below as motionless white figures against the blue sky, await the visitor. Within sight of the reception committee the newcomer is forced to ask himself whether he will ever manage to climb up to them. The observation in Sauter's register of rock churches – 'virtually unapproachable table-mountain' – hardly quells the visitor's fears. However the ascent proceeds with surprising ease along ledges of rock and eventually up some rickety stairs. Even so, it can scarcely be recommended for someone who has no head for heights.

Čerqos Weqro – like Mikā'ēl Ambo, a semi-monolithic excavated church – was hewn from a knobbly outcrop of rock just outside the village of Weqro. The shrine is visible from the road. The oldest mention of Čerqos Weqro comes from the last century – troops and baggage of the British expedition against the Emperor Theodore (1867/68) camped in its vicinity. Beatrice Playne gave the first intimation of Mikā'ēl Ambo. She was also the first to recognize the homogeneity of both churches (as well as of a third dealt with in the next chapter). They depart from the oriented basilican ground-plan in a way which is unique in Ethiopia. The second or third bays of the nave and aisles (figs. 107, 108) make a transept forming a crossing. Additional pillars supporting the transept give the impression of there being five aisles. Nave and transept are vaulted and a cross in relief decorates the flat-ceilinged area of the crossing. Arches are present only at the ends of the barrel vaults and to the east of the crossing; elsewhere in these churches lintels are imitated. The vestibule with a central pillar is only a little wider than the nave. The sanctuary in the eastward extremity of the nave ends in an apse.

In contrast to the similarities, the differences are of very little importance. There are rooms on either side of the narthex, only accessible from inside the church, at Mikā'ēl Ambo; the bay immediately east of the crossing is domed at Čerqos Weqro but has a flat ceiling with incised cross pattern at Mikā'ēl Ambo. On the whole the latter gives a heavily robust impression, perhaps because here the rock resisted the stonemasons with greater strength. Every attempt at decorating the vaults, the arches or the cross formed by the transept with bas-reliefs or the walls with frescoes, came to nothing. On the other hand, it contains remarkable carved door panels and the remains of a carved choir-screen with looped crosses and decorations, similar to the ones already found in the repertory of the oldest Ethiopian ornament.

174 Mikā'ēl Ambo: the north-west corner of the church and its courtyard. In the high wall surrounding the sacred precinct, the living rock keeps to the angle of the mountain's slope as it was before the excavation began. B. Playne, in the first description of this shrine, spoke of a monolithic church. In reality, however, as in the case of Čerqos Weqro, the part of the church east of the transept remains imprisoned in the rock, the separation from the surrounding stone being only half completed.

175 Like the ark stranded on the mount: aerial picture of the Church of Mikā'ēl Ambo. The pointed enclosure wall, like the bow of a boat, distinguishes the lay-out; fig. 110, from an aerial photo of Čerqos Weqro, shows the normal arrangement for comparison. The unusual height of the walls and their proximity to the church create the impression of a rock courtyard like those found with the true monolithic churches. The builder has achieved the same feeling of spiritual affinity in both. In the round huts on the mountain live the priests and dabtarās.

176 Mikā'ēl Ambo: the first bay of the vaulted nave. The windows with round arches on the corbel-impost combination open on to an upper storey of the narthex. The arches of the crossing also rest on the pseudo-capitals of corbels and imposts so typical of rock-church architecture.

177 The right wing of the vaulted transept: supplementary pillars with stepped capitals – one of the most ancient of Ethiopian building techniques – support the lintel-beam in the middle. Characteristics of the whole group of churches are: the frieze of metopes round the transept as well as the nave and 'choir'; the use of wood for window frames and the beam framework of the doors – not merely a stone imitation of them.

178 Crossing with cross in relief and, at the top of the picture, the vaulted ceiling above the first bay of the nave (pl. 176). With the church's total length of 22 m. and width of 16.5 m., the nave of Mikā'ēl Ambo seems rather short. With its diminutive aisles and exaggerated transept the church – in conformity with the terrain rather than in pursuit of a changing architectural goal – is close to the basilica with transverse nave, known from Mesopotamia.

179 Čerqos Weqro: first and second bays of the nave. The decoration in the vaulted ceiling – geometrical motifs in painted low-relief in stucco – is flaking off. The cuboid bases and capitals as well as the bevelled shafts – central supports of the narthex and several pillars of the church interior – are basic elements of Ethiopian architecture. A characteristic feature of the whole group of churches (apart from the frieze of metopes): two crosses in relief on pilasters both sides of the main entrance.

180 Saint with a shaggy beard: fresco in the narthex, on the left above the entrance to the inner church. Its inscription, hardly legible, contains the names of three of the Nine Saints of Rome: Pantalēwon, Aragāwi and Yem'ātā; that on the right refers to the saint painted next to it: Garimā is implored to protect a certain Samuel. The crosses belong to a different layer of plaster. Palaeographic considerations date the paintings to the fifteenth century at the latest.

181 Čerqos Weqro: a churchgoer kisses the ground before entering the shrine. Cement repairs around the entrance to the narthex have altered the façade: presumably it was originally flat and without ledges. The inscription on the built-up inset contains a pious sentiment.

Additional Sources

Mikā'ēl Ambo: *Sauter*, no. 14.
Čerqos Weqro: *Sauter*, no. 13.
References and descriptions: Playne; Gerster, *Drei Felskirchen* ...
Earlier references to Čerqos Weqro are of purely historical interest.

Fig. 109 Motifs on the choir-screen

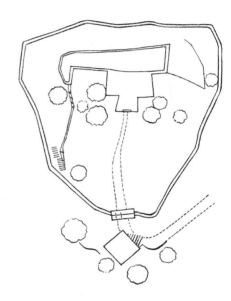

Fig. 110 Čerqos Weqro, from an aerial photograph

174 Mikā'ēl Ambo: the north-west corner of the church and its courtyard.
175 Like the ark stranded on the mount: aerial picture of the Church of Mikā'ēl Ambo.
176 Mikā'ēl Ambo: the first bay of the vaulted nave.
177 The right wing of the vaulted transept: supplementary pillars with stepped capitals support the lintel-beam in the middle.
178 Crossing with cross in relief and, at the top of the picture, the vaulted ceiling above the first bay of the nave.
179 Čerqos Weqro: first and second bays of the nave.
180 Saint with a shaggy beard: fresco in the narthex.
181 Čerqos Weqro: a churchgoer kisses the ground before entering the shrine.

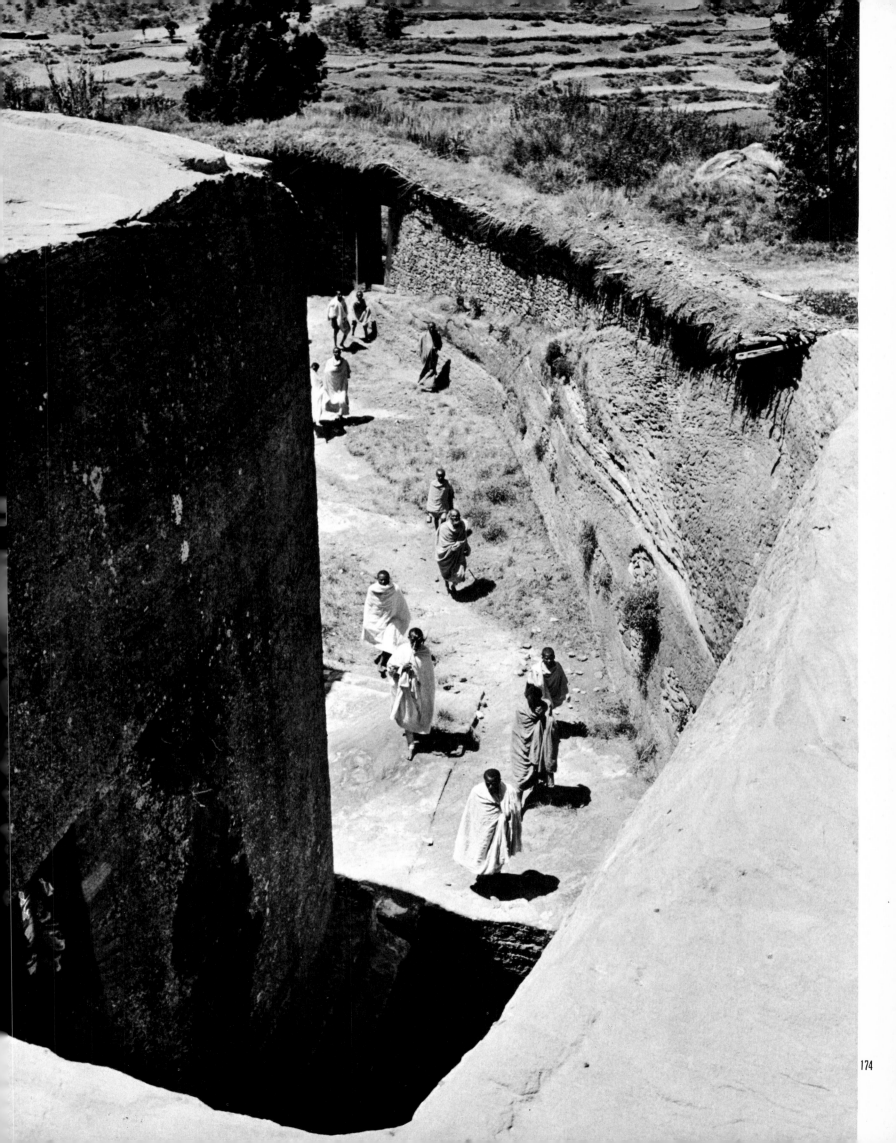

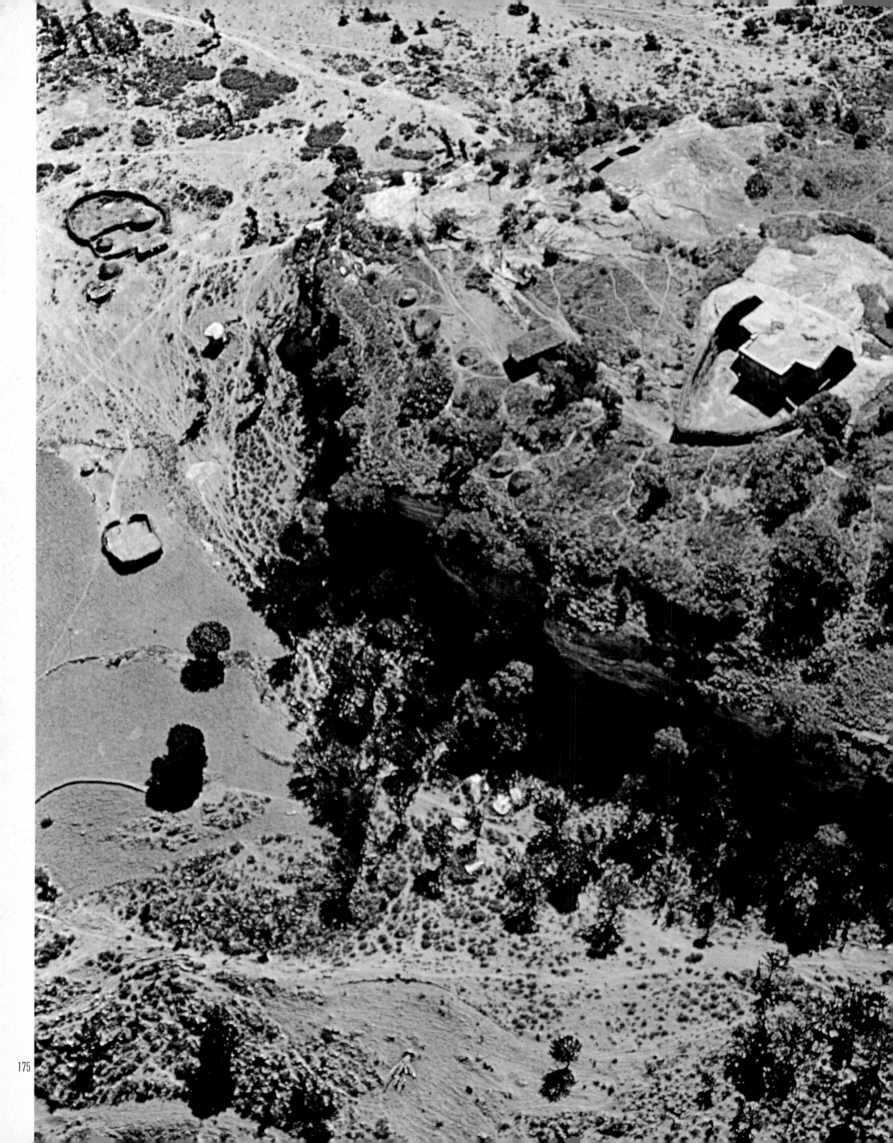

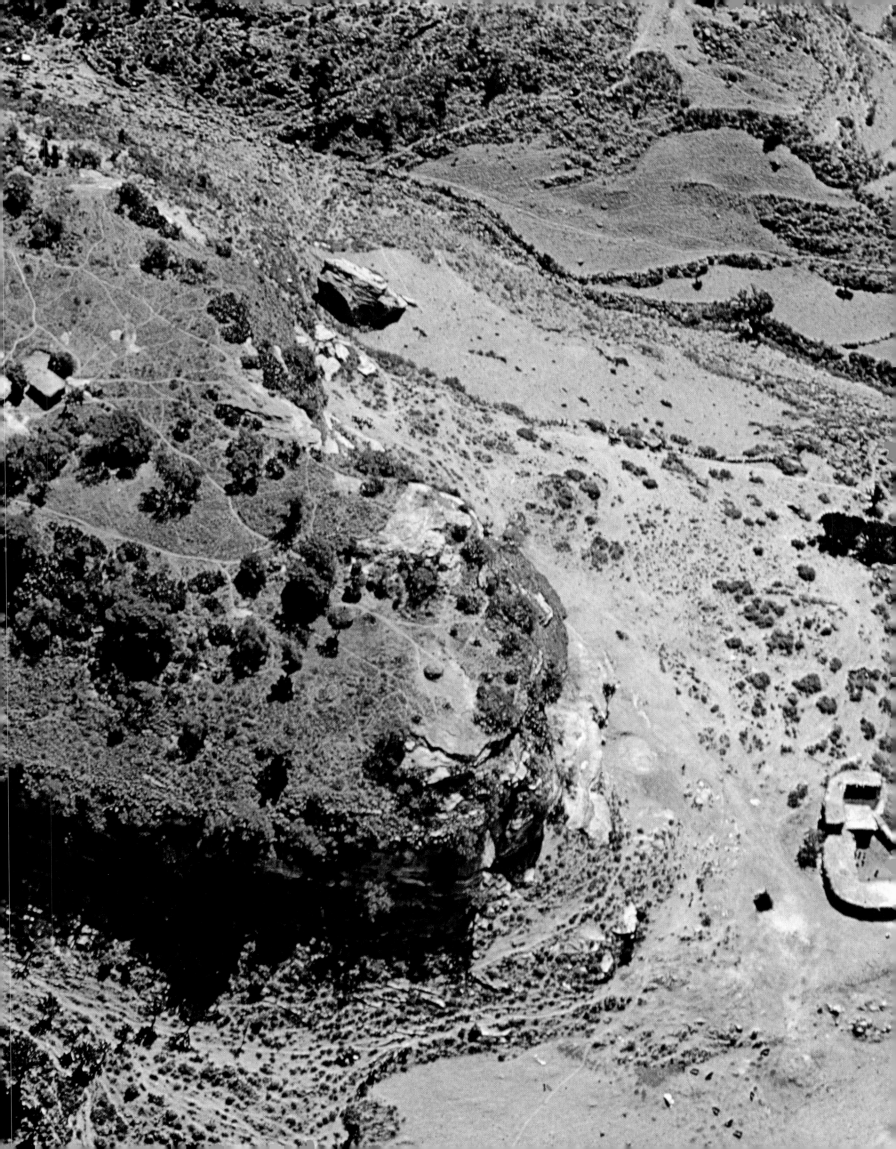

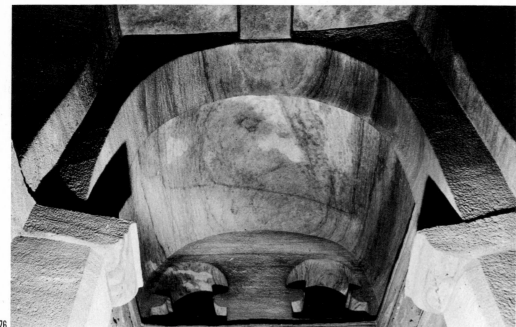

176

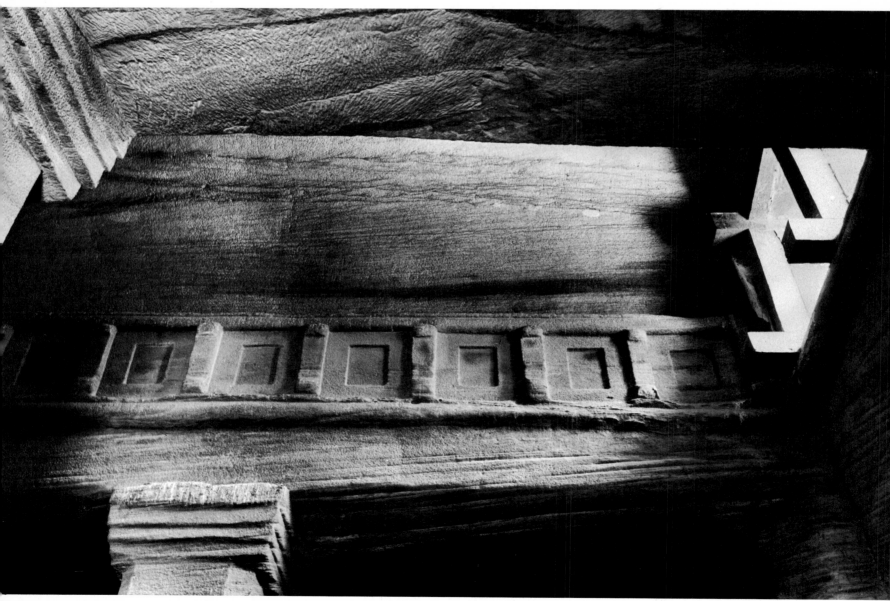

177

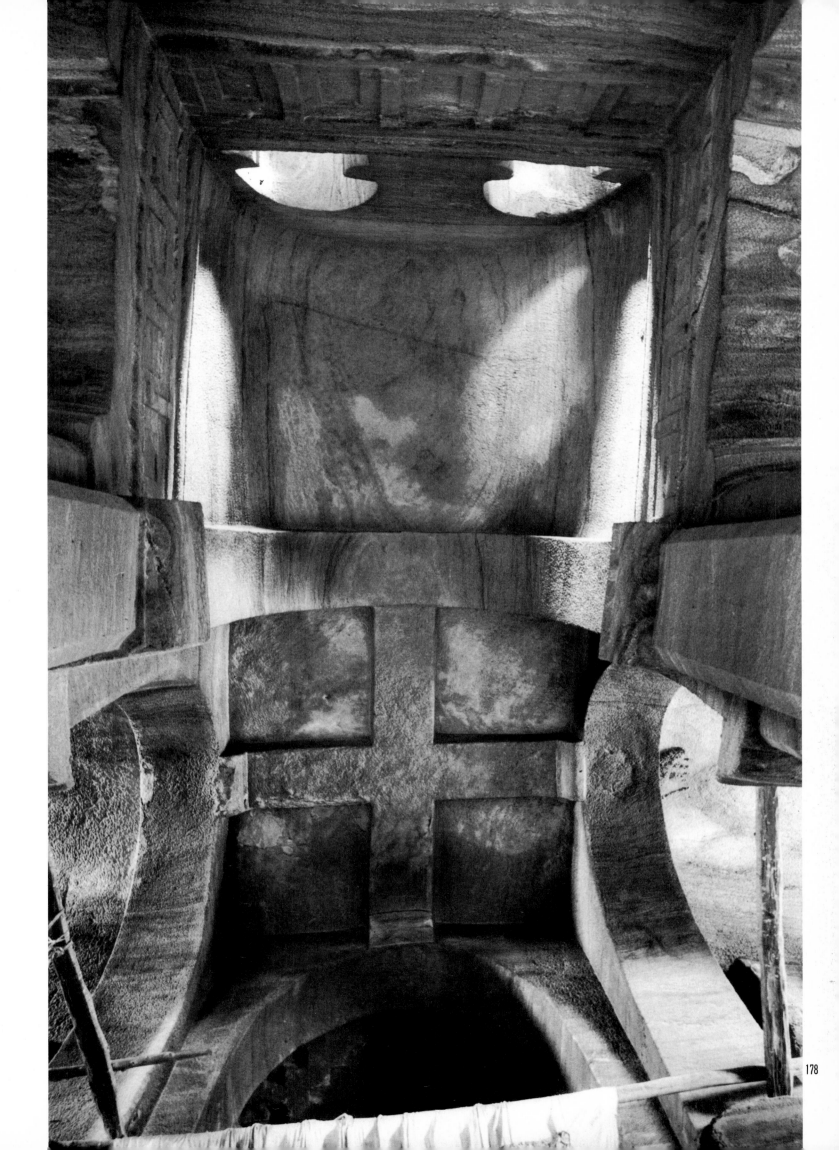

178

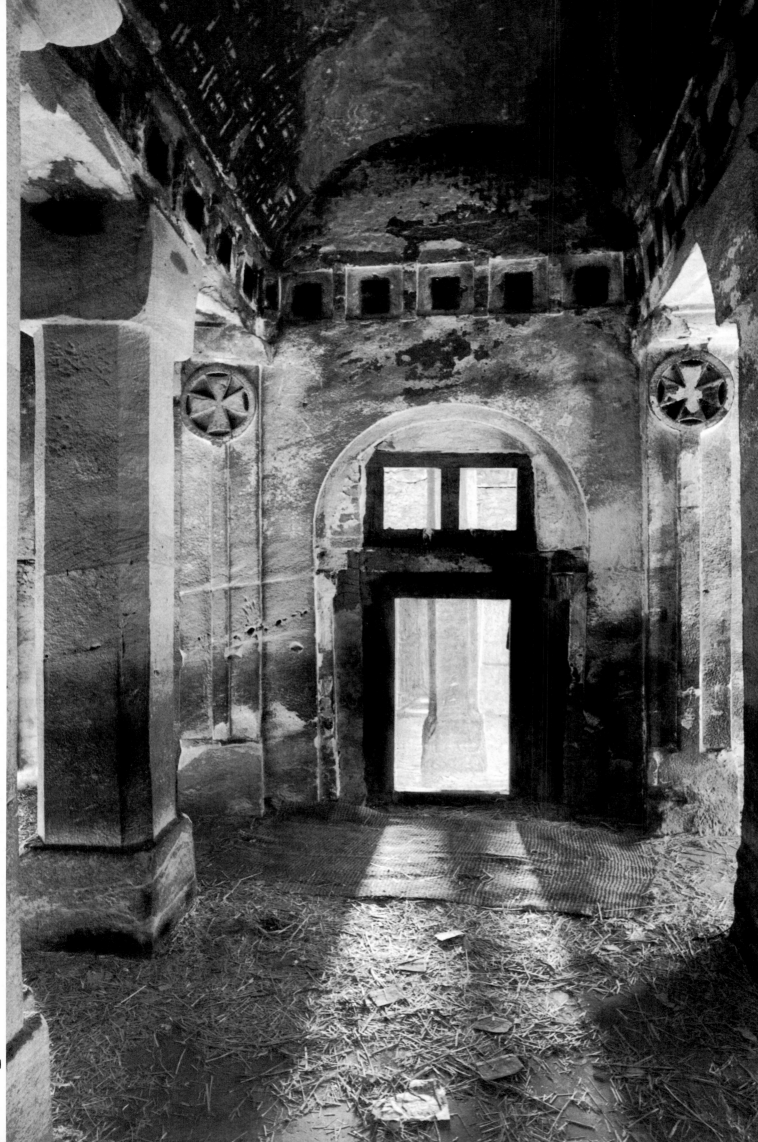

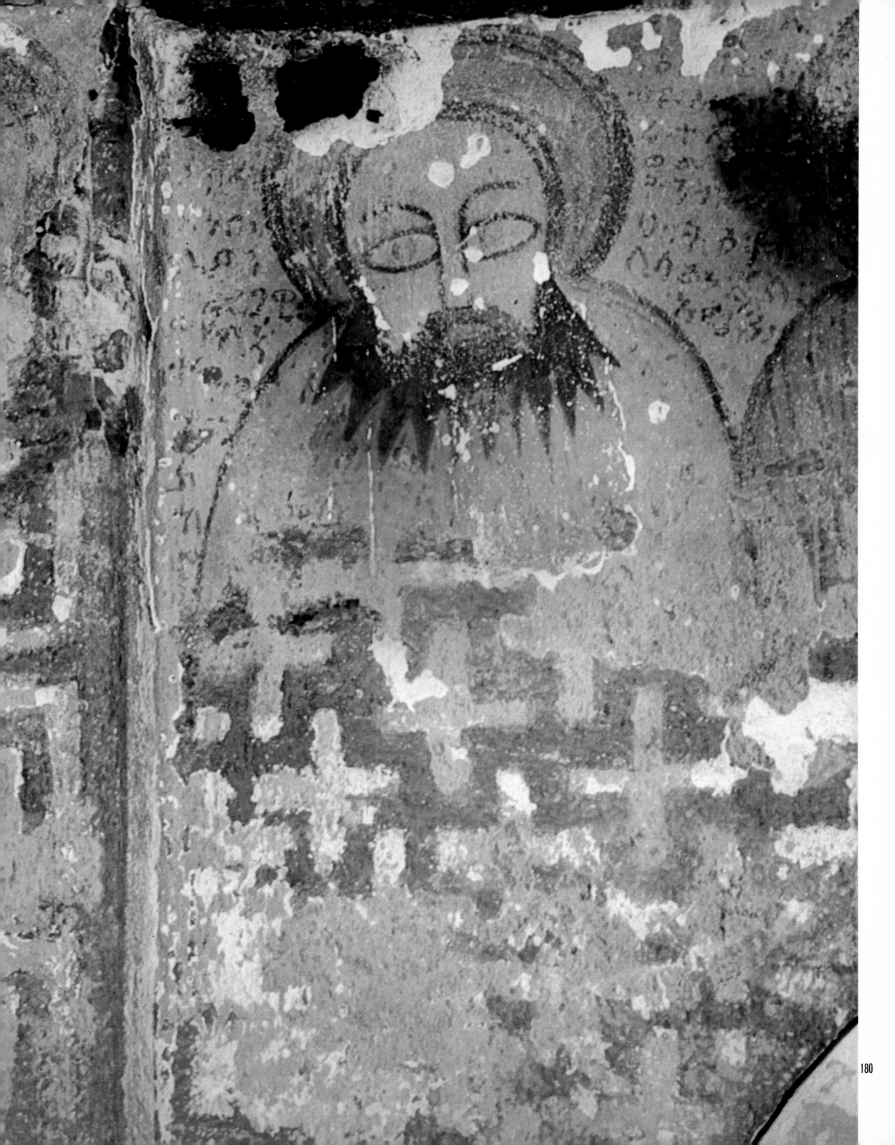

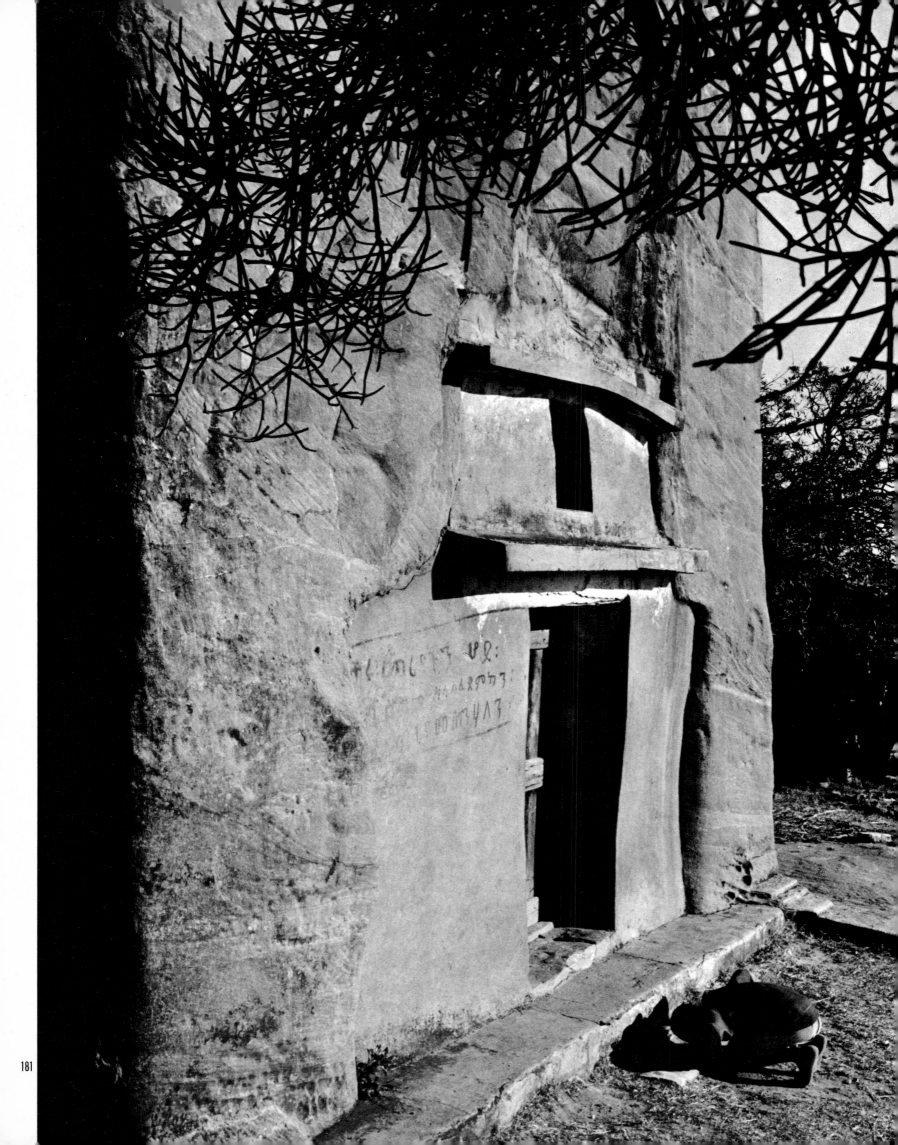

The Excavated Church of Abrehā Aṣbehā

To the south of Addigrāt, ten miles short of the village of Weqro, a track branches off on the right hand side of the road and, after eight miles, ends at the excavated church of Abrehā Aṣbehā. Alertness and care are necessary. Without alertness the visitor will miss the entrance to the track and if he is not careful he will probably find his way to the church, but not back to the main road again. The final stretch of the road curves steeply in hairpin bends which are difficult to negotiate down to the valley below, where the church is carved into the rock wall.

It shares its most important features (fig. 111) with the two churches mentioned in the preceding chapter: its semi-monolithic character; the cross imposed upon the basilican plan by giving prominence to a transept and the apparent presence of five aisles; the apse; pillars with capitals, which must already have been common in the palaces of Aksum; the employment of wood for window and door frames; details such as the frieze of metopes, the cross in the crossing and the crosses on the pilasters of the west wall. Differences, however, are evident in the arrangement of the vestibule, nave and sanctuaries. The vestibule occupies the width of the nave and two innermost aisles and opens into the interior of the church without doors. Before the crossing the nave is not vaulted. To the east of the crossing, in continuation of the nave, the church has not only a dome, but also, above the sanctuary, a semi-dome. In addition to this, the areas on both sides of the sanctuary have domed roofs. A second, external vestibule is partly built-up and partly cut from the rock; the open twin-arched porch in the front of it is a very recent addition.

The stonemasons who excavated Abrehā Aṣbehā proceeded much more carefully than the artisans who made the other two churches of the group and were apparently at war with plumb-bob and square. However Abrehā Aṣbehā is particularly distinguished by its rich decoration: bas-reliefs with geometrical patterns painted on plaster decorate the vaulting, the domes, the soffits of the arches and the crossing. In addition cross patterns cover the spandrils of the arches and the flat ceilings. Figurative paintings on the walls and pillars are largely of the last century, from the time of Emperor John IV. (1868–1889).

As long as serious study, based on B. Playne's information, had to regard Mikā'ēl Ambo as a monolithic church in the strict sense, the other churches of the group were considered as monolithic churches *in statu nascendi,* as stages in the development of the sculptured church completely freed from the surrounding rock on all sides. However much more attractive the idea of planned progress and advance may have been, it seems to be contradicted by the observed evidence of dwindling care and lowering standards. The discovery that Mikā'ēl Ambo is not, after all, a monolithic church frees us from this embarrassment. Mikā'ēl Ambo does not even present the greatest degree of separation from the living rock; Abrehā Aṣbehā surpasses both the other churches in that respect. In any case, I consider the question of the degree of separation from the rock as being of no importance. What does seem of much greater significance is that the builder resisted the temptation to free the church completely from the surrounding rock and retained at least the sanctuary chambers in the mountain. The monolithic church is not the product of small evolutionary steps. It is really more a revolution, a mutation, a leap. The only true monolithic churches which are known outside Lālibalā – Gannata Māryām and Weqro Madḫanē 'Ālam (*Sauter,* no. 20) – are, not without reason, expressly linked to the

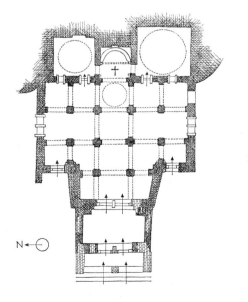

N ← ⊖

Fig. 111 Sketch-plan

Lālibalā tradition either on the basis of their architectural plan or with respect to their supposed builders.

Yet scepticism alone regarding a facile genealogy of the monolithic churches would not rule out a temporal sequence in view of the geographical contiguity and architectural unity of the three churches. Local tradition ascribes the Church of Abrehā Aṣbehā to the mythical kings of Aksum whose names it bears. Abrehā and Aṣbehā are supposed to have lived in the fourth century. In so far as the priests claim any knowledge of the founders of the other two sanctuaries, tradition confirms the relative chronology of the three churches suggested by the study of the buildings themselves. Abrehā Aṣbehā was more or less the mother church which the other two copied as architectural model – Mikā'ēl Ambo with a burning ambition which was extinguished before the work was finished. The intervals of time between the construction of the churches nevertheless remain unknown as does the historical situation which gave rise to a special group of rock churches in this area. Were they the result of commissions from the same patron? Or should we see them as the work of one architect who promoted this particular church plan within a limited area? We just do not know. Neither have we an answer to the question of the absolute date of the churches. The employment of the old Ethiopian stepped and cuboid capitals does not necessarily prove a greater age than the churches of Lālibalā.

182 Abrehā Aṣbehā: Cross in the crossing and dome in front of the sanctuary. The ends of the arms of the cross rest on corbels, so presumably the builder imitated crossed beams on brackets. The arms of the cross, corbels, area of the crossing, soffits of the arches and the domes are decorated in low relief. The crosses with fioriture on the corbels and the decoration of the dome – apical rosette, interlaced design and a border of stepped crenellations – betray Islamic influence. The domed bay connects with the aisles beneath flat lintels: the arches above these are blind.

183 Barrel vault and semi-dome over the sanctuary: in Ethiopia, Abrehā Aṣbehā shares this usually Byzantine arrangement only with St Michael's of Dabra Salām. The frieze of metopes – with coloured panels – follows the curve of the apse. In the side chambers a frieze of arches, partly interlaced, runs around the base line of the domes. Diagonally connected double crosses in the semi-dome correspond to the swastika pattern in the barrel vault.

184 One of two long-stemmed croix pattées: they decorate the west wall on both sides of the entrance into the vestibule and are a basic element of all three churches. The filling of palmettes, unique to Abrehā Aṣbehā, is reminiscent of Islam and of certain processional crosses.

185 Cruciform pillar of the crossing, with bevelled edges and the usual pseudo-capitals of corbels. The embossed swastikas in the vault and on the soffit of the arch have been whitened, whilst the ground of the low relief and panels of the metopes have been blackened.

186 View from the crossing into the south transept: a swastika meander in relief fills the soffit of the barrel vault and of the arch. (The vault over the north transept shows a freer form of surface filling also based on swastikas: fig. 112.) B. Playne was assured by the priests that at one time the reliefs were covered in gold until it was melted by a fire. The pillars inserted as intermediate supports for the transept carry beautifully carved stepped capitals of Aksumite design. The picture conveys some idea of the size of the church (roughly about 25 × 15 m).

Additional Sources

Sauter, no. 12. – References and description: Playne; Gerster, *Drei Felskirchen* . . .

Fig. 112 Vault decoration

182 Abrehā Aṣbehā: cross in the crossing and dome in front of the sanctuary.

183 Barrel vault and semi-dome over the sanctuary.

184 One of two long-stemmed croix pattées: they decorate the west wall on both sides of the entrance into the vestibule.

185 Cruciform pillar of the crossing, with bevelled edges and the usual pseudo-capitals of corbels.

186 View from the crossing into the south transept: a swastika meander in relief fills the soffit of the barrel vault and of the arch.

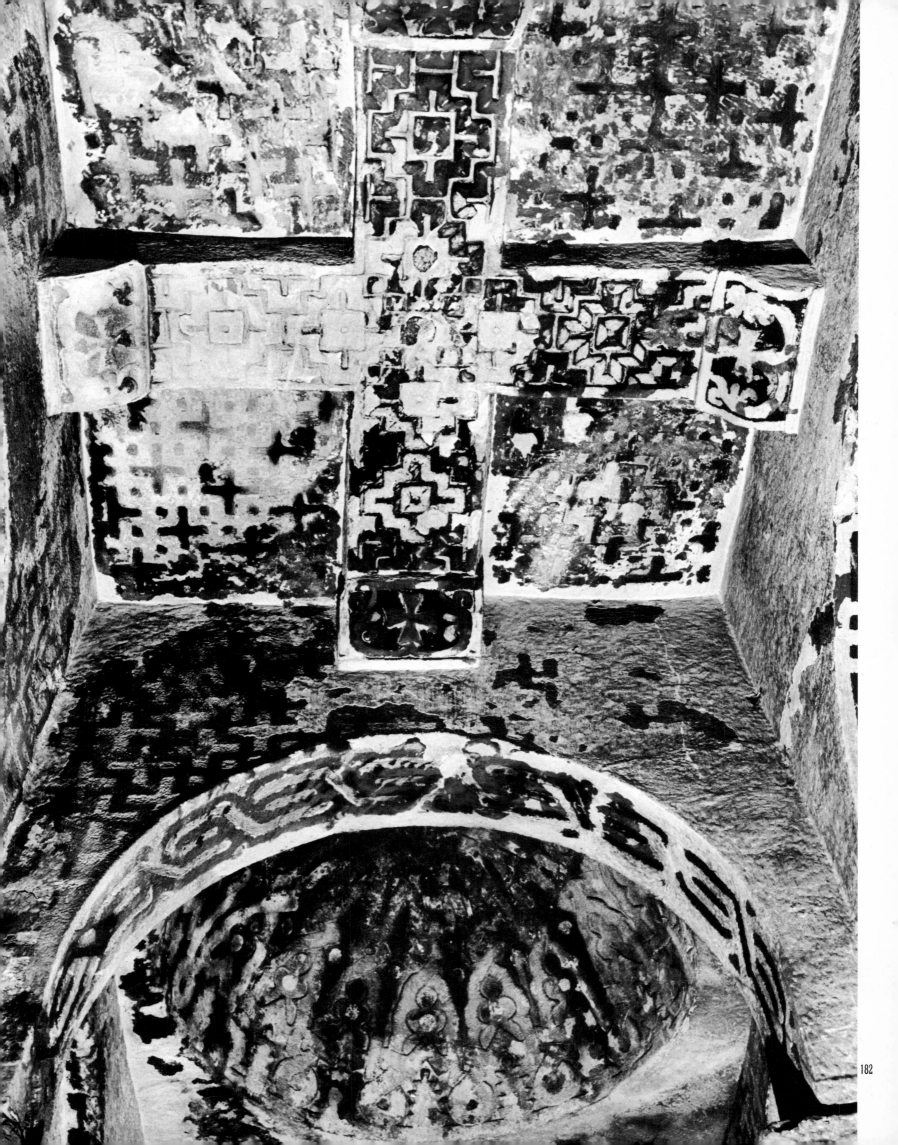

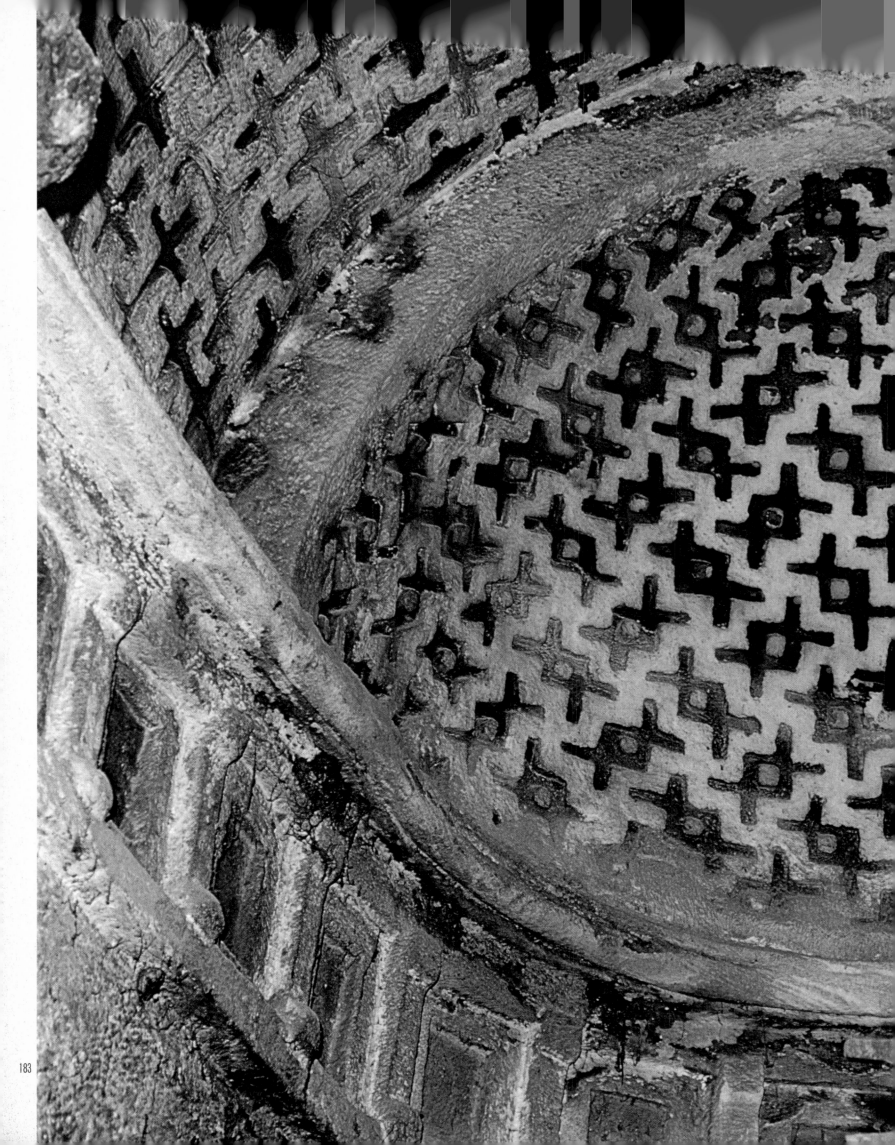

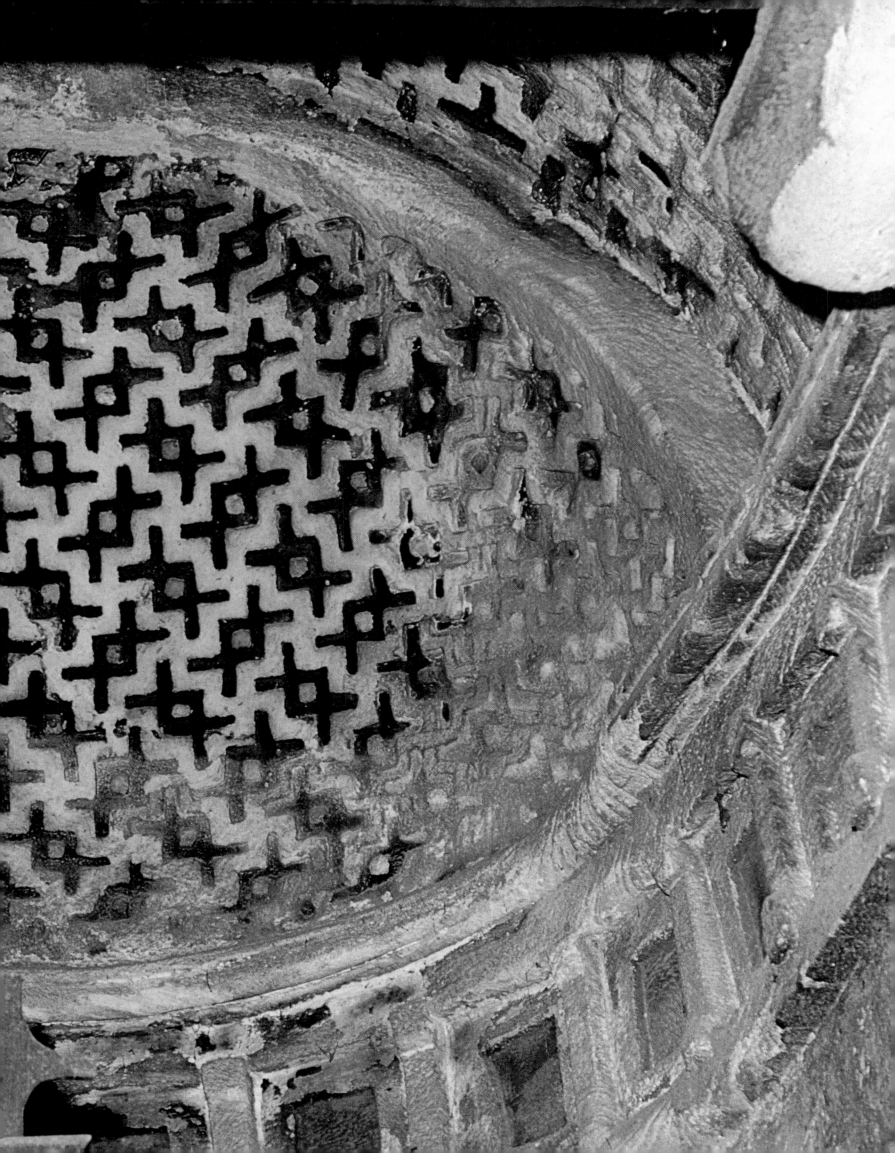

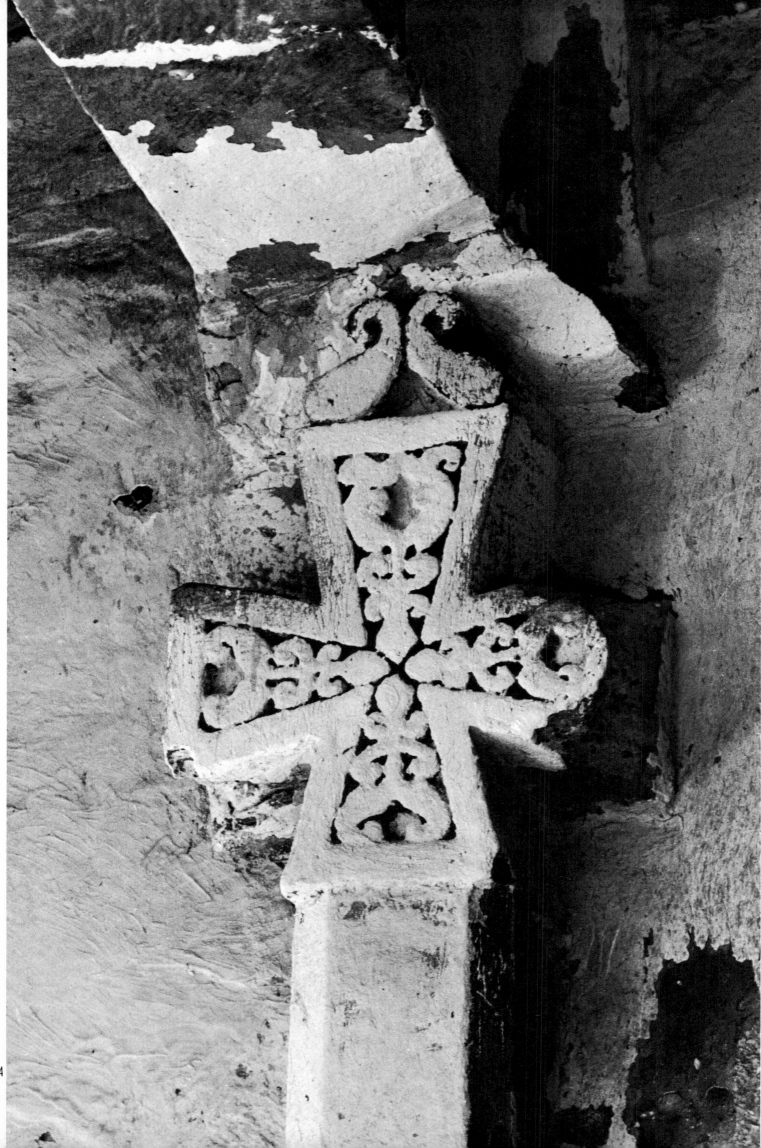

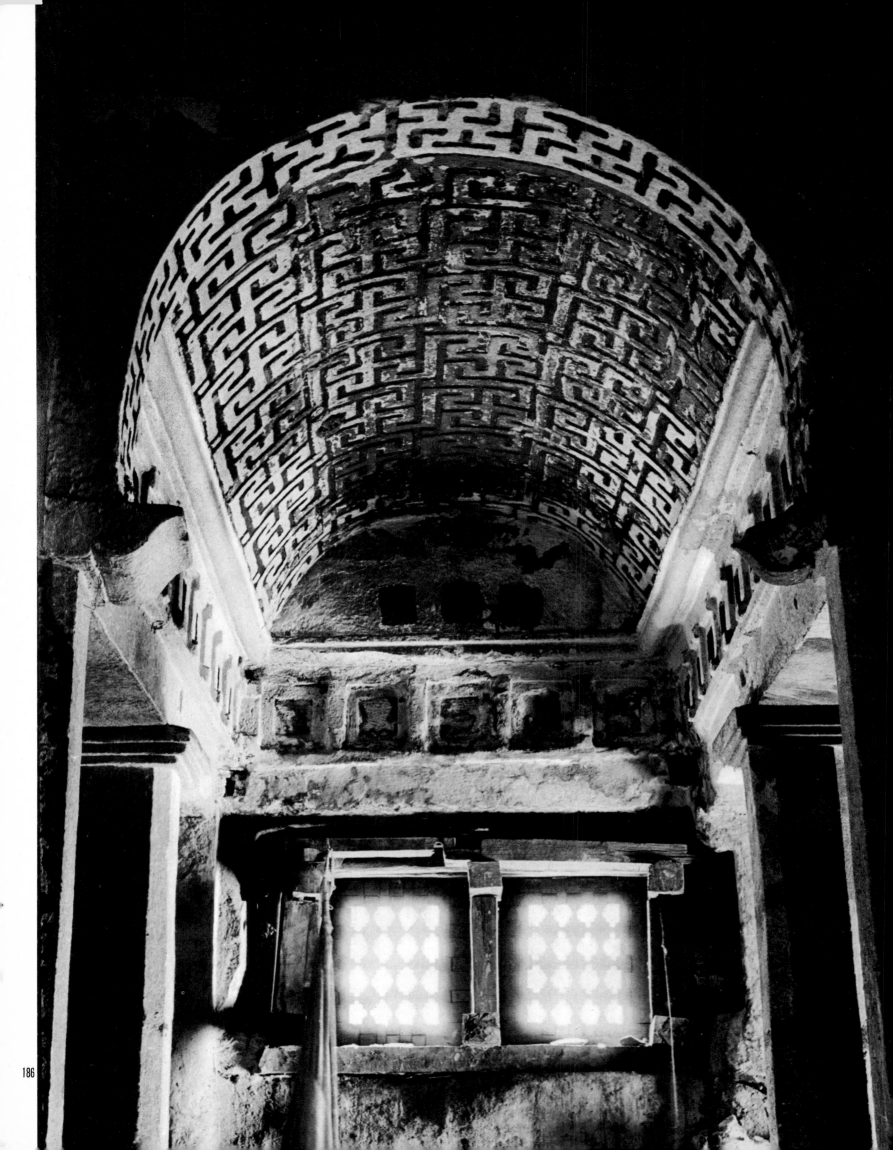

The Excavated Church of Guḥ

Fig. 113 Geometrically interlaced rosettes

Endā Abuna Yemʿāta of Guḥ is ten miles rough drive and an hour's exhausting climb to the south-west of Hawzēn in the province of Tegrē (map. fig. 36). It was first visited by non-Ethiopians in the middle of March 1966 within the framework of the Ethiopian Institute of Archaeology's reconnaissance in Garʿālta. Being carved from the mountain near the summit of one of the rock-towers, so characteristic of this landscape, it is a real prize for those who can stand the height. The last stretch of the ascent leads diagonally across an almost vertical rock face with few reliable foot or hand-holds.

The church is more or less facing east. A narrow ledge of rock leads to a low cave-like porch in the south-west corner. In it the only entrance to the shrine, completely imprisoned in the rock, opens out. One then enters a rectangular area, about ten paces long and six wide. A beam imitated in the rock divides the ceiling crosswise into two halves; at the walls it rests on pilasters with coussinet corbels, and in the middle, on a pillar. Shallow domes are carved out in both halves of the ceiling and in the centre of them a circular recess indicates a hole or lantern. The pendentives of the domes are also marked out, if only by painting. The rectangular hall communicates with the other areas of the church by means of archways screened off by curtains. The visitor is advised to respect this as a bound to his curiosity. As a special favour, the priest in charge of the church grants him a view of the fresco of the Church Fathers (pl. 190), on the vaulted ceiling behind the arched wall, then the curtains drop, not to be raised again.

The hall, in which the visitor is permitted to look round unhindered, gives the impression of being for the choir; the domes are unusual for this part of the church. The area is decorated all over with frescoes. The paintings are by several hands and in part were painted or restored at different times, as shown by overlappings. The ornaments employed – the borders around the base of the domes and on the pillars, the frieze on the architrave and on the forefront of the arches, the trellis-work on their soffits and the geometrically interlaced rosettes in the pendentives (fig. 113) – might have been taken from the pattern book of an Islamic interior decorator. Also giving an Islamic impression, but with less justification, are the mighty turbans which most of the figures painted in this church wear, since in Ethiopia the married priests and dabtarās wear the ṭemṭem, a headdress similar to a turban, as a distinguishing mark. This headdress, wound round from green, brown, yellow or white muslin, puts the nimbus in a doubtful position. Where the artist has omitted the internal markings of the strips of material, the question remains as to whether it is a halo or a turban. The frescoes may be considered to date from the sixteenth or seventeenth centuries.

187 Endā Abuna Yemʿāta in its rock tower. The window that is visible indicates the east end of the church, the altar end. It has been completed with the aid of dry-stone walling. The porch with the entrance to the church is out of the picture on the left, at the end of a ledge of rock. Helpers from the expedition of the Ethiopian Institute of Archaeology are starting the return journey with the author's photographic material.

188 Eight of the Nine Saints of Rome (i. e. Byzantium) in the northern dome: only seven are named in the inscription, and in very faulty spelling: Liqānos, Garimā, Panṭalēwon, Ṣeḥmā, Gubā, Aragāwi and Afṣē. The only one to appear without a turban is Abbā Liqānos, who wears a hood. Apparently the artist ran short of space while painting,

since he squeezed Abbā Gubā in afterwards and had to sacrifice the inscription of the saint on Gubā's left. No doubt it should be Alēf. The ninth saint, Yem'āta, the church's patron saint, is depicted on the wall below the dome, on horseback with flowing cape, his left hand on the reins, a hand-cross in his right hand, hood and turban on his head. Behind him stand one Abuna Anos and an Abuna Matthew, the latter with one hand on his prayer-stick and the other either blessing or holding a book. The inscription between the rider and the head of the horse implores Abuna Yem'āta's intercession for one Abuna Benyām – perhaps the founder of the church, a local churchman, or maybe even Benjamin II., Patriarch of Alexandria (first half of the fourteenth century). According to the Synaxarium, Pachomius himself introduced the Nine Saints to the monastic life before they organized monasticism in Ethiopia and, to quote the Gadla Aragāwi, 'settled the faith'. On the velarium of Dabra Damo (sixteenth–seventeenth century), two of the nine saints also appear with great turbans (along with haloes).

189 Eight apostles and James the Lord's brother, also bearer of a special apostolic calling, in the southern dome. Anti-clockwise, starting at the bottom (with an inscription partly incorrect): Mathias (the successor of Judas), James, John, James the brother of the Lord, Thaddeus, Andrew, Philip, Bartholomew, Nathaniel. In fact, the last two were probably one and the same person. In this painting the turbans leave the hair exposed as if haloes were subsequently turned into turbans. On the wall below the dome, cut off in the picture, there are two Egyptian saints on the left, Abbā Abib and Māmās, and on the right, Paul and Peter.

190 The Patriarchs Isaac, Abraham and Jacob on a vaulted ceiling behind the arched wall, Jacob holding an anachronistic hand cross. The lettering of the inscriptions is distinctly archaic. In this painting, too, Isaac and Jacob look as though they came by their turbans only as an afterthought.

191 Moses with turban and black beard: painting above the entrance to the church.

192–4 A hybrid ('dog's face') with a sickle, a lion and a cockerel accompanying the patron saint's bridled horse. Here we have a warning against too profound an explanation. The lion of Christian animal symbolism, of course, represents the guardian of the saints (because of the belief that it sleeps with its eyes open) and is also the symbol of the risen Christ as king. Then the cock, the Christian bird of vigil, like the priest, certainly rouses human souls. Time and again, however, the Ethiopian painter apparently makes use of pictures of animals for filling empty spaces without even thinking about it. The picture of the saint on horseback – with trappings in festal display: bells on the neck-strap and breast-plate – draws attention to his heavenly status.

195 Mary and Child with monastic saints on the pillar of the arched wall. The inscriptions implore the intercession of the Virgin and Abbā Ēsis, an Egyptian saint, 'Let us be blessed with your prayer. Amen.' The decorative border framing the picture is often found in Islamic buildings, e. g. of the Mameluke sultans, and as marble inlays in the cloister of Sultan Baibar II. (built in 1309) in Cairo (fig. 114). See also fig. 77. The trellis pattern is already known from Islamicising Byzantine illustrated manuscripts. The painting of the Madonna is related to the well-known icon of S. Maria Maggiore (pl. 154).

Fig. 114 Mameluke ornament (after *Hautecœur/Wiet*)

Additional Sources

Sauter, no. 1203.

On the velarium of Dabra Dāmo: Mordini, *Un antica pittura* . . . Schnyder.

Comparative ornament of the Mameluke period: Hautecœur/Wiet, pt. 98/99, 105, 185.

The trellis pattern in Byzantine manuscripts: Frantz, pt. VI, no. 11.

187 Endā Abuna Yem'āta in its rock tower.

188 Eight of the Nine Saints of Rome (i. e. Byzantium) in the northern dome.

189 Eight apostles and James the Lord's brother, also bearer of a special apostolic calling, in the southern dome.

190 The Patriarch Isaac, Abraham and Jacob on a vaulted ceiling behind the arched wall, Jacob holding an anachronistic hand cross.

191 Moses with turban and black beard: painting above the entrance to the church.

192–4 A hybrid ('dog's face') with a sickle; a lion and a cockerel accompanying the patron saint's bridled horse.

195 Mary and Child with monastic saints on the pillar of the arched wall.

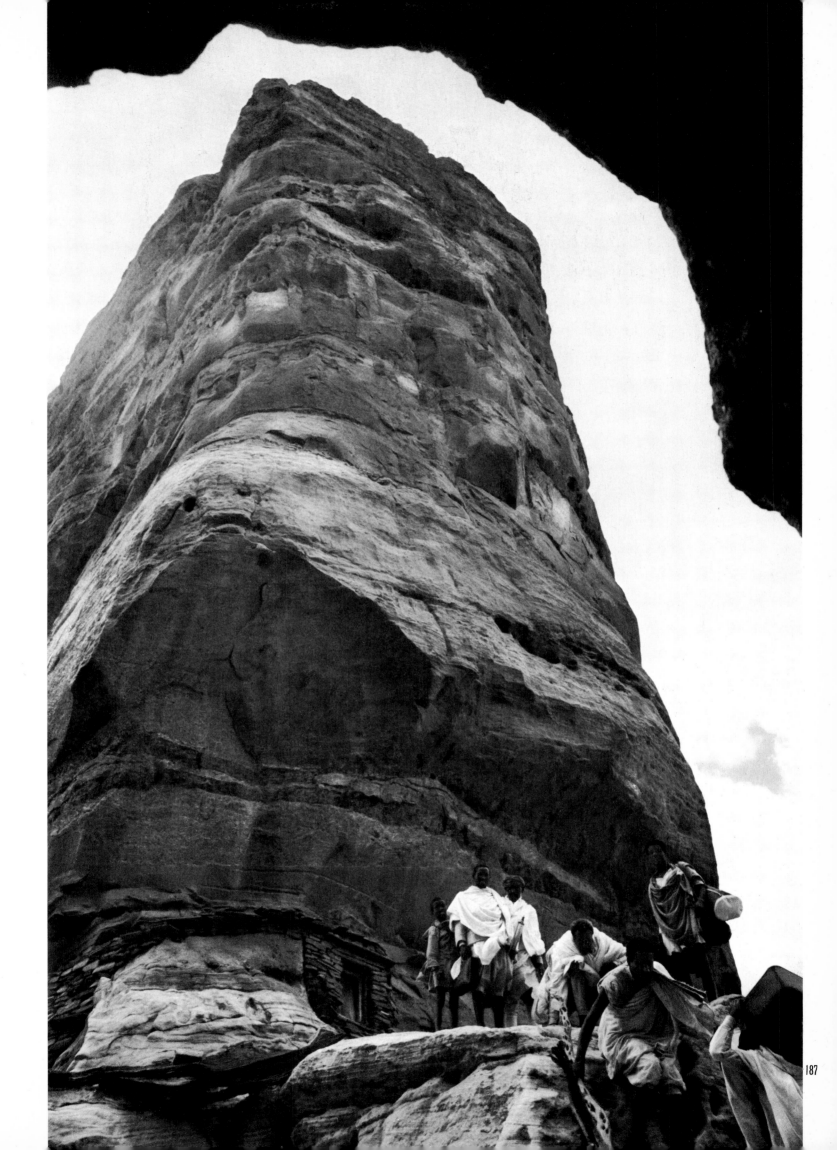

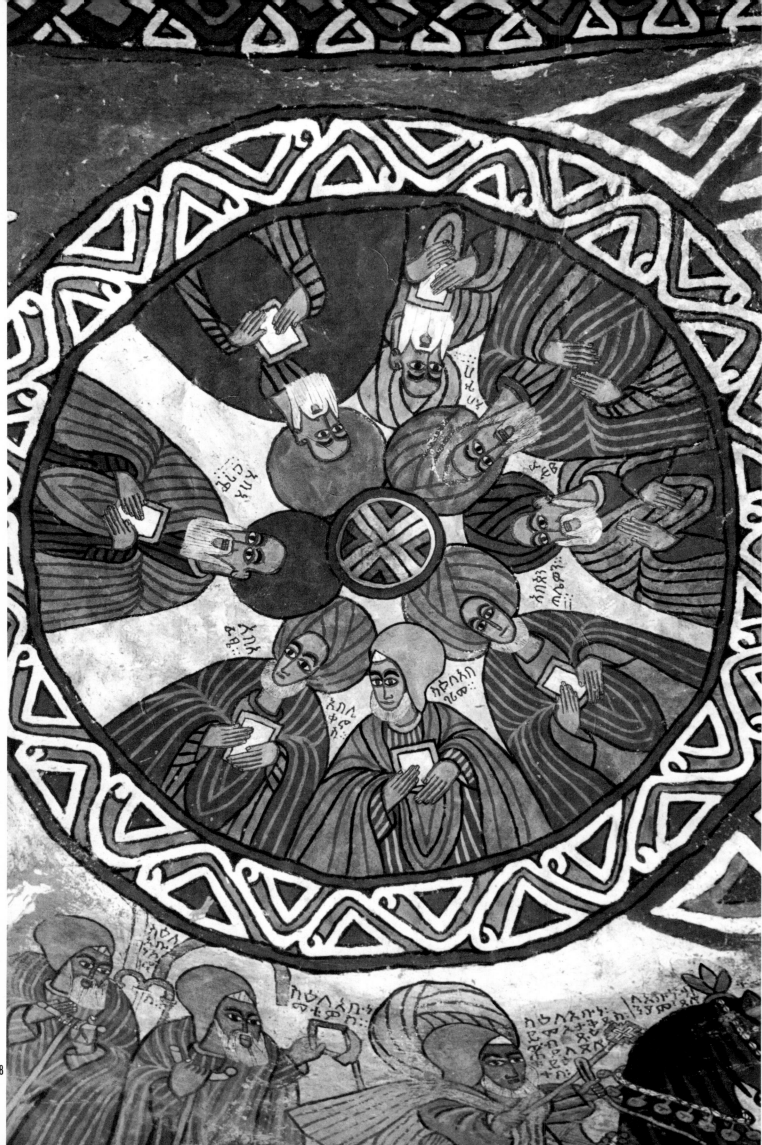

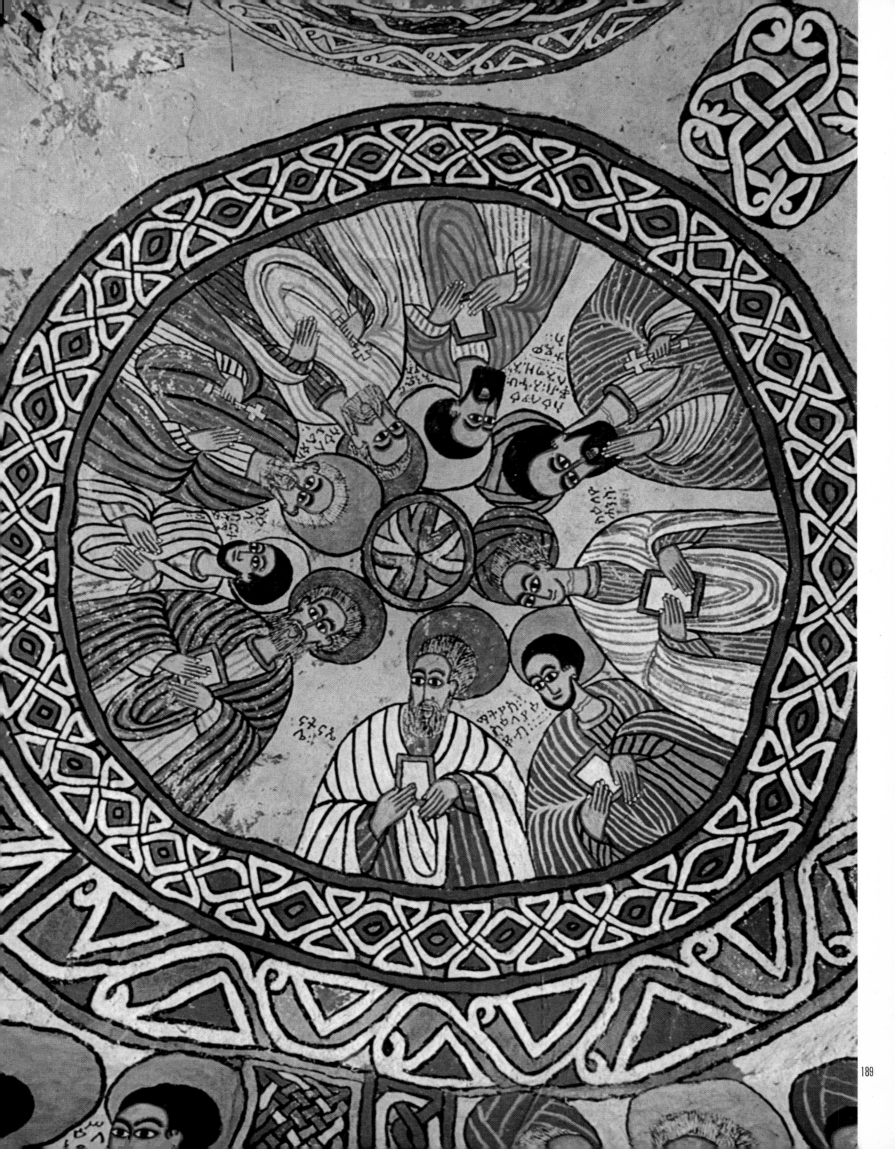

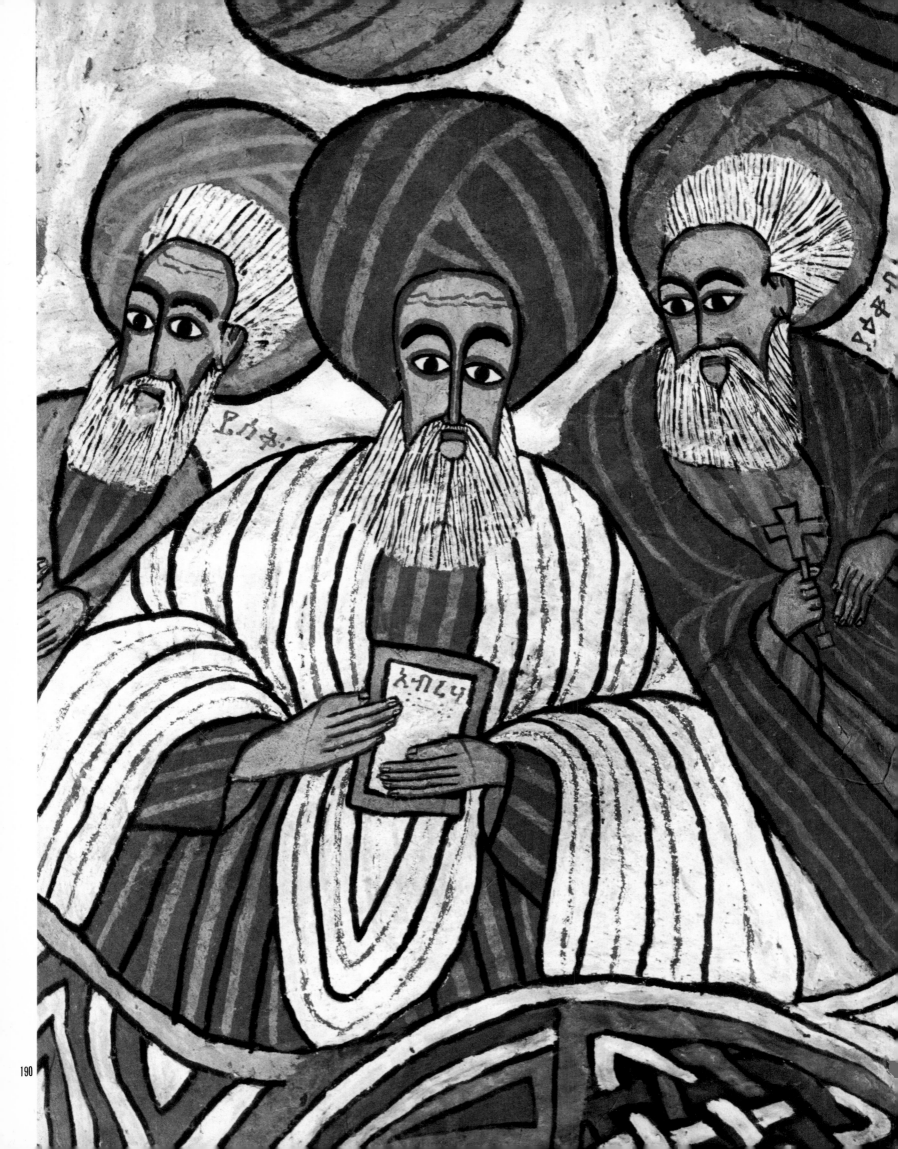

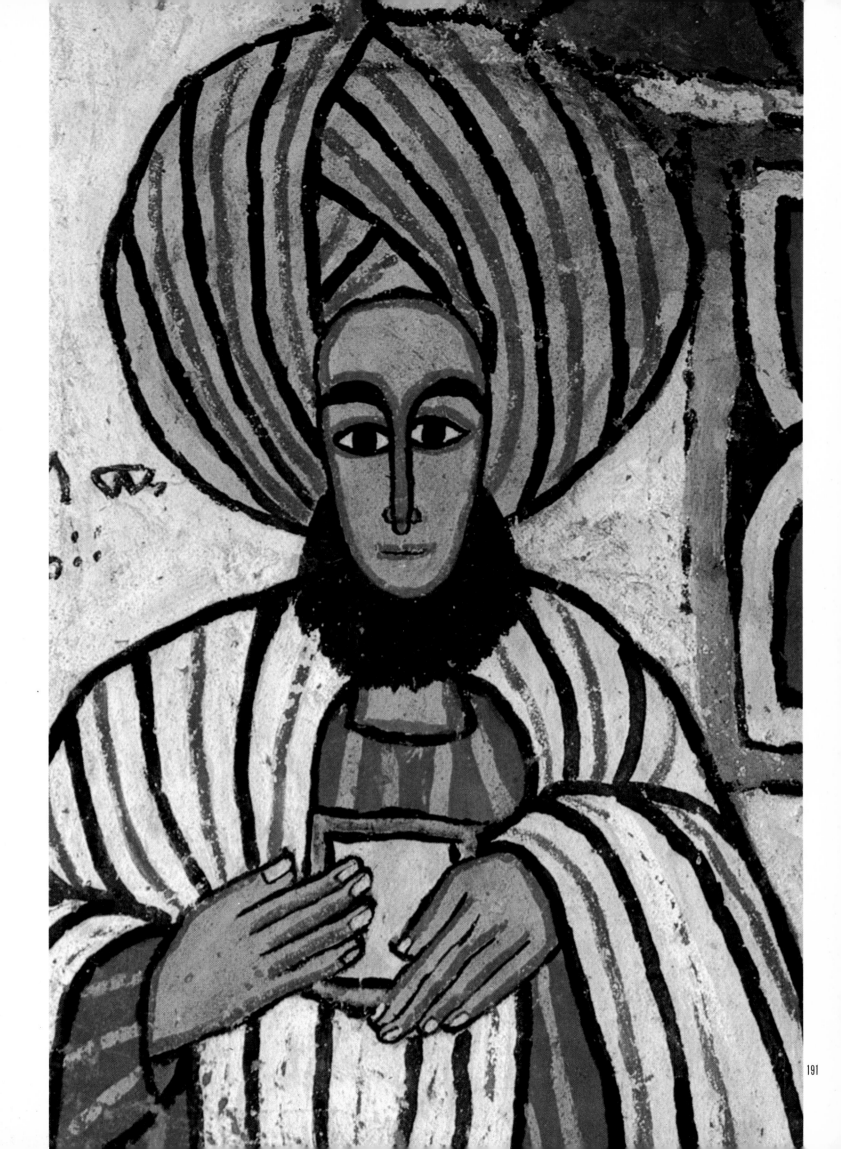

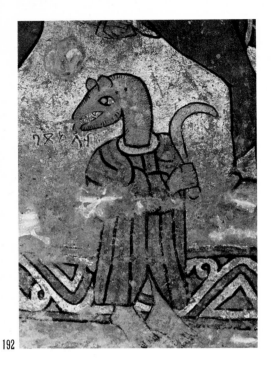

192

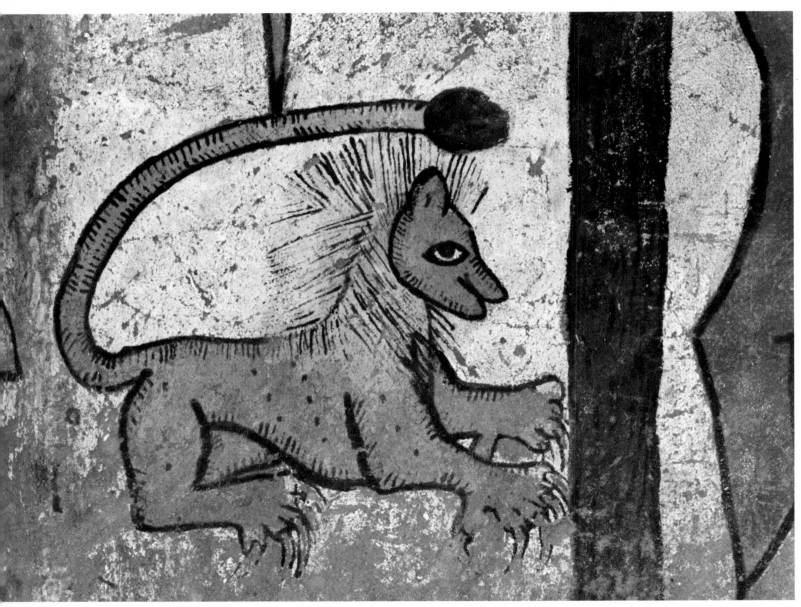

193

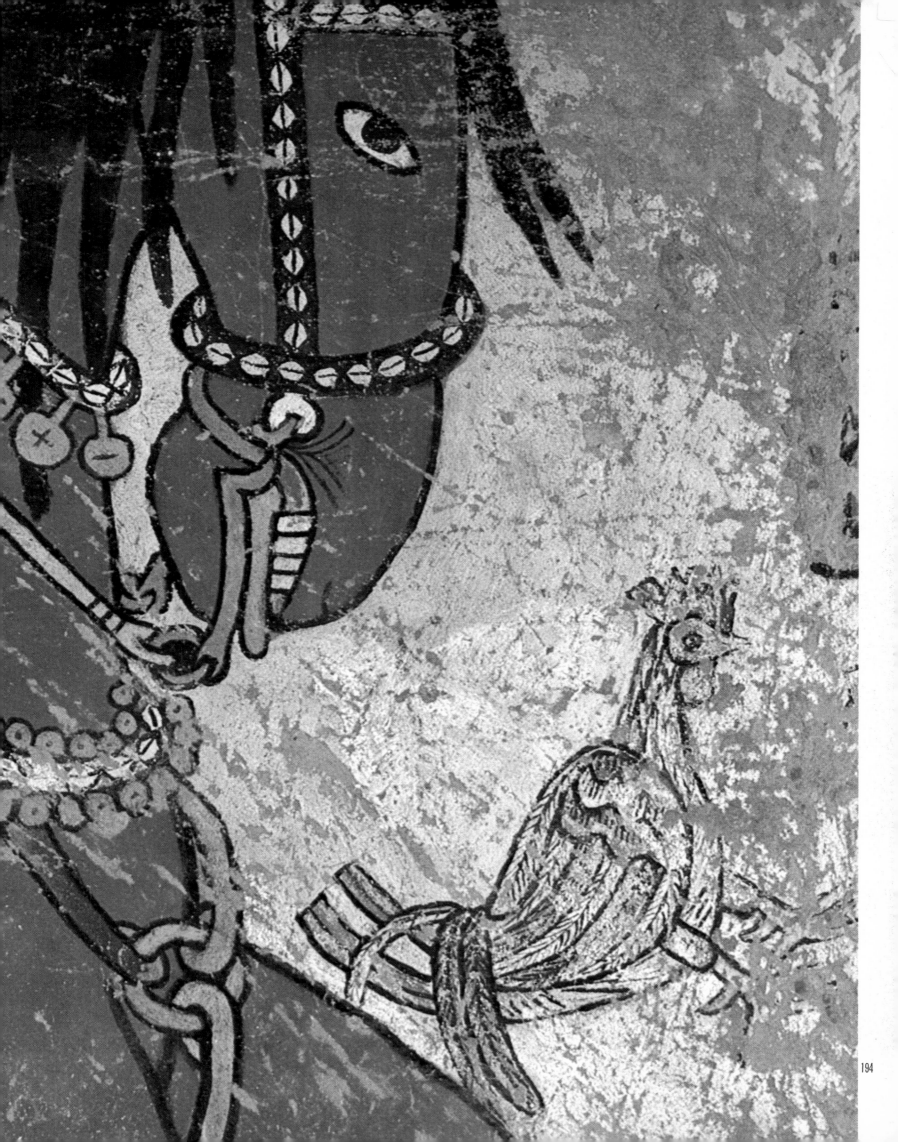

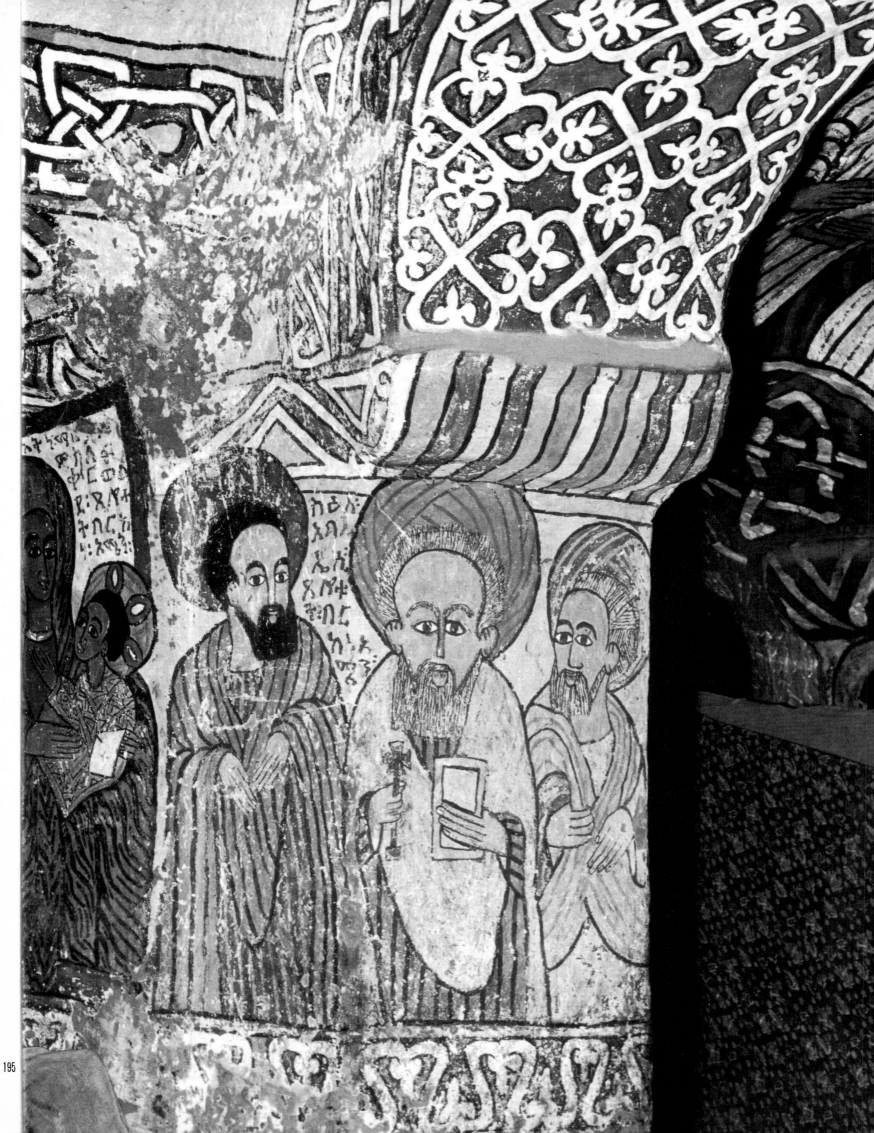

Bethlehem in Gāyent

Whether by intention or by chance, the distance between the Ethiopian Tabor and the Ethiopian Bethlehem corresponds roughly to the distance between the original Mount of the Transfiguration and the real birthplace of Christ. Bēta Leḥēm in the district of Gāyent lies south-east of the market-town of Dabra Tābor – 40 miles as the crow flies; by land it takes five hours in a vehicle such as a land-rover, travelling alongside the remains of the old Italian road, the bridges of which have collapsed and the surface of which is wrecked, then across country to the hamlet of Zur Ambā and finally another four hours on foot.

The traveller in Ethiopia cannot have a more beautiful experience than this pilgrimage to Bethlehem. The last stretch of the way, along mountain slopes and over rock spurs, is not only shortened by anticipation and the enjoyment of the landscape. Scientifically speaking, in the Ethiopian highlands two kingdoms of flora are encountered, the palaeotropical and that of the Cape. Even the botanically uninstructed layman is astonished at the great variety of vegetation. Here it is reminiscent of alpine meadows, there it resembles the Mediterranean macchia, and elsewhere it is tropical. Spreading warkā trees, habitation for hundreds of blue-black and lemon-yellow birds, dot the landscape: the warkā tree, a kind of fig, has a modest beginning as an epiphyte before its aerial roots, growing into trunks, strangle its host tree. The church and its cleared precincts themselves are the centre of a small oasis of nut and oil trees with a noisy population of thrushes and finches.

The visitor, it is true, should not trust blithely in the peace of nature. The province of Bagēmder is one of the less safe parts of the empire: here many a farmer, driven by poverty, ploughs by day and plunders by night. Rightly or wrongly, the people of the district of Gāyent have a bad reputation. There is a proverb among the Amhara, 'rather a thousand devils than a single man of Gāyent'. An armed escort is therefore necessary to frighten away vagabonds, and official consent to the excursion is, in any case, indispensable. Bethlehem falls within the sphere of responsibility of the governor of the sub-province located around Nafās Mawčā, about halfway along the caravan track linking Gondar with Dassē right through the highlands.

The church, dedicated to St Mary, was discovered in 1956 by Thomas Pakenham and Wilhelm Staude. The disappointment they must have felt on their first view of the church, looking down from the mountain, is hard for the present visitor to recapture, since he knows the secret of Bethlehem beforehand – that the straw-covered conical roof, which gives the appearance of one of the usual modern Ethiopian round churches, hides an unquestionably medieval free-standing structure which is actually rectangular (fig. 115).

Pillars support the conical roof and create an impressive ambulatory around it. The church, which faces east, stands on a socle and is built of very carefully dressed stone, mostly pale pink in colour, without mortar. Individual white blocks of stone, also incorporated into the wall without binding, pattern it to a little above eye-level. As one would expect with the use of worked stone, there is no wooden framework. The wall surface is smooth and pierced with up to five rows of windows. The door and window frames are of wood, invariably with external monkey-heads and sometimes with internal ones. The windows in the gable of the west façade form an equilateral cross. Wherever two window frames are adjacent they have monkey-head binders in common. In a structure of dressed stone, their main contribution is to

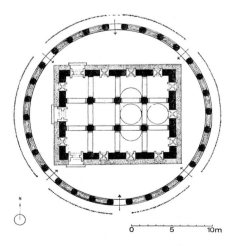

Fig. 115 Ground-plan (by permission of the Ethiopian Institute of Archaeology)

strengthen the framework of the door and window openings. However, they are probably there mostly for decoration. In many windows there does not seem to be any proper jointing between the sill and the lintel on the one hand and the binders on the other. Certainly no structural purpose is served by the decorated beams with monkey-heads above the lintels of the doors.

The ground-plan of the inner church corresponds to the basilican type, only it is without a vestibule. Two colonnades with pilasters and three pillars each divide the internal space of approximately 16 × 13 m. The first two bays of the nave are beneath a coffered saddle-back roof with open framework, the corresponding sections of the aisles having a flat, also coffered ceiling. Above the third bay of the nave there is a small dome supported by four wooden round arches; the aisles on both sides are vaulted with wooden barrel vaults. A second, larger dome rises above the sanctuary, in contrast to the flat ceilings of the adjacent side-chambers. Inside the church painted decoration is lacking, figure subjects being entirely avoided. Consequently, all the richer is the decoration by means of wooden architectural members – brackets, bosses and decorative lintels – most of which have, in addition, designs carved on them. The frieze of metopes gives an unmistakably Aksumite impression. Only beneath the dome in front of the sanctuary is it missing. It runs along the aisles beneath the ceiling and in the nave it provides the most important architectural ornament of the upper walls, in addition to which, between the frieze of metopes and the base purlin of the roof, five arched windows open into gallery-like areas on both sides.

In front of the church near the gatehouse in the surrounding wall, a rough-hewn stela lies amongst the tall grass. The priests maintain that it comes from the north. Similar rough and uninscribed cult-stones are known from excavations at Aksum and Maṭarā and there are stones still standing upright at the churches of Yeḥā and Hawzēn. They are indicative of the sacred character of the area.

St Mary's of Bethlehem, the renovation of which was commenced on Ethiopian initiative in 1967, presumably dates from the late Middle Ages; in type it would be older since the churches of Lālibalā already presuppose buildings with smooth unbroken wall surfaces. In its construction, the stone mason's technique from Aksumite times, already so highly developed, was still a living memory. However, certain features of the Aksumite style of architecture were now being used outside their original technical context. As an architectural paradigm, this monument has a significance possessed by few other churches in Ethiopia. There seems to be justification for our believing that here, at least as far as the ground-plan and method of construction are concerned, we have a standard example – and not, as probably in the case of Yemreḥanna Krestos and Dabra Salām, a special case complicate by its site and significance. The question remains as to whether at least the church's interior decoration is not unusual. The hypothesis that all the churches destroyed by Grāñ's hordes could compare with the splendour of the ornament in Bethlehem seems quite unreasonable. Although Bēta Leḥēm may not have figured on any ordinary map, it certainly appeared on the map of the religious life in letters of gold as a centre of ecclesiastical education for budding priests. The great speciality of Bethlehem is the teaching of church music. During the reign of a puritanical king who abolished church music and dancing, one of Bethlehem's Geʻez instructors preserved the Deggwā – a collection of hymns attributed to the monk Yārēd, the founder of Ethiopian church poetry – from the pyre. Local tradition bases Bethlehem's privileged position on this story.

196 Bethlehem in the district of Gāyent: an ostensibly round church with the huts of the theological students and their teachers in the foreground; in the background the

138

mountains of the province of Wallo. Gāyent is part of the catchment area of the Blue Nile. Attached to an extension of the central upright of the conical roof, above a huge strawcovered knob, is a head-piece (fig. 116): crosses within diagonally-placed squares, with birds and ostrich eggs, the latter originally totalling the sacred number of seven. The square symbolizes the 'four corners of the earth' (Rev. 7:1) over which the cross must reign. The ostrich eggs, which the 'Rules of the Church' summarily assert to represent unconfessed sins, stand for the virgin birth of Christ and the Lord's resurrection – according to the belief whereby the forgetful ostrich abandons her eggs for the sun to hatch. Even in the churches of the West, ostrich eggs with the same significance found entry after the Crusades. In the churches of Ethiopia one occasionally meets them as an altar decoration; but they are usually pinnacle ornaments – stylistically of the processional cross form – with either real ostrich eggs or spherical substitutes (fig. 117).

197 The west façade beneath the conical thatched roof. The façade reaches right up into the roof. A rafter framework transfers the load of the sloping thatched roof on to

Fig. 116 Decorative roof-top cross at Bethlehem

Fig. 117 Roof-top crosses at Aksum, Dabra Dāmo and Adwā

built-up pillars encircling the church and, to a lesser extent, on to the walls of the church itself; near the domes in front of and above the sanctuary a circle of masonry pillars standing on the roof of the inner church also help to support the mighty straw 'hat'. The external walls of the church were subsequently decorated at the turn of the seventeenth and eighteenth centuries at the earliest. In several places the artist applied the paint directly on to the stone or wood, but usually he stuck painted cloth on to the walls. The style of the paintings, and not least the heads of the seraphim, are reminiscent of the paintings in the Church of the Trinity of Dabra Berhān at Gondar (pl. 14). Curtains drape selected icon-like pictures – to the uninformed, a rather haphazard selection.

198 Coffered ceiling of wooden beams with decorative bosses, above the right aisle. There is a pattern of interlacing on the soffit of the architrave.

199 The upper wall of the nave: above the lintel-beam with interlaced pattern there is a frieze of metopes between beadings and trellised clerestory windows. These admit no light from outside and there are no stairs leading to the gallery-like space behind them. Chip carving on the rope-mouldings give the impression of rotation in opposite directions. The lintel-beam rests on the pseudo-capitals which are familiar from the imitations of them in the rock architecture. One of the four brackets forming the capital juts out into the nave without any function of support.

200 The saddle-back roof with flattened ridge and open framework above the nave. The technically functionless brackets and imposts on the walls on both sides must be regarded as a form of decoration, as must the bosses on the roof-trees. Masonry fills the spandrels and gables towards the front part of the church with its two domes.

201, 2 The dome over the sanctuary: wooden ribs alternate with fillings of wood and masonry (or white-washed wooden inlays resembling masonry). Functionless brackets decorate the fillings. The uppermost window of the sanctuary between the frieze of

metopes and the base of the dome displays a distinct ornamental treatment on the inside: the panel of the window breaks up into a knot-design under miniature arches.

203 The second, smaller dome in front of the sanctuary. In it, the brackets, which no longer even attempt to cover the width of the filling, are clearly present for the visual pleasure more than anything else. The dome rises above four arches with stone-built spandrels. At the sides next to the aisles, two boards with patterns of crosses and interlacing reduce the rectangle to a square base for the dome. Pakenham linked the total number of the ribs, eleven, with the number of faithful apostles. Although one must not rule out such a symbolic interpretation, this suggestion is hardly conclusive. Ethiopian artists always depict twelve apostles (with Mathias in place of Judas), or even thirteen (with the further addition of Paul).

204–6 Carved interlacing on the soffits of lintel-beams. For the record, we have here the looped cross, cross of squares and equilateral cross.

207 Windows of the first and second row to the left of the main entrance. The panel of the lower (blind) window shows the monk Gabra Manfas Qeddus ('servant of the Holy Ghost') in an attitude of prayer. At his feet rest feline beasts of prey which the saint has tamed through the power of his preaching and prayer; a bird quenches its thirst with moisture from his eye. Beneath the painted cloth, coming away from the wall and with the paint wearing off (and which was only applied centuries after the completion of the church), older carved decoration becomes visible on the door and window frames.

208 In the ambulatory between the pillars supporting the thatched roof and the inner church: in lieu of a vestibule, it serves as a choir area and a place for the people to rest. It is impossible to say with certainty when and why the straw 'hat' was built over the church. According to one frequently quoted view, it was a camouflage to protect the church from Grāñ's marauders. However, there is no proof for this and it is hard to see why the hordes' lust for destruction should have been halted by an insignificant country church any more than by a distinguished building. We must suppose that the church survived the troubles owing to its remoteness or to some fortunate chance. A more plausible theory is that its conical roof was erected much later – not for concealment but to adapt an old-fashioned building to the currently fashionable taste, rather like the adaptation of Gothic churches to the Baroque style. The subsequent painting of the outer walls favours this view: exactly as at Dabra Salām, the inner church became the maqdas (sanctuary) of the new, larger church – in the case of Bethlehem, an ordinary round church. The sanctuary of Ethiopian round churches is customarily a distinct structure with a square or rectangular ground-plan and completely covered on the outside with paintings (fig. 118). Consequently the thatched roof at Bethlehem may well be as old as the painted decoration of the dressed stone building and would therefore date, at the earliest, from the end of the seventeenth century.

Fig. 118 Ground-plan of a round church (after the *Deutsche Aksum-Expedition*)

Additional Sources

Not being a rock church, Bēta Leḥēm does not figure in Sauter's list.

On its discovery: Pakenham, *Bethlehem . . .* and *The Mountains . . .*; Staude, *Une peinture . . .*; Gerster, *Besuch . . .*; correspondence with Staude.

On the church: Pakenham, *Bethlehem . . .* and *The Mountains . . .*; Mordini, *Die äthiopischen Kirchen*; Gerster, *Besuch . . .*

On the symbolism of the ostrich egg: Griaule, *Règles . . .*; Meiss; Réau, vol. 1.

196 Bethlehem in the district of Gāyent: an ostensibly round church with the huts of the theological students and their teachers in the foreground.

197 The west façade beneath the conical thatched roof.

198 Coffered ceiling of wooden beams with decorative bosses, above the right aisle.

199 The upper wall of the nave: above the lintel-beam with interlaced pattern there is a frieze of metopes between beadings and trellised clerestory windows.

200 The saddle-back roof with flattened ridge and open framework above the nave.

201, 2 The dome over the sanctuary.

203 The second, smaller dome in front of the sanctuary.

204–6 Carved interlacing on the soffits of lintel-beams.

207 Windows of the first and second row to the left of the main entrance.

208 In the ambulatory between the pillars supporting the thatched roof and the inner church: in lieu of a vestibule, it serves as a choir area and a place for the people to rest.

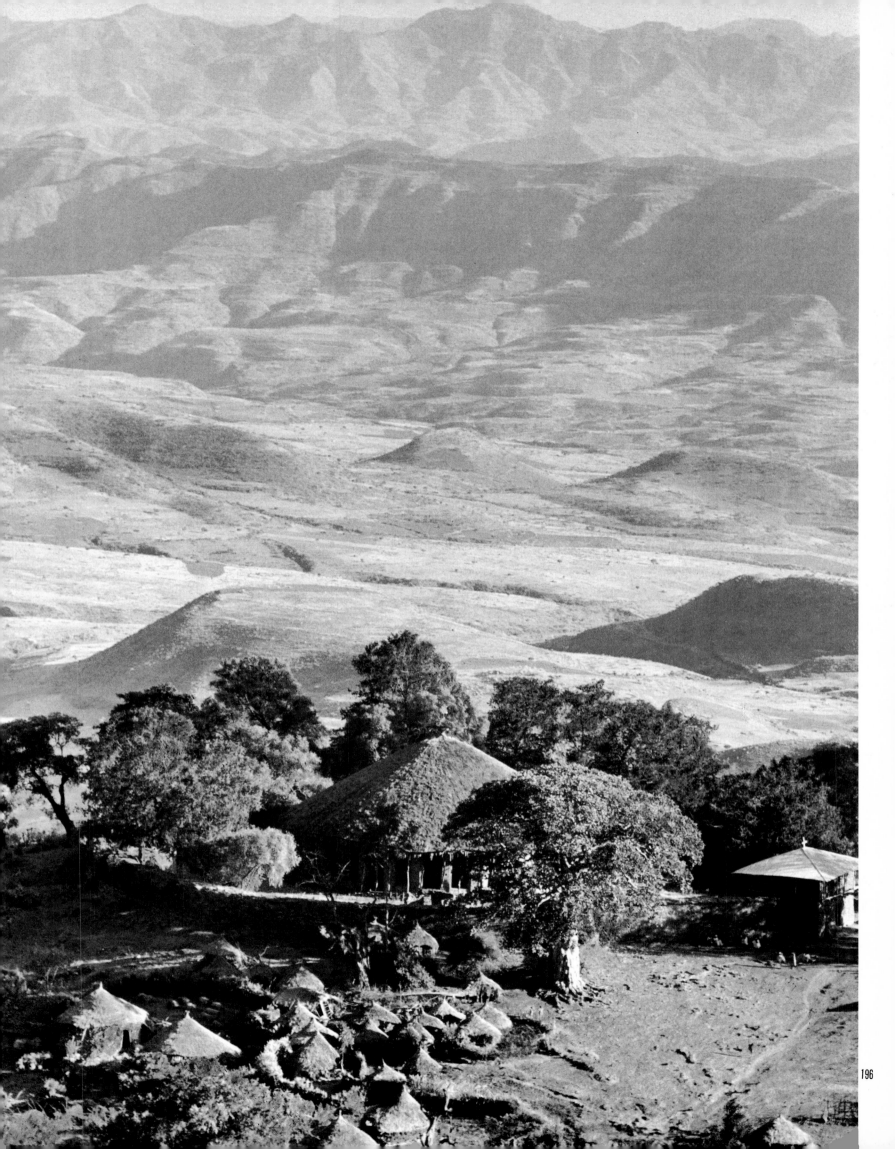

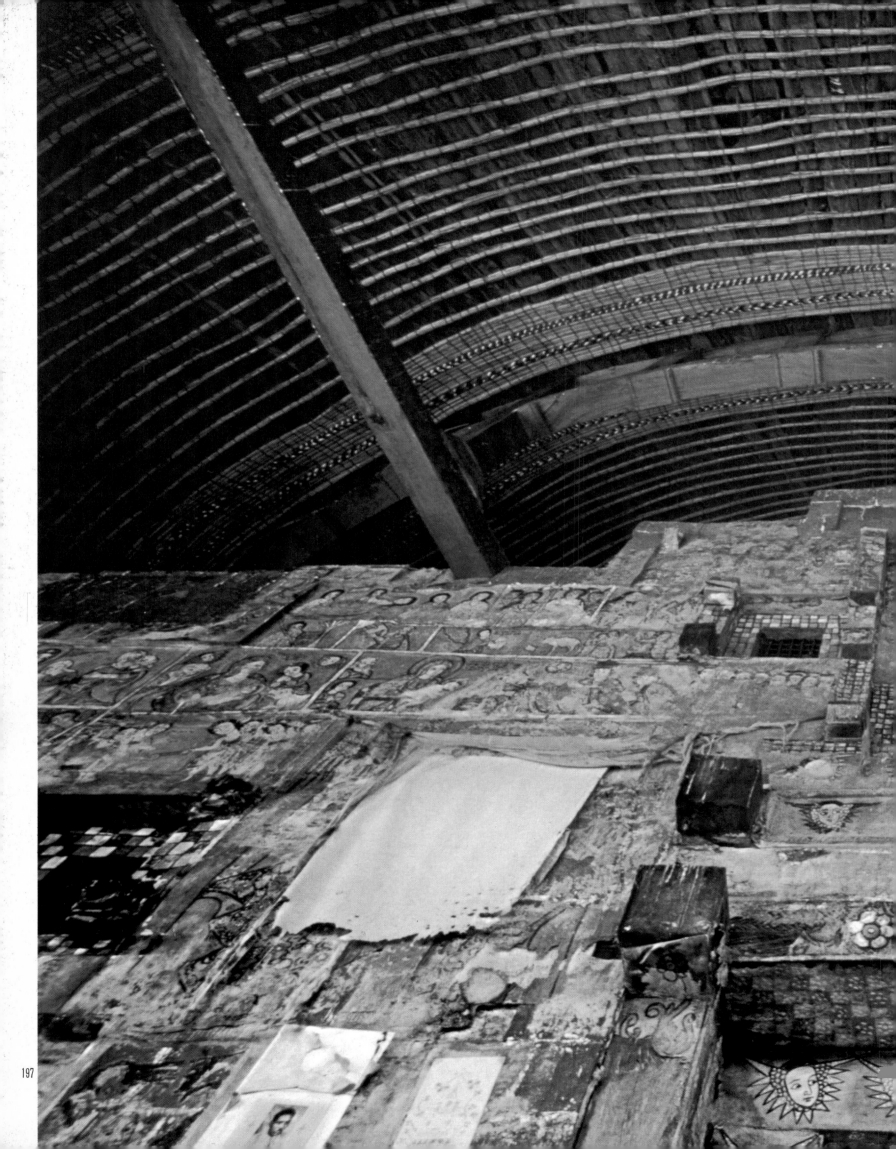

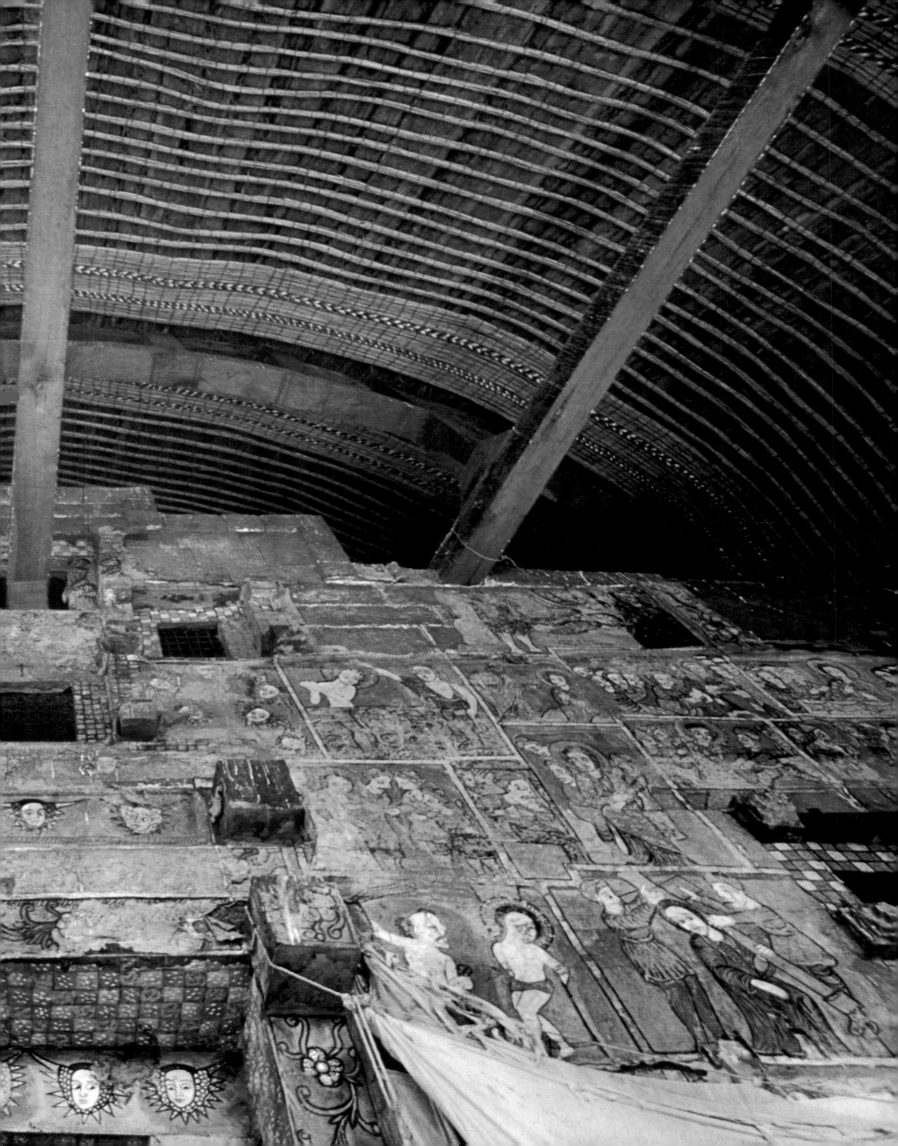

198

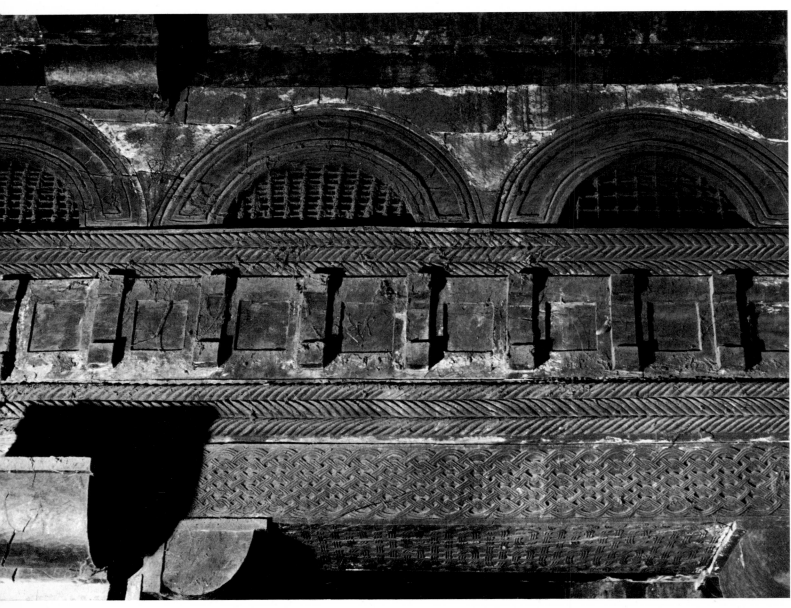

199

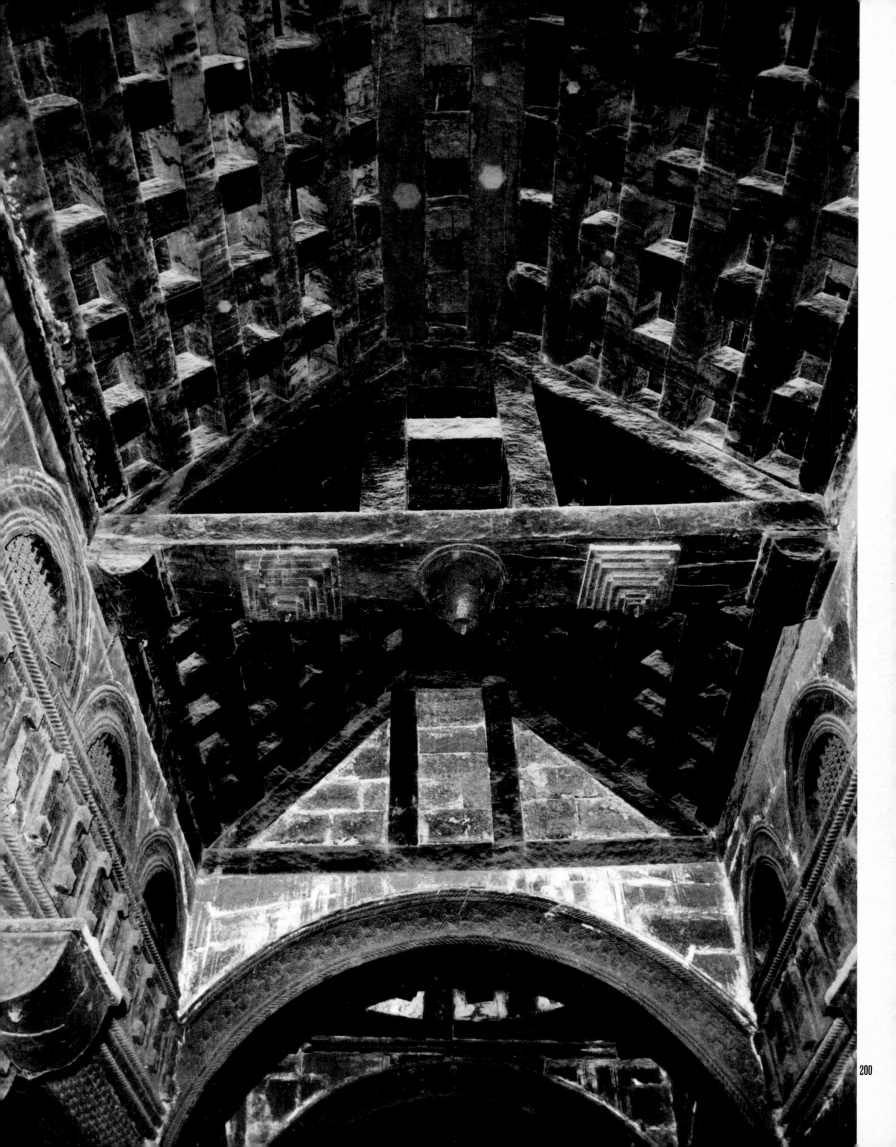

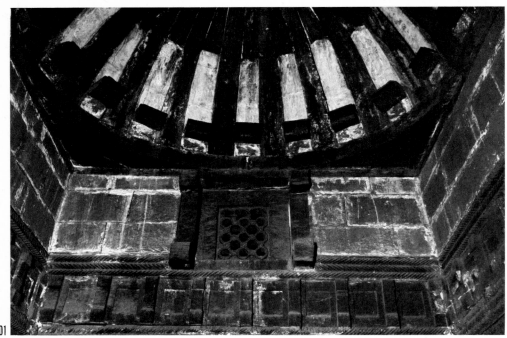

201

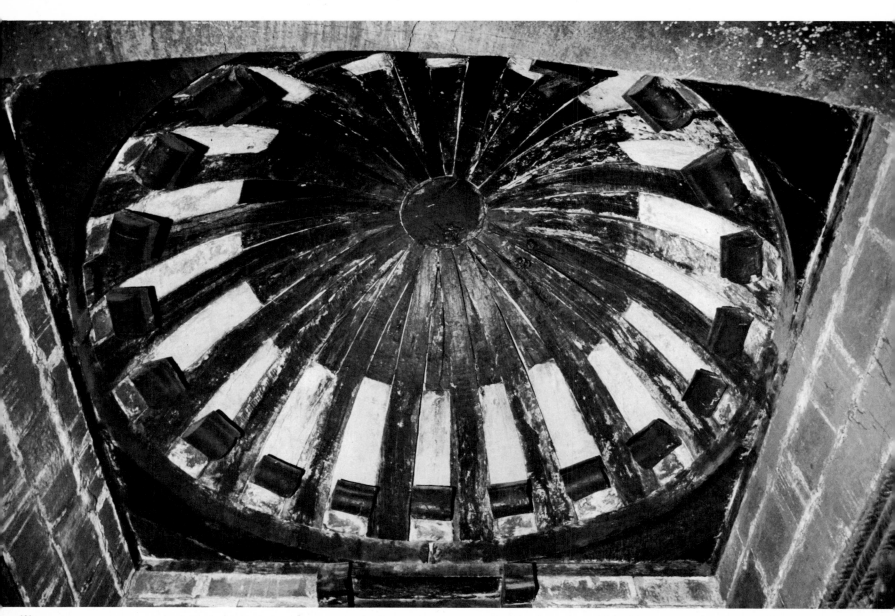

202

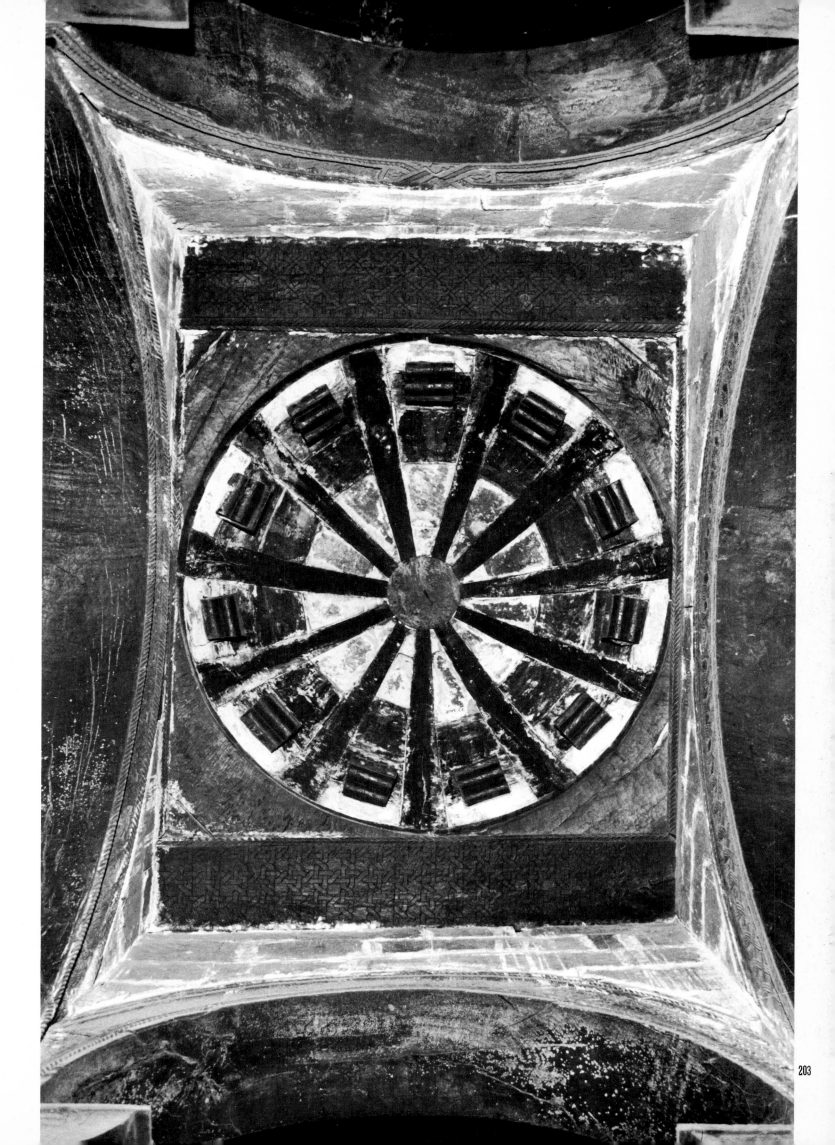

204

205

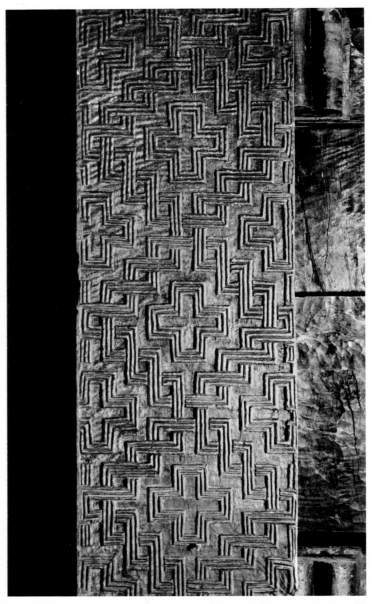

206

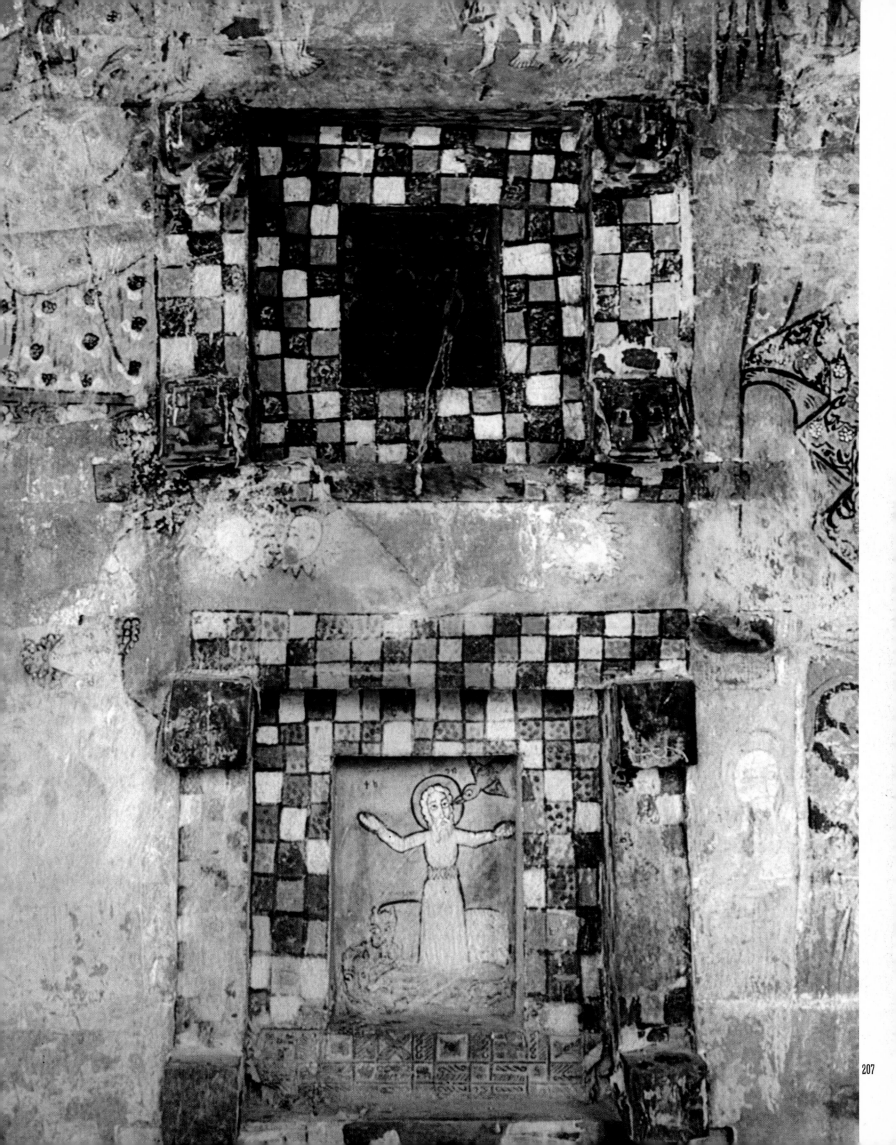

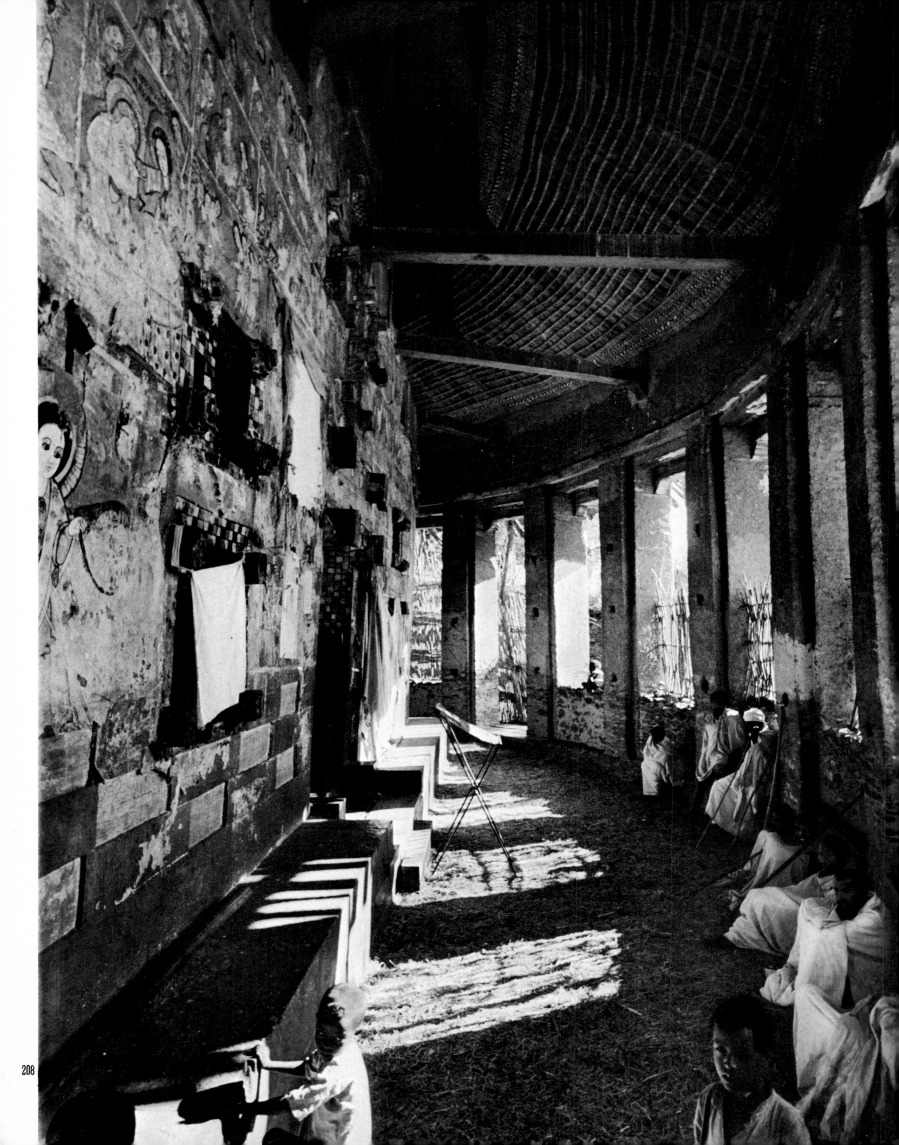

Masterpieces of carving in the church treasury: # The Portable Altars of Ṭelāsfarri Esṭifānos

Fig. 119 Sketch-plan

Fig. 120 The screen

Fig. 121 Two vessels

Ṭelāsfarri Esṭifānos lies two hours steep climb to the south of the market town of Kulmask, on the road from Kobbo or Waldeyā to Lālibalā. The ground-plan of the excavated church is circular (fig. 119); three pillars with barriers of more than human height cut off a segment with apparently no entry. A wooden screen (fig. 120) further subdivides the area. The church has two entrances. One of them leads into a vestibule with facilities for sitting or lying down carved from the rock. It is supposed to serve as a place for sleeping or instruction for the theological students of the monastery connected with the church.

Similar ground-plans are repeatedly to be found in small excavated churches to the south of the Takkaze; Sauter considers them to be more recent than the thirteenth century and thinks they arose from natural grottoes. Undoubtedly they show a weakening, in the late Middle Ages, of the basilican architectural ideal and to that extent prepared the way for the final victory of the modern, built-up round church.

Among the treasures of the church are four remarkable manbars. The significance of this piece of liturgical furniture as a portable altar may well be based on the identity of its form with monolithic altars. Its name in Ethiopia – 'manbara tābot', throne of the tābot – has little weight as evidence since the chalice box also has such a name. One must suppose that at an earlier period, when emperor and nobility led a nomadic life or marched to war, and still today on particular occasions – such as when the tābot remains outside the church overnight at the festival of baptism – it at least served as a shrine for the protection of the altar tablet. What is uncertain, however, is whether it was ever used as a true altar – as a table for the tābot – during the celebration of the eucharist. The majority of them seem to be too low for this purpose. Nowadays its use has become debased in many places: as a stool for the clergy during the service and as a receptacle for devotional literature. The absence of manbars in most churches and their profusion in others points to their accumulation in inaccessible places in times of war, possibly to protect them from Grāñ's plunderers. One also finds depots of this kind in Lālibalā, Yemreḥanna Krestos and Bēta Leḥēm.

Among the treasures of the church, along with the manbars, are two vessels (fig. 121) and a folding iron stool with a leather seat such as is depicted several times on the walls of Gannata Māryām (fig. 122) and on a relief of the 'Bethlehem' of Dabra Ṣeyon (pl. 53). According to the priest in charge of the church, the church's bells were taken from Grāñ – the little bells are supposed to have tinkled on the neck-strap of his horse. This statement is recorded only as a curiosity.

209 Crucifixion carved within a quatrefoil: relief carved on the top of a manbar. Christ's aureole has been entwined with the semi-circles of the quatrefoil. The decoration of the border has a decidedly Islamic effect. The more important elements in the frieze already appear in the minaret of the mosque of the Fatimid caliph al-Ḥākim in Cairo. It is also conceivably derived from an ornamental Arabic script going back to the Kufic style, a feature repeatedly found in Christian European art – and no better understood there than it would have been by the wood-carver, a Copt perhaps, or his employer. Decorations on hispano-moresque pottery also provide apposite material for comparison. The Geʿez inscription on the aureole reads, 'arbāʿtu ensesā', the Four Living Creatures. Presumably this relates to the manbar's origin – one of the numerous

churches with this dedication, such as *Sauter*, no. 31, in the neighbourhood of Lālibalā. Of course it is not impossible that the 'Four Creatures' of Revelation (4: 6 ff.) and of Ezekiel (1: 5 ff.), although not depicted in the quatrefoil, were nevertheless intended as symbols of the evangelists.

210 The four manbars: show-pieces from the church treasure. The one with figurative decoration is unique in Ethiopia. The side visible in the picture shows the archangel Michael with his cross-topped lance beneath a round arch on stilted columns. The wings of the crowned angel have scaly additions and his decoratively striped garment is richly draped. (For the treatment of the other sides see pls. 209, 211.)

211 The archangel Gabriel with a spear ending in a cross and an orb or paten: carving on the door-side of the manbar of plates 209 and 210. Over his garment Gabriel wears the tippet of the Byzantine emperor, and in other ways, too, he is made to resemble the Basileus. The architectural frame for both the archangels (on opposite sides of the manbar) is the same, as is the chosen decoration: zig-zag pattern on the shafts of the columns, linking the capital and the base; interlacing on the round arch and for the borders palmettes in the spandrels. Ornament compositions decorate the sides between the angels (fig. 123): a semi-circular arch decorated with interlacing, on stilted pillars with stepped base and stepped capitals to match; above this a gable with a cross; palmettes between the slope of the gables and the surrounding meander on the border; beneath the arch, standing out less from the ground of the relief, there is a quatrefoil, presumably regarded as a cross, on supports and with a round arch and gable; a zig-zag pattern with knobs in the field between the slope of the gable and the arch. The inscription reads 'Seraphim . . . and Cherubim'.

The architectural frame employed is well-known from Coptic gravestones. The stepped base, stepped capital and moulded shaft of the pillar belong to the oldest Ethiopian tradition (pl. 24). Details of the decoration – in particular the fillings of the spandrels – are reminiscent of ornament in the churches of Lālibalā and on their processional crosses. There is nothing against dating this masterpiece of wood-carving at the latest to the golden age of rock church architecture, the thirteenth century.

Fig. 122 Folding stool from a mural in Gannata Māryām

Fig. 123 Two sides of the portable altar with archangels and crucifixion.

Additional Sources

In Sauter, Ṭelāsfarri Esṭifānos is no. 63.

On the church: Wright.

On the problem of the portable altar: Coppet, p. 549 ff.; Monti della Corte; Beckingham, vol. 2.

The corresponding Fatimid ornament: Hautecœur/Wiet, vol. 2, pt. 22.

On the ornamental writing: Erdmann; Frothingham; Kühnel, *Maurische Kunst*; Mariën Dugardin.

209 Crucifixion carved within a quatrefoil: relief carved on the top of a manbar.

210 The four manbars: show-pieces from the church treasure.

211 The archangel Gabriel with a spear ending in a cross and an orb or paten: carving on the door-side of the manbar previously shown.

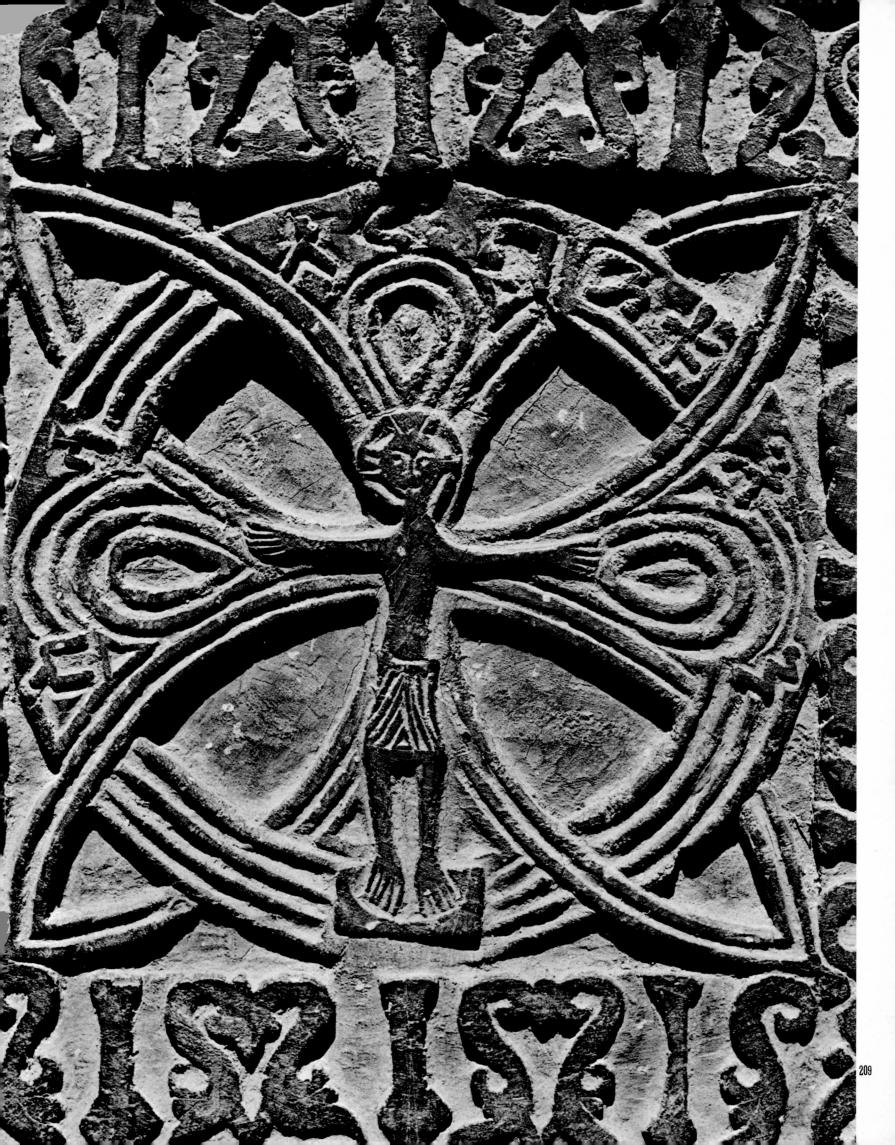

209

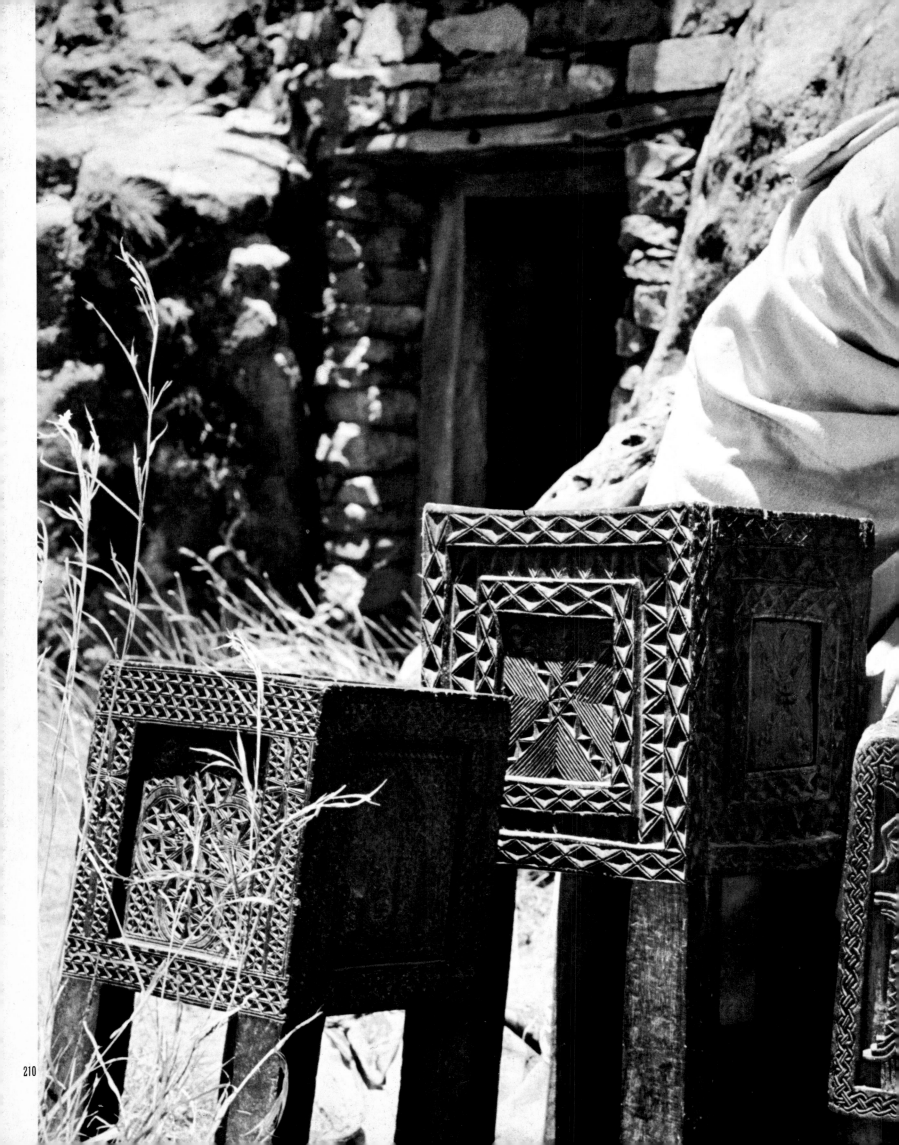

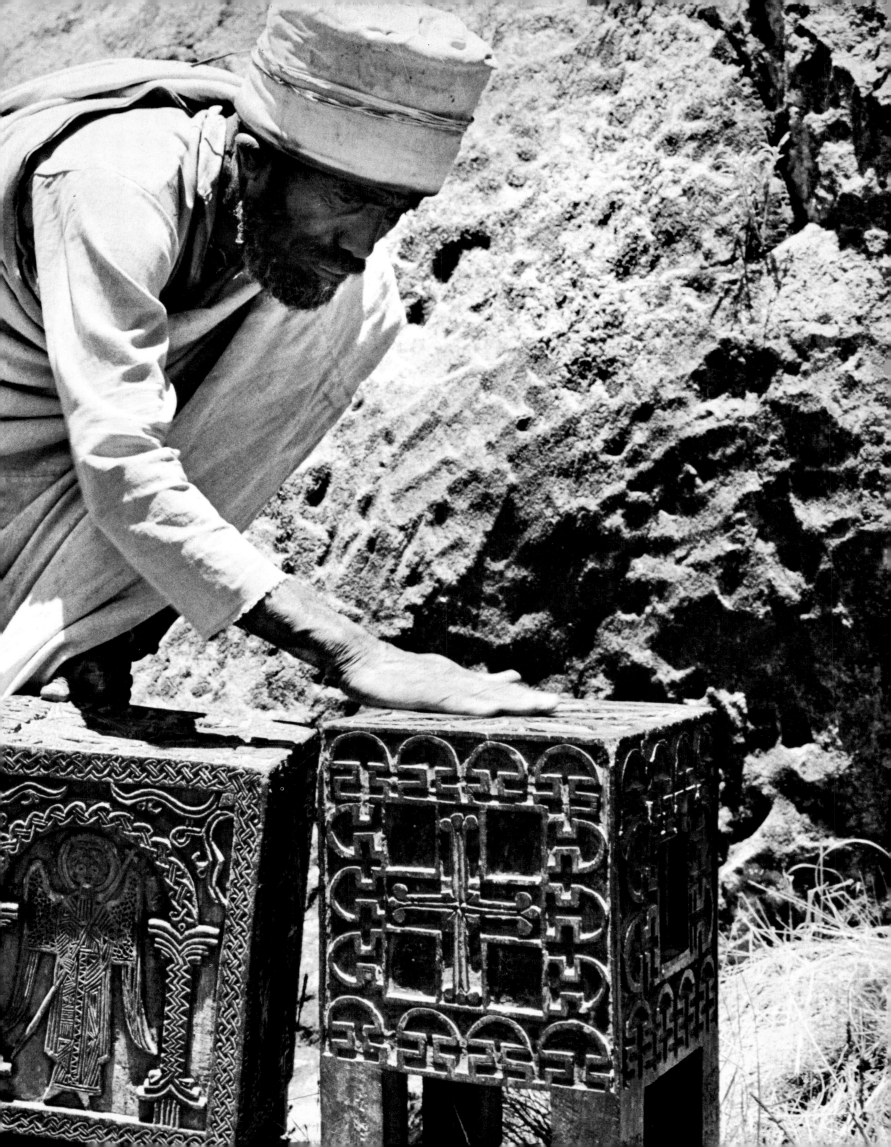

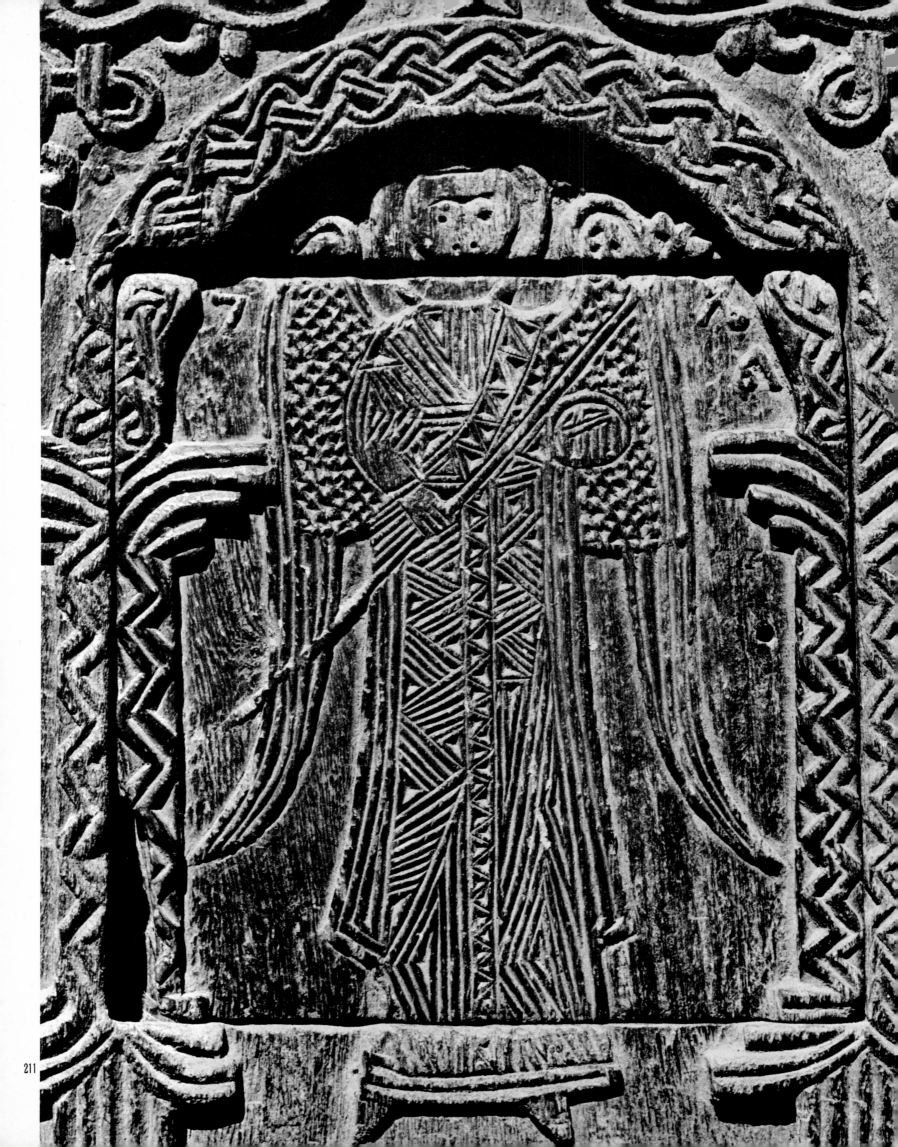

References

In order to reproduce the Ethiopian names of places, people and objects exactly, a system of transliteration has been used in this work which basically enables the re-creation of the original Ethiopic form. E. Hammerschmidt did the work of transliterating, consistently omitting the glottal stop /'/ at the beginning of words: Addis Ababā therefore represents 'Addis 'Ababā.

/ j / is pronounced as in 'jam'
/ č / is approximated by the / ch / in 'church'
/ š / is pronounced as / sh / in 'shop'
/ ʿ / was originally a stronger glottal stop than /'/.

The remaining diacritical points are only of concern to the specialist. It should be noted, however, that in one feature the transliteration attempts phonetic transcription by doubling consonants where they are so pronounced, although this is not indicated in the Ethiopic script. The partial obscuring of familiar word forms – resulting from wild transliterations and inconsistent transcriptions of English, French and Italian origin – is a small price to pay for clarity and consistency. The place whose name is written Weqro in a logical transliteration, appears in *Alvares* as Agroo, in *Lefebvre* as Mariam Corou, in the Italian *Guida* as Uogoro, in *Mordini* as Ucrò and in *Buxton* as Woghoro!

Bibliography

The following list does not attempt to be an exhaustive bibliography, but simply to give full bibliographical references for the additional sources accompanying each chapter. The abbreviation JA stands for Journal Asiatique, Paris; RSE for Rassegna di Studi Etiopici, Rome; JSS for Journal of Semitic Studies, Manchester; AdE for Annales d'Ethiopie, Paris. Hammerschmidt's *Äthiopien* indicates the available bibliographical aids; Sauter, *Où en est notre connaissance,* gives a bibliography of the rock churches virtually complete up to 1963.

Anfray, F.: Première campagne de fouilles à Maṭarā, in: AdE, vol. 5 (1963); *id.:* Une campagne de fouilles à Yĕḥā; in AdE, vol. 5; *id.:* Notre connaissance du passé éthiopien d'après les travaux archéologiques récents, in: JSS, vol. 9 (1964); *id.:* Le musée archéologique d'Asmara, in: RSE, vol. 21 (1965). *Anfray, F. / Annequin, G.:* Maṭarā (Deuxième, troisième et quatrième campagnes de fouilles), in: AdE, vol. 6 (1965). *Alvares, F.:* v. Beckingham/Huntingford. *Annequin, G.:* v. Anfray. *Bailloud, G.:* La préhistoire de l'Ethiopie, in: Cahiers de l'Afrique et de l'Asie, vol. 5. Paris 1959; *id.:* Les gisements paléolithiques de Melka Kontouré, Cahiers de l'Institut Ethiopien d'Archéologie, I, Addis Ababā 1963. *Basset, R.:* Etudes sur l'histoire d'Ethiopie, in JA, vol. 18 (1881). *Beckingham, C. F. / Huntingford, G. W. B.* (ed.): The Prester John of the Indies (... being the narrative of the Portuguese Embassy to Ethiopia in 1520 written by Father Francisco Alvares), 2 vols., Cambridge 1961. *Bianchi Barriviera, L.:* Le chiese monolitiche di Lalibelà e altre nel Lasta-Uagh in Etiopia, Rome 1957[2]; *id.:* Le chiese in roccia di Lalibelà e di altri luoghi del Lasta, in: RSE, vols. 18 (1962) and 19 (1963); *id.:* Le chiese monolitiche di Lalibelà e altre, nel Lasta-Uagh, in Etiopia, in: Fede e Arte no. 4, Rome 1962. *Bidder, I.:* Lalibela, Cologne 1959. *Blanckenburg, W. v.:* Heilige und dämonische Tiere, Leipzig 1943. *Bossert, H. Th.:* Das Ornamentwerk, Berlin 1937. *Brown, L.:* Ethiopian Episode, London 1965. *Buchthal, H.:* An Ethiopic Miniature of Christ Being Nailed to the Cross, in: Atti del convegno internazionale di studi etiopici (1959), Accademia Nazionale dei Lincei, Rome 1960. *Budge, E. A. W.:* The Lives of Maba Seyon and Gabra Krestos, London 1896; *id.:* The Miracles of the Blessed Virgin Mary and the Life of Hanna, London 1900; *id.:* A History of Ethiopia, 2 vols., London 1928. *Buxton, D. R.:* Ethiopian Rock-hewn Churches, in: Antiquity, vol. 20, 1946; *id.:* The Christian Antiquities of Northern Ethiopia, in: Archaeologia, vol. 92 (1947); *id.:* Travels in Ethiopia, London 1957[2]; *id.:* Ethiopian Medieval Architecture – the present state of studies, in: JSS, vol. 9 (1964). *Caquot, A. / Drewes, A. J.:* Les monuments recueillis à Maqallé (Tigré), in: AdE, vol. 1 (1955). *Cerulli, E.:* Gli Etiopi in Palestina, 2 vols., Rome 1943/47; *id.:* Il 'Gesù percosso' nell'arte etiopica e le sue origini nell'Europa del XV secolo, in: RSE, vol. 6 (1947); *id.:* Storia della letteratura etiopica, Milan 1961[2]; *id.:* Il monachismo in Etiopia, Orientalia Christiana Analecta 153, Rome 1958. *Chavaillon, J.:* Melka Konturé, Gisement paléolithique. Campagnes de fouilles 1965 à 1966, in: AdE, vol. 7 (1967). *Contenson, H. de:* Les fouilles à Axoum en 1957, in: AdE, vol. 3 (1959), ... en 1958, in: AdE, vol. 5 (1963); *id.:* Les premiers rois d'Axoum, in: JA, vol. 248 (1960); *id.:* Les principales étapes de l'Ethiopie antique, in: Cahiers d'Etudes Africaines, II (Paris 1961); *id.:* Les monuments d'art sud-arabe découverts sur le site de Haoulti (Ethiopie) en 1959, in: Syria, vol. 39 (1962); *id.:* Les subdivisions dans l'archéologie éthiopienne, in: Revue Archéologique (Jul.–Dec. 1963). *Conti Rossini, C.:* Un codice illustrato eritreo del secolo XV, in: Africa Italiana, I (1927); *id.:* Storia d'Etiopia, Bergamo 1928; *id.:* Il Fisiologo Etiopico, in: RSE, vol. 10 (1951). *Coppet, M. de:* Guèbrè Sellasié: Chronique du règne de Ménélik II, 2 vols., Paris 1931. *Cramer, M.:* Das altägyptische Lebenszeichen im christlichen (koptischen) Ägypten, Wiesbaden 1955; *id.:* Koptische Buch-

malerei, Recklinghausen 1964. *Creswell, K. A. C.:* Early Muslim Architecture, 2 vols., Oxford 1932/1940; *id.:* The Ka'aba in A. D. 608, in Archaeologia, vol. 94 (1951). *Dabbert, H.:* Die monolithenen Kirchen Lalibelas in Äthiopien, Berlin 1938. *Deutsche Aksum-Expedition* (E. Littmann, D. Krencker, Th. von Lüpke), 4 vols., Berlin 1913. *Doresse, J.:* L'empire du Prêtre-Jean, 2 vols., Paris 1957. *Drewes, A. J.:* v. Caquot. *Drower, E. S.:* Water into Wine. A Study of Ritual Idiom in the Middle Eeast, London 1956. *Erdmann, K.:* Arabische Schriftzeichen als Ornamente in der abendländischen Kunst, in: Abh. der Geistes- und sozialwiss. Klasse der Akad. der Wiss. und der Lit. Mainz, Jg. 1953, no. 9 (Wiesbaden 1954). *Ethiopia.* Statistical Abstract, Addis Ababā 1964. *Evans A. J.:* The Palace of Knossos, in: The Annual of the British School at Athens, no. 8 (London 1902). *Felicetti-Liebenfels, W.:* Geschichte der byzantinischen Ikonenmalerei, Olten 1956. *Fenoyl, M. de:* Le sanctoral copte, Beirut 1960. *Findlay, L.:* The Monolithic Churches of Lalibela in Ethiopia, Cairo 1944. *Frantz, M. A.:* Byzantine Illuminated Ornament, in: The Art Bulletin, vol. 16 (1934). *Frothingham, A. W.:* Lustreware of Spain, New York 1951. *Gerster, G.:* Nubien, Zürich 1964; *id.:* Besuch in Bethlehem, in: Neue Zürcher Zeitung (NZZ), Das Wochenende nos. 80/81, 1965; *id.:* Mariä Paradies, in: NZZ, Das Wochenende nos. 86/87, 1965; *id.:* Drei Felskirchen in Tigre, in: NZZ, Das Wochenende nos. 3/4, 1966; *id.:* Die Michaelskirche von Debra Selam, in: NZZ, Das Wochenende nos. 78/79, 1966. *Gjärder, P.:* The Beard as an Iconographical Feature in the Viking Period and the Early Middle Ages, in: Acta Archaeologica, vol. 35 (Copenhagen 1964). *Griaule, M.:* Règles de l'Eglise in: JA, vol. 221 (1932); *id.:* Peintures abyssines, in: Le Minotaure, I (1933). *Grohmann, A.:* Äthiopische Marienhymnen, in: Abh. der Sächs. Akad. der Wiss., Philol.-histor. Klasse, vol. 33, no. 4 (Leipzig 1919). *Guida dell'Africa Orientale Italiana*, Milan 1938. *Hammerschmidt, E.:* Die koptische Gregoriosanaphora (Text, Übers., Kommentar), Berlin 1957; *id.:* Äthiopische liturgische Texte der Bodleian Library in Oxford, Berlin 1960; *id.:* Studies in the Ethiopic Anaphoras, Berlin 1961; *id.:* Kultsymbolik der koptischen und der äthiopischen Kirche, in: Symbolik der Religionen, vol. 10, Stuttgart 1962; *id.:* Stellung und Bedeutung des Sabbats in Äthiopien, Stuttgart 1963; *id.:* Symbolik des orientalischen Christentums (Tafelband), in: Symbolik der Religionen, vol. 14, Stuttgart 1966; *id.:* Äthiopien, Wiesbaden 1967. *Hanssens, J. M. / Raes, A.:* Une collection de tâbots au Musée Chrétien de la Bibliothèque Vaticane, in: Orientalia Christiana Periodica, vol. 17, Rome 1951. *Hautecœur, L.:* Mystique et architecture, Paris 1954. *Hautecœur, L. / Wiet, G.:* Les Mosquées du Caire, 2 vols., Paris 1932. *Hennig, R.:* Terrae Incognitae, II (200–1200 n. Chr.), Leiden 1937. *Hövermann, J.:* Bauerntum und bäuerliche Siedlung in Äthiopien, in: Die Erde, no. 89 (Berlin 1958). *Hommel, F.* (tr.): Der äthiopische Physiologus, in: Romanische Forschungen, vol. 5, Erlangen 1890. *Huntingford, G. W. B.:* v. Beckingham. *Hyatt, H. M.:* The Church of Abyssinia, London 1928. *International Fund for Monuments* (ed.): Lalibela – Phase I, New York 1967. *Jäger, O. A.:* Äthiopische Miniaturen, Berlin 1957; *id.:* Some Notes on Illuminations of Manuscripts in Ethiopia, in: RSE, vol. 17 (1961); *id.:* see also Leroy. *Koptische Kunst.* Christentum am Nil (Ausstellungskatalog), Essen 1963. *Krencker, D.:* v. Deutsche Aksum-Expedition. *Kühnel, E.:* Maurische Kunst, Berlin 1924; *id.:* Islamische Kleinkunst, Brunswick 1963. *Kuls, W.:* Bevölkerung, Siedlung und Landwirtschaft im Hochland von Godjam, Frankfurt a. M. 1963. *Landström, B.:* Shepped, Stockholm 1961. *Leclant, J.:* Les fouilles à Axoum en 1955–1956, in: AdE, vol. 3 (1959); *id.:* Haoulti-Melazo (1955–1956), in: AdE, vol. 3 (1959); *id.:* Frühäthiopische Kultur, in: Christentum am Nil, Internationale Arbeitstagung zur Ausstellung 'Koptische Kunst' in Essen, Recklinghausen 1964; *id.:* Le Musée des Antiquités d'Addis-Ababa, in: Bull. de la Soc. d'Archéol. Copte, vol. 16 (Cairo 1962). *Lefebvre, Th.:* Voyage en Abyssinie, 6 vols., Paris 1845–1848. *Lefebvre des Noëttes, Ct.:* L'attelage et le cheval de selle à travers les âges, vol. 2, Paris 1931. *Leroy, J.:* Objectifs des recherches sur la peinture religieuse éthiopienne, in AdE, vol. 1 (1955); *id.:* L'évangéliaire éthiopien du couvent d'Abba Garima et ses attaches avec l'ancien art chrétien de Syrie, in: Cahiers archéologiques, vol. 11 (1960); *id.:* L'évangéliaire éthiopien illustré du British Museum (Or. 510) et ses sources iconographiques, in: AdE, vol. 4 (1961); *id.:* Recherches sur la tradition iconographique des Canons d'Eusèbe en Ethiopie, in: Cahiers archéologiques, vol. 12 (1961); *id.:* Une 'Madonna italienne' conservée dans un manuscrit éthiopien du British Museum, in: RSE, vol. 18 (1962); *id.:* Pittura etiopica, Milan 1964; *id.:* Notes d'archéologie et d'iconographie éthiopiennes, in: AdE, vol. 6 (1965). *Leroy, J. / Wright, St. / Jäger, O. A.:* Ethiopia. Illuminated Manuscripts, Paris 1961. *Lipsky, G. A.:* Ethiopia, New Haven 1962. *Littmann, E.:* Indien und Abessinien, in: Beiträge zur Literaturwissenschaft und Geistesgeschichte Indiens, Bonn 1926; *id.:* see also Deutsche Aksum-Expedition. *Lüpke, Th. v.:* v. Deutsche Aksum-Expedition. *Mariën Dugardin, A.-M.:* Un plat hispano-moresque, in: Bull. des Musées Royaux d'Art et d'Histoire, Brussels 1965. *Matthew, A. F.* (tr.): The Teaching of the Abyssinian Church as set forth by the Doctors of the Same, London 1936. *Matthews, D. H.:* The Restoration of the Monastery Church of Debra Damo, in: Antiquity, vol. 23 (1949). *Matthews, D. H. / Mordini, A.:* The Monastery of Debra Damo, in: Archaeologia, vol. 97 (1959). *Meiss, M.:* Ovum Struthionis, in: Studies in Art and Literature for Belle da Costa Greene, Princeton 1954, *Michalowski, K.:* Faras, Zürich 1966. *Miquel, A.:* Reconnaissance dans le Lasta, in: AdE, vol. 3 (1959). *Moll, Fr.:* Das Schiff in der bildenden Kunst, Bonn 1929. *Monneret de Villard, U.:* Storia della Nubia cristiana (Orientalia Christiana Analecta, vol. 118, Rome 1938); *id.:* Note sulle più antiche miniature abissine, in: Orientalia, vol. 8 (Rome 1939); *id.:* La chiesa monolitica di Yakkā Mikā'ēl, in: RSE, vol. 1 (1941); *id.:* La Majestas Domini in Abissinia, in: RSE, vol. 3 (1943); *id.:* La Madonna di S. Maria Maggiore e l'illustrazione dei miracoli di Maria in Abissinia, in: Annali Lateranensi, vol. 11 (1947); *id.:* La 'Coronazione della Ver-

gine' in Abissinia, in: La Bibliofilia, vol. 44 (1962). *Monti della Corte, A. A.:* Lalibelà, Rome 1940. *Mordini, A.:* La chiesa ipogea di Ucrò (Ambà Seneiti) nel Tigrai, in: Annali dell'Africa Italiana, vol. 2 (Rome 1939); *id.:* Un'antica porta in legno proveniente della chiesa di Gunaguna (Scimezana), in: Rivista degli Studi Orientali, vol. 19 (Rome 1940); *id.:* Il soffitto del secondo vestibolo dell'endā abuna Aragāwi in Dabra Dāmmò, in: RSE, vol. 6 (1947); *id.:* Un'antica pittura etiopica, in RSE, vol. 11 (1952); *id.:* Il convento di Gunde Gundiè, in: RSE, vol. 11 (1953); *id.:* La chiesa di Aramò, in: RSE, vol. 15 (1959); *id.:* L'architecture chrétienne dans l'Ethiopie du Moyen Age, in: Cahiers d'Etudes africaines, vol. 2 (Paris 1961); *id.:* La chiesa di Baraknaha, in: AdE, vol. 4 (1961); *id.:* Uno sconosciuto capolavoro dell'arte etiopica, in: antichità viva, no. 8 (Florence 1962); *id.:* L'église rupestre de Woqro-Maryâm, in: L'Ethiopie d'Aujourd'hui, Nov./Dec. 1962 (Addis Ababā); *id.:* Die äthiopischen Kirchen, in: Koptische Kunst, Ausstellungskatalog, Essen 1963; *id.:* La reconnaissance et la préservation des anciennes églises éthiopiennes, Lucca 1964; *id.:* Indagini sul convento di Gunde Gundiè e su problemi di storia medioevale etiopica; in: Mélanges Eugène Tisserant, Vatican City 1964; *id.:* see also Matthews. *O'Leary, De Lacy:* The Saints of Egypt, London 1937. *Pakenham, Th.:* Bethlehem in Ethiopia, in: The Illustrated London News, no. 6144 (9. III. 1957); *id.:* The Mountains of Rasselas, London 1959. *Perruchon, J.:* Vie de Lalibela, Paris 1893. *Petersen, Th.:* The Paragraph Mark in Coptic Illuminated Ornament, in: Studies in Art and Literature for Belle da Costa Greene, Princeton 1954. *Pirenne, J.:* Chronique d'archéologique sudarabe, in: AdE, vol. 2 (1957); *id.:* Un probléme-clef pour la chronologie de l'Orient: la date du Périple de la mer Erythrée, in: JA, vol. 249 (Paris 1961); *id.:* Arte sabeo d'Etiopia, in: Enciclopedia dell'arte antica, vol. 6 (Rome 1965). *Playne, B.:* St George for Ethiopia, London 1954. *Raes, A.:* v. Hanssens. *Raunig, W.:* Die Bedeutung des Periplus des erythräischen Meeres für Afrika, in: Mitt. der Anthropolog. Gesell. Vienna, vol. 95 (1965). *Réau, L.:* Iconographie de l'Art Chrétien, 3 vols., Paris 1955 ff. *Ricci, L.:* Note Marginali, in RSE, vol. 15 (1959); *id.:* Besprechung des Buchs 'I. Bidder, Lalibela', in: Rivista degli Studi Orientali, vol. 35 (Rome 1960). *Rice, D. T.* (ed.): The Dawn of Civilization, London 1965. *Richard, J.:* L'extrême-orient légendaire au Moyen-âge, in: AdE, vol. 2 (1957). *Sadwa, P.:* Un manoscritto etiopico degli Evangeli, in: RSE, vol. 11 (1952). *Sauer, J.:* Symbolik des Kirchengebäudes und seiner Ausstattung, Freiburg i. Br. 1924². *Sauter, R.:* L'église monolithe de Yekka-Mikael, in: AdE, vol. 2 (1957); *id.:* Où en est notre connaissance des églises rupestres d'Ethiopie, in: AdE, vol. 5 (1963); *id.:* L'arc et les panneaux sculptés de la vieille église d'Asmara (provisionally for publ. in RSE). *Schnyder, R.:* Maria Schnee in Abessinien, in: Weihnachtsausgabe 1963 der Neuen Zürcher Zeitung. *Simoons, F. J.:* Northwest Ethiopia, Madison 1960. *Skehan, P. W.:* An Illuminated Gospel Book in Ethiopia, in: Studies in Art and Literature for Belle da Costa Greene, Princeton 1954. *Staude, W.:* Les peintures de l'église d'Abba Antonios (Gondar), in: Gazette des Beaux-arts, 1934 (p. 94–108); *id.:* Die Profilregel in der christlichen Malerei Äthiopiens und die Furcht vor dem 'Bösen Blick', in: Archiv für Völkerkunde, vol. 9 (Vienna 1954); *id.:* Die ikonographischen Regeln in der äthiopischen Kirchenmalerei, in: Archiv für Völkerkunde, vol. 13 (Vienna 1958); *id.:* Etude sur la décoration picturale des églises Abba Antonios de Gondar et Debra Sina de Gorgorà, in: AdE, vol. 3 (1959); *id.:* Une peinture éthiopienne dans l'église de Bēta-lehem, in: Revue de l'Histoire des Religions, vol. 156 (Paris 1959). *Stiehler, W.:* Studien zur Landwirtschafts- und Siedlungsgeographie Äthiopiens, in: Die Erdkunde, vol. 2 (Bonn 1948). *Tekle Tsadik Mekuria:* Le roi Zera Yaicob et sa lettre, in: Christentum am Nil, Recklinghausen 1964. *Trimingham, J. S.:* Islam in Ethiopia, London 1952. *Troll, C.:* Die kulturgeographische Stellung und Eigenart des Hochlandes von Äthiopien zwischen dem Orient und Äquatorialafrika, in: Atti del convegno internazionale di studi etiopici (1959), Accademia Nazionale dei Lincei, Rome 1960. *Ullendorff, E.:* Hebraic-Jewish Elements in Abyssinian (Monophysite) Christianity, in: JSS, vol. 1 (1956); *id.:* The Ethiopians, London 1965². *Werdecker, J.:* Untersuchungen in Hochsemien, Mitt. d. Geogr. Ges. Wien, vol. 100 (1958); *id.:* Geographische Forschungen in Nordäthiopien, in: Festgabe für Friedr. Trost, Darmstadt 1961. *Wiet, G.:* v. Hautecœur. *Wright, St.:* Notes on some Cave churches in the province of Wallo, in: AdE, vol. 2 (1957); *id.:* see also Leroy.

The contributors

Buxton, David R., was born in 1910. He spent seventeen years in Africa, working part of the time for the British Colonial Service and the British Council, originally as an entomologist. Seven years of this time (1942–1949) he spent in Ethiopia (Travels in Ethiopia, London, 1949, 1957²), where his personal interest in architecture had great scope for enrichment. He was a pioneer in the investigation of Ethiopia's medieval monuments. His relevant scholarly publications are noted in the bibliography. Since 1962 he has lived in Cambridge, England, where he has a research fellowship at Clare Hall.

Caquot, André, born in 1923, teaches at the Ecole Pratique des Hautes Etudes (Sciences Religieuses à la Sorbonne), Paris. He was one of the founders of the Imperial Ethiopian Institute of Archaeology in Addis Ababā and is co-editor of the Annales d'Ethiopie. He has edited several Ethiopic texts in this periodical and published studies on Ethiopian history.

Hammerschmidt, Ernst, born in 1928, is Außerordentlicher Professor für Orientalistik at the University of the Saarland in Saarbrücken. He is an Austrian citizen. For some years his studies in the Semitic field have been concentrated on Ethiopia. His double competence as philologist and theologian has been used especially in his studies of liturgical history. His most important works relating to Ethiopia are mentioned in the bibliography.

Leclant, Jean, born in 1920, is Professor of Egyptology at the Sorbonne. From the beginning, his attention to archaeology and linguistics has not been confined to Egypt but has been extended to the upper (Sudanese) Nile valley and to the routes into Ethiopia. He was one of the founders of the Imperial Ethiopian Institute of Archaeology in Addis Ababā and is a co-editor of Annales d'Ethiopie. His most important works relating to Ethiopia are mentioned in the bibliography.

Leroy, Jules, was born in 1903. He is a chargé de recherche of the Centre National de la Recherche Scientifique in Paris. His principal field of research is the art of the Christian Near East (principally of Syria and Mesopotamia). As part of these studies he has visited the Ethiopian interior several times since 1959, partly as leader of a small group of archaelogists which France placed at the disposal of the Emperor Ḥāyla Sellāsē. His relevant publications are mentioned in the bibliography.

Mordini, Antonio, born in 1904, was head of the Servizio Etnografico of Italian East Africa, which also looked after archaeological matters. Along with Ethiopia, South Arabia is one of his special interests. For a time he was a co-editor of the Rassegna di Studi Etiopici in Rome. Over one hundred publications, the majority of which deal with Ethiopian architecture. The most important are noted in the bibliography. At present he lives at Barga, Lucca (Italy).

Sauter, Roger, was born in 1919. He spent twenty-two years in Ethiopia, being editor of the weekly journal L'Ethiopie d'Aujourd'hui in Addis Ababā from 1955–1957 and for the following ten years was a science teacher at Aśmarā. Inspired by a visit to Lālibalā in 1948, he began systematically collecting all the information about the Ethiopian rock churches and in 1963 published the list, which developed into a comprehensive inventory of these monuments, indispensable to those seriously interested in the subject (see the references in the bibliography). Since 1968 he has lived and taught in his home town, Geneva.

Schneider, Roger, was born in Luxemburg in 1917. He went to Ethiopia in 1956 on behalf of the French Centre National de la Recherche Scientifique, and since 1957 has worked for the Imperial Ethiopian Institute of Archaeology in Addis Ababā, primarily on linguistic and epigraphic questions. He wrote the chapter on Ethiopian literature for the Encyclopédie de la Pléiade and has published articles on particular problems of language and epigraphy.

The photographs

The author took the 211 photographs in this book between 1964 and 1967. With the exception of three exposures with the 'fish eye', they were taken with a Leica M 3 and with Leica lenses of every focal length on Ilford black-and-white film and Kodak colour film.

Sources of the text figures.

Pictures within the text or in the margin and for which no source has been indicated have been drawn by A. Gerster of Schaffhausen from the author's photographs. In a few cases (as indicated) he corrected the earlier sources in accordance with information provided by the author.

My thanks go to the editors of the Annales d'Ethiopie for figs. 7, 10, 11 and 12; to the Society of Antiquaries, London, for figs. 30, 32, 33 and 34 from Archaeologia, vol. 97; to A. Mordini, of Barga, for figs. 98, 99 and 100; and to the Imperial Ethiopian Institute of Archaeology, Addis Ababā, for fig. 115. The Jabal 'Addā expedition of the American Research Centre in Cairo and the National Geographic Society in Washington have kindly given permission for the preparation and publication of fig. 3. I am deeply indebted to L. Bianchi Barriviera of Rome for permitting me to reproduce numerous ground-plans, sections, etc., of the churches in and around Lālibalā. In considering the aesthetic quality of these masterly architectural drawings, the reader should bear in mind that they are simply reductions, taken from their artistic context, of etchings measuring 63 × 59 cm. The engravings first appeared in 1948 in Rome in an edition of two copies, with the title, 'Le chiese monolitiche

di Lalibelà e altre nel Lasta-Uagh in Etiopia' (60 stampe originali all'acquaforte di Lino Bianchi Barriviera, le vedute sono riprese dal vero, le tavole architettoniche sono state elaborate dall'autore sui rilievi di Elio Zacchia, ricognizione archeologica 1939 condotta da A. A. Monti della Corte). A second edition of 25 copies appeared in 1957. Reduced reproductions of the engravings accompanied Bianchi Barriviera's articles in vol. 18 (1962) and vol. 19 (1963) of the Rassegna di Studi Etiopici (Rome) as well as in Fede e Arte (no. 4, Rome, 1962). The artist himself brought the subjects to be reproduced in this volume up to date, with respect to the restoration work done in Lālibalā since 1948. Nevertheless, the author is solely responsible for the slight alterations, such as rearrangement of orientation signs, scale and the like, resulting from the new use of these engravings.

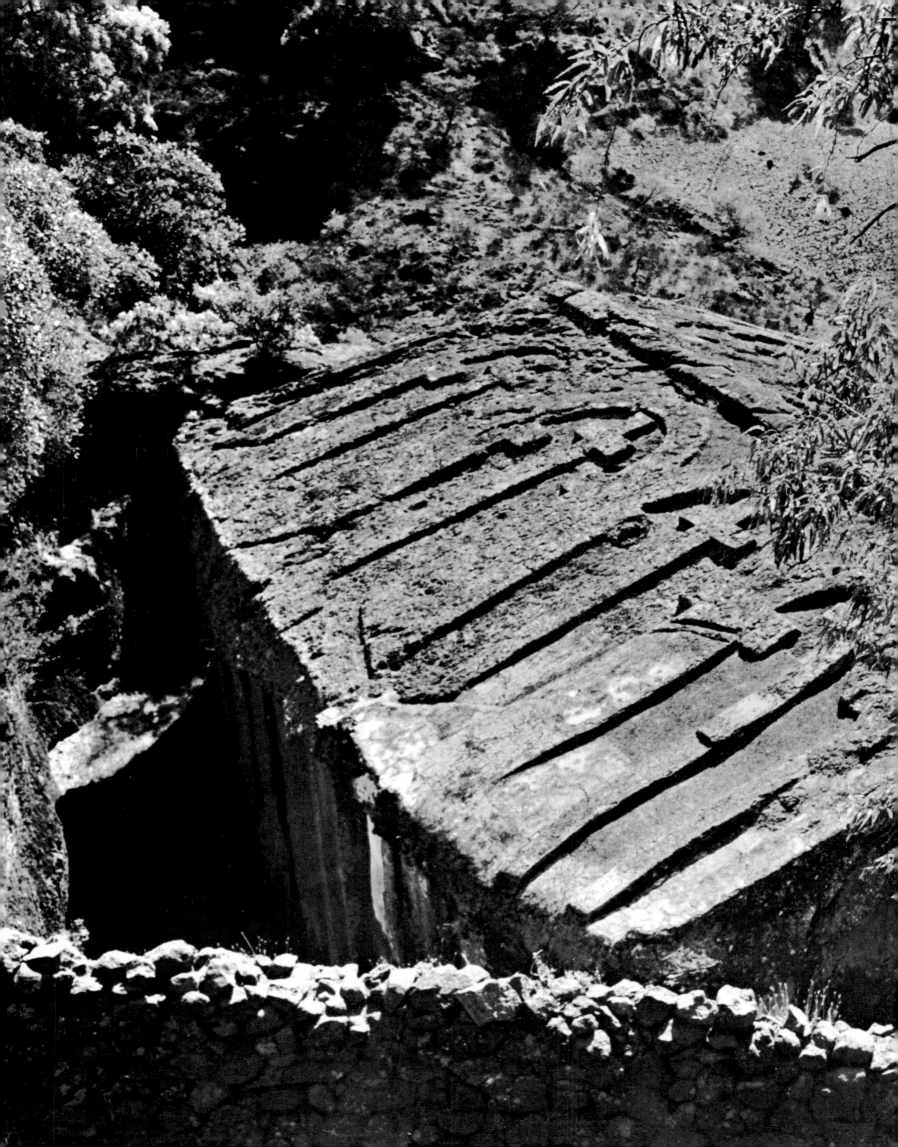